ALFRED STIEGLITZ

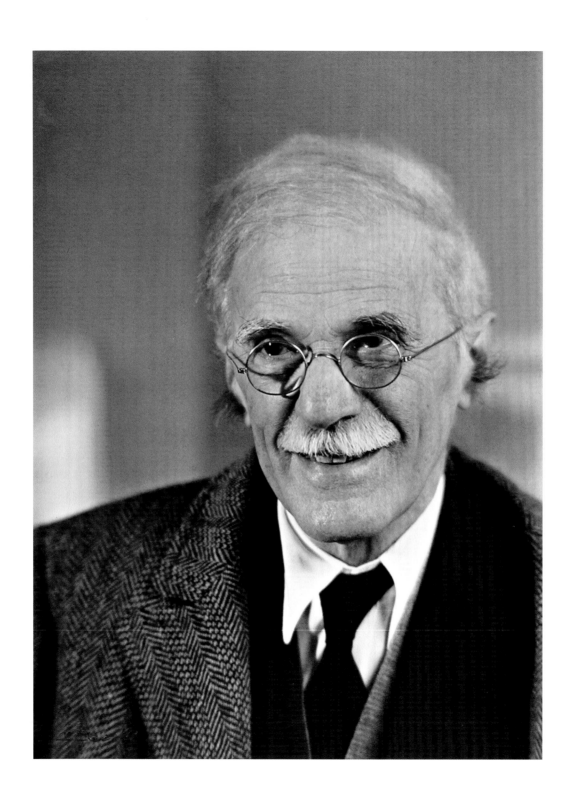

ALFRED STIEGLITZ

A Legacy of Light

Katherine Hoffman

Yale University Press New Haven & London

Designed by Paul Sloman

Printed in Singapore

Library of Congress Cataloging-in-Publication Data

Hoffman, Katherine, 1947-

Alfred Stieglitz : a legacy of light / Katherine Hoffman.

p. cm.

Includes bibliographical references and index.

ISBN 978-0-300-13445-2 (hardback)

1. Stieglitz, Alfred, 1864-1946. 2. Photographers--United

States--Biography. 3. O'Keeffe, Georgia, 1887-1986. 4. Modernism

(Art)--United States. I. Title.

TR140.S7H639 2011

770.92--dc22

[B]

2010049411

A catalogue record for this book is available from

The British Library

Frontispiece: Lotte Jacobi, *Alfred Stieglitz, c.*1939,

Currier Museum of Art, Manchester, New Hampshire.

Gift of Bernadette Hunter, 1986. 11.1.8

To my children,
Kristen, Geoffrey, and Ashley,
my granddaughters, Leyla and Audrey,
my grandson, Liam,
and my husband, Graham.
With much love.

So, while the light fails
On a winter's afternoon, in a secluded chapel
History is now . . .
With the drawing of this Love and the voice of this Calling
We shall not cease from exploration
And the end of all our exploring
Will be to arrive where we started
And know the place for the first time.
Through the unknown, remembered gate
When the last of earth left to discover
Is that which was the beginning;
At the source of the longest river
The voice of the hidden waterfall
And the children in the apple-tree
Not known, because not looked for
But heard, half-heard, in the stillness
Between two waves of the sea.
Quick now, here, now always-
A condition of complete simplicity
(Costing not less than everything)
And all shall be well and
All manner of thing shall be well
When the tongues of flame are in-folded
Into the crowned knot of fire
And the fire and the rose are one.

 – T. S. Eliot, *The Four Quartets*. "Little Gidding," 1942[1]

The deep parts of my life pour onward,
as if the river shores were opening out.
It seems that things are more like me now,
that I can see farther into paintings.
I feel closer to what language can't reach.
With my senses, as with birds, I climb
into the windy heaven, out of the oak,
and in the ponds broken off from the sky
my feeling sinks, as if standing on fishes.

 –Rainer Maria Rilke[3]

We're all after Light – ever more Light. So why not seek it
together – as individuals in sympathy in a strong unsentimental
spirit – as men – not politicians.

 –Alfred Stieglitz to Hart Crane, 1923[5]

CONTENTS

Acknowledgments

8

Author's note

9

Introduction

11

The Early Years: 1864–1914

15

The Teens: 1915–1919

49

The Twenties

135

The Thirties

261

The Forties

379

Epilogue

411

Notes

413

List of Illustrations

424

Appendix:

Exhibitions in Stieglitz's Galleries, 1905–1946

438

Selected Bibliography

449

Index

466

ACKNOWLEDGMENTS

This book has been a long road of ups and downs. Instead of a long list of names, I would like to acknowledge a few individuals and those institutions that were particularly helpful. Institutions include the Beinecke Rare Book and Manuscript Library at Yale University, the Art Institute of Chicago, the Georgia O'Keeffe Foundation in Santa Fe, the Philadelphia Museum of Art, the Metropolitan Museum of Art in New York, the J. Paul Getty Museum in Los Angeles, the Lee Gallery in Winchester, Massachusetts, the Adirondack Museum, in Blue Mountain Lake, New York, the National Gallery of Art, Washington, D.C., and the interlibrary loan department at St. Anselm College, Manchester, New Hampshire, along with other institutions from whom I procured illustrations. I am particularly grateful to the University of Memphis, where I served as the Dorothy K. Hohenberg Chair of Excellence in Art History for spring 2009. There I was given some time to write, along with teaching, and am grateful for some financial assistance toward the cost of illustrations. Meghan Strong, my graduate assistant in Memphis, is to be commended for her diligence in assisting with clerical work during that semester. In New Hampshire, I was grateful for the clerical assistance of Patricia Wood, who helped me with the final stages of the manuscript. The previous scholarship of those such as William Homer, Peter Bunnell, Sarah Greenough, and Richard Whelan, served as important foundations for the project. Gillian Malpass, my editor, is to be thanked for her support of the book, along with serving as editor for my first book on Stieglitz, *Stieglitz: A Beginning Light*.

Above all, I must thank my family, for the time I stole from them to work on this book – to my husband, Graham Ward, who patiently accompanied me on some of my research trips to New York, New Haven, and Lake George, and experienced with me various personalities from ill-tempered security guards to hospitable innkeepers. He, in particular, endured my unpredictable, sometimes frantic working hours. Thank you to my three wonderful children, Kristen, Geoffrey, and Ashley, for their support of the project. Their own creativity, sense of humanity, and awareness of the power of photography, as their studies send them throughout the globe from France to South Africa to Iraqi Kurdistan, and other places, is admirable.

Thank you also to one small little girl, my lovely, three-year-old granddaughter, Leyla, who, in her short life, has reminded us all of the power of the individual spirit, of wonder, of awe, of bringing new eyes to the world. It is for that continued sense of spirit, both inner and outer, and the freedom to create, that Stieglitz fought so tirelessly, and it is to that artistic spirit that this book is ultimately dedicated.

AUTHOR'S NOTE

As noted in the Introduction, I have included some material from my first book on Stieglitz that focused on his life and work up to 1917, the year his gallery, 291, closed. In 1917, Stieglitz was fifty-three; over half his life was over. A number of important influences, including his European heritage and experiences, had already become an integral part of the complex tapestry that made up his life and work. I have thus chosen to include some substantive quotations and have attempted to paraphrase, or summarize, some of the significant material from my first book, wanting the reader to be able to see in one volume some of the continuous threads that ran through Stieglitz's career. For further specific details and more photographs from Stieglitz's early years, it is hoped the reader will turn to *Stieglitz: A Beginning Light* (Yale University Press, 2004). I apologize for any overlap, but, like Stieglitz, who often repeated important concepts in his own writing in his career-long fight for photography to be recognized as a fine art, I have wanted to convey the distinctive strands, as well as the lasting "Light" of Stieglitz's career, that include its foundations, its cultural content, and its legacy for the future.

illustrations

Owing to circumstances and situations beyond my control or understanding, as well as expense, it is regrettable that it was impossible to obtain permission to reproduce a number of illustrations that were initially intended for this book. Some photographs are described in depth, to give the reader a sense of the visual image. The reader is referred to the National Gallery of Art's comprehensive two-volume catalogue by Sarah Greenough of 2002, the *Key Set* of Stieglitz's photographs, which were given to the museum by Georgia O'Keeffe. Therein are some of the images that are described but not reproduced. It is hoped that those illustrations that are reproduced here will serve as representative examples of Stieglitz's rich body of work, as well as of the work by those people whom he influenced and with whom he worked. Several similar illustrations were selected to show Stieglitz's working methods and his interest in subtle changes in lighting, position of subjects, hand gestures, and so on.

To those institutions that provided images, grateful thanks are extended: in particular, I thank the Art Institute of Chicago for its prompt and helpful service.

To the best of my ability, I have attempted to supply all appropriate copyright information.

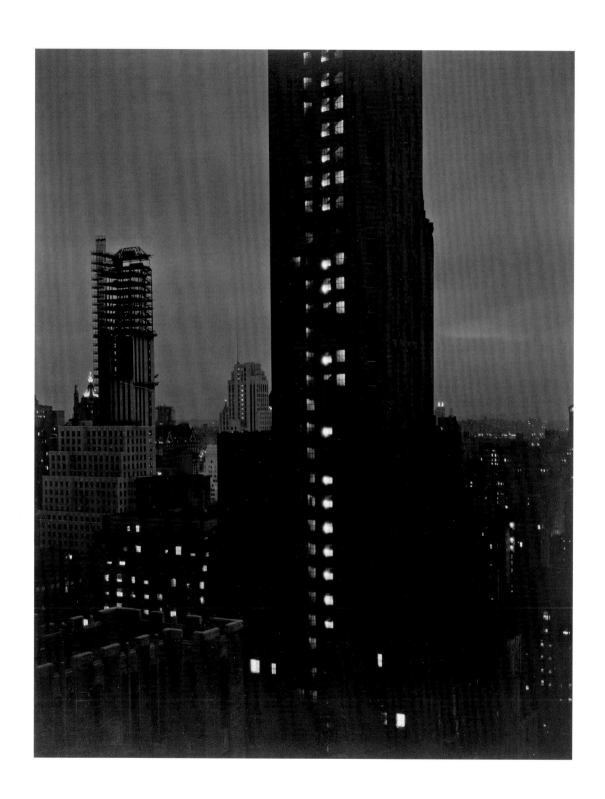

INTRODUCTION

Many decades have passed since the invention of the first practical form of photography, the daguerreotype, was announced at the Academy of Sciences in 1839 and Louis-Jacques Mandé Daguerre noted, "I have seized the light. I have arrested its flight."[1] Oliver Wendell Holmes, Jr. realized the power of the new discovery as he wrote,

> Wondering over the photograph, as a charming novelty; but before another generation has passed away, it will be recognized that a new epoch in the history of human progress dates from the time when he who never but in uncreated life dwelt from eternity took a pencil of fire from the hand of the angel standing in the sun, and placed it in the hands of a mortal.[2]

Early in the twentieth century, Pablo Picasso stated, "I have discovered photography. Now I can kill myself. I have nothing else to learn."[3] Henri Cartier-Bresson, who photographed Stieglitz in his late years, wrote, "Taking photographs . . . is a way of shouting, of freeing oneself, not of proving or asserting one's own originality. It is a way of life."[4] Photography in the twenty-first century has become a significant art form, a recognition for which Alfred Stieglitz fought throughout his career. Record-setting sales, along with numerous exhibits devoted exclusively to the photographic medium, attest to the influence and power of photography. On 14 February 2006, as an example, Edward Steichen's 1904 pictorialist photograph, *The Pond Moonlight*, sold at auction at Sotheby's in New York City for 2.9 million dollars (U.S.). According to the Sotheby's catalogue, Stieglitz's gallery 291 had sold the Steichen print for $75 in 1906 (approximately $1,500 in current prices). At the same sale, two of Stieglitz's photographs sold for more than one million dollars; one of the images titled *Hands* focused on Georgia O'Keeffe's hands, raised in a dramatic pose.[5]

I have been studying Georgia O'Keeffe and Alfred Stieglitz, on and off, for many years since I was a graduate student in the mid-1970s. Although I have pursued other projects and interests, I have continued to be drawn to the Stieglitz Circle, in more recent years, the photographs of

1 Alfred Stieglitz, *From My Window at the Shelton North*, 1931. The J. Paul Getty Museum.

Stieglitz and those with whom he was associated. Like Stieglitz, I have long been interested in clouds, painting and photographing them at various times in my career, as well as studying other artists' depictions of them. Like Stieglitz, I have returned each summer for most of my life to a clear blue mountain lake and its surrounding vistas, which continue to draw my family and friends from multiple generations, as Lake George did for Stieglitz and his family. The power of place can indeed be immense.

I wrote my first book on Stieglitz, *Stieglitz: A Beginning Light*, in the dark shadows of September 11, 2001. I wrote this second volume following the controversial election of Barack Obama as President of the United States, still in the shadows of death and destruction in the Iraq war and Afghanistan. Much of the manuscript was written in Memphis, Tennessee, where I was grateful to serve as the Dorothy K. Hohenberg Chair of Excellence in Art History, during the spring semester 2009. I was keenly aware that I was writing in a city that still suffered from racial problems, that I lived only fifteen minutes from the site of Martin Luther King's assassination, the Lorraine Motel in downtown Memphis, on that fatal 4 April day in 1968. Furthermore, I was writing during a significant downturn in a once buoyant United States and global economy, frequently hearing of those losing jobs, pension, and so on, along with the excesses of corporate executives in the past decade. One might ask what such details have to do with Alfred Stieglitz. Stieglitz fought tirelessly for the freedom to create, in an atmosphere that fostered freedom of thought and creativity; and for the integrity of artists and other individuals, who expressed their inner spirits. He also fought against excessive materialism and profit, and warned about the dangers of institutionalization and the powers associated with them. As he wrote to Guido Bruno, as early as 1916, "The abuse of freedom is undeniably greater than the understanding of what freedom really is."[6]

Stieglitz's life and work may be seen as a continuum that progressed from his early work in Europe to his final photographic images taken at Lake George and from the top floors of his New York City gallery, or apartment space, as he, an older man, contemplated the urban and rural worlds that he had known for many years. I have included here some material (especially quotations from others) from my first book, *Stieglitz: A Beginning Light*, since part of his early work and European influences continued to be significant throughout his career. I have also included a substantial number of excerpts from letters, many published here for the first time, by and to Stieglitz, feeling that the actual words, and "tone of voice," that cannot be experienced through paraphrasing or summarization are important for readers. It is clear, after reading numerous letters between O'Keeffe and Stieglitz, which had been sealed for fifty years following Stieglitz's death in 1946 and were opened in 2006 (but closed since January 2009), that the art and craft of letter writing was an integral part of Stieglitz's personal life and professional work. I could by no means read all the letters. Those that I did read show a man of intense emotional make-up, powerful on some days, quite fragile on others. The letters record the quotidian details

and activities of Stieglitz from weather observations to what he ate, doing errands, to conversations with various visitors to his galleries and his home, in New York City and at Lake George, to philosophical and metaphysical reflections. The letters also document what Stieglitz was reading, his response to various world events, along with exhibits or events in the art world, at his galleries and elsewhere. Many of the letters are passionate, some expressing his love for O'Keeffe, or his despair following a crisis in their relationship; others expressing his passion for photography and modern art, and his ongoing struggle for the recognition of photography as a fine art. The newly opened letters, along with those already available to scholars, reveal Stieglitz to be a man of "letters," as well as a man with a camera. His work as an editor and writer of short articles, along with his letters, illustrate a strong literary side of Stieglitz that balanced his visual work as a photographer and the director of his galleries. Given his literary bent, I have written sections focusing on Stieglitz's literary interests and influences, along with sample letters from different decades. The letters are to be viewed as part of the complex tapestry that made up Stieglitz's life and work.

In general, the book focuses on Stieglitz's work, in his galleries, as a writer, and as a photographer from 1915 to his death in 1946. Stieglitz was a complex and complicated man, revered and idolized by a community of loyal followers, and at the same time despised and hated by some. He could be quick to serve as an advocate for those whom he believed in. Yet he could also be quick to alienate those with whom he disagreed, even those with whom he had worked closely for many years, such as Edward Steichen or Paul Strand. The critic Robert Hughes has written of Stieglitz, "He was one of the most vivid, idealistic, stubborn, and thorny characters ever to appear in American culture. He was a battler, a moralist, an unstoppable advocate for the artists he loved, a connoisseur of the erotic, and one of the greatest photographers who ever tripped a shutter."[7]

Beyond his personality and the myths that have grown up around Stieglitz, some self-made, some through the power of the press, it is in the end the "work" that is perhaps most important, and enduring for the present, and for the future. It is that work, along with the fundamental ideas and inspirations that served as foundations for the work, on which this book focuses. As Stieglitz wrote the day after his seventy-first birthday, on 2 January 1935, to Thomas Hart Benton, "When finally I am to be judged, I think I will have to be judged by my own photographic work, by *Camera Work*, by the way I have lived, and by the way I have conducted a series of interdependent demonstrations in the shape of exhibitions covering over forty years."[8]

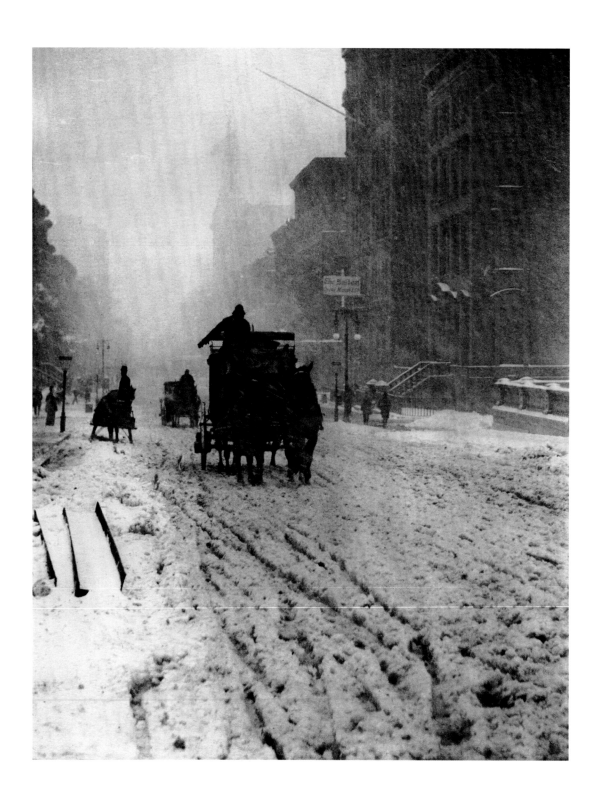

THE EARLY YEARS

1864-1914

People think that I am interested only in art. That is not true . . . Whether it is scrubbing
a floor or painting a picture – only the best work of which man is capable will finally satisfy
him . . . only work born of a sacred feeling . . . And what interests me is whether a man
will fight for the opportunity of doing the best work of which he is capable. It seems to
me that people will fight for almost anything except that right. And yet nothing else will
fulfill in the end.

Alfred Stieglitz[1]

Alfred Stieglitz was born at a time of war, January 1864, in Hoboken, New Jersey, the oldest son
of Edward and Hedwig Stieglitz. The United States was in the midst of a bloody civil war, a
nation torn asunder for four long years from 1861 to 1865. It was not the last war Stieglitz would
live through. The First and Second World Wars were to take their bitter tolls in loss of lives and
impact on the American economy and culture. Stieglitz's personal and professional ties, often
intertwined, reflected struggle. His was a life devoted to a fight for the recognition of photog-
raphy as a fine art, and for much of his life he came to consider photography as "an entire phi-
losophy and way of life – a religion",[2] important in the artist's struggle for freedom and liberation.
It was thus Stieglitz wrote in 1913, "It will be thirty years that I have been in harness trying to
give photography, the *idea* of photography its place . . . of course back of this so-called 'Photo-
graphic Fight' of mine there is something bigger than appears on the surface of things."[3]

The young Stieglitz grew up in a world that was already beginning to experience changes in
art and culture that became more pronounced and rapid at the turn of the century. Photography,
deriving its name from the Greek words for light and writing, had just been born with the
announcement in 1839 of the development of the daguerreotype by the French inventor Louis
Daguerre. In the same year Hippolyte Bayard made positive images on paper, and William

2 Alfred Stieglitz, *Winter, Fifth Avenue*, 1893, photogravure. Lee Gallery, Winchester, Massachusetts.

Henry Fox Talbot made known his photogenic drawings. Then, in the 1850s, inexpensive photographic portraits became available to all social classes, produced by large-scale photographic operations like that built by the French photographer André Adolphe Eugène Disdéri (the portraits measured about 4 by 2.5 inches). In France the possibilities for artistic expression were beginning to be explored by members of the Société Française de Photographie, founded in 1853–4. In Britain, London's Photographic Society was founded at the same time to promote a new scientific art of photography on the international level. Then, in 1859, photographs were admitted for the first time into the official Salon in Paris. Many, however, including Charles Baudelaire, were not willing to accept photography as an art. Several years later, a controversy over copyright covering works of art brought the status of photography to the French courts. On 4 July 1862, Independence Day for Americans, the French court declared photography to be an art. Back in America, as the Civil War was fought, the photographer Alexander Gardner in his *Photographic Sketchbook of the War* (1866) chronicled events in distant, removed images that were also seen in various mass periodicals of the time. The well-known images by Mathew Brady and his staff, documenting the Civil War were displayed, along with portraits, in Brady's successful gallery of national portraiture in New York City. Photographic expression lured William Henry Jackson to the western United States, where he became known for his photographs of the landscape and of Native Americans.

On 19 November 1863, Abraham Lincoln, in his famous Gettysburg Address, delivered the forever-famous words, "this nation under God shall have a new birth of freedom" and a "government of the people, by the people and for the people shall not perish from this earth." Slaves had also been freed through the Emancipation Proclamation on New Year's Day. That freedom became a part of Stieglitz's psyche. Yet, when Stieglitz was about sixteen months old, the actor John Wilkes Booth assassinated Lincoln during the performance of a play in Washington. The Stieglitz family saved the *New York Evening Express* edition from 15 April 1865 that reported Lincoln's murder.

Stieglitz's father, Edward, born in 1833 of German Jewish descent, became a partner in a prosperous wool business after serving in the Civil War, and in 1862 married Hedwig Werner, also from Germany. Alfred was born when she was nineteen. She was devoted to her family and friends and was reported to be a woman of generous spirit who loved reading. Tall and well dressed, Edward appeared the aristocrat. He loved flowers, fishing, horse racing, and art. Later, Stieglitz described his early days thus:

> Our house was filled with guests, forever guests, expected and unexpected, from all classes of society, but mainly musicians, artists, and literary folk, rather than business people. We had many books and pictures . . . our dining room in Hoboken was in the basement. I had my hobby horse there and while the men would drink, talk and smoke, I loved to sit on my

horse . . . listening to the conversation. This was when I was four ,until about seven years old . . . my parents created an atmosphere in which a certain kind of freedom could exist. This may well account for my seeking a related sense of liberty as I grew up.[4]

Several stories from Stieglitz's childhood seem to herald his career as a photographer and as an impresario of exhibitions and journals: when he was two years old, he carried around, like a talisman, a photograph of a handsome young male cousin. Another story reveals his admiration for a "lady in black":

> After her visits, my heart would sink. The lady in black was tall. She had dark hair, smoothed down, and white skin. While she was in the room, I had a lovely but sad feeling about her. I awaited her appearance, knowing the days when she was expected. I know of no pain any more intense than the one I experienced when she departed. My heartache, I realized later, was the same as that in which all love, like all art, is rooted. I always have been fascinated by black. I believe this may be related to my early infatuation with the lady in black. And I always have been in love.[5]

With thick black hair and dark eyes, Stieglitz, as an adult, also wore a long, flowing black cape. Alfred was the eldest of six children, the others being Flora, the twins Leopold and Julius (of whom he was often jealous), Agnes, and Selma. As Richard Whelan has noted in his biography, Stieglitz, at an early age searched for a soulmate: "In at least partial fulfillment of his wish, he was given to discerning 'reflections' of himself – narcissistic projections – often in rather unlikely people and phenomena. Surely, one factor that drew him to photography was that the medium would allow him to capture and collect those reflections."[6] In June 1871, the large Stieglitz family moved to Manhattan to a five-story brownstone at 14 East 60th Street, with a good view of Central Park. Today a luxurious condominium building stands at that address.

At age seven, Alfred became the wine steward for his father and friends, observing them all. Among those who attended Sunday gatherings were Joseph Keppler, the caricaturist and founder of *Puck* magazine; the Scottish-born John Foord, the editor of the *New York Times*; Howard Carroll, who became a *New York Times* Washington correspondent as well as a playwright; and Adolph Werner, a cousin of Hedwig and a professor of German language and literature at what was then the College of the City of New York. Foord and his family became close with the Stieglitzes, visiting each other in New York and New Jersey. Alfred must have been fond of Maggie, one of the Foord daughters, for he photographed her reading, and what seems to be a portrait of her features in a lantern slide of his studio, *My Room at 14 East Sixtieth Street*, of 1891. Next to a program for a Metropolitan Opera season that included *The Magic Flute, Carmen,* and *Tristan and Isolde*, in one of Stieglitz's voluminous scrapbooks from his student days, was an announcement of Maggie's wedding in February 1892.

3 Charlier Institute Certificate, 1874. Private collection.

In September 1871, Alfred began to attend the Charlier Institute, a private French and English school for "Young Gentlemen" on East 24th Street in Manhattan. An early report card shows him to have been a good student. A year later, the Stieglitz family made their first visit to the Lake George area in upstate New York in August 1872, staying at the famous Fort William Henry Hotel. Thomas Jefferson had praised the area in writing to his daughter, Martha, in May 1791:

> Lake George is unquestionably the most beautiful water I ever saw; formed by a contour of mountains into a basin 35 miles long, and from 2 to 4 miles broad, finely interspersed with islands, its water limpid as crystal and the mountainsides covered with rich groves of silver fir, white pine, aspen, and paper birch down to the water edge, here and there precipices of rock to checker the scene and save it from monotony. An abundance of speckled trout, salmon trout, bass, and other fish with which it is stored, have added to our other amusements the sport of taking them.[7]

Lake George, including its islands and surrounding area, was steeped in history as well as beauty, attracting artists and writers as well as vacationers to its shores. Visitors to the lake have included Benjamin Franklin, Thomas Jefferson, James Madison, Calvin Coolidge, and Theodore Roosevelt, who first went as a boy the year before the Stieglitzes. A number of the Hudson River School and Luminist painters found inspiration there, as seen in Jasper Cropsey's *Dawn at Morning, Lake George* (1865, Albany Institute of Art), John Frederick Kensett's *Lake George* (1853, Williams College Museum of Art), or Martin Johnson Heades's *Lake George, New York* (1862, Museum of Fine Arts, Boston). Other artists, such as Winslow Homer, depicted combined landscape and genre scenes such as *On the Road to Lake George* (1869, Adirondack Museum). The landscape, of broad vistas, smooth waters, and high mountains, evoked the

18

4 K. Hoffman, *Lake George*, 2008.

"sublime" while many patterns of light, shadow, color, shape, and form provided by the mountains, water, sky, islands, trees and rocks, conformed to ideas of the "picturesque" held by nineteenth-century artists. Stieglitz's photographs of the area reinforced these concepts. Several early images are intimate, closely cropped views of the lake and Tea Island, often taken from Oaklawn, his family home purchased in 1886, whereas his later Lake George work became more expansive and reached toward the abstract, as seen in his *Songs of the Sky* and *Equivalents* series.

At Lake George, Stieglitz learned to row, swim, and fish, was a noted miniature golf player, and also loved to run. As he noted later in life, in connection with sports and board games, "I quickly tired of playing games according to the rules that came with them."[8] Despite his interest in exercise, Alfred was viewed as a delicate child, tall, thin with a complex and brooding temperament. For much of his life, as Richard Whelan has noted, "Alfred would suffer terribly from incurable hypochondria, the first cousin of depression . . . As an adult, Alfred clearly had strong manic-depressive tendencies. Afraid he could not be loved for who he was, he resolved to ensure that he would at least be loved for what he did. To that end, he would expend a tremendous amount of energy in pursuit of perfection and the highest ideals."[9] As a young boy, from approximately 1874 to 1879, Stieglitz collected autographs, not only those of his friends and family, but

5 K. Hoffman, *Lake George – Lac du Saint Sacrament*, 2008.

also copies of signatures of those he admired and read about, such as Duke Karl August, the patron of Goethe, whom Stieglitz greatly admired; Johann Schadow, a sculptor and teacher, Karl Friedrich Schinkel, the great neoclassical architect; Julie Rettig, an actress; and Heinrich Schliemann, the archaeologist. On the back page of one of his albums is a poignant message from his father, writing in New York on 2 May 1874: "Be the master of Truth, Master of Passion. To his son, Edward Stieglitz."[10]

On the eve of his thirteenth birthday, 31 December 1876, Alfred carefully filled in the pages of a small, gold-lettered leather album entitled *Mental Photographs*, subtitled "Tastes, Habits and Concoctions," in which there were many entries from his family and friends begun in 1873. There were forty questions for each entry. Many of his entries reveal aspects of his character and personality that are telling in relation to his future and to his photographic interests:

Your Favorite Color: cardinalion black
Flower – violet and forget-me-not
Tree – oak
Object in Nature – mountains covered with snow
Hour in the day – twilight

6 *Mental Photographs: An Album for Confessions of Tastes, Habits and Convictions*, Robert Saxton, ed.
New York: Holt and Williams, 1872. Private collection. Alfred Stieglitz entry, 31 December 1876.

Season – whenever there is no school

Perfume – white rose

Gem – pearl

Style of Beauty – blue eyes and black hair

Painter – Fedor Encke

Musicians – Beethoven and Mozart

Poets – Longfellow and Shakespeare

Prose Authors – Dickens and George Eliot

Book to take up for an hour – dictionary

What book (not religious) would you part with last? – pocket book filled with money

What epoch would you choose to live in? – 1776

Where would you like to live? Lake George

What is your favorite amusement? To go to the races

What trait do you most admire in a man? Honesty

What trait do you admire most in a woman? Truth

What trait of character do you most detest in each? Dishonesty and Deceitfulness

If not yourself, who would you rather be? Nobody

What is your idea of happiness? To be married and live happily

What is your idea of misery? To be beaten in a race

What is your bête noir? To be buried alive

What is your dream? To live long and prosper

What is your favorite game? Race course

What do you believe to be your distinguishing characteristics? Inquisitiveness and changeableness

If married, what do you believe to be the distinguishing characteristic of your better half? Jealousy

What are the sweetest words in the world? Father and Mother

What are the saddest words? Too late

What is your aim in life? To be happy

What is your motto? Try and Trust[11]

The young Alfred did not answer the question "What is the sublimest passion of which human nature is capable?" whereas a number of family entries listed "love" as the sublimest passion. Alfred's mother, Hedwig, wrote "self-denial," and her chosen epoch in which to live was the twentieth century, while Edward chose the time of Adam and Eve. Alfred mirrored his father's response in his fear of being buried alive, his detestation of deceitfulness, his admiration of truth in a woman, and his desire "to be happy."

*

Stieglitz's education in Europe allowed him the freedom to pursue a variety of interests, from his studies in Europe from 1881 to 1890 at the Realgymnasium in Karlsruhe, Germany and Mechanical Engineering at the Technische Hochschule in Berlin in 1881–2, and further at the University of Berlin from 1882 to 1890. This arrival in Berlin coincided with the city's cultural and economic blossoming. Stieglitz relished the atmosphere of intellectual freedom he found there and spent hours reading in his room. He discovered the Russian authors Mikhail Yuryevich Lermontov, Nikolai Gogol, Alexander Sergeyevich Pushkin, Ivan Turgenev, and Count Leo Tolstoy; he particularly liked Lermontov's *A Hero in Our Times*. He read Alphonse Daudet's *Sappho* and his *Tartarin* series. Then he discovered Emile Zola, after which Stieglitz's own style of writing took on some of Zola's naturalism. This involved "Nature seen through a temperament." Paul Rosenfeld, Stieglitz's friend and a cultural critic, commented that Stieglitz was attracted to Zola's "employing fiction experimentally as a means of penetrating to the laws underlying the phenomenon of life."[12] Among Zola's works, Stieglitz was attracted to *L'Oeuvre* (1886) (*The Masterpiece*), which was said to be based roughly on the life of Cézanne and had caused a rift in the artist's friendship with Zola. Stieglitz even wrote to Zola, asking him if a

good translation of his work from the French existed. He also reread Goethe's *Faust*, which he had first read when he was ten, and he saw the operatic version on numerous occasions. "Marguerite and the Devil have continued to fascinate me," he said. "All thinking men must feel a similar concern about Woman and the Devil; due to something in the male and something beyond. What Woman feels about the male and the Devil, I do not know. People kill one another because they love one another too much. Jealousy, envy, are always at work, no matter what one does. The result is a constant. Yet everyone claims to be seeking peace."[13] Perhaps it was the purity of Marguerite that so attracted Stieglitz, who in many ways might be considered a Faustian figure in his continuous striving for perfection, whether it was working for hours on end on individual prints, or struggling for the recognition of modern art and for the recognition of photography as a fine art.

In Part II, Act IV, of *Faust*, a significant image appears and it perhaps remained subconsciously in Stieglitz's mind: Faust is carried by a great cloud that sets him down in high mountain country and then divides. A scholar of Goethe, Henry Hatfield, notes: "Faust describes how one part assumes the shape of a woman of classical beauty – Juno, Leda, or Helen – the other a less heroic but lovely form, suggesting 'beauty of the soul,' linked, Faust says, to what is best in him."[14] Much later, Stieglitz was to name some of his cloud photographs after women. At the end of Part II, Faust is "saved" from his pact with the Devil, through a series of metamorphoses, and the image of a chrysalis, which had appeared in earlier sections, is seen again. (A number of Georgia O'Keeffe's drawings from her 1915 *Specials* series, which Stieglitz praised highly, particularly numbers 2, 4, 5, and 9, have chrysalis-like forms and suggest metamorphosis.) Goethe's poem ends with the affirmation of love. It is easy to see how the storyline relates to Stieglitz's life-long interest in "Woman" as an ideal, and in particular the women with whom he was associated.

The stylistic elements in *Faust*, such as the alternating play of light and dark throughout the poem and the rapid changes of night and day, also probably captivated Stieglitz. A strong sense of emotion pervades much Romantic writing, and many of the playwrights and particularly the composers whom Stieglitz admired were inspired by *Faust*, for example, Robert Schumann, Franz Liszt, and Richard Wagner. Stieglitz saw a number of performances of the Faust story, as confirmed by the many drama and opera programs he carefully pasted in his scrapbooks.

Stieglitz spent many evenings attending concerts and theatrical performances. His copious, well-kept scrapbooks (housed at the Beinecke Library, Yale University), filled with hundreds of tickets and programs from his student days and his early years in New York, record his eclectic tastes, ranging from high opera to vaudeville, from Baroque, to classical, to Romantic, to more contemporary music. Besides performances of Shakespeare, Calderón, Goethe, Lessing, Schiller, Ibsen, Echegaray, Bach, Mozart, Verdi, Bizet, and others, he attended many Wagner operas, particularly *Tristan and Isolde*, along with *Tannhäuser*, *Die Meistersinger*, *Das Rheingold*, and *Götterdämmerung*. While Stieglitz was in Berlin, Wagner was becoming a major force both in

music and the arts in general. His notion of the *Gesamtkunstwerk* – the total work of art that united poetic drama, music, the visual arts, and dance – was seen as a way to counterbalance the growing fragmentation of modern man and woman. *Camera Work*, the periodical that Stieglitz edited from 1903 to 1917, may be considered as a kind of *Gesamtkunstwerk*, using it, as he did, to bring together works from the areas of art, music, literature, poetry, and drama in a powerful whole.

Wagner's narratives play out themes that probably appealed to Stieglitz: woman's Christian love over pagan sensuality, redemption through faith, and sexual love, with full union only in death. Shortly after Stieglitz's death in 1946, the writer, Ralph Flint, remarked that Wagner's *Die Meistersinger* was magical for Stieglitz:

> The four-hour flow of that magical work was to him the ultimate in creative art, and it was undoubtedly the Sachs [Hans Sachs, a cobbler-musician] in him that permitted such responsiveness, that kept him spellbound until that climactic moment when the victor's wreath is placed on the cobbler's brow amidst the town's rejoicing. I like Stieglitz best as Sachs and it was the *Meistersinger* note that sounded throughout our long summer at the lake [George]. For my part, he was first and foremost the embodiment of Wagner's greatest creation . . . the philosopher, the lover of mankind, the advocate of individuality and free expression, the apostle of enduring beauty, of inspirational activity, of art triumphant . . . But this fun-loving, flashing Stieglitz was not always apparent, not easily arrived at, for he could be almost anyone in the long list of Wagner's "dramatis personae" . . . as in Wagner's scoring, he could drop down into the depths where only the ponderous croaking of the double basses predominate.[15]

In Wagner's operas, the musical leitmotifs could express or link ideas, such as the unspoken thought of a character on stage. Similarly, Stieglitz's notion of Equivalents, where he linked the visual to ideas or states of emotion, and of his subtle use of black, white and grays, of intricacies of light and shade, which enhanced the expressive qualities of some of his photographs such as *Sun Rays, Paula* (1889), or his *Equivalent* series, as in Wagner's musical chromaticism. Music must be considered a significant factor in Stieglitz's development, and throughout his life. In Berlin, he frequented theaters and concerts, and played the piano himself. He noted that he "was never without a piano. Among my favorite scores were *Carmen* and those of Wagner and Gluck . . . At times I played Chopin's *Funeral March* or a Tyrolese song. I loved Beethoven, Mozart, and Schumann . . . Oftentimes at night I would sit bare-skinned on the piano stool and play."[16] Music became incorporated into Stieglitz's total aesthetic and approach to the visual arts, particularly in his *Songs of the Sky* (begun in 1922–3.)

*

While a student in Berlin, Stieglitz lived on a generous allowance from his father and recalled his time there as

> congenial, free – the freest I have ever experienced. What more could a person want than I had . . . I had no desire to drink or to eat rich food. I harbored no social aspirations and was devoted, above all, to photography. I was crazy about billiards and racehorses, but this neither complicated my life nor interfered with my work. I was interested in Woman, but not in women. I frequented cafés, mainly the Café Bauer, which was open day and night. There were no set times when I had to do anything. If tired, I slept, if hungry, I ate. When I wanted to read, I read. Even at the racetrack in Europe I thrived on the color, the movement, the jockeys on wild, rushing horses, the elements of nature controlled by man. I was excited by the entire picture of life: spectators, participants, comedy and tragedy – all dovetailing, breathing![17]

In 1883, Stieglitz made his first photographs. Walking in Berlin one day, shortly after his birthday in January, as he was returning to his room from a lecture, Stieglitz saw a camera in a small shop on Klosterstrasse. He bought it on impulse, a short transaction that would change the course of his life. Stieglitz changed his course of study from engineering to photochemistry to study with the well-known photochemist Professor Hermann Vogel, an intense but kindly man, with a full beard and often disheveled hair, whom Stieglitz photographed in 1885, capturing his thoughtful gaze. Vogel took Stieglitz under his wing for two years. The first official recognition of Stieglitz's photographs came in 1887 when he won first prize for his genre study from Bellagio, Italy, "*The Last Joke, Bellagio*," or "*A Good Joke*". This prize photograph appeared in the Photographic Holiday Work Competition of the London-based *Amateur Photographer*, appearing in the issue of 25 November 1887. It was considered the only spontaneous work in the competition, judged by British photographer Dr. Peter Henry Emerson. The photograph focuses on children laughing and talking, grouped around a woman who appears to be collecting water; its architectural arches in the background provide a stage set for the closely cropped image. There is another version of the subject in which a man stands in the background shadows in the upper left corner, overlooking the scene. As the writer Doris Bry has noted, the version with the male figure won the prize: "It is interesting that the print Stieglitz kept from this negative (now in the Key Set and the National Gallery of Art in Washington, D.C.) is not the print that won the prize, but is a later print made in the 1890s. The matting and cropping of the later print, resulting in a much stronger composition than the 1887 presentation, suggests the more discriminating use of space Stieglitz had learned in the intervening years."[18] This was the first of more than 150 medals and awards Stieglitz received throughout his career. British and German periodicals began publishing his work. In 1889, captivated by the world of photography he was beginning to explore, he attended an exhibition in Vienna which celebrated the fiftieth anniversary of the birth of photography. There he saw the work of early photographic pioneers such as Daguerre,

Fox Talbot, and Julia Margaret Cameron. That same year his own photographs were included in the fiftieth anniversary exhibition in Berlin, including photographs taken in Italy, Switzerland, Germany, and the United States. He won a silver medal and a prize for technical excellence given by the Steinheil camera and lens company (the camera used by him for his exhibition images). In the catalogue, he noted that his images were not retouched and only one, *Abendstimmung (Amerika) (Atmospheric Evening, America)* was toned.

That same summer, Stieglitz also photographed a young woman, Paula (probably Paula Bauschmied), ostensibly a young prostitute with whom he was romantically involved. His now famous *Sun Rays, Paula*, also exhibited as *Study in Light and Shade* and *Sunlight and Shadow*, was shown and published widely. The piece is remarkable for the modern abstract qualities of sun and shadow that pervade the image. On the back wall, well lit, are some of Stieglitz's photographs: two images of *The Approaching Storm*, recently published in *Die Photographische Rundschau*, flank pictures of Paula, two showing her dressed in white, one the reverse of the other from the same negative.[19] Another intimate image of her is placed at the bottom of the montage on the wall, and a portrait of her in a white hat is tucked into the mirror on the writing table. A small studio card, a portrait of Stieglitz himself, is tacked next to the photographs with three beribboned hearts. *Sun Rays, Paula* is a double portrait of two people whose lives were temporarily entwined, as if they were the two birds in the cage that hangs in the room, entrapped in circumstances that made a permanent relationship impossible. The bars of the birdcage also formally complement the "bars" in the room, formed by the shadows on the wall. The *Approaching Storm* photographs suggest the uncertainty and drama in his life.

On 14 February 1890, Stieglitz's sister Flora delivered a stillborn child and three days later died of blood poisoning. Grief-stricken, Stieglitz immersed himself in his work. He traveled that spring to study at the Graphische Lehr und Versuchsanstalt in Vienna, under Josef Eder, and joined the Wiener Club der Amateur Photographen. His photograph *Weary*, from that June, reflects both his grief and the subjects and forms of the Karlsruhe School paintings with their Barbizon School and impressionist elements.

He was persuaded by his family to return to New York in September 1890, leaving behind his more carefree days in Berlin. The city to which he returned was, in many ways, far different from the one he had known. Much of New York was now lit by electricity, making nightlife more plausible; Madison Square Garden was under construction; one of the early skyscraper-like buildings, the Manhattan Life Insurance Building, just across from the Stieglitz house on East 60th Street, was completed in 1893. In the art galleries, visitors could see the grand paintings of Bastien-Lepage, or the academic nudes of Adolph-William Bouguereau, the latter a popular representative of French salon painting. The wealthy Havemeyer family had begun to collect paintings by Corot, Manet, Degas, and Courbet, works which eventually became part of the collection of the Metropolitan Museum of Art in New York.

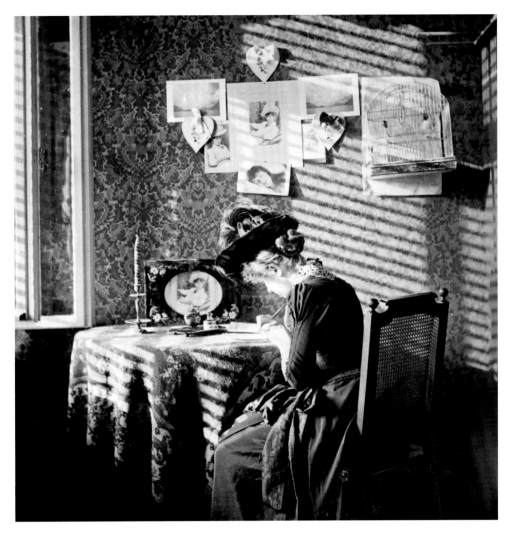

7 Alfred Stieglitz, *Sun Rays, Paula*, 1889, lantern slide.
Beinecke Rare Book and Manuscript Library.

At first Stieglitz had a hard time adjusting to life in the United States, and in New York in particular: he was lonely; there were no cafés; the streets seemed dirty. Shortly after arriving in the city in 1890, following a suggestion made by Emerson, he renewed his connection with Frederick Beach, the editor-in-chief and founder of the *American Amateur Photographer*. He joined that same year the Society of Amateur Photographers, of which Beach had been the first president from 1884 to 1888, and of which Stieglitz was president from 1890 to 1891. Collaborating with the Photographic Society of Philadelphia and the Boston Camera Club, the New York society hoped to promote the exhibition of photography, and thus to encourage artistic and

scientific excellence. At an exhibition in 1891, Stieglitz won a medal and, inspired, went on to write a passionate article, "A Plea for Art Photography in America," for the 1892 annual, *Photographic Mosaics*:

> Simplicity, I might say, is the key to all art – a conviction that anybody who has studied the masters must arrive at. Originality, hand-in-hand with simplicity, are the first two qualities which we Americans need in order to produce artistic pictures. These qualities can be attained only through cultivation and conscientious study of art in all its forms. Another quality our photographs are sadly deficient in is the entire lack [sic] of tone. These exquisite atmospheric effects which we admire in the English pictures are rarely if ever seen in the pictures of an American. This is a very serious deficiency, inasmuch as here is the dividing line between a picture and a photograph.[20]

Unlike some of Stieglitz's earlier writing, this article focused more on aesthetic, rather than technical concerns. Several years later, he wrote further on "Simplicity in Composition" in a contribution to a book, *The Modern Way of Picture Making* (1905). By "simple," he seems to have meant bold, direct, and perhaps daring, and he cited Whistler's *At the Piano* (1858–9) as an example of good composition. Further, Stieglitz made an analogy to music: "Just as in music we find that the simpler the theme, the more thorough must be the knowledge of the musician in order to compose acceptable variations thereon, so, in fact in every art this rule obtains . . . Those modern Pictorial photographs that have attracted so much attention . . . their keynote is simplicity in arrangement and the true rendering of tonal values."[21]

Stieglitz began to hone his writing skills and share his aesthetic concerns with a wider public by writing fairly regularly for the *American Amateur Photographer*, and by the spring of 1893 he was offered the position of editor, which he agreed to take without salary, since he was working at the time at Photochrome (formerly Heliochrome Company), a printing business in lower Manhattan, which specialized in color photographic reproduction. As the magazine's editor, Stieglitz attempted to secure ties with British photographers. In particular, he sought to make contact with a group known as the Brotherhood of the Linked Ring by asking the noted photographer George Davison to contribute regularly to the magazine. Davison's photographs, in their blurred, evocative style, were evocative of both symbolism and impressionism. The Linked Ring had been formed in 1892 when Davison, Henry Peach Robinson, and thirteen others resigned from the Photographic Society of Great Britain to form a group devoted to the "development of the highest form of Art of which Photography is capable. Those only are, in the first instance, eligible who loyally admit artistic capabilities in photography, and who are prepared to act with a spirit of LOYALTY."[22] The implied symbolism of the linked rings is quickly apparent on the information sheet for prospective members or "Postulants," where Loyalty and Liberty are referred to as the "devices" of the group. Stieglitz was elected to membership on 26 October

1894, remaining a member until 1909, and was awarded a special medal in 1924. The annual juried photographic salon in London sponsored by the Linked Ring was seen as significant in Stieglitz's eyes. This transatlantic link that he forged via Davison helped to give artistic photography a firmer foundation on which to build.

Shortly after seeing one of his favorite actresses, Eleonora Duse, in one of her performances in 1893, Stieglitz met his friend and fellow photographer William B. Post at the Society for Amateur Photographers on George Washington's birthday. Post was marveling at his new hand-held camera, which held 4-by-5-inch plates that Kodak had developed in 1889. He offered to lend the camera to Stieglitz, who quickly accepted and immediately went out into the snowy weather and stood for three hours (as he later claimed) on the corner of Fifth Avenue and 35th Street. The result, his now famous photograph, *Winter, Fifth Avenue*, is a testament both to his tenacity in getting the photograph he sought and to his technical versatility. He printed it as a photogravure, in two carbon prints, and later as gelatin silver prints in the 1920s or 1930s. In the latter prints, the viewer is somewhat at distance, and in one of them the horizontality of the scene is emphasized in contrast to the verticality of the earlier versions. A photogravure appeared in *Camera Work* on 12 October 1905. The large carbon print, 14⅝ by 10⅝ inches, is inscribed on the back: "This photograph is the basis of so-called 'American photography' shown in every important exhibition since then."[23] In the large carbon print and in subsequent prints the railroad ties do not appear, indicating that the negative was retouched by Stieglitz.[24]

Winter, Fifth Avenue – along with *The Terminal* (1893) – was to become a significant image for Stieglitz. Many years later he retold the taking of the two photographs in an impassioned tone, recorded and published in Dorothy Norman's *Twice a Year* in 1938:

There was a great blizzard. I loved snow, I loved rain, I loved deserted streets. All these seemed attuned to my own feeling.

During the blizzard I stood at the corner of Thirty-fifth Street and Fifth Avenue with Post's hand camera. I had been watching the lumbering stagecoaches appearing through the snow: the horses, the drivers, the driving snow – the whole feeling – and I wondered could what I felt be photographed.

The light was dim – at that time plates were "slow," and lenses were also "slow," but somehow I felt I must make a try. Wherever there was light, photographing was possible; that is what I had discovered in 1884 in the cellar of the Polytechnic when I made a photograph of a still dynamo lighted by a 16 power electric bulb, exposing over twenty-four hours and getting a perfect negative. That was an event that took my professor's breath away when he heard what I had done.

Yes, where there was light there was the possibility of making a photograph. Finally I ventured to make a photograph of the blinding snow and the stagecoach with its horses and its driver coming towards me.

I went to the Society of Amateur Photographers, of which I was a member, and developed the negative. I was terribly excited. I showed the still wet negative to the men. They all laughed and said, "For God's sake, Stieglitz, throw that damned thing away. It's all blurred and not sharp."

And I replied, "This is the beginning of a new era. That negative is exactly what I want." And when, twenty-four hours later, I showed them the lantern slide made from this negative there was great applause and none would believe that it was made from the negative they had told me to throw away.

The next day I walked the streets, and found myself before the old Post Office. The Third Avenue street railway system and the Madison Avenue car system had their terminal down there. Naturally there was snow on the ground. A driver in a rubber coat was watering his steaming horses. There seemed to be something related to my deepest feeling in what I saw, and I decided to photograph what was within me.

These two pictures, *Winter, Fifth Avenue* and *The Terminal (Streetcar Horses)*, became internationally famous. They still hold their own and now they are regarded as classics.

I bought myself a camera similar to the one of Post's and then began my series of New York pictures. I had in mind doing one hundred photographs – that is, to do one hundred different phases of New York – to do them as supremely well as they could be done and to record a feeling of life as I felt it. Maybe, in that way, to establish photography in its true position in the realm of plastic expression.

But somehow this series that was clearly in my mind never was fully realized. The struggle for true liberation of self, and so of others, had become more and more conscious within me and before I realized it I was editing magazines, arranging exhibitions (demonstrations), discovering photographers and fighting for them. In short, trying to establish for myself an America in which I could breathe as a free man.[25]

This commentary is the voice of an old man, proud of himself, self-absorbed, seeing himself as continuing to fight for his cause. Yet it also reveals much of the core of Stieglitz's passionate concerns and ways of working – his striving for perfection, his willingness to take risks, his wish to publicize his work, his use of lantern slides, and his interest in series. There is also, as was frequently the case, an emphasis on the struggle for liberation and freedom of the spirit.

Shortly after the turn of the century, Stieglitz began frequently to use a Graflex, a hand-held, single-lens, reflex camera that came in various sizes to accommodate different-sized plates. He used Goerz Double Anastigmat lenses with different-sized cameras, depending on the occasion. His devotion to Graflex was such that a letter of his to the company praising the camera was included in a Graflex advertisement that appeared in *Camera Work*. The hand camera allowed Stieglitz to roam the city and more easily take a variety of images. His blizzard image gives heroic

stature to the horse-drawn carriage and driver. The horses force their way through the driving snow toward the viewer. Stieglitz seems almost to have equated himself with the horses and driver. As they struggled through uncontrollable elements, so, too, did Stieglitz feel alone and somewhat adrift in a storm in his beginning days of fighting for the cause of photography. Stieglitz's other shots, taken during and shortly after the same storm, likewise celebrate the role of the horse and carriage as it ventures out into the empty snowy streets: *The Blizzard, New York* and *Winter, New York*, the latter title comprising three different compositions, appear like frames in a movie. In *Winter, New York*, the storm has subsided; there is less concentration on the elements and Stieglitz has widened his perspective to take in more of the city environment, including a commercial sign for the Union Tobacco Company.

In these New York photographs, unlike his earlier European photographs, Stieglitz set himself the task of photographing in difficult weather conditions. The snow also gave a certain picturesque or Romantic quality to his images. Beyond this Romantic emphasis, however, Stieglitz placed nature and civilization side by side, for in a number of his photographs where snow appears, it takes up approximately half the content of the image.

In *The Terminal*, of 1893, man and nature are shown again, but here the emphasis is on man and his horses, dealing with the cold and snowy weather. Again, perhaps Stieglitz identified himself with the driver, struggling, watering his horses, caring for them, as Stieglitz cared for photography and later for the artists he fostered at his 291 gallery. Later in life, Stieglitz commented about this photograph: "A driver I saw tenderly caring for his steaming car horses in a snow-covered street came to symbolize for me my own growing awareness that unless what we do is born of sacred feeling, there can be no fulfillment in life."[26] Like *Winter, Fifth Avenue*, this image was printed in a variety of formats – a photogravure shows more of the neoclassical post office building, its columns and pediment reflecting in some ways the window bars and roof lines of the horse car, giving more stature and dignity to the vehicle, its horses, and driver.

Shortly after being elected to the Linked Ring in 1894, Stieglitz pushed for the amalgamation of the two existing camera clubs in New York, the Society of Amateur Photographers on 38th Street and the New York Camera Club on Fifth Avenue. In 1896, the groups combined to become the Camera Club of New York, with Stieglitz as vice-president after he had declined the presidency. A year later, he became the founder and editor of *Camera Notes*, the official publication for the club. Each issue was an art object itself, with its finely printed photogravures, and well-designed layout of images and text.

The magazine, measuring 10¾ by 7½ inches, had a green cover with an Art Nouveau sunflower design in black. Within, the text was printed on heavy-stock, glossy paper in a standard typeface with half-tone illustrations, not necessarily related to the articles. But it was the meticulously printed photogravures and theoretical articles that distinguished the magazine. As the writer Christian Peterson stated in 1993:

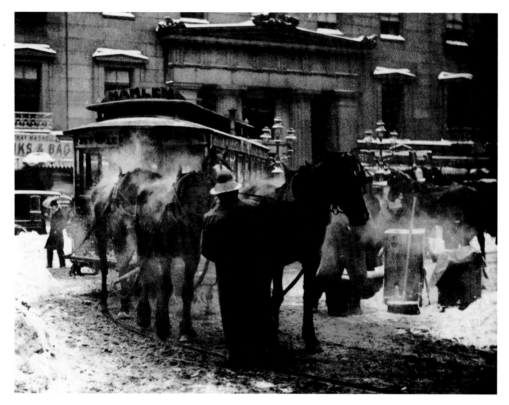

8 Alfred Stieglitz, *The Terminal*, 1893. Lee Gallery, Winchester, Massachusetts.

The imagery of *Camera Notes* typified the emerging aesthetic of American Pictorial photography, which was characterized by accessible subject matter, soft-focus effects, and simplified composition. pictorialists used a relatively limited number of subjects, easily identifiable by the general public. Avoiding anything that was topical, political, or controversial, they concentrated on figure studies, landscapes, and genre scenes. In their interest in distinguishing their images from ordinary photographs, pictorialists purged their pictures of all detail and extraneous elements. By simplifying the scene and softening the focus, they produced evocative and mysterious – hence artistic – images . . .

There was no question as to the magazine's first-place position among the American photographic periodicals. It included the most insightful articles and the best photographic illustrations available from throughout the world. Its outstanding photogravures, taken as a set, embody this country's first cohesive argument for photography as a fine art . . . The journal, in fact, stands as a monument to an idealized attempt at introducing strict aesthetic standards to a mass audience. Such a union will never be achieved, but in *Camera Notes*, it was given its best photographic incarnation.[27]

In 1897, Stieglitz had a portfolio of his own work – twelve photogravures in a large format of 14 by 27 inches, entitled *Picturesque Bits of New York and Other Stories* – published by the Russell Company with a foreword by Walter Woodbury. The images, a number toned in blue, green, and sepia, were beautifully presented, and this presentation format – large photogravures in a portfolio – helped to establish the role of the photograph as an independent work of art.

Perhaps his most significant images from the late 1890s are the night photographs, some of which appeared in *Camera Notes*, where he captured the glow of city lights reflected on wet pavements or freshly fallen snow. In 1897 and 1898, he produced a number of images, some printed later in the 1920s and 1930s. Some of his most striking night scenes were shot from Grand Army Plaza at Fifth Avenue and 59th Street, looking east across the wet pavement to the Savoy Hotel, where he and Emmeline (Emmy) Obermeyer, the sister of one of his partners in the Heliochrome Company, had been living since their marriage. His 1897 photograph *Savoy Hotel, New York* is a nocturnal study of the interplay of light, shadow, and reflection. It is both cityscape and landscape, the strong silhouette of a lone tree dominating the image.

Although Stieglitz preferred to reproduce his night scenes as lantern slides, feeling the luminosity was better presented in this medium, he did make some prints of the nocturnal images in 1897, and again in the 1920s and 1930s. His platinum prints were tinted with yellow dye, which adds a melancholy air to the image. Paul Martin had worked on night photography in London before much of Stieglitz's work was done, but Stieglitz later claimed that he had been the first to experiment successfully with the genre. In the *American Annual of Photography and Photographic Times Almanac for 1898*, he wrote an article discussing the introduction of life into nocturnal scenes: "We believe that this branch of photography opens up certain possibilities that have not as yet been attempted. We refer to the introduction of life into these scenes. The illustrations to this article are the first experiments made by the author in this time, and he is fully convinced that they are but the first steps to a most interesting field of work."[28] By reducing the exposure time to less than a minute, rather than a half-hour, Stieglitz was able to capture a human presence in some of his night images. His nocturnal scenes are also in many ways like musical nocturnes, a genre particularly popular with Romantic composers.

The same year that Stieglitz was experimenting with night photography, he celebrated the birth of his first and only child. Katherine, or "Kitty," who was born on 27 September 1898, shortly after he and Emmy had moved to a new apartment at 1111 Madison Avenue between 83rd and 84th streets. With the assistance of Emmy's family money, the couple was able to afford a cook, a chambermaid, and a governess. Stieglitz had feared having children, knowing that Emmy's mother had suffered from melancholia or post-partum depression after Emmy's birth. (Stieglitz did not know that this condition can skip a generation, and that his own daughter, following the birth of her son in 1923, would suffer severe post-partum depression, from which she never recovered, and would be institutionalized until her death in 1971.)

Although Stieglitz was no model father, he was at least initially devoted to his daughter, and he photographed her frequently, both alone and with her mother. He wanted to make a photographic record of his baby's growth and development, while Emmy was in disagreement, wanting to conform to the conventions of the day and often asking him to leave the baby alone. Stieglitz was particularly interested in the concept of a cumulative portrait and composite record. Despite Emmy's protests, he continued to photograph his daughter, sometimes obsessively, waiting for the "right" gesture or expression he wished to capture. He made photographs of her until about 1902 and then more irregularly into her teen years. Once she went to Smith College, in Northampton, Massachusetts (from where she graduated in 1921, before marrying Milton Stearns in 1922), there is little photographic record of her by Stieglitz. But the photographs that he did take over a period of years are, when viewed together, more than just family snapshots. Revealing his concentrating on form, light, and shadow, they allow the viewer to enter Kitty's world and to share in her experience – watching ducks feed, holding a butterfly net, and smelling flowers on a spring day, having a swimming lesson – conveying something of the wonder and delight of a small child.

A portrait of Kitty made in 1905 which was reproduced in *Camera Work* contains a sense of foreboding as she stands before a nursery-rhyme figure from "Three Blind Mice" who holds a knife. Dressed in a white dress, embroidered at the neck and sleeves, and holding a book, Kitty is a picture of innocence in front of the violent image.

Particularly powerful are the autochromes Stieglitz made of his daughter. He began to experiment with this procedure of producing color images with Edward Steichen and Frank Eugene in 1907. The subtly colored images frequently show Kitty with her long wavy hair, often tied with a large ribbon, well dressed and holding flowers, leaves, or a plant. Stieglitz's association of his daughter with blooming plant forms suggests the traditional analogy between the female and the life cycle of nature.

Stieglitz's photographs of Kitty were widely published, exhibited, and praised by critics such as Charles Caffin for their originality of concept. Caffin, in his book *Photography as a Fine Art* (1901), included a number of photographs of Kitty alone and Kitty with Emmy, along with other Stieglitz photographs, in a chapter entitled "Alfred Stieglitz and His Work." Caffin noted at the end of the chapter, "He [Stieglitz] excels in studies of human subjects, and in his best examples attains a realism that is no bare record of facts, but the realization of a vivid mental conception. When he sets his figures in a scene, they become part of it and one with it in spirit. He puts them there because he has seen that they belong to it. His sentiment, never degenerating in to sentimentality, is always wholesome and sincere, and his pictures have the added charm of handsome arrangement and of simple and controlled impressiveness. In his hands, the 'Straight photograph' in the broadest sense of the term, is triumphantly vindicated."[29] That Caffin and Stieglitz chose to publish images from the "Photograph Journal of a Baby" as part of a book

9　Alfred Stieglitz; prints from *Photographic Journal of a Baby*, 1900. Beinecke Rare Book and Manuscript Library.

10 Alfred Stieglitz, *Kitty in Profile*, 1912, print. Beinecke Rare Book and
Manuscript Library.

advocating photography as a fine art, suggests that these photographs had more importance for
Stieglitz than might be expected. In 1900, the "Photographic Journal of a Baby", was exhibited
as a series in London.

Stieglitz's photographs of his daughter may also be viewed in the context of other photo-
graphs of children at the time. In the early part of the twentieth century, a number of Pictorial
photographers such as F. Holland Day, Clarence White, Gertrude Käsebier, and Edward
Steichen chose children as their subject matter – quite often their own or their friends' chil-
dren. Kitty and Emmy were also photographed by Käsebier and White. On the other hand,
the photographs taken by Jacob Riis and Lewis Hine exposed slum conditions in New York
and the exploitation of children in the workforce in the early twentieth century. Hine's children
are depicted in factories, on the street, dirty, in ragged clothes. He was a pioneer in documen-
tary photography, his photographs representing social work where these of the pictorialists

represented camera work.[30] Hine emphasized social responsibility, while Stieglitz emphasized individual freedom.

Stieglitz's concept of a multifaceted or composite portrait – such as his series of images of Kitty – was significant and may well have had some of its roots in the newly evolving cinematic medium, which allowed subjects to be seen over time in moving pictures. He commented a number of years later, "To demand the portrait that will be a complete portrait of any person is as futile as to demand that a motion picture be condensed into a single still."[31]

His photographs of his daughter also provided a conceptual foundation on which he could build the composite portrait he made of Georgia O'Keeffe, beginning in 1917. Kitty is often depicted as a "child" of the pictorialist era, but she is also sometimes presented with a directness and intensity that tells us she is not "a" child but "the only" child of Stieglitz. In many of the O'Keeffe photographs, particularly the early ones, much of that directness and intensity is transformed into a lover's passion.

*

New Year's Day, 1 January 1900, was the beginning of a new century, and also Stieglitz's thirty-sixth birthday. In many of his photographs taken in New York in the early years of the new century, he captured the city as an emerging urban center. He depicted ferryboats, skyscrapers, railroad tracks, steam, smoke, and other aspects of the urban scene. His images celebrate the openness and possibilities of a new age. While some of his European photographs, although often formally innovative, celebrate tradition and a more rural way of life, the early New York ones seem to offer a bridge between nineteenth-century Romantic world views and twentieth-century progress. They also reflect Japanese design principles such as those espoused by Arthur Dow, as well as a symbolist aesthetic. The snowy scene in *The Street – Design for a Poster* (1900–01), also called *The Street, Fifth Avenue*, finds Stieglitz returning to the site of a photograph of the 1890s, looking up Fifth Avenue from 30th Street. The silhouette of a horse and part of its carriage is balanced by a tall, lone tree that thrusts upward, its leafless branches providing decorative linear elements in the background. The snowy atmosphere provides a dream-like quality for the intimate scene. Stieglitz shows the New York of the smaller neighborhoods of lower Manhattan, where there is a human dimension, with brownstone dwellings and horse and carriages on the street. This was the "old" New York, rooted in the nineteenth century, much different from the New York of later Stieglitz's photographs where the buildings, in their abstract, geometric configurations, speak of a coldness that represents in part, the rise of technology and urbanization in New York City in the twentieth century.

The year 1900 was to be important for Stieglitz: it marked the beginning of his relationship with Edward Steichen (Steichen changed the spelling of his first name from Edouard in about

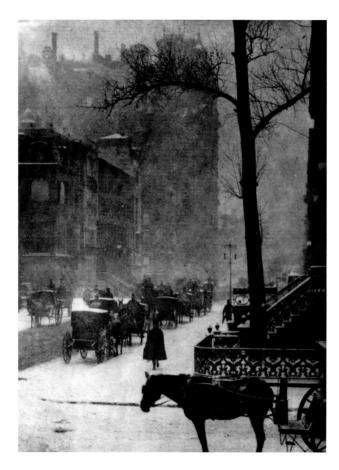

11 Alfred Stieglitz, *The Street – Design for a Poster*, 1900–01.
Lee Gallery, Winchester, Massachusetts.

1918). In May of that year, the twenty-one-year-old Steichen, a painter and photographer origi-
nally from Luxembourg, arrived in New York and stopped by the Camera Club, at the recom-
mendation of Clarence White, to meet Stieglitz, who was hanging a members' show there.
Stieglitz was greatly impressed with Steichen's work and his optimistic spirit. He bought three
photographs from Steichen for five dollars each and told Emmy at dinner that night, "I think
I've found my man."[32]

Steichen and Stieglitz were to collaborate on two extended endeavors that had a major influence
on modern art in America: the quarterly *Camera Work*, beginning in 1903, and the Little Galleries
of the Photo-Secession, established in 1905, later to be called 291 after the location at 291 Fifth
Avenue. Steichen's two years in Paris, from 1900 to 1902, had brought him into contact with artists
such as Auguste Rodin, Pablo Picasso, Constantin Brancusi, Paul Cézanne, and Henri Matisse,
whose work would be shown, in some cases for the first time in the United States, at 291.

On 17 February 1902, the Photo-Secession was formally born, with Stieglitz as its founder, modeling his group after the principles of European Secessionist groups of the time. Indeed, that same year Gustav Klimt completed his large-scale mural project celebrating Beethoven's Ninth Symphony at the Vienna Secession. The Viennese artists strove, like a number of Secessionist groups, to provide in art a surrogate religion, offering refuge from certain rigid aspects of modern life, and in founding the Photo-Secession, Stieglitz asserted that it was a "rebellion against the insincere attitude of the unbeliever, of the Philistine, and largely exhibition authorities . . . Progress has been accomplished only by reason of the fanatical enthusiasm of the revolutionist, whose extreme teaching has saved the mass from utter inertia . . . The Secessionist lays no claim to infallibility, nor does he pin his faith to any creed, but he demands the right to work out his own photographic salvation."[33]

The founding members consisted of seventeen fellows with thirty associates. Besides Stieglitz, the fellows included Frank Eugene, Joseph Kelley, Gertrude Käsebier, Eva Watson-Schütze, Clarence White, Alvin Langdon Coburn, and Mary Devens. In collaboration with the National Arts Club, they had their first exhibition as a group in March 1902, and despite the blinding snowstorm on 5 March, a good number of New Yorkers gathered for the opening, including Richard Gilder, the editor of *Century Magazine*.

Following the exhibition, Stieglitz made some of his best-known photographs, such as *The Hand of Man* (1902), *In the New York Central Stock Yards* (1903), and *The Flatiron* (1903). In the first two, he photographed oncoming trains, asking the viewer to contemplate the role of the mechanical and manmade in the context of the artistry of the curvilinear layout of the train tracks and the verticals of the power poles that Stieglitz included as major components of the composition. *The Flatiron* shows him exploring a precarious balance between the built environment and the world of nature. Designed by Daniel H. Bumham and Co. from 1901 to 1903, the Flatiron building, at 175 Fifth Avenue, not far from Stieglitz's gallery at 291 Fifth Avenue, was considered, at 307 feet tall, one of the first skyscrapers in New York. He chose to place the new building in the background of the photograph, while elements of nature – the delicate snow cover, the tall, dark Hiroshige-like forked tree – dominate the foreground. The triangle formed by the forked branch of the tree mirrors the shape of the building and frames the towering structure. There is a vestigial human presence: several small figures walk in the park, dwarfed by the trees and the building. Although the Flatiron is in the background, the viewer can still sense the beauty of the detailed façade. The photograph provides a balanced whole, containing the man-made structure, and the world of nature. Stieglitz was not the only photographer captivated by the towering Flatiron structure: Steichen, Coburn, and later Bernice Abbott also photographed the building. These photographers tended to be more concerned with the building as a part of city life: the building dominates their photographs more fully, and the viewer is more aware of traffic on the city street.

12 Alfred Stieglitz, *The Flatiron*, 1903.
 The Art Institute of Chicago.

13　Alfred Stieglitz, *The Flatiron*, 1903. Lee Gallery,
Winchester, Massachusetts.

The year 1903 also marked the birth of *Camera Work* with Stieglitz as editor and publisher. As noted, *Camera Work* was a type of *Gesamtkunstwerk*, presenting exquisite images laid out alongside visually pleasing texts, which explored and elaborated issues related to all the arts along with literature and philosophy. The graphic design was based, in part, on the designs of William Morris and the Arts and Crafts Movement. The articles were set in heavy, black text with red introduced in the first heavily ornamented letter, and the margins were wide. Each of the fifty issues was bound in a gray-green paper cover with the title and edition printed in a lighter gray. The photogravures were reproduced from original negatives, separated from the text by blank pages, and given prominence at the front of each issue. Even the advertisements were graphically interesting and primarily related to the field of photography – lenses, papers, and so on.

Camera Work was intended to be a quarterly, with an annual subscription rate of four dollars, or two dollars for a single issue. Initially, the publication was greeted with much enthusiasm, with 1,000 copies of every issue being printed and approximately 650 subscribers. By 1917, when publication stopped, only 500 copies of each issue were being produced and there were only 36 subscribers. Besides writings from Friedrich Nietzsche and Maurice Maeterlinck, there were also excerpts from Wassily Kandinsky, Henri Bergson, Gertrude Stein, William Carlos Williams, Marius de Zayas, and numerous others. Initially many of the texts of *Camera Work* were rooted in symbolist thinking, but gradually the magazine became an advocate for modernism and modern art. Another source of symbolist thought that in turn had an impact on Stieglitz and his circle was psychoanalysis. The symbolist exploration of dream states as a way to penetrate the spiritual was clearly influenced by Sigmund Freud, who began his studies of dreams and the unconscious in the 1880s. His *Interpretation of Dreams* (1900) was of great importance in both Europe and America.

The influence of figures, such as the French philosopher Henri Bergson, took Stieglitz and *Camera Work* in a modern direction. Bergson's view of time in his 1907 book *Creative Evolution* (an extract of which was published in *Camera Work* in October 1911) as a continuum in which there are no definite fixed objects, found expression in the images of simultaneity and dynamism of cubism, futurism, and their offshoots. Bergson's *élan vital*, or life-force, and his exaltation of the intuitive and instinctive over the rational, provided a sense of freedom for post-Victorian artists and intellectuals. Steichen greatly admired him, and Mabel Dodge (later Mabel Dodge Luhan), influential through her salons, translated Bergson's concept of the *élan vital* into the power of sexuality. Dodge became friends with both Stieglitz and Georgia O'Keeffe and also contributed to *Camera Work*.

In his book, *Camera Work: A Critical Anthology*, Jonathan Green divides the fifty issues of *Camera Work* into four major periods:

Consolidation, 1903–7, a time of transition from *Camera Notes*; Expansion, 1907–10, the development of the Little Galleries of the Photo-Secession, *Camera Work*'s initial contact

with modern art, and major exhibits of the Photo-Secession; Exploration, 1910–15, when *Camera Work* and the Little Galleries were vitally concerned with the radical new art movements of Fauvism, Cubism and Futurism; and the final period, 1915–17, when *Camera Work* offered an effective summation of the interest and activities of the preceding twelve years by publishing photographic tributes to Stieglitz and Paul Strand.[34]

Photographic highlights of the issues prior to 1915 included a special Steichen supplement in April 1906, and the reproduction of some of Steichen's autochromes in April 1908 (one of the first publications of the autochrome process). The October 1911 issue featuring sixteen photographs by Stieglitz, many of which pictured a new New York, as a port of trade and of new beginnings, and had titles such as *The City of Ambition* (1910), *The Ferry Boat* (1910), *Old and New New York* (1910), *The Aeroplane* (1910), *A Dirigible* (1910), *The Hand of Man* (1902), and *The Terminal* (1893). In *The City of Ambition* industrial smokestacks with billowing smoke rise in white splendor, in contrast to the dark buildings, up into the cloudy sky, joining nature and industry. Indeed, water and sky together embrace and frame the rising architectural structures, suggesting a harmonious union of the built environment and the natural world. The flag on the top of the towering Singer Building appears as a proud pinnacle on the modern building. The photographs of the aeroplane and the dirigible, while honoring the new airborne technology the Wright Brothers had invented just a few years before, honor also the grandeur and drama of the light of the sky and the clouds which serve as a backdrop to illustrate the wonders of flight. These sky images may be seen as harbingers of *Songs of the Sky* and the *Equivalent* series.

On the evening of 25 November 1905, the Little Galleries of the Photo-Secession at 291 Fifth Avenue, later to be called 291, officially opened. That small space decorated by Steichen was to become a haven as well as laboratory for exploration and nourishment of the artistic spirit. The decoration of the gallery was primarily in earth tones, influenced by designers such as the Vienna Secessionist architect Josef Hoffmann and the Scottish architect Charles Rennie Mackintosh. The main room was in olive tones, with a burlap wall covering in a warm olive-gray, while pleated canvas, olive-sepia hangings, behind which was storage, hung below a shelf that ran around the room.[35] The smaller room was covered with a natural-colored burlap on the walls, accented by white-and-yellow rectangular hangings. A little hallway, also serving as exhibition space, was decorated in gray-blue, soft almond, and olive-gray. In the main room Japanese vases adorned the shelf, and a large, circular, brass bowl sat on a burlap-covered table in the center of the room. The bowl's circular handles hung from lion-like fixtures, perhaps symbolizing courage and exploration. The bowl reflected to some extent the golden disk that became the gallery's logo. Works were hung in simple frames. A number of Stieglitz's installation shots of gallery exhibitions were not simple documentary records: they were also interior landscapes, and many showed a new precision and elegance in the interplay of objects, light, and space, just as notes might be com-

14 Marius de Zayas, *Camera Work*, no. 30, April 1910.
Beinecke Rare Book and Manuscript Library

bined in a musical score. The earth tones of the gallery rooms, along with the line of the horizontal shelf, provided the view with an initial sense of stability and balance.

Approximately eighty exhibitions were held between 1905 and 1917, initially concentrating on showing the best photographic images possible; then painting and other media were exhibited, beginning in 1907 with the exhibition of Pamela Colman Smith's work. Stieglitz estimated there were approximately fifteen thousand visitors during the first season and sales reaching $2,800 from prints sold, many of which were by Steichen.

In 1910, five years after opening 291, Stieglitz was asked to organize the International Exhibition of Pictorial Photography at the Albright Knox Gallery in Buffalo, New York, considered the most ambitious photographic exhibition of the time. With close to six hundred works, the exhibition was intended to be a comprehensive survey and show the vitality of Pictorial Photography. The works were hung by Stieglitz, Paul Haviland, Max Weber, and Clarence White, with Weber designing the catalogue cover.

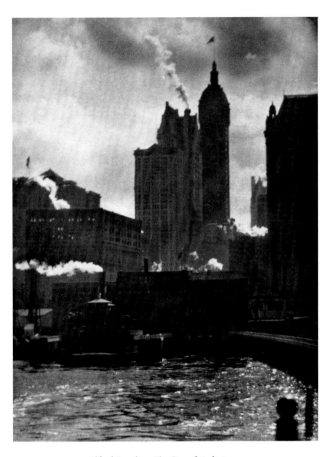

15 Alfred Stieglitz, *The City of Ambition*, 1910.
Lee Gallery, Winchester, Massachusetts.

In 1913, Stieglitz mounted a one-man exhibition of thirty of his own prints (made between 1892 and 1912) at 291, at the same time as the renowned Armory Show at the Sixty-Ninth Regiment Armory on Lexington Avenue at 25th Street, where visitors thronged the exhibition, often seeing European modern art for the first time. Stieglitz wished to measure himself against what came to be considered one of the most important exhibitions held in the United States. His photographs were well received at 291; even the conservative Royal Cortissoz described Stieglitz's "delightful breadth of mind, his enthusiasm for liberty and all those who fight for it. Mr. Stieglitz has been an exemplary pioneer . . . His liberality is a noble trait, and there is no better occasion than this one for offering it a public tribute."[36]

From the Armory Show, Stieglitz purchased Kandinsky's *The Garden of Love (Improvisation Number 27)* (1912) for $500, having recently published in *Camera Work* an excerpt from Kandinsky's book *Concerning the Spiritual in Art* (1912) that emphasized the role of inner necessity and spirit to be expressed in art. Stieglitz hoped to mount a Kandinsky exhibition at 291, but

45

16 Wassily Kandinsky, *The Garden of Love (Improvisation Number 27)*, 1912, oil on canvas.
The Metropolitan Museum of Art, New York.

this never happened. He formally photographed his Kandinsky painting in 1913 (the photograph is now in the Key Set at the National Gallery of Art in Washington, D.C.). Stieglitz also purchased works by Cézanne, Alexander Archipenko, and the sculptor Manuel Manolo, a friend of Picasso. His only American purchase was a drawing by Arthur Davies.

At this period, Stieglitz and a number of his followers, including Steichen, believed in the power of art to transform a larger world, and that a new life spirit was being born in those early years of the twentieth century. Writing to Stieglitz from Paris, Steichen tried to describe that evolving spirit:

> The relationship of all this [modern philosophy] towards a clearer and freer understanding of art as a means of expression interests me less in itself than as an element in the final relationship to life and the world problem everywhere and in everything. One is unconscious of unrest and seeking – a weird world hunger for something we evidently haven't got and don't

understand. To many it is a social and economic problem. But that is only one element of it. A bigger thing lies struggling beneath – I have a vague feeling of knowing it and yet it loses [sic] itself in its vagueness. Something is being born or is going to be.[37]

Stieglitz and Steichen's faith in the transformative powers of the arts was reflected also in part in the work of a loose coalition of cultural radicals primarily in lower Manhattan, such figures as John Reed, Max Eastman, Floyd Dell, Hutchins Hapgood, and Randolph Bourne.

New expressions in art, drama, literature, and cultural criticism, members of the Lyrical Left felt, could have a revolutionary impact on the world's social, economic, and political structures. To advance their belief in a burst of creative excitement they founded experimental magazines, clubs, theaters, art galleries, and schools. These they hoped would shake the foundations of the established world. Historians have referred to the phenomenon as "America's Coming of Age," the "Innocent Rebellion," the "New Paganism," the "Lyrical Left," and the "New York Little Renaissance." [38]

While Stieglitz did not necessarily espouse some of the political positions of those such as John Reed, he did believe fervently in the redemptive and transformative powers of art. In 1914, as the winds of war began to swirl through Europe with the onset of the "Great War," which, in the end, was to shatter and destroy many lives, dreams, and illusions, Stieglitz stood strong on the shores of the United States, in large part responsible for the advances photography had made at home and abroad in its short, seventy-five-year history.

THE TEENS

1915–1919

I am in the midst of experimenting along many lines. The first real chance I have had in
years to do what I want in photography. This may seem strange to you as I have been my
own master from the year one. But strange as it may sound, my photographic experimenting
had to be side-tracked for years, for the bigger work I was doing in fighting for an idea,
fighting practically single handed. This idea has finally taken firm root . . .

<div align="right">Alfred Stieglitz, 1915[1]</div>

It was Stieglitz's fifty-first birthday: 1 January 1915. The year has been labeled an important
cultural moment marking new beginnings in American history, a time for "New Politics, the
New Woman, the New Psychology, the New Art, and the New Theater in America."[2] The era
was to be marked by a breakdown of various conventions and hierarchies in a variety of spheres
of American life: "The New Politics took as its mandate the redefinition of the boundaries of
American democracy by extending the political rights 'to life, liberty and the pursuit of happi-
ness' into the economic, social and cultural spheres of American life. Woodrow Wilson
proclaimed a New Freedom, and the Progressive Party under Theodore Roosevelt, a New
Nationalism . . . The New Woman was no longer bound to the home, but was free to work,
study and pursue her own relationships."[3] In 1916, the National Birth Control League was
formed and Margaret Sanger helped open the first birth control clinic. "The New Psychology
promised to liberate the human personality from the false dichotomies of the rational and the
emotional, the spiritual and the sexual. It put artists in touch with unconscious drives that would
empower their work . . ."[4] Freud's theories of the unconscious were widely disseminated in sci-
entific and various intellectual communities. As noted, Freud's *Interpretation of Dreams* had
been published in 1900, and translated into English in 1911, by A. A. Brill, who was socially
connected to members of the Stieglitz circle. That, along with the publications of Einstein's

theory of relativity about 1915, and the development of quantum physics, helped support the notion that the world could not be viewed through one's sense as a single, concrete, unchanging reality. Instead there could be multiple and changing modes through which to look at a changing world. Practitioners of cubism, expressionism, surrealism, and the rise of modernism in general, defied conventional academic confines that art should primarily imitate reality. The "New Theatre" spawned smaller experimental theaters such as the Provincetown Players, rebelling against sentimental melodramas, and attempting to address political and social issues of the times. In 1915, D. W. Griffith's epic, *Birth of a Nation*, appeared in movie theaters presenting an array of well-developed significant cinematic techniques such as the close-up, the panoramic long shot, the fade-in and fade-out, and crosscutting to suggest simultaneous action in different locations. The movie advertised itself as a fully realized piece of art, of long feature length. But its narrative, focusing on two families, the Stonemans from the North, and Camerons from the South, was overtly white supremacist. Nineteen-fifteen also saw the opening of the first Ruth St. Denis and Ted Shawn School, devoted to modern dance and stepping away from ballet's conventions. Its earliest alumni included Martha Graham, Charles Weidman, and Doris Humphrey.

Despite the various cultural achievements around 1915, the backdrop of the European war theater moved ever closer. On 7 May 1915, a German submarine torpedoed the British ocean liner, the Lusitania; 128 Americans were among the 1,198 people who were killed, thus pushing the United States toward intervention in World War I. Woodrow Wilson won re-election in 1916 by promising peace and progressivism. That peace would be short lived. It was in this cultural milieu that Stieglitz accomplished some of his most significant editorial, curatorial, and photographic work.

camera work and other publications

In January 1915, Stieglitz saw the fruits of his question, "What is 291?" in the 47th issue of *Camera Work*, July 1914 (not published until January 1915). Stieglitz received over sixty-five responses, which he published unedited. The contributors included a diverse group of followers including Mabel Dodge, a patron of the arts, noted for her salons gathering artists and intellectuals together; Hutchins Hapgood, author, journalist, and social worker; Charles Rasay, Episcopalian clergyman; Hodge Kirnon, West Indian elevator operator at 291; Djuna Barnes, illustrator and writer; Charles Daniel, retired saloon proprietor who became a collector; Helen Gibbs, teacher of young children and writer; Marsden Hartley, painter; Eugene Meyer, Jr., banker; N. E. Montross, art dealer specializing in American paintings; Francis Brugière, photographer; Christian Brinton, art critic; Man Ray, painter, designer; Marie Rapp, music student

and stenographer at 291 since 1912; John Weichsel, civil engineer, writer; Belle Greene, librarian for J. P. Morgan; I. W. Hunter, lawyer and collector of Chinese art; Francis Picabia, painter; Charles Caffin, art critic; and Adolf Wolff, writer and anarchist, writing from a thirty-day prison sentence. The sampling of responses below reveals the immense impact of the small set of rooms. The artist William Zorach wrote:

> I rode up in the tiny elevator and entered the little gallery. The quiet light was full of a soothing mystic feeling and around the room, and on the square under glass in the middle of the room, I looked at what I now know were Matisse drawings. I was all alone and I stood and absorbed the atmosphere of the place and of the drawings. They had no meaning to me as art as I then knew art, but the feeling I got from them still clings to me and always will. It was the feeling of a bigger, deeper, more simple and archaic world. I stood long and absorbed 291 – the quiet, peaceful little room, the strange and wonderful life revealed to me and the square-faced, busy-haired man with penetrating eyes that swayed in and swayed out of the doorway. I left feeling I had seen something living, something that would live with me, and that has lived with me. For now, after an absence of three years, I have visited 291 very often and to me it is a wonderful living place palpitating with red blood – a place to which people bring their finest and that brings out the finest that is within all those that come in actual contact with it.

J. B. Kerfoot wrote: "But 291 is greater than the sum of all its definitions. For it is a living force, working both good and evil. To me, 291 has meant an intellectual antidote to the nineteenth century; a spiritual preparation for the twenty-first; and withal, a glorious training camp and practice ground for eclecticism." Marius de Zayas: "291 not an Idea, nor an Ideal, but something more potent, a Fact, something accomplished, being of a nature, although perfect, by no means final or conclusive, but much to the contrary . . . 291 magnificent school of Autobiography and – caricature." John Weichsel: "A cosmos-reflecting dewdrop, returning to each one of us his illumined specter – is 291 to me. Diverse images of life are here focused side by side." J. N. Laurvik: "291 – a human vortex." Emil Zoler: "The philosophy – if any – of 291 is vivisectional. The psychology is perfectly clinical . . . To me 291 is what the perfect beautiful spring is to the wayfarer who drinks of its living elements, which water refreshes, strengthens, enhances, and exhilarates life. It receives and welcomes with the same innocence, confidence, trust, hope, and purity, the same realism with which the child accepts as it sits and listens with an alertness of its own." Eugene Meyer, Jr.: "An Oasis of real freedom . . . A test. A solvent. A victim and an Avenger." Marsden Hartley: "A pure instrument is certainly sure to give forth pure sound. So has this instrument of 291 kept itself as pure as possible that it thereby gives out pure expression."[5]

Despite its magical powers to some, the gallery was not without its opponents. The critic Thomas Craven blasted 291 as a "bedlam of half-baked philosophies and cock-eyed visions,"

18 Francis Picabia, *Portrait of Alfred Stieglitz*, *291*, nos. 5–6, July–August 1915. Beinecke Rare Book and Manuscript Library.

19 *291*, nos. 7–8, September–October 1915, p. 1. Beinecke Rare Book and Manuscript Library.

where Stieglitz "shrewdly managed to hold the position of arbiter, to maintain a reputation for superior acumen." Craven also called Stieglitz "a Hoboken Jew without knowledge or interest in the historical American background."[6] Even the Luxembourg-born Steichen, who had spent much time in France and was deeply affected by the German invasion of France and Belgium, urged 291 to broaden its scope, to become a "vast force instead of a local one."[7]

Issue 48 of *Camera Work* did not appear until twenty-one months later. In the interim, the "Spirit" of the magazine inspired several significant smaller publications. One of these, *291*, edited under Stieglitz's sponsorship by Marius de Zayas, Paul Burty Haviland, and Agnes Ernst Meyer, a wealthy patron who had been a reporter for the *New York Morning Sun* before her marriage, appeared in March 1915. Its twelve issues, published from 1915 to 1916, reflected the influence of dada. Initially inspired by Apollinaire's *Les Soirées de Paris*, *291* appeared quite sophisticated for its time, frequently containing "ideograms" or poem-pictures. Art, music, and literature were referenced, with frequent emphasis on the duality of machine imagery. When Picabia returned to New York in 1915, he also helped with the publication, and readers were able to witness his evolving dada style.

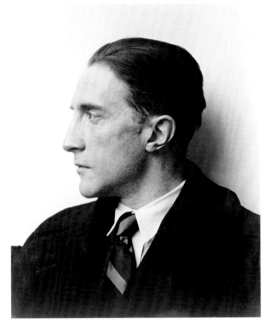

20 Alfred Stieglitz, *Marcel Duchamp*, 1923.
Beinecke Rare Book and Manuscript Library.

21 Alfred Stieglitz, *Marcel Duchamp*, 1923.
Beinecke Rare Book and Manuscript Library.

Stieglitz and Marcel Duchamp met shortly after Duchamp had first come to New York, just a few months after the publication of the January 1915 *Camera Work* issue, "What is 291?" The recollections of that meeting differ. Duchamp recalled that "Stieglitz's main characteristic was being a philosopher, a sort of Socrates. He always spoke in a very moralizing way and his decisions were important. He didn't amuse me much at the beginning. I must say he didn't think much of me either, I struck him as a charleton . . . then he later changed his mind about me, and we became good friends."[8] Stieglitz recalled, however (as recorded by his niece Sue Davidson Lowe in her memoir/biography), that he "became devoted to Duchamp in the mid-teens."[9]

The first issue of *291* featured an "Idéogramme" by Apollinaire, *Voyage*, in which the words are arranged into shapes that suggest, simultaneously, parts of a train or a ship, electric wires, and the signature of a musical staff. The concept of *Voyage* may be seen as metaphorical, suggesting the newly launched periodical as it set off on its maiden voyage to explore new models of expression. Below Apollinaire's image was the more densely set type of a text by Stieglitz, *One Hour's Sleep – Three Dreams*, which graphically became a base for *Voyage*. Freudian in nature, the dreams each involved a woman and death. Jay Bochner has interpreted this dream sequence, as representing an older Stieglitz "who has died, in part because of '291', but it is precisely '291' that needs him dead, yet is afraid of letting him die. His job is to leave, for himself, and stay

22 Alfred Stieglitz, *The Steerage*, 1907. Lee Gallery, Winchester, Massachusetts.

while appearing to leave, for her; that is he wanted another voyage, but '291' needed him along on theirs, as a father both honored and rejected."[10]

On the covers for issues 1 and 5–6 were cartoon-like portrayals by de Zayas and Picabia, respectively. The cover of the inaugural issue showed an image of Stieglitz and was titled *291 Throws back its Forelock*. The July–August 1915 issue (nos. 5–6) contained Picabia's machine-like "portraits" of Stieglitz, Haviland, de Zayas, and Meyer. The portrait of Stieglitz on the cover consists of camera and car imagery: the bellows and lens of a camera along with the handbrake and gearshift of a car. Although Stieglitz never drove himself, the car certainly represented movement and "forward" progress in technology in the U.S. at that time. But the gearshift and brake appear to be locked in place, implying a stop. Picabia may well be suggesting the precariousness of the times for 291 and Stieglitz. Yet the traditional, black-letter font used for the heading "Ideal," along with the title, *Ici, c'est Stieglitz, foi et amour, 291* ("Here, This is Stieglitz, Faith and Love, 291"), is a counterpoint to the mechanical imagery. Thus mechanical and humanist/artistic attributes are combined in the single image suggesting the multiple and complicated "layers" of meaning in Stieglitz's life and work. Inside, Haviland, de Zayas, and Picabia are depicted as some form of car or machine; and an anonymous young American girl is shown as a sparkplug.

In October 1915, Stieglitz's photograph *The Steerage* was the centerpiece, in deluxe and royal editions, for nos. 7–8 of *291*. The image, although made in 1907, was not published until its appearance as a small photogravure in no. 36 of *Camera Work* in October 1911, along with fifteen other prints by Stieglitz. In 1942, in an article for *Twice a Year*, he recalled making the image:

Early in June 1907, my small family and I sailed for Europe. My wife insisted upon going on the *Kaiser Wilhelm II* – the fashionable ship of the North German Lloyd at the time. Our first destination was Paris. How I hated the atmosphere of the first class on that ship. One couldn't escape the *nouveaux riches*.

I sat much in my steamer chair the first days out – sat with closed eyes. In this way I avoided seeing faces that would give me the cold shivers, yet those voices and that English – ye gods!

On the third day out I finally couldn't stand it any longer. I tried to get away from that company. I went as far forward on deck as I could. The sea wasn't particularly rough. The sky was clear. The ship was driving into the wind – a rather brisk wind.

As I came to the end of the deck I stood alone, looking down. There were men and women and children on the lower deck of the steerage. There was a narrow stairway leading up to the upper deck of the steerage, a small deck right at the bow of the steamer.

To the left was an inclining funnel and from the upper steerage deck there was fastened a gangway bridge that was glistening in its freshly painted state. It was rather long, white, and during the trip remained untouched by anyone.

On the upper deck, looking over the railing, there was a young man with a straw hat. The shape of the hat was round. He was watching the men and women and children on the lower steerage deck. Only men were on the upper deck. The whole scene fascinated me. I longed to escape from my surroundings and join those people.

A round straw hat, the funnel leaning left, the stairway leaning right, the white drawbridge with its railings made of circular chains – white suspenders crossing on the back of a man in the steerage below, round shapes of iron machinery, a mast cutting into the sky, making a triangular shape. I stood spellbound for a while, looking and looking. Could I photograph what I felt, looking and looking, and still looking? I saw shapes related to each other. I saw a picture of shapes and underlying that the feelings I had about life. And as I was deciding, would I try to put down this seemingly new vision that held me – people, the common people, the feeling of ship and ocean and sky and the feeling of release that I was away from the mob called the rich – Rembrandt came into my mind and I wondered would he have felt as I was feeling.

Spontaneously I raced to the main stairway of the steamer, raced down to my cabin, got my Graflex, raced back again all out of breath, wondering whether the man with the straw hat had moved or not. If he had, the picture I had seen would no longer be. The relationship of shapes as I wanted them would have been disturbed and the picture lost.

But there was the man with the straw hat. He hadn't moved. The man with the crossed white suspenders showing his back, he too, talking to a man, hadn't moved, and the woman with the child on her lap, sitting on the floor, hadn't moved. Seemingly no one had changed position.

I had but one plate-holder with one unexposed plate. Would I get what I saw, what I felt? Finally I released the shutter. My heart thumping, I had never heard my heart thump before. Had I gotten my picture? I knew if I had, another milestone in photography would have been reached . . . for here would be a picture based on related shapes and on the deepest human feeling, a step in my own evolution, a spontaneous discovery.

I took my camera to my stateroom and as I returned to my steamer chair my wife said, "I had a steward look for you. I wondered where you were. I was nervous when he came back and said he couldn't find you." I told her where I had been.

She said, "You speak as if you were far away in a distant world," and I said I was. "How you seem to hate these people in the first class." No, I didn't hate them, but I merely felt completely out of place.

As soon as we were installed in Paris I went to the Eastman Kodak Company to find out whether they had a darkroom in which I could develop my plate. They had none. They gave me an address of a photographer. I went there.

The photographer led me to his darkroom, many feet long and many feet wide, perfectly appointed.

He said "Make yourself at home. Have you developer? Here's a fixing bath – it's fresh."

I had brought a bottle of my own developer. I started developing. What tense minutes! Had I succeeded, had I failed? That is, was the exposure correct? Had I moved while exposing? If the negative turned out to be anything but perfect, my picture would be a failure. Finally I had developed and washed and rinsed the plate. In looking at it, holding it up to the red light it seemed all right, and yet I wouldn't know until the plate had been completely fixed.

The minutes seemed like hours. Finally the fixing was completed. I could turn on the white light. The negative was perfect in every particular. Would anything happen to it before I got to New York?

I washed it. No negative could ever receive more care, and when the washing was finished, I dried the negative with the help of an electric fan. I waited until it was bone dry, and when it was completely dry I put the glass plate into the plate holder which originally held it. In that way I felt it was best protected. I could not remove it from that place till I had returned to New York . . . I wanted to pay the photographer for the use of his darkroom, but he said, "I can't accept money from you. I know who you are. It's an honor for me to know you have used my darkroom". . . And when I got to New York four months later I was too nervous to make a proof of the negative. In making the negative I had in mind enlarging it for *Camera Work*, also enlarging it to eleven by fourteen and making a photogravure of it.

Finally this happened. Two beautiful plates were made under my direction, under my supervision, and proofs were pulled on papers that I had selected. I was completely satisfied. Something I not often was, or am.

The first person to whom I showed *The Steerage* was my friend and co-worker Joseph T. Keiley, "But you have two pictures there, Stieglitz, and upper and a lower one," he said.

I said nothing. I realized he didn't see the picture I had made. Thenceforth I hesitated to show the proofs to anyone, but finally in 1910 I showed them to Haviland and Max Weber and de Zayas and other artists of that type. They truly saw the picture, and when it appeared in *Camera Work* it created a stir wherever seen, and the eleven by fourteen gravure created still a greater stir.

I said one day, "If all my photographs were lost and I'd be represented by just one, *The Steerage*, I'd be satisfied.

I'm not so sure that I don't feel much the same way today."[11]

The writer Allan Sekula has read Stieglitz's account of his taking of the photograph as "pure symbolist autobiography," suggesting that Stieglitz "Invented himself in pure Symbolist clichés. An ideological division is made: Stieglitz proposes two worlds, a world that entraps and one that liberates . . . The photograph is taken at the intersection of the two worlds . . ."[12]

Many have interpreted the photograph as an image that memorialized the New York immigrant experience, just as Lewis Hine did in his Ellis Island series. But in truth, this is an image

23 Alfred Stieglitz, *Waldo Frank*, 1920.
The Metropolitan Museum of Art, New York, Alfred Stieglitz Collection.

that was taken on the way to Europe, not to the United States. It does depict a lower-class experience with an elegant composition that draws on cubist elements, and speaks of Stieglitz's wish to escape his upper-class upbringing and the expectations of his wife, Emmy. Stieglitz himself noted, "You may call this a crowd of immigrants . . . To me it is a study in mathematical lines, in balance, in a pattern of light and shade."[13] Stieglitz carefully used a gangplank, large column, and ladder to form the basis of his geometric exploration. Picasso is reported to have very much liked the photograph, appreciating its cubist elements. Both *The Steerage* and Picasso's *Les Demoiselles d'Avignon*, also of 1907, mark significant junctures in early twentieth-century art and photography. Picasso's painting opened the way to cubism; Stieglitz's photograph contained cubist elements and was not only a social document but also a metaphoric and formal experiment.

The photographer Emmet Gowin commented further about the image: "It represents something architectural, pictorial, geometric, which is moving the way music is moving, that before you have any idea of what it means, it's moving and embedded in the beautiful structure and

24 Alfred Stieglitz, *Paul Rosenfeld with Books*, 1929.
Beinecke Rare Book and Manuscript Library.

countless instances of humanness, expressed through body, stance, gesture. The picture is both an abstraction and a structure, like a piece of music, but where the notes would appear on the score are those beautiful gestures of humanity."[14] And John Szarkowski noted, "it is half Picasso and half 'Waiting for Godot' . . . There is the patience, the waiting . . . And all these terrific little portraits. A dozen portraits locked into this wonderfully resolved architecture. And they are all worth looking at and thinking about. Wondering do we know anybody related to any of these people? Did any of them make it?[15]

The last issues of *291* featured a Congolese sculpture on the cover, a discussion of modern and "Negro" art by de Zayas, and examples of work by Archipenko and Brancusi. Stieglitz's support for the publication – and for the new Modern Gallery, which opened in October 1915 at 100 Fifth Avenue at 42nd Street, sponsored by de Zayas and Meyer – had been shortlived. Although the gallery was initially intended as a branch of 291, with its opening exhibition featuring photographs by Stieglitz and paintings by Picabia, Braque, and Picasso, Stieglitz began to see the gallery as too commercial, insisting that art and "money" were not a good mix. In the combined

fifth and sixth issues of *291*, July–August 1915, de Zayas had already criticized Stieglitz, suggesting that he was not succeeding as a "prophet" of his times. De Zayas wrote, "The real American life is still unexpressed, America remains to be discovered. Stieglitz wanted to work this miracle. He wanted to discover America. Also he wanted Americans to discover themselves. But in pursuing his object, he employed the shield of psychology and metaphysics. He has failed. In order to obtain living results, in order to create life – no shields!"[16]

After the twelfth issue, Stieglitz dropped his support for the publication. Although *291* was shortlived, it continued to exert its influence particularly in Europe: when Picabia and his artist wife, Gabrielle Buffet, founded and published *391* in Barcelona in 1917, it was said to be modeled directly on *291*. Other dada publications were issued in Europe at about the same time. And many years later, in March 1949, Michel Tapié edited and published a single issue of *491* in Paris. Pierre André Benoit of Alès published *591* in 1952 and *691* in 1959. An issue of *791* was planned in France but never published.

Another short-term but significant publication that influenced Stieglitz and his circle was *The Seven Arts*, edited by Waldo Frank and Paul Rosenfeld with James Oppenheim and published from November 1916 to October 1917. Waldo Frank and Paul Rosenfeld had first met Stieglitz in about 1915 when they visited his gallery, 291, they in their mid-twenties, Stieglitz in his fifties. Frank and Rosenfeld had graduated from Yale University in 1911 and 1912, respectively, and hoped to establish careers in writing. Both were interested in what Stieglitz was attempting at 291. Stieglitz encouraged them and through the years carried on an extensive correspondence with each of them. He read some of their manuscripts, and he furnished illustrations from his gallery artists and some of his own photographs for their books. He invited them repeatedly to Lake George in the summer, to visit him and O'Keeffe, and photographed them both there. Rosenfeld visited more frequently, often spending two to three weeks in that quiet sanctuary. For Frank and Rosenfeld, Stieglitz was a father figure as well as artistic mentor: Frank often began his letters, "Dear Master," and Rosenfeld sometimes addressed Stieglitz as "291." Frank was drawn to left-wing causes and registered for the draft in World War I as a pacifist, while Rosenfeld was more an aesthete and was involved in the world of music, becoming particularly noted as a music critic.

Frank declared in the opening issue of *The Seven Arts*, "We are living in the first days of a renascent period, a time which means for America the coming of that national self-consciousness which is the beginning of greatness."[17] Along with Randolph Bourne, who had become an influential essayist, these men saw themselves as intellectual and artistic rebels, trying to bring about cultural change. For them, a close community of artists, which Bourne was to call "the Beloved Community," had the power to regenerate culture.[18] The editorial in the first issue also stressed that the new American art represented not only a new culture, but also a strong spiritual strength. Thus art was to take on a communal and religious dimension that was to contribute

to the formation of a renewed sense of American identity. Frank referred to the gallery 291 as a kind of religious altar. In general the editors at *The Seven Arts* were deeply committed to a cosmopolitan vision of an American cultural renaissance, brought about by these Young Americans as they came to be called. The magazine was a good early example of Jewish and Christian collaboration (Oppenheim, Frank, and Rosenfeld were Jewish, while Randolph Bourne and Van Wyck Brooks were "lapsed" Protestants). These five major writers read widely, drawing upon a variety of sources, American and foreign, including Marx, Nietzsche, Freud, Emerson, Thoreau, Whitman, and James.

Even after *The Seven Arts* ceased, Frank, in *Our America* in 1919 continued to emphasize the importance of a renewed, independent American culture and sense of national identity. He declared that "Ours is the first generation of Americans consciously engaged in spiritual pioneering," and that Stieglitz was "the prophet . . . the true apostle of self-liberation in a destructive land."[19]

While publications such as *291* and *The Seven Arts* were shortlived, albeit influential, Stieglitz's *Camera Work* had a longer life, but it, too, was unable to last past 1917, once the United States had entered the war. However, the last two issues (which followed the January 1915 issue, "What is 291?"), no. 48, October 1916, and nos. 49–50, June 1917, were significant. Number 48 contained six photographs by Stieglitz, six by the young Paul Strand, one by Frank Eugene, one by Arthur Allen Lewis, and one by Francis Brugière, along with articles on African ("Negro") art, the newly discovered Georgia O'Keeffe and the role of the Modern Gallery in relation to the gallery 291.

The six photographs by Stieglitz were installation shots of certain gallery 291 exhibitions: the African sculpture exhibition of November–December 1914; Brancusi sculpture, March–April 1914; German and Viennese photography, March 1916; the Picasso–Braque exhibit of December 1914–January 1915; and two images from the Elie Nadelman exhibit in October 1916. It is noteworthy that Stieglitz chose to include an image from the German and Viennese photography exhibit, the only installation shot of a photography exhibition at the gallery. That exhibit, with works by Heinrich Kühn, Hugo Henneberg, and the late Hans Watzek, was a tribute in some ways to Stieglitz's Germanic roots, and to his continuing connection with Europe, particularly with Kühn, alongside whom he had experimented with the autochrome process in the summer of 1907. The installation shot also clearly shows the relatively large scale of a number of the images – unusual for the time.

The installation shot of the African sculpture exhibition, organized by Marius de Zayas, shows Stieglitz and Steichen, who helped design the installation, using the large brass bowl filled with leaves, along with panels that were yellow, orange, and black, and creating a sense of a Synthetic cubist collage or assemblage in the room. The panels also created a sense of pulsating rhythms that evoked a suggestion of background drumbeats of music. Steichen had designed a lighting

25 Alfred Stieglitz, installation view of the Kühn,
Henneberg, Watzek exhibition, March 1936.
Beinecke Rare Book and Manuscript Library.

26 Alfred Stieglitz, *Primitive Negro Sculpture*
exhibition, installation view at 291, November 1914.
Library of Congress, Washington, D.C.

system for the gallery that included lights, skylights, and a dropped ceiling masked by a translucent cloth. The exhibit was considered to be the first in which "Negro" sculpture was displayed as "art."

The Picasso–Braque installation shot shows Stieglitz's juxtaposition of a wasps' nest with drawings and an African mask. The image reflects Stieglitz's interest in music and dance: the African mask suggests dance rituals and rites, while the cubist drawings display stringed instruments. The earth tones of the gallery room, along with the wasps' nest – which, placed on a pedestal, has become a work of art – suggests the radical significance of the world of nature for a number of modern artists, particularly those whom Stieglitz championed. It is perhaps worth noting that within the *Still Life* by Picasso (1912–13, charcoal and pasted paper, The Metropolitan Museum of Art, New York, Alfred Stieglitz Collection), the newsprint that is part of the wine bottle label reads, "M. Millerand, Ministre de la Guerre, flétrit l'antimilitarisme" ("M. Miller, the Minister of War, is corrupting the concept of anti-militarism"). When this work was exhibited at 291, World War I was already in its fifth month. Stieglitz, no doubt, had noted the newsprint.

Perhaps most significant in this issue were the photographs by Paul Strand, particularly those of lower Manhattan. Strand had made his first visit to Stieglitz's 291 gallery as a young, high-school student in 1907. He would have seen photographs by a number of Photo-Secessionists including Alvin Langdon Coburn, Frank Eugene, Gertrude Käsebier, Steichen, Clarence White, and Stieglitz himself. Between the time of Strand's initial visit to Stieglitz's gallery and his exhibition there in 1916, along with images published in *Camera Work*, Strand had emerged as a photographer of distinction. Inspired by that visit to 291, he had enrolled as a senior in Lewis Hine's photography class at the Ethical Culture School, where Hine emphasized the importance

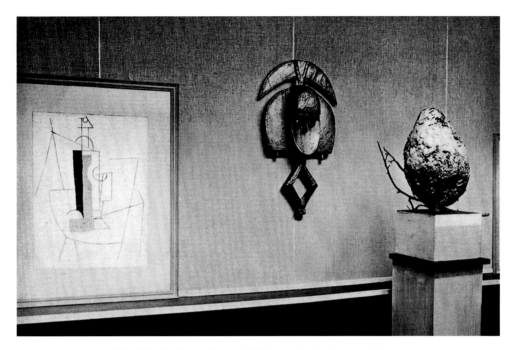

27 Alfred Stieglitz, *Picasso/Braque* exhibition, installation view at 291, January 1915.
Beinecke Rare Book and Manuscript Library.

of a sharpness of vision. While at the New York Camera Club, Strand learned various darkroom techniques. Initially working in a pictorialist style, he gradually moved toward experimentation with compositions containing abstract elements, stressing geometric design and new ways of organizing space, perspective, and tonal values. He became particularly interested in the work of Alvin Langdon Coburn and Karl Struss. In 1914, Strand, Coburn, and Struss participated in an exhibition of modern photography organized by Clarence White at the Ehrich Gallery. Strand also showed Stieglitz some of his work. Stieglitz's suggestion, made in 1915, for Strand to use smaller apertures, such as f/22, to allow for greater definition in the negatives was significant. With such a technique, Strand's New York City scenes became more vital and sharp, evoking with a new intensity various facets of New York City life, a life not only observed, but also seemingly intensely experienced. In *Wall Street* (1916), Strand photographed the recently completed monolithic structure belonging to J. P. Morgan and Company that symbolized the power of big business. Strand most likely stood on the steps of New York's Federal Hall, a Greek Revival building, to capture the early morning rush hour scene, as small humans with elongated shadows cast in the sunlit street, hurry to work. Strand wrote about taking the photograph, as he tried to organize a picture of that kind of movement in a way that was abstract and controlled: "I was aware for instance of those big, black windows of the Morgan building, these enormous black

63

28 Paul Strand, *New York – Wall Street*, in *Camera Work*, no. 48, October 1916. Lee Gallery, Winchester, Massachusetts.

shapes . . . I also was fascinated by all these little people walking by these great big sinister, almost threatening shapes . . . those black, repetitive rectangular shapes . . . sort of blind shapes, because you can't see in, with people going by. I tried to pull that all together."[20]

Strand's response to an observed oppression by Wall Street institutions constituted a powerful abstract expression of Strand's personal emotional response to his observations. Such a response appealed to Stieglitz. Two other Strand photographs from the October 1916 *Camera Work* issue also show Strand's unique angled perspectives; New Yorkers moving through their city, on a crowded street, and on park pathways.[21]

In the final issue of *Camera Work* in June 1917, Stieglitz devoted all the illustrations to Strand, with eleven reproductions and also an article by Strand entitled "Photography." Stieglitz wrote in his introduction to the issue:

No photographs had been shown in "291" in the interim, primarily because "291" knew of no work outside of Paul Strand's which was worthy of "291." None outside of his had been done

29　Paul Strand, *New York*, in *Camera Work*, no. 48, October 1916.
Lee Gallery, Winchester, Massachusetts.

30 Paul Strand, *New York*, in *Camera Work*, no. 48, October 1916.
Lee Gallery, Winchester, Massachusetts.

by any new worker in the United States for some years, and as far as is our knowledge none had been done in Europe during that time. By new worker, we do not mean new picture-maker. New picture-makers happen every day, not only in photography, but also in painting. New picture-makers are notoriously nothing but imitators of the accepted; the best of them imitators of, possibly at one time, original workers. For ten years Strand quietly had been studying, constantly experimenting, keeping in close touch with all that is related to life in its fullest aspect; intimately related to the spirit of "291." His work is rooted in the best traditions of photography. His vision is potential. His work is pure. It is direct. It does not rely up on tricks of process. In whatever he does there is applied intelligence. In the history of photography there are but few photographers who, from the point of view of expression, have really done work of any importance. And by importance we mean work that has some relatively lasting quality, that element which gives all art its real significance.

The eleven photogravures in this number represent the real Strand. The man who has actually done something from within. The photographer who has added something to what has gone before. The work is brutally direct. Devoid of all flim-flam; devoid of trickery and of

any "ism"; devoid of any attempt to mystify an ignorant public, including the photographers themselves. These photographs are the direct expression of today. We have reproduced them in all their brutality. We have cut out the use of the Japan tissue for these reproductions, not because of economy, but because the tissue proofs we made of them introduced a factor which destroyed the directness of Mr. Strand's expression. In their presentation we have intentionally emphasized the spirit of their brutal directness.

The eleven pictures represent the essence of Strand.

The original prints are 11 by 14.[22]

Strand in an essay of his own, which had been printed previously in *The Seven Arts*, referred to photography as "the first and only important contribution thus far of science to the arts . . . a new road from a different direction but moving toward the common goal, which is Life," and suggested that, instead of deploring or mistrusting the photograph, "Let us rather accept joyously and with gratitude everything through which the spirit of man seeks an even fuller and more intense self-realization."[23] Strand's photographic street portraits are indeed "brutally direct." Taken primarily in lower Manhattan with an Ensign camera and a prism lens to make sure the subjects did not know they were being photographed, these images are often raw and capture moments in the lives of those who are struggling to survive. With disheveled hair, wrinkled skin, or blind, these are American society's immigrants, and outcasts: Italians, Jews, a blind beggar woman, etc. Through Strand's lens, they struggle, but retain dignity, as Strand pushed the boundaries of photographic portraiture beyond traditional portraiture of the time.

In contrast to the street portraits, Strand had also made a series of abstract images based on architectural elements and still-life forms taken while on vacation at Twin Lakes in western Connecticut during the summer of 1916. Two of those, *Abstraction, Bowls* and *Abstraction, Porch Shadows*, reflect Strand's increasing interest in formal, modernist experiments. It is perhaps appropriate to note here, that in 1916, Stieglitz also reprinted his image of *Sun Rays, Paula* of 1889 in which he, too, was experimenting with linear elements of light and shadow as a major component of the photographic image. In Strand's photographs, the images are almost completely abstract, whereas Stieglitz's image still relies in part on narrative issues related to Paula and to the other photographs and objects that appear in the image.

Strand recalled his early connections with the Stieglitz group, that it was "very alive in terms of its spirits . . . Stieglitz was great: he was a marvelous polemicist and when people came into the little gallery of 291, and began to jeer at something they really caught it in a way that was not insulting but very forceful and not easy to answer. So there was a good deal of feeling of a struggle and a fight for something important happening in the world."[24] Stieglitz photographed Strand in 1917, and again in 1919. In the earlier image Strand is shown with his sleeves rolled up, in a work apron, a pipe in his mouth, shortly before 291 closed completely. The later image is darker, more contemplative, as Strand stands before an open door, with a cigarette in one hand,

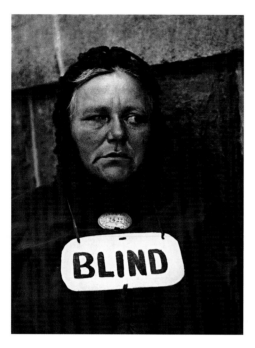 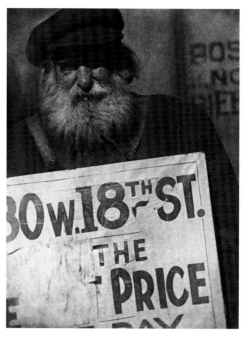

31 Paul Strand, *New York (Blind Woman)*, in *Camera Work*, nos. 49–50. June 1917. Lee Gallery, Winchester, Massachusetts.

32 Paul Strand, *New York*, in *Camera Work*, nos. 49–50, June 1917. Lee Gallery, Winchester, Massachusetts.

deep in thought. Strand and Stieglitz remained close into the 1920s. Strand was an ardent supporter of Stieglitz, and the one selected to go to Texas to bring Georgia O'Keeffe to New York. By the early 1930s, however, their relationship had cooled, as Strand began to be more concerned with social issues, hoping that his work would contribute to social and political change.

<center>*</center>

If *Camera Work* had not ceased publication in mid-1917, shortly after the United States' entry into World War I in April, Stieglitz's plan was to devote an issue to the photographs of Charles Sheeler and watercolors of Georgia O'Keeffe. Indeed, had no. 51 of *Camera Work* appeared, Sheeler's photographs might have received greater attention, along with his now widely acclaimed Precisionist paintings of the early twentieth century. In 1916, Sheeler had made his first visit to Stieglitz, and shortly thereafter wrote to him, "For the first time I saw a large and comprehensive collection of your photographs, which strengthened greatly my belief that they are absolutely unparalleled."[25] Stieglitz responded quickly, "I cannot tell you how glad I am that you feel as you do about me . . . And as you know this feeling that you have could not exist if I did not have a similar feeling towards you. And I have always had it from the first moment that you came into

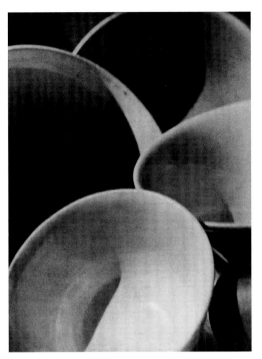

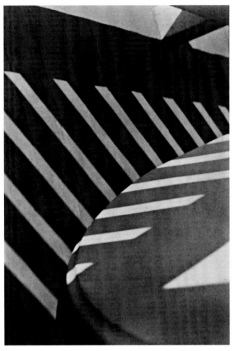

33 Paul Strand, *Photograph (Abstraction, Bowls)*, 1916, in
Camera Work, nos. 49–50, June 1917. Lee Gallery,
Winchester, Massachusetts.

34 Paul Strand, *Photograph (Abstraction, Porch
Shadows)*, 1916, in *Camera Work*. nos. 49–50, June 1917.
Lee Gallery, Winchester, Massachusetts.

291." During these years, Sheeler was in demand as an art photographer, recording private col-
lections and making prints of classical and oriental objects from the John T. Morris Collection
at the Pennsylvania Museum (now the Philadelphia Museum of Art). He had actually sent
Stieglitz a gift of his prints of Chinese and Roman sculpture in 1915, prior to their meeting in
person. Following the successful exhibition of African sculpture at 291 organized by Marius de
Zayas in 1914, and the publication of his book *African Negro Art: Its Influence on Modern Art*,
de Zayas asked Sheeler in 1918 to do the documentary photographs for another book, *African
Negro Wood Sculpture*, which, when it was published, included twenty tipped-in original pho-
tographs by Sheeler. De Zayas also sponsored an exhibition of photographs by Strand, Sheeler,
and Morton Schamberg at the Modern Gallery from 29 March to 9 April 1917. Five works by
Sheeler were shown: two of African sculpture, one of an obsidian Mexican mask, one of Bran-
cusi's sculpture *Head of a Child*, and one of a New York building. There was also an exhibition
of Sheeler's Doylestown photographs, of the house he and Schamberg rented in Bucks County,
Pennsylvania, where they whitewashed the walls and removed all extraneous furniture to emulate
the sparse environment of Stieglitz's 291 gallery. The Doylestown photographs, such as *Open
Door with Desk Mirror* (1917) or *The Stove*, showing the sparse but beautifully lit environment,

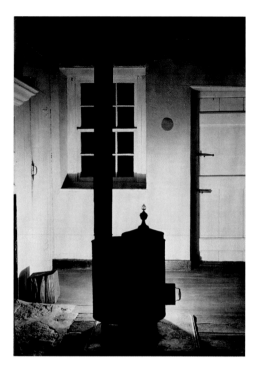 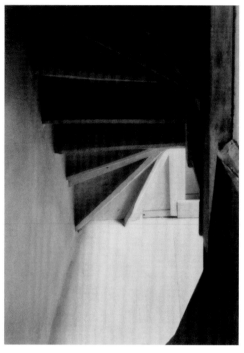

35 Charles Sheeler, *Doylestown House – The Stove*, 1917.
The Metropolitan Museum of Art, New York.

36 Charles Sheeler, *Doylestown House – Stairs from
Below*, 1917. The Metropolitan Museum of Art, New York.

celebrate a rural vernacular and the role of linear formal elements that dominate the composi-
tions. In *The Stove*, the stove is backlit, and with its black silhouette in contrast to the dimly lit
room, it appears to be surrounded by an aura. Here the secular becomes almost sacred in the
interplay of light and shadow that Sheeler created. He explained the scenes, in part, to Stieglitz
in a letter of 22 November: "I decided that because of something personal which I was trying
to work out in there, that they were probably more akin to drawing than to my photographs of
paintings and sculpture, and that it would be better to put them on a different basis – to make
only three sets – one to be offered as a complete set (12) at $150, and the remaining two sets
singly at $15.60." Stieglitz admired the five Sheeler photographs at the Modern Gallery, as well
as the Doylestown scenes, and chose three of the latter when, in December 1917, Sheeler, who
was visiting Stieglitz, suggested they trade photographs. Stieglitz wrote to Georgia O'Keeffe:

> Sheeler spent several hours with me too. He is always fine. Wears splendidly. I am to have
> three of his wonderful photographs in exchange for one of mine. He seems to get results more
> readily than I do. It's hellish hard work for me to get what I want – and I don't want to give
> him a print which isn't A1 + + – A1 plus plus – And I rarely make such. I want him to see

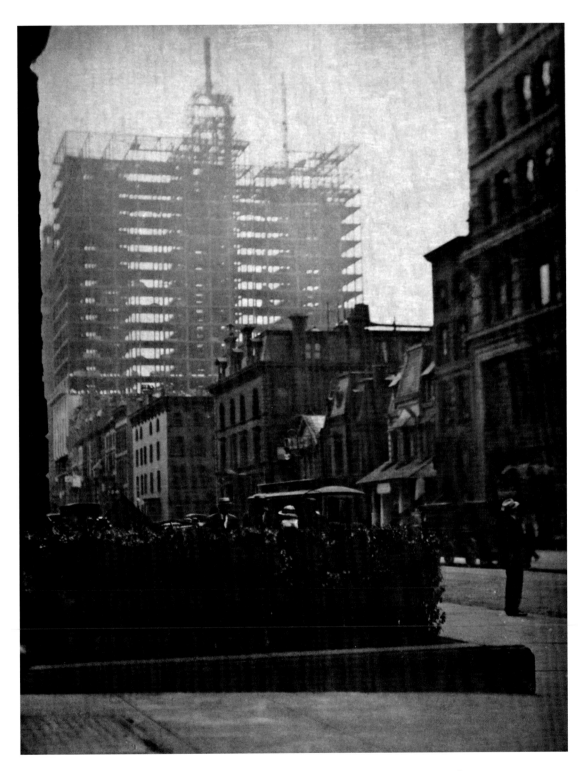

37 Alfred Stieglitz, *Old and New New York*, 1910 (print *c*.1913). Philadelphia Museum of Art.

several parts of your hands. I wonder how he'll like them. Trying to get one perfect print – one in which one isn't conscious of any process. I've gotten near to it – but . . .

The growing rift, relating to the Modern Gallery, between Stieglitz on one hand and de Zayas and Agnes Meyer on the other, was awkward for Sheeler, who wished to maintain good relations with everyone. The Modern Gallery closed in April 1918, but in the fall of 1919 it reopened as the De Zayas Gallery at 549 Fifth Avenue. Sheeler moved to New York permanently in 1919, initially to help de Zayas at the gallery. (Shamberg had died of influenza in 1918.) The gallery survived until April 1921. De Zayas continued loyally to support Sheeler, mounting a retrospective exhibition that displayed his development as a modernist in painting, drawing, and photography from 1916 to 1920.

Sheeler's move to New York had coincided with Strand's return to the city from military service in the army. Stieglitz had kept Strand informed of Sheeler's work while he was away at war, and in one letter he noted, "Sheeler – he has done some wonderful things, Pennsylvania Barns! Uses bromide paper now – smooth. Has much quality." Although Strand saw no real action while in the service, his heart was more closely aligned with Randolph Bourne's pacifist philosophy, and he returned home a changed man. Gone was some of the optimism and faith in the power of a group spirit. Nevertheless, he and Sheeler were to join forces in 1920 on their film *Manhatta*, which chronicled a work day in lower Manhattan and used lines from Walt Whitman's poems, including *Manhatta* as inter-titles. In the film, they attempted to explore relationships between still photography and moving pictures. It contains direct reference to Strand's photograph "Wall Street," along with an homage to a number of Stieglitz's photographs, such as his *Hand of Man* of 1902 and works from 1910: *City of Ambition*, *The Ferry Boat*, *Old and New, New York*, and *In the New York Central Yards*, all of which had been published in *Camera Work* in October 1911. The collaborative project, while successful aesthetically, lead to professional conflict and jealousies between Strand and Sheeler. Strand continued his freelance work in film in the 1920s, but Sheeler distanced himself from filmmaking, rarely mentioning his involvement in it later in his career. The two men were probably the most progressive American photographers in the late 1910s. It is significant that Stieglitz strongly supported them both, and that they, in turn, supported Stieglitz's work, at least into the 1920s.

Unfortunately, the *Camera Work* issue devoted to Sheeler was not realized; nor was another issue whose subject was suggested to Stieglitz by his friend Frederick Goetz (whose Munich firm had printed with great care, following directions from Stieglitz, many of the photogravures for *Camera Work*). As late as 1922, Goetz urged Stieglitz to devote a final issue to his own work: "Your life's work isn't yet complete. The finishing stroke is missing! You <u>must</u> still make a number of *Camera Work* – or three or four numbers – with the best work of Alfred Stieglitz. You must wind up the whole oeuvre to show what the <u>master</u> meant!" In 1923, Ward Muir honored Stieglitz in an article "*Camera Work* and Its Creator," in the *Amateur Photographer and Photography*,

by noting, "If only England had had a Stieglitz! But Stieglitzs are rare. It suffices that one Stieglitz has been born in one generation, and our debt to him is enormous. He is not only, as those who know his work have long been persuaded, the greatest living photographer: he has been (and solely for the love of it) the greatest propagandist for photography."[26]

It should perhaps be noted, that *Camera Work* reached relatively few, albeit influential readers. Photomechanical reproduction in the form of the postcard, or "low-art" form, was much more accessible for the general populace between 1905 and 1918. The postcard became the magic vehicle for circulating photographic images as a result of several coinciding factors: the United States postal service cut the price of mailing postcards by half; in 1906, Kodak offered to print images on postcard stock at no extra charge; while reproducing photographs in newspapers continued to be complicated. Postcards were used to record events from county fairs to portraits, to famous disasters. They encouraged the public to appreciate photographic images and also to appreciate the vernacular.

*

Camera Work was the major "literary" arm for the gallery 291 and a vehicle for promoting Stieglitz's ideas and various experiments in the arts; he and his circle, in turn, were influenced by the critical work of several early twentieth-century American writers and artists, including Ernest Fenollosa, Arthur Wesley Dow, Max Weber, and Willard Huntington Wright. The ideas of these men about art and aesthetics provided fresh perspectives on and inspiration for the development of American modernism.

Ernest Fenollosa, born in Salem, Massachusetts, in 1853, was a distinguished scholar, noted for his then groundbreaking studies of Chinese and Japanese art, along with Noh drama. As a young man at Harvard, class of 1874, he had studied poetry and philosophy, and he also took drawing and painting classes at the Art School of the Boston Museum with Charles Eliot Norton. Indirectly, through Norton, at the age of twenty-five, Fenollosa went to the University of Tokyo, where he was captivated by Japanese and Chinese art of all schools. His teacher in Tosa and Buddhist painting was Hirotaka, the last Sumiyoshi, who died in 1885, and his teacher in Chinese and Kano painting was the third Kano Yeitoku. Fenollosa lived in Japan for many years before returning to the United States where he spent five years as curator of the oriental collections at the Boston Museum of Fine Arts from 1891 to 1896. He also represented Japan at the World's Fair in Chicago, where for the first time Japanese art was classified as a fine art rather than an industry. His writings and lectures became well known, particularly his book *Epochs of Chinese and Japanese Art* of 1913. He saw in much of Chinese and Japanese art a new way of constructing space, which he wished to introduce to the west, and he dreamed of a new, world-wide artistic synthesis where east and west might combine their strengths.

Fenollosa's study of and writings about Chinese calligraphy influenced a number of artists and writers, particularly the imagist poets and Ezra Pound. In his teachings, his emphasis was on spacing and structure: "I do not like the word 'decoration.' It seems to imply too much artificiality, a superficial prettiness. The word we ought to use is 'structural.' The lines, the spaces, the proportions lie in the structure of the thing itself . . . It is a question of spacing, how the pattern is worked out, that interests us . . . not the representational element but the structural element . . . not the realist motive but the desire to find finer and finer space relations and line relations."[27] He also wrote, "we press . . . the organic union of parts, the intrinsic beauty of life . . . even the spiritual significance of trees and rocks, and mountains and water . . . all these like so many glintings of prismatic color refracted from the facets of matter, an elemental harmony which the Master Artist has woven into the substance of the world."[28]

Fenollosa's dreams of an east–west synthesis were to find resonance in the work of Arthur Wesley Dow, a practicing artist who had studied with the synthesist painters surrounding Gauguin at Pont-Aven. Fenollosa met Dow in 1891 and made him an assistant curator of Japanese art at the Boston Museum of Fine Arts in 1893. Dow became curator in 1897, when Fenollosa left the museum. Both Dow and Fenollosa were committed to art education, and Dow's beautifully designed book *Composition*, of 1899, was in many ways the epitome of the Fenollosa–Dow system of art education. Dow had introduced some of his ideas earlier, in February 1896, in *The Lotus*, a magazine run by Fenollosa and his friends; he argued for the power of composition over academic realistic representation. The goal should be synthesis and creative compositional construction, not imitation. Dow credited Fenollosa with the notion that music was a key to the other arts, and that the spatial arts might be called visual music. In his writings, he quoted Hegel, saying "wood, stone, metal, cameras, even words are themselves dead stuff. What art creates upon this dead stuff belongs to the domain of the spirit and is living as the spirit is living."[29]

Fenollosa and Dow also worked briefly together at Columbia, and at the summer school Dow established in Ipswich, Massachusetts. Dow's notion of filling space in a beautiful way inspired many of his students and readers. Among his most distinguished students were Alvin Langdon Coburn, Max Weber, Georgia O'Keeffe, and Pamela Coleman Smith, the latter being the first artist who was not a photographer to exhibit at 291, in 1907. Each acknowledged his or her debt to Dow; Coburn wrote in his autobiography, "Dow had the vision, even at that time, to recognize the possibilities of photography as a medium of personal expression. I learned many things at his school not the least in terms of what the orient has to offer in terms of simplicity and directness of expression."[30]

Dow's teaching of O'Keeffe, his defense of modernism, and his interest in the oriental arts, as well as in music, were to alter the course of O'Keeffe's work. She explained in retrospect: "This man had one dominating idea: to fill a space in a beautiful way . . . After all, everyone has to do just this – make choices – in his daily life, even when only buying a cup and saucer. By this time,

I had a technique for handling oil and watercolor easily; Dow gave me something to do with it."[31] The stately Dow, in turn, greatly respected O'Keeffe and her work. In a recommendation of 1915, he wrote, "She is one of the most talented people in art that we have ever had. She excels in drawing and painting . . . Miss O'Keeffe is an exceptional person in many ways. She has qualities of character that enable her to work well with other people and to interest them."[32] The oriental emphasis on simplicity, and the emphasis on linear and spacial composition are seen in much of O'Keeffe's early work, such as the watercolor and graphite *Blue Lines* of 1916 (Metropolitan Museum of Art, New York). These early works were among those that so appealed to Stieglitz and to his search for an artist's internal, intuitive expression. *Blue Lines* appeared as the frontispiece to F. S. C. Northrop's book *The Meeting of East and West: An Inquiry Concerning World Understanding* (1946), along with other abstractions by O'Keeffe in the body of the text. Northrop was professor of philosophy at Yale University and saw O'Keeffe's *Blue Lines* as representative of the unity of aesthetic (intuititive) and theoretic (verified by scientific documentation) components. He suggested that such a unity should be the cornerstone of a new American culture that would be "free and adventurous," and in which eastern and western cultural elements would be also united. Writing of the *Blue Lines* he noted,

> Long ago, Plato in his *Timaeus* identified the mathematically designated *theoretic component* in things with the male principle in the universe and the intuitive *aesthetic component* with the female principle. This is precisely the interpretation which Alfred Stieglitz, the informed student of Georgia O'Keeffe's art, places upon her Abstraction No. 11, *The Two Blues Lines*: the one blue line represents the female aesthetic component; the other, the male scientific component in things. And the common base from which the spring expresses the fact that although each is distinct and irreducible to the other, both are united. It is because this bold intuition of the artist, sensitive to the deeper intimations of her culture, is supported as the sequel will show, by considerations which are scientific and philosophic in their basis and worldwide in their scope, that *The Two Blue Lines* functions appropriately, both as the Frontispiece of this book and as the concluding topic of this chapter.[33]

O'Keeffe made several works related to this image: a charcoal drawing, *First Drawing of Blue Lines* and *Black Lines*, a watercolor, both of 1916. Throughout her career, she frequently concentrated on a single subject within a series (for example, the *Jack in the Pulpit* series from 1930), or on multiple images exploring the same subject, such as a clam shell or alligator pears. Daniel Catton Rich described such treatment of single subjects as closely allied to an oriental tradition: "Concentration like this on one subject is far more likely to be found in the Orient than in the West. In many ways O'Keeffe's approach is closer to Chinese and Japanese traditions of perspective and modeling than to European. She tends to flatten her forms, to design in two dimensions, and to eliminate some expressive brush strokes . . . Another Oriental trait is the variation in

format."[34] In the 1920s and 1930s, Stieglitz adopted some of this oriental sensibility in his own series of photographs of clouds and New York skyscrapers.

Another student of Arthur Dow was the painter Max Weber, who was probably the most significant modern-art theorist in the group around Stieglitz before World War I. Weber, a native of Russia, had emigrated with his family to Brooklyn in 1891 and had studied with Dow at the Pratt Institute. In 1905, he went to Paris to study with Henri Matisse, returning to New York in 1909, when his first one-man show at the Haas Gallery, consisting of work influenced by impressionism, fauvism, and cubism, was attacked by mainstream critics. Stieglitz was drawn to the work, and Weber became part of his circle, actually residing in his gallery for a short period of time. Weber was able to inform the group of recent experiments in European modern art and, as Stieglitz noted, it was "through the closeness of Weber and myself and my study of his work – living with it – that gave me an opportunity to enlighten myself in a way in which I couldn't have otherwise in America."[35] Weber's close connection to Stieglitz, however, was short-lived after they quarreled in 1911 about Weber's one-man exhibition at 291. When Stieglitz insisted that Weber be present each day to explain his work, Weber argued that the work spoke for itself. However, Weber's ideas about the "fourth dimension" were significant for Stieglitz and his circle. In *Camera Work* he described this dimension as "the consciousness of a great and overwhelming sense of space – magnified in all directions at one time . . . It is the immensity of all things. It is the ideal measurement; art is therefore as great as the ideal, perceptive or imaginative faculties of the theater . . . the stronger or more forceful the form, the more intense is the dream or vision."[36]

Despite the tension between them, Weber's book *Essays on Art* (1916) resonated with the Stieglitz circle. The book, derived from Weber's lectures at the Clarence H. White School of Photography in New York, called upon artists and the general population to cultivate and trust their senses and intuition in relation to nature, other people, and their general environment: "Culture will come when people touch things with love and see them with a penetrating eye . . . the wonder of and the faith in other human beings would kindle a new and spiritual life."[37] Weber still believed, as did a number of others on the eve of America's entry into World War I, that art could redeem society.

Another important spokesman for modern art in America was Willard Huntington Wright, the brother of the synchronist painter Stanton MacDonald-Wright, whose work was exhibited as one of the last shows at 291 from 20 to 31 March 1917. Willard Huntington Wright began to work at *Forum* magazine as an art critic, attacking academic art and defending modern artists. His comprehensive books *Modern Painting: Its Tendency and Meaning* (1915) and *The Creative Will* (1916) presented an up-to-date study of recent American and European artistic experiments. Part of Wright's analysis in the earlier work suggested that the new painting drew influences from both primitive and classical art. Wright was particularly favorable in his comments

about synchronist painting, which involved linking colors to music or states of emotion, as well as the attempt to express light through rhythmic colors. He emphasized that the abstract artist's "sensitivity to formal sequences must be developed to a degree where it becomes almost a new sense . . . Abstract form is not, as it is popularly believed, emancipation. It makes supremist demands on the artists by tightening his order and by intensifying his vision."[38] Wright saw the synchronists as relieving painting of the "dead cargo of literature, archaeology, and illustration," that their paintings could be as pure an art as music: "Modern painting strives toward the heightening of emotional ecstasy."[39] Further, Wright wrote of the synchronist paintings of his brother and Morgan Russell: "With them an art is born whose power to create emotion surpasses other contemporary painting just as the orchestra surpasses the harpsichord."[40]

<p style="text-align:center">*</p>

Such writings, along with those in *Camera Work*, served as the foundation of and complement to the various exhibitions in New York that showcased modern artists following the Armory Show of 1913. Examining some of those exhibitions between 1915 and 1919 will shed light on the nature of the new work, which may be seen at different junctures as iconoclastic, modern, and in search of a new national, cultural identity.

291, other galleries, and related issues

Besides the Modern Gallery and the De Zayas Gallery mentioned previously, other small galleries inspired by 291 opened and/or began showing modern art in New York. In January and February 1915, the conservative Montross Gallery had a Matisse exhibition – the first time modern European art had been shown there – and in January 1916, a Cézanne exhibition. At the same time as the Matisse exhibition, the Carroll Galleries showed "French Modernists and Odilon Redon." Charles Daniel, an ex-saloon-keeper with a great interest in modern art, opened a new "progressive" gallery. As Daniel noted, "291 was the original impulse of my going into the modern world of art . . . Aside from the pictures, the attitudes of Mr. Stieglitz toward art and life made a deep impression on me."[41] The Daniel Gallery showed the work of Man Ray in October 1915, as well as exhibiting the works of Charles Demuth, Abraham Walkowitz, and others connected to 291. Significant exhibits at the Modern Gallery in February and May 1916 included works by Picabia, Cézanne, Van Gogh, Picasso, Braque, and Diego Rivera.

One of the most important exhibits in early 1916 was *The Forum Exhibition of Modern American Painters* in March, at the Anderson Galleries, at 15 East 46th Street. The exhibition selection committee consisted of Stieglitz, Willard Huntington Wright, Robert Henri, W. H. de B. Nelson,

John Weichsel, and Christian Brinton. Wright conceived of the exhibition as a way to focus on new movements in American art, rather than on new European art. Each of the committee members wrote a foreword to the catalogue, which included also statements by the artists. In his contribution, Stieglitz wrote,

> This particular exhibit receives my cooperative support because the men represented in it should be given an opportunity to develop . . . To me many of their experiments are of value if anything in American painting is of consequence. No public can help the artists unless it has become conscious that it is only through the artist that it is helped to develop itself . . . The practical way to give the opportunity to develop his work is to give him moral support backed up by sufficient means to live reasonably and decently. This holds good for all other workers besides artists.[42]

John Weichsel noted that the exhibition was "dedicated to this superb art and through it, to the high mission of which the new art is a living token: the life of creativeness in art above dulling rot, debasing imitation, puerile stunt and technical futility . . . It is a privilege of discerning art lovers to share in this creative task by granting their active sympathies to the cause of living art."[43]

The exhibition included many of the American artists whom Stieglitz particularly championed, such as Oscar Bluemner, John Marin, Marsden Hartley, Arthur Dove, Alfred Maurer, Stanton MacDonald-Wright, Charles Sheeler, and Abraham Walkowitz. Other artists included were Thomas H. Benton, Man Ray, and William and Marguerite Zorach. William Zorach's statement in the catalogue captured much of the aesthetic sensibility of a number of the participating artists: "It is the inner spirit of things that I seek to express, essential relation of forms and colors to universal things. Each form and color has a spiritual significance to me and I try to combine those forms and colors within my space to express that inner feeling which something in nature or life has given me."[44]

In December of 1916, the Society of Independent Artists was founded by Marcel Duchamp, Man Ray, Walter Arensberg, John Covert, and others. Stieglitz was an early member of the group. John Quinn, an attorney and an art collector, assisted with the legal work for the society. Quinn had been acquiring works from Stieglitz since 1912, and by 1917 he had purchased twenty-seven, including pieces by European and American artists. In the spring of 1917, he bought ten items from the first American exhibition of the work of the Italian Gino Severini, held at 291. Quinn, as Stieglitz and Severini, was drawn to the world of music and dance, and half of the works purchased were devoted to dance imagery. Quinn and Stieglitz greatly respected each other and shared a concern for the professional survival of the modern artists they admired. Quinn also fought to make sure new federal tax legislation would not impose a ten percent tariff

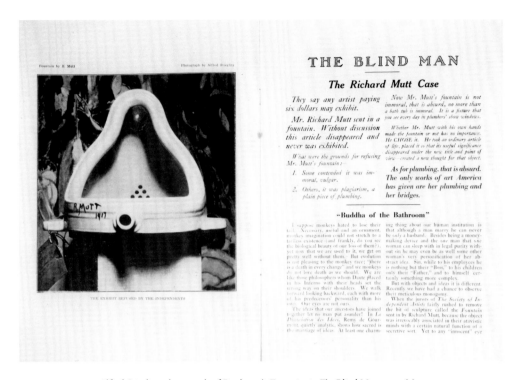

38 Alfred Stieglitz, photograph of Duchamp's *Fountain*, in *The Blind Man*, no. 2, May 1917.
The Philadelphia Museum of Art.

on sales such as those by Stieglitz and by de Zayas at the Modern Gallery. In January 1917, Quinn
had also helped to organize an exhibition of the vorticists at the Penguin Gallery.

The first exhibition of the Society of Independent Artists, which included approximately two
thousand works and lasted from 10 April to 6 May 1917 at Grand Central Palace, provoked
controversy when Marcel Duchamp's *Fountain*, submitted for exhibition under the society's
guidelines of "no jury – no prizes," was not displayed, being declared prefabricated and immoral.
Stieglitz and Arensberg protested and then resigned from the society. Stieglitz briefly exhibited
at 291 Duchamp's controversial "readymade" porcelain urinal from J. R. Mutt's Ironworks,
signed "R. Mutt." When the readymade arrived at the gallery, work by O'Keeffe was hanging
on the walls. Stieglitz chose, however, to place the piece in front of a Marsden Hartley painting
of 1913, *The Warriors*, which depicted German soldiers going to battle and which had curved
forms similar to those of the urinal. Just five days before the opening of the exhibition of the
Society of Independent Artists, the United States had declared war on Germany. A painting
such as Hartley's could not be hung in the wake of strong anti-German sentiment and thus was
placed on the floor.

39 Alfred Stieglitz, *Francis Picabia*, 1930s.
Beinecke Rare Book and Manuscript Library.

A cropped version of a photograph taken by Stieglitz while *Fountain* was at 291 appeared in 1917 in *The Blind Man*, a small magazine published by Duchamp and Arensberg. The photograph was also mounted onto part of a page of the periodical *291* in 1917, in support of the spirit of the dada movement.

At the time, dadaism was beginning to emerge in various art capitals, including New York. Just the year before, Hugo Ball had founded in Zurich the Cabaret Voltaire, a meeting place for dadaists. The war in Europe had stimulated the temporary migration of artists such as Duchamp, Albert Gleizes, and Francis Picabia to New York, where they became enamored with American mechanization and urban development. Once in New York, such emigrés also gravitated to the salons of the wealthy patron Walter Arensberg, where they could meet those sympathetic, in part, to dada's ideas, artists such as Man Ray, Charles Demuth, Morten Schamberg and Charles Sheeler. Arensberg and the French dadaists began to publish *The Blind Man*, an irreverent publication that attempted to present avant-garde culture but was issued only twice. That a number of dadaists saw New York as an art capital was a testimony to some extent to Stieglitz's endeavors in bringing modern art to the city.

40 Francis Picabia, *Star Dancer with Her Dance School*, 1913, watercolor on paper, 55.6 × 76.2 cm,
The Metropolitan Museum of Art, New York.

Stieglitz himself was drawn to the work of Picabia and exhibited his work at 291 in 1913 and 1915. He had first seen the works of the thirty-four year old French painter in the controversial Armory Show of 1913 where four of his large, color cubist abstractions had been included. Picabia visited 291 frequently, and he and Stieglitz quickly became friends. Picabia's wife, Gabrielle, who had studied music and singing, also became friendly with Stieglitz and contributed to *Camera Work*.

Picabia's show at 291 in 1913 opened two days after the closing of the Armory Show. His watercolor studies recorded his responses to New York. A number of his works shown at 291, in both 1913 and 1915, had their basis in the realms of music and dance, such as *Chanson Negre I and II (Negro Song I and II)* (1913), *Danseuse étoile et son école de danse (Star Dancer with her School)* (1913), and *Danseuse étoile sur un transatlantique (Star Dancer on a Transatlantic Liner)* (1913; private collection, Paris). The star dancer (*danseuse étoile*) was the popular dancer Stacia Napierkowska, who was *en route* to the United States when the Picabias met her. Picabia noted in his introduction to the catalogue of his first 291 show, "I improvise my pictures as a musician improvised music . . . creating a picture without models is art . . . We moderns, if you think of

us, we express the spirit of the modern time, the twentieth century, and we express it on canvas the way great composers express it in their music."[45] Picabia's abstract watercolor, *La Musique est comme la peinture* (1913–17), was shown at the Society of Independent Artists exhibition in New York in 1917. Picabia's theories were taken up by a curious New York press. In an interview in 1913 with the journalist Hutchins Hapgood, Picabia declared, "Art resembles music in some important respects. To a musician the words are obstacles to musical expression . . . the attempt of art is to make us dream, as music does. It expresses a spiritual state. It makes that state real by projecting on the canvas the means of producing that state in the observer."[46]

During his visit to New York in 1913, Picabia also met Marius de Zayas, and this resulted in a rich interchange between the two artists. De Zayas was instrumental in bringing Picabia's new large abstractions to New York for his 1915 exhibition at 291 and his caricatures began to take on more abstract, geometric qualities after he got to know Picabia. A caricature of Picabia was published in *Camera Work*, no. 46, in 1914. As remarked above, when he returned to New York in 1915, he helped de Zayas, Haviland, and Agnes Meyer with the publication of the new periodical *291*. There the public saw for the first time Picabia's newly evolving dada style.

Two of Stieglitz's photographs of Picabia in 1915 show him in front of two of his paintings that were shown at 291 in that year: *Mariage Comique (Comic Wedlock)* (Metropolitan Museum of Art, New York) and *C'est de moi qu'il s'agit (This Has to Do with Me)* (Museum of Modern Art, New York), both of 1914. In the photographic portraits, Picabia appears to be an integral part of the biomorphic and organic forms of his paintings. The curves of his body's outline and the gray tones of his suit flow with the lines and shapes of the works. He left New York in the summer of 1916 to go to Barcelona but returned in 1917, when he published three issues of his magazine *391*, a solo production that was circulated among different members of the Stieglitz circle.

Picabia, like a number of artists and intellectuals, was also interested in theories relating to the "fourth dimension." This signified an ideal or higher-dimensional reality, best attained by means of new spatial perceptions based on tactile and motor sensations, such as those experienced through music and dance. A new space could be created that denied the clear-cut three-dimensional approach of traditional academic paintings, suggesting instead the possibility of a new fourth dimension. As previously discussed, fourth-dimension theories had also been introduced to the Stieglitz circle by Max Weber, who was a close friend of Stieglitz until about 1911 and who also made several paintings with music as their basis. The Stieglitz circle became further imbued with fourth-dimension theories as a result of the arrival of Mabel Dodge and through the young architect Claude Bragdon.

Mabel Dodge, a wealthy socialite from Buffalo, New York had moved to New York City in December 1912, after having lived in Italy for almost ten years. She was drawn to the arts and to avant-garde thinking, particularly in the aftermath of the 1913 Armory Show. She later recalled

the effect of the controversial exhibition: "Men began to talk and write about the fourth dimension, interchangeability of the senses, telepathy and many other occult phenomena without their former scoffing bashfulness; only they did it with what they were pleased to call a scientific spirit."[47] Dodge's apartment at 23 Fifth Avenue became a gathering place for artists and intellectuals including Hutchins Hapgood, Carl Van Vechten, Lincoln Steffens, Max Eastman, John Reed, Max Weber, Francis Picabia, and other members of the Stieglitz circle. She bought several paintings by Weber, and the two became close friends. Dodge's article "Speculations" for *Camera Work* in June 1913 emphasized her interest in a cosmic sensibility and the role of the fourth dimension in art: "So for any work of art to completely depict a human being in his entirety, it would be necessary for it to also contain the fourth dimension . . . We are most of us creatures, aware as yet of only three dimensions, while perhaps here and there among us walks one who has become conscious of the fourth! Can we bear to admit it? But do we dare to deny it?"[48] Her article discussed also Weber's theory of art and the philosophy of "hyperspace." She called the notion of a fourth dimension a new language that would express an evocative higher stage of human consciousness that reached toward the cosmic. Dodge also referred to the significance of *Creative Evolution* by the philosopher Henri Bergson which emphasized the role of intuition and an *élan vital*. Stieglitz had already printed excerpts from *Creative Evolution* and Bergson's "Laughter" in *Camera Work* in October 1911 and January 1912, respectively. Bergson's lectures at Columbia University in February 1913 were publicized widely in newspapers and magazines of the time.

Dodge's ideas and influence not only permeated New York circles, but also later extended to New Mexico where she ultimately moved, married the Indian, Tony Luhan, and opened her doors there to visiting artists and writers, such as D. H. Lawrence and his wife, Frieda, and Georgia O'Keeffe.

Fourth-dimension theories were also espoused by the architect Claude Bragdon, who had published his *A Primer of Higher Space (The Fourth Dimension)* in 1913. Bragdon, two years younger than Stieglitz, was probably educated in modern art by his friend the writer Sheldon Cheney, whose book *Primer of Modern Art* (1924) made reference to Bragdon's ideas about the fourth dimension. Georgia O'Keeffe and Stieglitz became friends of Bragdon when they moved into the Shelton Hotel in 1925, where Bragdon had lived since the previous year. He had long been interested in correspondences between art and music, as had Stieglitz, and had attended what would become a legendary color-organ performance of Alexander Scriabin's *Prometheus: The Poem of Fire* in March 1915 at Carnegie Hall.

Bragdon lived in the Shelton until his death in 1946. Stieglitz and O'Keeffe lived there until 1932, and the three often ate dinner together. Between 1932 and 1943, the two men wrote frequent, warm letters to each another. Stieglitz praised the various texts that Bragdon sent him. Noteworthy was Bragdon's *Frozen Fountain: Being Essays on Architecture and the Art of Design*

in Space, which was published in five editions by Alfred A. Knopf between 1924 and 1932. Beautifully illustrated with line drawings, the book discusses, through the explanations of a fictional protagonist, Sinbad (named for the Arabian voyager), topics such as dynamic symmetry, fourth-dimensional ornamentation, and color-music. Life and architecture were both seen as "a fountain": "For if life indeed is a fountain – *a struggle upward* – and nature a symbolization of that struggle, a work of architecture must be that, too: a presentation, in terms of ponderable beauty, of the interplay of and adjustment of contradictory forces." Near the end of his book, Bragdon wrote, "the only further instruction which can be given can be summarized in the words: observe, reflect, feel, experiment."[49] Stieglitz recorded publicly his enthusiasm for Bragdon on an advertising flyer for Bragdon's autobiography of 1938, *More Lives Than One*, where he was quoted as saying, "A beautiful book in every way, a masterpiece of its kind."[50]

Bragdon was a great admirer of the Lebanese–American writer Kahlil Gibran, particularly after the publication of his work *The Prophet* in 1923, and it is likely that Bragdon could have discussed Gibran with Stieglitz, given Gibran's interest in "the Spirit" and issues relating to beauty, passion, and spiritual love. Bragdon also translated and published *Tertium Organum: The Third Canon of Thought, a Key to the Enigmas of the World* (1920) by the Russian philosopher and mystic writer P. D. Ouspensky. Ouspensky had led a study group in England dealing with theosophy and aspects of the fourth dimension attended by an English intellectual Alfred Richard Orage. Orage, in time, coming to New York as the representative of the Greek–American theosophist George Gurdjieff, gave a series of lectures on the neutral discipline of self-observation and spiritual development, what he called objective consciousness. O'Keeffe and Stieglitz attended the lecture series in November 1924.

These writings and ideas reflected a more spiritual approach to the fourth dimension which would have appealed to Stieglitz and his circle. Such ideas did not necessarily require that readers become a spiritualist or occultist or that they believe in the supernatural, but rather sought to find and define a meaningful relationship between the individual self and the Infinite, and to establish a faith in the unity of the world of nature. That world of nature was to become significant subject matter for a number of the inner Stieglitz circle, including Marin, Dove, O'Keeffe, Demuth, Hartley, and Stieglitz himself.

Bragdon's books and articles, including *A Primer of Higher Space, Projective Ornament, Four-Dimensional Vistas and Architecture*, and *Democracy*, were purchased by John Quinn, whose library may have been visited by artists such as Marcel Duchamp and Katherine Dreier, the founder of the Société Anonyme and an admirer of Bragdon's ideas and collector of his writings.

Thus, discussions of the fourth dimension were prevalent within intellectual and artistic circles of the late 1910s and into the 1920s and 1930s, impacting, in part, on Stieglitz's selections of work to be shown at 291. Friendly with Max Weber, and also exhibiting at 291, was the Rus-

41 Alfred Stieglitz, *Shadows on the Lake*, 1916.
The Metropolitan Museum of Art, New York.

sian-born Abraham Walkowitz, who became noted for his drawings and sketches of the dancer Isadora Duncan. Walkowitz, who had met Duncan at Rodin's studio in Paris, made more than five thousand drawings and sketches of the famed dancer, capturing her graceful movement in linear lyricism. His curvilinear elements in some of the almost abstract images suggest the spiraling and curved lines of some of O'Keeffe's early work. It was Walkowitz who persuaded Stieglitz to show children's art in 1912 and to show O'Keeffe's work in 1916. Stieglitz made several autochromes of Walkowitz in 1916, capturing the young artist's serious, intellectual expression. In two black-and-white photographs of the same title taken by Stieglitz the same year, *Shadows on the Lake*, Stieglitz and Walkowitz appear as dancing shadows, with leaves, water, and sunlight coalescing in sparkling patterns of light and shadow. The sunlit areas are like staccato notes in a musical composition. In one, the bow of an old wooden boat with its rope, reflected in the water, provides a stage set for the dancing figures.

When Walkowitz's work was shown at 291, *Camera Work* praised it as "the manifestation of a man who has given expression to a spirit of freedom that he has found in his contact with

society."[51] Arthur Hoeber in the *New York Globe* presented a quite opposing viewpoint, calling Walkowitz "as weird as the worst of them."[52]

In 1915, Stieglitz gave the German-born Oscar Bluemner his first one-man show in the United States. Bluemner had first started frequenting 291 in about 1909 or 1910 and had been so influenced by the Cézanne exhibition there in 1911 that he gave up his career as an architect and traveled around Europe, studying the latest avant-garde art works and painting himself. As a number of other artists, Bluemner was captivated by the relationship of the visual arts and music, or, as he noted, "the musical color of fateful experience."[53] Based on his study of Chinese and Japanese aesthetics, Bluemner believed there to be a relationship between landscape elements and various states of human emotion. He wrote, "My idea fully established: colors like music can excite moods and express emotions, are psychic agents or stimuli."[54] Bluemner's use of intense colors and forms, his strong suns, moons, and other nature imagery were to influence O'Keeffe and other artists of the Stieglitz circle, such as Arthur Dove, who made his own series of intense suns and moons. Stieglitz's portrait of Bluemner in 1915 emphasized his large eyes, gazing directly at the viewer with his pipe in his mouth.

Other significant exhibits at 291 during the 1915 season were: the photographs of Paul Strand, a number of which were published in *Camera Work*, as discussed above; forty paintings by Marsden Hartley, made during his two year stay in Berlin; an exhibition of charcoal drawings by Georgia O'Keeffe; drawings and watercolors by Charles Duncan; and oils by René Lafferty. In a final season at the gallery, from 1916 to 1917, Stieglitz showed the work of Hartley, Marin, Walkowitz, Stanton MacDonald-Wright, O'Keeffe, his ten-year-old niece, Georgia Engelhard, and Gino Severini. Severini was the only European artist shown that season and his exhibition marked the first time futurist paintings had been shown in New York, since they had not been included in the Armory Show. Several of the works exhibited had dance motifs, such as *Danseuse = Hélice = Mer* (*Dancer = Helix = Sea*, 1915). The exhibition also illustrated the beginning of a transition in Severini's oeuvre from movement-filled futurist pieces to quieter, more classical cubist pieces, such as *Femme et enfant* (*Woman and Child*, 1916). The fragmented nature of modern life was translated into both a dynamic synthesis and synthetic dynamism in Severini's dance pieces. Stieglitz's selection of Severini's diamond-shaped *Danseuse = Hélice = Mer* also points to a shared interest in conceptual ideas and wit. In the painting, Severini equated the idea of a spiral with images of a dancer and with the sea. The title contains a pun, since in French and Italian "helix" and "propeller" are translated by the same word. Severini, like a number of artists and writers, was captivated by the idea of flight and the aerial feats of men such as the Wright brothers, Henri Farman, and Louis Blériot. Stieglitz, too, had celebrated flight in *A Dirigible* and *The Aeroplane* of 1910. A number of Severini's paintings were also seen to encompass elements of the "fourth dimension" that continued to inspire Stieglitz and some of his contemporaries.

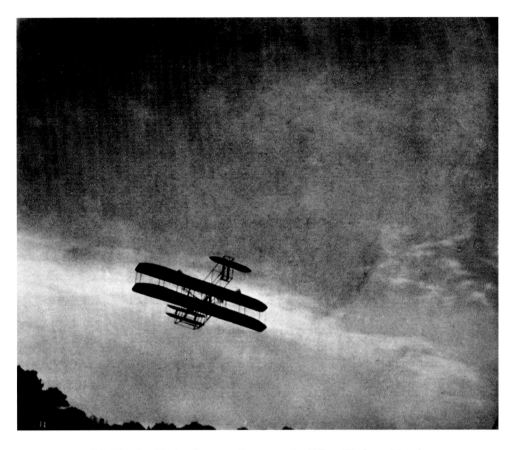

42 Alfred Stieglitz, *The Aeroplane*, 1910, photogravure. Lee Gallery, Winchester, Massachusetts.

At the close of the exhibit Severini wrote to Stieglitz (22 June 1917) that, because of the circumstances relating to the war, it was impossible to return the unsold works to France where Severini was located. He asked Stieglitz to become the caretaker of the works – four oils and ten drawings – and to exhibit them as he might see fit. Stieglitz did, in fact, dream of having a permanent gallery to house his collection of his own photographs and the works of the artists and photographers whom he exhibited, but this never came about. Severini's works were still in Stieglitz's possession at Stieglitz's death and were distributed, as was the rest of Stieglitz's collection, to various museums throughout the United States. The placement of Severini's paintings serves as an example of the far-reaching impact of those gifts. *Danseuse = Hélix = Mer* went to the Metropolitan Museum of Art, New York; *Femme et enfant* to Fisk University, Nashville, Tennessee; *Nature Morte (expansion centrifuge de couleurs)* to the Art Institute of Chicago; and *Danseuse* to the Museum of Modern Art in New York.

Stanton MacDonald-Wright's exhibition from 20 to 31 March 1917, with its striking synchronist imagery, was the artist's first one-man show in New York. MacDonald-Wright constructed musical chords based on triads of colors and was interested in the emotional values that colors might have. By equating color chords of the chromatic circle with equivalent notes of the musical scale, he and fellow synchronists such as Morgan Russell sought a harmonious and balanced spectrum. MacDonald-Wright was particularly admired by the artists Robert Delaunay and Wassily Kandinsky. Some years later, MacDonald-Wright wrote to Stieglitz that he thought painting had died, that he envisioned instead an art consisting of "colored light." Further he considered color to be a musical element and went on to describe the direct relationship between the sound of certain instruments and a deep ultramarine blue. MacDonald-Wright had studied music himself, as much as he had extensively studied painting.[55]

The last exhibition at 291, from 13 April to 14 May, was Georgia O'Keeffe's one-person show of watercolors, drawings, and oils, along with a small phallic sculpture she had made in 1916. Stieglitz had already included her work, as remarked above, in a 1916 exhibit with Charles Duncan and René Laferty and in a group exhibit, in the inner room, of paintings and drawings by Hartley, Marin, Walkowitz, and MacDonald-Wright. O'Keeffe was perhaps the most significant figure for Stieglitz to enter 291's doors before it closed. Although she had come to see the Rodin drawings at 291 in 1908, it was not until 1916 that Stieglitz saw O'Keeffe's own drawings, secretly brought to him by her friend Anita Pollitzer.

Discouraged by the continuing war, in which he felt unable to take sides, Stieglitz needed a new light in his life. Many of his friends had departed or there were rifts in old relationships. And his marriage was becoming increasingly difficult. In general, it was a dark period. In his words: "Much of the enthusiasm that had existed at 291 gradually disappeared because of the war. Close friends seemed to fall by the wayside. I could not turn 291 into a political institution, nor could I see Germany as all wrong and the allies as all right. The work going on at the gallery, I felt, was universal. Colleagues tried to prove to me that Beethoven was no German, that all the cruelty in the world came from Germany and that every Frenchman and Englishman was a saint. I was truly sick at heart."[56]

Stieglitz had hoped to devote an issue of *Camera Work* to the role of the subconscious in art, with a major article by A. A. Brill, a disciple and translator of Sigmund Freud's work, and color illustrations by psychiatric patients to be interspersed with children's work shown at 291. But because the war made the appropriate color-printing processes inaccessible, Stieglitz could not realize this nor several other projects involving color printing, which discouraged him.[57] He wrote to Paul Burty Haviland, who was now back in France, on 5 July 1916, despairing that no platinum paper was being manufactured because of the war, noting that 291 was very quiet and that he was using that time to put together three complete portfolios of issues of *291*:

Dear Haviland,

I spent the whole of yesterday – the 4th – at 291 undisturbed. And after nine hours of doing but one thing I finally got three portfolios of 291 finished – one for you, one for your brother George, and one for the Metropolitan Museum (not an order!) . . . The one for you is the most complete yet put together . . . Besides the portfolios, I have sent you Deluxe copies, Nos. 1–8, 9, 10–11, 12 to complete the set you have. Is there anything missing? Let me know. A complete portfolio certainly makes a magnificent impression . . . I'll be glad though, when I'm through with the portfolio business as it was fight-fight-fight for any inch of ground . . . I have finally, too, gotten another complete number of *Camera Work* together. It will be more of a record than anything else, but an interesting one. Weather has been rain-rain-rain, so that I've had no chance to print in weeks – months. And, to boot, all manufacture of platinum paper has been stopped. At 291 all is very quiet. Marie goes off on a 7 week vacation next week. I manage to keep busy. The Picabias sailed ten days ago – I was at the pier. He seemed a little stronger. I like both of them as much as ever.

I wonder how you are – I suppose on the job. And fully acclimated to your surroundings. Warm wishes to be remembered. The fellows often speak of you and of course all miss you.

With heartfelt greetings,
Your Old,
Stieglitz.[58]

Stieglitz had been sad to see Haviland return to his native France in 1915, and had attended a lively fourth of July picnic for him at the Meyer estate in Mt. Kisco, New York, in 1915. Photographs taken at the party show a congenial group of artists such as Marin, Walkowitz, Picabia, and de Zayas.

*

A new flame was kindled within Stieglitz as he looked at O'Keeffe's drawings: "Examining the first drawing, I realized that I had never seen anything like it. All my tiredness vanished."[59] He responded to them with his now famous words: "Finally, a woman on paper. A woman gives of herself. The miracle has happened."[60] Stieglitz seems to have found there part of the ideal of "Woman" that he had been seeking since reading Goethe's *Faust* as a young boy. There was a spirit and sexuality inherent in those free-flowing charcoal drawings by the twenty-nine-year-old O'Keeffe that captivated the fifty-two-year-old Stieglitz.

Although he had written to her in January 1916 saying that he might like to show her work, it was without her knowledge that Stieglitz hung her photographs at 291 that spring. The young

O'Keeffe was initially upset at his arrogance in showing her work without asking her. Upon confronting him, though, she was quickly convinced he had done the right thing. She was to write to him that July, "nothing you do with my drawings is 'nervy.' I seem to feel that they are as much yours as mine."[61] Much of the critical response to O'Keeffe's early work had its roots in symbolist language. William Murrell Fisher wrote of the show at 291 of the following year: "Of all things earthly, it is in music that one finds any analogy to the emotional content of these drawings, to the gigantic swirling rhythms and the exquisite tenderness so powerful and sensitively rendered. And music is the condition toward which, according to Pater, all art constantly aspires. Well, plastic art in the hands of O'Keeffe seems now to have approximated that."[62]

The O'Keeffe show of 1917 was both an end and a beginning: the end to 291, but the beginning of her life with Stieglitz, professionally and personally, as well as the beginning of her influence in the development of modern American art.

Stieglitz photographed the exhibition, making a series of approximately eight images (now at the Getty Museum) and sent them to O'Keeffe, who was living and teaching in Texas. One of the installation shots shows the one small sculpture on display "bowing" toward an O'Keeffe's charcoal drawing, *No. 12 Special* (1916), from which swirling lines reach toward the sculpture. In Stieglitz's photograph "male" and "female" appear to dance toward each other. He photographed another drawing, *No. 9 Special* (1915), which had appeared also in the 291 group show in 1916. The wave- and flame-like forms in O'Keeffe's piece may be viewed as visual metaphors for the art of dance. The metaphor of dance as a flame was prevalent among writers of the time, and the dancer Loïe Fuller, whom Stieglitz had seen perform, was noted for her fire dance.

The writer and poet Paul Valéry also turned to the metaphor of the flame in his symposium *L'Âme et la danse (The Soul and the Dance)*, published in 1921, in which Socrates speaks eloquently about dance: "Does she [the dancer] not look though she was living quite at her ease in an element comparable to fire, in a highly subtle essence of music and motion, while she inhales inexhaustible energy . . . O flame! Living and divine! What is a flame but not the movement itself?"[63] Valéry saw dance as a kind of state of intoxication and the dancer as capable of carrying others to that state. The dancer was a wave, "celebrating the mysteries of absence and presence."[64] Stieglitz's selection of O'Keeffe's flame- and wave-like forms, as well as other dance imagery by artists such as Severini and Rodin, is significant in light of Valéry's poetic imagery. It is uncertain if Stieglitz had any direct contact with Valéry while in France, or through Picabia, but he was reported to have heard a reading by Valéry at one of Paul Rosenfeld's weekly soirées in November 1924.[65] O'Keeffe's use of wave-like forms, as well as the flame, in this piece as well as others, such as *Blue and Green Music* (1919, Art Institute of Chicago) may well have analogies to Valéry's imagery. That Stieglitz chose to photograph *No. 9 Special*, and that O'Keeffe chose

to include the photograph in her selections for the Key Set given to the National Gallery of Art, indicates the significance of the form and content for both.

Stieglitz's organization of a variety of exhibitions that had strong connections to music and dance in the 291 years may be seen as one path to the *Gesamtkunstwerk* that Wagner strongly espoused. In supporting work where a variety of the senses could participate, Stieglitz appeared to be striving for a "total art," where synaesthesia played an important role and where the dynamism of modern life could be expressed in new spatio-temporal modes of expression.

But Stieglitz could not continue his work at 291. The war and increasing financial problems caused him to close his beloved gallery. On 31 May 1917, he wrote to O'Keeffe, "I have decided to rip 291 to pieces after all. I can't bear to think that its walls which held your drawings and the children's should be in charge of anyone else but myself . . . No the walls must come down – and very soon – in a few days. So that I am sure they're down. Others should move in and build anew."[66] And he wrote to O'Keeffe again on 24 June: "I didn't tell you this afternoon I set Zoler ripping down more shelving in the old little room – and ripping down the remaining burlap – I made a photograph of him – he enjoyed the job – and I enjoyed the destruction – and his enjoyment. – The place looks as if it had been raped by the terrible Germans!"[67]

In June 1917, the last issue of *Camera Work* appeared and, as noted, was devoted to Paul Strand. It was, in part, a funeral for pictorialism. Strand's clean, modernist lines and abstracted forms were printed on thick, hard paper stock to emphasize the directness of his expression. The soft, delicate Japanese tissue paper of previous issues was gone. *Camera Work* had come to an end. The short life of the proto-dada periodical *291*, on which Stieglitz had collaborated, had come to an end. The workspace for the two publications had, in part, been in the back room of the gallery. Now that was closed. Stieglitz sadly described his selling of the last issues of *291*:

Once *291* had come to an end, and the gallery 291 closed in 1917, I didn't know what to do with the nearly eight thousand copies of the publication that remained. I called in a rag picker. It was wartime. The cost of paper was high. Perhaps my gesture was a satirical one. The rag picker offered five dollars and eighty cents for the lot, including the wonderful Imperial Japan "Steerage" prints. I handed the money to my part-time secretary, and said, "Here, Marie. This may buy you a pair of gloves – or two."

I kept the greater part of the deluxe edition, but, in time, I destroyed most of that. I had no feeling whatsoever about the transaction except that it was another lesson. I asked myself why an official of a Berlin museum had been so willing to pay a hundred dollars for a print of *The Steerage* while my American friends did not want one at the cost of two dollars.[68]

Stieglitz's photograph, *The Last Days of 291*, shows his despair. On the shelf and floor can be seen the backs of pictures and issues of *Camera Work*; an old broom is visible on the rear shelf,

43 Alfred Stieglitz, *The Last Days of 291*, 1917. Philadelphia Museum of Art.

with dried, dying foliage, perhaps bittersweet, and a sculptural bust with a bandage on his head. The shrouded central figure, with its peeling paint, holds a makeshift sword in chains at his waist and surveys the devastation. Burlap from the walls is strewn on the floor. It is like a funeral scene after a lost battle.

Following the closing of 291, Stieglitz paid $10-a-month to rent a tiny room on the second floor of the 291 building. He spent the next year there, in order to have a place to get away from his house and failing marriage, and to have a professional mailing address. There were no exhibitions, but people seemed still to seek him out. That winter was extremely cold, the worst in decades. Stieglitz recalled, "I sat in the desolate, empty, filthy, rat-holed, ill-smelling little space that originally was part of 291. Or I walked up and down in my overcoat, my cape over the coat,

hat on, and I still would be freezing . . . I had nowhere else to go – no working place, no club, no money. I felt somewhere as Napoleon must have on his retreat from Moscow. The world seemed sad and gray. There was not only the war, but also labor unrest. The heydays of 291 were over. Yet I stuck to my post."[69] Fortunately, the interior decorator, S. B. Lawrence, based next door to 291, offered to let Stieglitz and his friends, who still came to visit him, warm themselves by his coal stove.

Stieglitz also wrote to O'Keeffe about the horror of the war situation for him:

It's all too horrible I can't work, up to the popular level – I was a real good American until I realized there was no America or American – I felt American for years for I believed Americans felt the universality of things and beings – I'm just nothing when the world is labeling individuals . . . Yes, I wish you were here to talk to . . . Faust on your table [Stieglitz had sent her a copy] . . . I read the papers today – Wall Street – The war . . . Roosevelt's Rantings . . . No German opera – The Boston Symphony refusing to play the Star-Spangled Banner – All such a mix-up – What a madness – hysteria – I hardly slept a wink last night – and ghastly things are happening all around me . . . Fortunes wiped out – Pathetic because the causes are not understood – My prayer if I have one is that all money be taken from all people . . . I wonder how much heart Wilson really has – I'd love to know exactly what he feels . . .[70]

*

Stieglitz was "at sea" with his gallery closed and the war raging around him – more difficult for him because of his German roots. But he had made more inroads than he realized in these early years of the twentieth century, in his fight for photography as a fine art, for modern art, and in general for a dynamic living spirit that was creative and humanistic. That fight was also on behalf of his own photographic work.

THE PHOTOGRAPHS

In general, Stieglitz's portraits of the late 1910s are close-ups of his subjects, who were not celebrities but friends – artists, writers, and those in his immediate environment, including the elevator operator. His portraits began to show more depth and intensity than earlier work as he attempted to reveal his subjects' inner being.

Konrad Cramer, a painter inspired by Kandinsky and the cubists, described being photographed by Stieglitz in 1914:

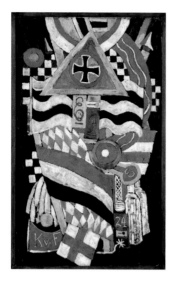

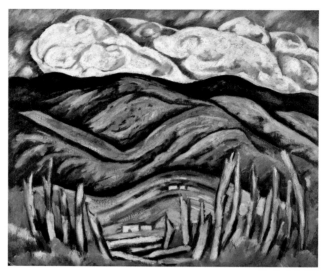

44 Marsden Hartley, *Portrait of a German Officer*, 1914, oil on canvas. The Metropolitan Museum of Art, New York.

45 Marsden Hartley, *Last of New England – The Beginning of New Mexico*, 1918. The Art Institute of Chicago.

The equipment was extremely simple, almost primitive. He used an 8 × 10-inch view camera, its sagging bellows held up by pieces of string and adhesive tape. The lens was a Steinheil, no shutter. The portraits were made in the smaller of the two rooms at 291 beneath a small skylight. He used Hammer plates with about three-second exposures. During the exposure, Stieglitz manipulated a large, white reflector to balance the overhead light. He made about nine such exposures, and then we retired to the washroom, which doubled as a darkroom. The plates were developed singly in a tray. From the two best negatives he made four platinum contact prints, exposing the frame on the fire escape. He would tend his prints with more care than a cook does her biscuits. The finished print finally received a coat of wax for added gloss and protection.[71]

In a number of the later portraits, subjects such as Paul Burty Haviland, Konrad Cramer, Charles Demuth, Alfred Maurer, Charles Caffin, and even Kitty Stieglitz, are photographed in front of art works at 291, either their own or others' works, thereby emphasizing the interplay between the subject, the art work, and the photographer. Frequently the formal elements in the art work being photographed become an integral part of the person being photographed – such as the outlines of Kitty's hat mirroring the lines on the charcoal Picasso drawing, *Head of a Woman* (1909; Metropolitan Museum of Art, New York), behind her, or Alfred Maurer's portrait in front of Picasso's *Still Life* (1909; a charcoal drawing now at the Metropolitan Museum of Art). Stieglitz showed Maurer's colorful oil sketches at 291 in 1910. Stieglitz's photographs of

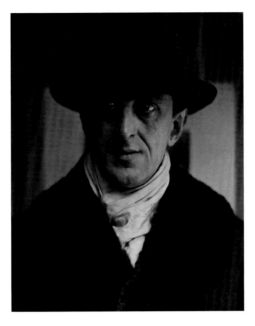

46 Alfred Stieglitz, *Marsden Hartley*, 1915–16.
The Metropolitan Museum of Art, New York

47 Alfred Stieglitz, *Alfred Maurer*, 1915.
The J. Paul Getty Museum.

Maurer in front of Picasso's work link the two artists and the two art worlds of Paris and New York. Maurer is depicted as a well-dressed, sophisticated gentleman with top hat, bow tie, and white scarf, in contrast to his classical dark top coat. In one photograph, Stieglitz has come closer to Maurer, concentrating on the intensity of Maurer's gaze, which quickly engages the viewer. The shape of the wine bottle in the Picasso drawing behind Maurer reflects Maurer's body shape. Stieglitz's juxtaposition of such shapes in a collage or assemblage format pays homage to Picasso's early cubist experiments.

The intensity and implied sense of trust in many of the portraits suggest that Stieglitz connected with his subjects and had developed some kind of relationship with them. Among those he photographed in 1915–16 were two women, Marie Rapp and Katharine Rhoades. Marie Rapp, a young voice student, had come to 291 in 1911 as Stieglitz's secretary and stayed there until 1917 when the gallery closed. She was photographed as an attractive young woman in various forms of dress – with a large bow in her hair, in a lace-collared dress, in a sailor dress, or swathed in a black fur-collared coat, standing in front of Picasso's drawing as Kitty did. There is a tenderness and wistfulness in her face captured by Stieglitz that draws the viewer to the young woman. She later married George Boursault, the son of a member of the Photo-Secession. In the early 1920s, Stieglitz photographed the couple and their young child, Yvonne, when they came to visit him and O'Keeffe at Lake George.

48 Alfred Stieglitz, *Konrad Cramer*, 1914.
The J. Paul Getty Museum.

49 Alfred Stieglitz, *Arthur Dove*, 1915,
The Art Institute of Chicago.

The young painter and poet Katharine Nash Rhoades contributed to both *Camera Work* and *291* and had her paintings exhibited along with those of Marion H. Beckett at 291. Stieglitz's portraits of Rhoades depict a sophisticated and theatrical young woman with an enigmatic gaze, dressed in transparent layers, far more provocative than Marie Rapp.

By 1917, some of Stieglitz's portraits taken at 291 show him experimenting further with hand gestures and the gaze of his subjects, and he began to photograph Georgia O'Keeffe. One sees the strong hands of the painter Emil Zoler, who helped Stieglitz install various exhibitions at 291. In one photograph of Zoler, the painter has one hand raised, the other on his hip. Leo Stein in 1917, whom Stieglitz had met with Steichen in 1909 in Paris, is shown with his hands on his hips, a book tucked in the crook of his elbow. Stieglitz wrote to Strand about taking Stein's photograph: "I think I finally got a negative of Stein. Developed in a developer 92° – fixing bath 94° – had to 'ice' Stein's face before taking – it was so hot up there under the roof. And still one picture shows beads of perspiration on his face."[72]

These theatrical gestural elements departed from more traditional portrait poses. Hodge Kirnon, the elevator operator at 291, was also photographed. In one photograph he is holding a copy of *Camera Work*; in another, he is lightly grasping his right suspender strap. His long, black hands quickly draw the viewer's eye to his long, oval face. Kirnan's perceptions of 291 were included in the *Camera Work* issues, devoted to "What is 291?": "I have found in 291 a spirit

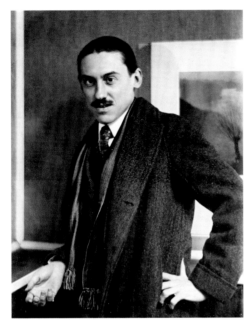

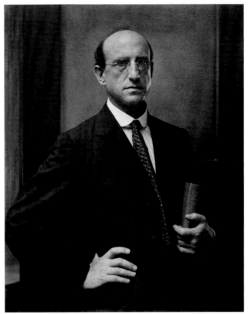

50 Alfred Stieglitz, *Charles Demuth, c.*1915.
Beinecke Rare Book and Manuscript Library.

51 Alfred Stieglitz, *Leo Stein*, 1917.
The J. Paul Getty Museum.

that fosters liberty, defines no methods, never pretends to know, never condemns, but always encourages those who are daring enough to be intrepid, those who feel a just repugnance towards the ideals and standards established by conventionalism."[73] On 23 July 1917, Stieglitz wrote to Marie Rapp about how pleased he was with the portraits of Zoler and Kirnon: "Did I tell you, I made a wonderful portrait of Hodge – a new one – and a wonder of Zoler – two of the finest things I have done . . ."[74] Stieglitz and Kirnon continued to keep in touch with each other even after the closing of 291. Kirnon was to write a few years later to Stieglitz in 1924,

My dear friend Mr. Stieglitz:

When I read in the *Nation* some weeks ago, Mr. Craven's critical remarks concerning you and your work, I experienced a slight mental tension due to the feeling of uncertainty as to what you would do. You would treat him with stoical scorn and contempt, which is characteristic of your nature, or would you in an aggressive and satirical spirit, attack and lay bare the mental and aesthetic shallowness of your critic, which is also more characteristic of you? The current issue of the *Nation* which I have just read relieves me of all further doubt and uncertainties. Your reply is smashing and conclusive. Congratulations!

What is both distinctive and remarkable about your career, however, is that your victories have been won, and your claims established not so much by controversy and dialectics as by the fact of your work.

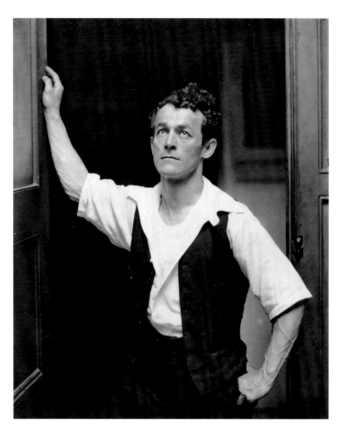

52 Alfred Stieglitz, *Emil Zoler*, 1917. Beinecke Rare
Book and Manuscript Library.

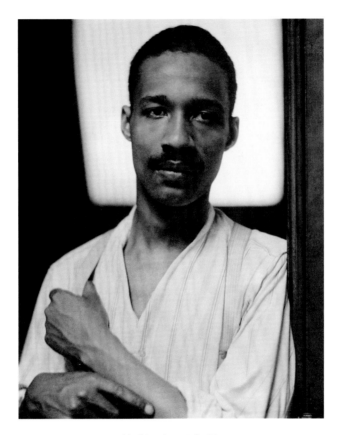

53 Alfred Stieglitz, *Hodge Kirnon*, 1917.
The Metropolitan Museum of Art, New York.

54 Alfred Stieglitz, *Katharine Rhoades in a Hammock*, *c*.1916. Beinecke Rare Book and Manuscript Library.

I dare say that you will be pleased to hear that I still turn occasionally to the "291" No. of *Camera Work* as a bracer whenever I suffer from mental and spiritual neurasthenia.

I see that Mrs. Meyers has written a work on Chinese art. When shall a large size volume be forthcoming on Alfred Stieglitz and 291?

Sincere wishes for all that concerns your well being.

As Ever–

Very Truly and Sincerely,

Hodge Kirnon[75]

Stieglitz also took a number of photographs from the back window at 291, some of them at night. From these photographs, it seems that Stieglitz had left pictorial photography behind. An image such as *From the Back Window of 291, Snow-Covered Tree, Back Yard* (1915) focuses on a snow-covered tree after a storm. Striking is the clarity of the patterns of light and dark. Here is nature with a city building dimly shown in the background. But going beyond nature, the photograph becomes an abstract pattern. The building-block qualities of other 291, back-

55–6 *Alfred Stieglitz Photographing at 4 July 1915 Party.* Photographer unknown.
Beinecke Rare Book and Manuscript Library.

window images recall the work of Cézanne and early cubist paintings. In some, Stieglitz has used the snow to provide geometric planes that contrast with the darker building shapes. In the night scenes the rectangular windows lit from within often form alluring visual grids or singular spotlights on the darkened façades of the buildings, emphasizing the geometry of the composition, and formal elements of modern design.

In several of the images taken from the back window of 291, Stieglitz photographed buildings in construction, as high-rise buildings began to dwarf smaller, brownstone constructions. During the construction of the Marquis Apartment/Hotel at 23rd Street and Fifth Avenue, for example, he explored changes in lighting, and a wall closing in. Unlike his 1910 photograph, *Old and New New York*, where there is a human presence and a sense of life in the street (the foreground figure has been identified as Max Weber), the later images focus on the cold geometry of the new construction. Only the leaves of the smaller trees, and the script of the hotel name, suggest a counter point to the rigid, more solid geometry of the new structure that thrusts its way skyward out of the frame of the photograph, and past the photographer's view. In most of this series nature has little presence; rather the layers and steps of building forms emphasize an urban life and a city that is expanding and growing upward. In a letter of 1 November 1916 to R. Child Bayley, an English photographer and the editor of *Photography*, Stieglitz described his recent photographs, emphasizing "straight" photography:

> I have done quite some photography recently. It is intensely direct – portraits, buildings from my back window at 291, a whole series of them, a few landscape and interiors. All interrelated. I know nothing outside of Hill's [David Octavius Hill] work which I think is so direct and

101

57 Alfred Stieglitz, *From the Window of 291*, 1915. The Art Institute of Chicago.

58 Alfred Stieglitz, *From the Back Window of 291, Snow-Covered Tree, Back Yard,*
April 1915. The J. Paul Getty Museum.

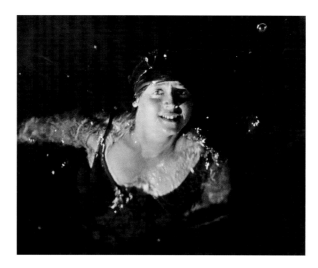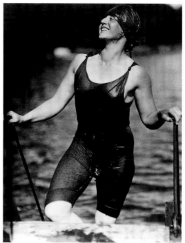

59–60 Alfred Stieglitz, *Ellen Koeniger*, 1916. The J. Paul Getty Museum.

quite so intensely honest. It is all 8 × 10 work. All platinum prints. Not a trace of hand work on either negative or prints. No diffused focus. Just the straight goods. On some things, the lens stopped down to 128. But everything simplified in spite of endless detail.[76]

Besides those photographs taken at 291 prior to its closing, Stieglitz also, at Lake George, embarked upon a significant series of the young Ellen Koeniger, the niece of the photographer Frank Eugene. In that series of approximately a dozen photographs, printed in crisp gelatin silver rather than platinum or palladium, Stieglitz created a modernist portrait. Ellen's strong athletic body is emphasized by her bare skin and the transparent fabric of her bathing suit. The series was made within a few minutes in the bright sunlight, as Ellen went in and out of the water. The sequence is very cinematic, recording Ellen's changing gestures – her arms raised, her body twisted, close-up shots, or longer shots. Her body is well formed, muscular, free to move as she wishes. She is a twentieth-century woman, not constricted by nineteenth-century conventions of propriety. One of the most striking images in the series is a close-up of Ellen's back: her cling-ing bathing suit emphasizes the curves and lines of her body, and light and shadow interact on her behind. This series, although it lacks the passion and sexuality of some of the portraits of Georgia O'Keeffe, may be seen as a precursor to the concentrated studies Stieglitz made of O'Keeffe, beginning in 1917. In the Koeniger photographs, Stieglitz revealed himself to be, as Weston Naef has noted, "an apostle of clarity. He simplified his subjects to their bare essence, eliminating the extraneous. Unity, logic, and the beauty of line are hallmarks of his style and result in the clarity that became his signature. Stieglitz invites us to see the duality that is often overlooked in everyday existence; he strives to express in his photographs elements of structure and content that are unseen on the surface of his subjects."[77]

61 Alfred Stieglitz, *Georgia O'Keeffe Sitting on the Lawn at Oaklawn*, 1918. Adirondack Museum, New York.

*

Georgia O'Keeffe's arrival in Stieglitz's life gave rise to a deep-seated passion and inspired a new sense of freedom in his photographic work. Stieglitz photographed her for the first time in June 1917. Those photographs taken in the 1910s expose an intensity on the part of the photographer that draws the viewer into a human relationship that is both private and personal, as well as public and universal. The most striking photographs were probably taken in 1918 and 1919. O'Keeffe had moved to New York from Texas with the promise of time to paint on her own without the responsibilities of teaching. She and Stieglitz had moved into the studio of his niece, Elizabeth Davidson, at 54 East 49th Street shortly after he left his wife in 1918. He made more than a hundred studies of her in the first two years they lived together. As seen in his early experiments with his daughter Katherine, and other short series of various subjects, Stieglitz's understanding of what constituted a portrait was not a single image. As O'Keeffe noted in an introduction to an exhibition of 1978, *Georgia O'Keeffe: A Portrait by Alfred Stieglitz*, "his idea

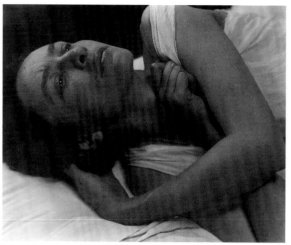

62 Alfred Stieglitz, *Georgia O'Keeffe*, 1918.
Beinecke Rare Book and Manuscript Library.

63 Alfred Stieglitz, *Georgia O'Keeffe*, 1918.
The Metropolitan Museum of Art, New York.

of a portrait was not just one picture. His dream was to start with a child at birth and photograph that child in all its activities as it grows to be a person and on throughout its adult life. As a portrait it would be a photographic diary."[78] O'Keeffe described the process of posing for him:

> In the beginning, Stieglitz used glass plates . . . For those slower glass negatives I would have to be still for three or four minutes. That is hard – you blink when you shouldn't, your mouth twitches – your ear itches or some other spot itches. Your arms and hands get tired, and you can't stay still. I was often spoiling a photograph because I couldn't help moving – and a great deal of fuss was made about it.
>
> The camera always stood near the wall – a box maybe a foot square and four or five inches thick. It stood on its rickety tripod with the black head-cloth over it – a bit worn with much use – maybe a bulb hanging down on a small rubber cord. Beside the camera was a dirty white umbrella that was a large white circle when opened. It was used to throw light into the shadow. These things were always nearby so he could grab them if he saw something that he wanted to photograph. At a certain time of day the light was best for photographing – so at that time we usually tried to be in Elizabeth's Studio.[79]

From the time of O'Keeffe's arrival from Texas, from where Paul Strand had been dispatched by Stieglitz to fetch her, in June 1918, to their departure to Lake George in August, Stieglitz made over fifty images of her.

64 Alfred Stieglitz, *Georgia O'Keeffe*, 1918. The Metropolitan Museum of Art, New York.

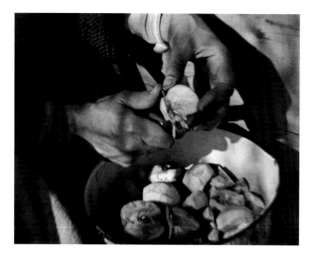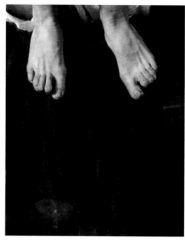

65 Alfred Stieglitz, *Georgia O'Keeffe*, 1918. 66 Alfred Stieglitz, *Georgia O'Keeffe – [Feet]*,
 The Art Institute of Chicago. 1918. The Art Institute of Chicago.

It is difficult to ascertain who was more "in charge" of the poses at this point. O'Keeffe was thirty-one, while Stieglitz was fifty-four. She was relatively "unknown" as an artist in 1918; he was well known in the world of art and photography. New York was his world; her world had been the open plains of Texas, with her roots in America's heartland as she grew up in Wisconsin. It is likely, therefore, that he was in charge, as her body, her face, her hands, her feet, her torso were lifted into the realm of the universal. But simultaneously, a spirit of O'Keeffe appears to radiate from many of the early images, as if her instincts were synchronized with the instincts and ideas of Stieglitz. Doris Bry, O'Keeffe's assistant after Stieglitz's death and later her dealer and agent, as well as friend, noted, "Although the Stieglitz portrait of O'Keeffe inevitably has its roots in the photographer and his subject, the series of prints transcend the two individuals concerned and becomes a moving symbol of the range of possibilities, life, and beauty inherent in human relationships."[80]

In his exploration of the female human form, Stieglitz not only follows in the tradition of numerous artists from the Renaissance to the twentieth century, but also reflects, to some extent, the influence of Freud's and Jung's writings. Although neither Freud nor Jung had been translated fully into English when Stieglitz started photographing O'Keeffe, as previously noted he had read their writings in German, and some translations by Brill. As Weston Naef remarked, "It's not until the O'Keeffe pictures that we really come to a clear reading of the opposite sex in terms of Freudian sensibilities. This has more to do with the kind of sexuality that Wagner was dealing with. We know of Stieglitz's love of the music of Wagner. References to creatures rising from a primordial soil are evocative not only of [these pictures] but also of the emotional reality behind Wagner."[81] Naef commented further: "O'Keeffe was the exact opposite of contemporary

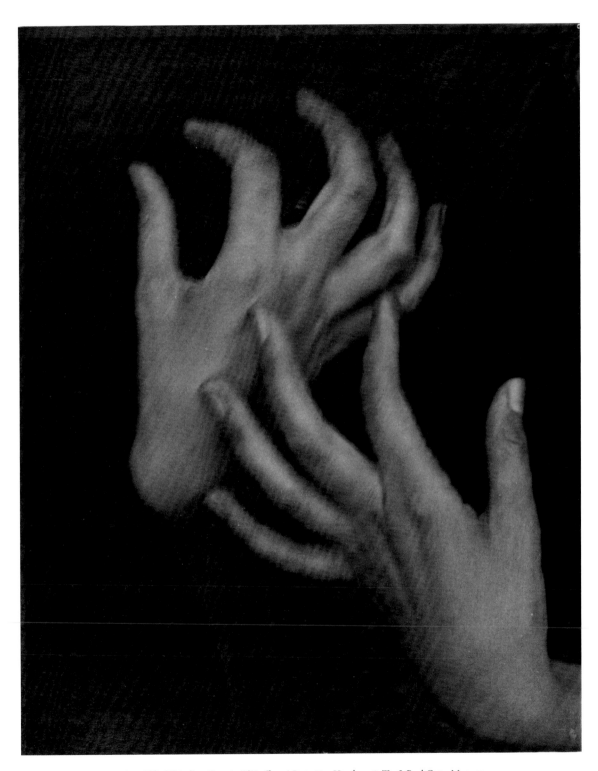

67 Alfred Stieglitz, *Georgia O'Keeffe – A Portrait – Hands*, 1918. The J. Paul Getty Museum.

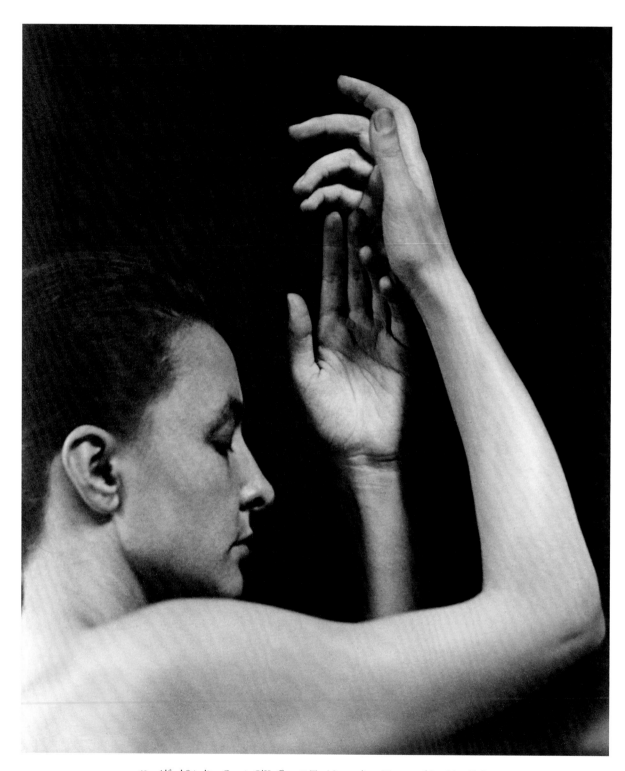

68 Alfred Stieglitz, *Georgia O'Keeffe*, 1918. The Metropolitan Museum of Art, New York.

ideals of feminine beauty. She was short, with short legs, and a long waist. But Stieglitz managed to make her appear to have classic proportions . . . of course every picture Stieglitz made of O'Keeffe is really a portrait of himself, but in fact, we're seeing Stieglitz's dream of a woman. He was attracted to women, and each of these is a different kind of woman that he may have been attracted to at some point."[82] Thus one sees not only the beauty and sensuality of O'Keeffe's nude body, but also O'Keeffe dressed more formally in a conservative "school-teacher's dress," her hair pulled back tightly; or dressed in a heavy sweater and white dress, seated with watercolor at Lake George and gazing at the viewer; or standing with a saw in her hand watching Donald Davidson prune trees. In the latter image probably from 1919, O'Keeffe appears quite small and child-like, with the trees framing her as she watches Davidson at work on the ladder. At times she has an androgynous air, wearing a top hat, and sometimes she wears Stieglitz's black cape. In a number of these works from the 1910s, she is depicted in front of her own works, such as her watercolor *Blue I* (1916), her charcoal drawing *No. 12 Special* (1916), her charcoal drawing *No. 15 Special* (1916/1917), or charcoal drawing *No. 17 Special* (1919). In these photographs her body becomes an integral part of the work, thereby uniting artist and art work into a comprehensive view made possible through the vehicle of the camera. Passion, sexuality, aesthetics, and "machine" thus become interconnected.

The photograph depicting O'Keeffe's hands about to pluck a round, fruit-like object from one of her own drawings is evocative of trompe-l'oeil. Her hands do not quite grasp or even touch the sought-after object, perhaps suggesting the idea of "the forbidden fruit" and all that was unconventional and by some seen as unacceptable in Stieglitz and O'Keeffe's early relationship. The photograph has also been interpreted as a "modern day reference to the ancient Greek story about a contest between two famous artists, Zeuxis and Parrhasius, to produce the most realistic painting. Zeuxis depicted a still life of grapes so real birds pecked at the fruit, but Parrhasius painted a curtain that was even more convincing, fooling his rival, who attempted to pull the drapery aside to see what lay behind."[83] Stieglitz may thus be posing the questions, "What is reality? What is abstraction? and What is the relationship between the two?"

Stieglitz also photographed O'Keeffe's hands and feet together with a small sculpture made by her in 1916 and titled *Abstraction*. The statue may be viewed from diverse perspectives – simply an abstraction as it is titled, as a cloaked figure, slightly bent forward in grief, or as a phallic symbol. Stieglitz's photographs of the statue alone appeared also in an exhibition of Stieglitz's work in 1921, and Paul Rosenfeld described their subject: "A tiny phallic statuette weeps; is bowed over itself in weeping while behind, like watered silk, there waves the sunlight of creation."[84] Stieglitz's image of O'Keeffe's feet and the small statuette is not only sensual, since O'Keeffe's feet caress and buttress the vertical piece, but it is also a strong study of light and shadow as large planes of black, white, and gray coalesce, emerging and receding across the photograph. Stieglitz photographed the small statue again in 1919, placed in front of O'Keeffe's

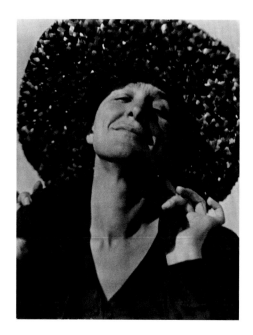

69 Alfred Stieglitz, *Georgia O'Keeffe: A Portrait*,
1919 (printed 1920s). The J. Paul Getty Museum.

1919 oil painting *Music Pink and Blue I*. Titled *Interpretation*, the subtly toned palladium print shows the statue standing in the central, blue aperture of the painting surrounded by pale pastel organic folds. The painting itself has been seen either as a purely abstract piece or as based on the enlarged segment of a shell that summons the sounds of the sea, thus reinforcing the connections between the visual arts, music, and nature, and recalling Kandinsky's advocacy of the notion that the artist expresses vibrations in the soul, and that musical sound acts directly on the soul. Stieglitz's placement of the "weeping" phallic statue in the center of the aperture provokes at least two interpretations – the vaginal and phallic forms suggest sensual/sexual male and female relations while the hint of a pointed-arch, Gothic entryway evokes the image of a weeping figure standing in front of a sacred/church structure. These interpretations bring together the sacred and sexual in a way that, to some extent, reflects the relationship between O'Keeffe and Stieglitz at that time.

As noted above, Stieglitz documented O'Keeffe's first solo exhibit at 291 in 1917 and sent her an album of eight images of the installation of the exhibition. The photographs are sparse, showing the clean lines of the gallery and the space Stieglitz left between works. The design of the exhibit was intended to allow the viewer to appreciate the spare, abstract forms of the watercolors and charcoal drawings O'Keeffe had made in South Carolina, and the watercolors and oils of the west Texas landscape where she was teaching. Stieglitz also made close-up shots of

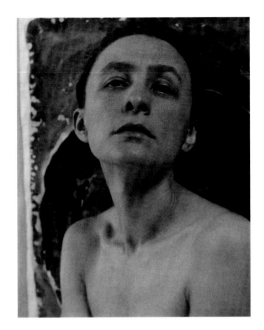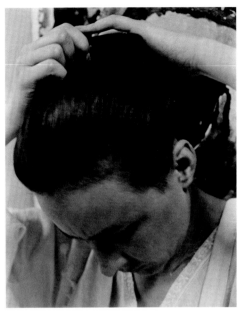

70 Alfred Stieglitz, *Georgia O'Keeffe*, 1919.
The Art Institute of Chicago.

71 Alfred Stieglitz, *Georgia O'Keeffe*, 1919.
The Metropolitan Museum of Art, New York.

some of the art works alone, such as the 1916 sculpture or *No. 9 Special*, the 1915 charcoal drawing, with its reference to flame imagery and wave-like forms associated with dance.

On 11 January 1916, Diaghilev and his famous Ballets Russes arrived in New York for the first of two lengthy tours of the United States. That spring, on 12 April, the famous dancer Vaslav Nijinsky made his debut in New York in *Le Spectre de la rose* and *Petrouchka*. Léon Bakst's flowing designs for a number of the company's productions, with their emphasis on movement and effervescence, share some affinity with O'Keeffe's early watercolors and drawings, such as her *Blue Nos. 1–4* (1916). Although there are no figures in O'Keeffe's pictures, there is a bodily "presence" in these pieces. As one writer noted, "[in] 1916 dance meant something very substantial to Americans . . . dance was an important but indefinable presence . . . There were no terms in ordinary language to discuss it . . . dance was a part of that impulse to find a freer, simpler relation to the physical world in the midst of the overwhelming rush to industrialize. And a mythological-type dance was pictured not only in people's minds, but in the popular graphics they saw around them – in drawings, posters, cartoons, photogravures, and moving pictures."[85]

Dance became synonymous at times with images of the New Woman of the twentieth century, as the physical and artistic became unified through dance. In 1916, the popular cultural magazine *Vanity Fair* ran monthly aesthetic-dance photography features, which included a series of photographs of Isadora Duncan's school in Rye, New York, and a story about Virginia Myers, a

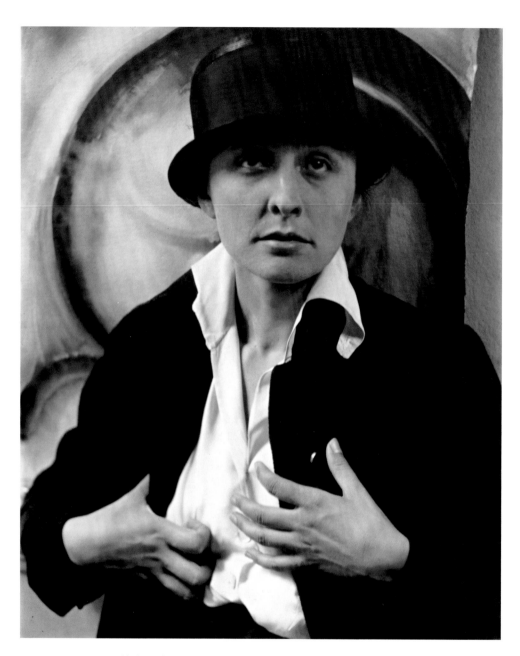

72 Alfred Stieglitz, *Georgia O'Keeffe – a Portrait*, 1918. The J. Paul Getty Museum.

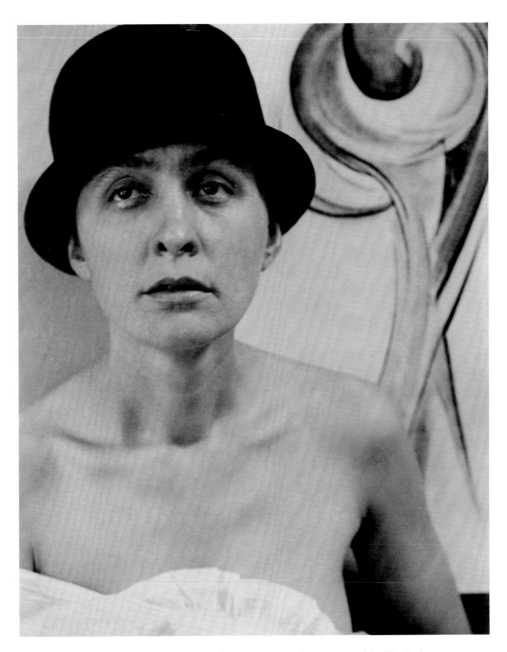

73 Alfred Stieglitz, *Georgia O'Keeffe*, 1918. The Metropolitan Museum of Art, New York.

celebrated child dancer, whom Hutchins Hapgood had also referred to in *Camera Work*. Hapgood saw the little girl as an example of an endangered life force whose spirit was being crushed by conservative authorities. Stieglitz, in a number of his early letters to O'Keeffe, sometimes referred to O'Keeffe as a child, a little girl, whose creative spirit needed to be protected.

The prevalence of dance imagery in America, particularly in the 1910s, was also in part due to the work of a number of American photographers, particularly those working initially in the pictorial mode, who used a soft focus to create a sense of mystery, sensuality, and spirituality. These photographers included Edward Steichen, Anne Brigman, George Seeley, Clarence White, Arnold Genthe, and Baron Adolf de Meyer, who came to the United States in 1914. A number of Stieglitz's early images of O'Keeffe, taken in 1919–20, depict her with her arms raised in the stylized gestures of an Asian dancer or modern dancer. Many of his photographs of O'Keeffe's hands in various poses may also be seen as having roots in dance, as well as emphasizing the role her hands played in her being an artist, and being a sensual and spiritual young woman. In 1918, Stieglitz sent to her, now back in Texas, some of his early images of her hands, along with seven issues of *Camera Work*. Her reply is telling of the impact *Camera Work* and Stieglitz were having on her, along with her perception of her own hands: "I put out my hand to reach for the one [issue of *Camera Work*] with your face in it – again – . . . I wondered at my hand – my left one as I saw it on the last printed page of the last book – and my mind wandered to the prints of my hands . . . the other hand reached for the book with you in a circle . . . I sat looking at the hand – then at them both – I've looked at them often today – they have looked so white and smooth and wonderful – I've wondered if they were really mine . . ."[86]

In some of the images of O'Keeffe's hands, they reach out to the world; in others, they are closely cropped, embracing her body and suggesting a private, dark, or mysterious world behind the hands – as seen in a number of the 1918 images. For some of the smaller studies of her hands, Stieglitz used platinum paper because of its delicate textual qualities, thus emphasizing the sense of touch associated with hands. He often used palladium paper for the 8 × 10 nudes because of its subtle tonalities and natural highlights. Lewis Mumford, cultural critic and friend of Stieglitz, was later to write about Stieglitz's focus on O'Keeffe's hands in 1918 and 1919; he wrote that the photographs were "the exact visual equivalent of the repeat of the hand or face as it travels over the body of the beloved," depicting "the unseen world of tactile values as they develop between lovers, not merely in the sexual act but in the entire relationship of two personalities."[87]

*

For Stieglitz, his images of O'Keeffe in the 1910s represented a kind of "breakthrough." As he wrote to Sadakichi Hartmann on 27 April 1919, "I am virtually alone – I refuse to budge – I am at last photographing again – just to satisfy something within me – and all who have seen the

74 Alfred Stieglitz, *291 – Georgia O'Keeffe Exhibition*, 1917.
Beinecke Rare Book and Manuscript Library.

75 Alfred Stieglitz, *Interpretation*, 1919.
The Georgia O'Keeffe Museum, Santa Fe.

work say that it is a revelation. – It is straight. No tricks of any kind. – No humbug. No senti-
mentalism. Not old nor new. It is so sharp that you can see the [pores] in a face. – and yet it is
abstract. All say they don't feel they are conscious of any medium. It is a series of about 100
pictures of one person – head and ears – toes – hands – torsos. It is the doing of something
I had in mind for very many years . . ."[88]

That breakthrough was fueled, in part, by Stieglitz's increasing passion for O'Keeffe, also
expressed verbally in his letters to her:

[16 May 1916] Let Me Hear From You – If you are near trees, send me some of their
Spirit . . . Trees and Water! 291 sends you Greetings

[18 July 1917] I wonder where you are – Perhaps lying on the sofa stripped – or on the
bed – or autoing. – How close you are to me – in spirit – all the time – day and night – awake
and asleep . . .

[6 August 1918] Is it a Great Madness the Desire to Live – To Experience Life – Fullest
Livingness. Through the Passion of Deepest Love – Love for You – Love You have for
Me – Here I am – again the wonderer it would seem – destined for ? – To accom-
plish? – Perhaps the Impossible – To make the Blind see – ? for themselves – for You – for
Me – for all the World – because of the Beauty of Life – the Beauty of Every
Moment – Dearest – Dearest – I love you greatly – Very greatly – Your trust in me is won-
derful – it frightens me too . . . for you are greatest Beauty – there is no greater Beauty think-

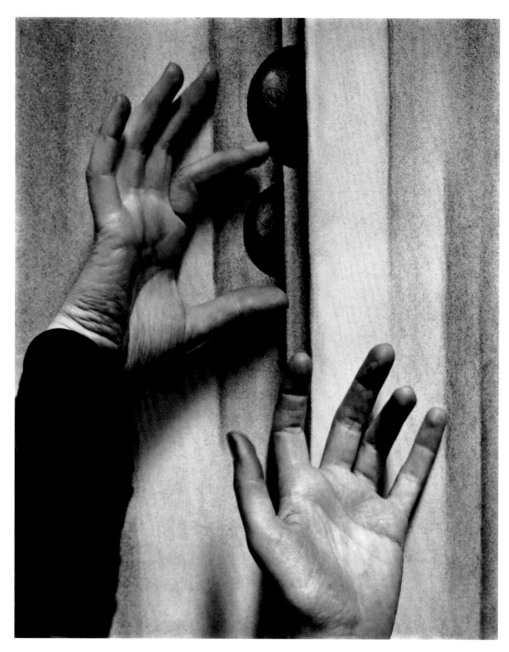

76 Alfred Stieglitz, *Georgia O'Keeffe: A Portrait*, negative 1919, printed late 1920s or 1930s. The J. Paul Getty Museum.

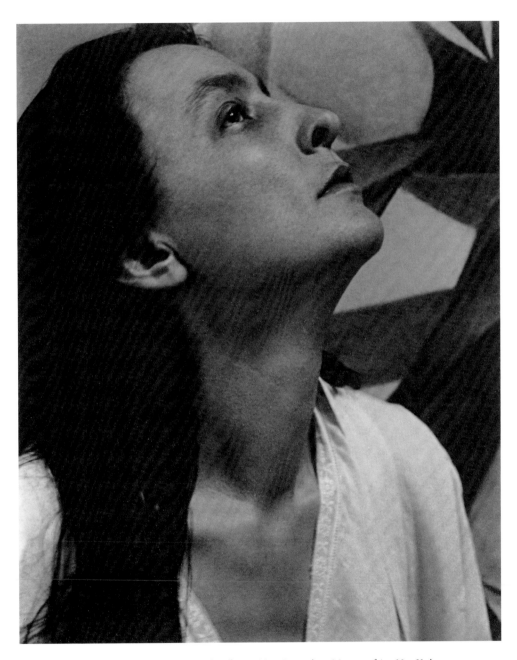

77 Alfred Stieglitz, *Georgia O'Keeffe*, 1919. The Metropolitan Museum of Art, New York.

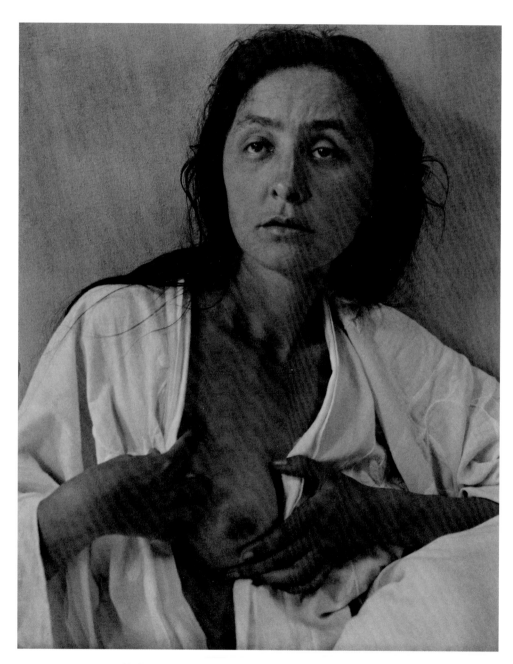

78 Alfred Stieglitz, *Georgia O'Keeffe: A Portrait*, 1918. The J. Paul Getty Museum.

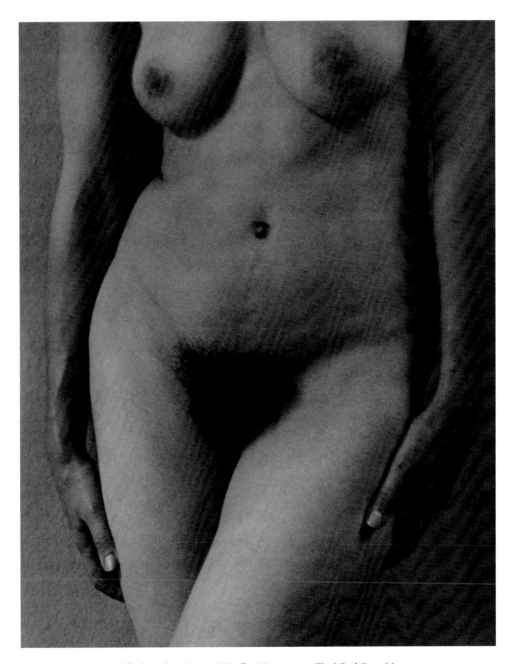

79 Alfred Stieglitz, *Georgia O'Keeffe: A Portrait*, 1918. The J. Paul Getty Museum.

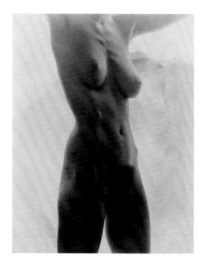
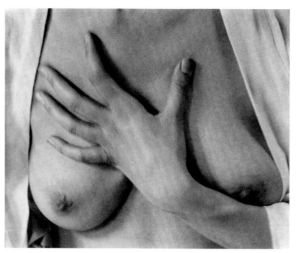

80 Alfred Stieglitz, *Georgia O'Keeffe*, 1919.
The Metropolitan Museum of Art, New York.

81 Alfred Stieglitz, *Georgia O'Keeffe*, 1919.
The Metropolitan Museum of Art, New York.

able – and you entrust all that to me – Why – I wonder – I'm really nobody – Perhaps a Wonderful Idea – Is it true we have been together 58 days – daily more close – daily more needful of each other – The World aflame – Relentless – Intensely Practical – We – mad children – Born perhaps too early to be thought Sane – Dearest – Tonight – Will you sleep – Yes – and rest – Yes – and greet the dawn – Yes – and be happy because of You and Me – Yes – and Await my return with Warm Lips – Yes – Impatiently Patient – Yes – Yes – Yes – Yes – Supper is over at Oaklawn – It's just 8 – I wonder what you're thinking – where you are – Loveliest of Lovelies – Is it all time – Every part of me cries out <u>Yes</u>[.] Yet my mind can hardly grasp it – It's all too incredibly wonderful – too incredibly beautiful – as extraordinarily natural – that it is the rarest exception – I love you dearest in a manner that I doubt a human ever has been loved –

In general, Stieglitz's portrayal of O'Keeffe in the late 1910s represented different facets of the complex puzzle of depicting who O'Keeffe was. Indeed, O'Keeffe, in retrospect, was to comment that "Stieglitz had a very sharp idea for what he wanted to do with the camera. When I look over the photographs Stieglitz took of me – some of them more than sixty years ago – I wonder who that person is. It is as if in my one life, I have lived many lives. If the person in the photographs were living in the world today, she would be quite a different person – but it doesn't matter – Stieglitz photographed her then."[89] These images also reach toward universal expressions; they depict at various junctures: passion, sensuality, spirituality, simplicity, child-like wonder, experiments in abstraction, contemplation, connections with other art works and forms.

122

"Woman," not simply an individual woman, was being presented in a new, complex, and composite manner to the American public – and to Stieglitz's close associates. The nudes were not publicly shown as a group until 1921 at a large Stieglitz exhibition at the Anderson Galleries.

Stieglitz's other portraits of the late 1910s included a number of images of his extended family: his mother, Hedwig; his twin brothers, Leopold – a physician, who often cared for Stieglitz and, later, O'Keeffe – and Julius – a professor of chemistry at the University of Chicago and an amateur photographer; Dorothy Schubart, married to Stieglitz's nephew William Schubart; and Flora Stieglitz Strauss, the daughter of Leopold and Elizabeth Stieffel Stieglitz. A number of the images are close-ups that project a poignant intensity and demonstrate Stieglitz's ability to capture depth in a suggestion of an "interior" life behind the exterior pose, even in members of his own family.

Stieglitz also did a small series in 1919 of Dorothy True, a friend of O'Keeffe, who had studied with her at Columbia University Teachers College. One sees Dorothy in contemplation, lying down, her head perched on her outstretched arm, or, in a less serious close-up, one sees Dorothy's half smile as she leans forward, her hand clasped on her cheek. The most well-known image of the series appears as a double exposure showing the shadow of Dorothy's face beneath her stockinged leg with high-heel shoe. Two other images depicting only Dorothy's leg and shiny high-heeled shoes are also complex studies in light, shadow, and texture. In each of the images the role of the diagonal is predominant, reminding one of the emphasis of the diagonal in many Japanese prints. The double image, dream-like as the shadow of Dorothy's face recedes into the background, evokes aspects of surrealism and dada collage, where parts and wholes are interchanged, as new modes of perception and observation are called into being.

In 1919, Stieglitz also photographed *The Dying Chestnut at Lake George*. Stark and alone in its tripartite structure, the tree represented for Stieglitz a "cry of the Human Soul." Indeed, it appears as a figure with outstretched arms. Stieglitz wrote to John Marin about the image, "there is a great chestnut tree up on the hill – some 150 yards behind the house – It's a majestic fellow attended only further down – not too near by a smaller tree – Possibly a concubine – Well, the old fellow has been dying for some years – And as the end nears he seems to become more majestic – more magnificent. It's the tree I photographed last year – A cry of the Human Soul – unheard – alone – ."[90] Although O'Keeffe had come into his life, Stieglitz, at some points, still saw himself as alone, alienated from the mainstream, as he fought for the role of photography as art and the role of modern art in America. The magic of the tree, thus, in some ways echoed Stieglitz's own voice. The subject of dead chestnut trees on the Lake George property appeared to fascinate Stieglitz, and he was to return to the subject in later work.

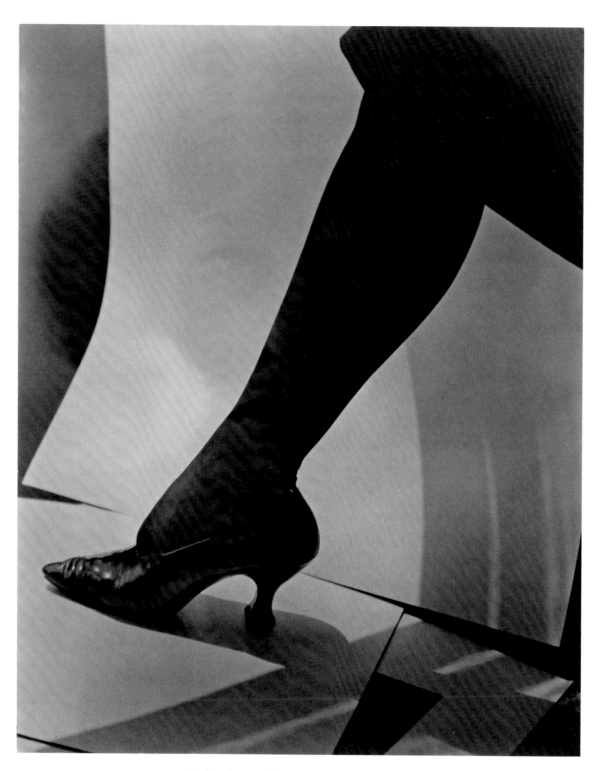

82 Alfred Stieglitz, *Dorothy True*, 1919. The J. Paul Getty Museum.

SOME LETTERS

The letters Stieglitz wrote in the late 1910s reflect his personal and professional relationships that in many instances are intertwined and cannot be separated. Included here are but a few of those letters, to and from Stieglitz that, as the visual art works, are best understood in the original voice of the writer. In these early letters one finds reference to some of the key themes that were to dominate the lives of O'Keeffe and Stieglitz – the world of nature, music, headaches and psychological/physical/medical issues, the need and frequent yearning for "quiet" often equated with a sense of calm, or the interaction with other artists and writers who were to become interwoven in the fabric of Stieglitz's life.

[Stieglitz to Marsden Hartley] 12 January, 1915
 291 Fifth Ave. New York

My dear Hartley:

During Xmas week your letter came to hand. I was glad to hear that you were again your old self and that you were at work expressing yourself. It is self-understood that you have made progress. My faith in you as an artist has never wavered for an instant as long as I have known you. That really means that I know that you must develop as you grow. In other words you cannot but help be yourself. That is all that means anything to me in anybody.

I am glad to know that you are doing some writing, putting down your ideas on art. Of course when you are ready and you want me to print what you have written send along a copy and it will go into *Camera Work*.

As for your financial standing, including the draft I am enclosing and all monies in sight, $844.50. This includes everything. Simonson never materialized so I kept the painting and I have paid $100.00 to your account myself. I am glad to have the painting as it is one of my favorites. Of course if Simonson had paid it would have been his. I waited until January 1st for him to pay, although he had promised to pay before July first. As for Daniel's payments, he is very slow. He seems to be pushing things up at his place and is getting a great many newspaper notices, but he must be short of cash. As Lawrence, who has come in says, the same old story. Within the next two weeks I shall forward you another $100.00. I hope by that time Daniel will have materialized something. Of course it would be a great thing for you if you did get to Vienna and Budapest, to gather new experiences and see new things. Today a week, I believe, Daniel hopes to open up your exhibition. I wonder how New York will accept the things it laughed at a few years ago. I am sure the exhibition will be a success. Although I am not so sure that anything will be sold. New Yorkers are still not buying "art."

The women are knitting socks at the Ritz Carlton dinners. So between the dinners, the cost of the elaborate gown, and the wool for the socks, not much money is left for art. The Americans are preoccupied with the poor Belgians. Everything also "poor" does not interest them. That is in regard to "poor" other people. The dislike for Germany is greater than ever. It is all very amusing, although very terrible, to one who sees.

At "291" everything is progressing in the same pure way as it has always progressed. Picasso show was splendid. Today the Picabia show opens up and excuse need be offered. No matter what one may think of Picabia as an artist, on this is sure, Picabia is developing along his own lines and he has developed most decidedly in the last two years. The little room doesn't look a bit queer with these three paintings, each at least eight by nine feet, or over. In the other room we have some Rodin drawings, Picasso and Matisse.

Recently I have been wondering, thinking, about you and your work; whether it would not be advisable of you to send two or three of your newer things to me so as to have them here. There is hardly any chance of Daniel's going into "abstraction" in the near future. "291" seems to be the only place really interested in the development of Today. And for that reason it is well to have on hand the work of today of the men we are interested in. Think this over. It has a practical side to it. For you and for us . . .

I wonder if I wrote you that Marin is a father. And he has broken the record. His offspring is a boy. He is the first 291er to have accomplished anything like that. But the youngest was not born in the ordinary way. Mrs. Marin had to undergo a Cesarean operation; but all is well in the Marin home. Marin is not overly happy. First of all he wanted a girl, as long as it had to be a baby, but he didn't want any baby. Now he is busy most of the time scrubbing milk bottles, which keep him from work and he is most anxious to work. He did some very beautiful things in Maine. To add to his troubles he bought an island in Maine. The island would be all right if it didn't need a house on it. And the house would be all right if it didn't need any money to build it. It is always that same infernal question: Money.

The "291" Number of *Camera Work* is finally on the press. It has been a terrible job to whip it into shape. I have been at work on it daily for over seven months. I wonder what you will think of it when it reaches you. Under separate cover I am sending you the De Zayas Number.

All is well at 1111, and the fellows of 291 all wish to be remembered.

Greetings,

Your old,

[Stieglitz]

[Marsden Hartley to Stieglitz: n.d., but 10 March 1915, Berlin [postcard]]

My dear Stieglitz,

I've simply got to try postal cards – it seems as if I would never get the letter off. I want to talk to you much yet letters are hard when life rushes as you know. The drafts come all right – except that the American Express Co. objects to "+ Co" being written on them and ask me to have the sender omit it as it complicates payment.

The "291" number of *Camera Work* came the other day. It has charm and novelty – certainly to me off here it's all so intimate and friendly. I love Marie's little contribution; it is so human and real – also Marion Beckett's, Agnes Meyer's – E. Meyer's also. But real affection for anything always calls for either austerity or [?] – I think in the main however it is thoroughly good. It interests me to see myself in print the second time – it's like seeing pictures of one's own in other places.

I am so pleased that De Zayas thought well of my show at Daniel's. I would like to have seen it. You must jack up Daniel in that matter. Don't be too kind – but that is silly to tell you that – you always are and must be I suppose. I am writing quite some and shall soon send you a packet of MSS which I hope you will want to print. No one else will.

Love to all,

M. H.

[Stieglitz to O'Keeffe: 1–2 October 1916]

Sunday. – Not a cloud in the sky all day. – The night was a very cold one and the sun rose in a real academic fashion! Perfect with no real character of its own!! Fooling aside it was in reality – a magnificent sunrise – but too perfect to move me as I lay there wide awake watching the sky first golden red and then gradually changing into blue – a morning blue. – There was a great north wind and as I looked at the Lake it seemed a seething sea of floating ice – moving down the centre of the Lake – We are in a protected bay – the water in the bay was relatively calm. – Like myself today. – The hills opposite are of warmer hue than they were yesterday. – And our Maple much changed – many red leaves over night. – And in the Wind a golden shower of falling leaves! – And now it's afternoon – near five. And the Wind has spent itself. – The lake is deep blue and very still. – The air is still crisp – but I'm sure to-morrow it will be much warmer. Indian Summerlike again. The swim to-day was great – the water seemed warm by contrast with the air. – Yet it was in fact colder than yesterday. – All a question of relativity. – Sensibility. – To-day most of the family left for town – as we are still fewer. – No date as yet has been fixed for our return. None can be fixed under the present conditions. – It is years since I have been in the country in October – and often I had hoped

for the chance – But my work never permitted. – A slave of my own ideals! – This year I'm free – of much of that Self which enslaved me for some 30 years! – I earned my freedom. – I sometimes wonder which is the more living – self-imposed slavery or earned freedom through having passed through such slavery! – Or are both identical – simply different names. – Still it's a funny feeling not to lead a fight – I led one for 32 years!! – Perhaps I'm fighting still I as leader and as follower – of my own leading. –

I'm anxious to send you Faust . . . Plenty of color withstanding the "shortage"of autumn tints. – The Lake hardly budged all day. – It was cold – the water – but the sun was warm. And it was great to go in for a swim and then lie on the dock. – Last Night I had a brisk walk in the dark – it was very dark – and then I took a look at the Lake. – It seemed severe – austere – cold and calm. – Forbidding!! – How thoroughly feminine that sheet of Water. – Finally so. –

I have just come in from another Walk through the Night. Starlight. And Wind still. – A child in the air. – But just right for brisk walking. – Somehow or other I'm aching for some music to-night. – There was a time when the piano was my lake! – But for upwards of 20 years I have practically not touched it. – It's a story I may tell you some day. – Do you like music? – <u>That is do you need it?</u> – Does it tear you to pieces? . . .

Why did you tear up that page meant for me – written on your way to Virginia? It was really mine as soon as written to me. Or don't you believe in that? –

A cold night does not mean the same to me that a Warm one does. – It's queer – I love Snow – Winter. – But to make me feel genuinely myself – genuinely alive – I need Warmth – lots of it. – Out-of-doors. – The Sun was great to-day. – I feel it still. –

Good night. – It is good to go to bed feeling the Sun. – I hope you are in as quite a mood as I am – it is like the ticks of those clocks – a quartette of them beating time. – Once more good night. –

The Stars shone very bright to-night. I wonder whether those peeping through my window will keep me awake again. They did last night. –

And I want to sleep although not a bit tired. – !

Stieglitz did send O'Keeffe a copy of *Faust* inscribing the front flyleaf, "I have lived – When I / was <u>NINE</u> I discovered Faust. / It gave me quiet then – / I know not why. – But it/ gave me quiet. – And I / have lived since then. – much / and had – and in consequence / suffered so that I could not/ suffer anymore. / Faust / quieted me in such despairing / moments – always – / And as I grew it seemed to / also grow. – It is a Friend. / – Like the Lake – / – To one who, without knowing, has given me much at / a time when I needed Faust and Lake. – 1916."[91] Inspired by an idealized conception of Woman he found in *Faust*, Stieglitz was beginning to equate O'Keeffe with that idealization, a woman whose purity might redeem a man's soul.

[John Marin to Stieglitz] Small Point, Maine, 31 July, 1917.

My dear Stieglitz,

There was a time about two weeks gone when I should have written to you. Then the mind was, if anything, clearer. Now it's hot, "dam hot." But there are degrees, and how much hotter other places in this poor old scrapping world. And what are they scrapping about? This question is now senseless, useless. There is only one statement, the soldier's statement, to wit, *They are scrapping*, and those, too, say, why are they scrapping?

They themselves are scrapping with those who do scrap. So that all are scrapping.

We up here get but few glimpses of the outer world. As to objects on the water, a fish boat looks big, a sail boat looms up, the eagles soaring overhead are big, or is not their bigness a something of the imagination. As, if you were floundering, how big a plank would look. As, if in the wilderness lost, what a little light would mean. As, in a city, one light means little or nothing. As, in a world harbor, the insignificance of one little boat.

> A native to show the traveler the way.
> A pilot to steer the boat through, knowing the channels.
> Can you trust him, blurts out this awful word – trust.
> Ignorance, stupidity, knavishness, selfishness. No.
> Kindliness. Kindliness and intelligence. Yes.
> Until then, we will have no peace, no rest.

The world does at times, or parts of it, get cocky. Seemingly we are cocky and we howl out our achievement. This time the parts seem to have pervaded the whole.

I have just been in for a swim and feel better. The water delicious, the sands to the touch of the feet. Big shelving wonderful rocks, hoary with enormous hanging beards of sea weed, carrying forests of evergreen on their backs. The big tides come in, swift, go out swift.

> And the winds bring in big waves, they pound the beaches and rocks.
> Wonderful days.
> Wonderful sunset closings.
> Berries to pick, picked many wild delicious strawberries. The blueberries are coming
> on.
> On the verge of the wilderness, big flopping lazy still-flying cranes.
> Big flying eagles.
> The solemn restful beautiful firs.
> The border of the sea.

Good night.

My island looks tantalizingly beautiful.

My boy is brown and well, full of life. My wife is brown and well. I am brown and well. You!!!

Get away.

Your friend, Marin

Got the two checks all right, many thanks.

Nibbling at work!

The fields were billowy with daisies and buttercups.

Now the wild roses are in bloom everywhere.

It's great to sit on a gigantic rock and look at the waters.[92]

[Stieglitz to O'Keeffe: 25 October 1917]

. . . Liberty Bonds – yes, here too. – everywhere Liberty Bonds! – a funny contradiction of terms – Liberty – Bonds – Like Life itself . . . I refused to go "home" tonight [Stieglitz is in his niece, Elizabeth's studio] won't go "home" until something <u>definite</u> is settled upon – I can't live as I have for 24 years. Our cook was at 291 – Mrs. S. [his wife Emmy] was in the country – Mrs. S. is finally beginning to realize that I am not entirely a dishrag – It's a long and frightful family story . . . she's never really grasped the meaning of Life and still more the meaning of another's feelings . . .[93]

[O'Keeffe to Stieglitz: 31 October 1917]

[Post-marked Canyon . . .]

Good Morning – Monday morning

I went to write you and I have nothing in particular to say but I want to write anyway – I just won't let myself wake up and so have to laugh at myself – It's great to see yourself asleep.

My bed isn't made – Things are strewn all over my room but I want to write first – I just came from breakfast and the post office – your yellow letter paper – the Negro Art and a page from Strand

There is something great about him – but somewhere – he seems to be getting too old too soon – What is it I want to say – too fixed in some of his ideas too soon . . . A good many of these folks have never seen a painting though you know I would like them to see Hartley's – I don't know why Hartley's – the different kinds of Hartley's seem so real – that lonesome little house that Daniels has – then all the changes since –

I wonder could they see then how a man's painting is the expression of himself – his life. Oh – I'm wondering – . . .

The country is really wonderful – and all so flat and empty – a yellow look – quite brilliant over it all – I just want it all I like it so much. Another day I went to the canyon – supper on the edge of the plains – the long drop right off the edge – the tremendous memorable sunset – not glowing sunset – It was great – I had wandered from the others. Found the cattle alone – watching them – alone –

. . . And I watched the moon come up and the sun go down – and the cattle – it was a wonderful moving line – and the great stretch of color – changing to night – And I don't know – I felt something – . . . Had a bad headache two or three or four days this week – stopped eating and tried to walk it off – stretch between us and the other side – Four or six miles at least I should imagine – wonderful colors – all colors – The shadows forming – one place where we could see it winking on it must have been much more than six miles – so far away that the color went in with the sky almost –

We had supper on the edge – between the sun set and the moon rise – Three of the faculty and Claudie and myself

It was the most wonderful view I have seen of it –

. . . Saw hundreds of cattle coming up the paths – smooth paths in the bottom – You can't see them till they are almost under you because you can't see the real bottom of it all –

The long line of them wound up crooked paths the other side of a little gulch and finally came out – looking like narrow black lace on the edge of the plains against the sun relentless in its whiteness

The wind is careless – uncertain

I like the wind – it seems more like me than anything else – I like the way it blows things around – roughly – even meanly

Then the next minute seems to love everything – some days is amazingly quiet

I wish you were here – or I were there or something

I don't know what . . .

I don't know – I just look around and wonder

A little girl

yes

probably more

Than ever

Not even knowing what to ask

It's like walking around in a dream with your eyes open – a queer stupefied sort of existence – I don't know

In the wind my black and close hat brim is like a flickering shadow between me and the gold of the plains that stretches seemingly to never and the grey blue of the sunny windy fall sky . . ."

[Stieglitz to O'Keeffe: 12 April 1918]

I have hung up your Self Portrait [most likely one of O'Keeffe's nude watercolors from 1917] . . . It looks wonderful and above my bed hangs your passionate landscape (oil) the room is keenly alive Strand will laugh when he sees it.

I don't know what made me do this. I guess everything seemed so dead around me I had to put your real life on these walls & I've got the material – all it needs is Rodin's drawing I call Mother Earth – a most wonderful nude – it will take some nerve to hang it up – Strand called for me at 4 o'clock, we went over to the museum to get another look at the Ryders. We also took the chance to look at a few bits of white pottery – white – Chinese – He seemed to like the same pieces! – Looking at things in a museum always gives me a frightful headache. We went out into the open and sat on a bench it's the first sunny day in a week . . . About to go to bed. – That headache undoubtedly comes from the eyes –

– You – How are you? – I wonder. Several times I started writing to you – . . . Well what I had to say sounded so silly to me that I couldn't get it to paper. Did I have anything to say? . . .

[O'Keeffe to Stieglitz: summer 1918]

Dearest – it is night again and I'm in bed and I have the curse. The day has been warmer – so hot for you I'm afraid – but all day I have felt you love me greatly – It gave me such a wonderful feeling that I felt very bad to think that maybe unpleasant things might be happening to you. I wonder if what you feel my giving to you, my loving you can make the day beautiful to you in spite of other things – Like what I feel you give me even where you are away all day and are not quite comfortable

– Still I am happy – singing – trusting – close to you way down in me
Dearest I love you

The water was fine so stayed in longer than usual, read some after dinner, then sewed – almost made an undergarment – So hot to sleep, too sleepy to read.

Sat on the porch and talked after supper all of us – your mother worried about Sel and you, after supper . . . then walked . . .

[Stieglitz to O'Keeffe: 3 September 1919]

. . . It's near six and the sun is actually breaking through the clouds which are no longer sullen gray – it's hard to believe that I'm on my way to the city – alone – very alone and yet not at all Alone for I know that you feel as I feel – You very dear Person

We were much to each other a year ago – how much more we are to each other today – not because of habit – but because of actual need and deepest feeling – a great respect – mutual – not blind – but actually seeing –

Is it a Great Madness the Desire to Live —
To Experience Life —
Fullest Livingness
Through the Passion of Deepest Love —
Love for Sun —
Love You have for Me —
— Here I am — again the Wanderer it
would seem —
destined for ? —
To accomplish ? —
Perhaps the
Impossible . —
To make the Blind see —
for themselves —
for You — for Me —

83 Alfred Stieglitz, letter to Georgia O'Keeffe, 6 August 1918. Beinecke Rare Book and Manuscript Library.

Very human – and still so very rare – I'm glad you are at Lake George – in spite of its unpleasantness – its beauties are great – and the family all like you – I know that – Like you not because of me but because of yourself –

I am glad a letter from Claudie came before my leaving – . . . tonight I hope the sky will be clear – + that through the tree tops you may see a star – or more –

How many nights two years ago – other years ago – I lay wide awake – + the world seemed all space – + I very very alone – but feeling all the possibility of a human relationship as pure as my own feelings towards those tree tops and sky and stars – and through those stars I saw the world – my family – my friends – male – + female – you are very beautiful . . . Remember me to all . . . Good night my dearest little Girl – I love you –

*

The decade came to a close; with a world war recently ended, and Stieglitz deeply in love with O'Keeffe. Although in his mid-fifties, Stieglitz was energized, and inspired, in his own photographic work and also in his fight for the recognition of photography as an art form and for the rise of modern art.

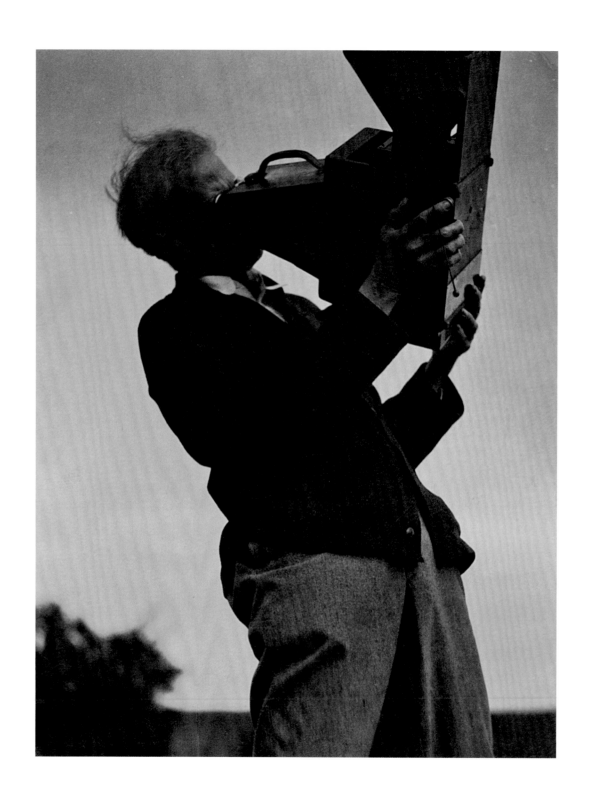

THE TWENTIES

My photographs are ever born of an inner need . . . an Experience of Spirit. I do not take
"pictures," that is I never was a snap-shooter . . . I have a vision of life and I try to find
equivalents for it sometimes in the form of photographs. It's because of the lack of inner
vision amongst those who photograph that there are really but few "true" photographers.
The *spirit* of my "early" work is the same *spirit* of my "later" work. Of course I have grown,
have developed . . . There is art or not art. There is nothing in between.

Alfred Stieglitz, letter to J. Dudley Johnston,

3 April 1925[1]

Having left his wife Emmeline of twenty-four years, Stieglitz lived with O'Keeffe for two years
in his niece's small studio at 114 East 59th Street. In 1920, they moved to rent-free quarters at
60 East 65th Street, owned by Stieglitz's younger brother, Leopold, who greatly admired
O'Keeffe's paintings. That spring O'Keeffe made the first of several trips to York Beach, Maine,
marking the beginning of her independent travels, which ultimately brought her to lengthy stays
in New Mexico, beginning in 1929. Her sense of independence was reflected in the 1920 amend-
ment passed by Congress giving American women the right to vote. Until 1929, O'Keeffe's and
Stieglitz's summers were spent at least in part at Lake George on the Stieglitz family estate. The
budding and flowering of their relationship and their connections to the art world around them
are best seen in the context of their wider environment, for theirs was a special world in many
ways, operating sometimes in isolation from, and sometimes in unison with, larger events in the
United States and abroad.

That decade in the United States is often stereotyped as one filled with fun and flamboyance,
colorful, with the sound of jazz rhythms and dancing flappers as the pace of American life
quickly accelerated after the end of the First World War and the signing of the armistice on 11

84 Paul Strand, *Alfred Stieglitz*, 1929. Beinecke Rare Book and Manuscript Library.

November 1918. Louis Armstrong and his Hot Five Band made a series of ground-breaking records and the sounds of cornets, trumpets, and scat-singing vocals established the importance of jazz improvisation in modern western music. All of the arts – music, dance, theater, the visual arts – flourished in New York's Harlem, as the Harlem Renaissance established itself when many African Americans moved north to escape "Jim Crow" segregation laws and Ku Klux Klan activity in the South. Other significant events in the arts included the First International Dada Fair in 1920 in Germany; the discovery of Tutankhamun's tomb in 1922; a major exhibit of "Primitive Negro" art at the Brooklyn Museum, whose roots were to be found in Stieglitz's 1914 African art exhibition at 291; the International Art and Industry exhibition in Paris in 1925 (Exposition Internationale des Arts Décoratifs et Industriels Modernes, or Art Deco), establishing the significance of modern design and its role in creating a harmonious and artistic living environment; the opening of the Galerie Surréaliste in Paris in 1926 with an exhibition by Man Ray, who later came to New York; and the opening of the Museum of Modern Art in New York in 1929, which became a major depository for modern art and the site of significant exhibitions.

Movies that were released during the decade that influenced the other arts included Fritz Lang's 1920 *Metropolis* with its expressionist scenery and science fictional depiction of a dehumanized metropolis where the capitalist "heads" conflicted with emotions of the heart; Sergei Eisenstein's 1925 *The Battleship Potemkin* with its pioneering use of montage technique, commemorating the Russian Revolution of 1905; and Luis Buñuel's and Salvador Dalí's sixteen-minute short, *Un Chien Andalou* (*An Andalusian Dog*) of 1928 that explored surrealist dreams and desires beginning with its shocking early images of a close-up of a woman's eyeball being slit with a razor. In the United States, Rudolph Valentino's 1921 film, *The Sheik*, in which he starred, established his fame as a suave, dashing new silver-screen hero, whom many women adored. On Valentino's unexpected death in 1926 thirty thousand women appeared at the funeral home. Warner Brothers' 1927 *The Jazz Singer* with Al Jolson revolutionized the film industry with its addition of sound. In 1928, Walt Disney amazed audiences with his short *Steamboat Willie*, combining music and animation. Stieglitz attended the movies frequently and many of his series of images grew from roots in cinematic elements.

Despite the mood of celebration and experimentation in some areas of the arts, the 1920s gradually became maimed by disillusionment and growing economic problems, ending with the stock market crash in the fall of 1929. Americans began to turn inward after the "war to end all wars," for there was disenchantment with the thought of becoming further involved with foreign affairs after Woodrow Wilson's League of Nations was rejected. There were broken-down values and a strange new world of technology and urbanization to face. So the "lost generation" began, with little of the optimistic crusading spirit of the intellectuals in the prewar years. The years directly following the war, with the Red Scare, Palmer raids, various labor strikes, and race riots,

and the ratifications of the Eighteenth Amendment, marked the beginning of the age of prohibition, or the "Jazz Age," as the 1920s came to be called. Warren Harding's economics of "normalcy" and foreign policy of isolation seemed to bring little more than the Teapot Dome scandal and increased paranoia to the nation. The Ku Klux Klan increased its membership across the nation with Blacks, Jews, and Catholics as its victims. After six long years of appeals, the murder trial and final horrible execution in 1927 of a poor Massachusetts shoemaker, Nicola Sacco, and a fish peddler, Bartolomeo Vanzetti, corresponded to the fear and persecution of radicals in the United States that began with the Palmer raids. With the indictment of John Scopes, a high-school biology teacher in Tennessee, the teaching of evolution became a crime. In many eyes "the trial was a battle between Fundamentalism on the one hand and twentieth-century skepticism (assisted by Modernism) on the other."[2] Characters of the day included "the stony Coolidge and the bloody Al Capone, the clergyman discoursing on spiritual principles in advertising, and the booster proclaiming that Rotary was a manifestation of the Divine."[3]

Since neither war nor domestic occurrences brought any genuine peace or re-established values for Americans, many sought escape in leisure activities. American life sharpened its pace with an increasing use of automobiles, the radio, movies, and more sex magazines, and more bootlegging. Frederick Allen described many Americans as similar to Lady Brett Ashley in Ernest Hemingway's *The Sun Also Rises*:

> They could not endure a life without values, and the only values they had been trained to understand were being undermined. Everything seemed meaningless and unimportant. Well, at least one could toss off a few drinks and get a kick out of physical passion and forget that the world was crumbling . . . And so the saxophones wailed and the gin-flask went its rounds and the dancers made their treadmill circuit with half-closed eyes, and the outside world, so merciless and so insane, was shut away for a restless night . . .[4]

WRITERS AND PUBLICATIONS

Many writers of the time probed the middle-class environment and American self-deceptions. Sinclair Lewis's *Main Street* and *Babbitt* were published and Upton Sinclair wrote *The Goose Step*. F. Scott Fitzgerald's and Ernest Hemingway's work portrayed much of the atmosphere and feeling of the 1920s. "In general, novelists of the period were realists who dealt with the commonplace American scene. Their literature was a literature of anger and self-deception."[5] Poets, as well as novelists, produced a significant body of literature during this time, among them Hart Crane, Wallace Stevens, and William Carlos Williams (all of whom had worked in the 1910s also). These poets' work reflected America's turn inward and the desire to define and understand the American experience. The uncertainty of the twenties produced a desire for cultural and

local identity. D. H. Lawrence wrote of the general psychic spirit in America: "every continent has its own great spirit of place. Every people is polarized in some particular locality, which is home, the homeland. Different places on the face of the earth have different vital effluence, different vibration, different chemical exhalation, different polarity with different stars: call it what you like. But the spirit of place is a great reality."[6]

The chosen subject matter of many poets was highly American. Williams believed strongly in the American locale, insisting that the universe exists only in the local, that there were "no ideas but in things." He was concerned with immediate experience of an object by the poet. Past, present, and future became one in the intensity of experience. For him there was a sense of growth or flowering in this moment of intense experience. A "radiant gist" (Williams's term) became present in the object. His subjects were primarily people and scenes from the American landscape. In 1925, he published *In the American Grain*, his account of American history, which was influential on other poets and artists of his time. Although poorly written as a scholarly study of history, Williams adamantly set forth his view of American history. His heroes were men such as Columbus, Daniel Boone, Aaron Burr, Walt Whitman, and Edgar Allan Poe, who continually sought new worlds. Williams indicted the Puritans as destroyers of anything new and condemned men such as Alexander Hamilton as a usurer. Although the book sold poorly, it was praised by D. H. Lawrence, Hart Crane, Charles Sheeler, Martha Graham, and Stieglitz, who took the name of his gallery, An American Place, from the book. Although much of Williams's most famous work, *Paterson*, was not published until the 1940s, he worked on the poem most of his life. The central theme of the city of Paterson, New Jersey, becomes intertwined with the other predominant images of the poem – Sam Patch, the poet, the divorced women, the river, the rocks. Through the fragments of local details, Williams hoped that the reader would see more general relationships, become more perceptive, less indifferent to the surrounding world.

Williams was closely associated with Stieglitz and his circle, as is well described by Bram Dijkstra in his 1969 study, *The Hieroglyphics of a New Speech*, including the Precisionist painters Sheeler and Demuth, and approached subjects in a manner similar to the Precisionists in their search for "the reality beyond the actuality" of a subject. Demuth based one of his more important paintings, *I Saw the Figure 5 in Gold*, on one of Williams's poems, "The Great Figure," and dedicated it to Williams. Sheeler was "the American artist whom Williams most specifically praised for realizing his local materials in a universal way."[7] The poet's ideas about the American condition were to some extent influenced by writers such as Lawrence and the *Seven Arts* critics such as Waldo Frank, Randolph Bourne, Van Wyck Brooks, and Paul Rosenfeld, all of whom, as previously mentioned, were friends or admirers of Stieglitz.

Hart Crane expressed a view of history similar to Williams's. His major work, *The Bridge* (1930), handles a myth of a nation concerning the past, present, and future of America. Various settings in the poem include the Brooklyn Bridge, Virginia, and New England. The poem also

covers various periods in time – the eras of Columbus, Pocahontas, Rip Van Winkle, and the twenties. Always there is a sense of bridges crossed or of bridges that need to be crossed. Both Crane and Stieglitz believed in the importance of intuitive perception and that art should record such perceptions. The photographer created his "equivalents" and the poet created his "ultimate harmonies"[8] believing that the reality of an object could symbolize an inner emotional state. Crane occasionally read his poetry at Stieglitz's gallery and corresponded with Stieglitz. Stieglitz wrote to Crane in 1923, "We're after Light – ever more Light. So why not seek it together – as individuals in sympathy in a strong sentimental spirit – as men – not as politicians,"[9] and Crane once exclaimed to Stieglitz, "I am your brother always."[10] The latter owned a first edition copy of Crane's *White Buildings: Poems by Hart Crane*, of 1926 (inscribed "White, through white cities passed on to assure / that world which comes to each of us alone – / for Alfred Stieglitz with affectionate homage – Hart Crane /2/30/26"). This collection was in fact Crane's first publication. The reference to "White" was significant for Stieglitz who believed that white was analogous to purity and directness of spirit. In a number of his letters to O'Keeffe he associates her with white and several of his photographs depict her in white. She frequently dressed in white or black in her later years.

Stieglitz and Crane corresponded with each other on numerous occasions often reflecting on their lives and work. Excerpts from a number of 1923 letters Crane wrote to Stieglitz reveal the affinity he felt for Stieglitz.

Dear great and good man, Alfred Stieglitz: I don't know whether or not I mentioned to you yesterday that I intend to include my short verbal definition of your work and aims in a fairly comprehensive essay on your work. I had not thought of doing this until you so thoroughly confirmed my conjectures as being the only absolutely correct statement that you had thus far heard concerning your photographs. That moment was a tremendous one in my life because I was able to share all the truth toward which I am working in my own medium, poetry, with another man who had manifestly taken many steps in that same direction in *his* work. Since we seem, then, already so well acquainted I have a request to make of you regarding the kernel of my essay, which I am quoting below as you requested. Until I can get the rest of my essay on your work into form, I would prefer that you keep my statement in strict confidence . . . The camera has been well proved the instrument of personal perception in a number of living hands, but in the hands of Alfred Stieglitz it becomes the instrument of something more specially vital – apprehension. The eerie speed of the shutter is more adequate than the human eye . . . Speed is at the bottom of it all – the hundredth of a second caught so precisely that the motion is continued from the picture infinitely: the moment made eternal.

This baffling capture is an end in itself. It even seems to get at the emotion of so-called inanimate life. It is the passivity of the camera coupled with the unbounded respect of this

photographer for its mechanical perfectibility which permits nature and all life to mirror itself so intimately and so unexpectedly that we are thrown into ultimate harmonies by looking at these stationary, yet strangely moving pictures.

If the essences of things were in their mass and bulk we should not need the clairvoyance of Stieglitz's photographs to arrest them for examination and appreciation. But they are suspended on the invisible dimension whose vibrance has been denied the human eye at all times save in the intuition of ecstasy. Alfred Stieglitz can say to us today what William Blake said to as baffled a world more than a hundred years ago in his "To the Christians":

> "I give you the end of a golden string:
> Only wind it into a ball, –
> It will lead you in at Heaven's gate,
> Built in Jerusalem's wall."[11]

Stieglitz wrote back to Crane on 16 April, "What you wrote is so concrete, yet so intangible that one becomes full of wonder."[12]

On 4 July 1923, Crane wrote further:

You see, I am writing to you perhaps very egoistically, but you will understand that I am always seeing your life and experience very solidly as a part of my own because I feel our identities so much alike in spiritual direction. When it comes to action we diverge in several ways, – but I'm sure we center in common devotions, in a kind of timeless vision.

In the above sense I feel you as entering very strongly into certain developments in *The Bridge*. May I say it, and not seem absurd, that you are the first, or rather the purest living indice of a new order of consciousness that I have met? We are accomplices in many ways that we don't yet fully understand. . . . I hope to make it the one memorable thing to you in this letter that I think you should go on with your photographic synthesis of life this summer and fall, gathering together those dangerous interests outside of yourself into that purer projection of yourself. It is really not a projection in any but a loose sense, for I feel more and more that in the absolute sense, the artist *identifies* himself with life. Because he has always had so much surrounding indifference and resistance such "action" takes on a more relative and limited term which has been abused and misunderstood by several generations . . .

I shall go on thinking of you, the apples and the gable . . . and writing you whenever I can get a moment . . . I am sending you a roughly typed sheet containing some lines from *The Bridge*. They symbolize its main intentions. However, as they are fragmentary and not in entirely finished form, please don't show them around. I only want you to get a better idea of what I'm saying than could be "said" in prose. Some of the lines will be clear enough to give a glimpse of some of my ideas whether or not the Whole can be grasped from such fragments or not."[13]

Then, on 25 August, he wrote:

It is very important for us all – that is, all who are trying to establish an honest basis for what work we get a chance to do. It isn't, as you say, a matter of politics, – but something akin to our spiritual bread and butter. Not all our manna comes from the skies. And we suffer all-too-much from social malnutrition once we try to live *entirely* with the ghostly past. We must somehow touch the clearest veins of eternity flowing through the crowds around us – or risk being the kind of glorious cripples that have missed some vital part of their inheritance.

It's good to hear that you have been "at the camera" again and that you are recovering, with physical and nervous rest, that extremity of delicate equilibrium that goes in to your best activities. I know what it is to be exiled for months at a time. They're the usual things with me, and lately it has been especially hard to be cut up between the necessities of a readjustment at the office (they've put me into a new department and I enjoy writing copy again to some extent) and the more natural propulsion toward such things as *The Bridge*. I've been in such despair about this latter for some time! . . . Every once in a while I [get] a statement or so noted down in regard to my interpretation of you and your photographs. There are still many things in the lucid explanation of them that simply baffle me. To use a modern simile that occurred to me in that connection – it's like trying to locate "the wires of the Acropolis;" indeed, I may call my essay by that name before I get through. A little recent study of Picasso and his Harlequins has been illuminating on the inner realities and spiritual qualities that both of you possess, and perhaps by the time you get back to town I'll have some other comparisons ready for you to deny or substantiate. I certainly miss seeing you, now, and wish you might send me one or two of those prints that are otherwise committed to the waste bucket sometime soon.[14]

Along with a number of artists and writers of the time, Crane struggled with the role that the machine might play in American culture, not wanting it to become a "false god." He saw in Stieglitz's work with the camera a marriage of the machine, nature, and man that could result in spiritual intensity and new energies for American culture.

Stieglitz not only encouraged writers such as Crane, but also was a close mentor, as previously mentioned, to young writers such as Paul Rosenfeld. Like Stieglitz, Rosenfeld had developed an early interest in Goethe's *Faust* and both shared a passion for music, a deep-seated interest in German Romanticism, with its emphasis on the divinity of man and the genius of individual instincts, and a conviction that democracy as a "religious" or mystical ideal could help liberate the souls of humanity from the bonds of a materialistic culture. For Rosenfeld, Stieglitz's work in photography helped further the humanization of society and create a democracy of the spirit. Stieglitz frequently reviewed some of Rosenfeld's manuscripts and the writer's books of the 1920s reflected in many ways their mutual interests and support of experimentation in the arts. Those

books include: *Musical Portraits, Interpretations of Twenty Modern Composers* (1920), *Port of New York: Essays on Fourteen American Moderns* (1924), *Men Seen: Twenty-Four Modern Authors* (1925), and *By Way of Art: Criticisms of Music, Literature, Painting, Sculpture, and the Dance* (1928). Among the musical portraits were those of Wagner, Strauss, Liszt, Debussy, Rimsky-Korsakoff, Mahler, Schoenberg, Ornstein, and Bloch. In *Port of New York*, Rosenfeld celebrated a number of American writers and artists whom he admired – Albert Pinkham Ryder, Van Wyck Brooks, Carl Sandburg, Marsden Hartley, William Carlos Williams, Margaret Naumberg, Kenneth Hayes Miller, Roger Sessions, John Marin, Arthur Dove, Sherwood Anderson, Georgia O'Keeffe, Randolph Bourne, and Alfred Stieglitz. As the title suggests, with New York as a gateway and port of entry to a new land, these Americans were seen to be pioneers of a new era:

> During the last eight or seven years, the works of fourteen men and women at different times gave me the happy sense of a new spirit dawning in American life, and awakened a sense of wealth, of confidence, and of power which was not there before. Through words, light, colors, the new world has been reached at last. We have to thank a few people – for the gift that is likest the gift of life.[15]

Rosenfeld's style was frequently poetic and sensual, at times reflecting the influence of the symbolist aesthetic and the writings of Kandinsky, emphasizing the power of music and inter-relationships of the arts. In the chapter devoted to Stieglitz, Rosenfeld made numerous musical allusions:

> Snaps from the hand camera and plates from the large camera all are infinite rhythms of warm, sensuous light, choral symphonies and dances of the sun power. The tiny scale between black and white is distended in these prints to an immense keyboard of infinitely delicate modulations. Black and white become capable of registering in strong and subtle relations a universe of ecstasy and dream and anguish . . . the more recent photographs are three-dimensional polyphony.[16]

On several occasions, Stieglitz wrote to Rosenfeld about *Port of New York* and his other reading. On 25 April 1924, he noted, "Your MS to hand – Bully – Really – Georgia delighted with what you have written about her! Well I'm glad you *did* write – It's more important that you realize – For yourself as well as for all of us. – Including myself – and the great U.S. – In haste – I have my hands full up – with love from us both. – Your old "291."[17] Again, on 12 July he wrote:

> Sorry when I had completed reading Voltaire. It's a very fine piece of work – entertaining every line of it. – and now I'm deep in Keyserling, enjoying too – at the same time reading quite a little Blake . . . I'm also reading *The Port of New York* from cover to cover – So you

see what a test I'm putting it to. You might say test I'm putting myself to – but really it reads splendidly in most parts so far – of course in parts it isn't closely knit enough for my taste. But I'm not reading to "criticize." I'm reading with all of me . . . Keyserling puts his fingers on many things which keep one to one's own clarity – and much I have found in Voltaire and Keyserling (and Blake for that matter) tallies with much I have found for myself in life and have been trying to express in photography, in everyday living – in many ways. – It's ever a seeking for a greater clarification the moment one dare permit oneself to "think" – and yet not lose the "feel" which with me is ever the starting point.[18]

Rosenfeld's *Port of New York* for Stieglitz became quickly integrated in a larger global context of philosophical and poetic readings, among them Voltaire's Enlightenment philosophy and works such as *Candide* advocating the concept of "cultivating one's own garden," and Blake's lyrical poems where one could see "the world in a grain of sand." The philosopher Count Hermann Keyserling (1880–1946) had recently founded the School of Wisdom, modeled on ancient eastern schools of wisdom, in Darmstadt, Germany in 1920, and published *Travel Diary of a Philosopher* the same year, promoting a planetary culture, recognition of nonwestern cultures and philosophies, change as a way of life, and a new "symphony" of the spirit. Keyserling's friends included Hermann Hesse and Carl Jung, whom Stieglitz was also reading.

In *Port of New York*, Rosenfeld emphasized the power of a group spirit that he saw embodied in Stieglitz's 291 gallery and some of Randolph Bourne's work. That group spirit was also likened to a "family feeling." As Rosenfeld noted, "At the root of the man's dream of a group of people, working together, each one preserving his own identity, there must be some strong unconscious family feeling, extended in this case not to individuals related in blood, but related in work and spirit."[19] The various group experiences resulting from this community became significant for fostering individual creative and artistic development, along an interior voyage in search of a more spiritual America.

Rosenfeld also worked with Van Wyck Brooks, Alfred Kreymborg, and Lewis Mumford in editing anthologies of contemporary American literature. The 1927 inaugural edition of *The American Caravan* was dedicated to Stieglitz: "The first American Caravan is inscribed by the editors to a teacher, Alfred Stieglitz." In their foreword, the editors noted, "The first issue is the result of a spiritual as well as geographical canvas of the country,"[20] representing known and unknown authors who submitted manuscript materials for consideration for publication. Those published that year included Hemingway, Williams, Gertrude Stein, John Dos Passos, Herbert Seligmann, Thomas Craven, Robert Penn Warren, Eugene O'Neil, and Crane. It seems significant that the dedication to Stieglitz called him a "teacher" not an artist, emphasizing his role as a leader, mentor, and friend, and the power of interpersonal and group experiences. Just a few years earlier, for example, Stieglitz had written to Rosenfeld about the excitement engendered by a Hartley auction:

85 Alfred Stieglitz, *Paul Rosenfeld*, 1925. Beinecke Rare Book and
Manuscript Library, Beinecke Rare Book and Manuscript Library.

The auction was a great success – Glorious weather – The house packed – all classes of
people – Every one full of excitement – Result: $4913!!! And had I desired, $6,000 could
have been reached. Hartley was speechless – Every one shaking hands. Lights had to be put
out in the hall of the gallery so that people would go. Groups standing about excited – Then
for a long time groups stood on the street – All talking about the miracle – and it was 2 A.M.
before we got home . . . The Beginning! – And Hartley I believe finally sees. – That's my
hope, – my "pay."[21]

Among several portraits of Rosenfeld by Stieglitz, those of 1920 and 1922/23 emphasize
Rosenfeld's dark, brooding eyes, depicting a man of deep sensitivity. In the 1920 gelatin silver
portrait, Rosenfeld is depicted at work, writing, his typewriter on the table, with copies of
Frank's *Our America* (1919), Van Wyck Brook's *The Ordeal of Mark Twain* (1920), Sandburg's
Smoke and Steel (1920), along with his own *Musical Portraits*. These books invoke the presence
of the other writers and a sense of community. The 1922/23 photograph is a close-up palladium
print, softer in tonality. It confronts the viewer with an intense gaze. Rosenfeld appears to be

standing in front of Dove's *Factory Music, Silver, Yellow, Indian-Red and Blue*, of about 1923. Stieglitz's 1925 portraits of Rosenfeld are less formal, snapshot-like outside, one in profile, one with a hint of a gracious smile.

Stieglitz's conviction that emotion and spirit were important aspects of the human psyche was also confirmed in his reading of George Santayana's "Little Essay" (1920), along with his well-known work of 1896, *The Sense of Beauty*, as well as William James's *Character and Opinion in the United States* (1921). For Santayana, beauty was an emotion, a value, and a sense of the good. As he wrote,

> Beauty seems to be the clearest manifestation of perfection, and the best evidence of its possibility. If perfection is, as it should be, the ultimate justification of being, we may understand the ground of moral dignity of beauty. Beauty is a pledge of the possible conformity between the soul and nature and consequently a ground of faith in the supremacy of the good.[22]

Stieglitz's photographs that drew on the natural world as well as the paintings of his inner circle – O'Keeffe, Marin, Dove, Hartley, with their abstract sensibilities – spoke to the marriage of the soul and nature. James's writings, no doubt, lent credence to Stieglitz's notion that experience was an important root, route, and possible product of artistic endeavors. For Stieglitz, the creative act involved an essential moment in the relationship between the artist's emotions and external forms in nature. Works of art were to be judged in large part according to the kind and degree of emotional experience the piece inspired in the viewer.

Telling of further literary influences and interest for Stieglitz are those works from his library dating from this time, which ultimately became part of O'Keeffe's library in Abiquiu, New Mexico. The following constitute but a few of these significant volumes. The 1929 *Urformen der Kunsts Photographische Pflanzenbilder*, which contained close-up photographs of plant forms by Karl Blossfeldt, a German sculptor and modelmaker who specialized in making plant models for the Royal Industrial Museum in Berlin, influenced both Stieglitz and O'Keeffe. Havelock Ellis's *The Dance of Life*, of 1923, inscribed by Stieglitz in the front, "1923/A.S./G.O.," provided him and his circle with the basis for their belief that sexual drive played a significant role in artistic creation. Stieglitz owned a number of the British psychologist's writings, which included both scientific and aesthetic approaches to psychology, to which Stieglitz with his chemistry background and his passion for the arts could easily relate. Ellis coined the terms "narcissistic" and "autoerotic" later used by Freud. As noted earlier, Stieglitz had read Freud's *Interpretation of Dreams* in 1900 in German and owned *Leonardo da Vinci: A Psychosexual Study of an Infantile Reminiscence*, translated by A. A. Brill in 1916. Brill had been a student of Freud's in Vienna and Freud's English translator in the United States, where he frequented Mabel Dodge's salons in New York and participated in debates on sexuality that took place at Stieglitz's 291 gallery. Stieglitz also owned a first edition copy of C. G. Jung's *Psychology of the Unconscious: A Study*

of the Transformation and Symbolisms of the Libido, a Contribution to the History and the Evolution of Thought, of 1916. In this first English translation of Jung's work, following his break with Freud, Jung set forth his theory of a "collective unconscious" and rejected Freud's idea that the libido was purely sexual. For Jung, and probably more appealing for Stieglitz, the libido was but one form of psychic energy, more analogous to Henri Bergson's *élan vital*. Jung made a trip to New Mexico in 1924–5 to study the Indian pueblos and visited Dodge Luhan, who was then living there.

James Joyce's *Ulysses*, of 1922, was also in the library. This controversial epic was banned in the United States after excerpts were published in *The Little Review* between 1918 and 1920. Its "stream of consciousness" style and devices such as the interior monologue were used to depict the Jewish Irish hero, Leopold Bloom, roaming about Dublin on a single day, 16 June 1904. The book would no doubt have appealed to Stieglitz, whose own interior ramblings and roamings were often expressed in his letters to O'Keeffe. Both Bloom's wanderings and the parallel wanderings of Ulysses in *The Odyssey* may be seen as somewhat analogous to Stieglitz's journey and explorations in the arts, and his own personal odyssey outside the confines of his "conventional" but difficult marriage to Emmeline, and his subsequent relationship with O'Keeffe. Stieglitz obtained a first edition copy of the book from the Egotist Press which managed to publish the complete book despite the censorship. The ban was not lifted in the United States until 1933, and 1936 in Great Britain.

Stieglitz also owned George Bernard Shaw's *Nine Answers* in a 1923 deluxe edition. He greatly enjoyed reading Shaw and had published his writings in *Camera Work*, appreciating Shaw's attacks on materialism and his frequent direct, sometimes outrageous commentary.

As an ardent admirer of D. H. Lawrence, Stieglitz owned a number of first editions, including *Lady Chatterley's Lover* (1928), *Pansies: Poems* (1928), and *Sun* (1926). *Lady Chatterley's Lover* had been written in Italy in 1926, after Lawrence had visited New Mexico staying with Dodge Luhan from 1922 to 1923 and again from 1924 to 1925. The novel was banned in the United States and parts of Europe, until 1959 in New York and 1960 in London. Stieglitz obtained a copy directly from the printer in Florence in 1928. The novel celebrates the role of erotic and sexual love in relationship to the world of nature as well as the intermingling of social classes. It explored the story of Constance Chatterley, a lonely woman trapped in an unsatisfactory marriage, and her attraction and growing love for the gamekeeper of her husband's estate. The book was filled with scenes of intimacy and was a celebration of passion and sexuality that could lead to a renewed sense of the meaning of life. Both O'Keeffe and Stieglitz applauded the book. He cabled Lawrence to praise the book, to which Lawrence responded:

> Many thanks for sending that cable to Florence. I'm glad you liked Lady C. She seems to have exploded like a bomb among most of my English friends and they are still suffering from shellshock . . . There are rumors of suppression in England and rumors of ban in America.

But I can't help it. I've shot my shot, anyhow I shot an arrow into the air tee-de-dum! . . . I want to come to America in late autumn anyhow, to go to the ranch [Dodge Luhan's ranch]. So I hope we shall meet. How did O'Keeffe take the book? Sincerely, D. H. Lawrence.[23]

Sadly, Stieglitz never met Lawrence, nor was he able to sponsor an exhibit of Lawrence's paintings as he and Lawrence had hoped.

Stieglitz had also read Lawrence's *Studies in Classic American Literature* of 1920 and had written positively to him about it. He included a copy of a letter from Lawrence of 17 September 1923 in one of 21 September to O'Keeffe, noting that the letter meant a lot to him. Lawrence's letter read in part:

Thank you for your letter about *Studies in Classic American Literature*. I am so glad. I expected abuse, and I get from the very first word a real genuine appreciation that I myself can appreciate . . . why the voice of America is absolutely silent these days . . . where is the onward striving America? They seem neither to call nor to answer. And such a big country full of people. It beats me. I am going down to Mexico again this week – to try that, and I am glad to take your letter with me, in my mind. Yours, Sincerely, D. H. Lawrence.[24]

In the book, Lawrence examined the work of Benjamin Franklin, Fennimore Cooper, Poe, Nathaniel Hawthorne, Herman Melville, Walt Whitman, and William Henry Dana. Lawrence's words, such as "Know thyself. That means know the earth that is in your blood," or "Men are free when they are obeying some deep inward voice . . . Men are free when they belong to a living, organic, 'believing' community active in fulfilling some unfulfilled perhaps unrealized purpose," or Whitman's message, "The American heroic message . . . The soul is herself when she is going on foot down the open road,"[25] spoke deeply to Stieglitz.

Not only the art of Marsden Hartley was fostered by Stieglitz but also the publication of his 1921 book, *Adventures in the Arts*, published by Boni and Liveright with an introduction by Waldo Frank. The book was dedicated to Stieglitz. He procured a first edition copy for O'Keeffe in which Hartley wrote to her on the dedication page, "I hope I may be able to apply certain of your characteristics in my work, or at least produce a similar precision of causation. You know you have in me one of your rarest admirers. I know of nothing like you in modern fields of expression. It is no small thing to stand for oneself. You do it. Cordially, Marsden Hartley."[26] His essay on her in the volume, which characterized her work in erotic, Freudian terms, as much of the critical commentary of the 1920s tended to do, was met with disapproval by O'Keeffe. Hartley also wrote of Sonia Delaunay and Marie Laurencin in his chapter on "Some Women Artists in Modern Painting," which included O'Keeffe. It was in describing O'Keeffe that he used his more passionate, poetic language:

With Georgia O'Keeffe one takes a far jump into volcanic crater ethers, and one sees the world of a woman turned inside out . . . The pictures of O'Keeffe . . . are probably as living

and shameless private documents as exist in painting certainly and probably in any other art. By shamelessness I mean unqualified nakedness of statement . . . These pictures might also be called expositions of psychism in color and movement.[27]

Hartley's chapter on "The Appeal of Photography" primarily paid homage to Stieglitz, written shortly after Stieglitz's large exhibition early in 1921 at the Anderson Galleries, including the first public showing of Stieglitz's intimate and often erotic serial portrait of O'Keeffe. He praised Stieglitz's ability to make portraits:

His creative power lies in his ability to diagnose the character and quality of the sitter . . . the Stieglitz exhibition is one that should have been seen by everyone regardless of any peculiar and special predilection for art. The photos will have opened the eye and the mind of many a sleeping one as to what can be done by way of mechanical device to approach the direct charm of life to nature.[28]

He went on to note dada approval of Stieglitz, which for Hartley was significant:

It may be confided he is an artistic idol of the Dadaists which is at least a happy indication of his modernism . . . Perhaps he doesn't care to be called Dada, but it is nevertheless true. He has ridden his own vivacious hobby horse with as much liberty and one may even say license, as is possible for an intelligent human being . . .[29]

A poem by Hartley and a Stieglitz photograph of a woman's leg in a tight shoe appeared in the sole issue of Duchamp and Man Ray's joint project, *New York Dada*, in April 1921. It is little wonder that Hartley was so devoted to Stieglitz, who had given him his first one-man show at 291 in 1909 and sponsored Hartley's trip to Europe in 1912, first to Paris, then to Munich and Berlin, where in 1913 Hartley exhibited with the Blaue Reiter at the first Herbstsalon (Autumn Salon, similar to the Paris Salon d'Automne).

The book was aptly titled *Adventures*, for Hartley explored with wit, humor, and deep seriousness the worlds of various artists from New Mexico to New York to Paris to Berlin, from salons to the American circus. Hartley's chronicles of the lives and works of these diverse artists, including Henri Rousseau, Walt Whitman, Emily Dickinson, Henry James, John Barrymore, or Winslow Homer, are indeed adventures or, as he calls them in his prefatory note, "entertaining conversations." These chapters were also a search for the magic and wonder of fairy tales. His foreword, "Concerning Fairy Tales and Me," emphasized that magic. "It is because I love the idea of life better than anything else that I believe most of all in the magic of existence and in spite of much terrifying and disillusioning experience of late. I *believe*."[30] As Waldo Frank described Hartley in his introduction, "He may weep, but he may smile next moment at a pretty song. He may be hurt, but he gets up to dance. In this book – the autobiography of a creator – Marsden Hartley peers variously into the modern worlds: but it is in search of Fairies."[31]

Hartley also wrote poetry and Stieglitz proudly owned two inscribed first editions of *Twenty-Five Poems*, published in Paris (undated, Contact Publishing).

Stieglitz was also close friends with the writer Sherwood Anderson (1876–1941) who met him and O'Keeffe when he moved to New York in 1922. A son of the Midwest, born in Ohio, and having also spent time in New Orleans, sharing an apartment with William Faulkner, Anderson's evocation of Midwestern small-town life in his work was considered new in American literature in the 1910s and 1920s. Anderson first achieved recognition with his *Winesburg, Ohio* (1919) and went on to publish *The Triumph of the Egg* (1921), *A Story Teller's Story* (1926), *Dark Laughter* (1925), and *Tar: A Mid-West Childhood* (1926). Stieglitz and O'Keeffe owned first editions of the last two volumes, inscribed to them, "With Love./ Sherwood Anderson." Influenced in part by Gertrude Stein, Anderson's style recalled everyday speech. His works often emphasized the significance of American versus foreign soil, and land, and attempted to capture intuitive moments in everyday American life which then might lead to revelations of a higher order of reality. *Tar*, for example, partially autobiographical, tells of a boy growing up in a small Ohio town, tracing his consciousness of a single room in his small family house to a much larger outside world. Anderson dedicated *A Story Teller's Story* to Stieglitz, writing that the photographer "has been more than a father to so many puzzled, wistful children in the arts in this big, noisy, growing and groping America."[32] He also wrote to Stieglitz in 1925, while visiting New Orleans, emphasizing Stieglitz's role as a mentor and father figure. The letter, in response to two letters from Stieglitz, also showed concerns for Stieglitz's health:

> Naturally I wish your own health might go on for twenty years, yet without your body giving you pain or uneasiness. There is a way in which you are so like a father of us, that when you are depressed, it depresses us too. Paul's [Rosenfeld] letter, however, reports you as flying around again. I am so glad Georgia is working. Her work last year meant so much to me . . . Love to all of you.[33]

The 1923 portraits of Sherwood Anderson by Stieglitz show Anderson in front of three O'Keeffe paintings, in separate portraits, *Untitled* (1923), *Lake George with Crows* (1921), and *The White Wave* (1922), all exhibited at the Anderson Galleries in 1923. Of six 1923 portraits, five are closely cropped head-and-shoulder frontal images. Anderson, with his tousled hair and serious gaze, appears intense, as his writing sometimes was. He seems to be at one with the O'Keeffe paintings, as foreground and background become entwined through formal linear elements in several of the images. The visual and verbal artists thus become linked in Stieglitz's portraits, alluding to a community of artistic spirits and reaching toward the concept of a *Gesamtkunstwerk*.

That same year, 1923, Jean Toomer's (1894–1967) novel *Cane* was published, with a foreword by Waldo Frank. O'Keeffe and Stieglitz met this African American author shortly after publica-

86　Alfred Stieglitz, *Sherwood Anderson*, 1923.
The Art Institute of Chicago.

87　Alfred Stieglitz, *Sherwood Anderson*, 1923.
The Art Institute of Chicago.

tion and they all became close friends. The novel was acclaimed as a new voice in American literature, representing untapped resources of American culture. Toomer was soon seen as a leader in the "Black Renaissance" through the lyrical expression of his racial and democratic idealism. He had devoted much time in 1920 to studying eastern philosophies, including Buddhism, as well as Theosophy and Occultism. Toomer perceived himself as a reconciler of opposites – black and white, east and west, north and south, light and darkness – particularly after living in Sparta, Georgia, in 1921, where he served in the Sparta Agricultural and Industrial Institute. He was also steeped in French symbolist writings, using Baudelaire's style as a model for his lyrical sketches in *Cane*, which takes place in both the north and the south of the United States, depicting aspects of African American culture. In part three of the book, Toomer presents a portrait of an artist struggling to represent his African American roots.

Shortly after the publication of *Cane*, Toomer began studying the idealism and mysticism of George Ivanovitch Gurdjieff, attending Gurdjieff's Institute for Harmonious Development in Fountainebleau, France in 1924, 1926, and 1927. Toomer attempted to spread Gurdjieff's gospel of spiritual self-development and a higher consciousness related to the fourth dimension and, as noted earlier, O'Keeffe and Stieglitz attended seminars given by Alfred Richard Orage, Gurdjieff's representative, in New York in 1924. Although Toomer distanced himself from Gurdjieff in 1935 after arguments over finances, he continued his faith in the philosophy, establishing

88 Alfred Stieglitz, *Jean Toomer*, 1925.
National Gallery of Art, Washington, D.C.

89 Alfred Stieglitz, *Waldo Frank*, 1920.
Beinecke Rare Book and Manuscript Library.

his own center in 1936 in Doylestown, Pennsylvania, and giving lectures on spiritual self-development. In his later life he became devoted to Quaker principles.

Toomer visited O'Keeffe and Stieglitz at Lake George in September and October of 1925. There Stieglitz took a number of photographs of the handsome young Toomer, who reminded O'Keeffe of her brother Alexius. The small gelatin silver prints were taken outside as Toomer casts his gaze around him, upward, outward, downward. In many of the fifteen images in the National Gallery Key Set, Toomer does not visually engage the viewer but gazes into a possible other realm, seeming to reflect his then growing interest in a higher consciousness. The sky and faint cloud cover serve as the sole backdrop for the dark-haired Toomer, dressed in a dark topcoat, gray-toned sweater, and white shirt, appearing strong and solid in the outdoor environment.

Soon after that visit Toomer went to Chicago, writing and lecturing about Gurdjieff's teachings. There he married the young writer Marjorie Latimer and spent his honeymoon in New Mexico with Dodge Luhan in 1931. A year later, Marjorie died in childbirth, bringing Toomer back to New York in November 1933, to collect the letters of his late wife from O'Keeffe, who had corresponded regularly with Latimer, and to seek publishers for his writings on Gurdjieff. O'Keeffe had been suffering from depression and difficulties in her relationship with Stieglitz. Toomer was a welcome visitor and was invited to Lake George immediately for Christmas, as

well as much of the month of December. Stieglitz appeared only two days before Christmas and left shortly thereafter. It appears that O'Keeffe was sexually drawn to Toomer and that they shared intimate moments in their time together in the farmhouse. Although there is no external evidence that Toomer and O'Keeffe were lovers, her letters to him suggest a relationship beyond platonic friendship. Shortly after Toomer left Lake George, O'Keeffe wrote, "I like knowing the feel of your maleness. I wish so hotly to feel you hold me very very tight and warm to you."[34] Toomer returned to Chicago without stopping to see Stieglitz but he contributed to the seventieth birthday volume dedicated to Stieglitz, *America and Alfred Stieglitz: A Collective Portrait* of 1934. In Toomer's contribution, "The Hill," he wrote:

> [H]e remains faithful to the high task of building his world with the materials and the people who belong to this world – all the while knowing, of course that what he does carries beyond the boundary of his immediate aims, and reaches people near and far . . . His function in life was not to fit into something that already existed but to create a new form by the force of his growth. Now he calls that form "An American Place" – which it is authentically. Whoever goes to room 1710 of 509 Madison Avenue or to The Hill at Lake George will find certain American essences in the paintings, in the photographs, in the very life and atmosphere too. Yet deeper than the national reality is the human reality. He himself and his form are of the great body and spirit of mankind. An individual who is himself, who is for those of the wide world that claim *him* by similarity of spirit and of values.[35]

Toomer also contributed from 1920 to 1929 to *The Dial* magazine, a small publication that celebrated the arts and culture, which Stieglitz and O'Keeffe read regularly. Having been begun early in 1840 as a transcendental publication edited first by Margaret Fuller and then by Ralph Waldo Emerson, the publication was re-established as a socially oriented humanitarian magazine in 1880. In 1918 the magazine failed, due to philosophical disagreements around Randolph Bourne's strong pacifist agenda and John Dewey's pragmatism. Two years later, a wealthy Harvard graduate, Scofield Thayer, rescued the magazine and attempted to publish it monthly. As the editor, he sought to publish significant new works of art, illustrated with critical commentary, along with the best in poetry, prose, and drama. Through his friendship with T. S. Eliot, Thayer established strong connections with leading artistic circles in Europe and the United States. For example, the first year included works by Anderson, Bourne, Crane, Cummings, Demuth, Gibran, Gaston Lachaise, Marianne Moore, Pound, Sandburg, Van Wyck Brooks, and W. B. Yeats. Later issues included work by Eliot, Williams, Vincent Van Gogh, Lawrence, Thomas Mann, Marcel Proust, Hermann Hesse, George Santayana, Wallace Stevens, Edvard Munch, Marc Chagall, Ernst Barlach, Rainer Maria Rilke, Keyserling, Gertrude Stein, Picasso, Stuart Davis, and Paul Valéry. Rosenfeld's contribution to 1921 issues included an article in January on Ernst Bloch, whose work prompted Stieglitz to show Bloch his first *Songs of the Sky* images, and

an essay devoted to Stieglitz's photography in the April issue. This essay formed the basis for his later *Port of New York* tribute to Stieglitz. The critic Henry McBride wrote frequently for *The Dial*, often lauding the work and exhibitions of Stieglitz and his circle. Thayer also created a yearly Dial Award of $2,000 to one of the contributors. Eight awards were granted from 1921 to 1928, to Anderson, Eliot, Van Wyck Brooks, Moore, Cummings, Williams, Pound, and Kenneth Burke. Thayer became ill in 1927 and by 1929 the magazine had ceased to exist without his financial support.

Another "little" magazine that Stieglitz read regularly was the monthly *Broom*, which began publication in November 1921 under the leadership of Harold Loeb, Alfred Kreymborg, and Matthew Josephson and Malcolm Cowley (until 1924). The magazine was published first in Rome, then Berlin, and finally in New York at 47 East 34th Street. Drawing on literary and visual artists' works, the magazine wished to bring ground-breaking artists from Europe and the U.S. together as well as to recognize their work. Contributors included Williams, Toomer, Gertrude Stein, Picasso, Cummings, Matisse, Feodor Dostoyevsky, and Moore. Although short-lived, the *Broom* was somewhat like an art object itself with its fine binding and printing, along with a rich use of color.

While enjoying *Broom* and *The Dial*, Stieglitz was not directly involved in their publications. He did, however, become involved with a shortlived publication *MSS* or *Manuscripts* that appeared irregularly between February 1922 and May 1923, in printings of two thousand. It was a collaborative effort with each writer or artist contributing to an issue's cost. Editorial interference was not allowed once an article or poem was accepted. Stieglitz served as an advisor to the whole project, while Rosenfeld and Herbert Seligmann served as editors with the exception of one issue, December 1922, edited by Paul Strand. That issue focused on "The Significance of Photography as Art" for which he solicited responses to his query, "Can a photograph have the significance of art?" The magazine included poetry, essays, fiction, and satire. Its somewhat satirical advertisement ran, "ten cents a copy if you like it, or subscribe one dollar for Ten Numbers to be issued in Ten Days – Ten Weeks – Ten Months – or Ten Years. The risk is yours. Act at once if you want to be one of the first 100,000 subscribers." Other contributors to the approximately twelve-page well-laid-out periodical included Anderson, Bloch, Kenneth Burke, Charlie Chaplin, Demuth, Dove, Frank, O'Keeffe, Sandburg, Walter Lippmann, Leo Ornstein, Williams, and Leo Stein. Some of the early favorable criticism of composers such as Arnold Schoenberg and Edgard Varèse appeared. O'Keeffe designed a striking cover for one issue and Stieglitz contributed some poetic musings. One finds, for instance, in the March 1922 issue his "Portrait – 1918."

> The flesh is starving
> Its soul is moving starward
> Seeking its own particular star

A man intercepts
Receives the flesh
Millions were ready to receive it
The flesh is no longer starving
Its soul keeps moving starward
Seeking its own particular star.[36]

This poem reflects to some extent Stieglitz's conviction that the sensual-sexual and spiritual needs of man and woman be integrated in the artistic process or act of creation as each aspires to find his or her "own particular star." In general, the pieces in *Manuscripts* were provocative and substantive. Stieglitz also considered briefly reviving *Camera Work*, devoting a new issue to current British photographers. He wrote a long letter to Dudley Johnston at the Royal Photographic Society in England, indicating such on 15 October 1923:

> As *Camera Work* is a 'history' – an idea – a spirit . . . I, of course always, have it on my mind . . . and Goetz in Leipzig put the slate printing and engraving plant . . . at my disposal at cost, but I'd have to come over to engineer the project . . . a half dozen real pictures will do more to stir up vital interest than all the lectures and books in the world . . . unfortunately the war has turned me into a poor man . . . I've all but killed myself for photography.[37]

Stieglitz's "fight" in his gallery work and in his own photographic work was enhanced and inspired by these various 1920s publications provided him rich resources related to avant-garde work at home and abroad. In general, the decade's world of ideas, literary, philosophical, and psychological, provided a significant stage and "backdrop" for his work with galleries and museums, and his work as a photographer.

Exhibitions, Galleries, and Museums

During the early 1920s, the New York art world began to regain its energies lost during the War. In 1921, there were more than twenty major modern art exhibitions in New York presented at galleries such as Bourgeois, Belmaison, Daniel and Montross, as well as at the Metropolitan Museum of Art and the Brooklyn Museum of Art. In April 1920, the Société Anonyme Inc. was founded by Katherine Dreier, Marcel Duchamp, and Man Ray. The organization saw itself as America's first experimental museum for modern art, promoting various progressive styles of both European and American artists. American artists particularly active in the early organization were Hartley, Walkowitz, and Joseph Stella. Throughout the 1920s and 1930s, the Société Anonyme sponsored more than eighty exhibitions of contemporary work, with public programming and approximately thirty publications. American audiences were introduced to work such

as Kurt Schwitters's *Merz* collages and the first United States solo exhibitions for Alexander Archipenko (1921), Kandinsky (1923), Klee (1924), and Fernand Léger (1925). Dreier also loaned works to university galleries such as the New School for Social Research, the Rand School for Social Science, and Black Mountain College. She began establishing a permanent collection in 1922 with the purchase of major works of Russian and German artists including Kasimir Malevich, Konstantin Medunetsky, Schwitters, Naum Gabo, and Albers. The inaugural exhibition of the Société opening on 30 April 1920, on the third-floor brownstone at 19 East 47th Street in Manhattan, was designed by Duchamp with white oilcloth walls that captured a blue light reflected from neighboring skyscrapers. Gray-ribbed rubber matting covered the wood floors. To enhance the dada effect, Duchamp placed lace trim around the paintings' frames. Included in the exhibition were Brancusi, Duchamp, Picabia, Man Ray, Joseph Stella, Morton Schamberg, Van Gogh, and Juan Gris.

A significant exhibition sponsored by the Société was its 1926 International Exhibit of Modern Art at the Brooklyn Museum, the largest presentation of modern art in America since the 1913 Armory Show. It was comprised of approximately three hundred works by 106 artists from nineteen countries. Dreier worked closely with European artists such as Anton Giulio Bragaglia, Heinrich Campendonk, Duchamp, Kandinsky, Léger, and Schwitters to organize the show. Artists such as Joan Miró and Piet Mondrian made their U.S. debuts at this exhibition. For Dreier, it was important to have Stieglitz as a participant and supporter along with O'Keeffe, Marin, and Dove. She wrote to Stieglitz on 30 August 1926:

> I am especially anxious to have you represented in this Exhibition, as I am issuing a very important catalogue in conjunction therewith. In this catalogue there will not only be a reproduction of a work of every exhibiter but also a photograph of the artist . . . I can assure you that the greatest care will be taken with each picture . . . The Brooklyn Museum and I are trying to make this an educational exhibition and we hope to have three lectures in the large room . . . It would mean a great deal to all of us if you would come and be a spear . . . I know you will be glad to hear that Duchamp will be over in time for the Exhibition. He has been perfectly splendid in helping me get this together . . . With cordial greetings and deep appreciations for your cooperation on this Exhibition, believe me, Faithfully yours, Katherine S. Dreier[38]

Dreier also offered Stieglitz complimentary advertising and an announcement about his Intimate Gallery in the catalogue. More than 52,000 visitors came to Brooklyn before the show traveled with a reduced number of pieces to three other venues. The catalogue with its vibrant black and red lettering had strong graphic design, an amalgam of Bauhaus and Constructionist design principles. An entire page was devoted to a profile of Stieglitz, with another page to his Intimate Gallery.

In February 1927, at the request of Mitchell Kennerley, the owner of the Anderson Galleries at 59th Street and Park Avenue, Stieglitz mounted an exhibition of his own work – 145 prints from 1886 to 1921, of which 128 had not been exhibited publicly. Stieglitz had not publicly shown his work since 1913 at the time of the Armory Show. Twenty-one of the images dated from 1887–1910, including *A Good Joke, The Terminal, Winter, Fifth Avenue, The Hand of Man, The Steerage,* and *The City of Ambition*. There were nine views from the back window of 291, three installation shots of the gallery, and three studies of Ellen Koeniger in her bathing suit. Most of the show was devoted to portraiture.

Perhaps most significant was the final section, "A Demonstration of Portraiture," of the new photographs of O'Keeffe, many of which were passionate and seductive. There were forty-five in total of O'Keeffe. Her name did not appear in the catalogue nor did her face appear in the photographs. The images were grouped into sections entitled "A Woman," "Hands," "Feet," "Hands and Breasts," "Torsos," and "Interpretations." The last section probably included O'Keeffe's phallic, abstract sculpture in front of her painting *Music, Pink and Blue I* of 1919. Henry McBride noted in his April 1921 review in *The Dial* that Stieglitz had asked $5,000 for one of the nude photographs, for which the plate had been destroyed, making it a unique image, which sent visitors back to the show to see a photograph priced as a painting. This large number of O'Keeffe images marked the importance of the series for Stieglitz. Such a series may be viewed as cinematic in one sense but also consists of single-frame still images that emphasize change, flux, and multiple levels of identity in the depiction of a single person. Some of the more provocative nudes of O'Keeffe were not shown. As Stieglitz noted in the catalogue, "some important prints of this period are not being shown, as I feel that the general public is not quite ready to receive them."[39] There, too, Stieglitz made his famous statement:

> The exhibition is photographic throughout . . . Every print I make, even from one negative, is a new experience, a new problem, for unless I am able to vary – add – I am not interested . . . I was born in Hoboken. I am an American. Photography is my passion. The Search for Truth is my obsession . . . Please note in the above statement, the following fast becoming obsolete terms do not appear: ART, SCENE, REALITY, RELIGION, every ISM, ABSTRACTION, FORM, PLASTICITY, OBJECTIVITY, SUBJECTIVITY, OLD MASTERS, MODERN ART, PSYCHOANALYSIS, AESTHETICS, PICTORIAL, PHOTOGRAPHY, DEMOCRACY, CÉZANNE, "291," PROHIBITION. The term TRUTH did creep in but may be kicked out by any one.[40]

Stieglitz's theme was Truth but what kind of Truth? His truth was not simply verisimilitude and accuracy of depiction with the camera or machine as tool. Rather, his truth and the search for its expression involved experience, which could grow and change, and emotion. His truth involved a completeness that included a convincing sense of the physical presence of the subject or object photographed along with the photographer's experience of the subject or object or the

picture occasion. A few years later, Stieglitz applied the word "equivalent" to his cloud pictures, saying that they were "direct revelations of a man's world in the sky."[41]

One reviewer, John Tennant, wrote of the photographs: "They made me want to forget all the photographs I had seen before . . . so perfect were these prints in their technique, so satisfying in those subtler qualities which constitute what we commonly call 'works of art.' This exhibition . . . aroused more comment than any similar event since photography began . . ."[42] Tennant noted that more than 8,000 people attended, many returning more than once. Herbert Seligmann wrote:

> What is it that this despised box fitted with lens and shutters and called a camera, has done in this man's hands? It has penetrated the fear which human beings have of themselves, lest these selves be made known to others. So doing it has laid bare the raw material which life in America has not yet dared to look upon and absorb . . . will the passions of self-seeking and fear which masquerade as patriotism, will intolerance and race hatreds respond to this unique experiment in the world? . . . The answer is in the challenge of Stieglitz's work. It is achieved in the spirit in which trans-national America will be realized if that is to come to pass . . ."[43]

Seligmann lifted Stieglitz's work to a global stage, seeing in it an exemplary and messianic spirit, that if emulated could lead to increased international understanding and peace.

Despite Stieglitz's dada-like denial of established terminology, his friends and reviewers continued to use many of the terms listed. McBride, Rosenfeld, and Hartley all wrote highly favorable reviews, focusing on the straightforward imagery that Stieglitz presented. In *Adventures in the Arts*, Hartley wrote, "I am willing to assert now that there are no [other] portraits in existence, not in all the history of portrait realization either by the camera or in painting, which so definitely present and in so many instances with an almost haunting clairvoyance, the actualities in the sitter's mind, body, and soul."[44] Strand, too, was inspired to write an accompanying pamphlet for the exhibit, *Alfred Stieglitz and a Machine*, recounting Stieglitz's fight for the acceptance of photography as a fine art. Of the show and Stieglitz's work Strand wrote:

> As a complete analysis and synthesis of a machine, the camera, and of the methods and materials which it connotes, this demonstration is epochal. Never before has New York or any other city of the world, had such an opportunity of examining and seeing what photography is, how it can be controlled, and what it can actually register under the guidance of a sensitive and keenly perceptive intelligence . . . Photography became a weapon for him, a means of fighting for fair play, for tolerance of all those who want to do anything interesting and well. Stieglitz was affirming life.[45]

Strand went on to question the relation between science and expression: "Are they not both manifestations of energy, whose reciprocal coming together might integrate a true religious

impulse? Must not these two forms of energy converge before a living future can be born of both?"[46] He viewed the work of Stieglitz as exemplifying a successful marriage of expression or art and science. Strand became further caught up in his advocacy for photography when he published his well-known essay "Photography and the New God" along with four of his photographs of machines and the urban landscape in *Broom* in 1922. There he warred against a possible tyranny of the machine and materialism as a new godhead, which would crush humanistic ideals, versus an artistic search for truth and feeling that he saw embodied in Stieglitz's photographs.

In May 1921, Stieglitz sponsored the successful exhibition and auction of Hartley's works at the Anderson Galleries, as previously discussed, and the following year featured 177 paintings, drawings, and prints by more than fifty artists approaching modernism in a variety of ways. Demuth, Dove, Hartley, Marin, and O'Keeffe were included.

A significant young visitor, Edward Weston, from California, who had stayed extra time in New York in hopes of meeting Stieglitz, finally met him in November 1922. He had written to Stieglitz, "You are the one person in this whole country (and photographically this surely means the world) with whom I wish a contact at this important time in my life."[47] Weston's four-hour meeting with Stieglitz gave him increased confidence and understanding in the area of straight photography and sharp focus. He reflected on his afternoon with Stieglitz:

> I am not extravagant, but I say it was one of the most significant days of my life, and memories of it are buried into my heart and brain forever. As to [Stieglitz's] work: solidity, nothing neglected, nothing indefinite nor wavering, a complete release; it had a clean cut truthfulness like the edge of a mountain range outlined against a rain cleared sky . . .[48]

Stieglitz's long exposures and small apertures and his frequent close-up framing were lessons that Weston carried with him into his work in California and Mexico.

In 1923 and 1924, Stieglitz mounted exhibitions of his own and O'Keeffe's work again at the Anderson Galleries. Late in January and, in February 1923, Stieglitz proudly presented one hundred works by O'Keeffe (137 were given on the price list). The announcement read, "Alfred Stieglitz Presents One Hundred Pictures, Oils, Watercolors, Pastels, Drawings by Georgia O'Keeffe, American." It had been six years since O'Keeffe's solo show at 291. Significant was the descriptive term "American" that emphasized Stieglitz's dedication to American culture and his belief that O'Keeffe and her work represented an authentic expression of the potential of America establishing its own unique national identity. O'Keeffe had not traveled abroad at all and thus, despite her exposure to European and other foreign influences, she was truly a product of American soil and its heartland, being born and brought up in the Midwest in Wisconsin. There were reported to be approximately five hundred people a day who came to see the work of the young woman who had appeared in the sensual photographs of just two years before. Once again, many of the critics chose to give a Freudian, sexual interpretation to the paintings,

90 K. Hoffman, *Lake George House with Gable*,
2008, pictured in *Music: No. 1.*

which sent O'Keeffe temporarily to her bed, although she was pleased at the sales results that justified her 1918 decision to leave teaching.

O'Keeffe's exhibit was followed in April by "The Second Exhibition of Photography by Alfred Stieglitz." Of the 116 prints, most were exhibited for the first time, including 85 portraits, along with landscapes and snapshots. Approximately twenty-five were of O'Keeffe, four of other women and others such as Marin, Anderson, Duchamp, and Demuth. A second section included barns, the chicken house, trees, and grasses at Lake George. Perhaps the high point of the exhibition was the third section, of ten 8 by 10-inch photographs of clouds floating above the Lake George skyline. Probably made between August and October 1922, the series was titled *Music: A Sequence of Ten Cloud Photographs* or *Clouds in Ten Movements*. Stieglitz's interest in music and the symbolist aesthetic is quickly seen in this well-orchestrated sequence that begins with distinct layers of light and dark and a slight suggestion of man in nature, with the front gable of a small white house in the foreground, progresses through an exploration of cloud movements above a decreasing horizon line, as in the development section of a symphony, to a recapitulation of the theme in the final pieces where the clouds have become calmer, less dramatic, and the rising moon more evident. Of the ten pieces, all but one are gelatin silver prints. Number 3 is a palladium print, with warmer tonalities, where sky and earth appear more closely allied. (I

91 Alfred Stieglitz, *Music. A Sequence of Ten Cloud Photographs, No. 1.* 1922. The J. Paul Getty Museum.

discuss these photographs, the *Song of the Sky*, and *Equivalents* of the 1920s later in this chapter, in the section, "The Photographs.")

There were several positive reviews of the works. Sheeler wrote: "In the grays of ten cloud photographs, he achieves his highest point of distinction in his last exhibition . . . Here is most convincingly demonstrated beyond a doubt that it is within the realm of photography to transcribe and fix eternal qualities."[49] Noteworthy was the enthusiastic response from Ananda K. Coomaraswamy, the curator of Indian and Islamic art at the Boston Museum of Fine Arts. After seeing the exhibition, Coomaraswamy wrote to Stieglitz about his photographs that "they were quite a revelation and totally different from all others."[50] Coomaraswamy was not only a respected art historian, curator, and philosopher but was also a photographer himself, having begun to use photographs in his scholarly work as early as 1903, in reordering the crafts and craftsmen of the Ceylon Armory in the United States in 1917. Coomaraswamy pursued his photographic interests and had a dark room built in his Boston home. He asked Stieglitz to select a dozen of his images to give to the museum. Such a request coming from one of the more prestigious but also conservative museums in the United States at the time, was a complete surprise for Stieglitz. He worked for the next fourteen months selecting, printing, reprinting, and mounting in the end twenty-seven photographs which he gave to the museum in the spring of 1924. Boston was thus the first American museum to collect photography. Stieglitz did not

92 Alfred Stieglitz, *Lake George – Music No. 2*, 1922 (NGA set, *Music. A Sequence of Ten Cloud Photographs, No. II*).
The Adirondack Museum, New York.

93 Alfred Stieglitz, *Clouds – Music No. 6*, 1922. Philadelphia Museum of Art.

94 Alfred Stieglitz, *Clouds – Music No. 7*, 1922. Philadelphia Museum of Art.

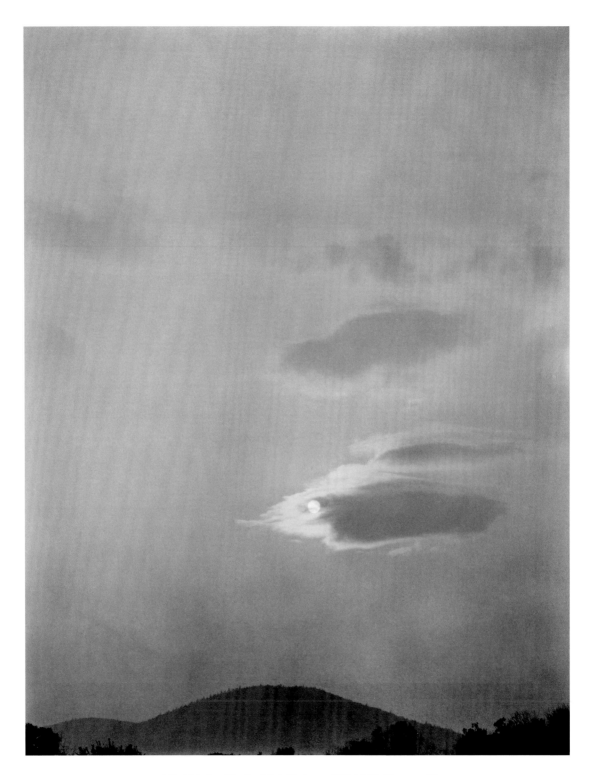

95 Alfred Stieglitz, *Clouds – Music No. 8*, 1922. Philadelphia Museum of Art.

actually see his works hung in Boston until 1931, on a day that became joyous for him. The collection "had been kept in its original immaculate condition. It was a wonderful day, that day in Boston. All of nature above all the sky, seemed to be singing. The prints seemed part of that singing."[51] In 1928, the Metropolitan Museum of Art in New York acquired a smaller group of photographs from Stieglitz. In his Christmas greetings to Coomaraswamy Stieglitz expressed his delight: "The Metropolitan Museum has opened its sacred halls to Photography – 22 of my photographs have performed the miracle! – I suppose Boston helped pave the way."[52]

Stieglitz was thirteen years older than Coomaraswamy but they kept in touch with each other throughout their lives. Both were fighters – Coomaraswamy, although more traditional in some ways than Stieglitz, believed that the modern world had lost a sense of the sacred. In his work he tried to provide a bridge from traditional religious art and literature, and Indian art, to the modern western world. Unlike Coomaraswamy, Stieglitz believed more in the power of personal inner experience and its role as creative modern expression. Coomaraswamy saw in Stieglitz's work, however, an important element of the tradition of the religious arts. In a conversation with Dorothy Norman, he stated strongly that Stieglitz "is the one artist in America today whose work matters. His photographs are in the great tradition. In his prints precisely the right values are expressed. Symbols are used correctly. His photographs are 'absolute' in the same sense that Bach's music is absolute music."[53]

Continuing at the Anderson Galleries, in March 1924, Stieglitz mounted "The Third Exhibition of Photography by Alfred Stieglitz. Song of the Sky – Secrets of the Sky as Revealed by my Camera and Other Prints." In the catalogue, Stieglitz described the work as "tiny photographs, direct revelations of a man's world in the sky – documents of eternal relationship – perhaps even a philosophy."[54] Even the conservative critic Thomas Craven managed to give some praise to the "beautifully printed" cloud images, but could not bring himself to view the works metaphorically as "portraits of human souls":

In his third exhibition at the Anderson Galleries he has a series of cloud formation, unusual selections beautifully printed. These pictures are better than the clouds of Tarr's physical geography because they are printed by a man with an uncanny understanding of his medium . . . It is as fine photography that Stieglitz's prints will stand and not as monuments of the creative will.[55]

Mounted simultaneously with Stieglitz's photographs from 3–16 March was O'Keeffe's recent work – "Alfred Stieglitz Presents Fifty-One Pictures, Oils, Water-Colors, Pastels, Drawings by Georgia O'Keeffe, American." Again the emphasis was on O'Keeffe as American, as she exhibited her calla lilies, images of Lake George, pears, and abstractions. A number of critics, including women, continued to interpret O'Keeffe's work in sexual terms, focusing on her work as a woman. Helen Appleton Read wrote:

Granting that much of this is hysterical exaggeration, and granting that such an interpretation of O'Keeffe's work must influence everyone who has read it seeing into her paintings Freudian complexes and suppressed desires, nevertheless, even without having read it, I think the most casual gallery frequenter would find some disturbing emotional content in her work. They are in some way an expression on canvas of an intense emotional life which has not been able to express itself through the natural channels of life. But distinctly they are not unhealthy or morbid. They are the work of a woman who after repressions and suppressions is having an orgy of self-expression."[56]

Paul Strand, writing in *Playboy: A Portfolio of Art and Satire*, noted:

Here in America, something rare and significant in the realm of the spirit, has unfolded and flowered in the work of Georgia O'Keeffe. Something has crystallized in the painting of this American, and neither here nor in Europe, has a similar intensity and priority of expression so found itself through a woman . . . one is made to feel at once in her work from the early to the late, that by the widest stretch of the imagination, the line, the form or the color, could not have been derived from a man's consciousness or experience of life . . . Here in America, no other woman has so created a deeply personal language, a communicable aesthetic symbology expressive of social significance of her world. And it is this very inter-relationship between social evolution and aesthetic forms, which gives the latter that vitality and livingness we call Art . . . Here is an achievement which distinctly ranges itself both in spirit and importance with the painting of John Marin and the photography of Alfred Stieglitz, with the writing of Randolph Bourne, of Sherwood Anderson at his best and Jean Toomer as a potentiality. Like these it springs from roots as deeply embedded in American soil, and is equally expressive of its spiritual reality.[57]

For those such as Strand, O'Keeffe became the embodiment of a social and artistic expression that could be viewed as revolutionary and evolutionary emerging from an American soil, budding and flowering, representing a new sense of American identity, freed from constricting social and sexual bonds. Stieglitz, too, believed that O'Keeffe's work was among the first to realize the potential of all women, that she represented that "new" woman of the times. Unlike O'Keeffe, who vehemently denied the sexual connotations in her works, Stieglitz continued to believe in and promote her work as having a strong emotional basis that was directly linked to her sexuality. As late as 1945, in a newspaper interview Stieglitz spoke about O'Keeffe and the power of "woman" as temptress. He referred to his ongoing interest in *Faust*, particularly Marguerite and the Devil:

We wanted to know why he [Stieglitz] associated Marguerite with the Devil. "Woman," he said very seriously, "is the arch-temptress and the arch-releaser." After a pause, he went on,

"Woman is the soil. Man is a moment. He comes, impregnates her in five seconds and then goes fishing. But woman is the earth. She makes the seed grow and flowers." "Woman is," gravely, he touched his forehead, his heart, his forehead, his genital region, "This is what her painting should be." Did he know of a woman whose paintings had those qualities? He looked at me as if that were a foolish question. "O'Keeffe," he said. "Georgia O'Keeffe."[58]

O'Keeffe's concerns about the nature of the critical commentary about her work must have carried some weight since it was not until 1927 that there were continued direct erotic references in writings by those associated with the Stieglitz circle. Lewis Mumford's review of O'Keeffe's paintings at Stieglitz's newly established Intimate Gallery marked a return to a celebration of sexual symbolism:

Miss O'Keeffe's paintings, on the other hand, would tell much about the departure of Victorian prudery, and the growing consciousness of sex in resistance to a hard external environment; were Sherwood Anderson's novels destroyed, were every vulgar manifestation in the newspapers forgotten, were the papers of the Freudian psychologists burned, her pictures would still be a witness, for apart from their beauty and their significance, they reveal and refocus many of the dominant aspects of our time.[59]

By 1924, O'Keeffe had established herself as a professional artist, so critical focus on erotic allusions was not the only approach to her work. Yet Stieglitz's opinions continued to be influential, as O'Keeffe described much later in her life in 1974: "Eroticism! That's something people themselves put into their paintings. They've found things that never entered my mind. That doesn't mean they weren't there, but the things they said astonished me. It wouldn't occur to me. But Alfred talked that way and people took it from him."[60]

The pairing of O'Keeffe's and Stieglitz's works at the Anderson Galleries was a kind of artistic engagement announcement for the two. In September, Stieglitz's divorce from Emmy was made final and on 11 December 1924, the couple was married in a brief ceremony in Cliffside, New Jersey, where the Marins were living. John Marin and George Engelhard (Stieglitz's brother-in-law) served as the witnesses. O'Keeffe insisted that the words "honor" and "obey" be omitted from the traditional wedding vows. On the way back New York, Marin sideswiped a grocery wagon and spun into a telephone pole, causing an uproar on the street with the angry grocer. The police gathered around the wedding party and a laconic Marin tried to explain what had happened. Although no one was injured, the event on a wedding day, in retrospect, seemed to be a harbinger of the ups and downs of O'Keeffe's and Stieglitz's relationship, which was at times stormy and intense but also fulfilling.

A backdrop for their wedding day was Stieglitz's daughter Kitty sinking into an ever deeper state of post-partum depression after the birth of her son, Milton, in June 1923. Her doctors had

actually suggested that if Stieglitz and O'Keeffe were married, Kitty might be better able to accept their situation and her parents' divorce. Kitty had graduated with honors in chemistry from Smith College in 1921. She seemed to be slowly forgiving her father for leaving her mother but she was unable to handle both their presences at her commencement and thus asked her father not to attend. Kitty married Milton Sprague Stearns, a Bostonian and a graduate of Phillips Exeter Academy and Harvard University. They had a quiet ceremony to which no members of either family were invited. Stieglitz visited Kitty on her initial hospitalization but learned quickly thereafter that she was sinking deeper into depression, alternating between expressions of love and of hate for her father. In moments of guilt and worry, he wrote to Elizabeth Stieglitz Davidson, "I certainly failed in so many ways in spite of all my endeavors to protect and prepare herself for life . . . I realize what a child I have been – and still am – absurdly so . . . Poor, poor girl. Completely innocent."[61] Alfred's parental and grandparental side of his nature did not predominate, however. Kitty regressed to the mentality of a young child, remaining institutionalized for the rest of her life until she died in 1971. Stieglitz sent her occasional gifts of fruit or candy but was not allowed to visit her, while her mother visited her weekly until her own death in 1953. Milton Stearns raised his son Milton Jr., sending him to Exeter and Harvard as well. Stieglitz had little contact with his son-in-law or grandson except for occasional letters and birthday remembrances or brief visits when the Stearnses visited New York.

The year 1924 contained several other noteworthy events. In January, the Royal Photographic Society awarded Stieglitz its highest honor, the Progress Medal, as noted before.[62] Stieglitz also found himself running a gallery again, when Montross, who became ill shortly before the opening of his annual Marin exhibition, asked Stieglitz to take over his gallery. At about the same time, Stieglitz also learned that Room 303 in the Anderson building would become free to rent in fifteen months. That space became Stieglitz's Intimate Gallery. In April, he suffered the first of several increasingly serious kidney attacks, following the mounting of his several 1924 shows. As the years passed, he became frequently preoccupied with his physical health and his aging body. Many of his letters to O'Keeffe as she came to spend more time away from him in the later years of their marriage detail his ailments, doctors' visits, and the various medications he took.

Stieglitz organized one other large exhibit at the Anderson Galleries in March 1925, "Alfred Stieglitz Presents Seven Americans: 159 Paintings, Photographs, and Things, Recent and Never Before Publicly Shown by Arthur G. Dove, Marsden Hartley, John Marin, Charles Demuth, Paul Strand, Georgia O'Keeffe, Alfred Stieglitz." This was the first group show Stieglitz had organized since 1916 and the only group show he sponsored in the 1920s. It also marked the twentieth anniversary of the opening of 291, which Stieglitz noted in his catalogue statement. Once again, he emphasized the importance of the show being uniquely American and modern, as well as declaring that "This exhibition is an integral part of my life . . . The pictures are integral

ON EXHIBITION FROM MONDAY, MARCH NINTH
TO SATURDAY, MARCH TWENTY-EIGHTH, 1925
[OPEN WEEK-DAYS 9-6, SUNDAYS 2-5 P. M.]

This Exhibition is an integral part of my life.
The work exhibited is now shown for the first time.
Most of it has been produced within the last year.
The pictures are an integral part of their makers.
That I know.
Are the pictures or their makers an integral part of
the America of to-day?
That I am still endeavoring to know.
Because of that— the inevitability of this
Exhibition—American.

ALFRED STIEGLITZ

ALFRED STIEGLITZ
PRESENTS
SEVEN AMERICANS
159 PAINTINGS PHOTOGRAPHS & THINGS
RECENT & NEVER BEFORE PUBLICLY SHOWN
BY
ARTHUR G. DOVE
MARSDEN HARTLEY
JOHN MARIN
CHARLES DEMUTH
PAUL STRAND
GEORGIA O'KEEFFE
ALFRED STIEGLITZ

AT THE ANDERSON GALLERIES
[MITCHELL KENNERLEY, PRESIDENT]
489 PARK AVENUE AT FIFTY-NINTH STREET, NEW YORK

96 *Alfred Stieglitz Presents Seven Americans,* Anderson Galleries. 9 March–28 March 1925.
Beinecke Rare Book and Manuscript Library, Beinecke Rare Book and Manuscript Library.

part of their makers."[63] Included in the catalogue were statements by Anderson, the sculptor Arnold Rönnebeck, and a poem by Arthur Dove. Rönnebeck emphasized an unusual creative spirit inherent in the seven artists' works, a creative spirit that was allowed to flourish in America in the twenties:

> Leonardo and Phidias and Richard Wagner are still "modern," that is universal, and therefore they will be understood as long as humanity lives. They gave full expression to the spirit of their period and lived in a profoundly human contact with the *topics of the day.* The same tremendous responsibility of facing the significant problems of the period faces the artist today. And he is able to express his reactions in universal language . . . The pictures in this exhibition which in spite of their being "contemporary" could have been made 2000 years ago or 5000 years from today – because they are animated and dictated by the ever-flowing sources of life itself. These seven Americans are explorers. They leave the traditional ruins to the archaeologist . . .[64]

Sherwood Anderson's statement spoke of an age where New Yorkers were tired, were "frightened children," to whom the seven artists brought significant moments of life, when they were "conscious of all – everything/ When they were conscious of canvas, of color, of textures – /When they were conscious of clouds, horses, fields, winds and water./ This show is more the distillation of the clean emotional life of seven real American artists."[65] The show received a variety of reviews. McBride called it "the most conspicuous group in town. Its ramifications in the social fabric are so great that it has arrived at the point where it can fill the rooms without the aid of publicity, but this is largely because it makes use of what might be called superpublicity – or in other words literature. From the first the Stieglitz group has known how to attach literature to

97 Alfred Stieglitz, *Arnold Rönnebeck*, 1924.
Beinecke Rare Book and Manuscript Library.

itself . . ."[66] Edmund Wilson opined: "Georgia O'Keeffe out-blazes the other paintings in the exhibition . . . Some of Mr. Stieglitz's recent experiments in this field are, I suppose, among his greatest triumphs. Especially impressive among those newest photographs are certain masses of striking somberness and grandeur which lift themselves as if in grief."[67] Helen Appleton Read was not as favorable as in previous reviews: "Americanism and emotionalism are self consciously and unduly emphasized . . . self-consciousness and lack of humor are what ails these artists . . . the visitor too, who reads the catalogue is affected with self-consciousness . . ."[68] Margaret Breuning, writing in the *New York Evening Post*, was even less favorable, with the exception of praise for Stieglitz's "beautiful" cloud images and the *Leaves* of Paul Strand, "exquisite in texture and color": "After all is said and done, it is hardly worth while to defend or defame an undertaking that cannot be taken very seriously by any but a limited circle of knowing ones; and, not having the password, I must profess to be outside the sacred shrine and quite unmoved by its artistic or literary (see catalogue) propaganda."[69]

THE

INTIMATE

GALLERY

ROOM 303

ANDERSON GALLERIES BUILDING
489 PARK AVENUE AT FIFTY-NINTH STREET, NEW YORK

announces its Nineteenth Exhibition—April 29 to May 18, 1929

FIVE NEW PAINTINGS BY CHARLES DEMUTH

The Intimate Gallery is dedicated primarily to an Idea and is an American Room. It is used more particularly for the intimate study of Seven Americans: John Marin, Georgia O'Keeffe, Arthur G. Dove, Marsden Hartley, Paul Strand, Alfred Stieglitz, and Number Seven (six + X).

It is in the Intimate Gallery only that the complete evolution and the more important examples of these American workers can be seen and studied.

The Intimate Gallery is a Direct Point of Contact between Public and Artist. It is the Artist's Room. It is a Room with but One Standard. Alfred Stieglitz has volunteered his services and is its guardian Spirit.

The Intimate Gallery is not a Business nor is it a "Social" Function. The Intimate Gallery competes with no one nor with anything.

The Gallery will be open daily, Sundays excepted, from 10 A.M. till 6 P.M. Sundays from 3 till 5 P.M.

Exhibition I	—JOHN MARIN, Dec. 7, 1925-Jan. 11, 1926.
Exhibition II	—ARTHUR G. DOVE, January 11-February 7.
Exhibition III	—GEORGIA O'KEEFFE, February 11-April 3.
Exhibition IV	—CHARLES DEMUTH, April 5-May 2.
Exhibition V	—JOHN MARIN, Nov. 9, 1926-Jan. 9, 1927.
Exhibition VI	—GEORGIA O'KEEFFE, January 11-February 27.
Exhibition VII	—GASTON LACHAISE, March 9-April 14.
Exhibition VIII	—JOHN MARIN, November 9-December 11.
Exhibition IX	—ARTHUR G. DOVE, Dec. 12, 1927-Jan. 7, 1928.
Exhibition X	—GEORGIA O'KEEFFE, January 9-February 27.
Exhibition XI	—OSCAR BLUEMNER, February 28-March 27.
Exhibition XII	—PEGGY BACON, March 27-April 17.
Exhibition XIII	—FRANCIS PICABIA, April 19-March 11.
Exhibition XIV	—JOHN MARIN, November 14-December 29.
Exhibition XV	—MARSDEN HARTLEY, Jan. 1-Jan. 31, 1929.
Exhibition XVI	—GEORGIA O'KEEFFE, February 4-March 17.
Exhibition XVII	—PAUL STRAND, March 19-April 7.
Exhibition XVIII	—ARTHUR G. DOVE, April 9-April 28.

The end of 1925 brought the inaugural exhibition, in Stieglitz's Intimate Gallery, a retrospective of John Marin's watercolors from 1912 to 1924. On his exhibition announcement Stieglitz regularly included the following statement:

The Intimate Gallery is an American Room. It is now used more particularly for the intimate study of Seven Americans: John Marin, Georgia O'Keeffe, Arthur G. Dove, Marsden Hartley, Paul Strand, Alfred Stieglitz and Number Seven. It is in the Intimate Gallery only that the complete evolution and the more important examples of these American workers can be seen and studied. The Intimate Gallery is a Direct Point of Contact between Public and Artist. It is the Artist's Room. It is a Room with but one standard. Alfred Stieglitz has volunteered his services and is its directing Spirit. The Intimate Gallery is not a Business nor is it a "Social" Function. The Intimate Gallery competes with no one nor with anything. The Gallery will be open daily, Sundays excepted, from 10 A.M. till 6 P.M. Sundays from 2 till 5 P.M. . . . Hours of Silence – Mondays, Wednesdays, Fridays, 10–12 A.M."[70]

It is perhaps significant that Stieglitz chose to use the words "evolution" and "workers," reflecting in part the country's recent focus on Darwin and the teaching of evolution prompted by the well-publicized Scopes Trial, and the impact of the 1917 Russian Revolution, which inspired writers such as John Reed and publications such as *The Masses* in New York's Greenwich Village. Stieglitz later sympathized with Diego Rivera in the Rockefeller Center mural controversy – Rivera included of a portrait of Lenin in his mural and refused a request to remove Lenin from the piece (the mural was then destroyed). Stieglitz's support for honest work is seen in his further words:

So here is the Room for Americans working. Dove, for example, was disinherited by his father fourteen years ago for doing work which the public now accepts . . . I am ready to fight for this work of the young Americans, not in any sectarian or narrowly national sense, but because it is honest, genuine, and done here, representing today. And men from all over the world come here . . . and say "This is the real America."[71]

Stieglitz's call for hours of silence stood in stark contrast to the many hours of conversation that took place in his galleries with Stieglitz as the center, catalyst, and facilitator of discussion or, in some instances, delivering a monologue. This request for silence emphasized the meditative and contemplative aspects of the works being exhibited, asking the viewer to look beneath the surface into his or her own inner being. The gallery for Stieglitz, in some instances, took on religious qualities. Much of what constituted traditional institutional religion was no longer meaningful and in his eyes, "business had become the new religion" and many of the new works he was exhibiting were evidence of a "new religion." Herbert Seligmann, who assisted Stieglitz

in the gallery, recorded a number of conversations there, later published in *Alfred Stieglitz Talking*. He recalled one of the conversations about religion with a woman who came to look at the Dove exhibit and O'Keeffe paintings in February 1925:

The woman asked . . . why it was civilization had gone wrong, why it was that things among people could not be as they were in Room 303. Stieglitz replied it was religion – that religion had been misunderstood, and now business had become the new religion. As he showed her one of the big, white O'Keeffe paintings, the woman said that it made her think of a head of Christ, she had seen in Florence painted by an early Italian who really believed. Stieglitz recalled that Marsden Hartley had written that the one person who could understand the paintings of the religious painters in Florence was O'Keeffe. Pointing to the O'Keeffe painting, Stieglitz said, "I might say this is the beginning of a new religion."[72]

Stieglitz commented further about religion,

Sometimes I think that if Christ and Buddha and Muhammad were together, and heard the people talking – Christians explaining their creed, and Christ wondering what it had to do with him; Buddhists talking of Buddha in terms of their creed, with Buddha wondering what it had to do with his life, and then Muhammadans talking of Muhammad – then the three, Christ, Buddha, and Muhammad would look at each other and understand each other amid all the noise of others' conversations and instead of their being the last supper, it might be the beginning of the first dinner. That is what the world is looking for: the First Dinner.[73]

For Stieglitz the Anderson Galleries linked religion, art, and science. As 291 had been, the gallery was also considered to be a laboratory: "This room is my laboratory. I have always carried on my research where light could enter . . . with the door open. Anyone is at liberty to come in and share my research. This way I can pursue my research more effectively than if I were reading books in a closed in study. This Room is not a business . . ."[74] Seligmann related other stories about Stieglitz's cynical view of the role of business in America:

During the war many people had come to talk to him about Germany, especially German-Americans. He told the businessmen they should erect a solid gold obelisk outside the White House in Washington. Unless America soon discovered the soul, that is net quantity competition by producing quality, she might eventually find herself without much business. During the war Stieglitz had been willing to enter the United States Service not because he believed in the war, but for the experience. But the head of the photographic division of the Army said: "We can't have Stieglitz here, he's a hell-raiser." If he had been in the Service, the Eastman Company might have made 198 million instead of 200 million dollars and produced material of good quality.[75]

173

Stieglitz's anti-commercial philosophy stood out against America's attempt to recover from a sharp Recession in 1921 that prompted a new era of installment buying and salesmanship skills, also allowing commercial photography to become more prevalent. Thus Steichen turned to advertising and celebrity photography, producing portraits of those such as Charlie Chaplin, Greta Garbo, and Gloria Swanson that brought out the personality of each subject or product through the use of a carefully designed and well-lit set. He became the chief photographer for Condé Nast Publications in 1923, introducing his ideas about modernism to his cosmopolitan audience. For approximately fifteen years Steichen published regularly in Condé Nast publications such as *Vogue* and *Vanity Fair*. He also served in the photographic division of the armed forces during both World Wars.

Photographers such as Charles Sheeler turned to the world of industry and the machine, in projects including his 1927 series of the Ford Motor Company's River Rouge Plant. Emphasis on machine imagery was supported by the 1927 "Machine Age Exposition" organized by Jane Heap, the editor of *The Little Review* from 1924 to 1929 and the director of the Little Review gallery. Held at Steinway hall in a large open loft space on 57th Street, the exposition included actual machinery as well as photographs, drawings, and models inspired by machinery. Sheeler, Duchamp, Man Ray, and Ralph Steiner were advisors. Although Stieglitz did not necessarily agree with the commercial and industrial emphasis of some of this imagery, the exhibition demonstrated the impact of the machine as a major player and symbol of the modern age, and that photography was an exemplary machine age art that needed to be recognized.

Sheeler had broken his close relationship with Stieglitz by 1923, in part due to their diverging philosophies about commercial photography. In 1926, he was invited by Steichen to join the staff at Condé Nast as a photographer. Sheeler's work began to be shown by J. B. Neumann, a Berlin dealer and publisher who had come to New York in 1923 and opened a small 57th Street gallery, the New Art Circle. Neumann met and was initially friendly with Stieglitz, each with a German Jewish background, as well as interest in Kandinsky's theories and the social benefits seen to be inherent in the rise of modern art. Initially, Neumann agreed to represent some works on paper by John Marin, as well as to try to sell unsold issues of *Camera Work*. There were conversations about collaborating with Stieglitz in opening the Intimate Gallery but, in the end, Stieglitz preferred to work alone. Neumann continued on his own path, showing European artists such as Max Beckmann, Chagall, George Grosz, Klee, Kandinsky, and Georges Rouault, who were not otherwise frequently shown in the United States. The New Art Circle provided a significant counterpoint to the growing emphasis on the exhibition of American art in New York.

Stieglitz, too, turned inward, showing primarily American work in the four-year life of his Intimate Gallery from 1925 to 1929. Of the approximately twenty exhibitions mounted in that time, only one was devoted exclusively to photography. In March 1929, "Paul Strand: New

99 Alfred Stieglitz, *Charles Demuth*, 1923.
The Metropolitan Museum of Art.

100 Charles Demuth, *I Saw the Figure 5 in Gold*, 1928,
oil on cardboard. The Metropolitan Museum of Art.

Photographs," was mounted, with thirty-two photographs including primarily prints from
Georgetown and Center Lovell, Maine from 1925 to 1928. The gallery's name was well chosen
as Stieglitz focused on the work of his intimate circle of O'Keeffe, Dove, Marin, Hartley, and
Demuth, and tried to establish an atmosphere within the gallery that was intimate and demon-
strated a depth of spirit. Like several artists and writers during the decade, Stieglitz was con-
cerned with finding an artistic definition of America and felt that support of individual American
artists would result in a more easily understood collective American spirit. He wrote in 1923 to
Paul Rosenfeld:

> That's why I'm fighting for Georgia. She is American. So is Marin. So am I. Of course by
> American I mean something much more comprehensive than is usually understood, if any-
> thing is really understood at all . . . But there is America – Or isn't there an America? Are we
> only a marked down bargain day remnant of Europe? Haven't we any of our own courage in
> matters "aesthetic?" Well, you are on the true track and there is fun ahead.[76]

Other artists whom Stieglitz chose to exhibit included Oscar Bluemner, Gaston Lachaise,
Peggy Bacon, and Picabia. Significant individual works that were introduced to New York
viewers included Dove's paintings *Rhapsody in Blue, Parts I and II* and *Gershwin* of 1927, Charles
Demuth's *I Saw the Figure Five in Gold – William Carlos Williams*, also of 1927, and Lachaise's

portrait bust of O'Keeffe, exhibited in 1927. The linearity of Dove's jazz paintings with their sense of improvisation and directness heightened by the use of metallic paint, conveyed the immediacy of jazz improvisation and the increasing tempo of modern twentieth-century life. That same year, *The Jazz Singer*, starring Al Jolson, premiered in New York. Besides being the first feature-length sound film, it also depicted the power of jazz music and its singers. Demuth's *I Saw the Figure Five in Gold* was one among a number of poster portraits he made beginning in 1924 that were dedicated to artists such as O'Keeffe, Dove, Marin, Eugene O'Neil, Gertrude Stein, and Williams, all of whom he knew well and admired. *I Saw the Figure Five in Gold* was based on Williams's short, succinct poem, "The Great Figure," which records a perceptive moment where flashes of color, sound, and movement are beautifully articulated:

> Among the rain
> and lights
> I saw the figure 5
> in gold
> on a red
> firetruck
> moving
> tense
> unheeded
> to gong clangs
> siren howls
> and wheels rumbling
> through the dark city.[77]

Demuth's portrait is precisionist, cubist, and cinematic as he "zooms" in on the axel of the fire truck. That Stieglitz chose to exhibit pieces such as these by Dove and Demuth, which alluded to other art forms, illustrates his ongoing interest in the concept of the *Gesamtkunstwerk* and the alliance of multiple art forms.

From his gallery and apartment at the Shelton, Stieglitz also frequently went to Erhard Weyhe's bookshop on Lexington Avenue and the gallery above it, run by Carl Zigrosser. Weyhe, a German emigré, and Zigrosser, a writer, critic, and print specialist, were both friends and admirers of Stieglitz. Zigrosser was also friends with Williams, Crane, Coomarasamy, and William Ivins, Jr., the curator of prints who was responsible for the acquisition of the Stieglitz photographic archive by the Metropolitan Museum. In New York, Zigrosser was the first to represent the new work of Weston in 1928, as well as the first American to show Eugene Atget's photographs in 1930, and Karl Blossfeldt in 1932. Both Weyhe and Zigrosser were strong supporters of Bauhaus artists. Zigrosser sold back issues of *Camera Work* for Stieglitz and the large

101 Alfred Stieglitz, *John Marin*, 1922.
The Art Institute of Chicago.

102 Alfred Stieglitz, *John Marin*, 1922.
The Metropolitan Museum of Art.

gravure of *The Steerage* that had been published in *291*. Stieglitz and Zigrosser were particularly close in the early 1920s and corresponded with each other throughout Stieglitz's life.

Of the many visitors who came to the Intimate Gallery, one was a young woman who wandered into the Park Avenue space on a fateful day in late 1927: she had a strong impact on the life and work of Stieglitz, O'Keeffe, and their surrounding circle. That woman was Dorothy Norman, who was interested in art and social action. She was just twenty-two when she first entered the gallery; Stieglitz was sixty-three. From a wealthy family, she had attended Smith College and the University of Pennsylvania from 1922 to 1925, the year she married Edward A. Norman, the son of a founder of Sears Roebuck. The Normans settled in New York City where Dorothy worked as a researcher at the American Civil Liberties Union (A.C.L.U.). On becoming pregnant, her doctor suggested she cut back on her activities and give up her job at the A.C.L.U. Having been introduced to the world of art as a young girl at the Barnes Collection outside of Philadelphia, Dorothy Norman welcomed the time she had to visit some New York galleries, such as Stieglitz's. Once in the small, intimate space, she was captivated by the John Marin paintings she saw before her. Not knowing about Marin, or Stieglitz, and too shy initially to interrupt Stieglitz as he spoke with other visitors, Norman returned to the gallery several times. After these visits, she still had not spoken to Stieglitz but chose to record what she had heard Stieglitz say to others in his unique, often idiosyncratic manner, such as:

177

103 John Marin, *The Red Sun – Brooklyn Bridge*, 1922. The Art Institute of Chicago.

we protect one another only by telling each other the truth . . . If an artist has a sufficiently deep feeling, the seemingly impossible will happen. He will find a form through which to create what he must, even if it means death . . . The world of our dreams is more real than the world that exists. All art, like all love, is rooted in headache . . . To do the best job of which you are capable, then to reach for a point even beyond that. To be in love is to wish to possess. To love is to seek release for the other.[78]

Finally, on a day when she was alone in the gallery with Stieglitz, and having recently met Strand and his wife Rebecca at a social gathering, she plucked up the courage to speak to the man whom she had come to admire. He graciously showed her copies of *Camera Work* and some of his cloud images which deeply impressed her. Her daughter Nancy was born soon after and Norman did not return to the gallery for several months. Once again, Stieglitz was alone and this time asked her if she was married, if the marriage was emotionally satisfying, and if her sexual relationship was good. He then inquired:

104 John Marin, *Blue Sea*, 1923. The Art Institute of Chicago.

"Do you have enough milk to nurse your child?" Gently, impersonally, he barely brushes my coat with the tip of a finger, one of my breasts, and as swiftly removes it. "No!" our eyes do not meet. Again, I am not affronted, nor self-conscious. Why has no one ever asked the questions Stieglitz does? I know I can speak freely, openly to this man about anything, everything. I soon discover that for years he has had the same effect on others. Try as I will, not to go to the Room. I go . . . His words pour forth like a torrent. No rhetorical flourishes heighten his simply spoken sentences. He does not lecture or theorize. I can't say after I leave that he has explained anything. But, without doubt his vision is changing something in me I cannot yet define. Why in the Room do I feel such a great stillness? A sweet quiet envelops me. Yet I am so excited and filled with such curiosity that I can barely move, barely speak.[79]

On 17 April 1928, Norman wrote Stieglitz a lengthy, laudatory letter, asking him if she might be able to help him in the gallery. Soon after, Stieglitz gave her one of his *Equivalents* and wrote to her, "My photographs and I are one. Each relationship has an undefinable difference. No two

179

105 Arthur Dove, *Chinese Music*, 1923. The Philadelphia Museum of Art.

moments are alike."[80] Norman bought some issues of *Camera Work* and a small Lachaise sculpture and sent one hundred dollars, left over from her birthday money. Soon Stieglitz and Norman began to correspond with each other frequently and Dorothy's need to go to the gallery became almost obsessive. In truth, her marriage was not entirely successful. As the years went by, Edward suffered increasingly from psychological problems, although they were not divorced until 1951. Stieglitz became Norman's lover and mentor and carefully encouraged her writing and her own work in photography. She is turn became the subject of many of Stieglitz's photographs and a crucial figure in his third and final gallery, An American Place, in 1929 (on which see my discussion in the Photographs section).

Norman described their growing intimacy in the last year the Intimate Gallery was open: "One day I enter the Room and find only Stieglitz, who motions me to sit far away from him. He smiles,

"bit of danger," . . . We look at each other intently, deeply. I hesitate to speak, "Say it," he repeats. "I can't say it." A huge effort. I feel almost strangled. "I love you." His face softens, his eyes glisten. His voice grown even more tender, his expression more intimate. "I

106 Arthur Dove, *Silver Sun*, 1929. The Art Institute of Chicago.

know – come here"... "We do," he says and brings a new world into existence. He adds, "I've wanted to do this for a long time." He kisses me as I have never dreamed a kiss could be . . . I am bewildered, exalted, tormented. Our mutual understanding is so surprising, Stieglitz is married, and so am I – for good. I love Edward as Stieglitz does O'Keeffe. But our relationship is different. We must be in touch with each other by letter, by phone, at every possible moment . . ."[81]

Following these moments, Stieglitz began to write more intimate letters to the young Dorothy, such as

We are of one spirit, of one everything – oneness – onlyness – sacredness rules us both – fills us, every fibre of us . . . your love for me is not merely a woman's love for a man – It is our spirits that merge – our very souls merge into an eternal Oneness of Being – I know that's True, and you know that's True. Dorothy – Before God. [or] I L Y – You know it – And it strengthens you – the knowing absolutely. And it will strengthen you more and more as years roll by.[82]

Norman also came to know Stieglitz through Coomaraswamy, whom she met in 1928 shortly after reading his book, *The Dance of Shiva*. They quickly expressed a common admiration for Stieglitz. As Norman recalled,

> Coomaraswamy awakened me to the most profound meanings of ancient ritual, symbolic imagery, myth . . . he made me conscious, too, of how the so-called opposing forces – tradition and experiment, the old and the new, the East and the West – also complement one another . . . I found it somehow incredible that a world famous traditionalist and a young American attracted to the modern spirit should agree about the grandeur of a contemporary photographer, working in one of the era's newest medium [sic] of expression, and fighting for avant-garde art.[83]

Stieglitz's gallery was also visited by the three Stettheimer sisters, Ettie, Florine, and Carrie, whose wealth allowed them to preside over lively salon sessions at their elaborate home on West 76th Street. O'Keeffe and Stieglitz were regular participants, along with McBride, Lachaise, Hartley, Demuth, Duchamp, Steichen, and Baron de Meyer. Ettie, the more intellectual of the sisters, with a doctorate from the University of Freiburg, had written a novel in 1923, *Love Days*, inscribed to O'Keeffe and Stieglitz. The book was loosely based on Ettie's flirtations with Duchamp and Elie Nadelman. Florine often presided over the evening salons in black velvet harem pants and turned some of what she saw and heard into her whimsical and fantastical paintings. In 1928, she painted *Portrait of Alfred Stieglitz* (Fisk University, Alfred Stieglitz Collection), in which one sees him, center stage, dramatically presented in his long black cape, in his gallery. His hand is outstretched, presumably to the cropped figure with the cane who walks toward him from the left. Another figure enters from the right. One sees a photographic mounting press; an etched profile of O'Keeffe, along with her name in reversed vertical lettering; a painting that appears to be by Dove; a standing figure next to a window overlooking New York City, most likely McBride; and a seated figure, probably Rosenfeld, reading. Next to Rosenfeld are various playing cards with names such as Marsden Hartley and Paul Strand inscribed on them. Stieglitz is a large floating figure dominating the scene, as he did his galleries. Stettheimer captures details of the complex web of personalities that comprised his gallery world – artists, critics, visitors, art works. Florine greatly admired O'Keeffe's work and sense of independence and placed her profile above Stieglitz's head on a bright white ground. Stettheimer admired Stieglitz as well and later wrote a poem about their relationship that appeared in *Crystal Flowers*, a volume of her poetry published posthumously by Ettie as a memorial to her sister in 1949:

HE PHOTOGRAPHS
She is naked
he proclaims
she has no clothes

182

other than his words.

Golden-brown and autumned

they drop fast

and cyclone about her

She turns them

into painted air

rainbow hued

that whirls and swirls

and sucks him in.[84]

From Stettheimer's perspective, O'Keeffe's paintings were powerful and capable of defusing the total domination by Stieglitz that might have resulted from being his model and his wife. Florine herself feared marriage, worried that a husband might curtail her creative interests.

Stieglitz also appeared in a later painting by Stettheimer, *Cathedrals of Art* of 1942–4, that depicts New York's major museums of the time, the Metropolitan, the Museum of Modern Art, and the Whitney Museum of Art, as being quite conservative. Outside of these well-fortified institutions, Stettheimer placed figures such as Stieglitz, Demuth, McBride, the young artists Pavel Tchelitchew and herself. The painting was part of a series painted over several years, depicting various "cathedrals" of New York life: *Cathedrals of Broadway* of 1929, *Cathedrals of Fifth Avenue* of 1931, and *Cathedrals of Wall Street* of 1939 (Metropolitan Museum of Art). Florine Stettheimer was probably best known for the design of the sets and costumes involving the creative use of cellophane in the 1934 production of *Four Saints in Three Acts*, an opera by Virgil Thompson with a libretto by Gertrude Stein, which Stieglitz probably saw. Florine also worked with her sister Carrie in constructing a large Stettheimer dollhouse that contained art works by friends such as Zorach and Lachaise.

While the Stettheimers were holding their salons, a far less affluent young woman, Edith Gregor Halpert, was making a mark in the Lower Manhattan art scene in the mid-1920s. Born Ginda Fivoosiovitch in Odessa, Russia in 1900, she had come to the United States in 1906, part of a mass-exodus of Russian Jews who were beginning to find it difficult to live amid waves of antisemitism in Odessa. In 1904, her father, Gregor, had died and her mother, Frances, sought refuge for herself and her two daughters with a half-brother in New York City. Once in New York the three quickly attempted to assimilate themselves into American life, learning English, no longer speaking Russian or Yiddish, and giving up almost everything associated with their past life except an old samovar used for making coffee, a symbol of Odessa. Edith and her sister Sonia entered the public schools and Edith ultimately found a world where she felt more comfortable, at the National Academy of Design. She worked also in the art departments of Bloomingdales and Macy's and at Sterns Brothers, which sold fur coats and Persian rugs to the New York wealthy. Edith continually tried to "sell herself," pushing forward with her interest in

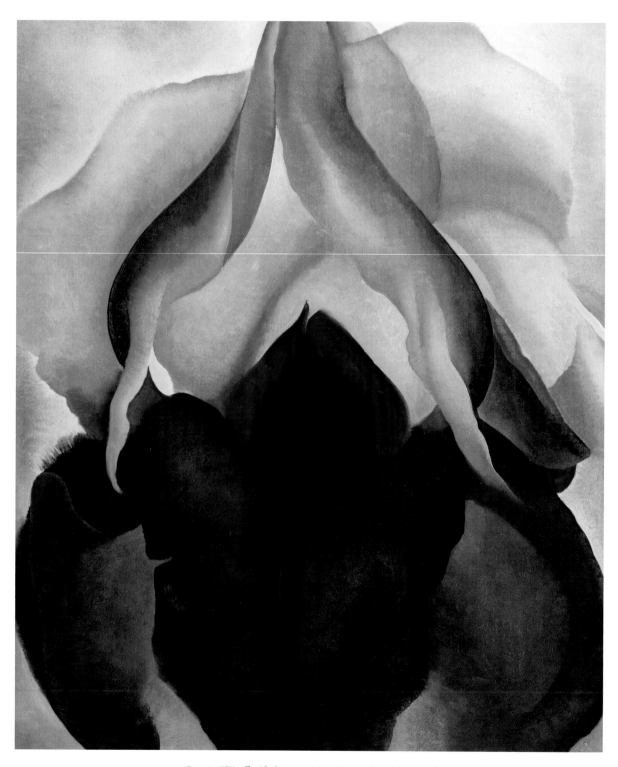

107 Georgia O'Keeffe, *Black Iris*, 1926. The Metropolitan Museum of Art.

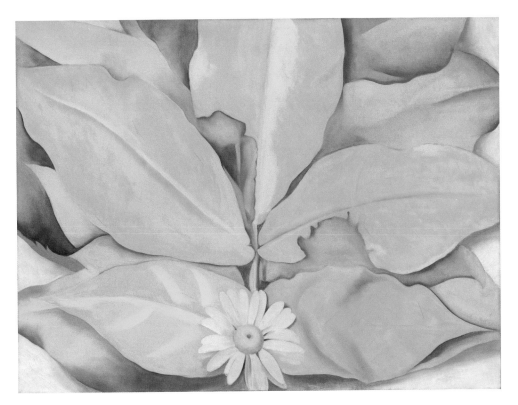

108 Georgia O'Keeffe, *Yellow Hickory Leaves with Daisy,* 1928. The Art Institute of Chicago.

the arts. One of her preferred places to visit was Stieglitz's 291 gallery. Although she was only a teenager when she first started visiting his galleries, she was captivated by what he showed and what he was doing and came to realize that there were few places in New York interested in exhibiting or collecting contemporary American art. Edith visited Stieglitz's galleries regularly, although it appears that initially he did not pay much attention to her. She also visited the Montross Gallery, the Whitney Studio Club, and joined the People's Art Guild where she became treasurer and quickly made friends with artists such as Nadelman and Max Weber, whom she later represented. There she also met her future husband, the painter Samuel Halpert, Russian Jewish-born and sixteen years older than she. They were married in 1918. In the summer of 1926, the couple spent time in Ogunquit, Maine, then a popular artists' colony begun in 1906 by the wealthy art patron Hamilton Easter Field, also a friend of Stieglitz. Although Field had died in 1922, his adopted son Robert Laurent continued to run the colony, where artists such as Zorach, Nadelman, Yasuo Kuniyoshi, Hartley, and the future director of the Whitney Museum, Lloyd Goodrich, found inspiration and a sense of community supportive of their work. O'Keeffe, too, traveled to the York Beach in the Ogunquit area, to stay at the inn owned

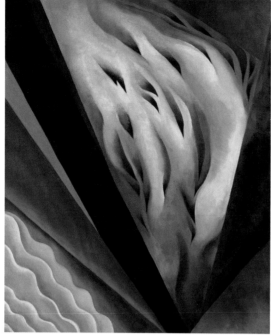

109 Georgia O'Keeffe, *Blue and Green Music*, 1921.
The Art Institute of Chicago.

110 Georgia O'Keeffe, *Birch and Pine Tree, No. 1*,
1925. Philadelphia Museum of Art.

by Bennet and Marnie Schauffler on several occasions, seeking solace and resources in the vast
stretches of water, sand, and sky along the Maine coast. Edith's visit to the art colony served as
the catalyst for the opening of her own gallery that fall in Greenwich Village, for she realized
she could not simply be Halpert's wife, that her own career as an artist was over, that she needed
something to involve her creative spirit and energies. Thus "Our Gallery," the collaboration of
Edith and Bee Goldsmith, the sister of a friend of Sam's, was born on 6 November 1926, in a
brownstone at 113 West 13th Street, just down the street from the offices of the *Dial* magazine.
The design of the gallery was influenced by Edith's visit to the Paris Art Deco Exposition, with
clean-cut lines of modernity. Decorative arts and furniture were displayed as Halpert attempted
to show visitors how art might be viewed in a home-like setting. The mission of the gallery
included sales of contemporary art works, as well as antiques and books, with extended purchase
plans if needed; rentals of art works; and the creation of an artists' meeting place in the evenings.
Halpert was determined to be democratic and eclectic in her selection of artists, as long as the
work showed promise of being enduring. She focused on promotion and soon garnered the
support of patrons such as William Preston Harrison, a well-respected Los Angeles collector,
who ultimately donated his collection to the Los Angeles Museum of History, Science and Art

(in 1961, the Los Angeles County Museum became a separate art museum). The gallery was renamed the Downtown Gallery in 1927. Halpert showed work by artists such as Weber, Zorach, Sheeler, and Stuart Davis. In the spring of 1931, O'Keeffe and Stieglitz sorted through numerous paintings they had stored at the Lincoln Warehouse and consigned some to Halpert. She also inherited a number of the artists Charles Daniel had represented following the closing of his gallery in 1932. Hartley, feeling he was only secondary to Stieglitz, after O'Keeffe, and Marin, chose Halpert as his primary dealer. Abby Aldrich Rockefeller also bought numerous works from Halpert for the Museum of Modern Art.

Shortly after the opening of Halpert's gallery in November 1926, Duncan Phillips, a significant collector and founder of the Phillips Memorial Gallery in his Washington, D.C., home in 1921, apparently bought from Stieglitz a 1925 John Marin painting, *Back of Bear Mountain*, for a record $6,000 for an American watercolor. (Earlier that year he had seen the Dove exhibition at the Intimate Gallery and several months later he became a patron for Dove, purchasing the first two of sixty-nine paintings.) Phillips requested the price be kept secret but Stieglitz and his circle could not keep such a price secret, alienating Phillips who had already bought two earlier Marin watercolors, *Maine Island* of 1922, and *Gray Sea* of 1924, from Stieglitz that spring. As part of the $6,000 deal, Stieglitz, to "celebrate" what he considered a miracle in pricing, also gave Mrs. Phillips the painting *Sunset Rockland County* as a gift and allowed a $1,000 discount on *Hudson River Near Blue Mountain* of 1925, as well as several days later, a $1,510 discount on *Near Great Barrington* of 1925. Phillips countered the $6,000 Marin stories in the press by his own published account:

> Field Marshal Stieglitz maneuvered negotiations so that I paid his record price for the Marin I liked best . . . Thus I secured for $6000 three of the best Marins in existence at an average of $2000 each. No doubt the misleading statement that I bought a single Marin for $6000 helped the cause of modern art in general, and Marin in particular . . . I realized well enough the news value of my bargain for propaganda, but as it was in a worthy cause and on behalf of America's finest painter, I not only understand but cooperated.[85]

Stieglitz strongly objected to Phillips's story involving averaging of the prices and was further angered when the April 1927 issue of *Artnews* published portions of Phillips's letter and an editorial entitled "Field Marshal Stieglitz," which went beyond Phillips letter by accusing Stieglitz of trying to manipulate the market. Although Phillips's subsequently sent a letter refuting any suggestion of market manipulation, Stieglitz felt compelled to issue a pamphlet with his own version of the story on 17 April 1927. After the publication of the dispute, correspondence between Phillips and Stieglitz stopped and Phillips boycotted the Intimate Gallery for at least a year.

The last exhibit at the Intimate Gallery was the work of Demuth in late April and May 1929, which included his well-known *I Saw the Figure Five in Gold*. That May, the Anderson Galleries

vacated the 489 Park Avenue space, forcing Stieglitz to close his gallery. Later that summer, O'Keeffe, already suffering strained relations with Stieglitz, in part due to the increasing presence of Dorothy Norman, travelled to Taos, New Mexico, with Rebecca Strand. Instead of returning to meet Stieglitz at Lake George as planned, O'Keeffe stayed in the southwest, visiting Dodge Luhan.

On 29 October 1929 the stock market crashed but less than two weeks later a new Museum of Modern Art opened, founded by Lillie Bliss, Mary Sullivan, and Abby Aldrich Rockefeller. The museum founders used as models for their fledgling institution the Armory Show, Stieglitz's gallery 291, and the Montross Gallery. Anson Conger Goodyear, the first president of the Modern, wrote:

> [At the Armory Show] for the first time the general public was excited, shocked, delighted, amused, disgusted by the paintings and sculpture of Picasso, Matisse, Brancusi, and their fellows of the school of Paris. The work of most of these men had been seen some years before in Alfred Stieglitz's 291 and the Montross Gallery, the pioneers in display of the modern school.[86]

The new institution was to educate the American public about modern art through exhibiting and establishing a permanent collection. Alfred Hamilton Barr, Jr., who had been teaching at Wellesley College, became the first director. He envisioned diverse curatorial departments that would include Painting and Sculpture, Architecture, Film, Photography, Industrial Design, and Theater Arts. Stieglitz did not like the idea of a large institution, run by committees in departments, seeing them as quickly going contrary to the "spirit" of art. That Duncan Phillips had been appointed to the new museum's board of trustees did not please him either. On hearing that the inaugural exhibition consisted of post-impressionist works by Cézanne, Van Gogh, Gauguin, Seurat, and others, Stieglitz further feared that the museum would not emphasize American works enough. Nevertheless, the museum opened with much fanfare on 8 November 1929 in its new home on the twelfth floor of the Heckscher Building at Fifth Avenue and 57th Street. The second exhibition, "Paintings by Nineteen Living Americans," included Demuth, Marin, and O'Keeffe, the only woman invited to exhibit. Other artists selected outside the Stieglitz circle ranged from John Sloan to Edward Hopper to Max Weber. Stieglitz would have liked his artists to boycott the exhibit but economic times were difficult and he knew that he could not afford to alienate possible patrons, even Duncan Phillips. He asked O'Keeffe not to exhibit her new works such as her first canvas of the Ranchos Church in Taos, or *Black Cross, New Mexico*, which he wished to show in the new gallery he was planning to open. O'Keeffe thus lent older works, among which was her 1927 *Radiator Building*, where she painted "Alfred Stieglitz" onto a red light sign that had actually read "Scientific American." Thus, despite his initial mistrust of the institution, Stieglitz, ironically, had a presence in the new museum.

Stieglitz was also acknowledged in another inaugural 1929 exhibition dedicated to American art at the newly formed Harvard Society for Contemporary Art, founded by the young writer, Lincoln Kirstein, along with Edward Warburg and John Walker. Kirstein was the director and in the catalogue to the first exhibition singled out Marin and O'Keeffe as being two of the highly original artists of the time. Kirstein acknowledged his debt to Stieglitz and his "spirit": "As an adventurer on a small scale, I embraced the avant-garde taste of Alfred Stieglitz and progressive Manhattan galleries . . . The fun was in the energy expended in a crusade and the opportunities this afforded to have contacts with movers and shakers."[87] In 1930, Kirstein mounted a significant photography show that included work by Stieglitz, Strand, Steiner, Sheeler, Abbott, Evans, Atget, Weston, Tina Modotti, and Doris Ulmann, Moholy-Nagy, Man Ray, and Cecil Beaton. Kirstein had also been influenced by books he read that were based on the important "Film and Photo" exhibition held in Stuttgart, Germany in 1929. This exhibition and books such as Werner Graeff's *Here Comes the New Photographer* and Franz Roh's trilingual *Foto-Eye* emphasized the revolutionary nature of both film and photography for twentieth-century creative expression. The international scope of the show marked the emergence of American photography from a period of more individualistic, local expression and reiterated photography's role as a fine art equal to the other arts with multiple capacities.

To return to the last days of 1929 and the significant date of 15 December. On that day, Stieglitz opened his third and last gallery at 509 Madison Avenue, Room 1710, a corner suite that he named An American Place. The gallery opened with fifty new watercolors by John Marin. In general, the Place was dedicated to exhibitions of Stieglitz's Seven Americans – Demuth, Dove, Hartley, Marin, O'Keeffe, himself, and Strand, with priority perhaps given to Dove, Marin, and O'Keeffe. Occasionally, there were exhibitions by others, primarily friends and associates such as Rebecca Strand, MacDonald Wright, Helen Torr, and William Einstein. Unusual was the 1935 exhibition of watercolors by George Grosz, for whom Hartley wrote the catalogue introduction. The photography exhibitions were infrequent and included two by Stieglitz in 1932 and 1934, Strand in 1932, Ansel Adams in 1936, and Eliot Porter in 1938. In 1937, a "Beginnings and Landmarks, '291' (1905–1917)" exhibition surveyed Stieglitz's career. Approximately seventy-five exhibitions were mounted in all between 1929 and 1946, the year Stieglitz died. In these American Place shows, he continued his "cause," to establish photography as a fine art and contemporary American art as equivalent in status to modern European art. The gallery stayed open until December of 1950. Dorothy Norman and Strand were the primary fundraisers for the enterprise, with the understanding that contributors would not necessarily have a say in running the gallery. The space included five rooms with a main gallery approximately thirty by eighteen feet. Two smaller rooms were also exhibition spaces; one became Stieglitz's office; the fifth space became a storage area where he also set up his first proper darkroom. At O'Keeffe's request, the cement floors were painted gray and left uncarpeted. The walls and ten-foot-high ceilings were white,

with the exception of the main gallery, painted a rich gray, on O'Keeffe's order during the second season, and subsequently repainted depending on the nature of the exhibition there. Long roll-up shades were placed in the large windows, to provide appropriate light with minimum glare. The austere space was beautifully serene, whether the walls were bare or hung with works of art.

Thus 1929, despite difficult days in his relationship with O'Keeffe, and the impact of the stock market crash, ended on a positive note for Stieglitz's continued celebration of American art.

tHE pHOTOGRApHs

Stieglitz's continuing composite portrait of O'Keeffe into the 1920s took on other dimensions besides the passion and sensuality that had been emphasized in the early pieces. One sees, for example, O'Keeffe eating corn, even laughing on rare occasions, or her hands peeling apples. In many, her hair is pulled back and she is shrouded or dressed in black, severe, austere. In some, she appears to be a female Balzac sculpted by Rodin, in a long black cape, probably Stieglitz's, standing in the wind. The close-ups of her body such as her neck muscles and veins are more studies in form, light, and shadow than they are female. Even the frontal and rear nude images have become "colder," more reminiscent of nineteenth-century academic nude studies. In several, O'Keeffe appears almost nun-like, hooded in black, with only a crisp white collar to complement her face, as if she were a young novice, escaping from a larger world into a world of contemplation. Several depict her with her own paintings such as a 1922 photograph where she stands outside, with *My Shanty* of 1922 gently resting on the ground at her side, or a 1925 image of her standing with *White Birch*, where the folds of her dress mirror some of the rhythmic lines of the painting. However, unlike some of the photographs of the 1910s where O'Keeffe and her art work are closely allied and integrated, the paintings are props, or a more traditional "stage set." In 1921, Stieglitz photographed O'Keeffe with a small bronze Matisse sculpture, *La Vie*, that was part of his collection. Here O'Keeffe is dressed in a light-weight white dress, in contrast to the dark nude that she holds in her left hand. The small nude, with its evocation of both modern and primitive elements, links O'Keeffe and her work to a larger world: primitive and modern, European and American, where the mysteries of Bergson's *élan vital* might be discovered and expressed.

A number of photographs show O'Keeffe with apples. In 1921, her hands peel apples or her face and shoulders appear in close-up, her hair tightly pulled back. One shows two small apples at the end of a branch, adjacent to her right ear. Although small, the apples connect her to the world of nature. Several photographs of the same year depict her hands, with dramatic stylized gestures, holding a large bunch of grapes. Several 1924 images show O'Keeffe holding full

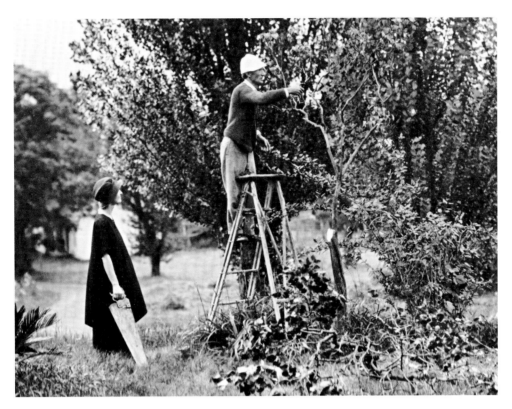

111 Alfred Stieglitz, *Georgia O'Keeffe and Donald Davidson Pruning Trees*, c.1920,
Beinecke Rare Book and Manuscript Library.

branches of apples, covered with a cloak, her hair covered by a brimmed, soft farm hat, which casts a shadow on her forehead. In one 1924 image, one sees her face and upper body lying on the ground, her eyes closed, with a basket of apples serving as her pillow. That piece recalls an early 1890 photograph, *Weary*, that Stieglitz probably took in Europe shortly after learning that his sister Flora had died in February 1890. In the earlier work, a young girl lies weary, on a pillow of sticks in an open field, reminding one of the Karlsruhe School and a somewhat "mechanical" impressionist style. Stieglitz reprinted this image again in the 1930s. In the 1924 O'Keeffe image, although resting, O'Keeffe appears buoyed up and well supported by the apples. Stieglitz's depiction of her with the apples and the grapes recalls imagery related to bacchanalia, celebration, the garden of Eden, harvest, the soil, or the earth, evoking the works of writers such as Lawrence or Anderson. Stieglitz's linkage of O'Keeffe with the soil was further seen in his photographs of her and Donald Davidson at Lake George, both depicted with shovels. In one, O'Keeffe holds the shovel closer to her body, as the shovel becomes a kind of breastplate and protective armor, as well as a tool to dig the earth and plant new life. All these photographs are carefully composed studies, more Apollonian than Dionysian, where O'Keeffe might be viewed as both earth mother

191

112 Alfred Stieglitz, *Georgia O'Keeffe – Hands*, 1920. Beinecke Rare Book and Manuscript Library.

113 Alfred Stieglitz, *Georgia O'Keeffe*, 1921. The Art Institute of Chicago.

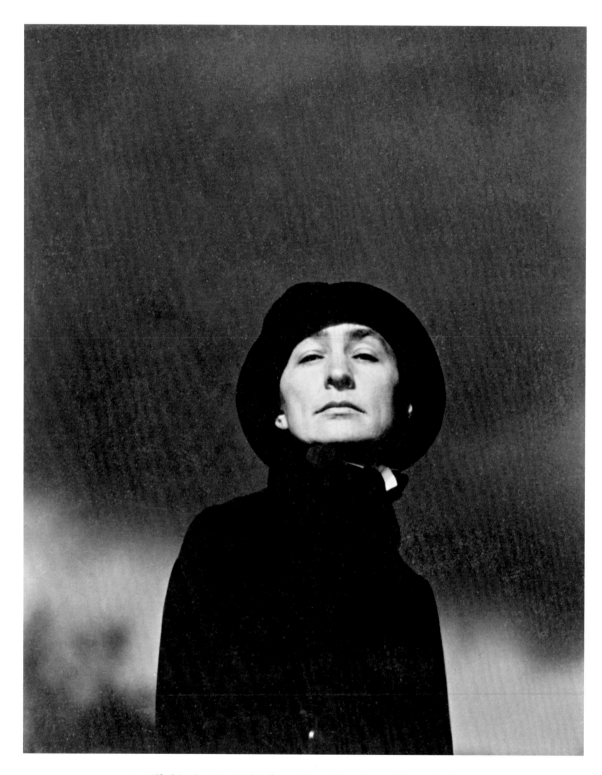

114 Alfred Stieglitz, *Georgia O'Keeffe*, 1923. Beinecke Rare Book and Manuscript Library.

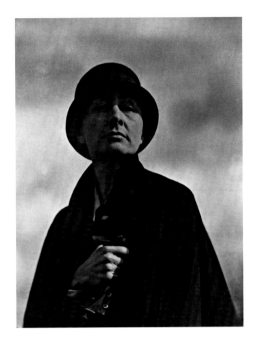

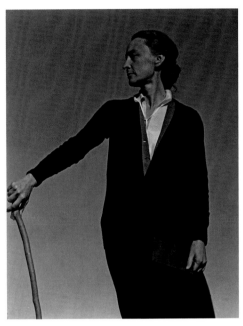

and as a creative, sensual being. Yet, although she may have picked the apples, she is more than an Eve temptress figure. In many of his photographs of her, particularly those with the apples and grapes, Stieglitz appears to be marrying intuition and intellect. As Bram Dijkstra has noted:

> Stieglitz's inspiration as an artist unquestionably came from his desire to bridge intuition and intellect. American transcendental materialism was in his bones . . . he was very much a *man* of his own time, influenced dramatically by his near decade of life and study in Germany as a teenager and young adult. The double image of woman, both saintly mother and vampire of man's intellectual and creative essence, as revealed by evolutionary science, had taken hold there . . . Stieglitz's teachers at the Berlin Polytechnic Institute had advised him to read Darwin, T. H. Huxley, Oskar Peschel, and Karl Vogt. The latter's *Lectures on Man* (1864) had been enormously influential in establishing the physiological bases for the intellectual inferiority of women.[88]

Through much of the 1920s, the images of O'Keeffe in general, however, depict her as independent, in control, in charge. A number are three-quarter views of her standing, strong, alone in the larger outdoor world. In most she is in sharp focus; the background landscape is in muted or soft tonalities. One sees her deftly wielding a staff, wearing the bold stripes of the American

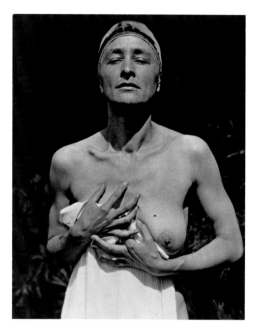

117 Alfred Stieglitz, *Georgia O'Keeffe: A Portrait*, 1921.
The J. Paul Getty Museum.

118 Alfred Stieglitz, *Georgia O'Keeffe*, 1923.
Musée D'Orsay, Paris.

Indian blanket, or dressed in a vibrantly printed dress whose linear abstract design appears to hold birds in flight, which reach for the box of berries that O'Keeffe is holding. The dress pattern, along with her placement outdoors with a vast sky behind her, recalls a 1925 letter Stieglitz wrote to Anderson, talking about the role of the Intimate Gallery: "I had decided to give birds a chance – will create an atmosphere for birds that fly lighter than sparrows . . . [for artists who are] free souls."[89]

A number of the late photographs of the decade depict O'Keeffe standing in front of a car after her return from New Mexico. One such image, closely cropped, depicting her head in front of the back window of the car, was also the first in a series of *Equivalents* that Stieglitz began in 1929. Its full title ran *Georgia O'Keeffe – After Return from New Mexico, Equivalent O*. The rest of the series was of clouds that are dark, dramatic, and somewhat ominous. Stieglitz had taken his first airplane ride that summer. This dark, somber *Equivalent* series with O'Keeffe as the introductory title image seemed to state his volatile emotional condition and serve as a statement of distance and mystery.

It had been a difficult summer for Stieglitz with O'Keeffe away for four months in New Mexico, with concerns about their relationship, and his actually burning some of his own photographs in a holocaust (as may be read in his letters at the end of this chapter). O'Keeffe learned to drive in about 1929, while Stieglitz did not. Her proud stance in various images with the car

119 Alfred Stieglitz, *Georgia O'Keeffe*, 1921. The Metropolitan Museum of Art.

120 Alfred Stieglitz, *Georgia O'Keeffe: A Portrait*, 1924.
Philadelphia Museum of Art.

121 Alfred Stieglitz, *Hedwig Stieglitz*, 1921.
The Art Institute of Chicago.

122 Alfred Stieglitz, *Katherine Dudley*, 1922. The Art Institute of Chicago.

that represented increased mobility and potential for travel suggests a further distancing between O'Keeffe and Stieglitz, as she came to spend more and more time away from Lake George and New York City. For Stieglitz, cars also represented an aspect of American commercialism against which he was continually fighting. As he had written to Anderson a few years earlier, "Every time I see a Ford car something in me revolts. I hate the sight of one because of its absolute lack of quality feeling."[90] By the time Stieglitz came to photograph O'Keeffe a few years later, his position must have mellowed to some extent. The car, with its shiny, reflective, metallic surfaces also provided him with new material with which to experiment with the play of light and shadow.

One cannot help but speculate about the extent of collaboration that existed in these late 1920s images of O'Keeffe, as she appeared increasingly independent and sure of herself. She, by then, was recognized professionally as an artist and was not simply the sensual temptress whom one could find in the early photographs. It seems that O'Keeffe and Stieglitz were on a more equal footing as artist and model in these later images, now depicting a strong woman who

123 Alfred Stieglitz, *Eva Hermann*, 1920. The J. Paul Getty Museum.

drives, who works as an artist, who is connected to the earth, who presents another facet of the New American woman beyond the sexual sexually liberated woman of the earlier images. If one wishes to argue that Stieglitz as the photographer still frequently had the "upper hand" with his model, then it is perhaps useful to link Stieglitz's possessive desire to control O'Keeffe with his activities as a gallery dealer, in directly controlling his artists, exhibitions, publicity, and sales transactions.[91]

O'Keeffe was not the only woman whom Stieglitz depicted in series of images during the decade. Other significant images of women in series, and taken individually, include those of Eva Hermann, Frances O'Brien, Rebecca Strand, Georgia Engelhard, as well as Claudia and Ida O'Keeffe, Georgia's sisters. In 1920, Stieglitz began to photograph Hedwig Stieglitz, Katherine Dudley, and Eva Hermann, the young daughter of Anna and Frank Hermann, an amateur photographer and painter who was a childhood friend of Stieglitz's, traveling with him in Europe and accompanying Stieglitz and Emmy to Katwijk in 1894. Stieglitz photographed his close friend that year and again as an older man in 1922. Hermann returned to the United States permanently in 1919 and their friendship continued throughout their lives. The early images of Eva might well be classical Renaissance portraits. In close-up images of her head and shoulders one sees her large, dark eyes, her oval symmetrical face and unblemished skin, her slight smile, in both profile and direct frontal images. Eva and her friend Frances O'Brien, a young painter who had studied with George Luks, as well as being a teacher and critic who wrote for *The Nation*, visited Lake George in August 1926. Stieglitz photographed the lovely Eva's upper body in bathing attire. One image shows Eva with her straps down, as the light fell on her bare chest and face, looking into the distance, with a towel flung over her shoulders, a frayed straw hat blowing in the wind. She is seen standing and reclining, nude, her young body becoming an integral part of the grassy surrounding. In the reclining image, delicate wisps of grass envelope Eva's smooth white skin, pushing toward a valley of pubic hairs, as Eva's body becomes a kind of landscape for itself. While the photographs of Eva are quietly alluring, images of Frances taken during the same visit are more coquettish and provocative. In one, Frances stands with her long hair flowing in the wind, draped in towels, her breasts exposed, a tea kettle in one hand, eating a piece of fruit with her other, raised to her mouth. Frances becomes simultaneously a woman who is the keeper of the hearth, the bearer of fruits, and sexual temptress. In a second image, she stands frontally nude, her arms raised, her hands clasped behind her head, her long hair flowing behind her. Her eyes are closed, as she appears to be in a state of contemplation. In this image she seems to be more closely allied to nineteenth-century nudes such as Ingres's *La Source* of 1856, in which the French Romantic and Neoclassical painter depicted an idealized female nude, with one arm raised, like Frances O'Brien, the other arm holding a jug of water. In both works, "woman," creation, and the world of nature become closely connected. Approximately a year later, O'Brien wrote a favorable review about O'Keeffe, emphasizing her individuality and independence:

124 Alfred Stieglitz, *Eva Hermann*, 1926.
National Gallery of Art, Washington D.C.

125　Alfred Stieglitz, *Frances O'Brien*, 1926.
National Gallery of Art, Washington, D.C.

126 Alfred Stieglitz, *Frances O'Brien*, 1926.
National Gallery of Art, Washington, D.C.

127 Alfred Stieglitz, *Rebecca Strand*, 1922. Lee Gallery, Winchester, Massachusetts.

[Y]ou must not, if you value being in her good graces, call her "Mrs. Stieglitz." She believes ardently in woman as an individual – an individual not merely with the rights and privileges of man, but what to her is more important, with the same responsibilities. And chief among these is the responsibility of self-realization. O'Keeffe is the epitomization of this faith. In her painting, as in herself, is the scattered soul of America come into the kingdom.[92]

Stieglitz also made a series of nudes using Rebecca Strand, Paul Strand's wife, as his model. During most of the summer of 1922, Rebecca spent time at Lake George while her husband was working in Maryland. Stieglitz photographed her frequently and, as he wrote to Seligmann, found her to be a "first class model . . . I have just come from a real days work – photographing and developing since 9 a.m. . . . experimental portraits and snapshots. Beck as a model mostly. Beck's really first class as a model – but somehow I am unable to make my end work as I want it to . . . Beck's getting an idea of my capacity for work if nothing else . . ."[93] With her strong regal features, Rebecca was photographed close-up, reclining, nude, sometimes contemplative, sometimes playful, sometimes in dramatic gestural poses. One sees her bending gracefully on a bar as if she were a dancer; only her feet "en pointe" as a ballerina, cupping her own breasts in

206

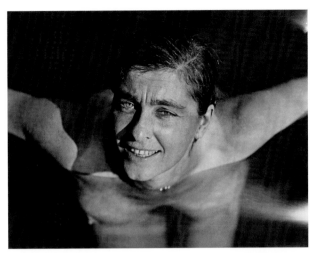

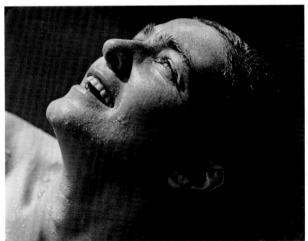

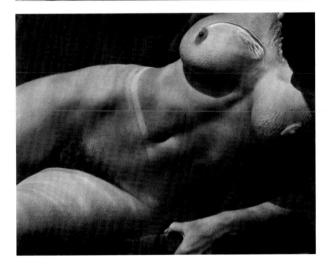

128–30 Alfred Stieglitz, *Rebecca Salsbury Strand*, 1922.
The Art Institute of Chicago.

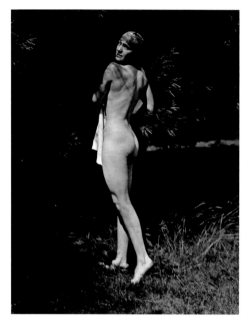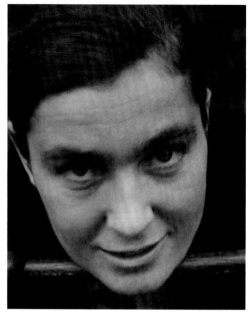

131 Alfred Stieglitz, *Untitled* [Rebecca Strand] 1922/23.
 The Art Institute of Chicago.

132 Alfred Stieglitz, *Rebecca Salsbury Strand*, 1922.
 The Art Institute of Chicago.

firm support, and so on. It is perhaps the nude images of her swimming in the water that are most powerful as the water reflections envelop her lithe young body. Stieglitz made both palladium and gelatin silver prints of her, often from the same negative, experimenting with the softer, more subtle palladium tones versus the sharper, crisp tones of the gelatin silver images. In the end, he was quite pleased with his images. He wrote to Seligmann, "Have quite a series of portraits of Beck. Eye-openers. Am surprised myself, for while she was here I imagined I had totally failed. The joke was on me."[94] Stieglitz wrote twice to Rebecca about his successful prints. "Palladioing – I got a few more 'priceless' treasures . . . – Have struck my gait – It's high time that in your eyes I have some of my reputation . . . Well I have a wonder of you in the hay . . ."[95] Two days later, he wrote again, "I have some beautiful prints of you . . . so your work and kind willingness would not all have been in vain. And I'm glad. And Paul will be glad when he sees the results. They are entirely different than his things of you. Perhaps they will clarify some things."[96] Stieglitz seemed to be infatuated with the young Rebecca, whose laugh he enjoyed greatly. The Strands' relationship was often strained and in 1933 they were divorced but there is no real evidence that "Beck" and Stieglitz became intimate themselves, despite their playful cavorting and her posing while swimming in the nude. In 1937, Rebecca married a wealthy New Mexican rancher.

133 Alfred Stieglitz, *Untitled* [Rebecca Strand], 1922/23. The Art Institute of Chicago.

134 Alfred Stieglitz, *Claudia O'Keeffe*, 1922. National Gallery of Art, Washington, D.C.

Stieglitz also photographed his young teenage niece, Georgia Engelhard, the same summer that he photographed Rebecca Strand. Georgia, about sixteen at the time, stands nude in the shallow waters of the Lake George shore, her bathing suit tan-line providing interesting linear contrast to her otherwise white young body. She appears much at ease, at one with the gently lapping waves hitting the shore. Two years before Stieglitz had also photographed his young niece nude, lying on the grass, and seated nude on a rustic cottage window, clutching apples under her breast. She recalled the difficulties of posing a number of years later: "At best a difficult pose to hold even for a few minutes, but I had to do this for more than an hour with no respite until Stieglitz was satisfied that the light was right, that my pose and expression were right, in other words until all conditions were perfect."[97] He also photographed Engelhard in a white tank-top dress, one shoulder strap provocatively fallen. In one she, like Rebecca Strand, cups and supports her breast as if it were a piece of round fruit. Stieglitz's photograph of Engelhard fully dressed in a baggy white shirt and shorts, shoes on her feet, standing against the white-framed glass door, appears to be that of a young tomboy, casting the young Georgia as almost androgynous in nature.

O'Keeffe's younger sister, Claudia, was also photographed by Stieglitz in 1922. O'Keeffe, on their mother's death in 1916, had taken care of her teenage sister, living with her in Canyon, Texas from 1916 to 1918. Stieglitz's photographs of the young Claudia are intimate close-ups of her face as she lies on a bed, her arms bare, hair tousled. In two of the images she gently holds

209

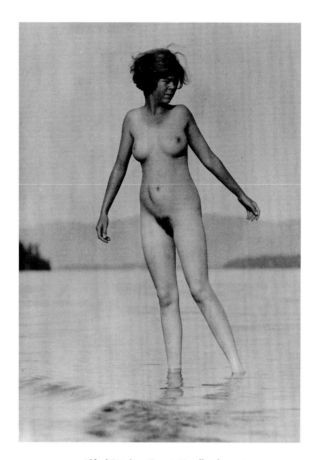

135 Alfred Stieglitz, *Georgia Engelhard*, 1920/22.
National Gallery of Art, Washington, D.C.

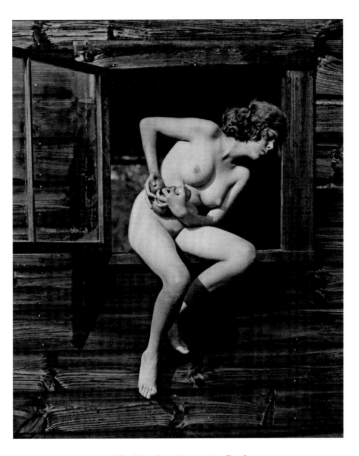

136 Alfred Stieglitz, *Georgia Engelhard*, 1922.
The Art Institute of Chicago.

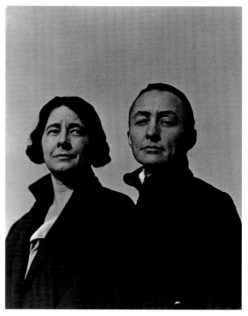

137　Alfred Stieglitz, *Georgia Engelhard*, 1920.
The Museum of Modern Art, New York.

138　Alfred Stieglitz, *Georgia and Ida O'Keeffe, Lake George, c.*1923. The J. Paul Getty Museum.

to her nude body a late nineteenth- or early twentieth-century African mask, which was probably exhibited at 291 in 1914. The dark mask with its primitive features links Claudia to another culture and evokes images of song and dance from the ceremony at which such a mask might have been worn. Such a mask also brings focus to the belief by Stieglitz and his circle, or Picasso and his contemporaries, that "primitive" cultures had much to teach a twentieth-century world and that such objects could be viewed as part of the roots of modern art.

During much of September and October 1924, O'Keeffe's younger sister, Ida, an amateur painter and licensed nurse, came to visit at Lake George, celebrating her birthday there on 23 October. "September was a marvelous month for us," Stieglitz wrote to Arthur Dove, "Each one really a free soul and all in harmony – natural cooperation – no words or theories – no tension – much work each in his own way – much laughter. Ida is a gem . . ."[98] A few weeks later, he wrote to Rebecca Strand about the visit. "Ida had a birthday, day before yesterday. She says it was a masterpiece. Georgia says it seemed God made. And all it was, was life moving freely and beautifully without theory or intellectualization. Incredible. Even the weather seemed to fall into line."[99] Ida appeared not to take any of Stieglitz's flirting seriously and refused to have him photograph her nude back when he came upon her sleeping. Any sexual fantasy was perhaps expressed in his photographs of an old crow's feather jabbed into an apple, for Stieglitz had nicknamed himself "Old Crow's Feather" and Ida "Little Red Apple," after the Ida Red

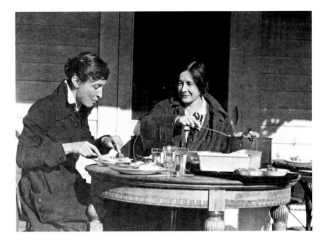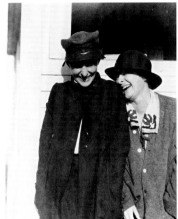

139–40 Alfred Stieglitz, *Georgia and Ida O'Keeffe, Lake George*, 1924.
Beinecke Rare Book and Manuscript Library.

apple – nicknames he used in correspondence with her in the fall of 1924. Many of the photographs show Ida smiling and laughing. One sees her eating, holding flowers, or standing by her long underwear on the line, blowing in the Lake George wind like long-legged dancing white creatures, with Ida as part of the outdoor choreography. Stieglitz inscribed one of these: "Who is this maiden fair/And why is she smiling?/May be she sees a bird – and maybe it's just a photo – /graphic smile – /Who is this maiden/with the raven hair?/What is hanging on the line? – /Nothing – oh Nothing/is hanging on the line – /except a smile . . ." On another similar photograph is inscribed "In Union/there is/Strength/and/A Smile."[100] Ida is depicted, for the most part, as a free spirit, spontaneous, wholesome in her looks, dress, and character. There are several photographs of Georgia and Ida together, eating together on the Lake George porch, laughing together, embracing one another, illustrating their sisterly bond. In one image, Georgia appears quite masculine, gazing somberly at Stieglitz taking the photograph. Weston Naef wrote of this image:

> Deep shadows from bright sunlight establish a somewhat sinister mood. O'Keeffe gazes reproachfully at Stieglitz through the lens of his reflex camera, which he is holding at waist level aimed upward, while Ida casts a nervous glance her sister's way, as if to suggest that she knows something that her sister doesn't. Stieglitz's divorce from Emmeline had been finalized about the time this picture was made . . .[101]

With these few examples of the women whom Stieglitz photographed in multiple images in the twenties, one can only wonder what O'Keeffe thought. It is clear that Stieglitz loved women as well as a woman. O'Keeffe later related how following the 1921 exhibition of a number of

213

images of her, some men had wanted Stieglitz to photograph their wives or girlfriends. Her comment was, "If they had known what a close relationship he would have needed to have to photograph [them] the way he photographed me – I think they wouldn't have been interested."[102]

Significant perhaps in considering Stieglitz's view of women at the time was the fact that, much to his conservative wife Emmy's dismay, he had hung two large reproductions of paintings by the German Secessionist painter, Franz von Stuck, *The Sphinx's Kiss* of 1895 and *Sin* [or *Sensuality*] of 1897, in their home. The second shows a large standing nude around whom is coiled a giant snake with menacing eyes, while the first depicts the naked body of a woman emerging from a sphinx, to embrace the naked young male kneeling beneath her. These images graphically depicted the female as the sexually liberated, seductive temptress. Given Emmeline's lack of interest in sex and sexuality, it is easy to see how Stieglitz would turn to viewing other women and how the act of photographing as well as the resulting images might be seen as part of an act of love and desire that would exist on various levels for Stieglitz. Bram Dijkstra has noted that it

> would be a mistake to interpret Stieglitz's numerous photographs of female nudes as indicative of a particularly vigorous interest in actual sexual relationship on his part. To him, as to many of his contemporaries, capitalizing on a woman's willingness to model nude became a far safer act of masculine self-assertion, of sexual appropriation, one not fraught with the mental and physical dangers of sex itself. In fact, the case for manly self-control had by 1915 actually been bolstered by the growing popularity of Freud's writings.[103]

Stieglitz's portraits of men, during the 1920s were mainly those of artist and writer friends and associates such as Anderson, Toomer, and Rosenfeld (discussed previously), along with Duchamp, Demuth, Arthur B. Carles, and Dove. For the most part, the images are close-up head shots. Several were taken in front of O'Keeffe paintings, thereby uniting male and female principles, which for Stieglitz represented a greater whole, and at the same time celebrated and publicized O'Keeffe's works. Anderson was photographed on different occasions in front of O'Keeffe's *Untitled* of 1923, *The Wave* of 1922, and *Lake George with Crows* of 1921, as mentioned previously. Carles, the Philadelphia-born modernist painter influenced by Matisse and the Fauves, was photographed in 1923 in several poses in front of O'Keeffe's *Music, Pink and Blue, No. 2* of 1918, as well as in front of *The White Wave*. Carles's dark hair, beard, eyebrows, and jacket stand in contrast to the light gentle folds of the womb-like forms of the rhythmic painting. Male and female, and the higher realm of music, become intertwined. Also in 1923, Dove and Duchamp were photographed individually, in profile as well as close-up frontal images, and palladium prints were made. Duchamp appears elusive, distant, enigmatic, as were his art works. In one photograph, Dove is depicted in front of his 1922 painting *Gear*, where he becomes

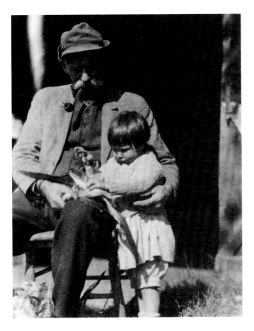

141 Alfred Stieglitz, *Granddaughter of Marie Rapp with a Farmer Shucking Corn, Lake George*, 1923. Private collection.

142 Alfred Stieglitz, *Lake George – The Barn with Tree*, 1923. Philadelphia Museum of Art.

framed by the lines of his own painting. Stieglitz wrote to Dove as he was working on the negatives and developing the prints: "new negatives of you . . . you moved in the most interesting one . . . have a profile which is ghastly in a way, but an addition. There is a full face which might be used for the book [Rosenfeld's *Port of New York*] . . . the first shot we made with your painting as 'background.' It just misses fine. Is photographically very fine."[104]

Most poignant are perhaps the 1923 images of Charles Demuth, who was suffering from diabetes and on his way to the Morristown sanitarium. Stieglitz sensitively photographed the slender, gaunt Demuth, concentrating solely on his hands, in several of the images. Demuth wrote to him, "From varied sources comes great enthusiasm, to me, and, too, Marcel. Could you send me some of the old proofs, that I might see," and on seeing the proofs,

> shall I remain ill retaining that look, die, considering the moment, the climax of my "looks," or live and change, I think the head is one of the most beautiful things I have ever known in the world of art. A strange way, – to write of one's own portrait, – but well, I'm a perhaps, frank person. I sent it this morning to my mother. The hands, too. Stieglitz – how do you do it? The texture in this one is, simply is.[105]

Demuth's long, slender hands are clasped in one image as if he were accepting an offering, in another accentuating his veins and bones, like a roadmap leading to his creative forces.

215

143 Alfred Stieglitz, *Chicken House, Window with Snow,*
Lake George, 1923. The Metropolitan Museum of Art.

144 Alfred Stieglitz, *Chicken House – Lake George*,
*c.*1920s. Private collection.

In the early twenties, Stieglitz also turned to imagery in his Lake George environs. During
the summer of 1922, he photographed his barn from a variety of angles, close-up and from afar,
alone, with a carriage, with a full hay wagon, experimenting with various aspects of light and
shadow. As he wrote to Paul Strand,

> I'm still battling with the barn – a particular problem which I have not succeeded in
> solving – interior in shadow and exterior in full sunlight – proper exposure for exterior
> should be about two seconds, f/64 and interior would be about five minutes! (at least). Then
> too, the sun must be at a particular angle and that happens only for a few minutes on very
> sunny mornings. And I'm only doing it so insistently because I started to get that
> picture . . .[106]

A number of the barn images are idyllic and Romantic in content, recalling earlier images that
Stieglitz took in Germany and Italy such as *Mittenwald* in 1886 or *The Last Load* of 1890. Several
of the barn images contain early modernist elements, as Stieglitz concentrates on the formal
elements of dark and light, the interplay of vertical, horizontal, and diagonal lines of the wood,
along with the close-up focus on the windows, gables, and roof lines. Romanticism has become
a foundation for modernist experimentation. Stieglitz returned to the barn as subject during the

216

145 Alfred Stieglitz, *Barns, Lake George*, 1923. The Metropolitan Museum of Art.

winter of 1923 when its snow-laden roof and snow-filled cracks in the wood add texture, contrast, and a stark somberness to the images. He titled one *The Black Barn and White Snow* to empha-size verbally the visual contrast he had created. In one of the winter barn images, Fred Varnum, who worked for the Stieglitz family, stands next to the large carriage in the open barn door. Varnum appears quite small, allowing the viewer to appreciate the grand scale of the old barn in the freshly fallen snow. Stieglitz also turned to the apple trees on his property that summer of 1922, since the fruit was particularly abundant. He photographed the trees flowering, with full fruit, in detail, and as a full free-standing entity, capturing its essence. Accompanying a photograph, *Apple Blossoms*, of one of the trees in full bloom near the farmhouse, Stieglitz included the following lines to O'Keeffe in a 24 July 1922 note: "In Springtime some little girls go crazy – Like apple trees sometimes do. – I know one such little girl – Guess who she is – a riddle for Georgia O'Keeffe – '291'."[107] Perhaps best known are the 1922 images *After the Rain* and *Apples and Gable*. When Crane saw these photographs in Stieglitz's 1923 exhibition, he was reported to have said, "That's it. You've captured life."[108] Stieglitz later responded to Crane, "The

217

Moment before the Apples and Gable will remain with me for all time – There never was truer seeing." That summer Stieglitz's mother was dying; some have viewed the rain or the apples in both images as symbolic teardrops, for Stieglitz had difficulties expressing his grief, and instead poured himself into his work, as he had when his sister died in childbirth. His mother was still living, very frail the day he took the photograph. He recalled, "My mother was dying. She was sitting on the porch that day. O'Keeffe was around. I'd been watching this thing for years, wondering could I do it? I did, and it said something I was feeling."[109]

Stieglitz hung the *Apples and Gable* in the 1923 exhibition in a sequence labeled *Birds, Apples and Gable, Death*. While it is unclear to which image *Death* refers, *Birds* probably refers to a 1922 image of birds perched on high wires that Stieglitz had chosen to depict vertically in the center of a cloud-covered sky forming the background to the image. Apples connote both life and death, in representing a fruit of life and, at the same time, withering and rotting away if not picked, or eaten, as winter comes each year. The apple tree was for Stieglitz a "symbol of the long neglected American artist, and its fruit the natural and true expression of the artist's soul . . . the apple . . . is the essence of that moment in which the subject is seen as a totality, both as the object that it is and its relation to the artist."[110] These apples may be viewed as an early Equivalent for Stieglitz as he used significant physical objects in his immediate environment to express an emotional state.

Between 1922 and 1926, Stieglitz also took a number of photographs of the farmhouse on the hill overlooking Lake George where he and O'Keeffe stayed, along with panoramic views of the lake and distant hills, the latter often taken at sunset. The house, with its numerous gables and large wrap-around porch, takes on an almost human presence in those images where it dominates the landscape. Distinct from the large Oaklawn property across the road where Stieglitz had spent his earlier years, The Hill, as the property came to be known, became a place where Stieglitz continued to welcome his large sprawling family, his friends, and find inspiration for his photographs.

The panoramic landscape scenes may be viewed as part of a long-standing tradition of landscape painting inspired by Lake George, dating back to the eighteenth century with artists such as Captain Thomas Davies and Captain William Pierie. Hudson River School and Luminist painters such as Thomas Doughty, Jacob Caleb Ward, Asher Durand, Martin Johnson Heade, Samuel Robinson Gifford, Jasper Cropsey, and Thomas Worthington Whittridge were among those inspired by the pristine lake and its lofty surrounding hills. The words of a writer for *Harper's New Monthly Magazine* in 1879 could describe, in part, Stieglitz's attraction to the landscape he returned to year after year:

It is difficult to describe the quiet delight one feels as he gazes on the expanse of tranquil azure spread before him, like a part of the sky inlaid on the emerald bosom of the earth. Peace is in the air which lazily slumbers over the water, while the monotone of the silvery ripples

146 Alfred Stieglitz, *Apples and Gable, Lake George,* 1922.
The Metropolitan Museum of Art, Ford Motor Company Collection.

147 Alfred Stieglitz, *Later Lake George*, 1920s.
The Art Institute of Chicago

148 Alfred Stieglitz, *The Dying Chestnut Tree –
My Teacher*, 1927. The Art Institute of Chicago.

rolling on the yellow sands, and the musical moan of the breeze in the cone scented pines seems to carry the soul back to other days. Lake George, is indeed, like a work of art of the highest order, for it has the quality of improving the more one studies it . . .[111]

Many of Stieglitz's landscape images taken at Lake George also possess an "intimate immensity,"[112] to borrow a term from Gaston Bachelard that is both interior and exterior. Bachelard, in *The Poetics of Space* (1969), introduced his chapter on "intimate immensity" with a line from Rilke, whom Stieglitz admired – "the world is large, but in us it is deep as the sea," referring to the immensity within the human soul. "Immensity is within ourselves. It is attached to a sort of expansion of being that life curbs and caution arrests, but which starts again when we are alone."[113] It is that inner sense that Stieglitz and many of his fellow artists sought to express.

The Equivalents and Related Works

Such a sensibility is further seen in the series of photographs Stieglitz began in this decade that came to be called the *Equivalents*. In 1922, he began with his well-known series, *Music. A Sequence of Ten Cloud Photographs*. His famous September 1923 statement, "How I Came to Photograph Clouds," points to the continuing importance of music for him:

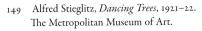

149 Alfred Stieglitz, *Dancing Trees*, 1921–22. 150 Alfred Stieglitz, *The Old Maple, Lake George*, 1926.
The Metropolitan Museum of Art. The Art Institute of Chicago.

Thirty-five or more years ago I spent a few days in Murren (Switzerland), and I was experimenting with ortho plates. Clouds and their relationship to the rest of the world, and clouds for themselves, interested me, and clouds that were most difficult to photograph – nearly impossible. Ever since then clouds have been in my mind most powerfully at times, and I always knew I'd follow up the experiment made over thirty-five years ago. I always watched clouds. Studied them. Had unusual opportunities up here on this hillside. What Frank [Waldo Frank] had said annoyed me: what my brother-in-law said also annoyed me. I was in the midst of my summer's photographing, trying to add to my knowledge, to the work I had done. Always evolving – always going more and more deeply into life – into photography.

My mother was dying. Our estate was going to pieces. The old horse of 37 was being kept alive by the 70-year-old coachman. I, full of the feeling of to-day: all about my disintegration – slow but sure . . .

So I made up my mind I'd answer Mr. Frank and my brother-in-law. I'd finally do something I had in mind for years. I'd make a series of cloud pictures. I told Miss O'Keeffe of my ideas. I wanted to photograph clouds to find out what I had learned in 40 years about photography. Through clouds to put down my philosophy of life – to show that my photographs were not due to subject matter – not to special trees, or faces, or interiors, to special privileges, clouds were there for everyone – no tax as yet on them – free.

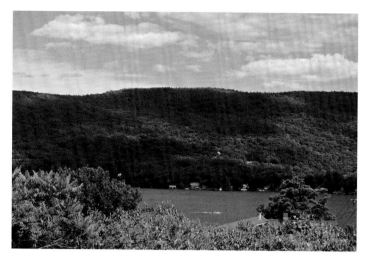

151–3 K. Hoffman, *Lake George – Location of House on "The Hill"*, 2008.

154 Alfred Stieglitz, *The Little House – Front View*, 1925. Beinecke Rare Book and Manuscript Library.

. . . I had told Miss O'Keeffe I wanted a series of photographs which when seen by Ernst Bloch (the great composer) he would exclaim: Music! Music! Man, that is music! How did you ever do that? And he would point to violins, and flutes, and oboes, and brass, full of enthusiasm, and would say he'd have to write a symphony called "Clouds." Not like Debussy's but much, much more.

And when finally I had my series of ten photographs printed, and Bloch saw them – what I said I wanted to happen, happened verbatim.[114]

Continuing his musical emphasis, Stieglitz wrote Anderson in November 1923: "I've been crazily mad with work – fun – some great sky stories – or songs."[115] Then in December, he wrote to Crane, who espoused a theory of "ultimate harmonies":

I'm most curious to see what the "clouds" will do to you . . . Several people feel I have photographed God. May be . . . I know exactly what I have photographed. I know I have done something that has never been done. Maybe an approach occasionally [found] in music. I also note that there is more of the really abstract in some "representation" than in most of the dead representations of the so-called abstract so fashionable now.[116]

223

155 Alfred Stieglitz, *Rain Drops*, 1927. The Art Institute of Chicago.

Ernst Bloch, a Swiss-born composer and photographer, had come to New York in 1916. He found himself stranded in New York after the concert tour he was conducting failed. While at a New York hotel, his overcoat was stolen; Waldo Frank lent him his and thus began Bloch's introduction to the Stieglitz circle. A few weeks later, Bloch's just completed *First Quartet* was performed in New York to much acclaim. Rosenfeld became a champion of Bloch's and introduced him to Stieglitz. In an essay on Bloch for *Camera* magazine in 1976, Eric Johnson wrote:

> Both Bloch and Stieglitz were romantics with a dramatic style in an increasingly cerebral, anti-romantic time in art. They felt a bond of understanding. Indeed, it appears that Stieglitz was encouraged to begin his series of cloud photographs not only because of a remark in a letter from Waldo Frank that his fine portraits were due to a hypnotic power over his sitters but also because of his friendship with the composer Ernst Bloch.[117]

While Bloch composed no symphony called *Clouds* after seeing Stieglitz's series, he did write a short impressionistic piano piece in 1922, "Poems of the Sea," and worked on his *Piano Quintet*.

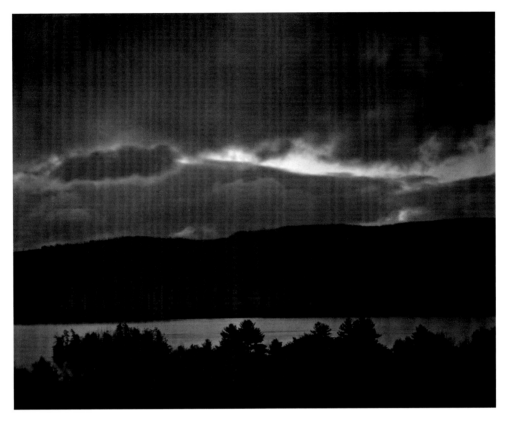

156 Alfred Stieglitz, *Untitled – Lake George*, *c*.1921. The Art Institute of Chicago.

Stieglitz saw him as a kindred spirit, as is evident from his letter of 1 July 1922 from Lake George after Bloch had seen the cloud photographs:

My dear Mr. Bloch,

Have you any idea how much it meant to me to have you feel about those photographs as you did – To have you see in them what you do – And to know that what you express I understand. And feel is true. – It was a memorable hour. A very rare one. There is much – very much – that you are suffering – physical and otherwise – that has been my lot, too. – It's all necessary for "foolish" people like ourselves I have to presume. Sometimes one wonders, though, must one go through torments over and over again to gain greater clarity – a still deeper sympathy – a greater unity? If it could be otherwise, I suppose it would be otherwise.

Yours gratefully,

Alfred Stieglitz[118]

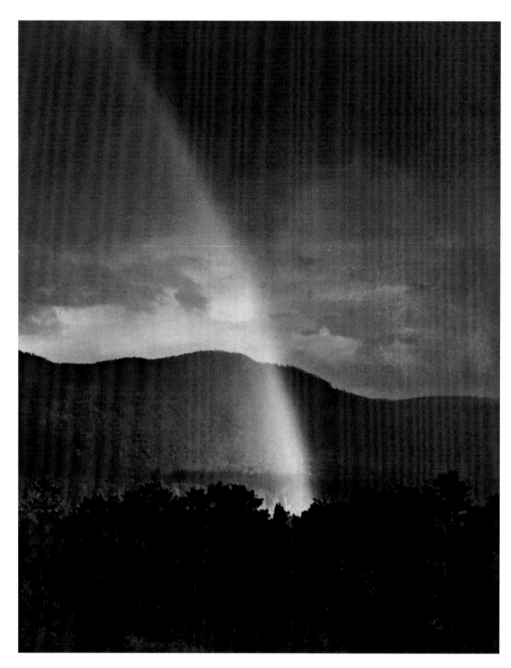

157 Alfred Stieglitz, *Rainbow, Lake George*, 1920. Philadelphia Museum of Art.

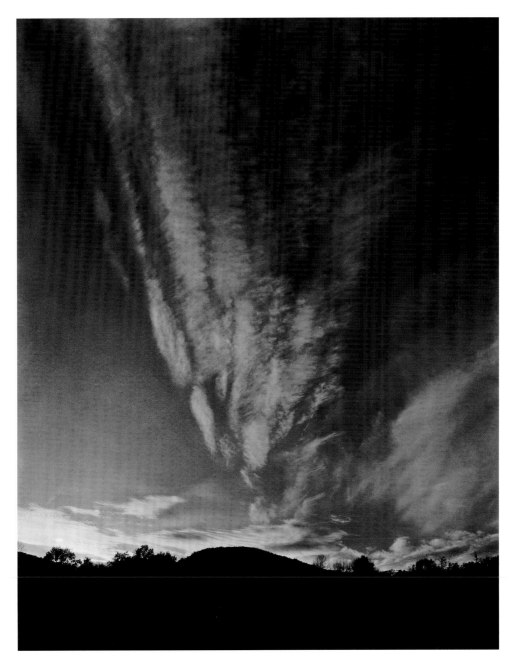

158 Alfred Stieglitz, *Lake George*, 1922–23. Philadelphia Museum of Art.

Bloch also took photographs, whcih had some affinity with Stieglitz's early European pieces, comprising landscapes, images of peasant life, and portraits. One of his musical compositions, *Five Sketches in Sepia* (1923), clearly refers to the visual arts and sepia-toned photographs. Strand solicited Bloch's input when he served as the guest editor for *Manuscripts* in 1922 and wished to report on the current state of photography as a fine art. Bloch's response to Strand included eloquent praise of Stieglitz and his work:

> In his [Stieglitz's] marvelous work, I see for the first time in history a man, a thinker, a philosopher, using the camera and all its resources to express himself fully and completely like a painter uses brushes and colors or a musician uses sounds . . . He has not only photographed things as they seem to be or as they appear to the bourgeois; he has taken them as they really are in the essence of their real life and he sometimes accomplishes the miracle of compelling them to reveal their own identity . . . as if all their potentialities could emerge freely; and this is the greatest Art because all signs of technique have disappeared for the sake of the Idea.[119]

In reviewing a performance of Bloch's *Concerto Grosso* for strings and piano, Rosenfeld wrote of Bloch's capacity for developing his ideas in a modern format: "the humanistic Bloch is present . . . Bloch's power and sincerity impose in this piece too. His capacity for developing and sustaining his ideas is second to no living composer's. Dignity and weight enter what he touches. The new piece seems to show the vehement modern observing others diddling with eighteenth-century forms."[120]

Stieglitz's musical aspirations related to the series of ten cloud photographs was also rooted in the symbolist aesthetic that had already played a large role in the production of *Camera Work*. The symbolist writers and artists, using forms and colors to communicate the intangible and mysterious realism of the spirit and soul, had given impetus to Stieglitz and his circle to move outside the confines of conventional representation and documentation. Rosalind Krauss noted in her discussion of the *Equivalents* that in using the term "equivalents," Stieglitz was invoking the language of symbolism with its notions of correspondences and that his works moved "to the deepest level of symbolist thought. Symbolism as it understood language to be a form of radical absence – absence that is of the world and its objects . . ." Yet, "if Stieglitz intended the cloud pictures to be symbolist, he also intended them to be photographically 'sui-generis,' that is they could only say something about music or the Idea, or whatever, insofar as they spoke out of the material being of photography."[121] For Stieglitz, "seeing" was as important as feeling, but seeing for him also implied a deep-seated sensibility that went beneath the surface, similar to Rilke's advice in his *Notebooks of Malte Laurids Brigge* (1910), that one must *sehenlernen* (learn to see).

The cloud series of 1922 retains elements of the Lake George hills in dark shadows forming the base of the image, in several instances resembling a reclining pregnant female. These images

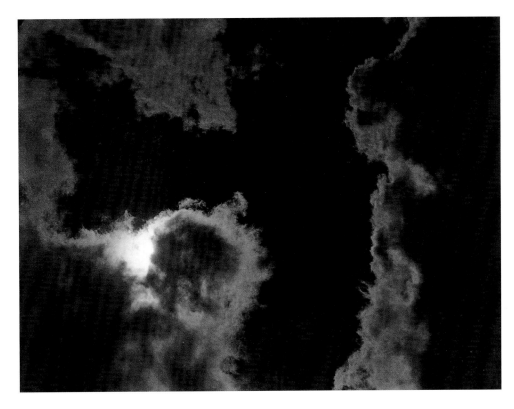

159 Alfred Stieglitz, *Portrait of Georgia, No. 3 – Songs of the Sky*. The J. Paul Getty Museum.

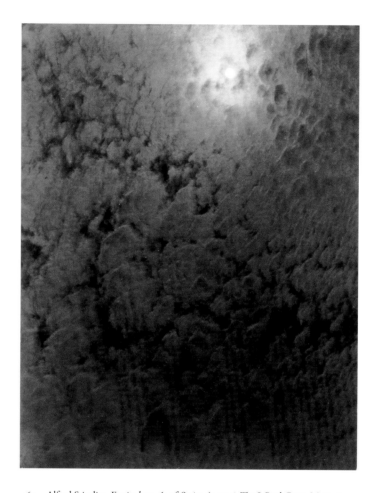

160 Alfred Stieglitz, *Equivalent, A3* of *Series A1*, 1926. The J. Paul Getty Museum.

were probably made between August and October 1922, followed two productive summers at Lake George with O'Keeffe. Despite the sadness of his mother's death, Stieglitz was deeply in love with O'Keeffe and, having no gallery to occupy his energies, had more time to devote to his own photographs. He seemed to be operating in the spirit of intoxication that Nietzsche had suggested was a precondition for artistic creation. "For art to exist, for any sort of aesthetic activity or perception to exist, a certain physiological precondition is indispensable: intoxication."[122] That the images would contain allusions to music and the female form seems to represent well Stieglitz's state of mind at that time. Several years later, Ralph Flint, an art critic for *The Christian Science Monitor* and the editor of *Artnews*, recorded that

> for twenty-four years [Stieglitz] had been dreaming of making a motion picture, that he wanted to take the clouds and the human body and the machine as he understood them, and put them all together, harnessed, in a motion picture so that anyone, sophisticated or ignorant, young or old, coming in and seeing it would recognize the thing going on, relate it to life. He said he hoped to make the motion picture for, unless he did it, it would not be made very soon.[123]

In the first image of the ten is the only reference to the manmade environment – a small gable of a white house. This first image contains only a central sliver of light, sandwiched between the dark hillside and ominous gray clouds dominating the sky. The last image begets a peaceful twilight with few clouds and none of the drama of some of the earlier images in the series. In the same year Stieglitz made other similar images at Lake George of the clouds and dark solid landscape as foundation, uniting earth and sky, but he did not include these in the series. Rather, he titled them *Lake George*. It was not the first time that he had photographed clouds. In 1888, he had taken a photograph of clouds alone and in the 1890s took shots of the Lake George skyline and clouds.

After 1922, Stieglitz switched from using his 8 by 10-inch view camera to the more mobile 4 by 5-inch Graflex. With the latter he could move more easily and aim higher into the sky. In 1923, he began to call his cloud images *Songs of the Sky*. Six 1923 images, *Portrait – K.N.R., No. 6 – Songs of the Sky*, along with being titled *Songs of the Sky* were also titled and exhibited in 1924 as a portrait of the artist, Katharine Rhoades. This time Rhoades appeared as a poplar tree, freely dancing in and with the movements of the clouds. She was excited about the portrait and wrote to Stieglitz, "So one of the clouds is a portrait of me! How very exciting! I hope it is winged – not too ominous – and is turned to the light. Tonight I should like a cloud to float upon – to float very far away – in a space where feeling and thought and – most of all – Being, are pure and clear."[124] Thus again Stieglitz conflated allusions to music, the world of nature, and "woman," thereby creating a multidimensional portrait that perhaps presents aspects of Rhoades's

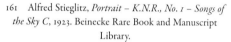

161 Alfred Stieglitz, *Portrait – K.N.R., No. 1 – Songs of the Sky C*, 1923. Beinecke Rare Book and Manuscript Library.

162 Alfred Stieglitz, *Portrait – K.N.R., No. 4 – Songs of the Sky C4*, 923. National Gallery of Art, Washington, D.C.

inner being not portrayed in conventional portraiture, and also asks the viewer to re-view his or her perceptions of the sky and landscape.

In his *Spiritual America – Songs of the Sky A*, Stieglitz linked the horse with the sky through his title. For years, as noted earlier, he had loved racehorses and the races. The racehorse carried elements of freedom, spirit, and strength. In *Spiritual America*, there is no sky, rather a gelding that Stieglitz viewed as representative of America's weakened spiritual life at the time. He wrote to Seligmann, "Wait until you see the first picture I made this summer – a picture of 'America!' – a gelding – you'll be amused."[125] Ten years later he also wrote, "If I had been a rich man I would have had racehorses and photographed the life of the Racehorse – It has never been done – The Sky – Woman – Racehorse – I have the 'Sky' – I have woman partly – I'll have to return to Earth to complete her story and also to get down my story of the Racehorse – All one story!"[126]

Several of the 1923 *Songs of the Sky* are also portraits of O'Keeffe: *Portrait of Georgia, No. 2 – Songs of the Sky* and *Portrait of Georgia, No. 3 – Songs of the Sky*. The images are dark and enigmatic, part of a "terrain" that had much to be explored. Their paths of light and dark invite exploration and contemplation, as one would in looking at a portrait. Significant, too, in these as in other cloud images, is that what appears as dark is actually a depiction of light. In

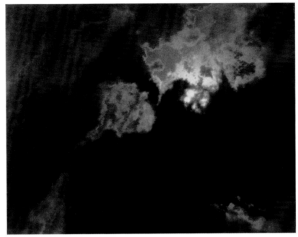

163 Alfred Stieglitz, *Spiritual America – Songs of the Sky A*, 1923. The J. Paul Getty Museum.

164 Alfred Stieglitz, *Songs of the Sky, A7*, 1923. Lee Gallery, Winchester, Massachusetts.

addition, "the photographic lens which is used to capture light is referenced by the sun, which is the source of light – the reciprocities inherent in such visual conundrums result in ambiguous interpretations. The consequent irresolution suggests one way in which Stieglitz's *Equivalents* (and *Songs of the Sky*) implicate their viewers in the emotionally affective realm of intangible experience. At the same time, their visual play with light and its effects reveals how much these photographs in particular are informed by references to the medium of photography."[127]

Stieglitz had also begun using the word "equivalent" for some of his *Songs of the Sky* and, by 1927, he also used the plural term, *Equivalents*. In some of the 1927 *Equivalent* (singular) titles, a poplar tree was photographed in full glory, dominating the images. Stieglitz had watched the poplars grow at Lake George and perhaps saw in them a stronger sense of humanity than he felt about himself at sixty-three, as he sometimes began to feel old physically and psychologically. In the later *Equivalents*, he seemed less concerned with music and more with the relationship of his life and work to the chaos he saw in the world around him. The cloud images were to "represent the chaos in the world, and my relationship to that chaos. My prints show the world's constant upsetting of man's equilibrium, and his eternal battle to reestablish it," and he wrote further, "My cloud photographs are '*equivalents*' of my most profound life experience, my basic philosophy of life . . . In looking at my photographs of clouds, people seem freer to think about the relationships in the pictures than about the subject matter itself . . ."[128] As Andy Grundberg wrote of the *Equivalents*, "They remain photography's most radical demonstration of faith in the existence of a reality behind and beyond that offered by the world of appearances . . . Emotion resides solely in form, they assert, not in the specifics of time and place."[129]

The small images were not printed on exotic palladium papers but rather were primarily gelatin silver prints. In a number of letters, Stieglitz referred to listening to music, such as that of Beethoven, Bach, or Wagner, while printing. The prints were in some ways like small windows looking into a large universe, with "intimate immensity." They may be interpreted as representing an emotional universe, and emotional equivalents, but they also should be viewed as part of an American continuum of artists' interest in the sky and clouds dating back to the nineteenth century, with which Stieglitz would have been familiar. In nineteenth-century Europe, Romantic writers such as Coleridge, Shelley, and Goethe, and painters such as Johan Christian Dahl, Karl Blechen, Constable, and Turner were among those fascinated with clouds as central themes of their work, not merely as elements to define lighting or general atmosphere. The great interest in clouds at this time was connected with scientific explorations of cloud formation in London. In particular, an essay, "On the Modification of Clouds" by Luke Howard, published in 1822, attracted and inspired artists and writers. Goethe's writings indicate direct contact with and admiration for Howard's work. Inspired by Howard's systematic organization and classification of the clouds into nimbus, stratus, cumulus, and cirrhus, Goethe wrote a series of poems, containing a hierarchy of spiritual levels, connected to various cloud forms, with cirrhus clouds the most noble. The poems were dedicated to Howard and his classification. John Ruskin's writings concerning clouds and the sky were also important at the time for various painters. He, too, developed a hierarchy of clouds, the lower rain clouds appearing most interesting. Particularly important were his chapters on the sky and clouds in his *Modern Painters*, a series of five volumes begun in 1836 and completed in 1860.

Contemporary painters were aware of and influenced by Goethe's or Ruskin's works. In Germany, Carl Gustav Carus wrote *Nine Letters on Landscape Painting*, urging the painter to observe carefully the scientific structure of the landscape, including the sky, and at the same time to be in touch, emotionally, with the world of nature. The Dresden painters, including the Norwegian Dahl and Blechen, came to share Carus's interests. In particular, a statement made by Carus concerning the inspirational power of the sky influenced his fellow painters: "The sky in all its clarity, as the quintessence of air and light is the real image of the infinite . . . and becomes the most essential and glorious part of the landscape."[130]

In England, John Constable was noted for his innovative cloud studies, most of which were painted in 1822, in oil on large sheets of paper with the date, time of day, direction of the wind, and other comments recorded on the back. He knew of the work of Howard and Thomas Forster and incorporated meteorological methods into his Romantic vision. In nineteenth-century America, land and sky became an important aspect of Americans' physical and spiritual heritage. Many of the Hudson River painters devoted much of their canvas to the sky and clouds to reach what Jasper Cropsey called the "noblest truth and beauty" in his 1855 essay "Up Among the Clouds." Of the Hudson River painters, Frederic Church and Albert Bierstadt were perhaps the

165–6 Alfred Stieglitz, (top) *Equivalents*, 1923. The Museum of Modern Art, NY; (bottom) *Equivalent*, 1924.
The Metropolitan Museum of Art.

167–8 Alfred Stieglitz, (top) *Equivalent*, 1924; (bottom) *Equivalent*, 1925.
The Metropolitan Museum of Art.

most dramatic in their cloud imagery. Bierstadt is best known for his dramatic scenes of the American West, such as his *Storm in the Rocky Mountains* and *Mt. Whitney*. A number of Church's paintings were made from his villa, Olana, built in the town of Hudson, New York. In his *Autumn View of Olana* and *Winter Landscape from Olana*, there is a sensitivity to the change in seasons emphasized and dramatized by the painterly skies. Both Bierstadt and Church tended to prefer the power of the cumulus cloud or some variation such as the altocumulus depicted in Church's *Twilight in the Wilderness*.

A good friend of Church, the Luminist painter Martin Johnson Heade, chose the cumulus lenticularis in many of his small, horizontally oriented landscapes that often devoted one half or more of the picture plane to the sky. The Luminists' palette became more vivid and light became a part of the subject matter of the painting. Many of the Luminists such as Heade, John Kensett, or Fitzhugh Lane painted a sweeping panorama across still waters. Heade's propensity for the cumulus lenticularis is seen in such works as *Lake George* (1862) or *Dark Hunters in the Marshes* (1866). These clouds, unlike the dramatic impact of the large cumulus, transmit a feeling of tranquility and calmness. The quiet horizontality of the cloud shape is echoed and reemphasized in the horizontal lines and waterways.

Thus empirical and scientific observation could lead to a sense of transcendental infinity, where the artist became a kind of priest or mediator between the world of nature and the transcendent or divine, echoing the tenets of Ralph Waldo Emerson and the American Transcendentalists. Stieglitz's belief that there was a spiritual American landscape had its roots, in part, in the philosophy of Emerson and Thoreau. Indeed, Waldo Frank, in his 1919 book, *Our America*, started his portrait of Stieglitz with a discussion of Emerson and Thoreau.

Stieglitz was also probably influenced by Theosophy, which promoted the unification of physical and spiritual being through religion that was a mélange of Hinduism, Buddhism, and Judeo-Christianity. For a number of Theosophists, each person still contained an element of divinity that could be tapped through study and meditation, and a Nirvana-like state was possible to be reached. Stieglitz would have known about Theosophy through Hartley who learned about it in Berlin, through references to the group in Kandinsky's *Concerning the Spiritual in Art*, an excerpt from which was published in the July 1912 issue of *Camera Work*; and through Claude Bragdon, who had translated Ouspensky's *Tertium Organum* on the mystical elements of the fourth dimension. In some ways the *Equivalents* may be seen as an expression of the fourth dimension, as discussed earlier.

Besides being *Equivalents*, Stieglitz's clouds might also be viewed as "multivalent."[131] If one looks at cloud imagery from various periods and cultures, its symbolism and use by Stieglitz becomes even more significant. As Jacqueline Basker summarizes, in her essay "The Cloud as Symbol,"

169 Alfred Stieglitz *Equivalent*, 1927. The Metropolitan Museum of Art.

for the Mesopotamians, Egyptians, and Greeks, the cloud represented creation, fertility, divine power, and protection. In China and India, images of the Divine were accompanied by clouds. Both Jesus and Muhammad ascended to heaven in a cloud, and both the gospels and Islamic scriptures employ the image of the cloud as a theophany . . . in our global situation the art and literature of the world reveals parallel use of the cloud beyond Judaism, Christianity, and Islam. In Tibetan mandelas, in Chinese dragon symbolism, in Native American art, in African mythology, the image of the cloud recurs as an important expression of inexpressible divine realities.[132]

Although Stieglitz may not have known of about all of these references, he could well have known of some through his exposure to the work of Fenellosa, Coomaraswamy, his showing African art, as well as through his own Jewish heritage. Having lived through one world war and living in America in its Depression years, his turning to the clouds and their endlessly changing forms could be viewed as a search for a universal, archetypal, spiritual brotherhood that would encompass a wider world. (He was reading Jung's *Psychological Types* in the mid-1920s.) As he wrote to Crane, he thought he had "photographed God."[133] A modern writer has also suggested

170–71　Alfred Stieglitz, (top) *Equivalent*, 1927, (bottom) *Equivalent*, 1929.
The Art Institute of Chicago.

that Stieglitz's "intellectual self" may have gained precedence as he got older. "Being over sixty, one can expect that his intellectual self might have been in better control of his emotional self. In looking at the *Equivalents*, one can sense a certain sovereignty of consciousness that is not as strong in his portraits of O'Keeffe."[134] In totality, the cloud images may be viewed as a Hegelian synthesis of the emotional and intellectual sides of Stieglitz, a synthesis, too, of the Dionysian and Apollonian.

The endless forms of the clouds Stieglitz depicted may also be viewed through a Darwinian lens. Darwin's ideas were much in the air in the twenties with the well-publicized John Scopes Trial. Darwin had promoted the idea of transforming species and "endless forms" in nature produced without any pre-existing design.[135] One of Darwin's concerns was how beauty could emerge out of natural accident. Stieglitz's *Equivalents*, the clouds, and other Equivalent imagery, seem to articulate Darwin's notion of emerging and "endless forms" that are continually changing.

The cloud photographs not only may be viewed as titled in the early works, as *Music* and *Songs of the Sky*, but also as exhibiting cinematic qualities when viewed together as a group. Stieglitz went to the movies frequently, particularly in the late 1920s and into the 1930s. The large panoramic vistas of the sky in contemporary movies such as *Ben-Hur, The Ten Commandments, The Four Riders of the Apocalypse*, or *Stagecoach* could well have influenced him. He also interacted with Charlie Chaplin who visited An American Place early in 1931. Stieglitz showed him some photographs; Chaplin was particularly impressed with one of the small cloud prints with a tree top, along with a torso, and small New York print, probably of some of the newly constructed buildings. Seligmann recounted that visit, recalling Stieglitz's interest in making a film, as he had mentioned to Ralph Flint five years before:

> Stieglitz told Chaplin that the prints he had seen were really only a prelude to an idea which he had had in mind for twenty years of a movie of a woman's eyes, their changing expression, the hands, feet, lips, breasts, *mons veneris*, all parts of a woman's body, showing the development of a life, each episode alternating with motion pictures of cloud forms on the same theme, always re-sounding, the main theme, all without text, without actors, sprung from life, as Stieglitz photography had sprung. "That is grand," said Chaplin, "it would be a symphony, a new form." Stieglitz said he did not believe he would ever do it and felt probably no one else would . . . Chaplin, on leaving asked if he could see Stieglitz again. Stieglitz replied, "I am always here."[136]

Taken together, the *Equivalents* may also be viewed as representing, to use Bachelard's terms, a "dialectic of outside and inside," as Stieglitz uses the exterior sky to express interior emotion, where his internal being may confront the chaos of an external world, and where memory and metaphor may intersect to produce a powerful sequence of expressions. Words from Rilke's

172 Alfred Stieglitz, *From the Shelton Looking North*, 1927.
The J. Paul Getty Museum.

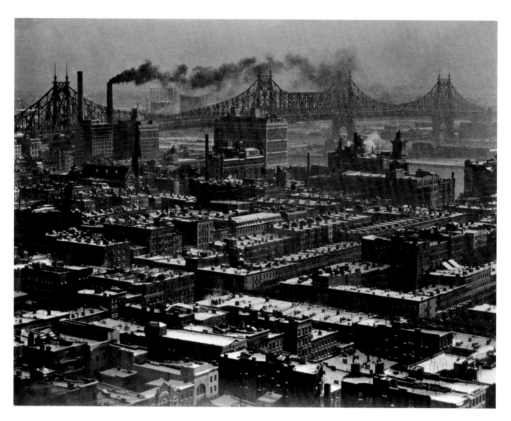

173 Alfred Stieglitz, *From Room 3003, The Shelton, New York, Looking North-East*, 1927.
The Art Institute of Chicago.

poems might well describe this sensibility. In *On Music*, Rilke wrote: "Music, the breathing of statues . . . Language – where/language ends Time/that stands head up in the direction/of hearts that wear out . . . Place where feeling/is transformed . . . when the innermost point in us stands outside, as amazing space, as the other/side of the air:/ pure,/ immense, not for us to live in now" (Munich, January 1918) or, in *Moving Forward*, "The deep parts of my life pour onward,/ as if the river shores were opening out,/ It seems like things are more like me now, that I can see further into paintings. I feel closer to what language can't reach./ With my sense, as with birds, I climb/ into the windy heaven, out of the oak . . ."[137]

Stieglitz continued his *Equivalents* until about 1933, just four years before he stopped taking photographs. The sky also appeared as a significant background for his ongoing interest in the dying chestnut tree on the Lake George property. Several of the 1924 images, titled *Tree Set 1–5*, depict the leafless dark limbs stretching into a cloud-covered sky. The stark black branches appear ominous and powerful, against the subtle gray tonalities of the moving clouds. Stieglitz wrote to Anderson about his "heroic" tree: "I am curious to see my old friend, the Dying Chestnut on

174 K. Hoffman, *The Shelton Hotel*
(currently a Marriott Hotel), 2008.

175 K. Hoffman, *Looking South From Near the Shelton Hotel*, 2008.

the Hill – what a wonder that lone tree is – May be this year I'll manage to get a real picture of that heroic figure. I have been 'looking' for years – and wonder how I can get it down."[138] Three years later, he continued his study of the heroic tree, as he wrote to Seligmann, "Even made an 8 × 10 of the old Chestnut Tree yesterday."[139] One of the 1927 images he called *My Teacher*, another *Life and Death*. In the 1927 images the old tree appears less powerful, as Stieglitz concentrates on the broken limbs and gnarled bark of the outstretched forms. Yet there is still a grandeur that he captured in his "hero" that had watched over his beloved property for many years and still stood silent and strong, still "a real presence" for those who visited and lived on "The Hill." In a conversation at the Intimate Gallery, he once described the "wisdom" of the trees at Lake George as a visitor asked him to say what he meant by wisdom:

> I have lived with trees at Lake George . . . For forty years I have watched some trees there and in watching them I have learned about myself. One dying oak tree in especial I have watched. Last year more limbs were torn off by the winds. Last summer there were only three leaves on the dying oak tree and those leaves were already marked by the hand of death. I wonder sometimes if I am not like the dying oak tree with the three leaves, and if there will be any leaves at all next year.[140]

176 K. Hoffman, *Looking East From Near the Shelton Hotel*, 2008.

In June 1929, as Stieglitz and O'Keeffe were suffering a marital crisis, he described spending an hour with the old dead tree in the howling wind, while lunch had to wait. "That grand, old dilapidated Tree, much gone since last year, but standing in all its Silence, while all living trees are torn by the raging wind . . . I had a dream of dying – how I think the Tree has taught me something new about myself. I love you, Georgia, I also love that Tree – two different loves – yet One . . ."[141]

Even in New York City, he photographed the sky. In 1926 and 1927, shortly after he and O'Keeffe moved from East 58th Street to the thirtieth floor of the newly constructed Shelton Hotel on Lexington Avenue between 48th and 49th Streets, Stieglitz began photographing New York from his apartment. His photographs, such as *From the Shelton, New York, Looking East*, look to the East River, a view that O'Keeffe painted twice in 1928, *River, New York* and *East River from the 38th Story of the Shelton Hotel*. Although the view contained a large number of city and industrial buildings, Stieglitz, unlike O'Keeffe, devoted much of his composition to the cloudy sky and river waters. In other images looking to the northeast and southeast, he emphasized more urban and industrial growth – smokestacks, billowing smoke, boats in the river, the bridge across the river, and density of the buildings. He does not pass judgment but, rather, as Sheeler did in a number of his factory paintings, depicts the scene as classical and well ordered, with the buildings' geometric shapes in some instances appearing as classical columns.

The photographs looking north from the Shelton thirtieth floor show emerging skyscrapers and new constructions such as the 1927 Beverly Hotel. Stieglitz also photographed from his upper-story Intimate Gallery emphasizing the verticality of what became almost phallic symbols as he cropped the images to concentrate on a single structure piercing upward into the sky. Yet, it was not until the 1930s that Stieglitz was to make his most powerful urban images, to be discussed in the following chapter.

SOME Letters

The excerpts from five of Stieglitz's letters to the young writer and dramatist, David Liebovitz, express some of Stieglitz's major interests and concerns during the twenties.[142] Early in the decade, Liebovitz met Stieglitz at the Anderson Galleries on a visit there with Seligmann and Lewis Mumford. He was drawn to Stieglitz's passion for art, his sharp eye, and wide-ranging interests. Liebovitz visited Stieglitz's galleries frequently in the 1920s, and also became friends with Hartley and John Marin. He often sent or brought books for Stieglitz to read and the two men corresponded. Liebovitz's own play *John Hawthorn* was produced in 1921 by the Theater Guild in New York, while his first novel, *Youth Dares All*, was published in 1930. The young man and his family left for Europe in 1930 for two and a half years and after returning to the United States was not as close to Stieglitz.

24 June 1924

Lake George

Dear Liebovitz: The Blake [William] came. And I was very glad to receive it. I had hoped you'd turn up and let me see some of your own writings. You had said you might when we got away finally on June 6th. I was really all in. "Moving" until the last moment. And when we arrived here on this Hill of Stillness I came near caving in. – O'Keeffe hadn't been well in town. The strain had been much for her too. She has the advantage of youth. – It was good to see her immediately in her element here – clean air and a calm feeling about all one came into contact with – Nature.

I'm finally beginning to feel like a human a little bit at least. I'm even beginning to think some of photography in spite of being devoid of all ideas – But perhaps they will appear as I begin to tinker – O'Keeffe is painting diligently and beautifully. –

But how about you? How are you? – How is your "work progressing?" – New York seems very, very far away and we seem to have been away a long, long time. The quiet here is impressive – bird sounds occasionally – and the wind too sometimes. And two or three times during the day in the distance a locomotive announcing its coming. – The station is 1½ miles distant.

Summer has come. When we arrived it was cold. A much belated Spring – lilacs abloom for some days. Cold and gray weather. A dearth of rain. The soil craving moisture –

The old lone chestnut on the upper Hill still stands there but has completely died – truly a heroic figure may be I'll be able to get it down. – Most difficult. For years I've hoped to get down what I *see*. – Photographing in my sense is trying. It's an obstinate medium: In some respects an impossible one.

I have done some reading: Georg Brandeis's *Voltaire* – in German. Also Graf Keyserling's *Tägliche Reisebuch eines Philosophen*. – besides Ulysses (Joyce). A great combination – Then too, two little amusing booklets: Daedalus or Science and the Future by J. B. S. Haldane, and Icarus or the Future of Science by Bertrand Russell.

And some Blake naturally. –

Once again, thanks.

O'Keeffe joins me in sending you heartiest greetings.

<div style="text-align: right">

Cordially,
Stieglitz

</div>

<div style="text-align: right">

11 August 1924

</div>

Dear Liebovitz:

I was interrupted the other day. It frightens me to see the days slipping away and so little to show for them. They are busy enough days – tinkering and tinkering – with tiny prints. Several dozen are finally complete. Of these a few are real good. New forms – simple and big. – And old negatives of New York City – over 30 years old – printed for the first time. At times all this I'm doing does seem so childish to me – so unrelated to the so-called practical work! And yet what is that world? – I guess I'll have to go on my own way – childish or not. But it's a heartbreaking way nevertheless particularly since the big practical World's material I have to use for my work becomes less and less dependable, higher in price, and worse in quality – And I'm after quality – ever more quality in my own work. – Life properly seen is quality after all.

I'm reading Psychological Types by Jung. Zigrosser sent it to me. It's a close reading. So I take very small doses at a time. I still take in glimpses of Blake. But there isn't much chance for reading.

Although the summer is not over New York looms up nearer and nearer and I rather dread the Winter in that room at the Anderson. I try not to think of it although it is ever in the back of my head I know. –

I wonder have you ever heard from your French poet and painter [Jean-Marie Guislain] you brought to see me –

It's a great cool morning and I'd better utilize it. More and may be some printing. – Thanks for those fine letters. O'Keeffe joins me in heartiest greetings.

<div align="right">Cordially,
Stieglitz</div>

<div align="right">24 September 1924
Lake George</div>

Dear Liebovitz:

. . . O'Keeffe is painting hard and well. And I'm "skying." Also as hard as possible. At last a real clear sky – Cold and bracing – a cloudless burning blue sky – and the trees turning yellow and red fast – hard frost last night. I'm glad you're feeling more settled.

<div align="right">Our greetings–
Stieglitz</div>

<div align="right">26 August 1927</div>

Dear Liebovitz:

. . . At best there are not so many working years ahead of one – not in the kind of photography I do. And I do it solely to satisfy something in me for I never hope to realize anything on my work – nor even see it understood for many years – if ever – That does not disturb me in the least. May be there isn't sufficient there. Still I know there is. Something that has never been done – not even in the Orient. – In spirit perhaps. – Even yes. – Well fortunately I'm not worrying about myself. – But I do worry about others. Much of the worry is rooted in economic problems – their problems. – I take them over to keep their spirit free to crystallize in the form of – let's say a water color – or an oil painting – or a bit of sculpture – things I know terribly worth while. Emma Goldman hits the nail on the head in her letter to you. She sees. Has a real soul. Yes, there are other things in life but economic freedom. And its these other things Americans seem not to grasp – unless it be prize fighting, baseball – gold – etc. etc. – Anything pertaining to *Art* (in its fullest sense) they seem not to feel . . .

<div align="right">Our heartiest greetings.
Stieglitz</div>

<div align="right">27 June 1929</div>

But I have been through one hell of a time with myself. For a few days I felt I made [sic. might] go on the rocks, a nervous breakdown. – The strain of the Winter and Spring were much beyond my capacity – O'Keeffe's having to be away for her health – the long separa-

tion – all the uncertainty about everything in the future and I at best only having a few more years! Well I won't tell you – I think the crisis was passed yesterday. –

I am at One with myself again – I see more clearly than ever what I must do. – And O'Keeffe is doing so well that I'm really glad she is not here – hard it is for me in may ways as I am really free for the first time in years and could give her much time etc. etc. – She couldn't be happy here not permitting herself to be – besides which Lake George never braced her and Taos does. The 7000 feet she needs – and lots of sun. – And no invitations!!

I'm hoping for you and your play. – I am holding thumbs for you and that you got the Marin and Camera Work. –

I did have a great day here – 7 hours of grand fire – I dedicated a complete set of Camera Work to the flames. And all other numbers of C.W. here I just couldn't bear the sight of them any more. And I burnt up photographs, some very old which I had treasured, magazines, and clippings all related to my work – And there'll be more cremation. Also in town. – It's all very necessary. My "dream" I can never realize. – So why keep the diapers of the children?

Zoler is fine. – I'm glad he's here. I guess if he weren't here I'd burn down the house – And collect no insurance. Just clean up fully. –

But I'm tame once more –

Zoler wished to salvage much but I told him if he dared save a single thing he and I would separate. And he knew I meant it. It was a great fire burning into the Night. –

<div style="text-align: right">

Our greetings –
Stieglitz

</div>

Of the many letters written by Stieglitz and O'Keeffe when the two were separated from each other, these represent but a sample. Their letters during the decade range from descriptions of the small details of their daily lives to expressions of their emotional states. In general, Stieglitz wrote longer, more detailed, emotionally laden letters, while O'Keeffe's were more reserved and shorter in length. They often wrote at least once a day to each other, Stieglitz often several times a day, some letters being more than forty pages. When not hearing from O'Keeffe for several days, he tended to become upset. There are a number of letters from summer 1929, which was particularly difficult for him. His volatile temperament, as evidenced in the crisis he and O'Keeffe experienced, along with the vivid description of his burning his photographs and issues of *Camera Work*, is passionately described. The letters provide a poignant portrait of his deep interior being that was frequently in agony and turmoil. A final letter, from the end of the decade, to Rosenfeld, illustrates Stieglitz's many interests and sensitivities. [143]

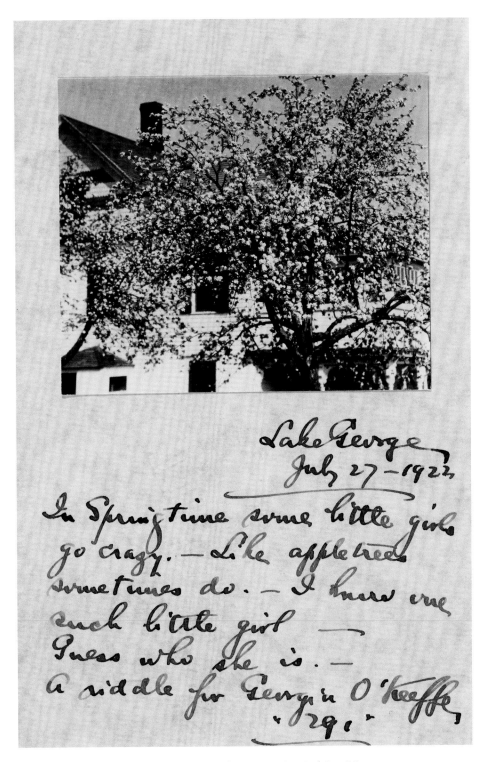

Lake George
July 27 – 1922

In Springtime some little girls go crazy. — Like apple trees sometimes do. — I knew one such little girl — Guess who she is. — A riddle for Georgia O'Keeffe "291."

177 Alfred Stieglitz, *Apple Blossoms*, 1922. The J. Paul Getty Museum.

Who is this maiden fair?
And why is she smiling?
May be, she sees a bird —
May be it's just a photo-
graphic smile —
Who is this maiden
with the raven hair?
What is hanging on the
line !? —
Nothing — oh Nothing
is hanging on the line —
except a Smile —

1924
/25
Lake George.

178 Alfred Stieglitz, letter to Ida O'Keeffe, 1925. Beinecke Rare Book and Manuscript Library.

[Stieglitz to O'Keeffe: 21 August 1921]

... at the station in Lake George I tried twice to get central on a public phone got no answer ... I guess I'll eat that fine lunch you prepared for me – but first a real big *kiss*. ... I'm full of food – very good saw your hands and face – *Sweet* – and the kitchen – I've completed reading the "Herald" smash of zeppelin, fire in Hoboken – smash on Wall Street – no murders or divorces but sporting news – I guess everything is "sporting" these days ... lots of love and lots of kisses.

[Stieglitz to O'Keeffe: 11 September 1923]

I looked out the window and saw a marvelous sight – a streaming down all a move in amazing shapes – I tried to photograph – but it was so dark – so impossible – And I watched a long while out of your window – and indescribable vision – And may Dear Great Wild Baby Woman behind that curtain like Brunnhilde behind the steaming vapors awaiting the Fearless One! The Pure One – For only He can be truly fearless for he does not know ... and the Lawrence book amazes me more and more as the clouds and you amaze me more and more.

[Stieglitz to O'Keeffe: 14 September 1923]

Many things are becoming clearer and clearer to me – I silently did my own work – finished up 13 little prints – clouds – 12 – one tree. It took me all day really. And after supper I developed a few snaps I made of the chestnut and of clouds – It was a great day for clouds – but I could not spend much time with them as I had decided I *must complete* "some clouds" before going on.

[O'Keeffe to Stieglitz: 14 September 1923]

Dearest – You are the nicest thing in the world. I really don't know how I was ever able to leave you – I don't quite understand how it is that I can stay away from you day after day except – that I felt I had to – to keep our togetherness clear. It's wonderfully quiet here [Maine] – The sea has been more beautiful today than any day – pure lovely color. It was very warm and lovely out but I picked away at my paintings ... I sat on the swing on the porch before supper – curled up with the pillows – I almost went to sleep – dreaming – day dreaming – of you and it came to me dearest you know the ocean wouldn't be wonderful to me the way it is without you. I can't imagine caring for anything without you. You have touched my soul ... I wish you would mail Mrs. S. a copy of the *Nation* with the Bertrand Russell article in it if you still have one – and one of Seligmann's number of M.S.S. She hasn't read any of the Lawrence book yet, but will get at it soon – I haven't read any of it – I seem to be letting myself drift along to whatever comes – The next thing will probably be new

attempts to capture the ocean – . . . Remember I will not feel right when I return or while I am here if you feel you are not being well cared for – You must be stirring up all the strength that the hill can give you . . . remember I can come at a moment's notice.

22 September 1923
Lake George

[Stieglitz to O'Keeffe]

Sweetest heart I'm down late this morning. It's a little after 8 – shaved and a clean shirt – . . . The night was not good . . . Tried to sleep and couldn't – Got up and walked about – Opened windows and closed them again . . . I thought of my sweetest one – I do feel we need each other, belong to each other – I know you wonder do I need you – as much as ever – perhaps a tiny bit more so I know you are by far the Whitest thing in life to me – and such Whiteness is perhaps the one thing I believe in – If Whiteness can't exist in this mad world we are living in I do not want to live. When once I realized that fully – if I ever can – I'm through . . . You may not be perfect but that means you are that much dearer to me and I wouldn't want you "perfect." I wouldn't dare to hold you so tight were you that – You dearest Far, Far Away One – I wonder do you feel a little like that about me. You'd put it differently, perhaps, but I know we do belong together . . . I'm going at my prints to clean up some and get them away . . . Rosenfeld is at work now . . . He is a perfect guest very unobtrusive . . . Grapes are ripe. Beck wants me to send you some, but I won't it would be silly – But I'll send you several baskets of kisses – and very wonderful ones – Very → Kiss ↑ . . . I love you. You smile . . . I'll stop – Be careful of yourself – And when you are ready to come – Come.

[Stieglitz to O'Keeffe: 14 April 1927]

. . . But somehow whenever I sense a bit of peace ahead – a crash appears instead – I try hard to avoid that seeming inevitability – not only for my own sake – but more really for yours – Maybe the 23 years' difference after all brings its own individual inevitability – I don't know – I'm too dazed to know – I do hope the quiet of the country will bring some clarity to you – I still feel you are arriving at very false values because of *personal* hurts due to things I do and don't do that I am unconscious of – are part of my makeup – idiosyncrasies perhaps – And I certainly am desirous of sparing you as much hurt as is in my power. Yet somehow I seem only to hurt you these last years – I must go to bed. Good night . . . I know that unfortunately the "perfect" is unattainable even in our own relationship which I know has been more wonderful than any relationship between any man and woman that I know of. It has produced much beauty and fineness for thousands and thousands of people. There is your work and my work as evidence of our Togetherness. If contemplating that

NATIONAL WOMAN'S PARTY
CAPITOL HILL
WASHINGTON, D. C.

LAWYERS COUNCIL
DEAN EMMA M. GILLETT, *Chairman*
MRS. ARTHUR KEITH, *Secretary*

Dearest One — It is a beautiful morning — I walked to the monument with a woman named something like Mona Lee — She writes poetry —

The monument and capitol are wonderful — I must paint them — No one has done it — That soft white shaft with its sharp triangle on the top — going way up into the blue past the clouds — making you dizzy is wonderful — and I've seen it grey and pink and lavender — It is wonderful always different

And the capitol all white against the night sky — Through bare trees and the lace curtains down stairs in the sitting rooms —

179 Georgia O'Keeffe, letter to Alfred Stieglitz, 28 March 1926, p. 1. Beinecke Rare Book and Manuscript Library.

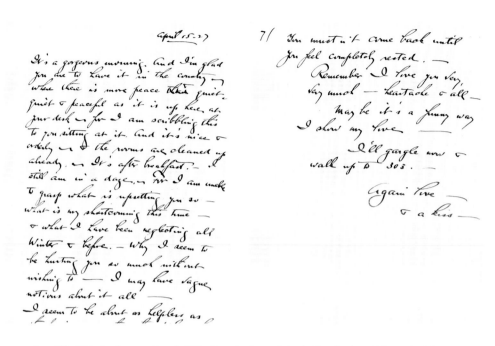

180 Alfred Stieglitz, letter to Georgia O'Keeffe, 15 April 1927. Beinecke Rare Book and Manuscript Library.

doesn't give you strength to find true values for yourself I can't see what will. My chief crime is my age with my infirmities – physical and otherwise. My spirit is all right enough – but – the carcass is certainly a sad drag to it – I don't know whether you'll be able to make out anything out of this hodge podge. I'm frankly without much life but I *must* clean up as much as I can – I really don't want to go to The Room . . .

[O'Keeffe to Stieglitz: 8 May 1929, New Mexico]
Dearest Boy – This is Mabel's paper that is on every table everywhere. It's the first time I've written on it. I think you should see it. [Paper contains line drawing with roosters and adobe buildings] – It's such a beautiful still morning – every morning since I left you husband still and sunny . . . A beautiful morning here means a sort of white morning. I can't say it any other way – And it seems so still I wish you could see it . . . I wish you could send her, Mabel, some books five or six – put in Ettie's *Love Days* and *They Are Incredible* and anything else you can think of, anything you think she would like to read – Her heart is bothering her . . . We are having a great time . . . Tony is much interested in your letters to me. He can't read but he thinks they're very nice to look at – I read them and then read them again – I'm glad you are being careful – I thought you would be – I dreamed about you last night. Many

people were about and I was waiting for them to go because I felt that when they would go, you would touch the center of me – And I wanted it . . . I must kiss you and go out to the sun . . .

[Stieglitz to O'Keeffe: 24 June 1929, Lake George]

It's just nine o'clock, night has set in for me – an hour I have poked the fire – and stood watching *Camera Work* and all else burn – five hours of burning. – The yellow flames – *Camera Work* burns a marvelous yellow – greets the stars as they appear it is wind still. And so silent – So pleasantly warm. – What a day it has been. – I don't quite see where my sudden energies have come from. – I have not rested all day. – Simply couldn't – I had an hours bath – windows and door open – No one in the house. Hot water first then very cold. Real pleasure. But not comparable to the burning – There are several more wheelbarrows full ready for the flames I may stay up and burn it all tonight. Begin tomorrow with a cleaner slate – I see much simplification in New York when I get back. Flames for many vaults of my stuff – Practically all *Camera Work* except a few bound sets. All must go and only in that way. I want no more out in the world – and many books will go too – and rafts of letters. And clippings. – It's all so clear – Negatives and prints too are in line everything that isn't satisfying to me – A marvelous cremation – now I'll go out – and pile in some more – the silence continues – it's perfect – It's not quite midnight – I'm so wide awake I hate the thought of bed. I'd like to go out on the lake now . . . but I daren't be too fool hardy. What a day this has been – what price we'll see. It makes no difference none is too high – the fire burnt merrily to a little while ago – and I have more ready for the morning . . . I wonder how much will be left when I decide to return to town to start cleaning up there – It's queer that I haven't a trace of feeling one way or another about it all – still there is a relationship between this and thirty years ago it will soon be that I left Lake George for New York to burn all diaries and all letters – What a terrible thought they might still exist – I see how wrong those were who said I should not have done what I did. And talked Freud and science and what not. I see it all in a very different light. – You have helped me to a new Clarity – and once again I am in your debt in a greater degree than ever . . . how still the night, I hear my heart beat as if it too were applauding what had been accomplished. It is a healthy heart beat. Good night. I hope it is another great night for you, it is a night of wonder here. Good night – a kiss.

[Stieglitz to O'Keeffe: 2 July 1929]

An hour with Bach with Beethoven – with Kreysler – Stokowski – a walk to and from the P.O. – a day so perfect – with wind and cool – the sky so clear – the trees swaying and singing – my day of rebirth – a great peace is within me – And you dear Child, so far away – A

different life entirely – receiving your own music – a life of speed – this so tranquil – so old fashioned I know I could walk Prospect [Mountain] . . . – 65! – I do not forget no matter how young I may feel again – I am not deceiving myself – I have no wish. Then no dreams. I am ready to except that which is – It's like the day – Above all hurt – Above that terrible torment in Self – Dearest Child! – As I listen to Bach . . . Thought of the machine on The Hill – The days and nights here on The Hill – The beautiful ones before the frightful mutual torturing – I felt I heard a chorus the likes of which was never heard before – By human mortals the stars you saw over head as you slept under them in Colorado could not have been more in harmony than the stars that are shining within me today. My Great great Child – For Child you are – an old Man, and very old I am. – There are the ages in you – there is a beginning in me. – And you too. – And now I'll go down to the Lake . . .

[O'Keeffe to Stieglitz: 3 July 1929]
Dearest – Last night I read most of your recent letters to Beck and myself several times. I've been sitting on the rug in front of the fire – when I got to the last one I just turned over and wept and wept. She just sat . . . What can I say to it all – you're being there alone and suffering alone – I am in such a rush and an uncertainty, for Mabel keeps us all unsure what we will do – . . . But just the same we are getting ready for the rodeo – . . . and between that and your letters I feel I am hanging in mid air

[Stieglitz to O'Keeffe: 10 July 1929, Lake George]
I have destroyed 300 prints today. And much more literature. I haven't the heart to destroy this [photograph of O'Keeffe and Stieglitz in deep embrace] Give it to Taos – To that part that no one can ever see! – Georgia! –

[O'Keeffe to Stieglitz: 17 July 1929]
Dearest Dearest . . . I can't have you going on this way – But I must have some nights out under the stars – If the stars will be kind enough to shine on me – I feel this long trip for you in the heat – even just to Chicago is too much – especially in your excited state – And I feel that in such a state coming to this altitude – in spite of doctors – is too much – . . . I am sure I am right about this . . . Forgive me for taking these few days in the mountains – I will be with you as soon as possible after that – Pete will make me a box for my paintings while I'm away . . . I had hoped to stay until some time in August anyway . . . I know we will work out something for next winter if you will just give yourself half a chance – But you will not be fit for anything if this keeps on – Maybe I should go to you without these days in the mountains – But it seems I just can't – It is that much just with that outdoors – And I seem to need it terribly . . . Please have patience with me – I hope it doesn't seem heartless to

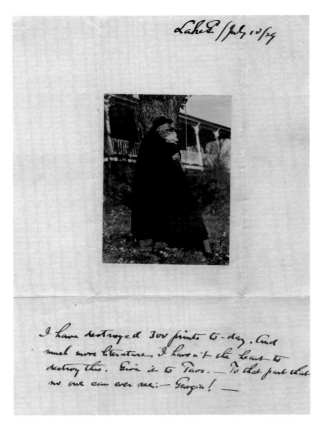

I have destroyed 300 prints to-day. And much more literature. I haven't the heart to destroy this. Give it to Taos. — To that part that no one can ever see:— Georgia! —

181 Alfred Stieglitz, letter to Georgia O'Keeffe, 10 July 1929. Yale Collection
 of American Literature, Beinecke Rare Book and Manuscript Library.

you – I wouldn't have been any use to you at all if I hadn't come away – Please please be very careful of yourself and very good to yourself till I come. I need you very much – And I know you need me – And all this carrying on is just too terrible – I will be there very soon. The moon carries you – Forward – A long quiet kiss – Holding you close till you sleep – Good night

[Stieglitz to O'Keeffe: 2 August 1929]

The telegram I read and reread. I could have yelled with joy. Yes Yes – Everything you say is right – Together – For ourselves – For everyone else – If we did not hold together, Kennerley, McBride and thousands of others would never believe in the possible togetherness of a Man and a Woman . . . Georgia, I love you – Yes – We together – I wrote this morning – So often without you I am dead. I have wired you – called up Beck and read her your telegram. I still can't believe its true really together again . . . I'd like to tell it to everyone. Tomorrow

is August 3 – a day in my life – Today is August 2 the greatest day in my life . . . It's fortunate you're not here – I'd smother you with love . . .

[Stieglitz to O'Keeffe: 4/5 August 1929 (midnight)]
Here I'm still up – The victrola going full tilt – Bach, Beethoven, Kreisler (Brahms) – now Parsifal – quite a concert in coat and cape. It's an icy night – in the 40's – could sit here all night and listen . . . The music I have here is all part of my early life – when I was saturated with music . . . the Canyon Days – my isolation after 291 – are very much on my mind – I crystallize nothing. But everything is there – constantly flowing – very still to rather rapid – like a flowing river with water very clear . . .

[Stieglitz to O'Keeffe: 5 August 1929]
You grand Woman – You say you are my Woman. Yes I know on Aug. 9th it will be 11? years that you gave me your virginity. During Thunder and Lightning. It's as if it were yesterday. It's a wonder I didn't give you a child! We were made to have one, but it was not to be. I realize how impossible such a child's chance would have been . . . You gave me your virginity. That's the reason you are my Woman for all Time. You are not like other women – and I am your man for all Time for I am not like other Men . . . you gave me your virginity. I couldn't have accepted it (or not taken it) hadn't I felt all was very right between Kitty, Emmy, and me. You know how "wrong" I eventually was . . . I love you my wild Georgia O'Keeffe. I'll never be able to hold you again – so I fear – But I really don't fear. It looks like snow. Nothing can surprise me – oh yes – something can – You. Beautiful surprises only – Lunch calls.

> Give me your body – let me kiss every inch of it . . .
> Remember you gave me your virginity – it still exists
> I kiss it – a kiss into Eternity – Do you feel it
> And still another kiss.

The sky is madder than ever outside . . . the wind is roaring mad. The house is empty. I like the feeling of aloneness without loneliness . . . The star – our star – even the stars themselves don't see it – our star – Give me your mouth in the starlight – give me your naked self in the starlight – I'll be naked too – we'll be together and go to sleep – we'll sleep embracing each other. And when the sun dispels the stars the world will sing a hymn which mankind is waiting to hear . . .

[Stieglitz to Paul Rosenfeld: 27 October 1929, Lake George]
Dear P. R.: *An Hour with American Music* arrived yesterday and I immediately sat down to read it. And I read it through and enjoyed it. It's the first real reading I have done in many

many months. My congratulations. – Its really very fine And I hope it will run into many editions . . . And you have said something no one has said before . . . The Caravan too is very solid – I have been running through its pages too the standard you have set is high – Congratulations to you and Mumford and Kreymborg . . . This morning Georgia and I had a dress rehearsal of my prints. – I don't know how she felt but they made me feel disgusted with myself. – I felt there was too little to show for the summer. – Of course I can find a million excuses why there hasn't been more – I can also tell myself that in view of conditions it is marvelous that I have done as much as I have – And a miracle that so much is so good – So I'm wondering what you'll find – At any rate you'll see a very grand O'Keeffe – Maybe several very fine ones – Of course I have a few very fine *Equivalents* – But I'm merely thinking of Work – time and opportunity – And many other things – the Past – and Present – Everything – Everybody And just at present I feel dangling between Heaven and Earth surrounded by beckoning Airplanes – the Darkroom – New York!!

The Hill is magnificently quiet and the landscape has been very wonderful and still is. – I hope it will be fine when you come. We'll be glad to see you. Of course the crash on Wall Street although "expected" stirs one – It is as if war were imminent with death peering from around the corner. One feels such a damn fool – And so helpless . . . – One is just dazed and ever wonders what *it's* all about – Life having a grand time – There is a wild wind blowing now – And night is fast approaching. – The poplars are bare – Excepting here and there still a yellow leaf glowing yellow against a dark sullen sky –

To think of New York when there is this is none too pleasant. Still I feel we must not give up all contact – I must continue – and so must Georgia. I'm curious to hear whether you have done much writing. – Georgia joins me in sending love. Ever your old, Al

I have been reading Wagner on Liszt. Do you remember what he says about form?

<center>*</center>

In the wake of the stock-market crash, and in the midst of the waves of bankruptcy, Stieglitz and O'Keeffe remained remarkably calm, despite their summer crisis, and remained convinced of the power of their own creative strength, individually and collectively. They continued onward in their work, relatively undaunted by the problems besetting the business community, and in December 1929, as mentioned earlier, Stieglitz's new gallery, An American Place, quietly opened.

The 1920s thus ended on the terrifying note of the stock-market crash. Yet the decade had brought a deepening of spirit on the part of many artists and writers, particularly for Stieglitz and his circle.

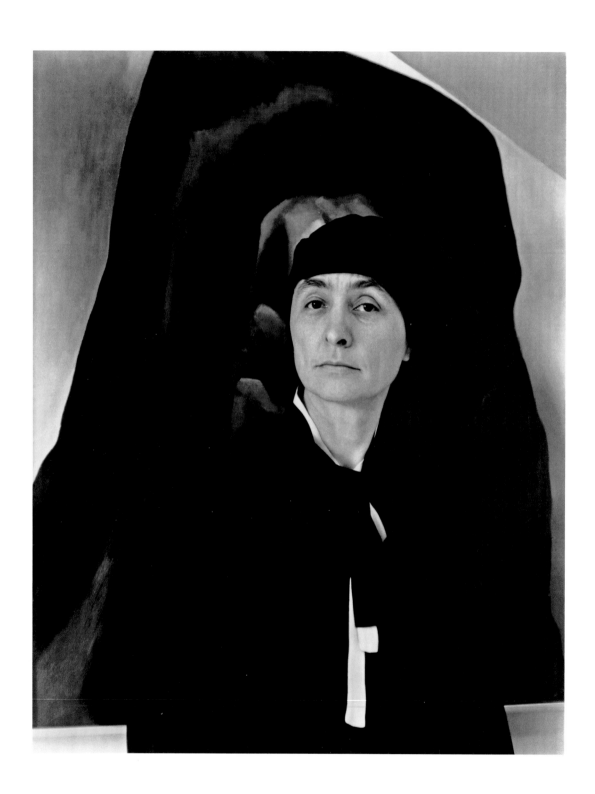

THE THIRTIES

... You ask what my attitude is. Man, can't you figure it out for yourself. I am trying to sustain life at its highest – to sustain a *living* standard. To let every moment *actually live* without any -ism or any fashion or cult attached to it. The Place is a Living Center even if deserted. Everything connected with it or found in it is rooted at its vital center . . . Is there no idea of nobility left in the world. Or does our Country not recognize that there is such a thing . . . I chose my road years ago – and my road has become a jealous guardian of me. That's all there is to it – I hate all sham and half business of any kind as I told you. But I refuse to sit in judgment. Everyone is his own judge as far as I'm concerned . . .

Stieglitz to Ansel Adams, 7 December 1933[1]

I have always been a revolutionist if I have ever been anything at all.

Stieglitz to Waldo Frank[2]

The 1930s became a darker time for Stieglitz as he aged and watched the world changing around him. His close association with some of the artists of the 1920s gave way to a more solitary existence with a less optimistic outlook than before. Stieglitz's own mood reflected to some extent the larger era of the Depression. Indeed, a number of artists such as Paul Strand felt that they had a moral responsibility to use their art to effect social and political change, a concept which Stieglitz found to be a corruption of any true expression of an artist's spirit. Thus Strand and Stieglitz went their separate ways by 1932 and the critic and writer Elizabeth McCausland parted company with Stieglitz when he criticized the Federal Art Project.

In March 1930, D. H. Lawrence died, at the age of forty-four. His death was mourned deeply by his admirers, including O'Keeffe and Stieglitz, both saddened by the loss of a prophetic voice calling for the freedom of a creative spirit that was passionate, sensual, and sexual, drawing from

182 Alfred Stieglitz, *Georgia O'Keeffe*, 1930. The Metropolitan Museum of Art.

man and nature. In the larger world, there was more widespread mourning as the dark cloud of the Depression set in. Industrial stagnation, bank failures, and rising unemployment brought despair to thousands of Americans. The Depression years were described in 1940 as "showing man as a senseless cog in a senselessly whirling machine which is beyond human understanding and has ceased to serve any purpose of its own."[3] Gone was the sense of individualism of the previous decades. Instead, there was a sense of social-mindedness and concern for economic and social salvation for the nation. More than ever did Americans seem to seek a cultural identity. Writers such as John Dos Passos, Erskine Caldwell, James Farrell, and John Steinbeck dealt more with problematic social environments. In 1939, Steinbeck completed his powerful *Grapes of Wrath*, depicting the ongoing struggles of the era's migrant-farmer family, the Joads. The novel was quickly made into a film in 1940. Among the poets, Archibald MacLeish wrote *Panic*, a radio drama about the crash, and Edna St. Vincent Millay in *Conversation at Midnight* turned to social and political themes. In drama, playwrights such as Robert Sherwood in *Petrified Forest*, Maxwell Anderson in *Winterset*, and Thornton Wilder in *Our Town* wrote of their time and people. Marxist communism, too, became more popular among the intellectuals. Frederick Allen wrote: "one man in three at a literary party in New York would be a communist sympathizer, passionately ready to join hands, in proletarian comradeship, with the factory hand or share-cropper whom a few years before he had scorned as a member of Mencken's 'booboisie'. . ."[4]

Public despair concerning conditions in America was epitomized in 1932 by heightened reaction to the kidnapping of Charles Lindbergh's child. Lindbergh had become a national hero with his transatlantic flight in 1927. Not only did domestic events threaten Americans' senses of security but so, too, did events abroad. In 1933, the Nazis burned the German Reichstag and Hitler was elected Chancellor of Germany. Gigantic staged rallies such as that in Nuremberg in 1933 became hallmarks of the growing totalitarian regimes abroad under Hitler, Mussolini, and Stalin. The filmmaker Leni Riefenstahl immortalized such rallies in her 1935 documentary, *Triumph of the Will*, recording the monumental 1934 Nuremberg rally for the Nazi Party. Stieglitz wrote enthusiastically to O'Keeffe on 19 September 1935 about seeing Riefenstahl's 1932 film, *The Blue Light*, for a second time with Rosenfeld, describing the beautiful chronicle of a young female free spirit, Junta, who guards a crystal grotto with magical blue light. In the end, the grotto is plundered by greedy villagers and Junta dies. It is likely that Junta represented, in part, the "spirit" Stieglitz fought for in his life and work.

With Hitler's rise to power the renowned Bauhaus school was forced to close completely by 1933, symbolizing the rise of Nazi interference with freedom of artistic expression in Germany. In 1937, Germany's modern Condor legion bombed the small town of Guernica in Spain, at the request of the Nationalist leader Franco, shortly after Civil War had broken out in Spain. This atrocity, killing approximately one thousand helpless civilians in the small holy Basque city, sparked international sympathies for the cause of "the people" and inspired Picasso to paint his

monumental *Guernica*. The painting's palette shows the influence of photography in its employment of the stark blacks, whites, and grays depicting the agony of human beings and animals, a statement against military brutality. After the Civil War, *Guernica* came to the Museum of Modern Art in New York, where Stieglitz could have seen it. Also in 1937, Hitler, seeking to establish the supremacy of German culture and Nazi racial and artistic policies, sponsored a commission to seize more than 16,000 modernist works from public collections. Many were sold or burned but some 650 works formed the core of his "Degenerate Art" exhibition, opening simultaneously with his Nazi-approved "Great German Art" show. More than two million visited the "degenerate" art exhibition while approximately 60,000 attended the state-sponsored show.

Stieglitz kept up with the news of the country he had loved as a student, through the newspapers and radio. He frequently wrote to O'Keeffe about his concern for what was happening in Europe and his wish to be able to get more detailed news. By September 1938, he was writing to her: "For I wonder what happened in Europe yesterday. Hitler and Chamberlain were to have their second meeting – 'Reality' versus 'Ideas' – Grim reality – How many on the Hill know the meaning of it? . . . I simply can't read anything except the newspapers . . ."[5] The following month he sent her several articles commenting on the threats of war and terrorism, as well as the potential dangers of Nazi domination of German education. An 11 October 1938 article by Walter Lipmann from the *New York Tribune* noted that Americans needed to take note of what Europeans were experiencing: "But Americans are not in the place of the Europeans and the essential difference is so great a good fortune that we must in honor realize that our failure to make the most of it by treating our problems with intelligence, good will and with hope would be the unpardonable sin."[6] The same day also featured an article, saved by Stieglitz, that described the dedication of the Squibb Institute for Medical Research in New Brunswick, New Jersey, by Dr. Abraham Flexner, the director of the Institute for Advanced Study at Princeton University. Under the headline, "Dr. Flexner Says, 'Lunatics' Ruin Reich Schools," Flexner wrote:

unless the world can be governed by the ideals of civilization, nothing can save it from ultimate destruction. If the destination of the efforts made in the great German research institutions are to be determined by madmen like Hitler and bullies like Mussolini, the world will sooner or later destroy itself. If the destination of these resources is to be determined by the spirit and ideals of the men who are enlisted in it, then we can look forward to a world in which peace and beauty and health and all the other good things of the human spirit may determine the conduct and the character of our lives.[7]

A day later Dorothy Thompson warned about the implication of terrorism in the modern world that could go on past the immediate concern about the horror connected with Hitler's recent annexation of Austria in March 1938 and the invasion of Czechoslovakia. Stieglitz wanted O'Keeffe to read her words:

The world becomes increasingly callous to means and tends increasingly to justify acts by the most perverse distortion and suppression of facts.

Our bodies are not being killed, but our minds are being corrupted and our eyes blinded.

It is hardly considered tactful in the midst of peace to raise the fact that five million Jews live in the territory which now comes under Hitler's sway, and these people, half the number of human beings killed in the great war, are being progressively submitted to the most inhumane, humiliating and inescapable terror.

Millions have paid for this peace, and will go on paying for it.

The attitude taken toward the events of the last month is important because it is profoundly symptomatic not only for Europe but for ourselves.

The human mind cannot live in a state of continuous division. Every act of terror which is approved and accepted prepares us for a new act of terror – not, perhaps from Nazi Germany but from other sources closer at home.

Slowly standards disintegrate to the point where they cease to exist. And then what we have is simply barbarism.[8]

Promises of change in the United States had come in 1932 with the election of Franklin Roosevelt and his subsequent New Deal legislation. In 1935, within the Works Progress Administration (W.P.A.), the Federal Art Project was begun, giving employment to artists. Much of the art for this project and by other artists in America consisted of social realist and American scene painting. Artists working in this vein included Thomas Hart Benton, Grant Wood, Raphael Soyer, and John Stewart Curry. Those such as Philip Evergood, Ben Shahn, and William Gropper conveyed political messages in their painting. The desire for the integration of art and life greatly increased. In 1930, Grant Wood painted his iconic *American Gothic*, depicting the austere midwestern farmer and his spinster daughter standing in front of a small Neogothic clapboard house. The painting, taken by some as serious, by others as satiric, expressed a regionalist consciousness and emphasized the lives of small-town, ordinary people.

During the Depression years the tradition of realism was revived and may be seen as an extension of the Ashcan School. Within the realist revival there were various areas of development. One focused on American scenes, in the city and in rural environments. Two such predominant painters were Edward Hopper and Charles Burchfield. Hopper's paintings of eerie street scenes and isolated houses depicted an ugly loneliness in American life. Many of Burchfield's paintings of the American landscape convey a sense of bleakness. Often, he portrayed the lifestyle of small midwestern towns about which Sinclair Lewis and Sherwood Anderson had written. More programmatic in approaches to regionalists and American scene imagery were painters such as Thomas Hart Benton and John Steuart Curry, who were aided by the conservative writings of

the critic Thomas Craven, who saw American history and mythology as a way to attack abstract and modern art.

The other form of American realism in the 1930s was a more strident social protest in the work of artists such as Ben Shahn, Jack Levine, and Philip Evergood. Shahn, one of the more prolific of the W.P.A. muralists, made a number of social and political statements. A large protest statement he painted in 1931–2 comprised a series of twenty-three paintings dealing with the Sacco–Vanzetti trial and execution. A number of black artists, too, emerged such as Romare Bearden and Jacob Lawrence. Black imagery was viewed as an extension of American scene painting and also as a form of social protest.

The Depression period brought a return to a more primitive type of expression, as evidenced in the work of Louis Eilshemius or John Kane. O'Keeffe greatly admired Eilshemius, who had studied at the Art Students League, as she had, and had abandoned his academic training. She wrote to McBride of a visit to see Eilshemius's work, "I have been at Eilshemius's. I saw St. Joan . . . Shaw and Strindberg made very deep impressions on me but not deeper, if as deep as my visit to Eilshemius."[9]

Yet not all of the art created in this decade was realist-oriented and socially minded. Artists such as O'Keeffe and members of the Stieglitz circle, who were part of the first wave of modernism before 1920, continued to paint much as before. Indeed, those artists "associated with Stieglitz retained their belief in the efficacy of individual enrichment over communal action and declined to participate in the W.P.A. Projects."[10] Other artistic directions of the thirties involved structural abstraction in the work of artists such as Josef Albers, Ilya Bolotowsky, Burgoyne Diller; expressionist abstraction – Milton Avery, Hans Hofmann, Willem de Kooning; or surrealism and magic realism – Peter Blume, Ivan Albright. The formation of the American Abstract Artists Organization in 1936 provided some support for artists moving toward abstraction. The group included Ibram Lassaw, Burgoyne Diller, Arshile Gorky, Stuart Davis, de Kooning, Alice Mason, and George L. K. Morris. There was a wide variety of abstract styles with constructionist, cubist, expressionist, and biomorphic elements in the work of these artists. The writings of some of these artists such as Stuart Davis and Balcombe Greene, who wrote for the radical journal *Art Front*, indicate that abstraction was seen as a moral force, as important as social realism. Indeed, the very activity of abstract painting was seen as an elevating force.

In the world of architecture William Van Alen's 1045-foot Chrysler Building, completed in New York in 1930, was briefly the tallest structure in the world. The glorious Art Deco style of the building with its nickel-plated steel radiator caps, eagle-faced gargoyles, and piercing tower, was a monument to its owner, Walter Chrysler, and, in a sense, a monument to American capitalism, far from the growing bread-lines of Americans out of work. Then, in 1931, the Empire State Building, designed by William Lamb from the firm Shreve, Lamb and Harmon, surpassed the Chrysler Building, soaring to approximately 250 feet. The remarkable structure was praised

for its lack of ornamentation and its sleek modernist lines, becoming an icon of modern architecture. Stieglitz and Rosenfeld visited the mighty building shortly after its opening and the former described their visit to O'Keeffe. It was "rather hazy, some sun. It's all overpowering; sometimes the city looks a bit ridiculous. The engineering staggers on. I'd like to go up some clear day with an electric storm coming along. We'll go up together now that I have started. We'll see it in different lights and season, etc."[11] The Empire State Building was further commemorated in the final sequence of the 1933 film *King Kong* where the giant ape is machine-gunned off the top of the grand building, as "beauty" supposedly killed the beast.

Further American technological achievements were celebrated in the 1936 Hoover Dam project and the Golden Gate Bridge, completed in 1937, becoming the largest suspension bridge in the world. Americans also looked to the past in their architectural monuments with the construction of the Lincoln Memorial and Mount Rushmore. They looked to the future with the world's fairs held in 1933 in Chicago and in New York in 1939. The New Deal and Roosevelt's various stimulus plans to provide work for Americans, such as the W.P.A. projects, had helped Americans become more confident by the end of the decade. Indeed, Stieglitz was asked by Holger Cahill, from the Museum of Modern Art, who had been made director of Roosevelt's Federal Art Project, to serve on an advising committee. Stieglitz wrote to O'Keeffe on 11 September 1935 about the project and request: "It's under the works Progress Administration. Whatever that may be. I don't follow all those myriads of experiments being made down there." He quoted Cahill's invitation in part: "We have the honor of inviting you to serve on the Committee . . . we feel confident that your participation will be of inestimable value to the program. And that in taking part in it, you will be participating in a constructive project beneficial to the American artist and to the public." Stieglitz continued to O'Keeffe, "I don't see that I can be of any use but I'll accept as I prefer Cahill to [others] and I'd like to see, if given a chance what is going on . . ."[12] On the following day he wrote her again that he had accepted the offer. It appears, though, that Stieglitz ended up doing little for the committee, although his willingness to accept the invitation suggests that he was more open to federal arts projects leading to social change than he is sometimes accorded.

At the 1939 world's fair, television was exhibited for the first time. By 1939, many New Yorkers had begun to revel in the beauty of its new structures. The George Washington and Triboro Bridges had been built. Rockefeller Center with its splendid R.C.A. building had been built with Paul Manship's giant golden *Prometheus* at its foot. Radio City Music Hall, with its huge stage framed by vivid colored lights, was part of what one writer termed "an unprecedented and never-equaled explosion of color"[13] in New York of the 1930s. The fair, covering approximately 1,216 acres in Queens, was brimming with optimistic exhibits related to transportation, production, communications, and medicine. Millions flocked to the fairgrounds to view displays from sixty nations (excluding Germany) celebrating the theme, "Building the World of Tomorrow,"

along with the giant structures created for the fair, a 700-foot obelisk, the Trylon, and a 200-foot globe, the Perisphere. With the repeal of Prohibition with the 21st Amendment in 1933, Americans had become free once again to celebrate events such as this as they wished.

Stieglitz and his circle had particular reason to celebrate when the World's Fair Commission named O'Keeffe one of the twelve most outstanding women of the previous fifty years, bringing press attention to O'Keeffe and Stieglitz's gallery. By 1939, more Americans were hopeful about the economy and hoped that the United States would stay out of a world war that was raging across the Atlantic as the Nazis invaded Poland on 1 September 1939 and the Russians invaded Finland in November. However, just before the fair closed, Paris fell in June 1940. Many Americans, including Stieglitz, then turned to listen to the now famous words of Winston Churchill, "we shall fight on the beaches, we shall fight on the landing grounds, we shall fight in the fields and in the streets, we shall fight in the hills; we shall never surrender."[14]

Despite the forebodings of world war and the Depression, Americans still also went to the movies. Stieglitz in his letters wrote fairly often of going, although he did not always name the films. He admired actresses such as Greta Garbo and Elisabeth Bergner. It seems that he went to a variety of foreign films, particularly French and Russian, during the decade, finding Russian films to be more "full-blooded" than French or American ones. He mentioned two in particular, the 1931 version of *The Brothers Karamazov* and the 1931 *Alone*, which he saw in 1937. The latter, noted for its musical score by Shostakovich, told the story of a young female teacher sent to a remote Siberian village, trying to overcome primitive conditions.

Stieglitz particularly noted two French films, René Clair's 1931 *A Nous La Liberté*, which opened in New York in 1932, and Jean Benoit-Lévy's 1933 *La Maternelle*, which came to New York in 1935. Both films dealt with social outsiders. In Clair's film two ex-convicts were depicted in well-designed prison and factory settings. By the end, the two cannot exist within their society and in the final fade-out they appear as tramps, happy in the freedom of the open road. The movie appeared to inspire scenes in Chaplin's *Modern Times*, although Chaplin denied this. *La Maternelle* was described by the *New York Times* critic André Sennwald, following its opening night in New York on 14 October 1935, as a film of "extraordinary insight, tenderness, and tragic beauty," depicting Montmartre's "tattered urchins of a day school. Without the rapturous squeals of the Shirley Temple school of baby drama, *La Maternelle* is a compassionate study of the sad-faced squalid children of the Paris slums who found daily sanctuary in la maternelle from the ugliness and terror of their lives at home."[15] Stieglitz and many Americans were particularly drawn to the young child, Marie, played by Paulette Elambert, who witnesses acts of cruelty and lust that destroy her sense of beauty and innocence, leading her to attempt suicide. Stieglitz could well have viewed Marie's purity and innocence as representing the purity of expression he sought to support in the artists he showed, and in his own creative work. In 1939, Stieglitz saw Sacha Guitry's 1938 *Champs Elysées*, a one-man history of France from 1617 to 1938. Stieglitz was

particularly interested in the era of the French Revolution and the concepts of Liberty, Equality, and Fraternity.

Stieglitz actively supported the film work of the young Henwar Rodakiewicz, whom he called, "an extraordinary rare soul . . . as sensitive and honest as anyone I ever know [sic]."[16] He showed Rodakiewicz's first experimental film at An American Place in 1931. The 1931 film, *Portrait of a Young Man in Three Movements*, was an abstract, non-narrative sequence of images without sound, beginning and ending with the sea rolling onto the screen. Its second movement focused on a leafy tree branch that gave away to images of the water, sky, and clouds. The only non-natural motions in the film are that of a machine at work but the emphasis was on the rhythms of nature and the shifting patterns of light and shade. There seems to have been some reciprocal influence between Stieglitz and Rodakiewicz, who would have seen some of the former's *Equivalents* and Lake George trees, while the cinematic sequences of the film gave rise to Stieglitz's continued experiments with series in his 1930s *Equivalents* and later Lake George imagery. Stieglitz and O'Keeffe both became close friends with Henwar, as they referred to him. When Stieglitz had his final stroke, Henwar was one of the few who remained at his bedside in silence for several hours before he died in 1946.

By 1939, film had claimed a strong foothold in United States culture, with the production of approximately 480 films, while, worldwide, approximately two thousand were released. The decade also boasted the first animated Technicolor film, Disney's 1933 *Flowers and Trees*, and the first animated feature film, Disney's 1937 *Snow White and the Seven Dwarfs*. In 1939, the most significant films were *Gone with the Wind* and *The Wizard of Oz*. When *Gone with the Wind* was premiered in Atlanta, the city declared a holiday. The epic movie won eight Oscars; its sweeping panoramic views of the countryside and last lines recalling the majesty of "Tara," the plantation, emphasized the role of the land and soil and that such would remain a resource and solace for the heroine, Scarlett O'Hara. As Tara was for Scarlett, so, too, on a similar scale, was the family Lake George property for Stieglitz, to which he returned each year. The *Wizard of Oz* depicted the colorful world of dreams and fantasy, as well as showing the influence of documentary photography in its black and white sequences that frame Dorothy's journey to Oz. It also emphasized the concept of "home" and "land," as Dorothy found herself back in her Kansas home with the now famous words, "There's no place like home."

On the dark side, the 1930s encompassed the economic traumas of the Depression, the dust-bowl storms, and the deep shadows of war, death, and destruction that loomed across the Atlantic. There were also individual deaths and events that marred the decade. In 1931, Thomas Edison died. As Stieglitz wrote to O'Keeffe, "Edison is dead – Queer how unsympathetic I always was toward him even as a boy – an extraordinary man of course but something lacking. – But I suppose everyone is lacking in one way or another. – Maybe the intuitive feeling that much that

was called Edison wasn't Edison at all, helped me anti [sic] as I did . . ."[17] He seems to be alluding to a "commercial" profile of Edison that did not necessarily capture a "true" Edison.

In 1930, Hart Crane's magnus opus *The Bridge* was published. The poem was an ode to Roebling's engineering feat in creating the Brooklyn Bridge and it became a symbol of how human creativity could connect the present to an antique past. Characters in *The Bridge* include Columbus, Whitman, Emily Dickinson, burlesque dancers, office workers, tramps, and Native Americans. As previously discussed, Stieglitz was a spiritual brother for Crane and had read parts of the poem before it was published. Crane had initially wanted Joseph Stella's modernist paintings of the bridge to illustrate the poem but reproduction rights were difficult to obtain. Instead, Crane's publisher chose photography by Walker Evans. Stieglitz and others applauded the publication but Crane could not fight off a sense of despair and in 1932 he committed suicide by jumping overboard on a ship returning to New York from Mexico where he had spent most of a year on a Guggenheim fellowship. Stieglitz was anguished by the terrible news of Crane's death in April 1932 and then, in August, learned that his friend, the 64-year-old painter Alfred Maurer, had hanged himself. Stieglitz considered mounting a memorial show of Maurer's work at An American Place but gave up when it appeared that Maurer's family wanted to ask unrealistically high prices for the works.

In 1937, thirty-six people died in Manchester, New Jersey as the luxurious German airship, the *Hindenburg*, exploded while attempting a routine docking. The radio broadcast was live as Herbert Morrison described the terrible explosion on 6 May 1937, losing his voice to grief at times, as he attempted to describe what he saw. That same year Amelia Earhart disappeared during a flight over the Pacific. The decade also brought the devastating hurricane of 1938 to the northeast. Stieglitz, always sensitive to meteorological conditions, and in many letters describing in colorful detail the weather conditions, wrote his *How the Steerage Happened* with the hurricane and threats of world war as backdrop. He wrote to O'Keeffe on 25 September 1938, "the New England coast was certainly hard hit by the hurricane. Still 250,000 telephones not working – Terrific devastation. Trains not running for several days from Boston. And the war situation still in suspense . . . wrote the story *How the Steerage Happened* long hand – certainly prefer to dictate – more of a swing . . ."[18]

The world was rocked at the end of the decade when on 3 September 1939, the Second World War began as Great Britain and France declared war on the German Reich. America passed a Neutrality Act, choosing to provide resources to the Allies but not send troops, until the invasion of Pearl Harbor in 1941 made it impossible to remain neutral. The background for Stieglitz's work of the 1930s was thus powerful. His continued belief in the power of individual and inner artistic expression did not waver. This chapter explores his work in the 1930s with the cultural influences and events that held significance for him.

Stieglitz's library holdings from the decade and his letters to O'Keeffe during that time illustrate, in part, his ongoing eclectic reading interests. One finds him reading the classical philosopher Santayana's *Realms of Truth*, part of a four-volume work on *Realms of Being* (1927–40); Thomas Mann's *Past Master*, writings on Wagner, and Mann's 1924 novel, *The Magic Mountain*. Mann's novel explores through the chronicle of the central character, Hans Castorp, diagnosed with symptoms of tuberculosis, and his years in a sanatorium in Davos, high in the Swiss Alps, issues of life and death, time, and space. The mountain serves as a kind of metaphor for a place distinct from the "flatland" of business and society. It also appears to have some reference to the Venus Mountain (Venusberg) that appeared in Wagner's opera *Tannhäuser*, which Stieglitz had seen numerous times. There the mountain is a kind of magical paradise of desire and abandon where visitors lose all sense of time. Castorp, as Stieglitz, loved music, and was deeply affected by it.

The character of Julien Sorel in Stendhal's 1830 *The Red and the Black*, which Stieglitz was rereading also attracted him. Stendhal's novel, in part, was a satire of French Restoration society with its emphasis on materialism and hypocrisy. Sorel, trying to rise above his plebeian birth, becomes a pawn of the manipulative political world around him and his passions bring about his downfall as he searches for some kind of meaningful truth that involves *la force d l'âme* or power of the soul. The novel's epigraph read "Truth, the bitter Truth." Just before his execution, Sorel speaks: "I have loved truth . . . where is Truth . . . Everywhere hypocrisy, or at least charlatanism, even among the virtuous, even among the greatest . . ."[19] Such words would have resonated with Stieglitz in his own search for truth. As he had noted in the catalogue for his 1921 exhibition of his photographs, "Photography is my passion. The search for Truth is my obsession."

Stieglitz also read the British poet Algernon Charles Swinburne (1837–1909), for whom he, no doubt, had some sympathy, since Swinburne was attacked for his sexually charged passages and departures from generally recognized standards of poetry for the times. D. H. Lawrence continued to affect Stieglitz, who owned the 1930 first edition of *A Propos of Lady Chatterley's Lover*, where Lawrence expressed his frustration with the controversy over the novel, explaining why he wrote it and its reflections on the role of sexuality. Lawrence's passage on marriage seems to mirror to some extent Stieglitz and O'Keeffe's own perceptions about marriage and its connection to a larger, sensual world of nature:

> Marriage is the clue of human life, but there is no marriage apart from the wheeling sun and the nodding earth, from the straying of the planets and the magnificence of the fixed stars. Is not a man different, utterly different, at dawn from what he is at sunset? And a woman too? And does not the changing harmony and discord of their variation make the secret music of life? . . .

Two rivers of blood are man and wife, two distinct eternal streams, that have the power of touching and communing and so renewing, making new one another, without any breaking of the subtle confines, any confusing or commingling. And the phallus is the connecting link between the two rivers, that establishes the two streams in a oneness, and gives out of their duality a single circuit, forever. And this, this oneness gradually accomplished throughout a life-time in twoness, is the highest achievement of time or eternity. From it all things human spring, children and beauty and well made things; all the true creations of humanity.[20]

For Lawrence, as for Stieglitz, sexual union was an important component of artistic creation. Stieglitz's interest in sexuality and his belief in the sexual act as a powerful expression of a universal life tone is further seen in his collection of books on sexuality. He owned the complete set of the British psychologist, Havelock Ellis's works and *The Sexual Life of Savages* by Bronislaw Malinowski. Further he owned Dr. Ivan Bloch's privately printed 1933 book, *Anthropological Studies in the Strange Sexual Practices of All Races in All Ages, Ancient and Modern, Oriental and Occidental, Primitive and Civilized*, translated by Reese Wallis.

Lawrence had visited and reportedly had an affair with the wealthy socialite Mabel Dodge Luhan following her move to Taos, New Mexico, where she became a self-proclaimed hostess of a utopian artists' community and married Tony Luhan, her fourth husband. Among the visitors to Luhan's place besides Lawrence were Toomer, Ansel Adams, John Marin, Maynard Dixon, Laura Gilpin, Weston, Jung, Rebecca Strand, and O'Keeffe. In 1935, Luhan completed her partially autobiographical novel, *Winter in Taos*, which included photographs by Adams, Van Vechten, and Weston. The novel told the story of a Pueblo Indian man and white woman, mirroring Mabel and Tony, establishing a new utopian community. Stieglitz and O'Keeffe were both friendly with Mabel Dodge Luhan and praised the book. She inscribed a first edition copy to them both, shortly after it was published.

While Luhan held her salons in the United States, Gertrude Stein continued to hold salons in Paris. In 1933, she completed her memoirs, *The Autobiography of Alice B. Toklas*, which Stieglitz read and enjoyed, but it generated protests about inaccuracies related to the contemporary art scene in Paris. Two years later, *Transition* magazine published "Testimony Against Gertrude Stein," with contributions from Braque, Matisse, André Salmon, Maria Jolas, Eugene Jolas, and Tristan Tzara, among others. The writers claimed that Stein was not as influential in shaping the epoch as she described. Continually interested in struggles such as this, Stieglitz made sure to buy the issue. He tended to look toward figures such as Stein who were trying to make a mark in society. One such was Vincent Sheehan, the war correspondent, whose personal history based primarily on experiences with the Spanish Civil War Stieglitz read (it was later used for Alfred Hitchcock's 1940 film, *Foreign Correspondent*). He also read the 1931 *Noguchi* by the writer Gustav Eckstein, who frequented Stieglitz's gallery. Stieglitz enthusiastically described the book being displayed in bookstores. He sent O'Keeffe a long article from the 2 May 1931 issue of the

Herald Tribune that described the significant contributions Hideyo Noguchi had made in research about trachoma, yellow fever, and polio. Noguchi was considered a bright international star, rising from an impoverished home in rural Japan to work for the Rockefeller Institute in the United States. In 1928, Noguchi had died from yellow fever himself, while working in West Africa.

That same year, 1931, the young cultural critic Lewis Mumford published one of his best-known works, *The Brown Decades: A Study in the Arts in America 1865–1895*. As noted peviously, Stieglitz was drawn to Mumford, as to Anderson, Frank, and Rosenfeld. Mumford inscribed a first edition of the book, "To Alfred Stieglitz/who provided a proper/conclusion to the/Brown Decades and who laid fresh/foundations for our/own/Lewis Mumford/24 December 1931."[21] He argued that the architectural achievements of those such as Henry Richardson, Louis Sullivan, and John Root late in the nineteenth century were significant in providing a bridge to the twentieth century. Mumford wrote for the *New Republic*, joined the staff of the *New Yorker* in 1931, and wrote weekly columns from 1932 to 1937. He and Stieglitz, who was thirty years older, met in 1924 through Rosenfeld. As Robert Wojtowicz has noted, "No account of Mumford's formation as an art critic is complete without mention of . . . Alfred Stieglitz. Mumford and Stieglitz, however, seemed almost perfectly attuned in their mutual quest to uncover a genuinely American artistic expression, with the former encouraging the latter to expand his outlook on modernism and the role that Americans were to play in its evolution."[22] In turn, Stieglitz gave Mumford works by O'Keeffe and Marin and Mumford wrote numerous reviews praising Stieglitz and the artists in his circle, frequently emphasizing the older man's prominent role in a growing and changing New York.

In 1934, the year Stieglitz turned seventy, Mumford and his colleagues Waldo Frank, Dorothy Norman, Rosenfeld, and Harold Rugg, a civil engineer and professor of education at Columbia Teachers College, edited a celebratory illustrated book, *America and Alfred Stieglitz: A Collective Portrait*. The twenty-three other contributors included Marin, Dove, Hartley, Gertrude Stein, Anderson, William Carlos Williams, Paul Strand, Toomer, Dorothy Brett, and Demuth. Artists whose works were illustrated included the photographers David Octavius Hill, Julia Margaret Cameron, J. Craig Annan, Langdon Coburn, Hans Watzek, Hugo Henneberg, Heinrich Kühn, Clarence White, Gertrude Käsebier, Strand, Steichen, and Stieglitz, and the artists Rodin, Matisse, Brancusi, Picasso, Maurer, Dove, Toulouse-Lautrec, Hartley, Demuth, de Zayas, Cézanne, MacDonald-Wright, O'Keeffe, and Gaston Lachaise. As the editors of the volume wrote in their introduction, "And this book we feel is significant, perhaps, in that it reveals this world through the collective portrayal of a contemporary whose life has been an incarnation, singularly perfect, of the struggle toward truth, an incarnation indeed, in humble modern form, of Man . . . and in American terms and on American soil."[23] A sacred tone was set by the choice of two Biblical quotations immediately following the title page, one from Isaiah 32 : 2–3

alluding to Isaiah's anticipating an ideal kingdom where the people will no longer be blind or deaf, which appeared to make some analogy to Stieglitz's helping people to "see" and being a "modern prophet." The passage from John 12 : 24 seems to anticipate the death of Jesus and his sacrifice for humankind and that only through death will there be "much fruit." These quotations give an added dimension to the volume, as sacred and secular become intertwined and Stieglitz is elevated to the realm of prophet and seer. Forty years later, Dorothy Norman wrote a preface to a new edition of the book in which she emphasized Stieglitz's passionate search for truth:

> Stieglitz was a man in love with truth. It shocked him that the world rebelled against the telling and hearing of the entire truth . . . He challenged people to say and feel what they really saw and felt, rather than what they thought they should see and feel . . . He expected nothing of others save that they tell him the truth, without fear: "Only by telling each other the truth can we help one another . . . the goal of the artist is to be truthful and then to share that truthfulness with others."[24]

The book's essays in general may idealize and idolize the role Stieglitz had played in American culture but, nonetheless, the language of the writers is articulate, passionate, and poetic. In some essays, they attempted to place Stieglitz in a historical continuum, leading to a new world order and culture. One writer, Victoria Ocampo, a native of Argentina, Dante scholar and architect, wrote of her finding An American Place as a special oasis for those who sought cultural nurturing, those who were exiles from Europe in America, or "who stifle in Europe because we already bear in us America."[25] The book was chosen by Carl Van Doren as the Christmas selection for the Literary Guild, with an edition of 30,000 copies. However, it also inspired a diatribe of responses to the authors' worship of Stieglitz. Edward Alden Jewell, writing for the *New York Times*, referred to An American Place's "atmosphere of incantation and pseudo-mystical brooding upon the thisness and thatness of life and the human soul . . . befogged by clouds of incense and bemused by an endless flow of words."[26]

Thomas Hart Benton, the regionalist, conservative painter, also ridiculed the book, writing an essay, "America and/or Alfred Stieglitz," published in the left-wing periodical *Common Sense*. According to a modern author, Benton's criticism "represented the completed transformation of American cultural nationalism from a set of potentially radical assumptions into a nostalgic anti-intellectual theory which endorsed a fiercely anti-modernist art movement . . . At the center of Stieglitz's world lay a deeply felt connection that culture was power. Believing as he did that art and life were truly synonymous, Stieglitz could not comprehend what critics meant when they charged him with supporting art for art's sake . . ."[27]

Other writers such as E. M. Benson noted that Stieglitz's audience had changed, that he had not kept up with the times, and that the birthday volume had made him appear too omniscient,

almost a Christ figure. "What one took for wisdom in 1905 sounded pretty flat in 1925, and sounds flatter still in 1935. It wasn't Stieglitz who had changed, but his audience . . . In short, Stieglitz didn't keep up with the parade."[28]

Setting aside the criticisms, the book reflects Stieglitz's ability to inspire a sense of community, to imbue in his fellow writers and artists a deep sense of purpose and hope for the future that would honor American culture and creativity, as well as become a building block for other true creative expression. The structure of the book, a "collective portrait," from interdisciplinary viewpoints, is in many ways more like a cubist collage than a traditional portrait, forcing the reader to think in layers and pierce beneath the surface, beyond traditional narrative essay styles.

Mumford's contribution, "The Metropolitan Milieu," was later reprinted in two collections of his writings, *City Development* in 1945 and *The Human Prospect* in 1955, each with additional material. The 1945 version contained a new introductory section that perhaps illuminates more moderately Stieglitz's role in New York in the 1930s:

> Stieglitz's integrity and his concentration upon essentials, his implacable refusal to be diverted by the trivial or the loudly advertised or the pseudo-good, give his personality a unique place in the development of the city. When all its shiny splendors have been reduced to their proper significance, when its inflated values have fallen, when the city itself finally saves itself by re-grouping in units that have some relations to the human scale, there will still be this to be said for the expansive New York of Stieglitz's generation: it produced an Alfred Stieglitz.[29]

MUSEUMS, GALLERIES, AND PHOTOGRAPHIC ORGANIZATIONS

Stieglitz's significance in New York's development is to be seen further in his gallery work and his own photographs of the city's buildings and skyline. The decade opened with an exhibition at the Museum of Modern Art, "Paintings by Nineteen Living Americans," continuing into the new year from its opening on 13 December 1929. O'Keeffe was included and she and Stieglitz kept a first edition copy of the catalogue. Then, in November 1931, there were two openings of art institutions in New York – the Julien Levy gallery and the Whitney Museum of American Art. The opening of Levy's gallery marked the establishment of another advocate for photography. Levy had become interested in film, photography, and contemporary art while an undergraduate at Harvard. He had frequented Stieglitz's gallery and with Duchamp's encouragement had gone to Paris to study the avant-garde there. His gallery at 602 Madison Avenue opened with a retrospective of American photography, about which he had written to Stieglitz, seeking his advise: "I am more anxious for your approval than that of any man I know. My summer in Europe was both very busy and exciting . . . I have almost an excess of material for the year and

all my exhibitions are planned except the first. For that I am anxiously awaiting your orders."[30] That first season Levy's photography shows included solo exhibits by Atget, Berenice Abbott, George Platt Lynes, Man Ray, and Lee Miller, as well as surveys of New York photography, modern European photography, and portrait photography. Levy's photographic exhibits, along with those such as an international survey of photography and the "42nd Annual Exhibit of Pictorial Photography" at the Brooklyn Museum, "Photographs of Art Forms in Nature" by Blossfeldt at the Weyhe Gallery, and in Oakland, California, the founding of the f/64 group (including Adams, Imogen Cunningham, Van Dyke and Weston), establishing the importance of "straight" photography, helped confirm the power of the medium of photography as an art form. Helen Appleton Read, writing for the *Brooklyn Daily Eagle* on 22 May 1932, noted "the growing recognition . . . that photography could be ranked as an art and not a soulless mechanical expression," and "that the Julien Levy Gallery of Photographs . . . was the crowning event of the season."[31]

Levy later wrote of Stieglitz in his memoir, "Like the Ancient Mariner, with his glittery eye and skinny hand . . . Stieglitz had his will with everyone, for who could choose but to listen when he talked, like a spell-bound three year old?"[32] He tried to convince Stieglitz to buy some of the work of photographers he was showing, such as Atget and Henri Cartier-Bresson (he introduced the work of Bresson to the U.S.), and recalled that it was "very funny to see Stieglitz finally open his mind, particularly to Cartier-Bresson, which was exactly the opposite of what Stieglitz stood for."[33] Stieglitz, with his emphasis on a well crafted composed image, was not as quick as Levy to embrace the more spontaneous aesthetic of Bresson's hand-held camera. In some ways, Levy was taking over where Stieglitz, in his later years, would leave off, no longer supporting new photographic talents. Besides showing Adams and Eliot Porter in 1936 and 1938 respectively, Stieglitz had not shown a strong commitment to new photographers since Strand, whose work he had shown in 1917 and 1929.

Besides the Levy gallery, there was one other small gallery, the Delphic Studios, located at 9 East 57th Street from about 1920, that was committed to the exhibition of photography, along with other works, in the thirties. The gallery was run by Alma Reed, who also showed contemporary Mexican art. Her interests in photography ranged from late pictorialism (Clara Sipprell and Doris Ulmann), to the elegant portraiture of Cecil Beaton, the work of the young Adams, to Weston's close-ups of shells, vegetables, rocks, roots, and so on. Reed's exhibits of Weston's work in 1930 and 1932 captured the attention of other photographers and critics such as Steichen, Sheeler, Steiner, and Lincoln Kirstein. In 1931, she hosted the first solo exhibition of László Moholy-Nagy in the United States. As one writer later noted,

> Sheeler's and Weston's aesthetic owed much to Stieglitz, of course, but both had parted from him in the early twenties. Then resistance to Stieglitz's overbearing personality and to his romantic notion of subjective equivalence strengthened their own alliance and brought them

closer to Steichen, who had long before withdrawn from Stieglitz's inner circle. Steichen and Weston, not Stieglitz, were asked to organize the American section of 'Film and Foto' [1929] and echoes from that exhibition placed Sheeler's River Rouge series at the pinnacle of American achievement. Until the mid-thirties, when Evans and the younger generation emerged, Steichen, Weston, and Sheeler were perhaps the most prominent photographers in the United States.[34]

Lincoln Kirstein also served as a pioneer in sponsoring photography exhibitions, such as the Harvard Society for Contemporary Art's extensive show in 1930, involving European and American photographers including Stieglitz, Strand, Steiner, Sheeler, Abbott, Evans, Weston, Steichen, Man Ray, Bourke-White, Moholy-Nagy, Anton Bruehl, and Cecil Beaton. Included, too, were utilitarian photographic images such as astronomical and aerial views, press photographs of accidents, and medical x-rays, thereby drawing together artistic and purely documentary photographic imagery, which lifted American photography into a larger international context. The Harvard show was also seen at the Wadsworth Atheneum in Hartford later that year. Inspired by Kirstein, George Washburn, a Harvard colleague of Levy and Kirstein and the acting director at the Albright Art Gallery (later, the Albright-Knox Gallery), mounted "Modern Photography at Home and Abroad" in 1933, while the Brooklyn Museum showed its "International Photographers" the same year. Washburn had hoped to include Stieglitz and Strand in his exhibition but neither they nor several collectors would agree to loan works for exhibition, feeling that the works should be bought for the collection of the museum. Strand wrote thus to Nora Christensen, the educational director of the Albright, in January 1932:

> The whole system seems to me to be futile and destructive, and I do not wish to be a party to it. But I am interested in the Gallery's photographic collection for it has . . . a nucleus to build upon which no other museum anywhere possesses . . . Stieglitz's and my work . . . is not available for general temporary exhibitions but should be in the Museum's permanent collection.[35]

Stieglitz, separating himself from such temporary shows, decided in 1932 to put on a forty-year retrospective of his own photographs at his new An American Place at the same time as the other larger exhibitions. I shall discuss this retrospective and other shows there shortly.

Kirstein continued to wield influence, becoming appointed to the Museum of Modern Art's advisory committee that included Edward Warburg, John Walker (also directors of the Harvard Society for Contemporary Art), Philip Johnson, James Johnson Sweeney, and Nelson Rockefeller, Jr. Two exhibitions that he curated featured photography – "Murals by American Painters and Photographers" in 1932 and "Photographs of Nineteenth Century American Houses by Walker Evans" in 1933. Evans became particularly noted for his photographs taken for the Farm Security Administration (F.S.A.), headed by Roy Stryker and begun in 1935, as part of Roo-

sevelt's W.P.A. New Deal programs. Along with Evans, Stryker hired photographers such as Dorothea Lange, Shahn, Arthur Rothstein, Russell Lee, Jack Delano, Marion Post Wolcott, and John Vachon, to photograph local scenes throughout the country, primarily documenting conditions of the Depression. Evans's portraits of rural southern families struggling to survive, such as those that appeared in his collaborative project begun in 1936 with the writer James Agee, *Let Us Now Praise Famous Men*, published in 1941, or Dorothea Lange's 1936 "Migrant Mother, Nipomo, California," became icons for the era and were used to portray an American past and Americans struggling to survive with dignity and perseverance, in the hope that these documents might lead to social change. For Evans and others, Stieglitz had become "somebody to work against." As Evans wrote, Stieglitz "was artistic and romantic. It gave me an aesthetic to sharpen my own against – a counter-aesthetic."[36] In 1938, the Museum of Modern Art devoted its first photographic monograph, *American Photographs*, to Walker Evans, with an introductory essay by Kirstein. Many of the photographs for that book were taken in 1936 for the F.S.A. Social change through photography was becoming an increasingly prevalent and popular idea, as mass-circulation picture magazines such as *Life* and *Look* were born in 1936 and 1937. The first issue of *Life* appeared on 23 November 1936 with a cover story about construction workers on the Fort Peck dam in Montana and a striking photograph of the dam by Margaret Bourke-White on the cover. Henry Luce stated *Life*'s mission was "To see life; to see the world; to witness great events . . . to take pleasure in seeing; to see and be instructed; thus to see; and to be shown, is now the will and new expectancy of half of mankind."[37]

The 1930s saw the rise of the photobook which included text and images as documentary "evidence," and among which stand out Margaret Bourke-White and Erskine Caldwell's *You Have Seen Their Faces* (1937), Dorothea Lange and Paul Schuster Taylor's *An American Exodus* (1939), Archibald MacLeish using F.S.A. photographs in *Land of the Free* (1938), or Richard Wright using Edwin Rosskam's selection of F.S.A. photographs in *12 Million Black Voices*, finally published in 1941. Containing more images than text was Bernice Abbott's 1939 *Changing New York* with brief captions by Elizabeth McCausland. Shooting with a large 8 by 10 camera, Abbott traveled throughout the city in cooperation with the Federal Art Project, from the mid- to late 1930s, to document a changing New York, recording store fronts, tenements, and street vendors, as well as celebrating technological accomplishments in many of the images. One sees, for instance, the cable towers of the Brooklyn Bridge juxtaposed with access to the Pennsylvania and Baltimore and Ohio Railroad lines, along with a cart with wooden wheels and barrel in one image. McCausland's caption read: "The cable towers of the bridge stand 272 feet above high water, to support the main span of 1600 feet. Sunk deep in the East River by virtue of the Roeblings' heroic struggles with . . . Caissons disease . . . the towers withstand the stress of approaches reaching to City Hall Park, Manhattan, and to Sands and Washington Streets, Brooklyn, a total of a mile and a sixth."[38] The images were shot from a variety of perspectives, many depicting the

tempo and life of the city, others being architectural studies of new and older buildings. Unlike many of Stieglitz's New York images from the decade, which often appear cold and formal in presentation, Abbott's contain a warmth and sense of real presence. As a photographer, following examples of Brody and Atget, she appeared to be genuinely engaged in the life of the city, even though she had only returned to New York in 1929 after eight years in Paris. The Museum of the City of New York showed Abbott's work in 1929, along with comprehensive one-person shows in 1934 and 1937. Stieglitz, in contrast, appeared to distance himself from the life of the city as he shot images from the upper floors of his gallery and apartment buildings.

In 1936, the Photo League, a leftist organization devoted to social issues, was formed. The group included older photographers such as Lewis Hine, Strand, and Weston along with younger photographers such as Helen Levitt, Adams, Lisette Model, and Richard Avedon. By 1936, though, in general, photography exhibitions in New York were limited. Stieglitz showed Adams (discussed later) at An American Place and Levy showed Atget but photography was becoming more harsh to sell in the difficult economic climate.

The Museum of Modern Art, however, continued to try to include photography in its exhibitions, wanting to be known as a museum that catered to a variety of media. Thus in 1936 two large-scale exhibitions, "Cubism and Abstract Art" and "Fantastic Art, Dada, and Surrealism," included film and photography, primarily European artists with the exception of Joseph Cornell and Walker Evans. The cubist show included many of the artists Stieglitz had shown at 291 such as Picasso, Brancusi, Braque, Cézanne, Duchamp, Matisse, Picabia, and Severini. That year, the Modern also mounted a major John Marin retrospective to which Stieglitz, with his wariness about large arts institutions, hesitantly loaned 160 watercolors, 21 oils, and 44 etchings and supervised the hanging. Stieglitz's influence had been also perhaps indirectly seen in MoMA's 1934 "Machine Art" show, which celebrated industrial design and mass-produced objects, displayed as sculpture. The show, a collaborative project of Alfred Barr, Jr., and the architect, Philip Johnson, used a quotation from one of Plato's later dialogues, the *Philebus*, as a major wall text and in the show's accompanying catalogue. The quotation read, "By beauty of shapes, I do not mean as most people would suppose, the beauty of living figures or of pictures, but to make my point clear, I mean straight lines and circles, and shapes, plane or solid, made from them by lathe, ruler, or square. They are not, like other things, beautiful relatively, but always and absolutely."[39] Stieglitz had used a somewhat different translation of this passage in his October 1911 issue of *Camera Work* alongside the illustration of Picasso's cubist charcoal drawing, *Standing Nude* of 1910, and again in 1913, in the brief catalogue accompanying Picabia's show at 291. The version that Stieglitz used stated that pure forms "are not beautiful for a particular purpose as other things are, but are by nature ever beautiful by themselves."[40] In both versions, a case is made for the power of formal elements and the role that abstraction could play in artistic expression.

In 1937, the Museum of Modern Art mounted a major photography retrospective, "Photog-

raphy 1839–1937," curated by Beaumont Newhall. To plan the show, Newhall had asked Stieglitz to be on an international board of advisors as a principal member along with Moholy-Nagy and Charles Peignot, who published *Arts et Métiers Graphiques*, devoted to contemporary French photography. Stieglitz considered Newhall inexperienced, refused to participate, and only agreed to lend some *Camera Work* photogravures for the exhibition, which filled the four-story townhouse that the museum then occupied on West 53rd Street. In general, the retrospective was widely praised, although Mumford strongly lamented the absence of Stieglitz's most recent work and noted that a number of the works were more valuable as historical than as artistic achievements:

> More than half the prints in the present show have greater significance as historical landmarks than as aesthetic achievements. A David Hill, an Atget, or a Stieglitz is a rare bird . . . a landscape by Paul Strand or Edward Weston, a building by Steiner or Sheeler, a torso by Steichen, a portrait of Sinclair Lewis by Man Ray, a street scene by Bernice Abbott or Walker Evans are all significant contributions to the art. But to single out these American names from a much longer list is a little invidious, especially because the most important photographer, Alfred Stieglitz, is not represented in this show by any of the work he has done during the past twenty-five years. An amazing omission that at least called for explanation in the catalogue.[41]

Stieglitz refused to attend the exhibition, which also traveled on a smaller scale throughout the country. The first edition of the catalogue for the show sold out. For the second edition Newhall asked Mumford to approach Stieglitz to include at least one of his images in the reprint. Mumford thus wrote to Stieglitz,

> What prompts me to write at the moment is the letter I am enclosing which I think sufficiently explains itself. [I] add my own very earnest pleas to Newhall's desires to make amends. A single photograph by you as the frontispiece of the revised volume would have an eloquence and an authority that would put the emphasis of the volume exactly where it should be. And it would be a handsome contribution to the true history of our time.[42]

Newhall also made several visits to Stieglitz at An American Place and Stieglitz finally agreed to allow one of his photographs to be used. The new catalogue was retitled, *Photography, A Short Critical History*, and was dedicated to Stieglitz, with his photograph *House and Grape Leaves, Lake George, New York* (1934) appearing as the frontispiece. Stieglitz's reluctant agreement implied a weary acceptance on the part of an older man, beginning to realize his battles for photography were now being fought and won by a younger generation, and that photography had expanded its perimeters beyond the private confines of individual artistic expression, to embrace social concerns, historic documentation, graphic experimentation, scientific usage, and

so on, to a new expanded language that would increase in prominence as the twentieth century passed.

The 1930s were framed by the openings of two other major New York institutions, the Whitney Museum of American Art and the Museum of Non-Objective Painting (changing its name to the Solomon R. Guggenheim Museum in 1949). As noted previously, the Whitney opened in November 1931. It was founded by Gertrude Vanderbilt Whitney following the Metropolitan Museum's refusal to accept her collection of modern American art as a gift. Stieglitz attended the opening on 17 November, and wrote to O'Keeffe at Lake George from An American Place shortly after spending about forty minutes at the opening:

> Just back from the Whitney Museum – well, I was there. And I'm glad I'm here now. – What's one to say – Bad taste, everywhere. – Cheap spirit . . . No Distinction. Cheap goods. Cheap paintings. Mobs of people . . . Mrs. Rockefeller came up to me . . . Artists galore . . . so many bad paintings. Awful. Demuth's "My Egypt" looks well, hung by itself . . . Well I was there. No more of that. An assignation house of art of the third order . . . It's drizzling. I'm feeling pretty well. A quiet day – Everything seems as if in a hidden veil like the city in the fog today.[43]

He also noted that O'Keeffe's painting was hung by itself and looked well but was really only a sketch. Although he spoke sparingly of the Whitney opening, he chose to attend the opening of the Whitney's "First Biennial Exhibition of Contemporary Paintings" a year later in November 1932. The 157 works exhibited included paintings by Dove, O'Keeffe, Demuth, and Hartley and the Whitney announced that it would purchase $20,000 worth of paintings for its permanent collection. On the day after, Stieglitz wrote to O'Keeffe:

> Well – last night I got to the Whitney at sharp 9. – I was the third to arrive – so had the galleries a while to myself and looked at the paintings. The room I walked into first had your picture, the Dove, Demuth, Stella, Spencer, in it. Yours [*Farm House Window and Door*] looked very distinguished . . . so simple and aristocratic – The Dove looks very well. The Demuth too [*Buildings*] . . . So many of the paintings in the show are stale – things done – not experienced. I looked at the 157 paintings by 157 painters. The crowd gradually gathered. I talked with Mrs. Whitney and Mrs. Force, Glackens, Speicher . . . Walkowitz . . . Peggy Bacon . . . Kenneth Hayes Miller . . . and a host of others. Of course with Florine [Stettheimer] whom I took home eventually but didn't go up with her. It was midnight. Her painting [*Cathedrals of Fifth Avenue*] is one of the few real things there. Still, I'm glad I went . . .[44]

A few days later, he sent O'Keeffe reviews of the show, pleased that some of his artists were highly praised. Ralph Flint wrote: "I feel that O'Keeffe's ultra simple composition, *Farm House Window and Door*, comes near being the most distinguished piece of design in the exhibition,

and surely Florine Stettheimer's enchanting *Cathedrals of Fifth Avenue*, is the most original canvas on hand."[45] According to Henry McBride, "The sparkling pictures in the show that make you smile with pleasure either at the idea or at the ingenious workmanship are these: . . . *Buildings* by Charles Demuth . . . *American Painting* by Stuart Davis . . . *Daughters of the Revolution* by Grant Wood . . . *From My Window* by Abraham Walkowitz, *Still Life* by Max Weber . . . *Cathedrals of Fifth Avenue* by Florine Stettheimer . . ."[46]

In May 1939, the Museum of Non-Objective Painting opened at 24 East 54th Street with a collection of the wealthy industrialist and philanthropist, Solomon R. Guggenheim, that had been gathered together with the enthusiastic encouragement of a young artist of aristocratic background, Baroness Hilla Rebay, who had come to the United States in 1927. An accomplished portrait painter, she was soon hired to paint a portrait of Guggenheim. With Rebay's guidance, Guggenheim began collecting and opened the museum with Rebay as director. The collection included works by Rudolph Bauer, Klee, Kandinsky, Moholy-Nagy, Chagall, Léger, and Mondrian. Around a quarter century earlier Stieglitz had purchased Kandinsky's *Garden of Love* from the Armory Show. Rebay, like Stieglitz, believed strongly in a spiritual dimension in art and gave money to artists finding themselves in difficult circumstances. Unlike Stieglitz, Rebay's vision for an "Art of Tomorrow" was more European-based and emphasized non-objective art versus abstraction. For her, abstract art was an abstraction of something – nature, an object, or a figure – whereas non-objective painting was completely pure, with no connection to what one might see in the world.

Outside New York, the Boston Museum of Fine Arts continued to remain significant in the lives of both O'Keeffe and Stieglitz. In 1931, they each visited the museum separately. Leaving on 10 March O'Keeffe wrote to Stieglitz with compassion and concern:

> I watched you going after you thought I didn't see you any more – and I almost ran after you. The way you put your hand down as you walked away alone, still upsets me way down the middle as I think of it. Let me kiss you – kiss you again good night . . . I don't know why I ever go away – it always disturbs me so – Good night dearest. Going away always makes me aware of you in such a painful way – Just love me a little – a little while I'm gone.[47]

The following day she spent at the museum, thoroughly enjoying herself, seeing Coomaraswamy, and going to his house:

> she [Mrs Coomaraswamy] wants to photograph me tomorrow – they are so insistent. I will probably let her tho it seems a bit dull – the museum is beautiful – I went back to many things that I remembered and found many I had not seen before . . . I would like to go back to the museum tomorrow, but I'll go to the Fogg . . . I'm so glad I came. I feel as tho I am in a village rather than a city. New York is certainly a fairy land – a quiet little kiss to you and my greetings to the Room. I mark in this folder [leaflet guide for the collection at the

museum, sold for $5] some things I particularly enjoyed. The Tintoretto was astonishing. I really had a beautiful day.

Among the items she marked were a twelfth-century Chinese wood sculpture, *Kuan-yin Pu-sa*, the Fourth Dynasty large Egyptian sculpture, *Mycerinus and His Queens*, the seventh-century Southern Indian *Dunga*, and Tintoretto's *Alessandro Farnese* of the mid-sixteenth century. Stieglitz responded quickly: "I just . . . looked at the folder you marked. Yes those things I like tremendously, too – the Egyptian thing is incredibly the same thing I feel – And the Indian is beautiful. Tintoretto – yes, yes. It is wonderful that such things exist for those who wish to see. Yes. I'm glad you are having the outing. It's just right in every way." The pieces with which they both resonated each seem to have a straightforward intensity that reflected a cultural moment. Such intensity and directness was also frequently seen in both their works.

In August 1931, Stieglitz traveled to Boston and visited Dorothy Norman and her family in Woods Hole, also wanting to see his grandson, Milton. His was a somewhat impromptu trip. As he wrote to O'Keeffe on 7 July, "I decided to make this trip . . . to kill several birds with one stone. I have been wanting to see my prints – to see what's there. I want to add to the collection. Also to the Metropolitan. I must get some prints out into the world. As for Woods Hole I had promised to go there sometimes . . ." On the train to Boston, he read Plato's *Symposium* as he watched a rain-sodden landscape, and passed through Springfield, Massachusetts where he had stopped on several occasions with his daughter Kitty on the way to Smith College in Northampton. Arriving in Boston he wrote, "the prints in the museum still amaze me . . ."

At the end of the same summer, he traveled once again to Boston and to Woods Hole to visit Dorothy Norman. As if to reassure O'Keeffe, he wrote near the end of a letter:

I see clearly I want to pitch into work as soon as I get to the Lake. I must do a lot. You'll help me and I'll help you. I know I'm much quieter and everything is all right . . . I've been thinking a great deal of you and me. A great deal. I feel we have much to do together. Very much. There won't be any "rehash" of the past. I'm clear, finally as clear as I can be . . . You looked "radiant" when I left. I want to photograph. I'll do it . . . A big kiss.

It is in the context of these museums, galleries, and arts organizations becoming prominent in the thirties that Stieglitz's own gallery, An American Place, must be viewed. In the words of Dorothy Norman,

Room 1710, 509 Madison Avenue, New York City was to be looked upon simply as a *place* in America where anyone truly searching might find a source of – key to – the spiritual nourishment required: [quoting Stieglitz], "If each will permit himself to be free to recognize the living moment when it occurs, and to let it flower, without preconceived ideas about what it *should* be. And if the moment is not permitted to live – is not recognized – I know the consequences."[48]

The gallery was not listed in the telephone directory and Stieglitz, in general, did not believe in advertising. A card placed in the gallery, with Stieglitz's handwritten statement, "Please do not take away," announced:

> No formal press views
> No cocktail parties
> No special invitations
> No advertising
> No institution
> No isms
> No theories
> No game being played
> Nothing asked of anyone who comes
> No anything on the walls except what you see there
> The doors of An American Place are ever open to all.[49]

In 1933, Mumford wrote in the *New Yorker* of the impact of An American Place and Stieglitz's other galleries:

> By accident I stumbled upon the most interesting exhibition of the whole season. It was nothing less than the accumulation of art and history that began a generation ago at Mr. Alfred Stieglitz's "291." The floors, racks, and shelves of An American Place were quaking under the impressive mess of pictures and documents. It was a sort of Resurrection and Last Judgment on art in America for the past twenty-five years . . . One regrets to add that this impromptu exhibition is not open to the public and one's regrets are all the more genuine because An American Place with its present contents, is potentially the finest small museum in America.[50]

As the name suggested, the gallery catered to American artists in particular, with regular, almost yearly, exhibitions of Stieglitz's inner circle – O'Keeffe, Marin, Hartley, Dove, and several Demuth shows. In the 1930s, exhibitions were also given to other painters: Rebecca Strand (1932, 1936), MacDonald-Wright (1932), Helen Torr with Dove (1933), Grosz (1935), Robert Walker (1930), and William Einstein. Frequently, Stieglitz published small pamphlets about the exhibitions, often including samples of critical reviews of the artists. O'Keeffe's work was exhibited yearly during the decade. Stieglitz recorded the shows with photographs and her specific checklists and announcements.[51] Sample critical commentary for O'Keeffe taken from her February–March 1937 brochure contained the following on her 1936 show that included flowers, skulls, and a katchima. In 1937, she showed her flower, skull, and barn images from 1934 to 1936. Two of her well-known *Black Iris* paintings from 1936, as well as *Summer Days* of 1936, were also shown:

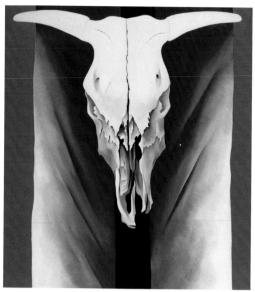

183　Charles Demuth, . . . *And the Home of the Brave,*
1931, oil and graphite on fiber board.
The Art Institute of Chicago.

184　Georgia O'Keeffe, *Cow's Skull; Red,*
White and Blue, 1931, oil on canvas.
The Metropolitan Museum of Art.

Ruth Lawrence, Curator, University Gallery, 1936: "she sees the world as elemental, a world with inner meanings and the thing she paints is merely the symbol . . . When one looks into the heart of her flowers its magic convulsions almost hypnotize. In her white flowers – and here is an artist who has created for us a new color – white – she gives us that miracle, the fresh fragment innocent melody of youth . . ."

Elizabeth McCausland, *Springfield Union and Republican*, 12 January, 1936: "In her flower paintings she reached heights of emotion which are like nothing else in American painting. If you reject emotion as a proper subject matter of her art, you will reject this phase of her work."

Although Stieglitz "advertised" within his gallery that he did not solicit formal press reviews or advertisements, he had some sense of "marketing" and gathered together articulate critical voices of his time who served to advance the reputations of the artists he chose to exhibit.

An early review of John Marin's 1931 show, "Artist in Exile," which Stieglitz sent O'Keeffe, captured his frequent perception of himself as a voice in the wilderness, a voice in exile:

The history of the artist in America is an eternal epic of the exile in his own country; to use a phrase of one of them, Alfred Stieglitz who for over 40 years has fought to remove that sentence of spiritual banishment . . . It has been Stieglitz's aim for many years to promote the

284

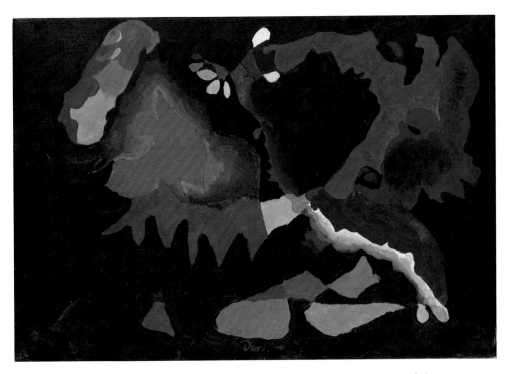

185 Arthur Dove, *Swing Music*, 1938, oil and wax emulsion on canvas. The Art Institute of Chicago.

cause of America against the world, to sponsor the artist who is himself, not someone else, to support art that is organic and spontaneous not synthetic . . . This is art [Marin's work], this is what Whitman was always dreaming for America, and when America respects such efforts and treasures them, perhaps a golden day, often mourned but never achieved, really will have dawned on this continent.[52]

Two publications initiated by Dorothy Norman were significant, *Twice a Year* and *Dualities*. The latter, Norman's collection of poems, was printed privately in 1933 by the Beekman Hill Press for An American Place and was dedicated to Stieglitz and "the spirit" of An American Place. The original edition consisted of 400 copies, selling for $3 each, on Worthy Aurelian laid paper, with numbers 1 to 30 including a photograph of Norman by Stieglitz; all were signed by Norman. A special September 1933 flyer advertising the publication contained an endorsement by Evelyn Howard, from the Department of Psychology at Johns Hopkins University: "It may be felt that these Dualities are disturbing because they are so abstract. That is their necessity because their God is jealous of compromise with imagery . . . They do not wear the body of meter and rhyme in which much of our poetry has been incarnated, but in those Dualities at their best, a new poet has spoken."[53]

In her Appendix, in place of an Introduction, Norman notes that her poems have arisen out of her experience beyond theory, bringing together Love, Art, and Religion as inseparable parts of existence. "These are statements which I could put down in no other way. These rhythms, stresses, and capitalization evolved out of the necessity to satisfy my own sense of their necessary flow . . . the word DUALITIES characterizes the approach, rather than limits or defines the content . . ."[54] One of the poems was devoted to Stieglitz, "The Purity of Alfred Stieglitz – White Disc Against Any Color." It reads in part:

> . . . Identifying Action – Interaction – Counteraction – Action
> Sensing the Infinite Variations on God's Single Theme
> Fearlessly he Affirms and Projects the Infinite clarifies
> That One.
> Preserving and Illuminating their Invisible Line
> Into Light
> Effortlessly Using every Equivalent,
> Relaxing each thing to all Things in –
> His Eyes wearing his Trust
> Into Eyes so often gazing Elsewhere, . . .
> – There's a Law of Equivalents –
> He says,
> Speaking tenderly to Life,
> Fearlessly living a Yes,
> Irresistible to Life seeking Life,
> Making his own Immortality
> Unalone –
> Recognized by God.

The publication of *Dualities* coincided with the ending of the affair begun with Stieglitz in about 1929. In the poem, Norman seems to have elevated Stieglitz to a more spiritual realm, concentrating on issues of Truth, Trust, and Equivalents. For a number of years they wrote to each other daily, often two or three times a day, as did O'Keeffe and Stieglitz when they were separated. Stieglitz and Norman often corresponded with each other through metaphorical language, whereas O'Keeffe's writing was straightforward, direct, more descriptive and narrative versus metaphorical or analytical. In the early years of Norman and Stieglitz's relationship, he would often note the number of days they had been apart:

29 August 1932/Day 73 7:07 a.m.

Good morning my ever unsettled body – beautiful – gentle – so – lovely soft one – ever sacred.

What a grand morning. For here I lay awake. Very quiet. Quiet as the night was quiet. I watched the crescent moon steal silently over the far hills . . . and finally the disc of the sun too seemed to steal over the far hills beyond as if searching for the crescent moon . . . 7:40 a.m. I stopped for I saw it was [useless] and I have been wanting to do another poplar with living leaves shooting up . . . So, I went and tried to find a vantage point. What I want is nearly impossible to do. To cap it all, the sun has hidden itself – the sky has become gray and threatening – the light "dead," deader than the poplar – So I lugged the camera back here again.[55]

By 1933, Norman had essentially assumed responsibility for the operation of An American Place. Then in January 1933, O'Keeffe became sick and moved to the New York apartment of her sister Anita Young. On 18 January, Stieglitz wrote to her "Anita called up. Too bad you were upset again. I feared it. I know *exactly* what you feel and how everything affects you. You *must get well*. You *will get* well. You must see your show."[56] Two days later he wrote, "I'm glad you are reading the Bible again. It will entertain you and not excite you as Lawrence's Letters might . . . *The New Yorker* is out, I'm sending you a copy. I'm glad Lewis Mumford ranks you with Emily Dickinson . . . I'm glad he put you first . . ."[57] In February 1933, O'Keeffe was hospitalized, suffering from psychoneurosis, although in March she was able to see her exhibit at An American Place. Her nervous breakdown was due in part to Stieglitz's relationship with Norman, as well as O'Keeffe's conflict with Stieglitz concerning a Radio City Music Hall commission, along with technical difficulties relating to the project, forcing her to abandon the commission in October 1932. O'Keeffe spent much of March and April in Bermuda trying to recover and then went to Lake George from May to December to recover further. It was only in December that she was able to begin some drawing again.

Stieglitz stayed in New York much of her recovery period. It appears from his January letters that O'Keeffe's personal and professional life were closely intertwined in his eyes at the time. He seems somewhat chauvinistic in his comment that he knew exactly how O'Keeffe felt. His reference to the Bible as "entertainment" seems to reflect some distinct cultural differences between his Jewish heritage and his primarily secular approach to organized religion, versus O'Keeffe's Christian and Catholic heritage, where the Bible would have had more meaning.

In the same month that O'Keeffe was hospitalized, a second issue of another An American Place publication, *It Must Be Said*, appeared. The small pamphlet contained a translation by the Tennessee writer, Cary Ross, a friend of Stieglitz, of a letter from Rilke's *Letters to a Young Poet*. Dated February 1903, the letter stresses the importance of an artist's inner search and fulfillment of an inner necessity. Stieglitz sent Rilke's letter to O'Keeffe, which stated in part,

Therefore my dear man, I know no other advice to give you than this; to go into yourself and examine the depths from which your life springs; at its sources you will find the answer to

186 Checklist for *127 Photographs (1892–1932) by Alfred Stieglitz*, New York, An American Place, 15 February–5 March 1932. New York. Beinecke Rare Book and Manuscript Library.

the question whether you must create. Accept it without question. Perhaps it will prove that you are called to be an artist. If you are, you must take up you destiny and carry it, with its burdens and its greatness, without ever asking for praise that can come from others, because the creator must be a world in himself and find everything in himself and in nature with which he has joined forces.[58]

Rilke's words well depicted Stieglitz's own philosophy and his advice to the artists whom he showed, as well as to the visitors to his galleries.

Norman, too, looked inward, as well as outward in her interest in social justice and civil liberty. From 1938 until 1948, Norman edited a journal published by An American Place, *Twice a Year – A Semi-Annual Journal of Literature, the Arts and Civil Liberties*. In the journal, which was dedicated to Stieglitz, and used his handwriting as a banner for the title, Norman created a publication which reaffirmed the power of the arts to serve as visionary in a difficult time. She wrote in her dedication,

> TWICE A YEAR would not have come into fruition without the faith and the affirmation of Alfred Stieglitz. But that is not why it is dedicated to him. Stieglitz has said, To show the moment to itself is to liberate the moment. And *Twice a Year* is dedicated to Stieglitz because he is one of the great *liberators*, one of the great spiritual forces of our time . . ."[59]

The periodical was interdisciplinary in nature and Norman published reproductions of photographs alongside articles that dealt with issues of social commentary, including both European

187 Checklist for *127 Photographs (1892–1932) by Alfred Stieglitz*, New York, An American Place, 15 February–5 March 1932. New York. Beinecke Rare Book and Manuscript Library.

and American writers such as Rilke, Kafka, André Malraux, Henry Miller, and Seligmann. Stieglitz's parables, stories, and aphorisms were also included in several issues. In retrospect, one writer noted,

It is ironic that *Twice a Year* begun as a syncretic journal, an instrument of revelation, now records a history not of triumphs, but of the disasters in national life form of the outset of war in 1939 until the onset of the House of Un-American Activities in 1948. Its history of incivilities is based not on repeat or paraphrase, but on the very documents reprinted in full or in excerpt, which report the process that led to the alienation of liberals from society during the late 1940's, the process which turned Americans into pariahs at home . . ."[60]

Stieglitz's own words in this context may perhaps be seen as all the more significant, a voice in the wilderness or exile. For example, from the winter 1938 issue:

No. 28 – If you put the imperfect next to the perfect, then people will see the difference between the one and the other. But if you give them the imperfect alone, they are satisfied with it . . . No. 30 – I care for those people to whom I am in debt for something that they made me feel . . . No. 31 – What I am really seeking is to have the physical strength of a scale that can weigh a thousand tons of coal and the psychic sensitivity that weighs a ray of light . . . No. 38 . . . Where there is no equality of respect there is no relationship."[61]

When Dorothy Norman began this journal she was thirty-three, Stieglitz was seventy-four, and O'Keeffe was fifty-one, spending much time in New Mexico. Hitler was about to annex

Ansel Adams

Exhibition of Photographs

October 27–November 25, 1936

AN AMERICAN PLACE

509 Madison Avenue, New York

WEEK DAYS 10 A.M.–6 P.M. SUNDAYS 3–6 P.M.

PHOTOGRAPHY is a way of telling what you feel about what you see. And what you intuitively choose to see is equal in importance to the presentation of how you feel—which is also intuitive. If you have a conscious determination to see certain things in the world you are a potential propagandist; if you trust your intuition as the vital communicative spark between the reality of the world and the reality of yourself, what you tell in the super-reality of your art will have greater impact and verity.

Through a straight application of the medium of photography certain perceptive experiences may be expressed with phenomenal clarity and depth. No medium of art has greater strength in subtlety (or more weakness in mannered or grandiose effects). Appropriate sonority of tone, accuracy of detail and texture, and a pure, unadulterated photographic effect, are the prime requisites of the art of photography.

The intellectual elements are, of course, necessary, but they relate more to generalization and analysis than to the creative moment. Perception, visualization, and execution are rigorously interrelated; each in itself has little meaning. A competent technique is quite essential in photography, and an adequate and precise apparatus also, but without the elements of imaginative vision and taste the most perfect technical photograph is a vacuous shell.

In this exhibit at "An American Place" I have tried to present, in a series of photographs made during the past five years, certain personal experiences with reality. I have made no attempt to symbolize, to intellectualize, or to abstract what I have seen and felt. I offer these photographs to the intelligent and critical spectator only for what I believe they are—individual experiences integrated in black-and-white through the simple medium of the camera.

Ansel Adams

PHOTOGRAPHS

1 Latch and Chain
2 Mineral King, California
3 Half Dome, Yosemite Valley
4 South San Francisco
5 Factory Building
6 Museum Storeroom
7 Old Firehouse, San Francisco
8 White Cross, San Rafael
9 Windmill
10 Pine Cone and Eucalyptus Leaves
11 Cottonwood Trunks
12 Grass and Burned Tree
13 Snow
14 Church, Mariposa, California
15 Courthouse, Mariposa, California
16 Mexican Woman
17 Detail, Dead Tree, Sierra Nevada
18 Fence
19 Fence, Halfmoon Bay, California
20 Political Circus
21 Americana
22 Winter, Yosemite Valley
23 Winter, Yosemite Valley
24 Family Portrait
25 Hannes Schroll, Yosemite (Advertising Photograph)
26 Phyllis Bottome
27 Annette Rosenshine
28 Tombstone Ornament
29 Early California Gravestone
30 Architecture, Early California Cemetery
31 Mount Whitney, California
32 Scissors and Thread
33 Leaves
34 Sutro Gardens
35 Picket Fence
36 Tree Detail, Sierra Nevada
37 Grass and Water
38 Clouds, Sierra Nevada
39 Architecture, Early California Cemetery
40 Early California Gravestone
41 Early California Gravestone
42 Anchors
43 Autumn, Yosemite Valley
44 Steel and Stone (Shipwreck Detail)
45 Sutro Gardens, San Francisco (Lion at Entrance)

Facsimile of original checklist for the exhibition, 1936

188 Checklist for Ansel Adams, *Exhibition of Photographs*, New York, An American Place, 27 October–25 November 1936. From Andrea Gray, *Ansel Adams, An American Place, 1936*. Center for Creative Photography, University of Arizona, 1982, p. 38.

Austria. Norman, in many ways, was forward-thinking, as she attempted to gather up European and American voices who addressed larger world issues as well as private, artistic expressions. Thus the spring–summer 1942 issue included: "Stories of War – of Tyranny – of Unemployment," by Malraux, Vladimir Pozner, Irving Nicholson, Paul Grossberg, Eve Merriam; "Observations on Barbarism and its Alternatives," by Seligmann, letters from George Sand, Flaubert, Rilke, as well as a special section on Stieglitz by Henry Miller and Zigrosser, along with Stieglitz's own "Stories, Parables and Correspondence" and two of his photographic *Equivalents*.

While few in number, the photography shows Stieglitz mounted during the 1930s were substantive. From 15 February to 5 March 1932, he showed 127 of his own photographs taken between 1892 and 1932. It was the first public airing of his later New York City views. As he noted on his handwritten exhibition list,

This exhibition is primarily held at the request of those who wished to see the recent photographs of New York. It includes sufficient of the older New York and other work, some new and some old, to establish the continuity and underlying idea of the work as a whole . . . Pho-

tography has a history. No's marked "x" are shown not merely for the pleasure they might give, but as having a place in that history. They represent pioneering in technical achievement – realizing what therefore had been considered impossible to photography."[62]

Among the marked images were *Winter, Fifth Avenue* and *The Terminal* of 1893, along with the 1897 *Night – The Savoy*, *Night – Fifth Avenue*, and *Icy Night*, where he was exploring working in difficult weather conditions and with early night photography. Twenty-nine new New York cityscapes were followed by seventeen new prints of work from the 1890s and early 1900s including the *Steerage* and *Hand of Man*. Several of the new prints of his older negatives differed from the older prints, in particular the new print of *The Flatiron* whose negative dated to 1902–03. Here Stieglitz

> replaced its former slim, *japoniste* format with a view of the whole negative. Where before only the synecdochic genre figures of two pedestrians had been visible at the base of the skyscraper, here a regular art-line of silhouetted figures appeared, heads down, across the width of the image. In Stieglitz's original photogravure the Flatiron had been a Symbolist metaphor – a "monster ocean steamer" of the future, a diaphanous vision floating above corporeal, foregrounded Nature. Laying new emphasis on the density of the façade looming over the clockwork life of the strut, Stieglitz's revised print made the image a critique of city's dehumanizing monumentality."[63]

Besides the New York images the exhibition contained sections titled "Equivalents" from 1924 to 1931, which included one titled *Tristan Motif*, of 1927, illustrating his continued interest in Wagner; "Small Miscellaneous" including images of O'Keeffe from 1926 and 1929, Dorothy Norman, *Nudes in Lake*, and images taken at Lake George of the poplar, old maple tree, and others; "Lake Portraits," including images of O'Keeffe of 1918–23, Anderson, Rosenfeld, Seligmann, Alma Wertheim (a collector of O'Keeffe's work and supporter of the Intimate Gallery), and Katharine Dudley (a teacher who had met O'Keeffe through their association with Columbia Teachers College); and a final section, "Miscellaneous," which included an early 1923 *Equivalent*, two 1918 *Torsos*, a 1930 interior of An American Place, and Lake George images, two of which were *The Dying Chestnut Tree – My Teacher*. In many ways, the show constituted an autobiographical overview of Stieglitz's life and work up to 1932, chronicling the people, places, and photographic "ideas" that made up an integral part of who Stieglitz was in early 1932.

This exhibition also emphasized Stieglitz's interest in series, as suggested in his use of the term in his section titles, "New York Series," "Older New York Series," and lists of various series of *Equivalents* (see fig. 186). Thus each single image is important not only for what it expresses, and represents, but also for its place within the series. As he continued his series throughout his photographic career, it seems that a series could be infinite, that Stieglitz was continually explor-

ing and searching, that his experiences could never be fully mirrored or captured in one moment or image.

This de-emphasis of the single image in his series work would seem to give Stieglitz a place among the genre- and format-breaking young New York modernists of the 1920s and 1930s, from William Carlos Williams to Walker Evans, who questioned the possibility, and even the wisdom of artistic expressions of wholeness in a fundamentally broken world, and who were driven to confront their audiences with ever more "direct" artistic languages in which to express their ontological skepticism . . . In his postwar serial photography Stieglitz at last found the means through which to invoke relationships between vital self and pregnant reality that had been too subtle and fugitive to be fixed in a single frame. In the apparent guise of modernism, in other words he finally brought the tentative Bergsonianism of his Symbolist years to fruitful ends.[64]

Later that year, in April and May, Stieglitz mounted a dual exhibition of the work of Paul and Rebecca Strand – Rebecca's paintings on glass and Paul's approximately one hundred photographs, including his 1929 driftwood series, Gaspé photographs, New Mexican landscapes from 1930 and 1931, along with his 1931 Colorado prints. This show, although it contained some of Strand's better photographs up to that time, marked the end of his and Stieglitz's friendship. Strand had become increasingly convinced that a purely aesthetic approach to photography in a Depression era was not socially responsible. When the show closed, he gave his key to the gallery back to Stieglitz. In retrospect, he wrote, "The day I walked into the Photo-Secession in 1907 was a great moment in my life . . . but the day I walked out of An American Place in 1932 was not less good. It was fresh air and personal liberation from something that had become, for me at least, second rate, corrupt, meaningless."[65] That same year Strand also separated from Rebecca and in 1933 they were divorced. Strand went on to pursue more socially oriented projects. While he had been in New Mexico he had met the Mexican composer, Carlos Chávez, the conductor of the Mexican Symphony Orchestra and the director of the Mexican National Conservatory of Music. With Chávez's assistance, Strand became the chief of photography and cinematography for the country's Secretariat of Education. In that role he spent a year making the social realist film, *The Wave*, that depicted the lives of exploited fishermen in a town on the Gulf coast. Strand returned to New York in 1934, becoming involved with the Group Theatre founded by Harold Clurman, Cheryl Crawford, and Lee Strasberg in 1931. During the summer of 1935, Strand, Clurman, and Crawford spent two months in Moscow, about which Stieglitz sent O'Keeffe a newspaper clipping. Strand also worked with Ralph Steiner and Leo Hurwitz on a documentary project in 1935 for the U.S. Resettlement Administration, depicting the plight of the Dust Bowl workers in a film, *The Plow that Broke the Plains*. He remained working in

film until about 1943 and by 1945 had resumed his career in still photography despite his break with Stieglitz, who by then was clearly elderly and suffering from various health problems.

With a 1933 exhibition at An American Place, celebrating twenty-five years of John Marin and twenty-nine years since the opening of 291, Stieglitz published a short catalogue in which he listed "a number of the outstanding public demonstrations at that laboratory [291]" as part of a continued "Progression" in artistic expression.[66] His list included the first American exhibits of Rodin (1908), Matisse (1908), Toulouse-Lautrec Lithographs (1909), Severini (1917); first exhibitions anywhere of Marin (1909), Hartley (1909), de Zayas (1909), Dove (1912); and the first one-man shows anywhere of Picasso's drawings and watercolors (1911), children's art (1912); Matisse's sculpture (1912), and "Negro" sculpture (1914). Further, there was a list of photography one-man shows at 291 beginning in 1905 that read: "Robert Demachy, C. Puyo, René Le Bégue, Hans Watzek, Heinrich Kühn, Gertrude Käsebier, Clarence White, J. Craig Annan, Fred H. Evans, David Octavius Hill, Edward J. Steichen, Alfred Stieglitz, Alvin Langdon Coburn, Baron de Meyer, Annie W. Brigman, Frank Eugene, George Seeley, Paul Strand, Color Photography First Introduced to America, etc."[67] Such lists constitute a statement of marketing skills and strategies, as Stieglitz attempted to place his galleries in a continuum or "progression" that was seen to be both scientific and artistic, evolving in a "laboratory" setting, and involving international players on an American stage.

From 11 December 1934 to 17 January 1935, Stieglitz held another exhibition, of sixty-nine of his own photographs dating from 1884 to 1934. Twenty-three works, dating from 1884 to 1924, primarily taken in Europe, became gelatin silver prints made from old negatives Stieglitz had found in the attic at Lake George the summer before. He had vowed that his 1932 show would be his last but wrote in his introductory statement accompanying the checklist "when I saw the new prints from the old negatives I was startled to see how intimately related their spirit is to my latest work. A span of fifty years. I had no choice . . ."[68] The later work, from 1924 to 1934, included several New York City photographs, images of O'Keeffe, Cary Ross, Louis Kalonyme, the *Equivalents*, and other photographs taken at Lake George including his *Dead Tree* series. Mumford, reviewing the show for the *New Yorker*, referred to Stieglitz's work as "prophetic," noting that "Stieglitz's demonic negations are part of the deepest vitalities; they play the same part in his personality that the blacks do in his prints . . . Indeed Stieglitz is closer to lonely Captain Ahab [in Melville's *Moby Dick*] than perhaps to any other figure in our life or literature. I emphasize these personal qualities of Stieglitz because his photographs are not alone his work but his life . . ."[69] For Ahab and for Stieglitz the great white whale, or the enigmatic "Truth" in Stieglitz's case, was always elusive but the "figure" and the search were an integral part of both men's lives. Ahab's conflict with Moby Dick resulted in death as Ahab, in the final struggle with the great white creature, became consumed by the sea, while Stieglitz was able to see his fight

for photography to be recognized as a fine art come to fruition, in part, along with recognition for the artists he supported. Yet, like Ahab, Stieglitz continued his "fight" that had become an integral part of his existence, and essence, to his death in 1946.

Mumford went on to praise Stieglitz for his ability to use Nature, Man, and the Machine as the "major chords" of his work to produce an "infinity of variations," remarking that "the secrets of his art are not in his camera, his papers, his developers; they lie in his mind."[70] In the same article, Mumford singled out one print, a double exposure *Dualities* of 1932, of Dorothy Norman. The title refers to the collection of poetry Norman was working on but the close-up facial image is dark, eerie, a surreal portrait with two mouths and a double left eyeball. As Mumford noted:

And though Stieglitz is a master of straight photography, he has done a double-exposure print, *Dualities*, that is almost diabolic both in its symbolism and its technical perfection. Norman's face is alluring and other worldly, causing the viewer to "step back" a moment. She becomes a kind of "femme fatale" as Stieglitz presents this one double exposure with his other straight images.

Besides the Stieglitz exhibitions, perhaps one of the more significant photographic shows at An American Place in the thirties was that of forty-five Ansel Adams prints in October–November 1936. In 1933, a young, apprehensive Adams had come to Stieglitz's gallery, seeking his opinion about his work. Stieglitz's initial response to Adams, who had traveled from California "to seek his fortune" in the east, was to tell him to come back later in the day. Adams was insulted by such arrogance and only returned at the insistence of his wife Virginia. However, that same afternoon, Stieglitz described his photographs as "the finest I have ever seen."[71] Adams's New York visit resulted in an exhibition at the Delphic Studio in November 1933 but he and Stieglitz did not see each other for another three years. They did, however, begin a long-lasting correspondence. Those letters established a relationship between the two photographers that provided a foundation for a vibrant East–West Coast cultural exchange. Both were committed to artistic "equivalents" – art was an equivalent of the artist's most profound experiences in life; and both for much of their careers were committed to "straight" photography. Both were also part of significant artistic communities. Although short-lived, the West Coast f/64 group, numbering Adams, Weston, Van Dyke, and Imogen Cunningham, promoted the achievement of a great depth of field and allover sharpness. The West Coast group may perhaps be viewed as somewhat analogous to the Stieglitz circle and related galleries on the East Coast.

Adams and Stieglitz were soulmates, touched by each others' spirits. The correspondence shows their relationship as multi-leveled, direct, and at times complex. Their letters involve exchanges on personal, artistic, and technical matters, while their language is often passionate,

deeply concerned for issues and personalities. Like their photographs, there is a clarity of thought and vision in the writing.

In the thirties, Adams attempted to make a living from commercial work – advertising photography, industrial brochures, and journalistic works for magazines such as *Time* and *Fortune*. He often expressed his scorn for and frustration with commercial concerns to Stieglitz. On 9 October 1933, he poured out his feelings to Stieglitz:

> I wish to issue a manifest – a manifesto to you, 3,000 miles away from me, and 3,000 miles away from you. It's a manifesto in the form of a grouch. (A grouch is wrath without guts – I have to save the guts for things here.) It's this – I hereby object to trying to support myself, my photography, my gallery with such a prostration of spirit as the following example indicates . . ."[72]

Stieglitz expressed similar concerns in reply, on 20 October 1933: "In the meantime the racketeering in the so-called world of art becomes more and more brazen and engulfing. The sordidness of it all is appalling and everyone coming into touch with Art is more or less contaminated by it and perfectly unavailed of that fact. That's really my fight and has been all these years . . ." In the same letter, he mentions the Marin show he had recently mounted as "perhaps the apex" of his lifework, and the importance of seeing and experiencing a work of art. "One can't tell about it. It must be seen." Adams's reply of 23 October 1933 shows his deep concern for Stieglitz's artistic, spiritual, and physical survival: "Frankly it isn't worth your neck . . . don't forget that your own self, your own spirit, is more important. Without *you* these things would not exist without your vision. God knows where photography would be . . . to me a living out of commercial things is certainly multiple crucifictions [sic]."

The letters also chronicle their responses to varied subjects such as W.P.A. work, the Second World War, technical matters of printing and lenses, the establishment of the Department of Photography at the Museum of Modern Art, and other artists' work important to them both. They did not always agree, as is seen in letters such as those involving Adams's attempts to show Stieglitz's and O'Keeffe's work on the West Coast, or those involving setting up MoMA's photography department with Beaumont Newhall. (As previously noted, Stieglitz was against institutionalization.) Yet, despite these disagreements, there was always a deep respect of one man for the other and mutual commitment to photography as an art.

As in several of their photographs, the letters of both illustrate their concern for music and synaesthesia. Adams was obsessed with music as a young boy and actually trained as a concert pianist before turning to photography. Some of his writing is quite musical. He later referred to hearing music, not in a sentimental sense but structurally in various photographs, which was a synaesthetic reaction. As previously discussed, Stieglitz, too, reached for the world of music in

189 Ansel Adams, *Latch and Chain*, 1927, printed *c.*1936.
The Metropolitan Museum of Art.

190 Ansel Adams, *Winter, Yosemite Valley*, 1933–34.
The Metropolitan Museum of Art.

his work, particularly in the *Equivalents*. In one of his letters to Adams, of 23 July 1945, Stieglitz described his response to his receiving a package of Adams's prints from the Museum of Modern Art: "what beautiful pictures – I feel a note running through them. A great tenderness – A lovely tenderness – Really I was bowled over and deeply moved – so my thanks dear Adams . . . all like good music."

In their letters, photographs, and personal meetings Stieglitz and Adams nurtured one another, thereby nurturing an important East–West connection. As the years progressed, Stieglitz reached out to Adams more and more as a tired and ailing old man, referring to his illnesses and how tired he was. On 9 October 1939, for instance, he wrote, "Your letters are like a breath of fresh air," and on 14 February 1940, "You are ever helping me in just doing and being what you are, doing and ever being."

Adams, encouraged and inspired by Stieglitz, grew in his photography and in the strength of his convictions. His sense of perfection and the emphasis on "visualization" (deciding in advance how a photograph will look), is seen in his letter of 15 March 1936: "I have done one good photograph since my return which I think you will like. It is a rather static one of a fence [*Picket Fence near Tomales, California*, *c.*1935] – the pickets covered with moss and dark rolling hills . . . My visit with you provoked a sort of revolution in my point of view – perhaps the word simplication would be better . . ." On 18 April 1938, he wrote again, "If you have not given me

191 Ansel Adams, *Americana*, 1933.
The Metropolitan Museum of Art.

the awareness of anything but a standard, I would be eternally grateful. It is up to me and to others that have so greatly benefited through your influence to pass on the message," and in an undated letter, "I am thinking of you, thinking I am a little more than one half your age, but with only a minute fraction of your accomplishments. Thank you for yourself."

The two photographers, although many years apart in age, produced works that are worthy of comparison. Although there is not always a direct influence to be found in Stieglitz and Adams's work, there are similar aesthetic and compositional concerns. Works such as Stieglitz's *Equivalents* and Adams's Yosemite clouds; the cropping and abstracting of details in the artist's environment such as Stieglitz's 1932 *Poplars* or Adams's 1938 *Poplars*; the barn details of Lake George of Stieglitz and those of California barns by Adams; the New York series by each artist; and some of the poignant portraits of each, all show significant affinities. Of particular note are the clarity of vision and precision of detail in both men's works. Both often created a new reality beyond actuality.

To return to the 1936 exhibition of Adams's work, the forty-five photographs primarily consisted of beautifully printed close-ups exploring texture, line, and shape, rather than the dramatic views of Yosemite and other landscapes for which Adams became noted. Thus, one sees the storeroom at the DeYoung Museum in San Francisco with its Greek sculptures, a factory building in San Francisco, the clouds rising over south San Francisco, the cottonwood trunks in

Yosemite Valley, the burned trees of the Sierra Nevada, or an early California gravestone in the Laurel Hill cemetery in San Francisco.

In his introductory statement to the show, Adams wrote,

> Photography is a way of telling what you feel about what you are. And what you intuitively choose to see is equal in importance to the presentation of how you feel . . . In this exhibit . . . I have tried to present . . . certain personal experiences with reality. I have made no attempt to symbolize, to intellectualize, or to abstract what I have seen or felt . . ."[73]

Stieglitz was pleased with this statement, which he had asked Adams to write. A letter from Adams of October 1933 discussing the quality of tenderness provides further insight into the mutual attraction of the two: "I will always remember what you said about the quality of 'tenderness' (it's a rotten word for a deep cosmic quality) in things of art. Tenderness – a quality of elastic appropriation of the essence of things into the essence of yourself into giving of yourself without asking too many intellectual questions, to the resultant combination of essences."[74] Adams wrote to his wife about the show:

> My Dearest – the show of Stieglitz is extraordinary – not only are they hung with the utmost style and selection, but the relation of prints to room, and the combination in relation to Stieglitz himself, are things which only happen once in a lifetime. He has already sold seven of them – one (*The White Tombstone*) for $100.00. The others for over $30.00 each. He is more than pleased with the show. I am now definitely one of the Stieglitz Group. You can

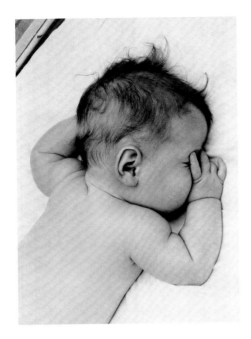

194 Eliot Porter, *Jonathan*, 1938.
The Metropolitan Museum of Art.

195 Eliot Porter, *Song Sparrow's Nest in Blueberry Bush*,
1938. The Metropolitan Museum of Art, New York.

imagine what this means to me. The numbers of people that have visited the Place and the type of response is gratifying. In other words, the show is quite successful!!![75]

Although Adams did not visit the Place often, it was important for him that it had an ongoing existence as a kind of oasis. As he wrote to Stieglitz in 1936, "The Place, and all that goes on within it is like coming across a deep pool of clear water in a desert . . . Whoever drinks from this pool will never be thirsty."[76] He dedicated his *Portfolio One* to Stieglitz.

The same year Adams met Stieglitz, he also met Eliot Porter, the older brother of the painter Fairfield Porter, in Cohasset, Massachusetts, and became influential, along with Stieglitz, on Porter's work as a photographer. Adams showed Porter many of the prints he had shown Stieglitz – Porter had never seen such photographs. Through O'Keeffe, Adams also met David Hunter McAlpin in 1933, which was the beginning of an important personal and artistic relationship. McAlpin purchased four prints from Adams's 1936 exhibition at An American Place and, with Adams and Newhall, was instrumental in founding the MoMA photography department in 1940. Adams also became close to O'Keeffe, traveling with her in the West and photographing her on several occasions.

In late December 1938, Stieglitz opened a show of twenty-nine photographs by Porter. The show included images taken in New England, Canada, and the Austrian Tyrol from 1934 to 1938, as well as an image of his sleeping infant son. It was Porter's first show anywhere. Stieglitz

196 Eliot Porter, *Penobscot Bay from Eagle Island*, Lee Gallery, Winchester, Massachusetts.

had met Porter in 1934 through his brother, Fairfield, at a dinner in New York while Eliot was doing advanced research in biochemistry at Harvard University. Porter had an early love of nature and was an amateur ornithologist, photographing birds as well as nature scenes. Although he became best known for his color photographs of nature, the photographs Stieglitz showed were in black and white, who noted in the catalogue, "In the very beginning, I felt he had a vision of his own. I sensed a potentiality."[77] The exhibition's success inspired Porter to leave his work at Harvard and pursue photography full-time. In the 1940s, he began to work in color, exploring Eastman Kodak's new dye-transfer process, a technique he continued to use throughout his career.

The late thirties also brought forth another exhibition commemorating 291: "Beginnings and Landmarks: 291, 1905–1917," from 27 October to 27 December 1937. It was divided into four sections: photography at 291, paintings and sculpture at 291, artists influenced by 291, and examples of related publications by Stieglitz and others, including *Camera Work*, *291*, *391*, and *America and Alfred Stieglitz*. Two prints by Paul Strand, *The East Siders* (of about 1916) and *Abstraction* (1917) had never been officially exhibited before. Norman in her catalogue essay wrote:

Stieglitz has always fought . . . for honesty, quality, integrity of workmanship and respect, in work, in human relationships . . . Stieglitz refuses to consider the significance of any human activity as separable from the spirit in which the activity is undertaken . . . 291, as his other centers served as a point of contact between Stieglitz and the public. The art for which he has fought has served as a further point of contact . . .[78]

Included in the exhibition were many of the European artists whom Stieglitz had sponsored at 291, including Picasso, Braque, Brancusi, Matisse, Picabia, Cézanne, Duchamp, and Severini, along with European photographers such as Julia Margaret Cameron, J. Craig Annan, Robert DeMachy, and David Octavius Hill. Relatively few Americans were exhibited.

The two exhibitions following "Beginnings and Landmarks" – the fourteenth annual exhibition of O'Keeffe's painting from 27 December 1937 to 11 February 1938 and Marin's recent watercolors and oils – were accompanied by catalogues that included writings by the artists, thereby emphasizing Stieglitz's belief in the power of the written word as well as in interdisciplinary connections, bringing together various art forms to present a more complete artistic expression, once again reaching toward a *Gesamtkunstwerk*. The catalogue material for O'Keeffe's show included eight letters written from O'Keeffe to Stieglitz from 29 July to 20 September 1937. Her words, while not substitutes for the paintings that included work from Ghost Ranch, along with flower, shell, and rock paintings, helped illuminate her life, inspirations, and working processes in New Mexico:

26 August 1937

I've been up on the roof watching the moon come up – the sky very dark – the moon large and lopsided – and very soft – a strange white light creeping across the far away to the dark sky – the cliffs all black – it was weird and strangely beautiful.

Goodnight – I wonder how you are –

2 September – 8:45 P.M. –

The wind is blowing – it doesn't often blow at night like this –

I have been painting all day – a painting that should be very good if I can really get it right – another cedar tree – a dead one against red earth but the red earth is most difficult – If this one doesn't go I'll try it again – At five I walked – I climbed my way up on a pale green hill and in the evening light – the sun under clouds – the color effect was very strange – standing high on a pale green hill where I could look all round at the red, yellow, purple formations – miles all around – the color all intensified by the pale gray green I was standing on. It was wonderful – you would have loved it too – Just before I went to walk I had two letters from you – Walking by yourself in the evening – up the hill too – If I had been there I would have encouraged you – It is too bad you rode so much when Einstein was

there – you sound lonely – and I wonder should I go to the lake and have two or three weeks with you before you go to town – I will if you say so – Wire me and I will pick right up and start.

<div style="text-align: right">20 September 1937</div>

It was the best ride I've ever had here – up and down all sorts of places that we could only get the horses to go by getting off and pulling several times – places I would never dare to go alone and cowboys wouldn't be much interested – perfectly mad looking country – hills and cliffs and washes too crazy to imagine all thrown up into the air by God and let tumble where they would. It was certainly as spectacular as anything I've ever seen – and that was pretty good – The evening glow on a cliff much higher than these here in a vast sort of red and gold and purple amphitheater while we sat on our horses on top of a hill of the whitish green earth – There was no trail to go back on but the one we went on and it got dark so I could barely see that my horse was following his own tracks back – Then the moon came up big – almost full and we could see out toward the trail and an easier way home. As we got to the top of the last ridge and looked down into the valley we had just crossed toward the moon, it was as beautiful as anything I have ever seen –

After supper . . . We dug out the piano – a very good Steinway Grand and Adams played for us – He plays very well . . . I'm sure nothing pleasanter every happened under its roof – I drove home alone – the open car – so bright and I didn't need to turn the light on the car – drove very slowly – right up to the face of the cliff and sat there alone a long time – It was so bright I could see all the color in the night . . . Well, that is what I'm about – I'm really fine.[79]

The catalogue to Marin's show included a poem he had written, "To My Paint Children." Dated 14 February 1938, the poem was a type of love letter from a protective parent watching his children "go forth to meet the public eye." It also evoked the world of dance, adding another dimension to Marin's work.

<div style="text-align: center">

To you who have been in the
making – these many years –
and who are now made to the
best of my making
and do now find yourself
hung in all your seeming nakedness – on
these walls
bear yourselves well and
disclose no more than can be disclosed by
your being what you are . . .

</div>

yes you are incomplete – you are

not quite rigged up – there'll be here and there

a – missing – to complete your balanced order

that's where your Poppa hasn't

quite clicked – your baffled Poppa – still you

have each and every one *somewhat* clicked – some

few of you *somehow* clicked

you – again don't meddle in other people's

affairs – if they love our AFFAIR – dance to

them Kids – DANCE – your loving Poppa

John Marin[80]

Stieglitz also inspired several other young photographers who came to visit his gallery in the mid-thirties. Frederick Sommer (1905–1999), raised in Brazil and initially trained as a landscape architect, seriously pursued photography after meeting Stieglitz in 1935. Although many of Sommer's works have surrealist underpinnings, his careful attention to portraying the essence of his subject matter and exploration of surface details would have pleased Stieglitz.

Consuelo Kanaga, originally from the West Coast, had met Stieglitz briefly in 1923, after having been inspired by seeing issues of *Camera Work*. They corresponded for a number of years, she frequently noting the impact Stieglitz's work had on her: "For years now I have carried about with me the image of your photographs. No gift has come so near me nor no possession so dear as having seen and known your work. It is not your technique alone but more some ringing message of truth and fearlessness which has helped me in living."[81] Kanaga began working for the W.P.A. and Photo League in the mid-thirties and in 1936 focused on a portfolio of "Negro Studies," spending some time in Harlem. That year she also fell in love with Wallace Bradstreet Putnam, an artist and writer, who became her third husband. Putnam identified strongly with the work of Toomer, whom the couple visited regularly in Doylestown, Pennsylvania. The Toomers introduced Kanaga and Putnam to the friends of Mabel Dodge Luhan, including Frieda Lawrence and Dorothy Brett, as well as O'Keeffe whom Kanaga already knew. Putnam and Kanaga spent their 1936 honeymoon in Vermont, stopping at Lake George to see Stieglitz. Kanaga photographed her mentor, standing on his Lake George porch, in a long black robe, flanked by lush foliage. Although he appeared elderly, his placement in the porch corner near the beautifully carved wood porch column grounded him, as he stood strongly in black, in his summer environment. Inspired by Stieglitz, Kanaga went on to be known perhaps best for her portraits, particularly of African Americans, especially those made on her trips to Tennessee in 1948 and Florida in 1950. Her well-known portrait of an African American mother and her two children, *She is a Tree of Life to Them* (Florida, 1950), was selected by Steichen for his 1955 "Family of Man" exhibition.

303

The mid- to late 1930s also brought sickness and death to Stieglitz's door. On 18 October 1935, the sculptor Gaston Lachaise, whom Stieglitz had shown, died of leukemia at fifty-three. For years following Lachaise's death, Stieglitz kept a small alabaster female torso by his friend, on a shelf in his gallery office. Just a week after Lachaise's death, Demuth died of complications related to diabetes. Stieglitz continued to exhibit Demuth's work until 1939, usually in group shows. He was particularly saddened by the untimely death of his younger brother Julius in January 1937 and worried about his brother Lee, a doctor to whom he often turned and the identical twin of Julius, but Lee lived until 1956.

Early in 1938, Stieglitz heard the terrible news of Oscar Bluemner's suicide. Then, on 22 April 1938, he himself, at seventy-four and already experiencing various health problems, suffered a near-fatal heart attack. Several weeks later, he developed double pneumonia and was unable to get out of bed until early June. Even then he had to limit his correspondence to one letter a day at first and use pencil instead of pen and ink. He was told he should not photograph since the excitement of trying to obtain a perfect negative would be too much for his heart. He did, however, continue to print for another two years. In early 1939, O'Keeffe traveled to Hawaii as part of a commission to produce paintings of pineapples for the Dole Pineapple Company. She chose to spend the summer of 1939 at Lake George with Stieglitz, in part because of his health, rather than travel to New Mexico, as she had in years past.

THE PHOTOGRAPHS

The most significant subject areas for Stieglitz in the 1930s were his New York series, his *Equivalents*, along with other Lake George images, and his portraits – of O'Keeffe, Dorothy Norman, Margaret Prosser, and others such as the Swami Nikhilanada.

His New York City images are best viewed within the context of his previous images of the city, as well as by other artists and photographers. The transformation of the city through the construction of high-rise buildings and skyscrapers early in the twentieth century brought both praise and criticism for the changing cityscape of the growing metropolis. Old brownstones and monuments of earlier eras gave way to tall corporate "cathedrals." For many artists, though, the contrast between old and new provided significant subject matter. Stieglitz's early 1910 photograph, published in *Camera Work* in October 1911, bore the title *Old and New, New York*. The image looks east from 34th Street and Fifth Avenue, where the sedate brownstones were becoming dwarfed by the new construction in the background, such as the Flatiron building of 1903, the Singer building of 1908, and the Woolworth building of 1913. Artists such as Marin, Steichen, and Coburn were all inspired by such structures. By the 1920s, the skyscraper and its steel skeleton were becoming pervasive in American urban centers. Images related to the tall buildings

became prevalent in art, music, literature, furniture, and stage design. The 1927 "Machine Age Exposition" in New York reflected "the prevailing belief that technology and the skyscraper were symbols of both rationality and transcendence – THE MACHINE IS THE RELIGIOUS EXPRESSION OF TODAY, reproduced in aggressive capitals, summed up this philosophy."[82] Novels such as *Manhattan Transfer* (1924) and *The Skyscraper Murder* (1926) by Samuel Spewack, or *The Cubical City* (1926) by Janet Flanner, turned the skyscraper into a significant setting. Furniture design, such as Paul Frankl's skyscraper furniture, employed cubic masses and setbacks akin to the new constructions. In music, many "likened the cacophonous, syncopated beat of jazz music to the clutter and rhythm of skyscraper construction. In John Alden Carpenter's 1926 ballet, 'Skyscrapers,' the composer employed a jazz-like idiom to convey the building of an American city."[83] Sheeler and Strand in their *Manhatta* film scanned the Woolworth building from top to bottom, calling attention to the spectacular geometry and height of the building for the time. By the completion of the Empire State Building in 1931, just two years following the stock-market crash, the skyscraper was beginning to be perceived, by Mumford and others, as a symbol of greed. To counter negative criticism, the Empire State Corporation made sure to glorify its workers when possible in the press. Lewis Hine, the photographer known for his images of workmen and immigrants often depicted in difficult working conditions, was commissioned to chronicle these workers. Rather than depicting oppressed laborers as in his earlier work, Hine climbed the enormous steel scaffolding himself to photograph and celebrate the feats of these workmen, their courage and skill. The resulting images were charismatic, poignant, and heroic, as the workers, the steel girders of the building, and the growing city below became one. Hine's 1932 book, *Men At Work*, was a photographic commemoration of men at work in various industries, including building. Men and machinery were considered allies not adversaries. Hine emphasized that machines did not create machines; it was men who created machines and operated them. His photographs shifted attention from the entrepreneur or businessman to the worker.

Unlike Hine, whose images emphasize the role of man in relation to the skyscraper, Stieglitz's 1930s images of the skyscraper and cityscape in general do not include human elements. Most were taken from An American Place, the Shelton Hotel, where Stieglitz lived, or from 405 East 54th Street, the penthouse where he and O'Keeffe moved in October 1936. He took the images from the upper floors of each building, looking, waiting, and reflecting; they were contemplative, exploring line, shape, and the change of light at different times of day and evening, as well as season. Stieglitz looked north, east, south, and west from his windows. From one perspective he celebrated new construction and the rise of a new metropolis that brought new engineering feats, a new sense of aesthetics, and a promise of a new world order inherent in the new technological feats. Through Stieglitz's lens can be seen the construction of or newly completed buildings such as the new Hotel Pierre, the New York Trust Company, the Squibb Company, the Waldorf Astoria Hotel, the RCA Victor Building (later the General Electric or GE build-

197 Alfred Stieglitz, *From An American Place*, *c*.1932. The Metropolitan Museum of Art, New York.

ing), the Hotel and Industrial Mart at 515 Madison Avenue, Rockefeller Center, the Cornell Medical Center, or, in later works, the Chrysler and Empire State Buildings. Several views from East 54th Street look toward the East River and Welfare Island (now Roosevelt Island). Yet, his views are more complicated than contemplation of new technological feats. As noted, he did not record human activity. He seemed to warn indirectly through his stark, often cold, minimalist images that he had continued concern for Americans' spiritual wellbeing. Unlike his early 1910 New York photographs, there was little reference to nature, except the sky and the river in a few images. The buildings frequently appeared as gridded geometric structures or light boxes, depending on the time of day. One image, *New York from An American Place*, of 1931, looking north, included a solitary figure barely visible behind a barred window of the newly completed Hotel and Industrial Mart on Madison Avenue. The man is seen in partial profile, bent over a desk. This piece appeared in Stieglitz's 1934 exhibition and Elizabeth McCausland wrote about it and her perception of New York at the time, "[Stieglitz] observes man in his less idyllic activities and milieus, in crowded and sordid cities built of pasteboard cornices, looking far more

198 Alfred Stieglitz, *From An American Place Looking North*, 1931. The Metropolitan Museum of Art, New York.

199　Alfred Stieglitz, *Looking North From An American Place, New York*, 1930. Philadelphia Museum of Art.

200 Alfred Stieglitz, *From An American Place*, 1931. The Metropolitan Museum of Art.

201 Alfred Stieglitz, *New York*, 1931.
Philadelphia Museum of Art.

202 Alfred Stieglitz, *From the Shelton Hotel*, 1931. The
Metropolitan Museum of Art.

203 Alfred Stieglitz, *New York from the Shelton*, 1934.
The Art Institute of Chicago.

204 Alfred Stieglitz, *New York, Spring*, 1931–5.
Philadelphia Museum of Art.

205 Alfred Stieglitz, *From the Shelton*, 1933–5.
The J. Paul Getty Museum.

206 Alfred Stieglitz, *From the Shelton West*, 1935.
The Museum of Modern Art, New York.

207 Alfred Stieglitz, *Window, An American Place*, 1930s. Beinecke Rare Book and Manuscript Library.

flimsy and meretricious than a house built of cards ever could."[84] The modern author, Peter Bunnell, has written about these New York images:

> There is nothing instantaneous about the pictures; rather they project the sensation of a monumental stasis, a logic with an aura of perfection. Stieglitz's arrangements encourage the belief that nothing could be changed without having to start over again to rebuild the entire image. The cityscape becomes a metaphor for the architectures of photography itself – about planning, of composition, or rendering in silver, as in steel and stone . . . Most of these pictures were made in a relatively short space of time after he had observed a place for many months . . . There can be no doubt that Stieglitz was commenting on the ironic state of American society, when he turns his camera toward the massive towers of Rockefeller Center . . . That the skyscrapers loom higher and higher and more luxuriant than the twin spires of St. Patrick's Cathedral leaves little uncertainty as to his concern for American culture. The skyscraper had become the new icon, but though Stieglitz knew that the city was being

208 K. Hoffman, *New York from Rockefeller Center, Looking South*, 2008.

209 K. Hoffman, *From Near An American Place Location*, 2008.

robbed of its history and of what he perceived as its traditional values, he knew, too, that it was the symbol of the future.[85]

Further interpretation of these late city views, particularly those taken from An American Place, saw them as a

> new kind of Equivalent . . . in a pictorial language of self-revelation through self-projection that Stieglitz traced back to *The Steerage*. These were spiritual "self-portraits" of An American Place as Stieglitz would have it be, direct windows onto that noble and tragic vision of the world that the Place was supposed to make possible . . . The city – "America" – was not looking back; it was missing out on its own transcendental "living moment," by failing to recognize its redemption in Stieglitz's life and work.[86]

These late cityscapes, thus, may be viewed on a variety of levels from document, to formal compositional study, to metaphor; as secular or as transcendent, reaching to the beyond, a world of infinite possibilities, both earthbound and stretching into the sky and wider universe. Stieglitz

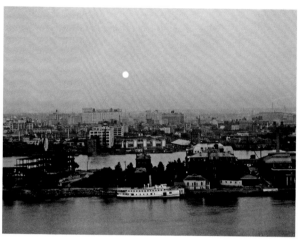

210　Alfred Stieglitz, *New York from 405 E. 54th St*, 1936–7. National Gallery of Art, Washington, D.C.

211　Alfred Stieglitz, *New York from 405 E. 54th St*, 1937. National Gallery of Art, Washington D.C..

looked out but he also invited the outside in, challenging the viewer to contemplate the city-scape. As he was reported to have said one day, while looking out the window of An American Place, "If what is happening in here cannot stand up against what is out there, then what is in here has no right to exist. But if what is out there can stand up against what is in here, then what is in here does not need to exist."[87]

Stieglitz's images of the sky and clouds, or *Equivalents*, in the 1930s mostly omit references to the Earth. Of the few references, tree fragments are primary, such as those in several 1930 *Equivalents*, where leafless, perhaps dead, branches reach into a dark foreboding sky, or a 1933 series made from one negative, *Equivalent 27A, 27B*, and *27C*. In the latter series, fragile tips of small, leafy branches hover on the bottom edge and lower corners of the image, reminding the viewer of the vastness of the open sky in relation to the earth. Edward Alden Jewell likened the series exhibited in Stieglitz's 1934 show, with its subtle changing tonalities, to a musical composition: "Three Equivalents . . . are as many prints from one negative, yet each is found to possess an altogether distinct orchestration of tone values. They are the separate reading from a page of music; readings in which so much depends upon the interpretation of the individual musician or conductor."[88]

A number of the 1930s *Equivalents* are dark, almost eerie, as if a specter of death or old age looms in Stieglitz's mind. Yet the images are not static – they almost always evoke some sense of changing, or evolving, or becoming. Significant, too, in both the 1920s and 1930s, is the altered orientation from a traditional viewing of the sky, clouds, and earth, which Stieglitz sometimes chose. The rejection of traditional representation allowed him to emphasize modern-ist expression that included the dynamics of form, space, and changes in light, along with ele-

316

212–13 Alfred Stieglitz, (top) *Equivalent*, 1930. Philadelphia Museum of Art;
(bottom) *Equivalent*, 1930. The Metropolitan Museum of Art.

214 Alfred Stieglitz, *Equivalent*, 1930.
The Metropolitan Museum of Art.

215 Alfred Stieglitz, *Equivalent*, c.1929/30.
Lee Gallery, Winchester, Massachusetts.

ments of fragmentation. His cloud photographs were taken on "The Hill" at Lake George, where he, O'Keeffe, their guests, and his extended family continued to gather. For Stieglitz, the Adirondack setting, with its pristine view of a beautiful lake, its islands, surrounding hills, and abundant foliage, was a source of continuity, stability, and renewal. It is perhaps only in such a setting that Stieglitz could have photographed those clouds for almost two decades, as he sought to capture the pleasure of changing, evolving, endless forms. Andy Grundberg wrote, in 1990, that the *Equivalents*

> in a sense represent the apotheosis of Stieglitz's art. They remain photography's most radical demonstration of faith in the existence of reality behind and beyond that offered by the world of appearances. They are intended to function evocatively, like music and they express a desire to leave behind the physical world . . . Emotion resides solely in form, they assert, not in the specifics of time and place . . .[89]

Stieglitz could not live without returning to Lake George each year but he could also not live without New York City. His two worlds and his New York City series coupled with the cloud photographs are, in a sense, the yin and the yang of a larger whole; perhaps they are best viewed together. The organic flow of the cloud images, juxtaposed with the frequent hard edges of the New York images, are like the Apollonian and Dionysian coming together in Stieglitz's aesthetic.

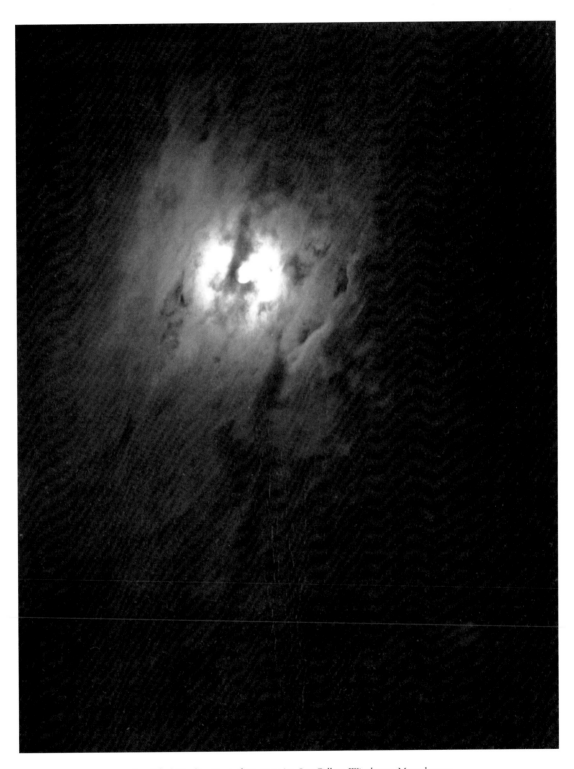

216 Alfred Stieglitz, *Equivalent*, *c.*1929/30. Lee Gallery, Winchester, Massachusetts.

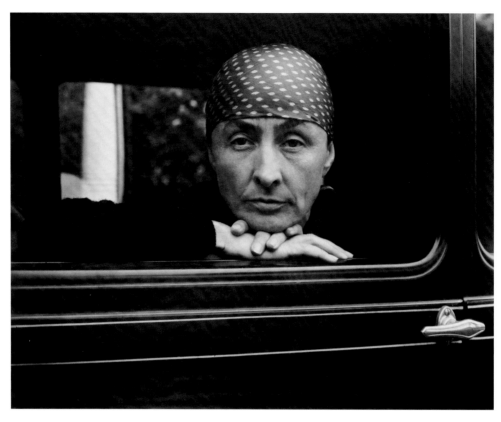

217 Alfred Stieglitz, *Georgia O'Keeffe*, 1932. The Metropolitan Museum of Art, New York.

Taken together, the two different worlds also unite the urban and the rural, the man-made and nature, the Machine Age and romanticism or symbolism, from which the Equivalents were born.

Grundberg further wrote about Stieglitz's photography that the "real centre of Stieglitz's considerable accomplishment as a photographer" lay "in the sensual and sexually charged portraits of women he made throughout his mature career."[90] Most renowned is his composite portrait of O'Keeffe. His images of O'Keeffe in the 1930s are distant and cooler than the images of the previous decades, reflecting, in part, her growing independence and public recognition, the increased time she spent away from Stieglitz, and the ups and down of their relationship. A 1930 photograph of her standing in front of one of her own 1929 paintings, *After a Walk Back of Mabel's*, depicts her nun-like, dressed in black, her head covered, her body engulfed in the dark tunnel lines of the painting. In a number of photographs, her hair is covered or drawn tightly back from her face. Several images show O'Keeffe holding a deer skull, or simply her hands on the skull, or her wrapped in an Indian blanket. The skull and blanket "spoke" of

320

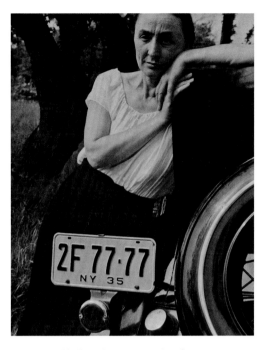 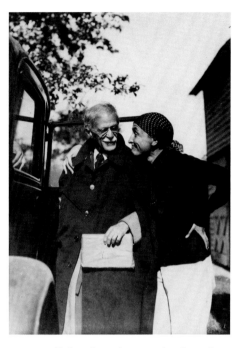

218 Alfred Stieglitz, *Georgia O'Keeffe Leaning on a Car*, 1935. Beinecke Rare Book and Manuscript Library.

219 *Alfred Stieglitz and Georgia O'Keeffe at Lake George*, c.1932. Photographer unknown. Beinecke Rare Book and Manuscript Library.

O'Keeffe's New Mexican world, a world Stieglitz never visited. (She had a number of bones shipped east and used them in her paintings.) Her expression in the photographs with the skull and blanket is severe, serious and she appears distant from the viewer and the photographer. Stieglitz exhibited his 1930 image of O'Keeffe's hands with the skull, with an alternative title of *Life and Death – Hands and Skull*, suggesting a symbolism in the imagery, relating in part to their sometimes difficult relationship or his growing older. This image was published in *Life* magazine in 1943 and could then be more easily read as a statement on their waning relationship and his increasing health problems.

Although Stieglitz photographed O'Keeffe in the nude in 1931, the images are studied and almost classical in the depiction of the female form. Gone are the sensuality and passion of the early O'Keeffe nudes. These 1930s images are studies in light, shadow, line, form. The edges are clean, clear cut; O'Keeffe's torso, photographed from the front and rear primarily in a reclining position, became a minimalist still-life object.

A group of photographs made by O'Keeffe in 1933 depicts her with the wheel of a car and within a car. That summer, she had bought a new Ford V-8 convertible coupe. Stieglitz photographed her with the spare wheel, her hands, and her head resting on the shiny metal of the wheel. The V-8 symbol is prominent in several of the images, emphasizing the power of the

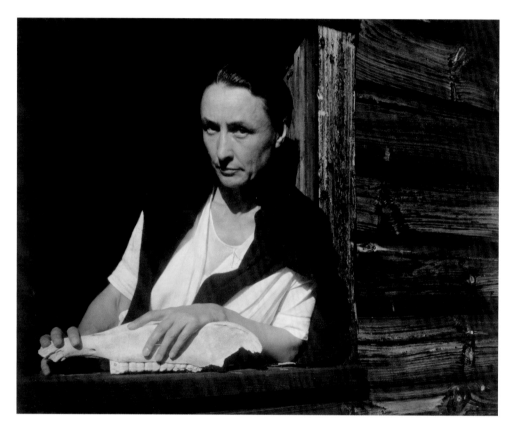

220 Alfred Stieglitz, *Georgia O'Keeffe*, 1931. The Metropolitan Museum of Art.

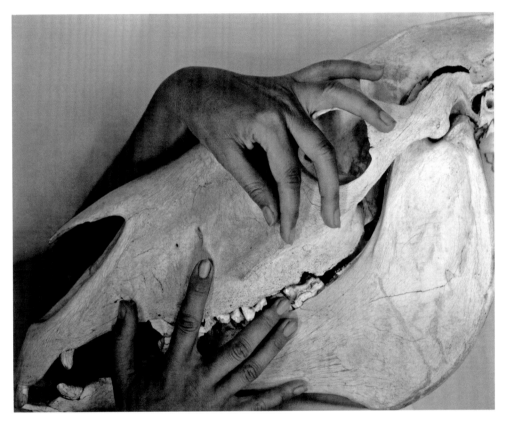

221 Alfred Stieglitz, *Georgia O'Keeffe – A Portrait*, 1931. The J. Paul Getty Museum.

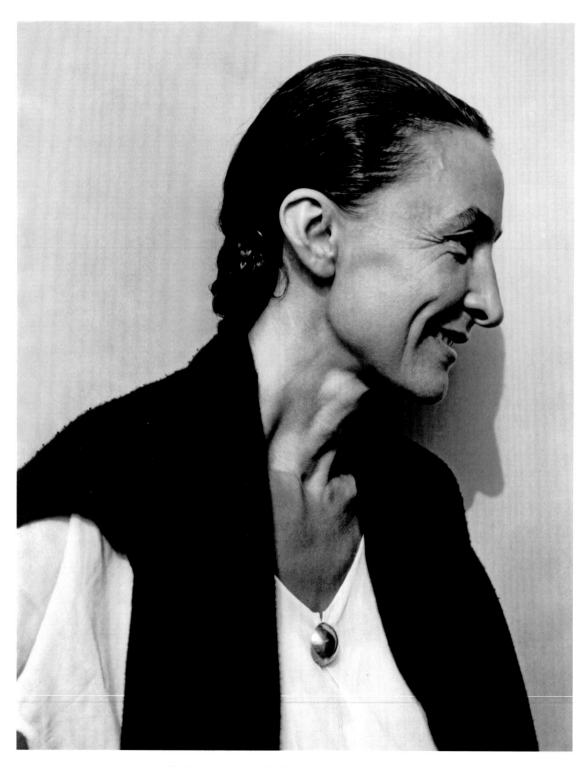

222 Alfred Stieglitz, *Georgia O'Keeffe*, 1932. The Metropolitan Museum of Art.

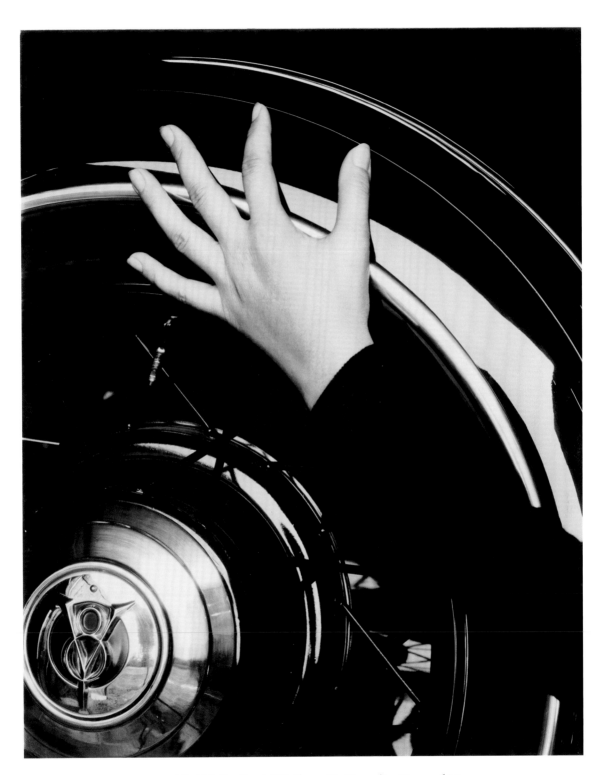

223 Alfred Stieglitz, *Georgia O'Keeffe*, 1933. The Metropolitan Museum of Art.

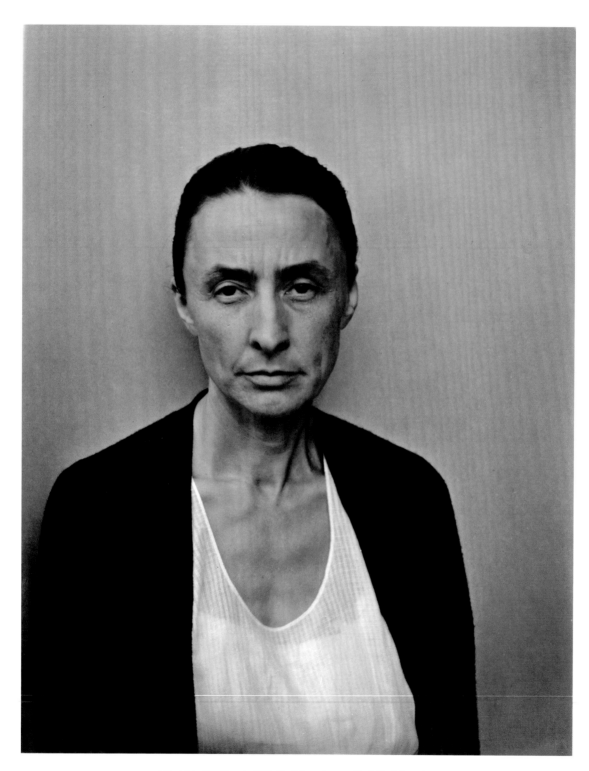

224 Alfred Stieglitz, *Georgia O'Keeffe: A Portrait*, 1932. The J. Paul Getty Museum.

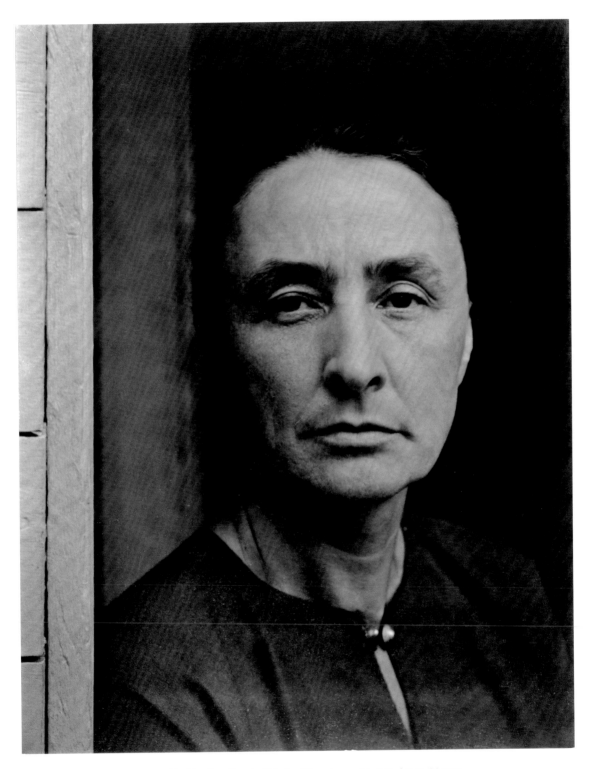

225 Alfred Stieglitz, *Georgia O'Keeffe: A Portrait*, 1933. The J. Paul Getty Museum.

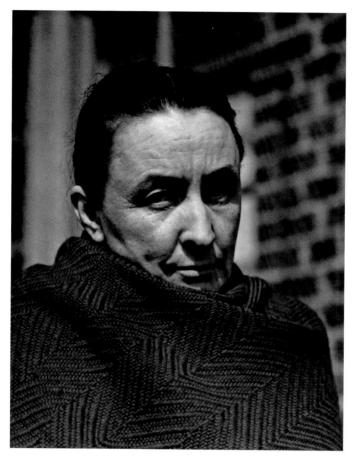

226 Alfred Stieglitz, *Georgia O'Keeffe*, 1936/37. National
Gallery of Art, Washington, D.C.

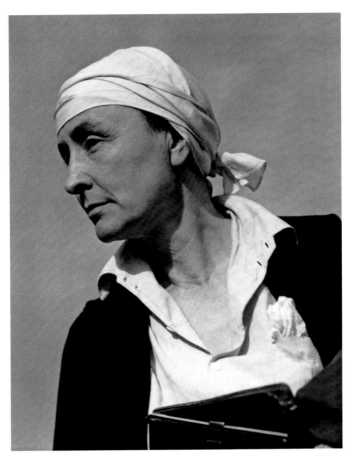

227 Alfred Stieglitz, *Georgia O'Keeffe*, 1936. National
Gallery of Art, Washington D.C.

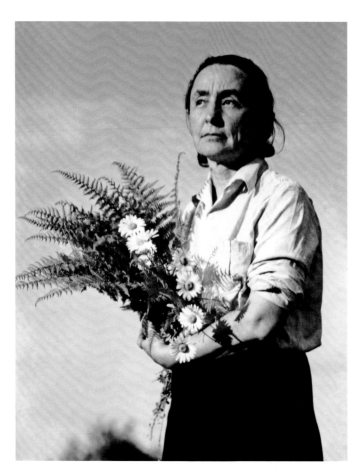

228 Alfred Stieglitz, *Georgia O'Keeffe*, 1936.
National Gallery of Art, Washington D.C.

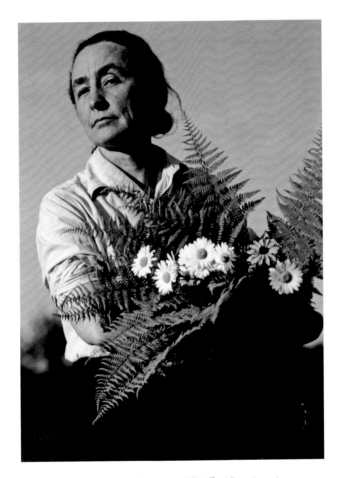

229 Alfred Stieglitz, *Georgia O'Keeffe: A Portrait*, 1936.
The J. Paul Getty Museum.

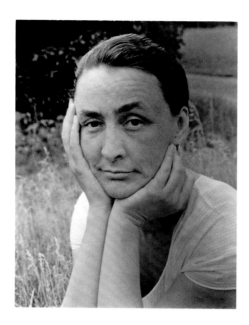
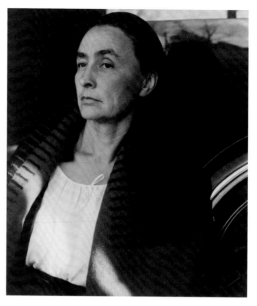

230 Alfred Stieglitz, *Georgia O'Keeffe: A Portrait*, 1933.
The J. Paul Getty Museum.

231 Alfred Stieglitz, *Georgia O'Keeffe*, 1935.
The Metropolitan Museum of Art.

automobile and machine. In several of the photographs O'Keeffe's silver bracelet, probably from the southwest, of Navajo, Native American origin, balances the metallic reflections of the hub cap, thereby uniting two disparate cultures. Such may have been unintended but her braceleted wrist unites an individual craftsman or woman with the mass-produced Ford product. In 1935, Stieglitz photographed the rear of the car alone, its shiny metallic surfaces providing reflections of the nearby house and landscape at Lake George.

Some of the late photographs of O'Keeffe, in 1936, depict her with a bouquet of daisies and ferns, dressed in a white shirt and dark skirt. The flowers are wild, yet she appears older and posed, the bouquet arranged in her arms. Together, the flowers and O'Keeffe are distinct reminders of the age-old connections in art history between women and nature, of women's connection to fertility and new life. Yet Stieglitz's images seem highly posed and O'Keeffe's expression is one of tolerance, or remembrance of another time with him, as she looks into the distance. One of the last images of O'Keeffe was probably taken in 1936 or 1937 at their new penthouse at 405 East 54th Street, with its brick wall in the background. O'Keeffe's hair is pulled back tightly; she is wrapped in a blanket, partially covering her chin. One sees only the blanket from just below her shoulders, as she peers at the viewer, distanced, perhaps skeptical. She appears to be withdrawing from the gaze of the photographer and the viewer.

Perhaps more poignant are Stieglitz's photographs of Dorothy Norman taken in the 1930s. These reveal a young woman with large eyes, serious, with classical, symmetrical features. As with

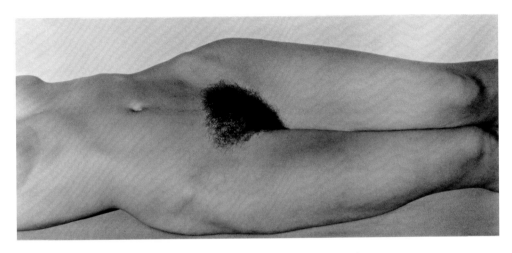

232 Alfred Stieglitz, *Georgia O'Keeffe: A Portrait*, 1932. The J. Paul Getty Museum.

O'Keeffe, Stieglitz photographed her in diverse poses, close-up, her hands, nude, and so on. In some, as in O'Keeffe's portraits of the time, Norman's hair is pulled tightly back, or she wears a hat. In some, she stands in front of a work of art. Several of the photographs of her appeared in both Stieglitz's 1932 and 1934 exhibitions. Although they do not contain the passion of the early O'Keeffe images, they suggest a sense of deep attachment between the two. From Lake George, Stieglitz wrote while printing images of her:

> Oh, Dorothy Child – What is it you give to me? – What happened to bring me the complete acceptance of everything you are . . . the continuous sense of ever greater beauty . . . Yes, you love me. And I love you. And I know it is no crime. Not before God. Not before thinking Men and Women. ILY beyond all measure. It's beyond belief my feeling about you. I'm very quiet At Peace . . . I was working on a print of you. Really one of the finest things I ever did. But there should have been hundreds more . . . We are alike – so alike . . . And it's wonderful to hear you say, "I finally know completely." And all of you tells me you do. As I do.[91]

In general, the images were closer and softer of Norman than the more monumental images of O'Keeffe. Stieglitz rarely enlarged the Norman images, retaining the 4 by 5-inch contact print. Many of the images were taken at An American Place, where white walls and light-filled rooms provided a setting that often allowed for dramatic lighting.

Stieglitz not only photographed Norman but also taught her how to photograph. Initially he loaned her a 4 by 5-inch Graflex camera during the spring of 1931 and taught her how to use it. That Graflex was too heavy for her so he suggested a smaller model producing 3¼ by 4¼-inch negatives, which Norman obtained later that year. The darkroom at An American Place became a classroom where they spent hours together. On the backs of her prints Stieglitz often wrote

333

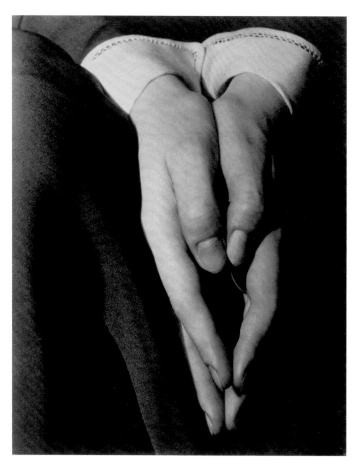

233 Alfred Stieglitz, *Dorothy Norman (Hands)*, 1930.
Philadelphia Museum of Art.

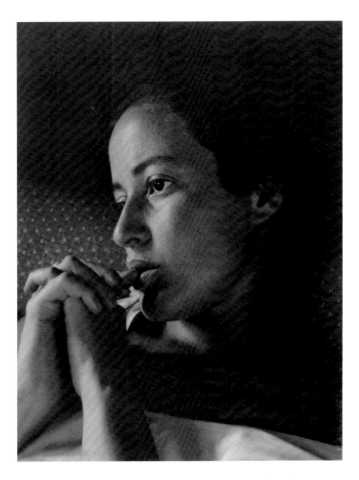

234 Alfred Stieglitz, *Dorothy Norman XIV – Woods Hole*,
1931. Philadelphia Museum of Art.

235 Alfred Stieglitz, *Dorothy Norman XLII*, 1931.
Philadelphia Museum of Art.

236 Alfred Stieglitz, *Dorothy Norman XXVII*, 1932.
Philadelphia Museum of Art.

237 Alfred Stieglitz, *Dorothy Norman LXXIV*, 1936.
Philadelphia Museum of Art.

238 Alfred Stieglitz, *Dorothy Norman LXXVII*, 1937.
Philadelphia Museum of Art.

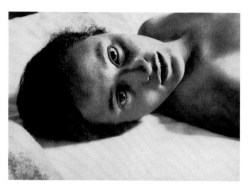

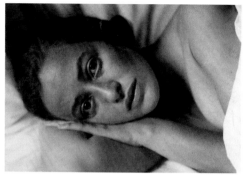

239 Alfred Stieglitz, *Dorothy Norman LXXXVII*, 1930–31. Philadelphia Museum of Art.

240 Alfred Stieglitz, *Dorothy Norman LXXXII*, 1931. Philadelphia Museum of Art.

lengthy instructions or corrections, along with frequent praise. Many of his inscriptions ended with ILY or IBO (I Bow Out), referring to her success with an image and no need for continued assistance from Stieglitz. For example, he wrote on the back of an image of bending grass tendrils from Woods Hole, of around 1931–2, "Lovely, Lovely, Lovely. Very different kind of feeling than the other – Just as beautiful – just as intense – technically sensitive and delicate – but very positive . . . *IBO*."[92]

The earliest photographs Norman took were primarily of Stieglitz, the first taken in 1931. She continued to take photographs of him up to shortly before his death in 1946. Many are close-up, some partially cropped, revealing Stieglitz as an older man, serious, intense, a "seer." A 1933 photograph shows him in profile, intently spotting his portrait of her. Several images from the mid-1930s focus on his hands, often clasped, prayer-like, illuminated against a dark black field. In one 1935 image he holds his glasses, reminding the viewer of the importance of his "seeing" as well as his hands in the process of creating any given image, from shooting to image to the final print. Another image simply shows his hat and coat in the "vault" where he stored a number of works. The last portrait Norman took of Stieglitz in 1946 is a tightly cropped profile of his head and left shoulder as she captured him in a moment of intense contemplation. She also photographed the interior of An American Place, her images often capturing the play of light and shadow on bare walls.

Norman was clearly influenced by Strand also in her careful attention to detail and in choosing some of the same kinds of subject matter. Like Stieglitz, she was drawn to the world of nature near her home in Woods Hole, Massachusetts, even photographing the sky; to the New York City metropolis; and to portraiture. Her portraits, in general, tended to be taken closer to her subjects than Stieglitz's and included little background setting. As she wrote, "I

 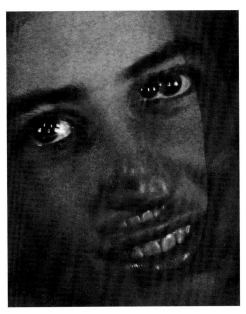

241 Alfred Stieglitz, *Dorothy Norman with Telephone XXXVIII*, 1933. Philadelphia Museum of Art.

242 Alfred Stieglitz, *Dorothy Norman*, [key set – NGA title *Dualities – Dorothy Norman*] 1932. The Art Institute of Chicago.

loved to photograph certain faces when I took portraits. I wanted most of all to make close-ups that showed as much as possible of the face. Its expressiveness must come through in order to illuminate character."[93] Among those Norman photographed in the 1930s and 1940s were Demuth, Frank, Anderson, Paul Bowles, Theodore Dreiser, Mumford, Edgard Varèse, Harold Clurman, Elia Kazan, Hans Richter, Coomaraswamy, Marin, Chagall, Brecht, and Richard Wright.

For Norman, the act of photography was an act of transformation, a kind of sacred contemplation, which she learned, in part, from Stieglitz. As she wrote,

I would peer into my camera, obsessed by the trembling edge and texture of white in a petal . . . A moon flower. Petunia. Cosmos. Water Lily. Round. The feeling of white . . . Everything was magically still . . . I shut down my lens, held my breath. I clicked, again and again. Each moment the light changed. Did I catch anything or not? I was never certain, but I was transformed.[94]

Besides assisting and being involved with Stieglitz, she also joined the Board of Directors of the Union for Democratic Action and the Board of the India League of America. Forming the Board of the India League reflected the influence of Coomaraswamy whom Norman had met

341

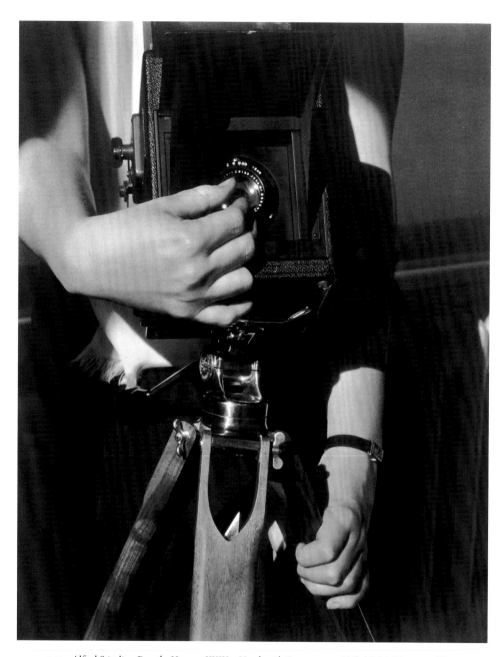

243 Alfred Stieglitz, *Dorothy Norman XXIV – Hands with Camera*, 1932. Philadelphia Museum of Art.

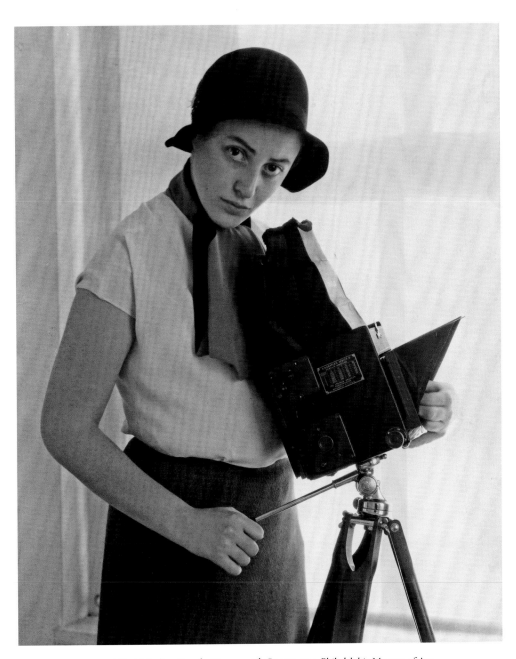

244 Alfred Stieglitz, *Dorothy Norman with Camera*, 1932. Philadelphia Museum of Art.

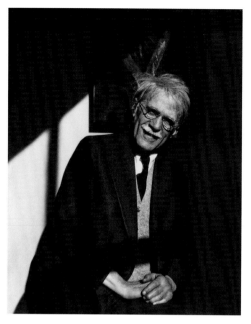

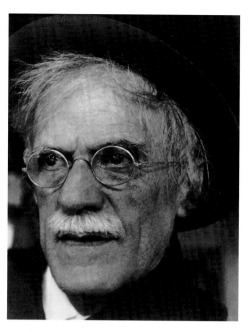

245 Dorothy Norman, *Alfred Stieglitz, New York*, 1930s 246 Dorothy Norman, *Alfred Stieglitz, New York*, 1932.
University of Arizona. University of Arizona.

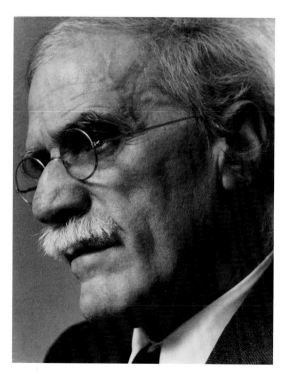

247 Dorothy Norman, *Portrait, Alfred Stieglitz*, 1935. University 248 Dorothy Norman, *Alfred Stieglitz*, 1930s.
of Arizona. The J. Paul Getty Museum,

249 Dorothy Norman, *Alfred Stieglitz Spotting Portrait of Dorothy Norman
(with Marin paintings and Stieglitz Photograph in Background) An American Place, New
York*, 1930s. The J. Paul Getty Museum.

250 Dorothy Norman, *Telephone in
Front of Stieglitz Equivalent*, 1940.
University of Arizona

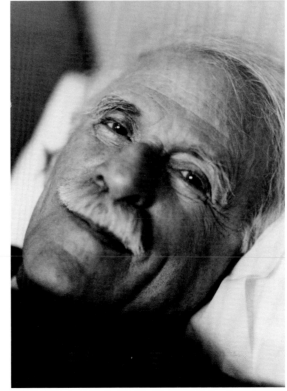

251 Dorothy Norman, *Stieglitz's Hat and Coat in Stieglitz
Vault, An American Place*, 1940s. University of Arizona.

252 Dorothy Norman, *Alfred Stieglitz XXII, New York*,
1944. University of Arizona.

253 Dorothy Norman, *Stieglitz and Steichen, An American Place*, 1946. The J. Paul Getty Museum.

in 1928 in Boston. She took a number of photographs of Indira Gandhi and Jawaharlal Nehru, as well as photographs of India in 1950, attending the celebration of the founding of the Republic of India in 1950 at Nehru's invitation. From 1942 to 1949, she wrote a tri-weekly column, "A World to Live In" for the *New York Post*. In 1955, Steichen selected her to choose the captions for his monumental "Family of Man" exhibition at the Museum of Modern Art.

Quite different from Norman was Margaret Prosser (1880–1969) whom Stieglitz also photographed in the thirties. Prosser, a stocky woman, worked as the housekeeper at Lake George for Stieglitz, his family, and their guests from 1927 to 1946. She was cherished by the family and those who knew her. Strong and capable, she was good natured and exuded warmth and generosity. Stieglitz referred to her frequently in his letters to O'Keeffe. Prosser made most of the major decisions in the running of the household and, in Stieglitz's later years, she became a pillar of stability and certainty for him.

Stieglitz made two portrait series of her, the first late in the 1920s, then again in the mid-1930s, the latter among his last photographs. Many were not simply snapshots but full studied portraits, carefully printed. A portrait of around 1936 in the kitchen depicts Margaret after a meal, her

254–7 (Clockwise) Alfred Stieglitz, *Margaret Prosser, Lake George, c.1935, Margaret Prosser, Lake George, 1937, Georgia O'Keeffe and Margaret Prosser at Lake George, c.1936, Margaret Prosser*, inscribed "For Margaret/1936". The Adirondack Museum, New York.

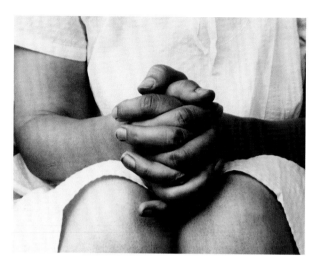 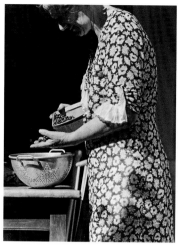

258 Alfred Stieglitz, *Margaret Prosser's Clasped Hands in Lap*, 1933. The Metropolitan Museum of Art, New York.

259 Alfred Stieglitz, *Margaret Prosser Sorting Blueberries, Lake George, c.1936*. The Metropolitan Museum of Art, New York.

left arm on a chair back, supporting her head and also providing a strong visual triangle that is balanced by her right elbow resting near the boat-shaped empty melon rind. Strong verticals and horizontals of the background and of the chair back complement the multiple triangular lines of Margaret's pose and her V-necked dress. Several close-ups of her face illuminate her strong features and suggest an inner strength. She is seen at work, sorting blueberries, wearing a floral dress with a pattern complementing that on the strainer and emphasizing the juxtaposition of female, flowers, and fruit. Or she is outside washing apples in the afternoon light; or she holds apples from a nearby tree, apples that also appeared in other Stieglitz photographs taken at Lake George. The outdoor photographs of Margaret tend to stress her vitality, such as the 1936 image of her carrying wildflowers and a striped dishtowel draped over her arm. Her low-cut daisy-patterned dress emphasizes the flower motif; she was noted for gathering wildflowers and plants to make beautiful bouquets for the house. Prosser was also photographed in 1934 reclining in an odalisque position, in back of the Little House at Lake George, and also seated there in her underslip, her dress draped on her lap.

Frank Prosser, Margaret's son, who spent much time at the Stieglitz home as a young boy, since his parents had broken up, noted that "word had it that Margaret was photographed nude by Stieglitz."[95] He further recalled that O'Keeffe was a "thing of beauty" but she had a "mean side," that she had once "belted him" when he forgot to return the keys to her car.[96] Frank remembered more than once being the subject of O'Keeffe's anger: when she was in her nineties she phoned him from New Mexico, asking if he would visit. He refused but talked on the phone about a half hour. "She reminded me of the time from years ago when she had just finished a

348

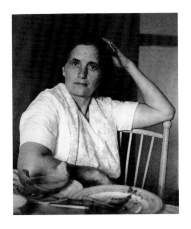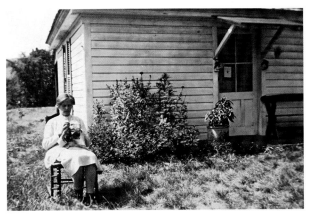

260 Alfred Stieglitz, *Margaret Prosser,* 261 Alfred Stieglitz, *Margaret Prosser Seated Outside, Sewing*, 1930s.
Kitchen, Lake George, c.1936. Private Private collection.
collection.

painting and I – who was a little kid at the time – proceeded to draw all over it when she wasn't looking. She saved the painting, though."[97] Stieglitz's photographs of Frank as a young boy suggest a genuine interest in the youth. The photographs seem spontaneous but well composed. In one Stieglitz has captured Frank, along with Peggy and Sue Davidson, forming a human pyramid, waving in delight to the photographer. Prosser referred to Stieglitz as a "kind gentleman," "a lady's man," and someone who regularly remembered him at Christmas, on birthdays, and at his high school graduation.[98]

Stieglitz photographed Margaret Prosser and O'Keeffe together in about 1936, standing in a grassy field not far from laundry blowing in the wind. Margaret was fifty-six, Georgia forty-nine. O'Keeffe is well dressed, carrying a large purse, a coat, and a blanket she used to sit on while painting outdoor subjects, suggesting her work as an artist. Margaret is wearing an apron over her dress, probably having come from hanging the laundry, representing her work. The two women, both a significant part of Stieglitz's life at that point, stand with their arms in similar positions, as counterparts, each appearing strong and independent.

Following Stieglitz's death, Margaret Prosser wrote to Anita Pollitzer about her perception of O'Keeffe's role in Stieglitz's work:

Mr. Alfred never would have been the photographer he later was if he hadn't gotten with Georgia. I saw his early photographs, I saw his late photographs, the negatives would hang up in my kitchen to dry. I saw them all, and I heard him talk about them all, and what they meant. He did wonderful street scenes, railroad tracks, and all that before Georgia came. But after Georgia came, he made the clouds, the moon, he even made lightning. He never photographed things like that before.[99]

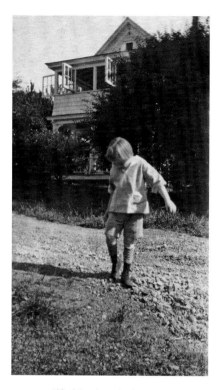

262 Alfred Stieglitz, *Frank Prosser*, 1920s.
Private collection.

263 Alfred Stieglitz, *Frank Prosser and Friends at Lake George*,
c.1930. The Adirondack Museum, New York.

Prosser and O'Keeffe became close during and after O'Keeffe's 1933 crisis following her failure to complete the mural at Radio City Music Hall and problems with Stieglitz. As noted earlier, O'Keeffe came to The Hill, under Margaret's care. From Lake George she wrote frequently to Toomer: "Here I am alone with just a maid who does things for me, a person I like very much," or "I started to paint on Wednesday – it will undoubtedly take quite a bit of fumbling before I get started on a new path – I am busy putting myself together piece by piece – I need time – Margaret is very good natured."¹⁰⁰ In 1939, she wrote to Margaret from New Mexico, asking to have her copy of the *Arabian Nights* and the Bible sent to her. After Stieglitz's death, she also asked Prosser to work for her in New Mexico but Prosser declined.

Besides his photographs of Margaret Prosser, as part of his last series of photographs, Stieglitz also photographed Swami Nikhilanada, the head of the Hindu Center in New York and a friend of Stieglitz's niece, Elizabeth Davidson. "The Swami," as he was called, came to Lake George for most of summer 1937 into September. Stieglitz appeared to enjoy talking to him about a variety of subjects from religion, to politics, to sports. The Swami was particularly noted for his transla-

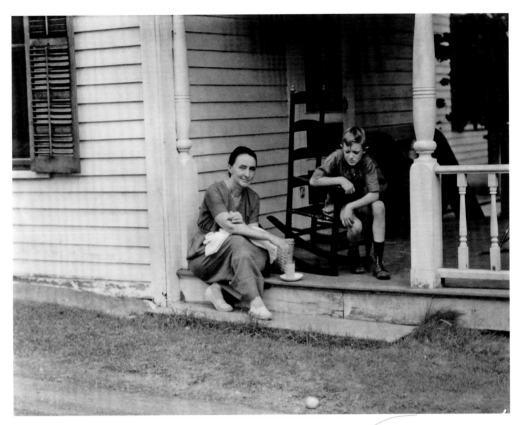

264–6 (Clockwise) Alfred Stieglitz, *Georgia O'Keeffe and Frank Prosser at Lake George, c.*1933, *Frank Prosser and Emil Zoler, Lake George,* 1936, and *Frank Prosser, Lake George, c.*1935. Courtesy of Adirondack Museum, New York.

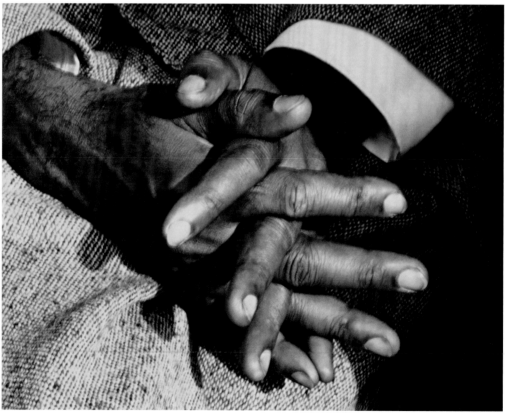

267–9 Alfred Stieglitz, *Swami Nikhilanada*, 1937. National Gallery of Art, Washington D.C.

tions of *The Upanishads* and the *Bhagavad Gita*, along with his two books, *Hinduism, Its Meaning for the Liberation of the Spirit* and *Man in Search of Immortality*. Writing to O'Keeffe in New York on 15 September 1937, at 9 a.m., Stieglitz seemed to be especially pleased with some of the photographs he had just taken of the Swami:

> What a perfect day. . . . And I made 10 shots of the Swami up at the barn where so often I snapped you and rarely got anything – You see the Swami in a very becoming black halfcoat was coming down with Peggy and Sue [Davidson] to say good-bye. I never had seen the Swami in the A.M. He [was] busy always then – And I not wanting to disturb his routine – So on the spur of the moment . . . I said to Swami: Come along. I must snap you. He followed me. I had gotten the camera. I made 10 snaps inside of five minutes. You know me. The Swami was relaxed. He said to me: This morning you look like a child playing with a toy. – Yes, I was alive heart and mouth and all the other nonsense didn't exist. – There was the Swami in the barn and there was the brilliant sunlight – no clouds – and I know Elizabeth was glad about what was happening . . . It was all alive and joyous and immediate. Elizabeth looked very satisfied. The children happy. The Swami beaming . . . The Swami said he was coming to read to you. You had asked him . . . And he is coming to the Place . . . [It was said] Uncle Al you look like the priest (I had my cape on) and the Swami looks like a sport. He did in a way. He loves clothes. It was all very alive. – Fine – Rare . . .[101]

Stieglitz's photographs of the Swami are small, intimate, but powerful. One sees the striking Swami close-up, his head and shoulders, in contrast to the sky behind him or against the dark background of an interior shot. As with other subjects, Stieglitz photographed his hands, clasped with extended dark fingers on his finely woven tweed jacket. Although the facial images appear somewhat informal, the Swami exudes a strong presence even in the small format of the images.

The portrait series of the Swami and Margaret Prosser at Lake George represent two significant distinct presences in Stieglitz's life at the time. Margaret may be seen as the working-class woman who provided stability and a well-kept household, while the Swami represented a spiritual presence, well educated, international in background, "the other." Both figures found a place to be in Lake George and in Stieglitz, the one for a long term, the other for a short. For each the power of place and presence of a significant figure was important.

This power of place is seen in the Lake George photographs of the decade as Stieglitz turned to the buildings, vistas, trees, and plant life in his immediate surroundings. He made numerous studies of the Little House where he developed and printed images. That house, a simple square, with a triangular, pyramid-shaped roof, as it is photographed from various angles, different times of day, and in different seasons, is transformed from its vernacular status to a realm of contemplation and reverie. Stieglitz photographed the farmhouse from various vantage points – close-up,

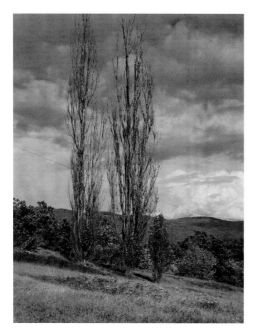

270 Alfred Stieglitz, *Poplars. Lake George*, 1935.
The Art Institute of Chicago.

271 Alfred Stieglitz, *Poplars, Lake George*, 1936.
Lee Gallery, Winchester, Massachusetts.

far away, as a crown on the hilltop, as an integral part of the hills and trees. Sometimes he photographed parts of the house such as a triangular gable juxtaposed with fluffy cumulous clouds and leafy tree branches (1931) or the door to the kitchen with the changing light patterns on the threshold (1934) or the various images of the porch and lush grapevine covering the railing. One of these images, *House and Grape Leaves*, of 1934, illustrates Stieglitz's continuing abilities at age seventy to compose, and meticulously present, the details of his print, from the architectural ornamentation of the house, to the rich mass of beautifully shaped leaves that grounds the image, to the glint of light in the window, to the misty lake and hillside in the background. A modern writer has described the impact of this piece:

In the "Phaedo" of Plato, seventy year old Socrates demonstrates how the soul commands the body, rather than the other way around. On the day of this picture in the summer of 1934, Stieglitz commandeered his seventy-year old eyes, ignoring his aches and fears, and peered at the dim glass to level the camera and align pillar and shutter, shade-pull with window light, column turnings with clapboard. Feeling the emotional, as well as visual weights of light and dark masses, he set the picture's margins to adjust their balance. Precision of line, deployment of tone, response to the season, its humid air and its growth – these and other components, sensed but surely never named by Stieglitz (perhaps he thought of notes, even instrument sounds in orchestral music, possibly a German tone poem or song), settled into place, into

354

272 Alfred Stieglitz, *Chestnut Tree, Lake George*, 1932–34. The J. Paul Getty Museum.

273 Alfred Stieglitz, *Later Lake George*, 1933. The Art Institute of Chicago.

274 Alfred Stieglitz, *Tree Set 3*, 1930.
The Art Institute of Chicago.

275 Alfred Stieglitz, *The Barn,
Lake George*, 1936.
The Art Institute of Chicago.

an open, resonant structure, a structure responsive to his and the place's past, to their history.

All of Stieglitz is here. His will, his masterful ability, his artistic sophistication, his gloomy Romanticism, his age, his heroic refusal to give in to the inevitable – all are in this picture. As much as the sky pictures, the earthbound view is the "direct revelation of a man's world." The *truth* it contains is based on the accuracy of its grasp of the visible, physical reality – on its accurate report of the scene in front of the lens, but the larger Truth, greater than this, is the picture's fidelity, its correspondence, to Stieglitz's experience of life "as it was felt at the moment of the picture's making."[102]

Stieglitz frequently photographed the poplars located in various places around the Lake George property. The tall slender trees appear in full view or cropped, with leaves or leafless, like giant monarchs reaching into the sky, sometimes still, sometimes dancing and swaying in the wind. In 1925 and 1927, Stieglitz had included photographs of these trees as part of his series, *Songs of the Sky* and his *Equivalents*. By the thirties, however, the poplars were gradually dying and that process became the subject of Stieglitz's images beginning in about 1932. Such images seem to reflect, in part, Stieglitz's own aging process. Although he depicts the dying limbs, there are still leaves on some of the branches, and in the cropped images, depicting the middle section of the trees, the slender trunks and branches still appear strong, continuing to reach upward. Stieglitz wrote to Seligmann about one of his 1932 images, "Have finally one thing I think pretty grand – a tree – a dead one. But one of the last poplar images of 1937, shows a healthy poplar, standing straight and strong, defying the odds of death."[103]

276 Alfred Stieglitz, *Lake George, House on the Hill*, *c.*1930. The Adirondack Museum, New York.

277 Alfred Stieglitz, *House and Poplars, Lake George*, 1932. The Adirondack Museum, New York.

278 Alfred Stieglitz, *First Snow and the Little House*, c.1930. The Adirondack Museum, New York.

279 Alfred Stieglitz, *Back of the Little House*, c.1930. The Adirondack Museum, New York.

280 Alfred Stieglitz, *Later Lake George*, 1934. The Art Institute of Chicago, Alfred Stieglitz Collection.

281 Alfred Stieglitz, *Lake George Porch*, 1934. The Art Institute of Chicago.

282 Alfred Stieglitz, *Lake George From the Hill*, c.1931. Courtesy of the Adirondack Museum, Blue Mountain Lake, New York.

283 Alfred Stieglitz, *Study at Lake George*. c.1930. Lee Gallery, Winchester, Massachusetts.

As he photographed his Lake George world, Stieglitz looked upward, outward, and downward. His photographs of the grasses around him with changing light and shadows, distinct textures and forms, sometimes swaying in the wind, recall Blake's words of being able to see the world in a grain of sand. Unlike the soaring poplars, there is a sense of respite in the grasses, of being "grounded," physically and psychologically.

The views of Lake George from The Hill are often breathtaking as Stieglitz allows the viewer to watch the ground shadows widen and deepen, or the light and cloud cover change on the horizon across the lake. Among his last series, Stieglitz produced a "portrait" of the "Dead Chestnut Tree," also probably in 1937, along with a series of poplar trees. The chestnut tree was photographed in juxtaposition to living foliage, implying the role of the old, the dying, in relation to young new life. He inscribed one of this series to Norman, "The Last Shot I made in Lake George/Summer 1937/For Dorothy/ May 1939."[104]

By most accounts, Stieglitz stopped photographing in 1937. However, in a letter of 22 August 1938 to O'Keeffe from Lake George, he referred to photographing.

4:45 P.M. It is a beautiful day. Warm summer. Sky uncertain. Sun blazing for a while, then hidden for another while . . . I have been in and out like the sun . . . the telegraph poles outside the window are very insistent today . . . I do wonder could I by hook or crook turn them in "universal beauty" were I to photograph them . . . I want to start printing. Queer urge when there are no particular negatives here I want to print. – Well I'll start – maybe I'll surprise myself. – I hope so. It will take quite a bit to do so. I wonder are you painting. Have you started to start as Marin would say. – Margaret [Prosser] is in Glens Falls. I wonder when Frankie will be able to turn up. 8:15 P.M. . . . The evening is cloudless and cool and silent here. At about 5:30 walked [to] your shanty [where O'Keeffe often painted] Alone. Came back here and got the camera and returned half way to the shanty to photograph the House, Poplars, Sky. An experiment . . . So it turned out to be quite a day after all. Now I'll await after effects. I have to try myself out some without getting too gay. It gets me too much on edge just sitting around – I'll take it very easily now – Read a bit. Go to bed early – Goodnight. More in the morning. A good-night kiss."[105] [Stieglitz was reading *The Red and the Black* mentioned earlier in the same letter.]

It appears from this letter that he indeed picked up his camera and, despite warnings that his health could be affected by his getting too "excited" by photographing, that he could not stay away from his camera and the act of photography.

Two existing photographs that are dated after 1937 show the young curly haired daughter of Rhoda Hoff de Terra whose mother, Amanda, was the second wife of Leopold Stieglitz.[106] In one image, in summer light, the little blond-haired child is depicted with her nurse or nanny, in

284 Alfred Stieglitz, *Untitled – Grasses, Lake George*, 1933. The Art Institute of Chicago.

a grassy area. In the other, the child stands alone, in her bathing suit, supported by her father's arm. Nearby is the old barn, depicted in earlier Stieglitz photographs, its door open, its strong wood structure forming a firm backdrop for the image of the little girl standing center stage on the grass. Young and old are thus juxtaposed, the child still needing assistance from her father. There is promise of new life here, in the potential of this child whom Stieglitz chose to photograph in his late years. Given that his relationship with his own grandson was not close, photographing this child related to his brother makes sense. The two images appear to be more than random snapshots, as Stieglitz continued to pay attention to line, shape, form, and tonality. His interest in the playful lives of young children was also seen in his images of Frank Prosser, along with his 1920s images of his grandnieces, Sue and Peggy Davidson, as young children. In late summer 1937, he also wrote to O'Keeffe about photographing the adopted daughter of his brother, Julius's second wife, Mary Reising, an associate professor of chemistry and colleague of Julius at the University of Chicago, whom Julius married in 1934 (Julius adopted the little girl after their marriage). Stieglitz found the five-year-old girl appealing and described the pleasure of a group gathering with his brother's family and the Swami:

285 Alfred Stieglitz, *Later Lake George*, 1933. The Art Institute of Chicago.

Mary photographed groups. The Swami did, too. Mary finally asked me to photograph her child, so what was I to do but get the Graflex. So I made a few snaps of her, a few of the Swami . . . All along I would have liked to have made a snap of her child, but you know me . . . I sent you some prints (proofs) today. I wonder what they will look like to you. Of course mounted they will look better. I have no mounting paper here. Intentionally, I prefer to print and not be tempted to mount . . . Goodnight kiss.[107]

The small proofs were close-up head shots of O'Keeffe reclining, showing Stieglitz's working process as he experimented with composition, lighting effects, and clarity of detail.

It seems significant that Stieglitz chose to photograph young children and the Swami among his last photographs, depicting the vitality of youth and the vitality of what the Swami's faith and scholarly work stood for. They illustrate, in part, Stieglitz's continued search for Truth and inner Spirit, on a variety of levels. Along with his pictures of his beloved Lake George surroundings, these photographs perhaps show the elder photographer coming to terms with his aging years, hoping to make the invisible visible, and providing the viewer with equivalents of his emotional experience in those late years. As he himself wrote:

365

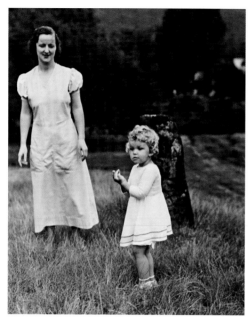 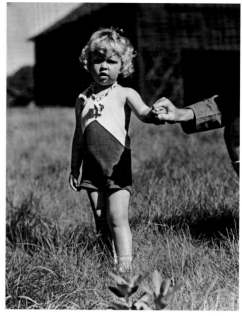

286 Alfred Stieglitz, *Untitled*, (daughter of Rhoda Hoff de Terra and nurse, Lake George, New York), (?)1939 (dated by Harvard Art Museum), Harvard Art Museum, Fogg Art Museum.

287 Alfred Stieglitz, *Untitled*, (daughter of Rhoda Hoff de Terra, Lake George, New York), (?)1939 (dated by Harvard Art Museum). Harvard Art Museum, Fogg Art Museum.

I can do nothing because another does it, nothing that is not for me to do because of some inner need. I clarify for myself alone. I am interested in putting down an image only of what I have seen, not what it means to me. It is only after I have put down an equivalent of what has moved me that I can even begin to think about its meaning . . . I feel that all experiences in life are one, if truly seen. So that what one puts down in any particular form must be an equivalent of any other felt experience.[108]

The landscapes, the clouds, the buildings, the people whom Stieglitz knew and photographed were all part of the fabric of his experience and existence before they were incorporated into photographic images and, in the late work of the thirties, became equivalents of his life experience and his feelings.

SOME LETTERS

The following letters contain "verbal snapshots" of Stieglitz's world in the 1930s and his responses to it. Although Stieglitz turned seventy in 1934, he continued to write numerous letters to O'Keeffe, along with letters to other artists, writers, and museum personnel. The letters between

288 K. Hoffman, *Leopold Stieglitz's House,*
Lake George, 2008.

289 K. Hoffman, *Back of Leopold Stieglitz's House,*
Lake George, 2008.

Stieglitz and O'Keeffe reflect their continuing interests in music and literature and the significance of the world of nature in each of their lives.

[O'Keeffe to Stieglitz: 27 May 1930, Lake George]

Dearest . . . it is beautiful here tonight . . . I walked up the back road, then down to the lake – came in with lots of flowers – the big soft dark lilacs that grow down by the lake – and white ones – a huge bouquet on the dining room table . . . your telegram tonight was so sweet . . . I am playing spirituals for Margaret – they are lovely. She says this is the first night she has been away from Frankie since he was born – she seems happy to be here tho. – I feel so loved – all around – you seem to have left it in the air . . . the painting is small – quite dumb I think . . . I don't know why you should love me so much when I am so dumb sometimes – but I do feel very much loved and like it . . . I think the thing between you and me really begins to be something that almost nobody else could make or do or be – It feels very wonderful to me . . . It does seem quiet to be alone – but I don't feel alone – I feel very happy . . . Good Night. I am going to sleep in your bed without even making it – so it will feel soft and I'll kiss you when I get in.[109]

[O'Keeffe to Stieglitz: 14 June 1930, New Mexico]

Dearest – The sky becomes more and more, the land less and less – more and more a line – and mountains like shadows – dreams begin to rise in the distance . . . the sky so lovely – it all makes me quite crazy . . . a kiss warm and tender . . . It is 5:30 in the morning – Dearest and my country is bare – there are no trees . . . It is so removed from the loveliness you will wake up to . . . The sun is bursting through wild dark clouds. I feel like falling into the country like one sometimes wants to fall off a sheer wonderful edge – it has such a feeling of death and terrific life – side by side . . . when I think of you as busy – looking out the window – I feel

you would smile – but I think I would feel, too, that you would not care for it as I do – Well, I love you anyway – a nice warm morning kiss!

[Stieglitz to O'Keeffe: 18 August 1930, Lake George]
Here I am again. I believe the third time today. There is a marvelous sunset. Golden lined gray clouds following the curves of the hills, above a transparent light blue cloudless sky. The camera won't register what I'd like to get down. – For an hour R [Rosenfeld] played the Victrola . . . Played Bach and Beethoven, ended up with a Strauss Waltz! – A Bach you haven't heard – and a Beethoven Symphony – the 5th I believe – I was only half listening, having my eyes on the sky . . . am feeling without discomfort of some sort for the first time in ten or more days . . . was reading Bragdon's New Image . . . 9:45 P.M. It has been a very quiet evening . . . I played Beethoven's Quartet 59, No. 3 . . . outside of playing Beethoven I was rummaging thru books – reading bits here and there – am always amazed at my ignorance. I feel more and more ignorant every day – A sad confession one has to make to oneself at my period of life. . .Margaret [Prosser] brought in a vase of huge flowers this morning – Dahlias – red and yellow . . . and there are salmon colored gladiolas. – A handsome affair . . . Goodnight – sweetest heart – two kisses – real ones.

[O'Keeffe to Stieglitz: 28 April 1931, Train to New Mexico]
Dearest . . . I was terribly upset as you left. It seemed as tho I might not be able to bear it – as tho my consciousness were leaving me . . . you have been so beautiful in helping me with everything – It makes me wonder if I have done my share – and – that I have no answer . . . The river is hazy and lovely . . . the green very new . . . I wish you were riding up the river here with me . . . I know, too, that I will always carry you with me – I just looked at the lock of hair – it is so soft and beautiful and white . . .

[O'Keeffe to Stieglitz: 15 May 1931, New Mexico]
. . . was playing Brahms Quintet, Brahms Symphony and Beethoven's 7th . . . then played the slow part of the seventh over again – it is so certainly beautiful – I have to laugh – they seem so reminiscent of you, it almost seems as if you had written them – it was a good evening. SO much better than people . . . I kiss you good night – I almost feel like taking the train back to you when I play those things . . . wish I could hold you close for a little while – feel you warm and soft and smell you . . .

[Stieglitz to O'Keeffe: 4 June 1931, An American Place]
. . . 2:30 P.M. Just back from lunch, Demuth and I. Such a morning, again. – Purple . . . Clarence White's son . . . Another girl with paintings who wanted your Santos painting last

year . . . And talk about the amputation of your Ranchos Church in Creative Art – the rotten black and white printing – Mess! Mess!! Mess!!! I do hope the Marin books won't look too awful. Demuth is writing at his back. I hope it will materialize while I'm still alive. Hartley is doing poems only "that no one understands," and he will paint gouache. Too old to try watercolor. And why oil? – And so it goes

5:15 Such chaos . . . 5 advance copies of Marin. Looks all right some errors. I'll send you a copy tomorrow . . . Seligmann in – Zorach – Margulies – talking – reading – Tower of Babel – Really a madhouse. The creative art business rages in me – that dastardly cutting down of your Rancho's Church. The tabloids, Police Gazette, etc. have more respect for a picture . . . Much much love – Good night – A big big kiss.

[Stieglitz to O'Keeffe: 20 June 1931, Lake George]
. . . 3:15 A sun bath. A wet bath. A bath of nakedness. Feels great . . . Would like to start printing again but I suppose it would be worse than madness to start in such weather. A cloudless sky. Sun beating down mercilessly, gloriously. I sat out on the back porch . . . with Margaret while she was finishing lunch Rosenfeld typing – Just doing nothing – not even thinking or even dreaming – is a variant, too . . . I'm tempted to go to the Lake but I don't even know if the boat is in the water – I'm not quite ready to climb the two hills – not on a day like this. – It's rotten to be aged. I can't accept age gracefully . . . I may get out a few old prints – tinker with them . . . We'll have to do quite some mounting together. Must get these things completed . . .

9 P.M. I'm half dead – at 4 I decided to start printing . . . I have just hung up some small prints to dry. Rosenfeld is playing . . . Stravinski – Cappricio [sic] – Some small prints. A start was hot work and to make it particularly exciting the door was suddenly bolted from outside . . . I tore down the one window – jumped out and ran to the house to see whether any one was there. Rosenfeld . . . It felt queer to be sealed up over there. And I so hot . . . I had to pack up all the exposed paper before opening the window. I never moved faster. And good for the heart!! . . . To-night I take Phanadorm. Last night was too awful: The crescent moon is clear . . . goodnight sweetest heart – a kiss – I'm going out on the front porch – Again Goodnight – another kiss

[Stieglitz to O'Keeffe: 10 November 1931, An American Place]
. . . yesterday afternoon . . . Frank Lloyd Wright – Wright spic and span. Liked the Place – asked to see the photographs. Sends his greetings to you. Is certainly a smooth article – just returned from Rio de Janeiro – says it's the most beautiful city in the world unspoiled – untouched by the USA . . . He liked the photographs, but I feel he sees only one thing – like so many geniuses do and often "*sees*" nothing. He is certainly a person . . .

[Stieglitz to O'Keeffe: 11 November 1931, An American Place]

. . . I'm thinking about my New York photographs. And about photography generally – oh about anything which is to do with what I call "my work." And I guess it may be that that gives me my mood which is far from pleasant . . . Today is Armistice's Day – 13 years ago I remember Ida's arriving in the afternoon and telling us, but really telling you of your father's death. What I lived then I prefer to what I live now . . . Well I hope you are enjoying your freedom – A big kiss . . . may read Lawrence. He may stir me into some activity or may be into greater indolence . . .

[Stieglitz to O'Keeffe: 31 January 1933, The Place]

10:45 A.M. . . . It was past midnight when I got to bed . . . Hitler Chancellor of Germany! My head buzzing with the events of the day – of the world and I trying to be ready to meet them as best I know how – I took Phanadorm – Sleep. I slept 5½ hours like one dead. It's the grandest thing in the world – outside of seeing you well again . . . I bring Light wherever I go – but with it I bring inevitable heartache . . . 11:45 A.M. I'm making an exposure in the dark gray room. Have tried several times. Always failures. Am trying once more And then I'll print. Focus – Focus. Eyes not accurate enough . . . Zoler drymounting carthorses and locomotives – What for? – A completed job started 40 years ago.

[Paul Rosenfeld to Stieglitz: 4 August 1933, York Village [Maine]]

Dear 291: At noon to-day the photograph and your letter arrived. I thank you a thousand times; your goodness is very great, particularly in view of present circumstances. I am glad to have the photograph, for even if it is fearfully earnest and unsmiling and tragic, it is very interesting, the eyes are live . . . It is too bad that your hernia prevents your lugging the big camera about, and I suppose the small camera doesn't fit your present conceptions. (I wish I might tell you not to lose faith, or rather, I wish I could, for it is always you who have had the faith and sustained others in their downward crises; and there is no one of us can lift you as you have lifted and still so beautifully lift us.) But I was speaking of the small songs of the sky with Phelps Putnam who was here about a week ago, and he asked excitedly and enthusiastically about them, and how many of them there were, and I was saddened to think that so few knew about them or had a chance to see them; and also knew what a treasure the world would have on the day they were set out on the walls fit to reveal them . . . With your photograph this noon there arrived the table of contents of *Camera Work* which Cary Ross in his usual blessed and lovely way has prepared for me. It embraces fifty typewritten pages, and is of tremendous value to me, and I am more than lucky to have it and in one more way to have him and yourself.

6-16-31

This is the Lobo Mountains ——— I went out to the pueblo ——— beautiful ~ clear and blue ——— around noon it turned grey ——— to me it seems a bit sour ~ a dirty grey ——— I came back after making some nondescript drawings ——— was so irritated not to go on with my painting that nothing much interests me ——— so have I sit on my back porch ~ a bit cool ——— I want to paint this mountain ——— wanted to every year ——— but it is quite impossible ——— Saw Charles in the village ——— He and Mary have been camping all this time ——— He announces he is coming out to eat dinner with me —

It is lovely here on my third story porch ——— facing what ought to be a sun set and isnt much ——— So far ———— so far ——— one sees ——— but it is quite uninteresting this evening and just too cool to be comfortable out here ——— still I like being here better than inside

My love to you little one ——— I am just a bit stupid because the sun didnt shine for me today ———

290 Georgia O'Keeffe, letter to Alfred Stieglitz, 16 June 1931, p. 1. Beinecke Rare Book and Manuscript Library.

[Stieglitz to O'Keeffe: 28 September 1935, Lake George]

. . . Prints are washing. A curious lot. Some of you and then some of that exhibit at 291 – of yours – with little plaster figure. It's a very beautiful picture. Made prints before. Have quite a few. – Really did nothing but you and relating to you except one New York, a print finally of Man Ray (never before printed) and a couple of early Marins. Some glossy paper prints. More quality than some of the new paper. At least for my negatives. Prints washing . . . Also have been reading Mary Lincoln by Sandburg and Mabel's latest which came at 11. Mabel and Sandburg . . . are a great combination.

[Stieglitz to O'Keeffe: 2 November 1935, The Place]

. . . I didn't tell you that Grosz spent a couple of hours with me . . . Told me about the people in Europe. He was in France, Holland, Denmark. Dared not venture to Germany but his wife was there. It's pretty terrible all that's actually happening . . .

[Stieglitz to Paul Rosenfeld: 29 September 1936, Lake George]

Dear P.R. . . . The weather has been trying. Georgia and I are alone – She is fit and painting – I'm doing all I know how to get into half shape at least, for I must run that Room another year without fail. I've had letters from Demuth, and Weber and Hartley – with these of Bluemner – and one yesterday from Marin – The painters' lot in America is pathetic . . . These letters would make quite a picture[.] I'd publish them but it wouldn't be fair to the men for there is no "public" to understand that picture any more than there is really to understand their work. – I know the song is older than the Hills. That's why it's no longer heard. Georgia reminds me my breakfast is getting cold.

<div align="right">Our greetings, May the gods be with you – Your old, A.S.</div>

[Following signature] . . . I appreciate yours and Mumford's thought of me, wishing to dedicate the [American] Caravan to me. I have certainly fought – I shall continue to "fight," as long as I can get that old carcass of mine to move along . . . Of course at the root of nearly all trouble is the economic questions ever and ever grimacing at one . . .

[O'Keeffe to Stieglitz: 17 July 1937, Cheyenne, Wyoming]

. . . 9 o'clock – 148 miles on the road this morning. We were cold in bed so we got up made coffee and ate and started to travel by 5:30

As I write I have a platter of 3 slices of bacon a fried egg and a large portion of fried potatoes – the platter is about a foot long – looks very substantial but I seem to be eating it all – a glass of milk and some toast and jelly.

I didn't get anything written later yesterday because I didn't want to miss Dakota and was too tired when we stopped . . . big wide spaces that make much of the trash that goes through

PIEDRA LUMBRE CATTLE COMPANY
GHOST RANCH
ABIQUIU, NEW MEXICO

TELEGRAPH:
ESPANOLA, NEW MEXICO

2 —

— Thought about you — wondered about your cold — wondered should I go East before I had planned — wondered what I would do when I got there — got up walked out and looked at the sky — — the moon gone — one very bright star over the high cliff to the East — Thought how nice it is to go across the room out of bed — about six steps and I am on the ground out side my door — under the stars — got back into bed and slept again till 7:30 — — breakfast — then this —

Yesterday I got out a painting from early in the summer and worked on it all

291 Georgia O'Keeffe, letter to Alfred Stieglitz, 18 October 1935, p. 2. Beinecke Rare Book and Manuscript Library.

my "so called mind" only fit to blow away with the wind – Then the Bad Lands and after that the Black Hills – After that we got out into very big spaces in Wyoming where a shanty seems to be considered a town –

It has been the same this morning – really wide far away rolling country with hardly a human sign on it – The whole trip has been very comfortable . . . This is a very unusual town as there seems to be a lot of experimental planting – The first good vegetables and fruits that we have seen since Iowa – Helps the food – and there are lots of your trees – nice after nearly 300 treeless miles – Will be off–

[Stieglitz to O'Keeffe: 18 July 1937, Lake George]
5 P.M. . . . the day is a grand one here – Beautiful – a real mountain day! Sat on the porch of Red Top, while the Swami was very entertaining. All pleasant. Margaret went off to the woods today. The prints of yesterday – some are very acceptable – new paper nothing to brag about.

9 P.M. . . . I have just come from the Little House where I hung up 22 small prints to dry. Nearly all of you. Some taken in N.Y. – of you – Not a bad lot. – A few good – Not as art – but good nevertheless. I started printing at 6. Got tired of not having "done" anything . . . Ag [Stieglitz's sister] is sitting in the armchair reading . . . Reminiscences of D. H. Lawrence. I don't think you ever read them. May be you did . . . It's an interesting book. I wish my eyes permitted me to read more . . .

[Stieglitz to O'Keeffe: 24 July 1937, Lake George]
4:30 P.M. . . . Last night I dreamed I fluffed you good and hard, old fashioned kind . . . You enjoyed it hugely, as did I. Particularly your enjoyment . . . I suppose your letter made me dream – Sweet – if you were here now you'd be in "danger" – would you call it that? – I'm alone in the house. Just came home from the Little House. Printed for 1½ hours. Was getting too much on edge just sitting . . . Played miniature golf – 40 for 18 holes. – Record for year.

[Stieglitz to O'Keeffe: 27 July 1937, The Place]
5:50 P.M. . . . Well to make a long story short I have in my pocket a draft for $3000 for a Ranchos Church (with blue and white sky) size like Phillips [a man from Buffalo on his way to Europe wanting to see O'Keeffe paintings]. So a year's rent is assured you. – He took the painting with him . . . I promised him to meet you at the Penthouse. Well, my Congratulations . . .

[O'Keeffe to Stieglitz: 15 September 1938, Yosemite Valley, camping with Ansel Adams]
Good Morning Mr. Stieglitz – I feel so fine – and it is all so perfect here I don't know where

292　Alfred Stieglitz, letter to Georgia O'Keeffe, 20 July 1936. Beinecke Rare Book and Manuscript Library.

to being – I sit in the shade of a big dead tree stump . . . We are camped at a little lake about 10,000 feet above sea level – a little patch of green around it then the rocks rise up on every side – one fantastic sharp peak right across the lake very nearby – then another long ridge with a less fantastic peak – and the rest just very large rocks piling up – very big rocks – the whole rock formation is a light gray granite – seeming almost white when you walk over it and a few trees weathered and blown – half a dozen magnificent trees here near camp . . . We rode away at 12 instead of ten – 22 animals – all mules except 3 horses ridden by the men who have to chase the mules – I have a wonderful mule – very smooth riding – and very willing – they are all big and strong and very sure footed.

We were almost all the first day climbing up and up – zigzagging out of Yosemite valley – very good trails – very steep – and very handsome as we seemed to get up on the level with some of the good rocky spaces on the other side of the valley – the valley is very narrow you know –

We had lunch among very big trees by a little stream that rushed over the granite rocks – making them seem so very clean and smooth – I saw a bear – a great big one – he was galloping through the bushes before I saw him – We lunched at about two – and such very good lunches – best I ever had – everyone seemed to think the same . . . then we walked on – climbed and climbed till one got a bit mad at the rocks – or I did anyway – Adams and I had rubber soled shoes – The others had hob nails – Finally when I got to the top . . . It was pretty exciting to suddenly see the very vast range with much snow splotched on it stretching all around – what we had come up from and seen before seemed rather meager – I lay down in the shade of a bush – almost went to sleep – got up and lay in the sun . . . I hope you do not worry – my arm is so much better it is a bit ridiculous – It pulled me up over rocks yesterday as if there were nothing the matter with it –

A kiss goes to you out over the high white granite ridge –

This country seems almost just black and white

Guess I'll just sit –

I have a big blanket up against a tree leaning trunk as I sit on a rounded piece of rock – my bare feet in the sun – the rest of me in the shade – Adams is having a wonderful time showing his country –

Give the Yosemite booklet I sent you to little Frank [Prosser] – will you please.

[Stieglitz to O'Keeffe: 31 January 1939, The Place]
. . . Finally got to bed. And was surprised and delighted to find the message in my wrapper . . . where did you dig up the four leaf clover – of course I was deeply stirred. How little I realized that there was a 2nd message in my pajama sleeve – Yes, Georgia – I know you love me – I know you were sad . . . And you must know what I feel for you – even tho at moments, I do wonder can you know. I'm such a contradictory muddle. Yet there is a line running through that muddle which coincides with your Blue Lines. Oh Georgia – Living

becomes more and more desperately difficult . . . Oh Georgia, Oh, Georgia – What do people do to each other? What do they do? . . . Oh, Georgia, Oh Georgia – How silent the Place and all the pictures – years and Marins, too . . . when you get back we'll go through the photographs together. [O'Keeffe was on her way to Hawaii for the Dole Pineapple assignment]

[O'Keeffe to Stieglitz: 27 March 1939, Hawaii]
. . . was out painting 'til 3, then drove up the volcano for the sunset. It is a long twisting drive – up through clouds to the top of the earth – nothing but rocks and clouds and some sort of red and golden earth piled in huge piles down inside the black crater – the wind is hard and damp and cold – in my winter coat and green shawl I was cold but it was worth it – sort of terrifying – separated from the earth by the vast mass of clouds – a spot of ocean in a couple of places, an edge of the island here and there the sun setting – a small moon overhead – really sort of unbelievable – Hawaii's 3 highest mountains rising out of the sea of clouds . . . A good night kiss to you . . .

*

By the late thirties the United States economy seemed to be on the mend and O'Keeffe's work was selling fairly well, although the Depression years made it difficult to sell art that was not "socially" oriented. In 1938, O'Keeffe was awarded an honorary doctorate at the College of William and Mary in Williamsburg, Virginia and in 1939, as previously noted, she along with Eleanor Roosevelt and Helen Keller were chosen as being among the twelve most outstanding women of the past fifty years by the New York World's Fair Tomorrow Committee. In 1939, O'Keeffe again suffered from a case of nervous exhaustion and was ordered to bed but she recovered more quickly than she had in 1933. By the close of the decade, Stieglitz was frequently in a state of poor health and O'Keeffe's income became more significant. Thus it was she who began to support Stieglitz, as he had once supported her. She seemed to find it increasingly difficult to leave him, as indicated in several letters. In the summer of 1937, she wrote, "You sound a bit lonely up there on the hill – It makes me wish that I could be besides you for a little while – I suppose the part of me that is anything to you is there – even if I am here."[110] Despite problems and changes in their relationship, they appeared to remain close to each other, perhaps primarily due to their work, as they continued to write almost daily to each other.

With the Nazi annexation of Austria and Czechoslovakia in 1938 and the invasion of Poland in 1939, artistic discussion at An American Place was frequently interrupted to turn on the radio to hear the latest news from Europe. Stieglitz with his European heritage was more concerned than O'Keeffe about the oncoming war. The decade thus ended with the shadows of world war but Stieglitz was determined to continue his work and his "fight" for his artists and for the role of photography as a significant modern art, as long as he could, into the next decade.

THE FORTIES

You seem to assume that a photograph is one of a dozen or a hundred or maybe a million prints, all prints from one negative necessarily being alike and so replaceable. But then along comes one print that embodies something that the others do not have . . . it is something born of spirit, and spirit is an intangible, while the mechanics is tangible. If a print that I might send did not have this intangible, what would be the value of sending it out? . . . A print lacking these elements is simply an illustration, and I have no objection to illustration, but I am assuming that you have in mind something more than mere illustrations, something to be giving, something inspiring, something with a spiritual message. For I feel, whether you are aware of it or not, it is a spiritual message, you are desirous of sending to the soldiers in the camps . . . I would either send you the best I am able to produce, or send you nothing at all. The "good enough," which is nearly a religion in this country, and is so apt to dominate the American world in so many phases of our life, I not only cannot subscribe to, but hate with all the hate within me. I hate all half-things, otherwise I am devoid of hate.

<div align="right">

Alfred Stieglitz to James Thrall Soby,
curator at the Museum of Modern Art and
director of the Museum's Armed Services Program,
19 January 1942.[1]

</div>

In 1940, Stieglitz was seventy-six years old. Although he was an older man, slowed by health problems, he continued to fight for standards of excellence and an inner spirit that he believed was an integral part of any great work of art. His last years are best viewed within the context of the cultural milieu around him and the world stage on which war and devastation were taking place for much of the remainder of his life.

In 1940, also, Franklin Roosevelt was nominated for a third term, later defeating the Republican Wendell Wilkie. On 6 January 1941, Roosevelt delivered his famous "Four Freedoms

293 Lotte Jacobi, *Alfred Stieglitz at An American Place*, 1935. Currier Museum of Art, Manchester,
New Hampshire. Museum Purchase: The Henry Melville Fuller Acquisition Fund, 2004.38.

Speech," which became the subject matter for a series of Norman Rockwell paintings and *Saturday Evening Post* covers – Freedom of Speech and Expression, Freedom of Religion, Freedom from Want, and Freedom from Fear. The Japanese attacked Pearl Harbor on 7 December 1941, a date that Roosevelt stated would "live in infamy" in his address to the American people on the following day. Stieglitz's letters to O'Keeffe frequently referred to the war, usually interspersed with goings on at his gallery or Lake George, commentary on letters he received, or things he was attempting to read:

[15 July 1940] . . . Today the Democratic convention in Chicago – we'll soon know about Roosevelt . . . It's all beyond individuals – even Roosevelt and Hitler, or any of the other autocrats-dictators, or whatever label you wish to plaster them with. And yesterday was Bastille Day in France – their 4th of July! Gone forever probably. And what next? The whole world waiting for the next moment. Wondering if there is time left for wondering . . .[2]

[6 June 1944] Well, the invasion is on – D Day. They say the excitement in the streets is great. Here the Place is very quiet. The day clear and very cool – came here at 9:30. A letter from Milton Jr. [his grandson] a fine letter, thanking me for his birthday gift. I slept nearly an hour – tired . . .

[7 June 1944] . . . it seems all his [Milton Jr.] monies were turned over to him. I hope he'll know how to take care of them. His father has undoubtedly been a good example to him, and I so worthless. One lives in a daze – one isn't supremely busy these days. This spectra of Bloodshed–Murder–Murder–Blood–Blood, and the killing all night – but the horror of maiming body and soul – and the young – what they are absorbing – what is it doing and making of them – Education – Schools – Teachers. Oh, Georgia, I'm glad you are there where there is some reality – a beautiful one – your world . . . Nancy Newhall and Adams appeared – she photographed the rooms. Also me . . . I feel so antedated . . .

[6 May 1945] I listened to something about the San Francisco conference [formation of United Nations]. What a week in Europe – what a world – Russia looms up bigger and bigger . . . I wonder will you have your radio working?

[8 May 1945] noon. This is official VE II [Victory in Europe Day]! Truman, at 9 a.m., spoke simply – direct – short. I seem to have no feeling about it at all. A numbness possesses me . . . 6:10 p.m. . . . VE II Day – It's queer how dead I seem to be to it – and yet I suppose there is nothing queer about it – as a matter of fact, everything looks grimmer than ever. The Place continues. I feel more than ever it does represent something worthwhile. Time soldiers – every Dove, Marin and O'Keeffe – so I see it. Good-night. A kiss, Georgia.

Several months later, following the atomic bomb attacks on Hiroshima and Nagasaki, Stieglitz also sent O'Keeffe an article by William Shirer from the *New York Tribune*, warning about the new world of peace that had atomic energy and bomb capabilities, and questioning how the three powers that won the war, Britain, Russia, and the United States, would interact:

> And how will the three dominate and run the vast continents . . . How will they agree? How will they hold together in their great task? On the sands here [Cape Cod] a puny human being can feel a swelling headache at the mere formulation of a few of the questions. Yet why should man shrink from the answers you ask, man who has conquered the vast ocean and unlocked the secret of the stars overhead and of the atoms of the sand at your feet?[3]

Stieglitz, as Shirer, seemed to raise questions about the future of the world but, at the same time, seemed to retain faith in humanity's capabilities. For Stieglitz's "soldiers," in war and peace, were the works of the artists he supported, his "beloved community" that would somehow lay the foundation for a better world.

War efforts spread throughout the United States, once it entered the war. In 1942, the Women's Auxiliary Army Corps was created while the first African American seamen were admitted to the navy. The Office of War Information (O.W.I.) began broadcasting the "Voice of America," aimed at Nazi occupied territories. The O.W.I. also put pressure on Hollywood, asking that it not make any films that questioned the war or in any way portrayed the Allies in a negative light. The war became dramatized as romantic entertainment that same year when Michael Curtiz's *Casablanca* was released – just two weeks after the Allies landed in Morocco – starring Humphrey Bogart and Ingrid Bergman. The tale of espionage and lost love touched the hearts of many, as war raged around them. By 1943, the O.W.I. had the power to censor movies. The early forties also spawned films such as Charlie Chaplin's *The Great Dictator*; Orson Wells's *Citizen Kane*; John Austin's *The Maltese Falcon*; Walt Disney's *Fantasia, Bambi*, and *Dumbo*; Alfred Hitchcock's *Spellbound*, with contributions from Salvador Dalí, and Billy Wilder's *Double Indemnity*.

In the world of music, Woody Guthrie released *This Land is Your Land* and *Dust Bowl Ballads*, while Dick and Mac McDonald opened the first hamburger restaurant in California. A new Broadway musical, *Oklahoma*, premiered in 1943 with the new team of Rodgers and Hammerstein and the choreography of Agnes de Mille, glorifying the strengths of the people of America's heartland and ushering in a new era of Broadway musical theater. Irving Berlin's *This is the Army*, featuring his earlier hit song, *God Bless America*, also premiered. Duke Ellington's *Black, Brown, and Beige* opened in Carnegie Hall to a standing-room only audience. The piece included motifs from spirituals, blues, jazz, and West Indian music, marking a coming of age for the world of jazz as a serious form of music. The first jazz concert at the Metropolitan

Opera House was in 1944, the same year that Aaron Copland composed his *Appalachian Spring*, which contained elements of "American" folk tunes. Although Stieglitz did not go to the movies or concerts as frequently as in his younger years, he refers in his letters to going to the movies, as well as to listening to jazz, spirituals, and contemporary composers, along with classical music.

Visual art works of the time, outside Stieglitz's realm, included Jacob Lawrence's 1941 sixty-panel work, the *Migration Series*, based on the exodus of the African American community from the south to the north following the First World War, which was exhibited and also published in *Fortune* magazine. Edward Hopper created his well-known *Nighthawks* in 1942, depicting the alienation of lone figures in a diner late at night. This eerie tableau, with its dramatic lighting and sharp edges, was quite photographic in its details. Joseph Cornell's *Medici Slot Machine* of the same year also incorporated small photographs in the intricate assemblage, in which Cornell explored his fascination with one of the Medici clan, Piero.

Stieglitz also attempted to keep up with contemporary writing, fiction and non-fiction. Although he complained frequently that he could not read as much as he once did, due to failing eyesight, he nevertheless continued to read and referred to books in his letters. Among the books in his library was Henry Miller's *The Amazing and Invariable Beauford Delaney*, from the *Outcast* series. Stieglitz wrote of Miller coming to An American Place with William Saroyan in 1940, while Miller wrote of Stieglitz, "I never knew him in the days of 291; if I had met him then . . . the whole course of my life would probably have been altered."[4] The controversial expatriate novelist and playwright had probably met the African American artist Delaney when Delaney emigrated to Paris. He had come to An American Place when Stieglitz had sponsored the first major African American art exhibition in the United States. O'Keeffe found Delaney special and made several charcoal drawings of him. Delaney inscribed the Miller book, "To Mr. Alfred Stieglitz, whose imperishable vision and humane understanding of the world of art and people, have given me reason to shake hands with the enigmatic idea of beauty – Beauford Delaney."[5]

Edward Weston's 1946 book, *California and the West*, had been made by him and his wife, Charis Wilson Weston, when he took photographs traveling through the American West in 1937 and 1938 on a Guggenheim Fellowship (the first photographer to be awarded one). Although Stieglitz had not favorably commented on Weston's work when the young photographer visited him in 1922, Weston acknowledged Stieglitz's stature in his inscription in the book, "For Alfred Stieglitz/Pictures and tales of a two year adventure. With high esteem and warm regard, from Edward Weston and Charis Wilson Weston."[6]

Stieglitz wrote favorably of Mumford's 1940 *Faith for Living*, in which Mumford, as he had before in his 1938 *New Republic* article and his 1939 book, *Men Must Act*, urged the United States to pledge its help in assisting other democracies to guard against attacks from totalitarian

powers. When his son was killed during the war, Mumford spoke out against the atomic bomb. Like Stieglitz, he was also concerned about the impact of large-scale urban renewal projects, particularly on the human condition and environment.

Further, Stieglitz was reading Havelock Ellis, the British psychologist and pioneer in the study of sexuality. In 1935, Ellis had put together his essays on various French writers, *From Rousseau to Proust*, which Stieglitz was also reading, indicating his ongoing interest in aspects of French culture. In 1944, he reported reading Waldo Frank's new book, *The Jew in Our Day*, in which he explored aspects of Judaism, Jewish history, and the role of Jews in America. Stieglitz, as an older man, although not a practicing Jew, appears to have looked back to his Jewish roots.

Among the writers he was reading in 1945 were the Russians, Gorky and Tolstoy. In particular, Stieglitz was re-reading Tolstoy's 1896 *What is Art?* "Much good stuff in it. I certainly read it very differently than I did years ago when it was first published. He is away off in much, but when he's 'on,' he's mighty good."[7] No doubt Stieglitz resonated to Tolstoy's emphasis on the role of art as a significant expression of any experience, or of aspects of the human condition. Tolstoy saw art as an expression of experience in a way that would allow the audience to share that feeling or experience. For Tolstoy, art did not belong to any particular class of society and it contributed to a sense of community.

In 1945, Stieglitz was re-reading Shakespeare's *Othello* and *King Lear*. Both plays are tragedies focusing on deceit, love, loyalty, and death. Stieglitz sent O'Keeffe a copy of *King Lear* with a handwritten note, pinned into the text, approximately one year before Stieglitz's death. He appeared to be taking on the role of the tragic king who dies at the end of the play. His note read, "This expression of Lear's – this call, such a basic feeling of the gift to intimate living of one with another. From an ill, old King. But the longing, the dreaming, go with health . . . "[8] He asked her to read Lear's words, from Act V, scene 3, to his dead daughter, Cordelia. Lear's words of pain and grief resound through the air as he holds her in his arms: "Cordelia, Cordelia! Stay a little. Ha! What is't thou sayst? Her voice was ever soft,/Gentle and low, an excellent thing in woman. I kill'd the slave that was a-hanging thee." Stieglitz, more than twenty years older than O'Keeffe, sometimes called her "child," although she was not his daughter. The passage, if applied to them, could refer to his attachment to her and his fear of losing her from his life. The literary *Lear* analogy may be seen as "one bookend of the couple's thirty year relationship, Goethe's *Faust* being the other."[9] O'Keeffe responded to his gift of the play without the depth of feeling with which it seems to have been sent.

Well My Friend: I have two letters from you, from your "prison" on the hill. You are sweet and funny. I am glad you are alone for a while . . . you seem to be quiet . . . I read your letters in the car and under a tree looking toward those ice cream cliffs I paint. They are nice letters. I'll try to read King Lear again! I read it not long ago . . .[10]

Since Stieglitz's failing health and eyesight made it difficult to read extensively, and since he could no longer take photographs, he spent much time, while in New York, at his gallery. In 1942, he and O'Keeffe moved from their apartment to a brownstone, a block from the gallery on East 54th Street, so Stieglitz, when alone, would have no difficulty getting to the gallery. From there he could supervise his exhibitions, as well as talk with visitors, and have some sense of the larger art world.

The decade opened with the Museum of Modern Art's establishment of a department of photography, the first such department in any art museum. It was formally established in December 1940 with Beaumont Newhall as the curator while the committee overseeing the department consisted of David McAlpin, James Thrall Soby, and Ansel Adams. Newhall expressed his excitement in a letter to Stieglitz: "The Trustees are ready to set up a department on an equal footing with the departments of Painting, Sculpture, Architecture, Industrial Art, and Films, and want me to be curator. It is all very exciting, for, so far as I know, this is the first time that a museum has recognized the importance of having a separate section devoted solely to photography"[11] He and Adams had invited Stieglitz to play an active role in the department's beginnings but he had declined, as noted earlier, in part due to ill health but also because of his inability to "accept a subsidiary or ancillary position in an arena he had created . . . Nevertheless the gesture was productive. Henceforth, despite [his] continuing lectures on the normal relationship between museums and art, there would be a truce of sorts between him and the MoMA.[12] To celebrate the opening of the department, Newhall and Adams organized an exhibition, "Sixty Photographs: A Survey of Camera Aesthetics." McAlpin, a collector and a regular visitor to Stieglitz's gallery, gave Stieglitz a thousand dollars for three works that later became part of the museum's collection. The thirty-odd photographers included Adams, Dorothy Norman, Eliot Porter, Henwar Rodakiewicz, and Stieglitz. Stieglitz contributed four photographs, including a 1920 photograph of O'Keeffe's hands sewing and a later Lake George poplar image. He attended the opening and gave his approval for most of the show. The museum's December–January 1940–41 bulletin celebrated the opening of the new department with a Stieglitz photograph on the cover, one of his New York skyscraper images. In the bulletin, McAlpin acknowledged and praised Stieglitz for his contributions to the field of photography:

> Photography is deeply indebted to Alfred Stieglitz for his courageous pioneering and experimentation, for his untiring struggle to have it recognized as a medium of artistic expression, for his impact on more than a generation of workers, and his uncompromising demands on them to achieve the finest quality of craftsmanship and perception, and for his influence on

STIEGLITZ:
NEW YORK—NIGHT, 1931

THE NEW DEPARTMENT OF
PHOTOGRAPHY

The Bulletin of

THE MUSEUM OF MODERN ART

2 · VOLUME VIII · DEC.-JAN. 1940-41

VIII – 2

294 Article, illustrated by Stieglitz's *New York – Night* (1931), announcing the new Department of Photography at
the Museum of Modern Art, from the *Bulletin of the Museum of Modern Art*, vol. VIII, December/January 1940/41.
The Museum of Modern Art Archives, New York.

the taste and discernment of the public. He, more than anyone else, has summed up with the camera his experiences and feelings about life.[13]

*

In 1942, Newhall took a leave of absence from the department to serve as photo-interpreter in the Army Air Force. His wife, Nancy Newhall, served as acting curator and became friendly with Stieglitz. In 1943, she helped negotiate a Stieglitz "gift" of ten photographs to the museum that involved a donation to An American Place. Newhall recounted Stieglitz's description of several of his *Equivalents* for the Museum of Modern Art collection:

1. *Apples and Gable of the Farm, in Rain*
 "My mother was dying. She was sitting on the porch that day. O'Keeffe was around. I'd been watching this thing for years, wondering, 'Could I do it?' I did, and it said something I was feeling."
2. "This, as you know, is the Immaculate Conceptionx. I can tell you that because you understand – you don't misinterpret me."
3. "And Dorothy's hands – what is it that they are? It's related to the other two. She didn't have any idea what I saw, just sitting there. That's the one Charlie Chaplin sat half an hour in front of, and said, 'Stieglitz, what you've gotten in that!' I didn't ask him what he saw."
4. "And that – that's death riding high in the sky. All these things have death in them." "Ever since the middle Twenties," I said. "Exactly," he said, "ever since I realized O'Keeffe couldn't stay with me."
5. "And that's reaching up beyond the sun, the living point, into darkness, which is also light."
6. "And that's related to the other – see the same forms."
7. *Rainbow*
 "And that's something I never thought I'd get. Never been done before, Oh, they've made pictures of rainbows, yes – but not that."
8. "And that's when Georgia's sister was nursing me. A very powerful woman."

5 May 1943.[14]

Stieglitz's new photographs were exhibited in the "New Acquisitions: Photographs by Alfred Stieglitz" show from December 1942 until February 1943. The acquisition transaction took place during another exhibition at MoMA, "Twentieth Century Portraits," which included portraits by Stieglitz of Marin, Hartley, and Maurer. The loan of these photographs caused some anxiety since Stieglitz placed high valuations on his prints to which the insurance company would not

initially agree. For Stieglitz it was a test case to see if the museum and insurance company would treat photography as a medium equal to painting; otherwise he would not loan his works. In the end, the valuations were approved, ranging from five hundred to five thousand dollars per print.

Of Stieglitz's circle, the museum also mounted exhibitions such as "Romantic Painting in America" from 17 November 1943 to 6 February 1944 that included Marin and O'Keeffe; a 1944 show, "Art in Progress: Fiftieth Anniversary Exhibition," that included Stieglitz prints in the museum's collection; a Paul Strand solo exhibition in 1945; and the large O'Keeffe retrospective of seventy-five paintings that opened on 14 May 1946, shortly before Stieglitz's death, and closed on 25 August shortly after his death. When Stieglitz saw the O'Keeffe he was pleased and wrote to the curator, James Johnson Sweeney, "I say once more, it is a glorious exposition. In a sense, a miracle in a time like this."[15]

The Museum of Modern Art, like a number of institutions in the early forties, chose to contribute to the war effort. Photography seemed to be a particularly appropriate medium to do so. Thus, it mounted exhibitions such as "War Comes to the People, a Story Written with the Lens" by Theresa Bonney (1940); "Britain at War" (1941); and "Road to Victory" (1942). Steichen served as the guest curator for "Road to Victory" and again for "Power in the Pacific," in 1945. Internal politics at the museum, however, contributed to the fragility of the photography department. Alfred Barr was hired as the director in 1943, although he was named Director of Research and, in 1947, Director of Museum Collections. There was an attempt to establish a Photography Center as an adjunct to the photography department, with Willard Morgan as the director, but nothing came of it. In July 1947, Steichen became the director of the photography department, after Newhall had submitted his resignation in March 1946 on hearing that Steichen was to be made the director and that he would have to work under him, caring for the collection and planning historical exhibitions. Steichen had long ago diverged in his thinking from Stieglitz about the role of photography. For Steichen, photography increasingly had become a vehicle of mass communication, not a medium of artistic expression. As remarked earlier, Steichen's viewpoint culminated in 1955 with his "Family of Man" show at the museum, comprised of 503 photographs by 273 photographers from 68 countries. Many of the images were cropped or taken out of context by Steichen for his "Mass Media" installation. The United States Information Agency also circulated the exhibition overseas, bringing audience numbers to more than seven million people.

Among the photographers included in MoMA's "Twentieth Century Portraits" was Lotte Jacobi, a young German photographer, noted for her "celebrity" photographs. To escape Nazi Germany, she had officially immigrated to the United States in 1936 and established a studio in New York in 1937. She was inspired by her visit to Stieglitz and took a number of portraits of him in 1938, at An American Place, both close-up and seated. In one close-up, she seems to have

captured a man of genuine spirit, engaged with the photographer and the outside world. Seated in his gallery, below two Marin works, one of the Brooklyn Bridge, with an open newspaper beside him, Stieglitz exhibits a Bohemian seriousness, the edge of his desk visible with its pile of papers. Stieglitz is "at work" but he is also "at home" in a more relaxed pose, surrounded by things to which he was passionately connected: his artists and their works, his letters and paperwork, and the newspaper, representing connections to the larger world beyond the gallery. In 1941, Jacobi celebrated the ninetieth anniversary of the Atelier Jacobi, her father's portrait studio in Berlin, with an exhibition at her New York studio. Among those included were Thomas Mann, Stieglitz, and Albert Einstein, all photographed by Jacobi. Besides portraits, Jacobi also became noted for her "photogenics," cameraless images produced solely by using directed light. Five of her luminescent images, titled *Abstractions*, were included by Steichen in his 1948 "In and Out of Focus" exhibitions. Jacobi's abstractions were considered by some as having roots in, or connections to, Stieglitz's *Equivalents*, for they were hung alongside one another at a 1951 MoMA exhibition, "Abstraction in Photography."

Another significant New York exhibition space was born in October 1942, when the wealthy young Peggy Guggenheim opened her Art of this Century Gallery. Although the gallery remained open only until 1947, it was significant in its fostering of surrealism and the New York school of abstract expressionists, including Mark Rothko, Jackson Pollock, and Clyfford Still. Pollock and Still had their first solo exhibitions at the gallery. Other artists shown at the gallery included Braque, Picasso, Dalí, Ernst (to whom Guggenheim was briefly married), Kandinsky, Léger, Calder, Cornell, Robert Motherwell, Miró, and de Kooning. Located at 30 West 57th Street, the gallery was designed by the architect and artist, Frederick Kiesler. In Kiesler's "kinetic" installation at the gallery in 1942, the furniture was biomorphic, appearing as organic, kidney-shaped forms, which later inspired designs for chairs, tables, beds, and even swimming pools in the United States in the 1940s and 1950s. Although Stieglitz was not directly involved with the gallery, his early support of abstraction and a number of the artists whom Guggenheim showed, paved the way for her influential gallery.

Outside New York, several significant exhibitions occurred relating to Stieglitz and his circle. In 1943, a large-scale O'Keeffe retrospective of sixty-one paintings was held at the Art Institute of Chicago, the museum's first retrospective of a female artist. Although Stieglitz did not attend, he set terms for the show, insisting that the museum purchase a painting from the exhibition, which it did – *Black Cross*, 1929; that the gallery walls be repainted, and that O'Keeffe be allowed to hang the show herself. A substantive catalogue was produced with a major scholarly essay by the curator, Daniel Catton Rich, who had met O'Keeffe while visiting Mabel Dodge Luhan in Taos in 1929. Rich was the director of the Art Institute from 1943 to 1958. He inscribed a copy of the catalogue to Stieglitz, "For Stieglitz with admiration and appreciation, Daniel Catton Rich, January 21, 1943."[16]

That same year, a large Marin exhibition was held at the Phillips Memorial Gallery in Washington, D.C., during which Marsden Hartley sadly died on 2 September, in Ellsworth, Maine. About four months later, Stieglitz wrote to Adams about Hartley's death, "[It] was his masterpiece, $15,000 cash for the year. . . . 3 busts by Lipschitz. A very fashionable photographer of 57th Street had photographed him. The Museum of Modern Art was to give him a one-man show. And wasn't Hartley proud! Ye gads, what a scream life is in a way."[17]

In 1944, Henry Clifford and Carl Zigrosser organized a major Stieglitz exhibition, "History of an American: Alfred Stieglitz, '291' and After," at the Philadelphia Museum, consisting of thirty-five carbon, gelatin silver, and platinum prints, as well as photogravures of Stieglitz's work, along with almost three hundred paintings, photographs, and drawings from Stieglitz's collection. The catalogue's introductory essay was a tribute to Stieglitz, emphasizing his unique role as an American personality:

> In this loan exhibition . . . the Philadelphia Museum presents a personality, and, through him, certain intrinsically and historically important facets of the art of the time. He is not, and never was, a collector in the usual sense of the word. He once said: "I did not collect, I was collected!" These pictures, therefore, have meaning, not as the private collection of Alfred Stieglitz, but as the embodiment of the idea and attitude which animated the three galleries with which he was connected: "291," the "Intimate Gallery," and An American Place . . . Because Stieglitz is a creator himself, a man of sensitive and discriminating taste, and because he was a pioneer during a particularly exciting period of art in this country, these pictures have a very special value . . . the Museum takes this occasion to thank Alfred Stieglitz for his generous cooperation, without which the exhibition would not have been possible. It is dedicated to Alfred Stieglitz, for it is the product of eighty years of rich and creative work.[18]

Two years before, Zigrosser had also equated Stieglitz's legacy with that of D. H. Lawrence, each wanting to find utopias:

> Stieglitz is loved or hated by many, but comprehended by few. A prophet is seldom understood in his time. If it has seemed that Stieglitz has spoken or acted in parables, it is because people have not had the insight or foresight to discern that he was speaking plainly . . . He is the seer, a see-er of both near and far, the greatest living photographer and a prophet as of old.[19]

The Philadelphia exhibition was divided into three major sections: landmarks in pictorial photography, including photographers such as Hill, Cameron, Steichen (early work), Clarence White, Frank Eugene, Coburn, J. Craig Annan, Robert Demachy, and Strand (1916 and 1929 work), along with Stieglitz; a summary of the impact of European modern art in America, including artists such as Rodin, Matisse, Lautrec, Cézanne, Renoir, Picasso, Picabia, Manolo,

Brancusi, Kandinsky, Severini, and work by Rivera in Paris; and a record of achievement by American artists in the first part of the twentieth century. These Americans included Maurer, Walkowitz, Charles Duncan, MacDonald-Wright, and Morgan Russell, along with a special section devoted to The Five – Marin, O'Keeffe, Dove, Hartley, and Demuth. Another section, "Innovations at '291,'" showed the work of Utamaro, the Japanese woodcut designer, children's drawings, African sculpture, and the caricatures of de Zayas. Further, there were portraits of Stieglitz made since 1902, by Käsebier, Steichen, Heinrich Kuehn, Man Ray, de Zayas, Picabia, Florine Stettheimer, Norman, and Marin. And there were photographic portraits by Stieglitz of various artists – Bluemner, Demuth, de Zayas, Duchamp, Marin, O'Keeffe, Picabia, and Maurer. "Reciprocal" portraits, inverting artist and subject, provided insights into diverse approaches to portraiture and issues of identity, as well as abstraction. There were also samples from selected gallery exhibitions and acquisitions at the Intimate Gallery and An American Place, including Lachaise, Sheeler, Bourke-White, Adams, Porter, and Eilshemius. Finally, there were sample publications from Stieglitz's career, including *Camera Notes, Camera Work, 291, 391, New York Dada, MMS, America – Alfred Stieglitz*, and *Twice a Year*. The show was a multi-dimensional survey of Stieglitz's gallery, editorial, photographic, and collecting career. As a tribute, it was substantive, and important that a major established museum was giving him acknowledgment for his work in the arts. This recognition also placed him in history, however, not in a current avant-garde movement. His days standing in the forefront were over; in 1944, his innovations had become quiet, albeit significant, memories.

In 1941, Steichen, despite his past differences with Stieglitz, had also recognized his impact on contemporary photography in a *Vogue* article entitled, "The Fighting Photo-Secession," as he noted that Stieglitz's "Photo-Secession movement stands out in bold relief, as a great tree against the sky, and the trunk of that tree is Alfred Stieglitz."[20] Steichen's article and praise of Stieglitz opened the door to reconciliation after many years of animosity, particularly from Stieglitz's perspective. His words to Steichen were heartfelt: "If you were here I'd grasp your hand and stand before you . . . And words would not be possible from either of us . . . My love to you . . . "[21]

By the 1940s, as one writer noted in April 1940, in *Popular Photography*:

There is an Olympian quality about Stieglitz. He stands over and above anything small or personal. There is almost no personal side to him. He has no secrets, no petty nostrums, no conventional abracadabras . . . His feeling is that what is, is – and the knowledge it belongs to everyone. He has great kindliness and a tremendous openness. But, like the sun, he scorches hypersensitive plants. He will take off his coat, and as he is go bravely out to fight for anyone he thinks worth it, but to smallness of spirit he is as hard as life . . .[22]

The same magazine celebrated Stieglitz's eightieth birthday in 1944 with an article and color photograph by the young photographer, Nelson Morris. Stieglitz was referred to as "the

295 John Marin, *Pertaining to New York – Circus and Pink Ladies*, An American Place Exhibition Announcement, 21 March–12 April 1942.

dean of American camera workers," and, perhaps surprisingly, linked to *Life* magazine reportage:

> Few realize that Alfred Stieglitz pioneered in this type of photographic reportage at the turn of the century, working through such seemingly insurmountable obstacles as cumbersome equipment, snowstorms, and freezing weather, in a documentation of his times. His photograph of a steamship steerage . . . will long rank as an example of the high type of work we present-day journalistic photographers seek to emulate. On his eightieth birthday, it is again fitting to pay tribute to the greatness of Alfred Stieglitz.[23]

Although Stieglitz was aging, the spirit that was an integral part of An American Place did not seem to weaken during the years up to his death in 1946 or to the gallery's closing in 1950. Indeed, Stieglitz's "ghost," in his black cape, seemed to pervade the space. The new decade opened with exhibitions by Marin and O'Keeffe and closed with O'Keeffe's final show there in

November 1950: "O'Keeffe's rewarding new paintings comprise the last one [exhibit]. And since everything was still done in the manner of Stieglitz, and since his ghost (clad in the familiar black pancake hat and the flowing German student days cape) was so distinctly present, An American Place was still alive."[24]

The exhibitions at An American Place in the 1940s represented Stieglitz's intimate inner circle, the works of O'Keeffe, Dove, and Marin in group and individual exhibits. From 1940 to 1946, there were ten shows devoted to Marin, seven to O'Keeffe, and seven to Dove. In 1942, a group show included Dove, Marin, and O'Keeffe, along with three works by Picasso, and twelve photographs by Stieglitz taken between 1894 and 1936. A 1978 exhibition at the Zabriskie Gallery in New York, commemorating shows at An American Place, documented those Stieglitz mounted between 1929 and 1946. The photographic shows included those of Adams and Porter, three of Strand, and four of Stieglitz. Paintings, in group and solo exhibitions, from Stieglitz's circle included Demuth – five; Dove – twenty-six; Hartley – eight; Marin – twenty-nine; and O'Keeffe – thirty-four. The Zabriskie catalogue statement by Doris Bry, who had worked as O'Keeffe's assistant, summarized the last years of exhibits:

> After 1939, the last years of An American Place were devoted principally to exhibits of the New York work of Dove, Marin, and O'Keeffe. Stieglitz became old and increasingly frail, but he never lost faith in his beliefs, nor in his role as living guardian of his artists – his children – against the changes of a hostile and insensitive world. Stieglitz and An American Place were one.[25]

During the war years the gallery was often deserted. Writing to Adams in 1943, somewhat discouraged, Stieglitz noted, "The Place should be called The Sarcophagus, wherein I lie entombed with the glory of the Marins, O'Keeffe, Dove, your photographs, as well as mine and what else."[26] Among the rare visitors, not long before Stieglitz's death, were several young photographers, wanting to visit the venerable photographer. In 1945, Arthur Fellig, known as Weegee, a photographer noted for his constant attention to a police radio and subsequent prompt arrival at crime scenes, arrived at the gallery. He and Stieglitz spent several hours together, with Stieglitz doing most of the talking from his gallery cot. Weegee included a portrait of Stieglitz and account of their meeting in his *Naked City* later the same year. In 1946, the young Minor White, who had recently returned from active military service in the war in the Philippines, experienced a profound sense of liberation after visiting Stieglitz. White was inspired by the man and his *Equivalents*, seeing the opportunity to view photography as a statement of an inner spirit that could lead the viewer on an inward path to myth and transcendence, and to personal wholeness, distinct from a world of suffering and oppression. Like Stieglitz, White came to view photographic images as "equivalents," as having the capability of expressing the photographer's emotional experiences. As he stated, "I photograph not that which is, but that

which I AM."[27] White went on to emphasize that a photograph may have multiple meanings, that viewers would be the source of such meanings and could be as creative as the photographer.[28] He came to be influenced, too, by Zen Buddhism and the teachings of George Gurdjieff, with whose work Stieglitz also had had some contact via the architect, Claude Bragdon. White was one of the founding editors of *Aperture* magazine in 1952, which emphasized a contemplative and intuitive approach to photography. As the editor from 1952 to 1975, "White used *Aperture* to champion his reinterpretation of Stieglitz's photographic equivalents as a form of Zen meditation . . ."[29]

In the spring of 1946, Steichen appeared for a "second teary reunion,"[30] and late in June Dorothy Norman came by the gallery with Cartier-Bresson, before she left for Woods Hole. Bresson photographed Stieglitz as an integral part of the gallery space. Stieglitz had chosen to stay in New York instead of going to Lake George since he greatly enjoyed the few visitors that stopped by. He had taken down the Dove show, which ended on 4 June, the last show he ever hung, but seemed content to be in his beloved gallery with its walls bare. The quiet, empty space and "presence" of Stieglitz was further recalled by John Morris, the former picture editor of *Life* magazine during the war:

> I went to American Place on Madison Avenue during a kind of lull in my life. It was the spring of 1946 and I had decided to leave *Life* magazine, where I had worked in six cities during World War II . . . One lunchtime (I think I was still at *Life*), out of curiosity, I went to American Place, not for any particular show but just to see what it was like. I took the elevator of course, and entered quietly – I remember no receptionist and I believe I was alone so far as visitors were concerned. I walked toward Madison along the 53rd Street side of the gallery, and looking back, away from the window, I saw the office and a couch and Alfred Stieglitz lying on it, just as he did in the photo taken at about that time by Henri Cartier-Bresson. Neither of us said a word. I was about to go when a man I recognized as John Marin walked in with a wrapped painting under his arm. I soon left.[31]

On 5 July 1946, Todd Webb, a young photographer, came to visit with Ferdinand Reyher, who was working on a book about the French photographer, Atget. Stieglitz, feeling quite well, brought out a number of his old prints to show and describe. However, the next day, he suffered a bad attack of angina and on 11 July he had a massive heart attack, while at the gallery looking through some plates he had made during his student days in Europe. Two days later, the master photographer was dead at age eighty-two.

About twenty people attended a small, brief service, held at Frank Campbell's funeral home in New York, among them Strand, Steichen, O'Keeffe, Norman, and family members. There were no lengthy tributes, no music, and no flowers. He was laid in a simple pine coffin that O'Keeffe had searched for and then lined with a white sheet. Although Steichen and Stieglitz

296 K. Hoffman, *Lake George* (the site where Stieglitz's ashes were supposedly scattered), 2008.

had traveled divergent paths, Steichen placed a pine bough on the black-shrouded coffin, which he said was from "Alfred's tree" on Steichen's Connecticut farm. In the end, he was perhaps Stieglitz's "greatest mourner."[32] Stieglitz's body was cremated and his ashes were scattered at the base of an old tree not far from Oaklawn, on the quiet shoreline of Lake George, his lifelong source of renewal and inspiration. Stieglitz's own epitaph for himself, as recorded by Norman, read "At last it can be said of me, by way of epitaph that I cared."[33]

Following Stieglitz's death, there were a variety of tributes and obituary notes that clearly stated the contributions he had made to the world of photography. The day of his death, The *New York World Telegram* ran a headline on its obituary page: "Alfred Stieglitz, 82, father of modern photography, dies. Known as Patron Saint of Cameramen, he also sponsored Modern Art."[34] Large headlines also appeared in *The Sun* that Saturday, 13 July. On 14 July, the *New York Times* printed a lengthy tribute referring to Stieglitz as a

famed photographer who brought about a one-man revolution in camera technique . . . A most incessant talker, he raised his voice for more than half a century to proclaim his powers as a prophet, soothsayer, and arbiter of all matters pertaining to the free spirit of mankind. With absolute faith in his own visions, with incredible ego, and with the ability of a seer to look around the corner, under the table, or into the camera for divine confirmation of his

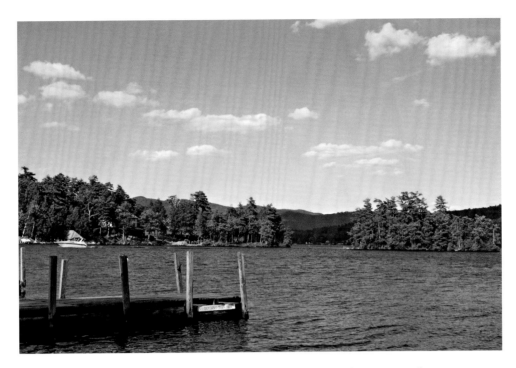

297 K. Hoffman, *Lake George* (taken from the site where Stieglitz's ashes were scattered), 2008.

utterances, he was long ago recognized as a born leader and he has not neglected his eminence. He has not been defeated because he had not acknowledged defeat; he has not been silenced; and his voice will go on ringing down the corridors of art forever.[35]

Strand, too, despite the differences he had had with Stieglitz, wrote a glowing tribute in August for *The New Masses*. He not only articulately recounted Stieglitz's work as photographer, editor, and gallery director but also called for younger artists to carry on the fight that Stieglitz had begun, which Strand believed was an integral part of a larger societal struggle for political and economic freedoms:

> The importance of Alfred Stieglitz and his work cannot be contained in a few words, for as a valiant leader and as an artist he has left deep and indelible imprints upon our culture . . . we artists who have shared, and inherited the fruits of all he fought for and won, must carry on the struggle with an intensity and integrity no less than his. We realize, as perhaps he did not, that the freedom of the artist to create and to give the fruits of his work to people is indissolubly bound up with the fight for the political and economic freedom of society as a whole. We know that our culture can only flourish in a complete democracy in which reaction and fascism have been forever smashed. In this America, which will surely be won, Alfred Stieglitz will be revered as one of the great engineers who helped build its soul.[36]

In September, Thrall Soby wrote in the *Saturday Review*,

> he was one of the few very great photographers in the medium's short history . . . he was in control of the medium and had a tremendous amount to say with it. In a technique-ridden and defensive profession, he worked richly, with varied eloquence, and an authentic sense of visual revelation . . . there is finally Stieglitz the magnetic personality, who drew to him many of the first rate creative people of our century and gave them tremendous stimulation and devotion . . .[37]

Just eight days after Stieglitz died, Rosenfeld also died, on 21 July and, on 22 November, Dove, too, died. Before he died, Rosenfeld had penned his tribute to his close friend:

> . . . Alfred Stieglitz, from the beginning of the century until three days before "death," fought one of the most shining battles in New York ever fought for art. Unhesitatingly one sets it beside such splendid struggles as Courbet's and Manet's for realism in mid-nineteenth century Paris; as Wagner's long struggle with the opera-house public of Europe . . . what actually he desired was the functioning of the entire group of which he was a member. Probably the reason was that he was deeply lonely . . . Actually he created a sort of spiritual climate in which it was possible for artists to give their best . . . His fellows knew he was there, ready to struggle for them. They knew the higher and purer their endeavors the gladder he was to see them, and to try and bring the rest of the world around to seeing. Other things might change, but he would not.[38]

Tributes to Stieglitz, as well as to Rosenfeld himself, were included in the 1946–7 edition of *Twice a Year*.

Approximately a year after Stieglitz's death, the Museum of Modern Art commemorated him with an exhibition entitled "Alfred Stieglitz: His Photography and Collection," from 10 June to 21 September. O'Keeffe arranged to have James Johnson Sweeney, who had recently resigned as the director of the department of painting and sculpture, to organize and hang the show. The large undertaking took up two floors of the museum with ninety-eight Stieglitz photographs from 1889 to 1935, with a second floor devoted to prints, drawings, paintings, sculpture, and photography in his collection, a total of 151 pieces. O'Keeffe, Marin, Dove, Hartley, and Demuth each had a room devoted to his or her works. Although the 1946 exhibition of Stieglitz's work that the museum had hoped to mount was canceled, due to his poor health, this memorial show was a tribute to his efforts to have photography accepted as a fine art. Press reviews, however, were mixed. A preview in the Sunday *New York Herald Tribune* observed:

> The late Alfred Stieglitz, like many other artists, was widely misjudged throughout his long life. In youth, maligned as an irresponsible iconoclast, his vision as a pioneer in the arts was

underestimated. But later, when his indomitable spirit brought general recognition, the photographer was deified to excess. Between these two extremes, on a plane which might come into focus at last, Alfred Stieglitz will be presented this week by the Museum of Modern Art in the first truly comprehensive exhibition of his life's work . . . flashing a mind and a tongue as quick and brilliant as a strobe light, he jarred photography out of its soft-focus imitativeness and brought modern art, photographic and otherwise, to this side of the Atlantic . . .[39]

Following the opening, Emily Genauer wrote: "It is a monument to a man who was a legend even during his lifetime. It is a manifest not only of his courage and his excellent judgment, but also of the success of his crusading efforts . . ."[40] In *Art News*, Thomas Hess considered that Stieglitz's ideas were no longer relevant: "The tragedy of Stieglitz was that he thought his fight for a pure art could be a way of living, but the issues for which he fought were forgotten, and he died at eighty-two, an embittered old man."[41] Bruce Downes, in a *Popular Photography* review, worried about the myths that had come to surround Stieglitz from self-proclamation and the words of his "apostolic circle . . . Whatever he said – and he said much in his life – was taken down by the apostles, reverently passed among them, and frequently, like rumors, became greatly exaggerated . . ."[42] In the same issue, Strand wrote again of Stieglitz and the memorable exhibition: "Here they will see, reflected in these photographs, the spirit of an American artist of the first rank, one who did see deeply into the America of his time, and, as a master of his medium, was able to put what he saw into clear and beautiful form . . ."[43] In the same article, he commented that a number of Stieglitz's late Lake George photographs, such as the dying poplars or grass covered with raindrops "the tears, were harbingers of the death of an age that Stieglitz had cared about, hoped and fought for as a young man,"[44] more than harbingers of Stieglitz's own death.

A tribute by Milton W. Brown also appeared in the late summer, in *Photo-Notes*, published by the Photo League. Perhaps somewhat ironic was the announcement, in an adjacent column, of an upcoming talk by W. Eugene Smith, the photo-journalist, on war photography. The inclusion of a Stieglitz tribute in this publication is perhaps indicative of the far-reaching influence he had. Indeed, Brown refers to Stieglitz's early work as belonging to the realist trend in art that emerged at the turn of the century amid the struggle for social reform, "the finest expression of the Ashcan School was not the work the painters who gave it its name, but in the photography of Alfred Stieglitz . . ."[45] Yet, Brown was also careful to note the mythology that seemed to have grown around the legendary Stieglitz. As he wrote:

Alfred Stieglitz was a storm center in life and remains one after death. His reputation is compounded of truth and myth. How much is truth and how much myth is difficult to say, for in his later years Stieglitz allowed the myth to color his own existence. The memorial

exhibit . . . should have served to separate fact from legend, or at least to present with forth-rightness the success of the legend. Unfortunately, the exhibition is a disappointment . . .[46]

Despite the "failings" of the exhibition and problems with the "myths" surrounding Stieglitz, Brown ended with high praise for Stieglitz's photographs: "His pictures have a marvelous rich-ness of range and technical perfection. How few American photographers or artists can match this integrity and sense of quality? Unquestionably, Stieglitz belongs with the finest artists America has ever produced. Perhaps someday his contributions to our culture will be adequately presented and understood."[47]

In the three years following Stieglitz's death, O'Keeffe, rather than staying in New Mexico, spent much of her time in the east, organizing Stieglitz's collection and distributing it to various locations throughout the United States, rather than burning much of it, as Stieglitz had sug-gested to Seligmann in 1927:

> The dealers were waiting for his death – and an auction. There would be no such auction. Rather the pictures would be burned . . . Stieglitz said it was strange how the possession of money changed people. It seemed only those without money responded passionately to the pictures. Yesterday he said people lived in the year of the Lord; now they live in the year of the Landlord.[48]

O'Keeffe herself, in a 1949 article in the *New York Times* Sunday magazine, wrote:

> Stieglitz often said that he didn't collect pictures, that the pictures collected him. I think he had no particular feeling of ownership about the collection. It was more a feeling of protecting the artist and his work as something rare that no one can own, that should be given to the people. For this reason, I did not wish to keep the collection and preferred not to sell it. I had no choice but to give it to the public.[49]

Thus, she gave a key set of 1,550 Stieglitz prints to the National Gallery of Art in Washington, D.C. The Museum of Modern Art might well have received that set had Newhall, instead of Steichen, been head of the photography department there but Ansel Adams had written to Nancy Newhall early in 1946 that he and Stieglitz would rather have their prints destroyed than let MoMA have them if Steichen was the curator.[50] The rest of the collection was divided among a variety of institutions; the Metropolitan Museum in New York received a large share, approxi-mately six hundred pieces. Other locations that received gifts included Fisk University, an all-black university in Nashville, Tennessee, due in part to O'Keeffe's friendship with Carl Van Vechten, the curator at Fisk; the Boston Museum of Fine Arts; the Art Institute of Chicago; the Library of Congress; the San Francisco Museum; and the Philadelphia Museum, where Dorothy Norman later also gave works and established an Alfred Stieglitz Center. All of Stieg-

litz's personal correspondence and papers were given to the Beinecke Rare Book and Manuscript Library at Yale University. Writing of these letters in 1951, Doris Bry enumerated the correspondents:

> The list of the writers goes into the hundreds. A few of the best known may be mentioned: Sherwood Anderson, over 130 letters from 1922 to 1938; Oscar Bluemner, 75 letters from 1912 to 1930; Hart Crane, 12 letters from 1923 to 1929; Charles Demuth, 60 letters from 1916 to 1934; Arthur Dove, over 300 letters from 1913 to 1945; Waldo Frank, 112 letters from 1916 to 1944; Marsden Hartley, 292 letters from 1911 to 1942; Frieda and D. H. Lawrence, 10 letters from 1923 to 1934; John Marin, about 200 letters from 1910 to 1945; Lewis Mumford, 55 letters from 1925 to 1946; Paul Rosenfeld, 113 letters from 1915 to 1938; Herbert Seligmann, 176 letters from 1918 to 1937; Edward Steichen, 150 letters from 1900 to 1921; Gertrude Stein, 10 letters from 1912 to 1913; Edward Weston, 26 letters from 1922 to 1942, and numerous others.[51]

Much of the correspondence between O'Keeffe and Stieglitz was sealed until fifty years after his death. That correspondence was voluminous, as has been seen, ranging in length from brief (or a telegram) to more than forty pages. Of these Bry wrote further:

> The letters taken as a whole have an aspect that, in transcending the personal elements, reflect that quality in Stieglitz that made him, throughout his life, so much *of* his time, and at the same time ahead of it. They become the history of an era of which his life is a parallel part, on which his life made an undeniable dent . . . On trying to know Stieglitz better through the letters, the dominant themes that emerge are those of energy and passion, directed by a creative force. It was the extraordinary fusion of these three elements that made Stieglitz what he was.[52]

Those letters also reveal the private, intense emotion of Stieglitz, his need for attention, and his moments of insecurity, as he worried about his relationship with O'Keeffe, or his inability to find a sense of "quiet" or calm in his personal and professional life. Personal/private and professional/public were often intertwined. The volatility of their relationship, of two intense creative personalities trying to co-exist personally and professionally, to create a body of meaningful work, is manifest in a number of the letters. So, too, is the fabric of Stieglitz's daily life, from his conversations in his galleries, to his interactions with other artists and institutions, his days at Lake George, his accounts of the changing weather, what he was reading, listening to in music, what he ate, his state of health, and so on. All were there, often in colorful detail.

After completing her task of distributing Stieglitz's collection and letters, O'Keeffe moved to New Mexico permanently early in 1949. She lived at Ghost Ranch in the summer and autumn and in Abiquiu in the winter and spring. O'Keeffe died in Santa Fe in 1986 at the age of ninety-

eight. In 1950, the last show at An American Place was of her work. Thereafter, Edith Halpert represented her work, along with that of Marin and the estates of Dove and Demuth. A review of the works in that final exhibit at An American Place read, "they count among her very best work. There is in them a joyousness, a certainty, and a creativeness which seem counterpart to the spirit which marked the gallery itself."[53] Thus, Stieglitz's spirit and presence appeared with O'Keeffe, in one last tribute to their work together in the space that had played a highly significant part in Stieglitz's final days.

Despite the volatility of their relationship, it was probably the work, individually and together, that kept O'Keeffe and Stieglitz together for the many years. As she wrote,

> There was a constant grinding like the ocean. It was as if something hot, dark, and destructive was hitched to the highest, brightest star. For me he was much more wonderful in his work than as a human being. I believe it was the work that kept me with him – though I loved him as a human being. I could see his strengths and weaknesses. I put up with what seemed to me a good deal of contradictory nonsense because of what seemed clear and bright and wonderful . . .[54]

SOME LETTERS

Even while he was growing older and often in poor health, Stieglitz continued to write letters frequently. He also continued to encourage other artists and writers, and to describe to O'Keeffe the details of his days at An American Place and at Lake George. Here are some of the last letters Stieglitz and O'Keeffe wrote to each other, with a selection from his other correspondence.[55]

[Stieglitz to Henwar Rodakiewicz: 4 August 1940, Lake George]

Dear Henwar:

I've been wanting to send my love all along but you can't conceive how incorrigibly indolent I am up here . . . But here comes a second letter from you. And your first received a week or so as yet not acknowledged. Acknowledged and to tell you how much it meant to me. But as I have said I have become incorrigibly indolent – and I commit many unforgivable sins because of it. – I don't like myself a tiny bit in this role. – . . .

– I come up here in a meaner condition than I had realized I was in while in town. It's only since a day or two that I show signs of life. – That is I walk some and read some. – And you are working at Film II. And Film I is nearly ready – music and all. I'm sure the work is good.

– You have seen Strand's portfolio and have seen him. The portfolio I saw. Newhall showed it to me. – It's all "right" yet so lacking. – His still-lifes are very good. The figure pieces I don't think are what he professes them to be. Yes why not some light in darkness?

– I'm glad for his sake that he has finally gotten this portfolio out of his system. That he is friendlier is good to hear. – It does seem queer at moments for me to be without camera or photographic material of any kind.

– I have opened up my little white house. Windows and doors let full light in. And Margaret sleeps there.

– So another Chapter is closed as far as I am concerned. – Zoler left 10 days ago. Except at meals I did not see him. Einstein was here a week. Most interesting to hear about his experiences in France. Real experiences. – I'm alone most of the day. – I like it. – There is no radio. – And the Victrola is old fashioned and must be cranked so it remains silent and I rather like it best that way. – Well Henwar I'm glad you are at 405 and comfortable there.

Once more my love
Your old Stieglitz

[O'Keeffe to Stieglitz: 15 August 1940]

. . . When I wanted a place near N.Y., I didn't expect you to commute. I told you that I thought of being there in the summer with you and that I would use it weekends most of the year. The only place around there that I felt I would like was at the ocean . . . you think that would not have been good for you – so here we are as we are.

I look at the clouds – particularly at night – and it's so funny – but I am so often seeing you in the clouds. Your head, your face . . . I suppose the human race will struggle along one way or another – even if it is bewildering – I wish I could walk in and sit with you an hour . . .

[Stieglitz to O'Keeffe: 15 November 1940, noon, The Place]

It's your birthday. I wonder how you are – I woke about 5 and wondered. And thought about you. And all the years. – Yesterday was a bit strenuous. Varèse at the end of the day a bit much. And yet he made the day a very worth while day. What a relief a positive creative force is. So clear seeing. So unafraid in Henwar . . . coming to dinner – I'll get a bottle of wine and we'll drink to your health Georgia! – A magazine arrived this a.m. – Independent Woman – A portrait of you on its cover. Inside a reproduction of your large 2 Calla Lilies with Red Rose . . . and a few very nice lines about you. – All in relationship to National Art Week . . .

2

Don't worry about my being alone. That you must cut out. It is essential. I know how you feel about it but it doesn't solve problems which can't be solved. — You are at your place. Make use of it. Stay as long as needful. I don't want anything regarding you undone. — Should you feel it best to renew the lease for the coming year even if expensive & we work out the problem before next Spring don't become panicky because the "art reason" will be a hard one. That we knew would be the case — It has been a gamble all along with luck on your side in every respect except health

[O'Keeffe to Stieglitz: 14 June 1941]

Mr. Stieglitz – The Vogue came and I must really laugh – Thank you – it's a real Steichen job isn't it – not mentioning the Modern Museum in relation to photography at all – It made me feel like throwing fifteen or fifty hats in the air all by myself at once. I haven't read it very carefully yet, but I will – however, my sketchy look at it made me feel very good – I think I look very well – most people will not think me pretty but what of that. I went to an Indian dance yesterday . . . It has been warmer for 3 days – I got really hot yesterday – it was fine – I kiss you and love you – and Steichen seems to me lots of fun. I am going to write him – He at any rate knows something of what you have been about . . .

[Stieglitz to Anne Brigman [a photographer]: 19 June 1941, An American Place]

Dear Anne Brigman:

I am delighted to hear that your book, Songs of a Pagan, has finally found a publisher and that you have a contract for two more books . . . what should I say about you and your photographs that I haven't said before – You *count* and not many of the shiny lights in photography of today really *count* as you do . . . Too bad I had to give up publishing Camera Work. Your photographs in Camera Work represent a landmark. That is why I published them at the time. Do you know that most of the prints I had of yours are in the Metropolitan Museum of Art? – There are quite a few. – I fear I'm not much of a warhorse these days. Still the fight goes on.

 My affectionate greetings.
 Stieglitz.

[O'Keeffe to Stieglitz: 26 June 1941]

Alfred: I think I finally got warm this morning – that means so hot it was difficult to see . . . and I love it. . . . I was out in the hills getting drawings for what I want to paint . . . When I bring my drawings in the house I see them all quite differently than out in the open. I came in at 12:30 – really hot – ate lunch at a little after one – then took to my bed a couple of hours. I will mail this and go at the drawings again so I paint tomorrow – I guess the war will get into every corner of the earth – Russia and Germany at it makes one wonder, as we have been wondering for a long time . . . what next? – It makes one laugh to think how hard it must be for England to side up with Russia . . . and how annoying for the people in power in this country – All seems so peaceful off in the country like this . . . Yes, I know how you feel about having things to do and too easily tired when you try to do them . . . you better not do them . . . You are a lunatic and I love you.

[Stieglitz to O'Keeffe: 22 August 1941, The Hill]

. . . you would have gone to the southwest sooner or later because of my lack of fitness – fitness for that which I wanted most to have and didn't know how to give it to you. That is not a new conclusion I have arrived at. I wish I could arrive at another. Yes, I know you are very alone . . . and I believe in your way of living . . . I realize full well, and have for years realized it, that all this set up [Lake George] is not for you, that you couldn't stand what I am forced to stand . . . It's all in my photographs – It's all in your paintings. Oh, Georgia – living is so difficult. You know that as well as I do – but one goes on . . . and on . . . There is a wild wind blowing – The Lake is lashed into a frenzy. A mad south wind . . . A very dark western sky forebodes a possible storm . . .

[O'Keeffe to Stieglitz: 16 November 1942, Abiquiu]

Good Morning – Yes – my birthday came and went. I had your birthday letter this morning – Thank you – also two other letters and the Marin catalogue – so that Marin show begins today. It is a fine day here – I was not painting yesterday – it was sunny and windy.

Last night I wrote letters – clearing up many little things I want done when I leave here – again this morning I've been at the same thing.

Yesterday two Mexican women from a little town down the road came to see me. I had often talked with one of them at her house – it is on a cliff where I often stop because the river view is fine – They are so quiet – and so warm and alive – It was nice.

Otherwise there is no news – With country living quite a bit of time is spent just managing to live – and it doesn't make news – Yesterday after the two women left we went out and gathered wood for our dining room fire place – it is a fire place where we stand long sticks of wood on end – heats very quickly and is very pretty. – I like gathering wood – but such things aren't exactly news.

The cats catch big rats now – Maybe that is news – I don't know – Yes my life here is different.

The wind blows hard today – long white clouds but much blue and sun – it greets you with a kiss.

[O'Keeffe to Stieglitz: 31 August 1943, Abiquiu]

Tuesday morning. . . . your letters last night make me sad – You in bed a day and going to town tomorrow or Thursday or Friday – You may not have written me exactly as things are but your letters have sounded as if the air and sun and lazyness were good for you – I suppose I should be there to keep you longer in the country. Here – the sun shined this morning on our wet world – bees hum in the Jimson flowers in the patio – it is still –.

299 Georgia O'Keeffe, letter to Alfred Stieglitz, 26 June 1941, p. 1.
Beinecke Rare Book and Manuscript Library.

At about nine we all went to Abiquiu for the Fiesta dance – Of course no young men worth speaking of – but it was crowded with what is still at home from babies to great grand fathers –

The young men are the ones that shoot and stab and as they have all gone to war . . . it was quiet and orderly and I enjoyed it – the faces – almost all dark but even at that it seems a population of many mixed bloods. The young girls about fifteen are very beautiful – the boys too –.

Yes, I was interested –. My neighbors – I never before looked so carefully at so many of them at one time – beautiful – but not my civilization. . . .

. . . Well – I send this to town – to greet you there – do be careful and take things easy.

A kiss to you – greet your new white room for me . . . !

[Stieglitz to O'Keeffe: 16 April 1944, 2:45 p.m., The Place]

. . . I have been steeling myself for your leaving. I know only too well how essential the southwest is to you. Have known long before you started going in 1929. Your going is very right – For you. So it must be right for me. As it is the essential thing for you I have wanted uppermost. For you create and give the world something very sacred to me – I know I have my own peculiar way sometimes – but I have a feeling more than ever that we have much in common – more today than ever – It's all a difficult lesson – living if one is truly conscious of the significance of the moment – letter writing has become more and more difficult for me to whom at one time it was so easy. I want to assure you I will take care of myself. I want you to be as free as possible of worry about me . . . The Place is so still. It's good to know your Dark Place is here. Also the large painting, Pelvis with Shadows and the Moon. They are two grand messages. So beautiful . . . I'd like to see you arrive "home" – I'm with you and you are with me. Another kiss. . . .

[Stieglitz to O'Keeffe: 8 May 1944, The Place]

. . . the strain of the Place has been great. The ever waiting for one thing or another. Release of self. Release and protection of others. The ever increasing rebellion against bad workmanship in whatever form – or wherever – the intrigue, deception, the jealousies, the ambitions, the tramplings under foot of what's fine – What am I trying to say. Oh, I guess that I'm very sick of myself, my incompetencies and what not. Phillips and Mrs. were so fine [Phillips Gallery] the whole meeting incredibly so. But ye gods, my ultrasensitivity and elation and taking the money end – that poison of poison. Yes, I'm a bit nuts on the question I suppose . . . Mrs. P. . . . said to me "Have you any idea what you are doing for America, Showing the Way" . . . And I said: "Remember it is not I – for what am I but the best of O'Keeffe, Dove, Marin, Hartley, Weber, White and others all helping me to be the best in me. I but the reflection of the aggregate best, the true, in them. And so I said "You, Mrs. Phillips, and you, Mr. Phillips, are an integral part of the Place – the best of you is at the Place. . . . Down there where you [are] in the midst of the grandeur of nature – far away from the claptrap of sophisticated people all this cry of mine must seem like so much hysteria – weakness – impotency. Well, whatever it is, the thought of you is as grand as the sunlight – and so Marin and Dove and I'm really a very lucky mortal – in spite of the 59 variety of ailments" . . .

[Mahlon Naill (Hedgerow Theatre Group) to Stieglitz: 30 April 1945]

My Dear Alfred Stieglitz . . . Instead of making a "thing", *you've* made a "way" – a channel – no, a spiritual space *through which* "things" can be seen more fully for some, and for the first time for others. God knows, there's enough art in the world to save us from our own self-destruc-

tion, but "we, having eyes, see not, and we, having ears, hear not," so the art is of no use to us. But you've opened eyes and ears and I wonder if that isn't more important than filling the world with more "things?" And even *your* "things" – your photographs – *invite* us *beyond themselves* instead of *showing* us how great *they* are. "For now we see thru a glass darkly – but then we shall see face to face."

That's why I like the Steerage. It's not a photograph at all! I'm standing beside you on that bridge spiritually at one with those people.

For most artists the horizon is an end to the limitation of their vision – for you it's only a means! No wonder so many of us are still children – and how alone you must have been sometimes.

I'm coming to New York this Sat. night for a few days. I will look in upon you on one of the days early next week – Monday or Tuesday.

Warm regards to O'Keeffe and be careful – we need you!

> Yours
> Mahlon Naill
> (Hedgerow Theatre Group)

[Maria Chabot [who worked for O'Keeffe] to Stieglitz: 10 May 1945, The Ranch]
Dear Mr. Stieglitz . . . Today is my last day at O'Keeffe's [Chabot left reluctantly] and I'm saying goodbye to the Ranch. I must somehow say it to you. Through the five years I have been here I have felt you to be the guiding spirit of the Ranch, the Rightness of it. Georgia has been the instrument through which I have learned to listen – the eye through which in a small way I have begun to see. Last night in reading we came across the Six Canons of Hsieh Ho. This Chinese painter of fifteen hundred years ago conceived the creative inspiration not as a personal gift, but as "the Spirit" of the Cosmos entering into the artist and enabling him to produce in his forms the movement of life. Curiously I have felt that thing happening between Stieglitz and O'Keeffe. In your generosity and in hers – by proximity – have I shared it. There is nothing in nature so generous as the artist. In his willingness and whole heartedness to give of the best, he is like the singing of a bird, the determination of a mother . . . whatever I have done for O'Keeffe has been a material thing. What she has done for me has been a spiritual thing. That is the difference – and therein lies my sense of gratitude to her. The unpayable debt sprung of a devotion that cannot altogether have to do with the individual . . . With warm love to you, and appreciation always – I am devotedly, Maria Chabot.

[O'Keeffe to Stieglitz: 5 June 1946]
. . . Have a good sleep – I will be alright and thinking of you. Kiss to you. Good Night and Good-bye My friend. I will to [sic] wish you here. Be good to yourself for me. It means so much for me.

[Stieglitz to O'Keeffe: 18 June 1946, The Place]

. . . Last evening was quiet. A miserable shave at 9. Horrible. The torture awful and I so tired – World and Place tiredness. And above all tired of self – not equal to what should be done – and to be witness to its not being done is a torment . . .

12:20 Two young Texans, painters just left – Had been twice to O'Keeffe show . . . very alive. Sensitive. Intellectual. Rare individuals. A treat. The one for his 21st birthday 5 years ago, bought a Marin with the $500 his grandmother had given him as a birthday gift. The other is now. Really a treat for me that visit – No one else here. No phone calls. I'll lie down. How shaky my writing. Awful . . .

4:30 p.m. What a day. Alone. Z [Zoler] out for ice cream. At about 1 people began coming . . . Steichen (!!), Dorothy, and others. Mrs. Halpert. My head buzzing. Steichen here 2 hours. A great meeting. Too much to get into. Very fine. Straight – very right for all. Thinks your show very beautiful. A real event . . .

[Stieglitz to O'Keeffe: 3 July 1946, 9:45 a.m., The Place]

Still another day. Clear. Cool. Dry. A relief – Here I am. Came in. Lay down. Mean night. Fired. Yesterday took much out of me. The Cooper incident [Gary Cooper and his wife were interested in buying a painting] – Nothing brought to a real head. So the waiting. Uncertainty. Yet all so fine – For me at any rate. Yet the agony of indecision. Oh, Georgia, why must the money question taint all it touches – For it finally always seems to come down to that and the color of the walls in which a picture is to be hung. The Jimson Weed would go beautifully in the big living room but Mrs. C. wants her O'Keeffe in the bedroom and that room is too small for the Jimson Weed. And so it goes . . . what's the matter with me? . . .

[Stieglitz to O'Keeffe: 7 July 1946, 5:35 p.m.]

In bed. Heart attack yesterday at Place . . . I was alone . . . Kiss – much love. Don't worry, no cause.

[Stieglitz to O'Keeffe: 9 July 1946]

I'm sitting in your room. At your desk. Zoler cleaned my pen last night. Needed it badly . . . letters from you. And you also weary in spite of your country . . . Oh, Georgia. Living is quite a job these times. Kiss. A woman called up yesterday asking if you took pupils! Anita called up – asked how you could be reached by phone. She is writing. Telephone to you is a joke! I feel so stupid. Am stupid. My eyes prevent reading. Just as well – newspapers rather loathsome. Well, I'll get this into an envelope. Another kiss. I'm all right. Tomorrow I'll go to the Place for a while. Today I felt it best to stay here [at the apartment] . . . Lazy.

[6-28-46]

2:25 P.M.

Glad when lunch was down,
It was good. — I tried to
rest after but was too
restless to remain lying long
— So here I am. Restless.
On edge. — Wouldn't mind
sitting in a bath tub filled
with cooling water, And
doze off in it. —

— Instead I'll get this off.

With a special
kiss

My reckoning was
wrong in yesterday's letter — or was it right?
To-day is
Day 24

300 Alfred Stieglitz, letter to Georgia O'Keeffe, 28 June 1946, p. 5. Beinecke Rare Book and Manuscript Library.

[O'Keeffe to Stieglitz: 11 July 1946 [from New Mexico]]

Oh, my friend – I don't like to think of you being ill and I not there. It bothers me. I hope you are alright by now. A kiss to your funny face. It's a fair, clear quiet day – however Flora tells me it will rain – we will see.

<p style="text-align:center">*</p>

Through their last letters O'Keeffe and Stieglitz continued to express care for each other. Stieglitz appeared to continue to wrestle with O'Keeffe's regular departures from the northeast, seemingly justifying to her and to himself the need for her to be in the southwest to pursue her creative work – work that was born of a free spirit. Such work Stieglitz continued to call "sacred."

In his last years, Stieglitz did not "cease from exploration," as he attempted to continue his work at An American Place. As in Eliot's lines quoted in the beginning of this book, Stieglitz perhaps had arrived, to some extent, at the place where he had started; the spirit of 291 was still embodied at An American Place. In some of his last photographs, he had sought out children and the "condition of complete simplicity" at Lake George, which Eliot mentions in his *Four Quartets*. The "fire and the rose" from Eliot's verse did seem to become one – the rose of nature, of purity, with a flame of the spirit, and of the flesh, as Stieglitz in his late years observed the world around him from his porch at Lake George, and from the upper floors of his gallery and apartment. Demuth's words that introduced O'Keeffe's 1931 exhibition at An American Place might well be applied to Stieglitz in his late years:

> With these go a movement of flames. Flame of the spirit? Flame of the flesh? – perhaps a flame, only, of creation. However, it consumes – that is the success of the flame . . . moved at times like great flames fanned by great winds from the sea, at other times like things burn indoors, as candles burn the elevated Host . . .[56]

Spending increasingly more time alone in his late years, observing the world from his porch at Lake George, and from the upper stories of his apartment and An American Place, Stieglitz appears to have come closer to the embodiment of Rilke's poem "Moving Forward," also quoted at the beginning of this book: "The deep parts of my life pour onward,/as if the river shores were opening out...I feel closer to what language can't reach./With my senses, as with birds, I climb/into the windy heaven, out of the oak,/and in the ponds broken off from the sky/my feeling sinks, as if standing on fishes."[57]

With Stieglitz's death and the closing of An American Place, an era had come to an end but Stieglitz, through his work as gallery director, collector, editor, writer, and above all as photographer, had left a legacy of light that would shine on generations to come.

EPILOGUE

With the end of the Second World War, and Stieglitz's death in 1946, an era had indeed come to a close, as Americans attempted to return to "normalcy" in the post war period and as artists turned to new forms of artistic expression, notably in the realm of abstract expressionism. Stieglitz's support of the early American Moderns' expressionist abstraction, often drawing on the world of nature as subject and inspiration, may be viewed as a foundation for the larger and bolder abstractions by artists such as Helen Frankenthaler, Frank Kline, and Mark Rothko. Critics have interpreted Stieglitz's modernist "project," the art of his immediate circle, as well as his own modernist work, in a variety of ways: from "significant form," to use Clive Bell's term from his 1913 book *Art* that Stieglitz sent to O'Keeffe while she was in Texas; to Freudian interpretations of male/female principles, such as those of Rosenfeld or Mumford on various occasions; to an "embodied formalism" by those such as Marcia Brennan in her 2001 *Painting Gender, Constructing Theory*, combining formalist and gendered discourse.

In a 2009 article, "Return of the Suppressed: Pictorialism's Revenge," the critic, A. D. Coleman, noted that pictorialism, had "reached its heyday with the work of Stieglitz and the Photo-Secession," but has now "climbed out of the dustbin of art history," and "stepped into the mainstream once again."[1] Coleman cites photographers such as Cindy Sherman, Laurie Simmons, Jeff Koons, Sarah Charlesworth, or Yasumasa Morimura, as being influenced by pictorialist methods, and considers that "many of the structural and stylistic tropes that postmodernism employs for the purposes that its advocates identify as 'transgressive,' come straight from the pictorialist toolkit."[2]

A number of the modernist photographers whom Stieglitz influenced have in part been discussed in previous pages – Steichen, Strand, Sheeler, Adams, Porter, White, and others. Even after Steichen and Stieglitz parted company for many years, Steichen diverged from his commercial fashion photographs to return to the seclusion and the spirit of the natural world as he photographed at Walden Pond, in 1934, to illustrate Henry David Thoreau's *Walden*. In that series, Steichen seemed to be closer to many of Stieglitz's Lake George photographs of the time

than to his own commercial images for Condé Nast publications such as *Vogue* or *Vanity Fair*, during the 1920s and 1930s. Beyond these Modernist photographs, one also sees affinities with Stieglitz's *Equivalents* in the sky and cloud images of artists or photographers as diverse as Brett Weston, Harold Leban, Werner Schnelle, Joel Meyerowitz, or Sol Le Witt.

Although Stieglitz left the center stage of influence, which he occupied for much of his life, his legacy has indeed lived on. That legacy is a complex one that is filled with paradoxes, polarities, and dualities: he was American, yet European; a family man, and yet an independent individual also; an artist and a scientist; both democratic and elitist, and so on. Who was the real Stieglitz? His life and work, as writer, editor, gallery dealer, photographer, leave no one objective answer. He was continually multifaceted and multivalent. Perhaps most consistent was his fighting spirit. In his world there always seemed to be a battle that needed to be waged, sometimes small, sometimes large. As he wrote to J. Dudley Johnston at the British Royal Photographic Society, as early as 1923,

> I have all but killed myself for photography. My passion for it is greater than ever. It's forty years that I have fought this fight – and I'll fight to the finish – single handed and without more if need be. It is not photographs – it is not photographers I am fighting for . . . It's a world's fight. This sounds mad . . . All that's born of spirit seems mad in these [days] of materialism run riot.[3]

In the end, it is the legacy of light in both concrete and metaphysical terms that is perhaps most significant, that, as Stieglitz noted, out of darkness may come light and hope. In more contemporary terms, one may speak of an "audacity of hope," in Stieglitz's terms, a hope for light. As he wrote:

> It is at the point at which black and white together form a positive manifestation of life that I am moved. I am moved by light. There is within me ever an affirmation of light. Thus, no matter how much black there may be, I never can feel futility. I feel tragedy – beauty – but never futility. I feel the duality of the world forces at work. But it is when conflict hovers about a point – and light is in the ascendancy, that I am moved.[4]

It is hoped that the "light" Stieglitz brought forth in his life and his work will not be extinguished and that it will continue to shine distinctly for generations to come. For, as Nancy Newhall wrote,

> Photography for the photographer is a deeply religious experience, and it does not matter what your religion may be – Buddhist, Muslim, Zen, Roman Catholic, Jewish, one of the many Protestant sects, atheist, or tribal – when that still small voice speaks to you or you hear visually that voice of thunder, then you know. And you know what you have to do. And then, perhaps, you understand what Stieglitz said, and let us hope you can even hear him thunder – "Photography is my passion; the search for truth my obsession."[5]

NOTES

acknowledgments

1 T. S. Eliot, *The Four Quartets*, "Little Gidding," 1942, in *T. S. Eliot Collected Poems, 1909–1962*, New York: Harcourt, Brace and World, 1963, pp. 208–9.

2 Rudolf Arnheim, quoted in University of California tribute to Arnheim, *New York Review of Books*, 2007, p. 49.

3 Rainer Maria Rilke, "Moving Forward," *Selected Poems of Rainer Maria Rilke*, trans. and commentary by Robert Bly, New York: Harper & Row, 1981, p. 101.

4 Alfred Stieglitz, 1915, quoted in *Alfred Stieglitz: Photographer*, VHS production, Museum of Modern Art, New York.

5 Alfred Stieglitz [AS] to Hart Crane, 15 August 1923, ASA/YCAL.

introduction

1 Louis-Jacques Mandé Daguerre, quoted in *Photo Antiquities*, Pittsburgh, Penn.: Museum of Photographic History, n.d., p. 3.

2 Oliver Wendell Holmes, Jr., quoted in ibid.

3 Pablo Picasso, quoted in ibid.

4 Henri Cartier-Bresson, quoted in Philippe L. Gross and S. I. Shapiro, *The Tao of Photography: Seeing Beyond Seeing*. Berkeley, Cal. and Toronto: Ten Speed Press, 2001, p. 52.

5 Randy Kennedy, "A Big Sale Spurs Talk of a Photography Gold Rush," *New York Times*, 17 February 2006.

6 AS to Guido Bruno, 28 December 1916, ASA/YCAL.

7 Robert Hughes, "Missionary of the New," *Time*, 26 February 2001.

8 Alfred Stieglitz to Thomas Hart Benton, 2 January 1935, quoted in Susan Greenough and Juan Hamilton, eds, *Alfred Stieglitz: Photographs and Writings*, New York:

Callaway; Washington, D.C.: National Gallery of Art, 1983, p. 219.

the early years

1 AS, quoted in Dorothy Norman, "Writings and Conversations of Alfred Stieglitz," *Twice a Year* 1 (Fall–Winter 1938), pp. 78–9.

2 Ibid., p. 13.

3 AS, letter to R. C. Bayley, 11 December 1913, ASA/YCAL.

4 AS, quoted in Dorothy Norman, *Alfred Stieglitz: An American Seer*, Millerton, New York: Aperture, 1973, p. 15.

5 Ibid., p. 16.

6 Richard Whelan, *Alfred Stieglitz: A Biography*, New York: Da Capo Press, 1997, pp. 15–16.

7 Thomas Jefferson, quoted in Trip Sinnott, *Tea Island: A Perfect Little Gem*, New York: Attic Studio Press, 1993, p. 9.

8 AS, quoted in Norman, *Stieglitz: American Seer*, p. 18

9 Whelan, *Stieglitz: Biography*, p. 53.

10 Autographs, vol. I. ASA/YCAL.

11 AS, in Robert Saxton, ed, *Mental Photographs*, New York: Holt and Williams, 1872.

12 Paul Rosenfeld, "The Boy in the Dark Room," in Waldo Frank et al., eds, *America and Alfred Stieglitz: A Collective Portrait*, New York: Doubleday, Doran & Co., 1934, p. 41.

13 AS, quoted in Norman *Stieglitz: American Seer*, p. 20.

14 Henry Hatfield, *Goethe: A Critical Introduction*, New York: New Directions, 1963, p. 211.

15 Ralph Flint, "Prize Song," in Dorothy Norman, ed., *Stieglitz: A Memorial Portfolio: 1864–1946*, New York: *Twice A Year* Press, 1947, pp. 37–8.

16 AS, quoted in Norman, *Stieglitz: American Seer*, p. 32.

17 AS, quoted in ibid., pp. 31–2.

18 Doris Bry, *Alfred Stieglitz: Photographer*, Boston: Museum of Fine Arts, 1965, p. 11.

19 *Die Photographische Rundschau* 5 (1888): 7.

20 AS, "A Plea for Art Photography in America," *Photographic Mosaics* 28 (1892): pp. 136–7.

21 AS, "Simplicity in Composition," in *The Modern Way of Picture Making*, Rochester, N.Y.: Eastman Kodak, 1905, p. 163.

22 "The Linked Ring Information Sheet," in Margaret Harker, *The Linked Ring*, London: Heinemann, 1979, n.p.

23 Sarah Greenough, *Alfred Stieglitz: The Key Set*, 2 vols., New York: Harry N. Abrams; Washington, D.C.: National Gallery of Art, 2002, vol. I: *1886–1922*, p. 51.

24 Ibid.

25 AS, "From the Writings and Conversations of Alfred Stieglitz," *Twice a Year* 1 (Fall–Winter 1938), pp. 96–7.

26 Alfred Stieglitz, quoted in Dorothy Norman, "Stieglitz's Experiments in Life," *New York Times Magazine* (29 December 1963): 9.

27 Christian A. Peterson, *Alfred Stieglitz's "Camera Notes,"* New York: W. W. Norton; Minneapolis: Minneapolis Institute of Art, 1993, pp. 19 and 60.

28 AS, "Night Photography with the Introduction of Life," in *American Annual of Photography and Photographic Times Almanac for 1898*, New York: 1898, p. 205.

29 Charles H. Caffin, *Photography as a Fine Art* (1901), Hastings-on-Hudson: Morgan and Morgan, 1972, p. 49.

30 See Alan Trachtenberg, ed., 1989 for *Reading American Photographs: Images as History, Mathew Brady to Walker Evans*, New York: Hill and Wang, Lewis Hine's and Stieglitz's photographs.

31 AS, quoted in the wall text for his photograph *Georgia O'Keeffe* (1921), at the exhibition *Twentieth-Century Photographs*, at the Metropolitan Museum of Art, New York, 2002.

32 AS, quoted in Nancy Newhall, *From Adams to Stieglitz*, New York: Aperture, 1999, pp. 118-19.

33 AS, "The Photo Secession," *Bausch and Lomb Lens Souvenir*, Rochester, N.Y.: Bausch and Lomb Optical Company, 1903, p. 3

34 Jonathan Green, ed., *Camera Work: A Critical Anthology*. Millerton, New York: Aperture, 1973, p. 12.

35 The gallery was described in *Camera Work* (14 April 1906), p. 48.

36 Royal Cortissoz, quoted in *Camera Work* 42–3 (April–July 1913), n.p.

37 Edward Steichen to AS, November 1913, ASA/YCAL.

38 Edward Abrahams, *The Lyrical Left: Randolph Bourne, Alfred Stieglitz, and the Origins of Cultural Radicalism in America*, Charlottesville: University Press of Virginia, 1986, pp. ix–2.

THE TEENS

1 AS to H. C. Reiner, 11 June 1915, ASA/YCAL. Reiner was connected with the M.A. Seed Plate Company of St. Louis and had advertised in *Camera Work*.

2 See Adele Heller and Lois Rudnick, eds., *1915, The Cultural Moment: The New Politics, the New Woman, the New Psychology, the New Art, and the New Theater in America*, New Brunswick, N. J.: Rutgers University Press, 1991.

3 Ibid., p. 3.

4 Ibid, p. 5.

5 AS, in "What is 291?" *Camera Work* (January 1915), pp. 36–8, 40–42, 70–73.

6 Thomas Craven, *Modern Art: The Men, the Movements, the Meaning*, New York: Simon and Schuster, 1935, p. 312.

7 AS, in "What is 291?" p. 66.

8 Marcel Duchamp in Pierre Cabanne, *Dialogues with Marcel Duchamp*, trans. Ron Padgett, New York: Viking, 1971, p. 54.

9 Sue Davidson Lowe, *Stieglitz: A Memoir/Biography*, New York: Farrar Strauss and Giroux, 1983, p. 197.

10 Jay Bochner, *An American Lens: Scenes from Alfred Stieglitz's New York Secession*, Cambridge, Mass., and London: MIT Press, 2005, p. 133.

11 AS, "How *The Steerage* Happened," *Twice a Year* 8–9 (1942), pp. 175–8.

12 Allan Sekula, "On the Invention of Photographic Meaning," *Artforum* 13 (January 1975), pp. 41–2.

13 AS quoted in Richard Whelan, ed., *Stieglitz on Photography: His Selected Essays and Notes*, New York: Aperture, 2000, p. 197.

14 Emmet Gowin quoted in *Alfred Stieglitz: Photographs from the J. Paul Getty Museum*, Los Angeles: Getty Publications, 2002, p. 116.

15 John Szarkowski quoted in Weston J. Naef, ed., *Alfred Stieglitz*, In Focus series, Los Angeles: J. Paul Getty Museum (1995), 2002, p. 117.

16 Marius de Zayas, *How, When, and Why Modern Art Came to New York*, ed. Francis M. Naumann, Cambridge, Mass., and London: MIT Press, 1996, p. 85.

17 Waldo Frank, in *The Seven Arts*, November 1916, p. 52.

18 See Casey Nelson Blake, *Beloved Community: The Cultural Criticism of Randolph Bourne, Van Wyck Brooks, and Lewis Mumford*, Chapel Hill: University of North Carolina, 1996, pp. 127–56.

19 Waldo Frank, *Our America*, New York: Boni and Liveright, 1919, pp. 9 and 15.

20 Paul Strand in Calvin Tomkins, "First Interview with Paul Strand," 30 July 1973, Joyce F. Menschel Library, Metropolitan Museum of Art, New York, p. 14.

21 These Strand images, as well as all the images in *Camera Work*, may be seen in Marianne Fulton Margolis, ed., *Alfred Stieglitz – Camera Work: A Pictorial Guide*, New York: Dover, 1978. The October 1916 Strand images are on pp. 134–5.

22 AS, "Our Illustrations," *Camera Work*, June 1917, 49/50, reproduced in Jonathan Green, ed., *Camera Work: A Critical Anthology*, Millerton, N.Y.: Aperture, 1973, p. 239.

23 Paul Strand, "Photography," *Camera Work* (June 1917), 49/50, in ibid., p. 327.

24 Interview with Paul Strand, 28 December 1971, quoted in Maria Morris Hambourg, *Paul Strand: Circa 1916*, New York: Metropolitan Museum of Art, 1998, pp. 20–21.

25 This and the next five letters in ASA/YCAL.

26 Ward Muir, "*Camera Work* and Its Creator," *The Amateur Photographer and Photography* 56 (28 November 1923), p. 466.

27 Ernest Fenollosa quoted in Van Wyck Brooks, *Fenellosa and His Circle*, New York: Dutton, 1962, p. 49.

28 Ernest Fenollosa, "Imagination in Art" (1894) and "The Nature of Fine Art," *The Lotus*, IX (1896), pp. 759–60, quoted in Marianne W. Martin, "Some American Contributions to Early Twentieth-Century Abstraction," *Arts Magazine* (June 1980), p. 159.

29 Arthur Dow quoted in Frederick C. Moffatt, *Arthur Wesley Dow*, Washington, D.C.: Smithsonian Institution Press, 1977, p. 110.

30 Helmut and Alison Gernsheim, *Alvin Langdon Coburn: Photographer*, New York: Praeger, 1966, p. 22.

31 Georgia O'Keeffe, quoted in Katherine Kuh, *The Artist's Voice: Talks with Seventeen Artists*, New York: Harper & Row, 1962, p. 190.

32 Arthur Dow to Mr. C. J. Scott, Superintendent of Schools, Wilmington, Del., 12 July 1915, quoted in Frederick C. Moffatt, *Arthur Wesley Dow*, Washington, D.C.: Smithsonian Institution Press, p. 129.

33 F. S. C. Northrop, *The Meeting of East and West: An Inquiry Concerning World Understanding*, New York: Macmillan, 1946, pp. 163–4.

34 Daniel Catton Rich, *Georgia O'Keeffe: Forty Years of Her Art*, exh. cat., Worchester, Mass.: Worchester Art Museum, 4 October–4 December, 1960, pp. 3–4.

35 AS, "From the Writings and Conversations of Alfred Stieglitz," *Twice a Year* 1 (Fall–Winter 1938), p. 83.

36 Max Weber, "The Fourth Dimension from a Plastic Point of View," *Camera Work* 31 (1910), p. 25.

37 Max Weber, *Essays on Art*, New York: Rudge, 1916, pp. 32 and 55.

38 Willard Huntington Wright, *The Creative Will: Studies in the Philosophy and the Syntax of Aesthetics*, New York: John Lane, 1916, p. 33.

39 W. H. Wright, *Modern Painting: Its Tendency and Meaning*, New York: John Lane, 1915, p. 10.

40 W. H. Wright, foreword to exhibition of synchronist paintings by Morgan Russell and S. MacDonald-Wright, Carroll Galleries, New York, 2–16 March 1914, quoted in Gail Levin, *Synchronism and American Color Abstraction, 1916–1925*, New York: George Braziller and Whitney Museum of American Art, 1978, p. 131.

41 Charles Daniel, list, *Camera Work*, 47 (January 1915), p. 33.

42 AS, "Foreword to the Forum Exhibition of Modern American Painters, March 1916," in *Commemorating the 50th Anniversary of "The Forum Exhibition of Modern American Painters,"* New York: ACA Heritage Gallery, 1916, n.p.

43 John Weichsel, "Foreword," in ibid., n.p.

44 William Zorach, "The Forum Exhibition of Modern American Painters," exh. cat., New York, Anderson Galleries, March 1916, n.p.

45 Francis Picabia quoted in Arthur Jerome Eddy, *Cubists and Post Impressionism*, Chicago: McClurg, 1914, p. 220.

46 Francis Picabia quoted in Hutchins Hapgood, "A Paris Painter," *New York Globe and Commercial Advertiser* (20 February 1913), p. 12.

47 Mabel Dodge Luhan, *Movers and Shakers*, vol. 2 of *Intimate Memories*, New York: Harcourt Brace and Co., 1936, p. 39.

48 Mabel Dodge, "Speculations," *Camera Work* (June 1913), p. 9.

49 Claude Bragdon, *The Frozen Fountain: Being Essays on Architecture and the Art of Design in Space*, New York: Alfred A. Knopf, 1932, pp. 10 and 125.

50 AS quoted in advertising circular for *More Lives*, quoted in Linda Dalrymple Henderson, *The Fourth Dimension and Non-Euclidian Geometry in Modern Art*, Princeton, N.J.: Princeton University Press, 1983, p. 197.

51 *Camera Work* 41 (January 1913), p. 24.

52 Arthur Hoeber quoted in ibid., p. 26.

53 Oscar Bluemner, diary, 4 July 1925, AAA/SI (340: 1516–19).

54 Ibid.

55 Stanton MacDonald-Wright to AS, 8 March 1917, ASA/YCAL.

56 AS quoted in Dorothy Norman, *Alfred Stieglitz: An American Seer*, Millerton, N.Y.: Aperture, 1973, p. 124.

57 Ibid., p. 130.

58 AS to Paul Haviland, 5 July 1916, Fonds Haviland, Musée d'Orsay, Paris.

59 AS quoted in Norman, *Stieglitz: American Seer*, p. 130.

60 AS quoted in Elizabeth McCausland, "Georgia O'Keeffe in a Retrospective Exhibition," *Springfield Republic* (May 1946).

61 Georgia O'Keeffe to AS, 27 July 1916, quoted in Anna Pollitzer, *A Woman on Paper: Georgia O'Keeffe*, New York: Simon and Schuster, 1988, pp. 140–41.

62 William Murrell Fisher, "Georgia O'Keeffe: Drawings and Paintings at 291," *Camera Work*, 49–50 (June 1917), p. 5.

63 Paul Valéry quoted in Walter Sorrell, *Dance in Its Time*, New York: Doubleday, 1981, p. 341.

64 Ibid.

65 Richard Whelan, *Alfred Stieglitz: A Biography*, New York: Da Capo Press, 1997, pp. 474–5.

66 AS to Georgia O'Keeffe, 31 May 1917, ASA/YCAL.

67 AS to Georgia O'Keeffe, 24 June 1917, ASA/YCAL.

68 AS quoted in Norman, 1973, p. 127.

69 Ibid., pp. 134–5.

70 AS to Georgia O'Keeffe, 3 November 1917, ASA/YCAL.

71 Konrad Cramer, "Stupendous Stieglitz," *Photographic Society of America Journal* (November 1947), n.p.

72 AS to Paul Strand, 4 August 1917, ASA/YCAL.

73 Hodge Kirnon quoted in *Camera Work* 4 (July 1914), p. 16.

74 AS to Marie Rapp, 23 July 1917, ASA/YCAL.

75 Hodge Kirnon to AS, 9 May 1924, ASA/YCAL.

76 AS to R. Child Bayley, 1 November 1916, quoted in Sarah Greenough and Juan Hamilton, eds., *Alfred Stieglitz: Photographs and Writings*, New York: Callaway; Washington, D.C.: National Gallery of Art, 1983.

77 Weston Naef, *Alfred Stieglitz: Seen and Unseen*, Los Angeles: J. Paul Getty Museum, 1996, n.p.

78 Georgia O'Keeffe, "Introduction," in *Georgia O'Keeffe: A Portrait by Alfred Stieglitz*, New York: Metropolitan Museum of Art and Viking, 1978, n.p.

79 Ibid., n.p.

80 Doris Bry, *Alfred Stieglitz: Photographer*, Boston: Museum of Fine Arts, 1965, p. 18.

81 Naef, in *Stieglitz*, In Focus, p. 123.

82 Ibid., pp. 127–8.

83 Susan Danly, "Miss O'Keeffe – Photography and Fame," in *Georgia O'Keeffe and the Camera: The Art of Identity*, New York and London: Yale University Press and Portland Museum of Art, Maine, 2008, p. 12.

84 Paul Rosenfeld, "Stieglitz," *The Dial* 70 (April 1921), pp. 408–9.

85 Elizabeth Kendall, *Where She Danced*, Berkeley and Los Angeles: University of California Press, 1979, p. 123.

86 Georgia O'Keeffe to AS, 8 January 1918, ASA/YCAL.

87 Lewis Mumford, "The Metropolitan Milieu," in Waldo Frank et al., eds., *America and Alfred Stieglitz: A Collective Portrait*, New York: Doubleday, Doran & Co., 1934, p. 57.

88 This and the next three letters in ASA/YCAL.

89 O'Keeffe, *O'Keeffe: Portrait by Stieglitz*, n.p.

90 This and the next three letters in ASA/YCAL.

91 AS to Georgia O'Keeffe, quoted in Ruth Fine, Elizabeth Glassman, and Juan Hamilton, *The Book Room: Georgia O'Keeffe's Library in Abiquiu*, New York: Grolier Club, 1997, p. 34.

92 John Marin to AS, 31 July 1917, ASA/YCAL, also quoted in Dorothy Norman, ed., *The Selected Writings of John Marin*, New York: Pellegrini and Cudahy, 1949, pp. 34–5.

93 This and the next four letters in ASA/YCAL.

THE TWENTIES

1 AS to J. Dudley Johnston, 3 April 1925, RPSA; also quoted in Sarah Greenough and Juan Hamilton, eds., *Alfred Stieglitz: Photographs and Writings*, New York: Callaway; Washington, D. C.: National Gallery of Art, 1983, pp. 208–9. Johnston was president of the Royal Photographic Society and in 1924 awarded Stieglitz the Society's Progress Medal: ibid., p. 234.

2 Fredrick Allen, *Only Yesterday*, New York: Harper & Row, 1931, p. 168.

3 Oliver W. Larkin, *Art and Life in America*, New York: Rinehart and Co., 1949, p. 372.

4 Allen, *Only Yesterday*, p. 109.

5 Barbara Hastell, *Arthur Dove*, San Francisco Museum of Art, 1974, p. 47.

6 D. H. Lawrence quoted in ibid.

7 James Guimond, *The Art of William Carlos Williams: A Discovery and Possession of America*, Urbana: University of Illinois Press, 1968, p. 82.

8 AS to Hart Crane, 27 July 1923, ASA/YCAL; also quoted in Greenough and Hamilton, *Alfred Stieglitz*, p. 235.

9 AS quoted in Dorothy Norman, *Alfred Stieglitz: An American Seer*, Millerton, N.Y.: Aperture, 1973, p. 228.

10 Hart Crane quoted in R. W. B. Lewis, *The Poetry of Hart Crane*, Princeton University Press, 1967, p. 122.

11 Hart Crane to AS, 15 April 1923, *The Letters of Hart Crane, 1916–1932*, ed. Brom Weber, Berkeley and Los Angeles: University of California Press, 1965, pp. 131–2.

12 AS to Hart Crane, 16 April 1923, Columbia University Library, quoted in Robert Haines, "Alfred Stieglitz and the New Order of Consciousness in American Literature," *Pacific Coast Philology* 6 (April 1971), p. 29. Stieglitz here quoted O'Keeffe's remark.

13 Hart Crane to AS, 4 July 1923, *Letters*, pp. 137–8.

14 Hart Crane to AS, 25 August 1923, ibid., pp. 145–6.

15 Paul Rosenfeld, *Port of New York: Essays on Fourteen*

American Moderns, New York: Harcourt Brace, 1924, pp. 2 and 295.

16 Ibid., pp. 238–9.

17 AS to Paul Rosenfeld, 25 April 1924, ASA/YCAL.

18 AS to Rosenfeld, 12 July 1924, ASA/YCAL.

19 Rosenfeld, *Port of New York*, p. 264.

20 Van Wyck Brooks et al., eds., *The American Caravan: A Yearbook of American Literature*, New York: Literary Guild of America, 1927, p. ix.

21 AS to Rosenfeld, 25 April 1924, ASA/YCAL.

22 George Santayana, *The Sense of Beauty* (1896), New Brunswick, N.J. and London: Transaction, 2003.

23 D. H. Lawrence to AS, 15 August 1928, *The Selected Letters of D. H. Lawrence*, ed. Diana Trilley, New York: Farrar, Straus, and Giroux, 1958, pp. 284–5.

24 D. H. Lawrence to AS, 17 September 1923, copied in letter from AS to O'Keeffe, 21 September 1923, ASA/YCAL.

25 D. H. Lawrence, *Studies in Classic American Literature*, New York: Doubleday and Co. [1923] 1953, pp. 17, 121, 186.

26 Marsden Hartley quoted in Ruth Fine, Elizabeth Glassman, and Juan Hamilton, *The Book Room: Georgia O'Keeffe's Library in Abiquiu*, New York: Grolier Club, 1997, p. 36.

27 Marsden Hartley, *Adventures in the Arts: Informal Chapters on Painters, Vaudeville, and Poets*, New York: Boni and Liveright, 1921, pp. 116–18.

28 Ibid., p. 110.

29 Ibid., p. 111.

30 Ibid., p. 10.

31 Waldo Frank, "Introduction," ibid., p. xvi.

32 Sherwood Anderson, *A Story Teller's Story*, Garden City, N.Y.: Garden City Publishing, 1924; also quoted in Sarah Greenough, *Alfred Stieglitz: The Key Set*, 2 vols, New York: Harry N. Abrams; Washington, D.C.: National Gallery of Art, vol. 2, p. 502.

33 Sherwood Anderson to AS in Horace Gregory, ed., *The Portable Sherwood Anderson*, New York: Viking, 1949, p. 586.

34 Georgia O'Keeffe quoted in Hunter Drohojowska-Phillip, *Full Bloom: The Art and Life of Georgia O'Keeffe*, New York: N.W. North, 2004, p. 351.

35 Jean Toomer, "The Hill," in Waldo Frank et al., eds., *America and Alfred Stieglitz: A Collective Portrait*, New York: Doubleday, Doran & Co., 1934; reprint Aperture, 1979, pp. 145–6.

36 Alfred Stieglitz, "Portrait – 1918," *MSS* 2 (March 1922), p. 61.

37 AS to J. Dudley Johnston, 15 October 1923, RPSA.

38 Katherine Dreier to AS, 30 August 1926, ASA/YCAL.

39 AS quoted in Richard Whelan, *Alfred Stieglitz: A Biography*, New York: Da Capo Press, 1997, p. 418.

40 Ibid., p. 419.

41 AS quoted in Jerry L. Thompson, *Truth and Photography*, Chicago: Ivan Dee, 2003, p. 25.

42 John A. Tennant, "The Stieglitz Exhibition," *The Photo-Miniature* 16, 183 (July 1921), pp. 135–7.

43 Herbert Seligmann, "A Photographer Challenges," *The Nation* 112 (16 February 1921), p. 268.

44 Hartley, *Adventures in the Arts*, p. 105.

45 Paul Strand, "Alfred Stieglitz and a Machine," New York: privately printed, 14 February 1921, n.p.; reprinted in *MSS* (March 1922), pp. 6 and 7.

46 Ibid.

47 Edward Weston to AS, "Stieglitz–Weston Correspondence," compiled by Ferdinand Reyher, *Photo Notes* (spring 1949), p. 11.

48 Edward Weston quoted in Beaumont Newhall and Amy Conger, *Edward Weston Omnibus: A Critical Anthology*, Salt Lake City: Peregrine Books, 1986, p. 7.

49 Charles Sheeler, "Recent Photographs by Alfred Stieglitz," *The Arts* 3, 5 (May 1923), p. 345.

50 Ananda Coomaraswamy quoted in Roger Lipsey, "Double Portrait: Alfred Stieglitz and Ananda Coomaraswamy," *Aperture* 16, 3 (1972), n.p.

51 Alfred Stieglitz, "The Boston Museum and the Metropolitan Museum," *Twice a Year* (1940–41), quoted in "Photographs in the Metropolitan," *The Metropolitan Museum of Art Bulletin*, n.s, 27, 7 (March 1969), pp. 335–6.

52 AS to Ananda K. Coomaraswamy, 30 December 1928, Boston, Museum of Fine Arts, archive files.

53 Ananda K. Coomaraswamy quoted in AS, "From the Writing and Conversations of Alfred Stieglitz," *Twice A Year* 1 (Fall-Winter 1938), p. 175.

54 Alfred Stieglitz, March 1924 catalogue introduction, quoted in Sarah Greenough et al., eds., *Modern Art and America: Stieglitz and His New York Galleries*, Washington D.C.: National Gallery of Art; Boston, New York, and London: Bulfinch Press, Little, Brown, 2000, p. 548.

55 Thomas Craven, "Art and the Camera," *The Nation* (16 April 1924), p. 457.

56 Helen Appleton Read, "Woman Artist Whose Art is Sincerely Feminine," *Brooklyn Sunday Eagle Magazine* (6 April 1924), p. 4.

57 Paul Strand, "Georgia O'Keeffe," *Playboy: A Portfolio of Art and Satire* 9 (July 1924), pp. 16–20.

58 Jean Evans, "Stieglitz: Also Battling – and Retreating." *PM* (23 December 1945), p. 14.

59 Lewis Mumford, "O'Keeffe and Matisse," *New Republic* 50 (2 March 1927), pp. 41–2.

60 Georgia O'Keeffe quoted in Dorothy Seiberling, "The Female Voice of Erotica," *New York Magazine* 7 (11 February 1974), p. 54.

61 AS to Elizabeth Stieglitz Davidson, 11 October 1923, ASA/YCAL.

62 Royal Photographic Society, 1924 citation, quoted in Greenough, *Modern Art and America*, p. 566.

63 AS, statement in *Alfred Stieglitz Presents Seven Americans*, exh. cat., New York: Anderson Galleries, 1925, n.p.

64 Arnold Rönnebeck, "Through the Eyes of a European Sculptor," in ibid.

65 Sherwood Anderson, "Seven Alive," in ibid.

66 Henry McBride, "The Stieglitz Group at Anderson's," *New York Sun* (14 March 1925), p. 13.

67 Edmund Wilson, "Greatest Triumphs: The Stieglitz Exhibition," *New Republic* 42 (18 March 1925), pp. 97–8.

68 Helen Appleton Read, "News and Views on Current Art: Alfred Stieglitz Presents 7 Americans," *Brooklyn Daily Eagle* (15 March 1925), p. 2B.

69 Margaret Breuning, "Seven Americans," *New York Evening Post* (14 March 1925), sec. 5, p. 11.

70 Various Intimate Gallery exhibition announcements are held in ASA/YCAL. AS also sometimes wrote letters on the backs of old announcements.

71 AS quoted in Herbert Seligmann, *Alfred Stieglitz Talking: Notes on Some of His Conversations, 1925–1931*, New Haven: Yale University Library, 1966, p. 28.

72 Ibid., p. 41.

73 Ibid., p. 28.

74 Ibid., p. 27.

75 Seligmann, ibid., p. 29.

76 AS to Paul Rosenfeld quoted in Greenough and Hamilton, *Alfred Stieglitz*, p. 212.

77 William Carlos Williams, *The Collected Earlier Poems*, New York: New Directions, 1951, p. 230.

78 Dorothy Norman, *Encounters: A Memoir*, New York: Harcourt Brace Jovanovich, 1987, p. 55.

79 Ibid., pp. 56–7.

80 AS quoted in ibid., p. 60.

81 Norman, ibid., p. 71.

82 AS quoted in ibid., pp. 72–3.

83 Dorothy Norman quoted in *Selections from the Dorothy Norman Collection on Exhibition at the Philadelphia Museum of Art, May 24–September 1, 1968*, Philadelphia Museum of Art, 1968, n.p.

84 Florine Stettheimer, "HE PHOTOGRAPHS," *Crystal Flowers*, New York: Banyon Press, 1949, p. 53.

85 Duncan Phillips to Deven Fulton, 22 March 1927, quoted in Timothy Robert Rodgers, "Alfred Stieglitz, Duncan Phillips and the '$6000 Marin'," *Oxford Art Journal* 15, 1 (1992), p. 63.

86 Anson Conger Goodyear, *The Museum of Modern Art: The First Ten Years*, New York: Vrest and A. C. Goodyear, 1943, p. 13.

87 Lincoln Kirstein, "'Hound and Horn': Forty-Eight Years After," foreword to Mitzi Berger Hormovitch, ed., *The Hound and the Horn Letters*, Athens, Ga.: University of Georgia Press, p. xv.

88 Bram Dijkstra, *Georgia O'Keeffe and the Eros of Place*, Princeton University Press, 1998, p. 167.

89 AS to Sherwood Anderson, 9 December 1925, ASA/YCAL.

90 AS to Sherwood Anderson, 7 July 1924, ASA/YCAL.

91 See Jonathan Weinberg, *Ambition and Love in Modern American Art*, New Haven and London: Yale University Press, 2007.

92 Frances O'Brien, "Americans We Like: Georgia O'Keeffe," *The Nation* 125 (12 October 1927), p. 362.

93 AS to Herbert Seligmann, 28 September 1922, ASA/YCAL.

94 AS to Herbert Seligmann, 29 October 1922, ASA/YCAL.

95 AS to Rebecca Strand, 30 October 1922, ASA/YCAL.

96 AS to Rebecca Strand, 1 November 1922, ASA/YCAL.

97 Georgia Engelhard, "Alfred Stieglitz: Master Photographer," *American Photography* 39, 4 (April 1945), p. 9.

98 AS to Arthur Dove, 4 October 1924, ASA/YCAL.

99 AS to Rebecca Strand, 25 October 1924, ASA/YCAL.

100 AS inscription on photographs, 1924/25, ASA/YCAL, MSS. 85, box 148, folder 2747.

101 Weston Naef, ed., *Alfred Stieglitz*, In Focus Series, Los Angeles: J. Paul Getty Museum, 1995, p. 70.

102 Georgia O'Keeffe, *Georgia O'Keeffe: A Portrait by Alfred Stieglitz*, New York: Metropolitan Museum of Art and Viking, 1978, introduction, n.p.

103 Dijkstra, *O'Keeffe and the Eros of Place*, p. 171.

104 AS to Arthur Dove, 18 July 1923, Arthur Dove Papers, AAA/SI, cited in Greenough, *Stieglitz: Key Set*, vol. 2, p. 508.

105 Charles Demuth to AS 16 April and 2 May 1923, ASA/YCAL.

106 AS to Paul Strand, 7 September 1922, ASA/YCAL.

107 AS, reproduction of text and photograph in Naef, *Alfred Stieglitz*, In Focus, p. 65.

108 Hart Crane to AS quoted in Sarah Greenough, "From the American Earth: Alfred Stieglitz's Photographs of Apples," *Art Journal* 41, 1 (spring 1981), p. 51. The article discusses the use of the apple as a symbol, both sexual and related to the role of artists in America.

109 AS quoted in Nancy Newhall, unpublished notes, quoted in ibid.

110 Ibid., pp. 50–51.

111 S. G. W. Benjamin, *Harper's New Monthly Magazine*, 1879, quoted in Erin Budis Coe and Gwendolyn Owens, *Painting Lake George*, Glens Falls, N.Y.: Hyde Collection, 2005, p. 21.

112 Gaston Bachelard, *The Poetics of Space*, Boston: Beacon Press, 1969, p. 163.

113 Ibid., p. 184.

114 AS, "How I Came to Photograph Clouds," *Amateur Photographer and Photography* 56 (1923), p. 255.

115 AS to Sherwood Anderson, 1 November 1923, ASA/YCAL.

116 AS to Hart Crane, 10 December 1923, ASA/YCAL.

117 Eric Johnson, "Ernest Bloch, A Composer's Vision," *Camera* (February 1976), p. 7.

118 AS to Ernest Bloch, 1 July 1922, quoted in Bonnie Ford Schenkenberg, *Ernest Bloch: Photographer and Composer*, Tucson, Ariz.: Center for Creative Photography, 1980, p. 6.

119 Ernest Bloch to Paul Strand, 1922, quoted in ibid., p. 8.

120 Paul Rosenfeld, *By Way of Art*, New York: Coward-McCann, 1928; reprint, Freeport, N.Y.: Books for Libraries Press, 1967, p. 57.

121 Rosalind Krauss, "Alfred Stieglitz's *Equivalents*," *Arts* 54 (February 1980), p. 137.

122 Friedrich Nietzsche quoted in John Gross, *The Oxford Book of Aphorisms*, Oxford and New York: Oxford University Press, 1983, p. 297.

123 Ralph Flint quoted in Seligmann, *Stieglitz Talking*, p. 76.

124 Katharine Rhoades to AS, 21 December 1923, ASA/YCAL.

125 AS to Herbert Seligmann, 10 October 1923, ASA/YCAL.

126 AS to Evelyn Scott, 9 July 1933, Harry Ransom Humanities Research Center, University of Texas, Austin, quoted in Greenough, *Stieglitz: Key Set*, vol. 2, p. 528.

127 Daniell Cornell, *Alfred Stieglitz and the Equivalent: Reinventing the Nature of Photography*, New Haven: Yale University Art Gallery, 1999, pp. 13–14.

128 AS quoted in Norman, *Stieglitz: American Seer*, pp. 144 and 161.

129 Andy Grundberg, *Crisis of the Real: Writings on Photography, 1974–1989*, New York: Aperture, 1990, p. 20.

130 Carl Carus, *Nine Letters on Landscape Painting*, quoted in Barbara Novak, *Nature and Culture: American Landscape and Painting, 1825–1875*, New York: Oxford University Press, rev. 1995, p. 82.

131 The term "multivalent" was used by Mircea Eliade in *Images and Symbols* (1916), cited in Jacqueline Taylor Basker, "The Cloud as Symbol," *Crosscurrents* (spring 2006), p. 112.

132 Ibid., pp. 111–14.

133 AS to Hart Crane, 10 September 1923, quoted in Greenough and Hamilton, *Stieglitz*, p. 208.

134 David Travis, *At the Edge of the Light*, Boston: David Godine, 2003, p. 136.

135 "Endless Forms" was a term used by Darwin and was the title of an exhibition at the Yale Center for British Art, New Haven, Conn. exploring the impact of Darwin's theories on the visual arts.

136 Seligmann, *Stieglitz Talking*, pp. 138–9.

137 Rainer Maria Rilke, *Selected Poems*, trans. and commentary Robert Bly, New York: Harper & Row, 1981, pp. 161 and 169.

138 AS to Sherwood Anderson, 18 June 1924, ASA/YCAL.

139 AS to Herbert Seligmann, 31 October 1927, ASA/YCAL.

140 AS quoted in Seligmann, *Stieglitz Talking*, p. 21.

141 AS to O'Keeffe, 28 June 1929, ASA/YCAL.

142 AS to David Liebovitz quoted in Bettina Knapp, "Alfred Stieglitz's Letters to David Liebovitz, 1923–1930," *Modern Language Studies* 15, 3 (Summer 1985), pp. 13–34.

143 This and all following letters in ASA/YCAL.

THE THIRTIES

1 AS to Ansel Adams in *Ansel Adams: Letters and Images 1916–1984*, ed. Mary Street Alinder and Andrea Gray Stillman, Boston and New York: Little, Brown, 2000, pp. 69–70.

2 AS to Waldo Frank, quoted in Edward Abrahams, "Alfred Stieglitz and/or Thomas Hart Benton," *Arts Magazine* 55 (June 1981), p. 108.

3 Frederick Allen, *Since Yesterday: The Nineteen Thirties in America*, New York: Harper and Brothers, 1940, p. 55.

4 Ibid., pp. 158–9.

5 AS to O'Keeffe, 23 September 1938, ASA/YCAL.

6 Walter Lipmann, "The Atlantic Ocean," *New York Tribune* (11 October 1938).

7 Dr. Abraham Flexner quoted in "Dr. Flexner Says, 'Lunatics' Ruin Reich Schools," *New York Tribune* (11 October 1938).

8 Dorothy Thompson, "On the Record," *New York Tribune* (12 October 1938).

9 O'Keefe to Henry McBride, n.d., Henry McBride papers, AAA/SI.

10 Barbara Haskell, *Arthur Dove*, New York: New York Graphic Society, 1975, p. 69.

11 AS to O'Keeffe, 24 May 1931, ASA/YCAL.

12 AS to O'Keeffe, 11 September 1935, ASA/YCAL.

13 David Gerlernter, *1939: The Lost World of the Fair*, New York: Avon Books, 1995, p. 2.

14 Winston Churchill quoted in ibid., p. 18.

15 André Sennwald, "American Debut of 'La Maternelle' at the Fifth Street Playhouse," *New York Times* (15 October 1935).

16 AS to Eliot Porter, 21 January 1939, Estate of Eliot Porter, quoted in Richard Whelan, *Alfred Stieglitz: A Biography*, New York, Da Capo Press, 1997, p. 525.

17 AS to O'Keeffe, 18 October 1931, ASA/YCAL.

18 AS to O'Keeffe, 25 September 1938, ASA/YCAL.

19 Stendhal (Henri-Marie Beyle), *The Red and the Black*, New York: Penguin, 2002, pp. 522–3.

20 D. H. Lawrence, *A Propos of Lady Chatterley's Lover* (1930), New York: Bantam, 1983, pp. 348–9.

21 Lewis Mumford quoted in Ruth Fine, Elizabeth Glassman, and Juan Hamilton, *The Book Room: Georgia O'Keeffe's Library in Abiquiu*, New York: Grolier Club, 1997, p. 49.

22 Robert Wojtowicz, *Mumford on Modern Art in the 1930's*, Berkeley: University of California Press, 2007, p. 7.

23 Waldo Frank et al., eds., *America and Alfred Stieglitz: A Collective Portrait*, New York: Doubleday, Doran & Co., 1934, p. 13.

24 Dorothy Norman, December 1973, in ibid., p. 10.

25 Victoria Ocampo, "A Witness," in ibid., p. 130.

26 Edward Alden Jewell, "Alfred Stieglitz and Art in America," *New York Times* (23 December 1934).

27 Abrahams, "Stieglitz and/or Thomas Hart Benton," p. 108.

28 E. M. Benson, "Alfred Stieglitz: The Man and the Book," *American Magazine of Art* (January 1936), p. 40.

29 Lewis Mumford, "The Metropolitan Milieu" (1945 version), quoted in Wojtowicz, *Mumford on Modern Art*, p. 40.

30 Julien Levy to AS, 11 September 1931, ASA/YCAL.

31 Helen Appleton Read, *Brooklyn Daily Eagle* (22 May 1932), quoted in Katherine Ware and Peter Barberie, *Dreaming in Black and White: Photography at the Julien Levy Gallery*, New Haven and London: Yale University Press; Philadelphia Museum of Art, 2006, p. 9.

32 Julien Levy quoted in ibid., p. 31. Stieglitz's letters to Levy are held at the Julien Levy Archives, Newtown, Conn.

33 Levy quoted in ibid.

34 Maria M. Hambourg, "From 291 to the Museum of Modern Art: Photography in New York, 1916–1937," in Maria M. Hambourg and Christopher Phillips, eds., *The New Vision: Photography Between the World Wars*, New York: Metropolitan Museum of Art and Harry N. Abrams, 1989, p. 52.

35 Paul Strand to Nora Christensen, 24 January 1932, Albright-Knox Art Gallery Archives, Buffalo, N.Y., quoted in ibid., p. 284.

36 Walker Evans quoted in ibid., p. 58.

37 Henry Luce quoted in Philip B. Kunhardt, Jr., ed., *Life: The First Fifty Years, 1936–1986*, Boston: Little Brown, 1986, p. 5.

38 Elizabeth McCausland, *New York in the Thirties* (formerly *Changing New York*) as photographed by Bernice Abbott, New York: Dover Publications, 1973, image 17, n.p.

39 Plato, *Philebus*, quoted in Jennifer Jane Marshall, "In Form We Trust: Neoplatonism, the Gold Standard, and the 'Machine Art' Show, 1934," *Art Bulletin*, 90, 4 (December 2008), p. 600.

40 Ibid., p. 614.

41 Lewis Mumford, "Prints and Paints," *New Yorker* (3 April 1937), quoted in Wojtowicz, *Mumford on Modern Art*, pp. 242–3.

42 Lewis Mumford to AS, 20 May 1938, ASA/YCAL.

43 AS to O'Keeffe, 17 November 1931, ASA/YCAL.

44 AS to O'Keeffe, 21 November 1932, ASA/YCAL.

45 Ralph Flint, "Whitney Museum Opens its First Biennial Show," *Artnews* (December 1932).

46 Henry McBride, "Great Variety Marks the Invitation Exhibition at the Whitney Museum," *New York Sun* (26 November 1932).

47 This and the next five letters in ASA/YCAL.

48 Dorothy Norman, "Alfred Stieglitz: Introduction to an American Seer," *Aperture*, 8, 1 (1960), p. 28.

49 Ibid.

50 Lewis Mumford, "The Art Galleries: Resurrection and the Younger Generation," *New Yorker (*13 May 1933).

51 See Barbara Buhler Lynes, *Georgia O'Keeffe: Catalogue Raisonné*, 2 vols, New Haven and London: Yale University Press; Washington, D.C.: National Gallery of Art and Georgia O'Keeffe Foundation, 1999, vol. 2, pp. 1118–33, for listing of exhibitions of O'Keeffe's work at An American Place in 1930–46 with photographs and checklists.

52 "Artist in Exile," 17 October 1931, article (author and source not included), enclosed in letter from AS to O'Keeffe, 24 October 1931, ASA/YCAL.

53 Evelyn Howard, *It Must be Said*, New York: An American Place, September 1933, n.p., ASA/YCAL.

54 Dorothy Norman, *Dualities*, New York: An American Place, 1933, n.p.

55 AS to Dorothy Norman quoted in Judith Mara Gutman, "Dorothy Norman, Love and Muse," *History of Photography* (Winter 1996), p. 338.

56 AS to O'Keeffe, 18 January 1933, ASA/YCAL.

57 AS to O'Keeffe, 20 January 1933, ASA/YCAL.

58 Rainer Maria Rilke, *Letters to a Young Poet*, 17 February 1903, trans. Cary Ross, published in *It Must be*

Said 2 (An American Place, February 1933), n.p., ASA/ YCAL.

59 Dorothy Norman, ed., *Twice A Year* 1 (Fall–Winter 1938), quoted in William Wasserstrom, ed., *Civil Liberties and the Arts, Selections from Twice a Year 1938–1948*, Syracuse University Press, 1964, p. 2.

60 Ibid., pp. xxv–xxvi.

61 AS in "From the Writings and Conversations of Alfred Stieglitz," *Twice a Year* 1 (Fall–Winter 1938), pp. 91, 92, 102.

62 AS, "Stieglitz Photography at An American Place, New York, New York" (exhibition checklist), 15 February–5 March 1932, ASA/YCAL.

63 Joel Smith, "How Stieglitz Came to Photograph Cityscapes," *History of Photography* 20, 4 (Winter 1996), p. 322.

64 Ibid., pp. 323–4.

65 Paul Strand to Rebecca Strand, 13 December 1966, quoted in Whelan, *Alfred Stieglitz*, p. 535.

66 AS, *It Should Be Remembered*, 1, exh. cat., New York: An American Place, 1933, n.p., ASA/YCAL.

67 Ibid.

68 AS, introductory statement, "Alfred Stieglitz: An Exhibition of Photographs" (exhibition checklist), 11 December 1934–17 January 1935, n.p., ASA/YCAL.

69 Lewis Mumford, "A Camera and Alfred Stieglitz," *New Yorker* (22 December 1934), quoted in Wojtowicz, *Mumford on Modern Art*, p. 143.

70 Ibid.

71 AS quoted in interview by Andrea Gray with Ansel Adams, September 1981, in Andrea Gray, *Ansel Adams: An American Place, 1936*, Tucson: Center for Creative Photography, University of Arizona, 1982, p. 13.

72 This and the next seven letters in ASA/YCAL.

73 Ansel Adams, introduction to exhibition of photographs, 27 October–25 November 1936, An American Place, New York, n.p., quoted in Gray, *Ansel Adams*, p. 38.

74 Ansel Adams to AS, 7 October 1933, ASA/YCAL.

75 Ansel Adams to Virginia Adams, 16 November 1936, quoted in Mary Street Alinder and Andrea Gray Stillman, eds., *Ansel Adams: Letters and Images 1916–1984*, Boston, New York, and London: Little, Brown, 1988, pp. 86–7.

76 Ansel Adams to AS, 29 November 1936, ASA/YCAL.

77 AS, "Catalogue of Eliot Porter: Exhibition of Photographs," 29 December 1938–18 January 1939, An American Place, New York, quoted in Whelan, *Alfred Stieglitz*, p. 558.

78 Dorothy Norman, "Introduction; Beginnings and Landmarks: 291, 1905–1917," 27 December 1937–11 February 1938, New York, An American Place, n.p., ASA/YCAL.

79 Georgia O'Keeffe to AS, in *Some Recent O'Keeffe Letters: Catalogue of the 14th Annual Exhibition of Paintings with Some Recent O'Keeffe Letters*, 27 December 1937–11 February 1938, New York, An American Place, pp. 8–11.

80 John Marin, "To My Paint Children," in *John Marin: Recent Paintings, Watercolors, and Oils*, exh. cat., New York: An American Place, 22 February–27 March, 1938, n.p.

81 Consuelo Kanaga to AS, n.d., ASA/YCAL.

82 Merrill Schleier, *The Skyscraper in American Art 1890–1931*, Ann Arbor, Mich.: UMI Research Press, 1986, p. 75.

83 Ibid., p. 71.

84 Elizabeth McCausland, "Photographs by Stieglitz Now at An American Place," *Springfield Union and Republican* (16 December 1934).

85 Peter Bunnell, "Three by Stieglitz," in *Alfred Stieglitz: Photographs from the Collection of Georgia O'Keeffe*, New York: Pace MacGill Gallery; Santa Fe, N.M.: Gerald Peters Gallery, 1993, pp. 53–4.

86 Smith, "How Stieglitz Came to Photograph Cityscapes," p. 328.

87 AS quoted in Norman, "Stieglitz: Introduction," p. 59.

88 Edward Alden Jewell, "Stieglitz in Retrospect," *New York Times* (16 December 1934).

89 Andy Grundberg, "Alfred Stieglitz and the Contradictions of Modernism," *Crisis of the Real: Writings on Photography 1974–1989*, New York: Aperture, 1990, p. 20.

90 Ibid.

91 AS to Dorothy Norman quoted in Dorothy Norman, *Encounters: A Memoir*, New York, Harcourt Brace Jovanovich, p. 107.

92 AS to Dorothy Norman, notation on verso of *Woods Hole*, *c*.1931–2, quoted in Miles Barth, ed., *Intimate Visions: The Photographs of Dorothy Norman*, San Francisco: Chronicle Books, 1993, p. 33.

93 Dorothy Norman quoted in ibid., p. 74.

94 Ibid., p. 156.

95 Frank (Buckie) Prosser, telephone interview with author, 12 July 2008.

96 Ibid.

97 Frank Prosser quoted in Marisa Muratori, "Georgia O'Keeffe: The Lake George Years," *Adirondack Life* (April 1989), p. 39.

98 Prosser, telephone interview with author, 12 July 2008.

99 Margaret Prosser to Anita Pollitzer, n.d., quoted in *Stieglitz: Photographs from the Collection of Georgia O'Keeffe*, p. 6.

100 Georgia O'Keeffe to Jean Toomer quoted in Muratori, "Georgia O'Keeffe," p. 76.

101 AS to O'Keeffe, 15 September 1937, ASA/YCAL.

102 Jerry L. Thompson, *Truth and Photography*, Chicago: Ivan R. Dee, 2003, p. 30.

103 AS to Herbert Seligmann, 6 September 1932, ASA/YCAL.

104 AS to Dorothy Norman quoted in Sarah Greenough, *Alfred Stieglitz: The Key Set*, 2 vols, New York: Harry N. Abrams; Washington, D.C.: National Gallery of Art, 2002, vol. 2, p. 924.

105 AS to O'Keeffe, 22 August 1938, ASA/YCAL.

106 The photographs owned by the Harvard University Art Museums are accompanied by an October 1975 notarized statement by Rhoda Hoff de Terra, attesting that the images were made when she visited Lake George around 1939. Rhoda Hoff had married Helmut de Terra, noted for his archaeological and geological discoveries, particularly in India in the 1930s. Stieglitz referred to his visiting Lake George on a couple of occasions and that he looked forward to seeing him. Given that the Beinecke Library unexpectedly withdrew the newly opened Stieglitz–O'Keeffe correspondence from public circulation for an indefinite period in January 2009, without much advance notice, it was not possible to check in the letters of 1938 or 1939 to ascertain if any visit of the de Terras was actually described.

107 AS to O'Keeffe, 9 August 1937, ASA/YCAL.

108 AS quoted in Norman, "Stieglitz: Introduction," p. 36.

109 This and the next twenty letters in ASA/YCAL.

110 Georgia O'Keeffe, from eight letters to AS, 29 July–30 September 1937, in *Georgia O'Keeffe: 13th Annual Exhibition of Paintings*, exh. cat., 27 December 1937–11 February 1938, New York: An American Place.

THE FORTIES

1 Alfred Stieglitz to James Thrall Soby; first published, addressed to "My Dear Y.," in *Twice a Year*, double number 8–9 (Spring–Summer, Fall–Winter 1942), pp. 175–6.

2 This and the next four letters in ASA/YCAL.

3 William Shirer, "Propaganda Front," *New York Tribune* (September 1945).

4 Henry Miller, in *Twice a Year* 8–9 (Spring–Summer 1942), p. 153.

5 Beauford Delaney quoted in Ruth Fine, Elizabeth Glassman, and Juan Hamilton, *The Book Room: Georgia O'Keeffe's Library in Abiquiu*, New York: Grolier Club, 1997, p. 48.

6 Ibid. p. 63.

7 AS to O'Keeffe, 11 May 1945, ASA/YCAL.

8 AS to O'Keeffe, quoted in Fine et al., *Book Room*, p. 55.

9 Ibid.

10 O'Keeffe to AS, 30 July 1945, ASA/YCAL.

11 Beaumont Newhall to AS, 17 September 1940, ASA/YCAL.

12 Sue Davidson Lowe, *Stieglitz: A Memoir/Biography*, New York: Farrar Straus and Giroux, 1983, p. 363.

13 David Hunter McAlpin, "The New Department of Photography," *Bulletin of the Museum of Modern Art* (December–January 1940–41), p. 2.

14 Nancy Newhall, *From Adams to Stieglitz*, New York: Aperture, 1999, p. 108.

15 AS to James Johnson Sweeney, quoted in Anita Pollitzer, *A Woman on Paper: Georgia O'Keeffe*, New York, Simon and Schuster, 1988, p. 247.

16 Daniel Catton Rich quoted in Fine et al., *Book Room*, p. 53.

17 AS to Ansel Adams, 28 January 1944, ASA/YCAL.

18 Henry Clifford and Carl Zigrosser, *History of an American: Alfred Stieglitz, "291," and After*, Philadelphia Museum of Art, 1944, p. 3.

19 Carl Zigrosser, "Alfred Stieglitz," *Twice a Year* 8–9 (Spring–Summer, Fall–Winter 1942), pp. 144–5.

20 Edward Steichen, "The Fighting Photo-Secession," *Vogue* (15 June 1941), p. 23.

21 AS to Edward Steichen, 15 June 1941, Edward Steichen Papers, Museum of Modern Art, New York.

22 Robert W. Marks, "Stieglitz: Patriarch of Photography," *Popular Photography* 6 (April 1940), p. 79.

23 Nelson Morris, "Alfred Stieglitz: A Color Portrait and Notes on Photography's Grand Old Man," *Popular Photography* 14–15 (March 1944), p. 53.

24 Aline B. Louchheim, "An American Place to Close Its Doors," *New York Times* (26 November 1950).

25 Doris Bry, *Alfred Stieglitz and An American Place, 1924–1946*, New York: Zabriskie Gallery, 1978, p. 1.

26 AS to Ansel Adams, 8 August 1943, quoted in Richard Whelan, *Alfred Stieglitz: A Biography*, New York: Da Capo Press, 1997, p. 568.

27 Minor White, *Mirrors, Messages, Manifestations*, Millerton, N.Y.: Aperture, 1969, p. 186.

28 Minor White, "Extended Perception Through Photography and Suggestion," in Herbert Otto and John Mann, eds., *Ways of Growth*, New York: Grossman, 1968, p. 35.

29 Robert Hirsch, *Seizing the Light: History of Photography*, Boston: McGraw Hill, 2000, p. 351.

30 Whelan, *Alfred Stieglitz*, p. 571.

31 John Morris, email to the author, 12 February 2009.

32 Whelan, *Alfred Stieglitz*, p. 573.

33 AS quoted in Dorothy Norman, *Alfred Stieglitz: An American Seer*, Millerton, N.Y.: Aperture, 1973, p. 229.

34 Alfred Stieglitz obituary, *New York World Telegram* (13 July 1946).

35 "Alfred Stieglitz Dies Here at 82," *New York Times* (14 July 1946).

36 Paul Strand, "Alfred Stieglitz 1864–1946," *New Masses* 60 (6 August 1946), p. 7.

37 James Thrall Soby, "Alfred Stieglitz," *Saturday Review* 29 (28 September 1946), pp. 22–3.

38 Paul Rosenfeld, "Alfred Stieglitz (1 January 1864–13 July 1946)," *Twice a Year* 14–15 (1946–7), pp. 263–5.

39 Fendall Yerxa, "Photography: Exhibit will Honor Stieglitz," *New York Herald Tribune* (9 June 1947).

40 Emily Genauer, "Monument to Stieglitz Legend," *New York World Telegram* (14 July 1947).

41 Thomas B. Hess, "Dealer in Prophecies: The Modern Museum's Stieglitz Memorial," *Art News* 5 (July 1947), pp. 22–3.

42 Bruce Downes, "Let's Talk Photography," *Popular Photography* 21 (July 1947), p. 9.

43 Paul Strand, "Stieglitz: An Appraisal," *Popular Photography* 21 (July 1947), p. 98.

44 Ibid.

45 Milton W. Brown, "Alfred Stieglitz: Artist and Influence," *Photo-Notes* (August–September 1947), p. 7.

46 Ibid., p. 1,

47 Ibid., p. 8.

48 Herbert Seligmann, *Alfred Stieglitz Talking: Notes on Some of His Conversations, 1925–1931*, New Haven: Yale University Library, 1966, p. 119.

49 Georgia O'Keeffe, "Stieglitz: His Pictures Collected Him," *New York Times Magazine* (11 December 1949).

50 Ansel Adams to Nancy Newhall, 7 January 1946, quoted in Whelan, *Alfred Stieglitz*, p. 574.

51 Doris Bry, "The Stieglitz Archive at Yale University," *Yale University Library Gazette* 25, 4 (April 1951), p. 236.

52 Ibid., p. 127,

53 Louchheim, "American Place."

54 Georgia O'Keeffe, *Georgia O'Keeffe: A Portrait by Alfred Stieglitz*, New York: Metropolitan Museum of Art and Viking, 1978, n.p.

55 This and the next eighteen letters in ASA/YCAL.

56 Charles Demuth, introduction to catalogue (apparently unprinted) for Georgia O'Keeffe exhibition, 1931, quoted in Emily Farnham, *Charles Demuth: Behind a Laughing Mask*, Norman: University of Oklahoma Press, 1989, p. 163.

57 Rainer Maria Rilke, "Moving Forward," *Selected Poems of Rainer Maria Rilke*, New York: Harper & Row, 1981, p. 101.

epilogue

1 A. D. Coleman, "Return of the Suppressed: Pictorialism's Revenge," *Photo Researcher* 12 (2009), p. 16.

2 Ibid., p. 22.

3 AS to J. Dudley Johnston, 15 October 1923, quoted in Sarah Greenough and Juan Hamilton, eds., *Alfred Stieglitz: Photographs and Writings*, New York: Callaway Editions; Washington, D.C.: National Gallery of Art, 1983, p. 217; original letter in RPSA.

4 As quoted in Mark Holborn, *Beyond a Portrait: Dorothy Norman, Alfred Stieglitz*, New York: Aperture Books, 1984, intro.

5 Nancy Newhall, *From Adams to Stieglitz: Pioneers of Modern Photography*, New York: Aperture, 1999, p. 161.

ILLUSTRATIONS

(Frontispiece) Lotte Jacobi, *Alfred Stieglitz*, c.1939. Currier Museum of Art, Manchester, New Hampshire. Gift of Bernadette Hunter, 1986. 11.1.8.

1 Alfred Stieglitz, *From My Window at the Shelton North*, 1931, gelatin silver print. The J. Paul Getty Museum, 87.XM.62. © 2010 Georgia O'Keeffe Museum/Artists Rights Society (ARS), New York.

2 Alfred Stieglitz, *Winter, Fifth Avenue*, 1893, photogravure. Lee Gallery, Winchester, Massachusetts.

3 Charlier Institute Certificate, 1874. Private collection.

4 K. Hoffman, *Lake George*, 2008.

5 K. Hoffman, *Lake George – Lac du Saint Sacrament*, 2008.

6 *Mental Photographs: An Album for Confessions of Tastes, Habits and Convictions*, Robert Saxton, ed. New York: Holt and Williams, 1872. Private collection. Alfred Stieglitz entry, 31 December 1876.

7 Alfred Stieglitz, *Sun Rays, Paula*, 1889, lantern slide. Yale Collection of American Literature, Beinecke Rare Book and Manuscript Library, New Haven, Conn.

8 Alfred Stieglitz, *The Terminal*, 1893, photogravure. Lee Gallery, Winchester, Massachusetts.

9 Alfred Stieglitz; prints from *Photographic Journal of a Baby*, 1900. Yale Collection of American Literature, Beinecke Rare Book and Manuscript Library, New Haven, Conn.

10 Alfred Stieglitz, *Kitty in Profile*, 1912, print. Yale Collection of American Literature, Beinecke Rare Book and Manuscript Library, New Haven, Conn.

11 Alfred Stieglitz, *The Street – Design for a Poster*, 1900–01, photogravure. Lee Gallery, Winchester, Massachusetts.

12 Alfred Stieglitz, *The Flatiron*, 1903, gelatin silver print. The Art Institute of Chicago, Alfred Stieglitz Collection, 1949.707. Photograph by Greg Harris. Reproduction: The Art Institute of Chicago.

13 Alfred Stieglitz, *The Flatiron*, 1903, photogravure. Lee Gallery, Winchester, Massachusetts.

14 Marius de Zayas, *Camera Work*, no. 30, April 1910. Yale Collection of American Literature, Beinecke Rare Book and Manuscript Library, New Haven, Conn.

15 Alfred Stieglitz, *The City of Ambition*, 1910, photogravure. Lee Gallery, Winchester, Massachusetts.

16 Wassily Kandinsky, *The Garden of Love (Improvisation Number 27)*, 1912, oil on canvas. The Metropolitan Museum of Art, New York, Alfred Stieglitz Collection, 1949 (49.70.1). © 2010 Artists Rights Society (ARS), New York/ADAGP, Paris. Image copyright © The Metropolitan Museum of Art/Art Resource, NY.

17 Alfred Stieglitz, *Georgia O'Keeffe*, 1918. Musée d'Orsay, Paris. © 2010 Georgia O'Keeffe Museum/Artists Rights Society (ARS), New York. Photo: Réunion des Musées Nationaux/Art Resource, NY.

18 Francis Picabia, *Portrait of Alfred Stieglitz*, *291*, nos. 5–6, July–August 1915. Yale Collection of American Literature, Beinecke Rare Book and Manuscript Library, New Haven, Conn.

19 *291*, nos. 7–8, September–October 1915, p. 1. Yale Collection of American Literature, Beinecke Rare Book and Manuscript Library, New Haven, Conn.

20 Alfred Stieglitz, *Marcel Duchamp*, 1923. Yale Collection of American Literature, Beinecke Rare Book and Manuscript Library, New Haven, Conn.

21 Alfred Stieglitz, *Marcel Duchamp*, 1923. Yale Collection of American Literature, Beinecke Rare Book and Manuscript Library, New Haven, Conn.

22 Alfred Stieglitz, *The Steerage*, 1907, photogravure. Lee Gallery, Winchester, Massachusetts.

23 Alfred Stieglitz, *Waldo Frank*, 1920, palladium print. The Metropolitan Museum of Art, New York, Alfred Stieglitz Collection, 1928 (28.128.2). Copy photograph © The Metropolitan Museum of Art.

24 Alfred Stieglitz, *Paul Rosenfeld with Books*, 1929, platinum print. Yale Collection of American Literature, Beinecke Rare Book and Manuscript Library, New Haven, Conn.

25 Alfred Stieglitz, installation view of the Kühn, Henneberg, Watzek exhibition, March 1936. Yale Collection of American Literature, Beinecke Rare Book and Manuscript Library, New Haven, Conn.

26 Alfred Stieglitz, *Primitive Negro Sculpture* exhibition, installation view at 291, November 1914. Library of Congress, Washington, D.C.

27 Alfred Stieglitz. *Picasso/Braque* exhibition, installation view at 291, January 1915. Yale Collection of American Literature, Beinecke Rare Book and Manuscript Library, New Haven, Conn.

28 Paul Strand, *New York – Wall Street*, in *Camera Work*, no. 48, October 1916. Lee Gallery, Winchester, Massachusetts.

29 Paul Strand, *New York*, in *Camera Work*, no. 48, October 1916. Lee Gallery, Winchester, Massachusetts.

30 Paul Strand, *New York*, in *Camera Work*, no. 48, October 1916. Lee Gallery, Winchester, Massachusetts.

31 Paul Strand, *New York (Blind Woman)*, in *Camera Work*, nos. 49–50. June 1917. Lee Gallery, Winchester, Massachusetts.

32 Paul Strand, *New York*, in *Camera Work*, nos. 49–50, June 1917. Lee Gallery, Winchester, Massachusetts.

33 Paul Strand, *Photograph (Abstraction, Bowls)*, 1916, in *Camera Work*, nos. 49–50, June 1917. Lee Gallery, Winchester, Massachusetts.

34 Paul Strand, *Photograph (Abstraction, Porch Shadows)*, 1916, in *Camera Work*, nos. 49–50, June 1917. Lee Gallery, Winchester, Massachusetts.

35 Charles Sheeler, *Doylestown House – The Stove*, 1917, gelatin silver print. The Metropolitan Museum of Art, New York, Alfred Stieglitz Collection, 1933 (3.43.259). Image copyright © The Metropolitan Museum of Art/ Art Resource, NY.

36 Charles Sheeler, *Doylestown House – Stairs from Below*, 1917, gelatin silver print. The Metropolitan Museum of Art, New York, Alfred Stieglitz Collection, 1933 (33.43.343). Image copyright © The Metropolitan Museum of Art/Art Resource, NY.

37 Alfred Stieglitz, *Old and New New York*, 1910 (print c.1913), photogravure. Philadelphia Museum of Art, from the collection of Dorothy Norman, 1968-68-3.

38 Alfred Stieglitz, photograph of Duchamp's *Fountain*, in *The Blind Man*, no. 2, May 1917. The Louise and Walter Arensburg Collection, Philadelphia Museum of Art. Beatrice Wood © copyright. Photo: The Philadelphia Museum of Art/Art Resource, NY.

39 Alfred Stieglitz, *Francis Picabia*, 1930s. Yale Collection of American Literature, Beinecke Rare Book and Manuscript Library, New Haven, Conn.

40 Francis Picabia, *Star Dancer with Her Dance School*, 1913, watercolor on paper, 55.6 × 76.2 cm. The Metropolitan Museum of Art, New York, Alfred Stieglitz Collection, 1949 (49.70.12). © 2010 Artists Rights Society (ARS). New York/ADAGP, Paris. Image: © The Metropolitan Museum of Art/Art Resource, NY.

41 Alfred Stieglitz, *Shadows on the Lake*, 1916, gelatin silver print. The Metropolitan Museum of Art, Alfred Stieglitz Collection, 1949 (4.55.21). Copy photograph © The Metropolitan Museum of Art.

42 Alfred Stieglitz, *The Aeroplane*, 1910, photogravure. Lee Gallery, Winchester, Massachusetts.

43 Alfred Stieglitz, *The Last Days of 291*, 1917, gelatin silver print. Philadelphia Museum of Art. From the Collection of Dorothy Norman, 1967.

44 Marsden Hartley, *Portrait of a German Officer*, 1914, oil on canvas. The Metropolitan Museum of Art. Alfred Stieglitz Collection, 1949 (49.70.42). Image copyright © The Metropolitan Museum of Art/Art Resource, NY.

45 Marsden Hartley, *Last of New England – The Beginning of New Mexico*, 1918, oil on cardboard. The Art Institute of Chicago, Alfred Stieglitz Collection, 1949. 546. Photograph by Robert Lifson. Reproduction: The Art Institute of Chicago.

46 Alfred Stieglitz, *Marsden Hartley*, 1915–16, gelatin silver print. The Metropolitan Museum of Art, Gilman Collection, Purchase, Gift of Marsden Hartley, by exchange, and Gift of Grace M. Mayer, by exchange, 2005 (2005.100.290). Copy photograph © The Metropolitan Museum of Art.

47 Alfred Stieglitz, *Alfred Maurer*, 1915, gelatin silver print. The J. Paul Getty Museum. © Estate of Georgia O'Keeffe.

48 Alfred Stieglitz, *Konrad Cramer*, 1914. The J. Paul Getty Museum © Estate of Georgia O'Keeffe.

49 Alfred Stieglitz, *Arthur Dove*, 1915. The Art Institute of Chicago, Alfred Stieglitz Collection, 1949.7.7. Photograph by Greg Harris. Reproduction: The Art Institute of Chicago.

50 Alfred Stieglitz, *Charles Demuth*, c.1915. Yale Collection of American Literature, Beinecke Rare Book and Manuscript Library, New Haven, Conn.

51 Alfred Stieglitz, *Leo Stein*, 1917, platinum print. The J. Paul Getty Museum, Los Angeles.

52 Alfred Stieglitz, *Emil Zoler*, 1917, palladium print. Yale Collection of American Literature, Beinecke Rare Book and Manuscript Library, New Haven, Conn.

53 Alfred Stieglitz, *Hodge Kirnon*, 1917, palladium print. The Metropolitan Museum of Art, Alfred Stieglitz Collection, 1949 (49.55.38). Copy photograph © The Metropolitan Museum of Art.

54 Alfred Stieglitz, *Katharine Rhoades in a Hammock*, c.1916. Yale Collection of American Literature, Beinecke Rare Book and Manuscript Library, New Haven, Conn.

55 *Alfred Stieglitz Photographing at 4 July 1915 Party*. Photographer unknown. Yale Collection of American Literature, Beinecke Rare Book and Manuscript Library, New Haven, Conn.

56 *Alfred Stieglitz and Marion Beckett (?), 4 July 1915 Party*. Photographer unknown. Yale Collection of American Literature, Beinecke Rare Book and Manuscript Library, New Haven, Conn.

57 Alfred Stieglitz, *From the Window of 291*, 1915, platinum print. The Art Institute of Chicago, Alfred Stieglitz Collection, 1949.709.

58 Alfred Stieglitz, *From the Back Window of 291, Snow-Covered Tree, Back Yard*, April 1915, platinum print. The J. Paul Getty Museum © Estate of Georgia O'Keeffe, © Georgia O'Keeffe Museum/Artists Rights Society (ARS), New York.

59 Alfred Stieglitz, *Ellen Koeniger*, 1916, gelatin silver print. The J. Paul Getty Museum, 93.XM.25.6, © J. Paul Getty Trust.

60 Alfred Stieglitz, *Ellen Koeniger*, 1916. The J. Paul Getty Museum, © J. Paul Getty Trust.

61 Alfred Stieglitz, *Georgia O'Keeffe Sitting on the Lawn at Oaklawn*, 1918. Adirondack Museum, Blue Mountain Lake, New York.

62 Alfred Stieglitz, *Georgia O'Keeffe*, 1918. Yale Collection of American Literature, Beinecke Rare Book and Manuscript Library, New Haven, Conn.

63 Alfred Stieglitz, *Georgia O'Keeffe*, 1918, palladium print. The Metropolitan Museum of Art; Gift of Georgia O'Keeffe through the generosity of The Georgia O'Keeffe Foundation and Jennifer and Joseph Duke, 1997 (1997.61.49). Copy photograph © The Metropolitan Museum of Art.

64 Alfred Stieglitz, *Georgia O'Keeffe*, 1918, gelatin silver print. The Metropolitan Museum of Art. Gift of Georgia O'Keeffe through the generosity of The Georgia O'Keeffe Foundation and Jennifer and Joseph Duke, 1997 (1997.61.31). Copy photograph © The Metropolitan Museum of Art.

65 Alfred Stieglitz, *Georgia O'Keeffe*, 1918, palladium print. The Art Institute of Chicago, Alfred Stieglitz Collection, 1949.752. Photograph by Greg Harris, Reproduction: The Art Institute of Chicago.

66 Alfred Stieglitz, *Georgia O'Keeffe – [Feet]*, 1918, palladium print. The Art Institute of Chicago, Alfred Stieglitz Collection, 1949.746. Photograph by Greg Harris. Reproduction: The Art Institute of Chicago.

67 Alfred Stieglitz, *Georgia O'Keeffe – A Portrait – Hands*, 1918, gelatin silver print. The J. Paul Getty Museum, 91.XM.63.6. © J. Paul Getty Trust.

68 Alfred Stieglitz, *Georgia O'Keeffe*, 1918, platinum-palladium print. The Metropolitan Museum of Art. Gift of David A Schulte, 1928 (28.127.2). Copy photograph © The Metropolitan Museum of Art.

69 Alfred Stieglitz, *Georgia O'Keeffe: A Portrait*, 1919 (printed 1920s), gelatin silver print. The J. Paul Getty Museum, 93.XM.25.78. © J. Paul Getty Trust.

70 Alfred Stieglitz, *Georgia O'Keeffe*, 1919, palladium print. The Art Institute of Chicago, Alfred Stieglitz Collection, 1949.751. Photograph by Greg Harris. Reproduction: The Art Institute of Chicago.

71 Alfred Stieglitz, *Georgia O'Keeffe*, 1919, palladium print. The Metropolitan Museum of Art. Gift of Georgia O'Keeffe through the generosity of The Georgia O'Keeffe Foundation and Jennifer and Joseph Duke, 1997 (1997.61.60). Copy photograph © The Metropolitan Museum of Art.

72 Alfred Stieglitz, *Georgia O'Keeffe – A Portrait*, 1918, gelatin silver print. The J. Paul Getty Museum, 93.XM.25.32. © J. Paul Getty Trust.

73 Alfred Stieglitz, *Georgia O'Keeffe*, 1918. The Metropolitan Museum of Art, New York.

74 Alfred Stieglitz, *291 – Georgia O'Keeffe Exhibition*, 1917, Todd Webb print. Yale Collection of American Literature, Beinecke Rare Book and Manuscript Library, New Haven, Conn.

75 Alfred Stieglitz, *Interpretation*, 1919, palladium print. The Georgia O'Keeffe Museum, Santa Fe. © Georgia O'Keeffe Museum/Artists Rights Society (ARS), New York. Photo: Georgia O'Keeffe Museum, Santa Fe/Art Resource, NY.

76 Alfred Stieglitz, *Georgia O'Keeffe: A Portrait*, negative 1919, printed late 1920s or 1930s, gelatin silver print. The J. Paul Getty Museum, 93.XM.25.43. © J. Paul Getty Trust.

77 Alfred Stieglitz, *Georgia O'Keeffe*, 1919, palladium print. The Metropolitan Museum of Art, Gift of Georgia O'Keeffe through the generosity of The Georgia O'Keeffe Foundation and Jennifer and Joseph Duke, 1997. © Georgia O'Keeffe Museum/Artists Rights Society (ARS), New York. Image copyright © The Metropolitan Museum/Art Resource, NY.

78 Alfred Stieglitz, *Georgia O'Keeffe: A Portrait*, 1918, platinum-palladium print. The J. Paul Getty Museum, 93.XM.25.53. © J. Paul Getty Trust.

79 Alfred Stieglitz, *Georgia O'Keeffe: A Portrait*, 1918, palladium print. The J. Paul Getty Museum, 87.XM.94.1. © J. Paul Getty Trust.

80 Alfred Stieglitz, *Georgia O'Keeffe*, 1919, gelatin silver print. The Metropolitan Museum of Art. Gift of Mrs. Alma Wertheim, 1928 (28.130.2). Copy photograph © The Metropolitan Museum of Art.

81 Alfred Stieglitz, *Georgia O'Keeffe*, 1919, palladium print. The Metropolitan Museum of Art, Gift of Mrs. Alma Wertheim, 1928 (28.130.1). Copy photograph © The Metropolitan Museum of Art.

82 Alfred Stieglitz, *Dorothy True*, 1919. The J. Paul Getty Museum.

83 Alfred Stieglitz, letter to Georgia O'Keeffe, 6 August 1918. Yale Collection of American Literature, Beinecke Rare Book and Manuscript Library, New Haven, Conn.

84 Paul Strand, *Alfred Stieglitz*, 1929. Yale Collection of American Literature, Beinecke Rare Book and Manuscript Library, New Haven, Conn.

85 Alfred Stieglitz, *Paul Rosenfeld*, 1925. Yale Collection of American Literature, Beinecke Rare Book and Manuscript Library, New Haven, Conn.

86 Alfred Stieglitz, *Sherwood Anderson*, 1923, gelatin silver print. Alfred Stieglitz Collection, 1949.725. Photograph by Greg Harris. Reproduction: The Art Institute of Chicago.

87 Alfred Stieglitz, *Sherwood Anderson*, 1923, palladium type print. The Art Institute of Chicago, Alfred Stieglitz Collection, 1949.726. Photograph by Greg Harris. Reproduction: The Art Institute of Chicago.

88 Alfred Stieglitz, *Jean Toomer*, 1925, gelatin silver print. National Gallery of Art, Washington, D.C., Alfred Stieglitz Collection, 1949.3.644. Image courtesy National Gallery of Art.

89 Alfred Stieglitz, *Waldo Frank*, 1920, Yale Collection of American Literature, Beinecke Rare Book and Manuscript Library.

90 K. Hoffman, *Lake George House with Gable*, 2008, pictured in *Music: No. 1*.

91 Alfred Stieglitz, *Music. A Sequence of Ten Cloud Photographs, No. 1*. 1922. The J. Paul Getty Museum, © J. Paul Getty Trust.

92 Alfred Stieglitz, *Lake George – Music No. 2*, 1922 (NGA set, *Music. A Sequence of Ten Cloud Photographs, No. II*). Adirondack Museum, Blue Mountain Lake, New York.

93 Alfred Stieglitz, *Clouds – Music No. 6*, 1922, gelatin silver print. Philadelphia Museum of Art, from the Collection of Dorothy Norman, 1970-241-11. Photographed by Lynn Rosenthal.

94 Alfred Stieglitz, *Clouds – Music No. 7*, 1922, gelatin silver print. Philadelphia Museum of Art. From the Collection of Dorothy Norman, 1970-241-12.

95 Alfred Stieglitz, *Clouds – Music No. 8*, 1922, gelatin silver print. Philadelphia Museum of Art. From the Collection of Dorothy Norman, 1997-146-106. Photographed by Lynn Rosenthal.

96 *Alfred Stieglitz Presents Seven Americans*, Anderson Galleries. 9 March–28 March 1925. Yale Collection of American Literature, Beinecke Rare Book and Manuscript Library, New Haven, Conn.

97 Alfred Stieglitz, *Arnold Rönnebeck*, 1924, Yale Collection of American Literature, Beinecke Rare Book and Manuscript Library, New Haven, Conn.

98 Alfred Stieglitz, The Intimate Gallery Exhibition Announcement, 29 April–18 May 1929. Yale Collection of American Literature, Beinecke Rare Book and Manuscript Library, New Haven, Conn.

99 Alfred Stieglitz, *Charles Demuth*, 1923, gelatin silver print. The Metropolitan Museum of Art, Alfred Stieglitz Collection, 1928 (28.128.1). Copy photograph © The Metropolitan Museum of Art.

100 Charles Demuth, *I Saw the Figure 5 in Gold*, 1928, oil on cardboard. The Metropolitan Museum, Alfred Stieglitz Collection 1949 (49.59.1). Image copyright © The Metropolitan Museum of Art/Art Resource, NY.

101 Alfred Stieglitz, *John Marin*, 1922, gelatin silver print. The Art Institute of Chicago, Alfred Stieglitz Collection, 1949.721. Photograph by Greg Harris. Reproduction, The Art Institute of Chicago.

102 Alfred Stieglitz, *John Marin*, 1922, palladium print. The Metropolitan Museum of Art, Alfred Stieglitz Collection, 1949 (49.55.39). Copy photograph © The Metropolitan Museum of Art.

103 John Marin, *The Red Sun – Brooklyn Bridge*, 1922, watercolor and charcoal with gouache and scraping and wiping on ivory watercolor paper. The Art Institute of Chicago, Alfred Stieglitz Collection, 1949.561R. Reproduction: The Art Institute of Chicago.

104 John Marin, *Blue Sea*, 1923, watercolor with charcoal on off-white watercolor paper. The Art Institute of Chicago, Alfred Stieglitz Collection, 1949.563R. Reproduction: The Art Institute of Chicago.

105 Arthur Dove, © copyright, *Chinese Music*, 1923, oil on panel. The Philadelphia Museum of Art, The Alfred Stieglitz Collection, 1949. Photo: The Philadelphia Museum/Art Resource, NY.

106 Arthur Dove, *Silver Sun*, 1929, oil and metallic paint on canvas. The Art Institute of Chicago, Alfred Stieglitz Collection, 1949.531. Reproduction: The Art Institute of Chicago.

107 Georgia O'Keeffe, *Black Iris*, 1926, oil on canvas. The Metropolitan Museum of Art, New York, Alfred Stieglitz Collection, 1969 (69.278.1). © 2010 Georgia O'Keeffe Museum/Artist Right Society (ARS), New York. Photograph by Malcolm Varon. Image: © The Metropolitan Museum of Art/Art Resource, NY.

108 Georgia O'Keeffe, *Yellow Hickory Leaves with Daisy*, 1928, oil on canvas. The Art Institute of Chicago, Alfred Stieglitz Collection. Gift of Georgia O'Keeffe, 1965.1180. Photograph by Robert Hashimoto. Reproduction: The Art Institute of Chicago.

109 Georgia O'Keeffe, *Blue and Green Music*, 1921, oil on canvas. The Art Institute of Chicago, Alfred Stieglitz Collection. Gift of Georgia O'Keeffe, 1969.835. Photograph by Robert Hashimoto. Reproduction: The Art Institute of Chicago.

110 Georgia O'Keeffe, *Birch and Pine Tree, No. 1*, 1925, oil on canvas. Philadelphia Museum of Art. Bequest of Georgia O'Keeffe to The Alfred Stieglitz Collection, 1907. Photo: The Philadelphia Museum of Art/Art Resource, NY.

111 Alfred Stieglitz, *Georgia O'Keeffe and Donald Davidson Pruning Trees*, c.1920. Yale Collection of American Literature, Beinecke Rare Book and Manuscript Library, New Haven, Conn.

112 Alfred Stieglitz, *Georgia O'Keeffe – Hands*, 1920. Yale Collection of American Literature, Beinecke Rare Book and Manuscript Library, New Haven, Conn.

113 Alfred Stieglitz, *Georgia O'Keeffe*, 1921, gelatin silver print. The Art Institute of Chicago, Alfred Stieglitz

Collection (1949.760). Photograph by Greg Harris. Reproduction: The Art Institute of Chicago.

114 Alfred Stieglitz, *Georgia O'Keeffe*, 1923. Yale Collection of American Literature, Beinecke Rare Book and Manuscript Library, New Haven, Conn.

115 Alfred Stieglitz, *Georgia O'Keeffe: A Portrait*, 1921, gelatin silver print. Philadelphia Museum of Art, The Alfred Stieglitz Collection, purchased with the gift (by exchange) of Dr. and Mrs. Paul Todd Makler, the Lynne and Harold Honickman Fund for Photography, The Alice Newton Osborn Fund, and the Lola Downin Peck Fund, with funds contributed by Mr. and Mrs. John J. F. Sherrerd, Lynne and Harold Honickman, John J. Medveckis, and M. Todd Cooke, and gift of The Georgia O'Keeffe Foundation, 1997-38-44. © 2010 Georgia O'Keeffe Museum, Artists Rights Society (ARS), New York. Photographed by Lynn Rosenthal.

116 Alfred Stieglitz, *Georgia O'Keeffe*, 1927, gelatin silver print. The Museum of Modern Art, New York, Alfred Stieglitz Collection, Gift of Georgia O'Keeffe (113.1984). © 2010 Georgia O'Keeffe Museum/Artists Rights Society (ARS), New York. Digital image: © The Museum of Modern Art/Licensed by SCALA/Art Resource, NY.

117 Alfred Stieglitz, *Georgia O'Keeffe: A Portrait*, 1921, gelatin silver print. The J. Paul Getty Museum, 93. XM.25.44. © J. Paul Getty Trust.

118 Alfred Stieglitz, *Georgia O'Keeffe*, 1923. Musée d'Orsay, Paris. © 2010 Georgia O'Keeffe Museum/Artists Rights Society ARS), New York. Photo: Réunion des Musées Nationaux/Art Resource, NY.

119 Alfred Stieglitz, *Georgia O'Keeffe*, 1921, palladium print. The Metropolitan Museum of Art. New York, Gift of Georgia O'Keeffe, and the generosity of The Georgia O'Keeffe Foundation and Jennifer and Joseph Duke, 1997 (1997.61.65). Copy photograph © The Metropolitan Museum of Art.

120 Alfred Stieglitz, *Georgia O'Keeffe: A Portrait*, 1924, gelatin silver print. Philadelphia Museum of Art, The Alfred Stieglitz Collection, purchased with the gift (by exchange) of Dr. and Mrs. Paul Todd Makler, the Lynne and Harold Honickman Fund for Photography, the Alice Newton Osborn Fund, and the Lola Downin Peck Fund, with funds contributed by Mr. and Mrs. John J. F. Sherrerd, Lynne and Harold Honickman, John J. Medveckis, and M. Todd Cooke, and gift of The Georgia O'Keeffe Foundation, 1997-38-5. © 2010 Georgia O'Keeffe Museum/Artists Rights Society (ARS), New York.

121 Alfred Stieglitz, *Hedwig Stieglitz*, 1921, gelatin silver print. Alfred Stieglitz Collection, 1949.732. Photograph by Greg Harris. Reproduction: The Art Institute of Chicago.

122 Alfred Stieglitz, *Katherine Dudley*, 1922, palladium print. The Art Institute of Chicago, Alfred Stieglitz Collection, 1949.723. Photograph by Greg Harris. Reproduction: The Art Institute of Chicago.

123 Alfred Stieglitz, *Eva Hermann*, 1920, palladium print. The J. Paul Getty Museum, 86.XM.622.4. © 2010 Georgia O'Keeffe Museum/Artists Rights Society (ARS), New York.

124 Alfred Stieglitz, *Eva Hermann*, 1926, gelatin silver print. National Gallery of Art, Washington D.C., Alfred Stieglitz Collection, 1949.3.635. Image courtesy National Gallery of Art.

125 Alfred Stieglitz, *Frances O'Brien*, 1926, gelatin silver print. National Gallery of Art, Washington, D.C., Alfred Stieglitz Collection, 1949.3.636. Image courtesy National Gallery of Art.

126 Alfred Stieglitz, *Frances O'Brien*, 1926, gelatin silver print. National Gallery of Art, Washington, D.C., Alfred Stieglitz Collection, 1949.3.637. Image courtesy National Gallery of Art.

127 Alfred Stieglitz, *Rebecca Strand*, 1922. Lee Gallery, Winchester, Massachusetts.

128 Alfred Stieglitz, *Rebecca Salsbury Strand*, 1922, gelatin silver print. The Art Institute of Chicago, Alfred Stieglitz Collection, 1949.696. Photograph by Greg Harris. Reproduction: The Art Institute of Chicago.

129 Alfred Stieglitz, *Rebecca Salsbury Strand*, 1922, gelatin silver print. The Art Institute of Chicago, Alfred Stieglitz Collection, 1949.733. Photograph by Greg Harris. Reproduction: The Art Institute of Chicago.

130 Alfred Stieglitz, *Rebecca Salsbury Strand*, 1922, gelatin silver print. The Art Institute of Chicago, Alfred Stieglitz Collection, 1949.734. Photograph by Greg Harris. Reproduction: The Art Institute of Chicago.

131 Alfred Stieglitz, *Untitled* [Rebecca Strand[1922/23, gelatin silver print. The Art Institute of Chicago, Alfred Stieglitz Collection, 1949.694. Photograph by Greg Harris. Reproduction: The Art Institute of Chicago.

132 Alfred Stieglitz, *Rebecca Salsbury Strand*, 1922, palladium print. The Art Institute of Chicago, Alfred

Stieglitz Collection, 1949.718. Photograph by Greg Harris. Reproduction: The Art Institute of Chicago.

133 Alfred Stieglitz, *Untitled* [Rebecca Strand], 1922/23, gelatin silver print. The Art Institute of Chicago, Alfred Stieglitz Collection, 1949.695. Photograph by Greg Harris. Reproduction: The Art Institute of Chicago.

134 Alfred Stieglitz, *Claudia O'Keeffe*, 1922, gelatin silver print. National Gallery of Art, Washington, D.C., Alfred Stieglitz Collection, 1949.3.519. Image courtesy National Gallery of Art.

135 Alfred Stieglitz, *Georgia Engelhard*, 1920/22, gelatin silver print. National Gallery of Art, Washington, D.C., Alfred Stieglitz Collection, 1949.3.587. Image courtesy National Gallery of Art.

136 Alfred Stieglitz, *Portrait* [Georgia O'Keeffe], 1922, palladium print. The Art Institute of Chicago, Alfred Stieglitz Collection, 1949.715. Photograph by Greg Harris. Reproduction: The Art Institute of Chicago.

137 Alfred Stieglitz, *Georgia Engelhard*, 1920, gelatin silver print. The Museum of Modern Art, New York, Alfred Stieglitz Collection, Gift of Miss Georgia O'Keeffe (58.1950). © 2010 Georgia O'Keeffe Museum, Artists Rights Society (ARS), New York. Digital Image: © The Museum of Modern Art/Licensed by SCALA/Art Resource, NY.

138 Alfred Stieglitz, *Georgia and Ida O'Keeffe, Lake George*, c.1923. The J. Paul Getty Museum, 94.XM.25. © 2010 Georgia O'Keeffe Museum/Artists Rights Society (ARS), New York.

139 Alfred Stieglitz, *Georgia and Ida O'Keeffe, Lake George*, 1924. Yale Collection of American Literature, Beinecke Rare Book and Manuscript Library, New Haven, Conn.

140 Alfred Stieglitz, *Georgia and Ida O'Keeffe, Lake George*, c.1924. Yale Collection of American Literature, Beinecke Rare Book and Manuscript Library, New Haven, Conn.

141 Alfred Stieglitz, *Granddaughter of Marie Rapp with a Farmer Shucking Corn, Lake George*, 1923, chloride print. Private collection.

142 Alfred Stieglitz, *Lake George – The Barn with Tree*, 1923, gelatin silver print. Philadelphia Museum of Art. From the collection of Dorothy Norman, 1976-212-1.

143 Alfred Stieglitz, *Chicken House, Window with Snow, Lake George*, 1923, gelatin silver print. The Metropolitan Museum of Art, New York, Alfred Stieglitz Collection, 1949 (49.55.42). Copy photograph © The Metropolitan Museum of Art.

144 Alfred Stieglitz, *Chicken House – Lake George*, c.1920s, chloride print. Private collection.

145 Alfred Stieglitz, *Barns, Lake George*, 1923, gelatin silver print. The Metropolitan Museum of Art, New York, Gift of David A. Schulte, 1928 (28.127.5). Copy photograph © The Metropolitan Museum of Art.

146 Alfred Stieglitz, *Apples and Gable, Lake George*, 1922, gelatin silver print. The Metropolitan Museum of Art, New York, Ford Motor Company Collection. Gift of Ford Motor Company and John C. Waddell, 1987 (1987.1100.103). Copy photograph © The Metropolitan Museum of Art.

147 Alfred Stieglitz, *Later Lake George*, 1920s, gelatin silver print. The Art Institute of Chicago, Alfred Stieglitz Collection, 1949.770. Photograph by Greg Harris. Reproduction: The Art Institute of Chicago.

148 Alfred Stieglitz, *The Dying Chestnut Tree – My Teacher*, 1927, gelatin silver print. The Art Institute of Chicago, Alfred Stieglitz Collection, 1949.781. Reproduction: The Art Institute of Chicago.

149 Alfred Stieglitz, *Dancing Trees*, 1921/22, palladium print. The Metropolitan Museum of Art, New York, Gift of David A. Schulte, 1928 (28.127.7). Copy photograph © The Metropolitan Museum of Art.

150 Alfred Stieglitz, *The Old Maple, Lake George*, 1926, gelatin silver print. The Art Institute of Chicago, Alfred Stieglitz Collection, 1949.730. Photograph by Greg Harris. Reproduction: The Art Institute of Chicago.

151 K. Hoffman, *Lake George*, 2008.

152 K. Hoffman, *Lake George*, 2008.

153 K. Hoffman, *Lake George – Location of House on "The Hill"*, 2008.

154 Alfred Stieglitz, *The Little House – Front View*, 1925. Yale Collection of American Literature, Beinecke Rare Book and Manuscript Library, New Haven, Conn.

155 Alfred Stieglitz, *Rain Drops*, 1927, gelatin silver print. The Art Institute of Chicago, Alfred Stieglitz Collection,

1949.810. Photograph by Greg Harris. Reproduction: The Art Institute of Chicago.

156 Alfred Stieglitz, *Untitled – Lake George*, c.1921, gelatin silver print. The Art Institute of Chicago, Alfred Stieglitz Collection, 1949.765. Photograph by Greg Harris. Reproduction: The Art Institute of Chicago.

157 Alfred Stieglitz, *Rainbow, Lake George*, 1920, gelatin silver print. Philadelphia Museum of Art. From the collection of Dorothy Norman, 1997-146-112. Photographed by Lynn Rosenthal.

158 Alfred Stieglitz, *Lake George*, 1922/23, gelatin silver print. Philadelphia Museum of Art. From the collection of Dorothy Norman, 1997-146-104. Photographed by Andrea Nuñez.

159 Alfred Stieglitz, *Portrait of Georgia, No. 3 – Songs of the Sky*. J. Paul Getty Museum. © J. Paul Getty Trust.

160 Alfred Stieglitz, *Equivalent, A3 of Series A1*, 1926, gelatin silver print. The J. Paul Getty Museum, 84.XM.217.6. © 2010 Georgia O'Keeffe Museum/Artists Rights Society (ARS), New York.

161 Alfred Stieglitz, *Portrait – K.N.R., No. 1 – Songs of the Sky C*, 1923. Yale Collection of American Literature, Beinecke Rare Book and Manuscript Library, New Haven, Conn.

162 Alfred Stieglitz, *Portrait – K.N.R., No. 4 – Songs of the Sky C4*, 1923, gelatin silver print. National Gallery of Art, Washington, D.C., Alfred Stieglitz Collection, 1949.3.866. Image courtesy National Gallery of Art.

163 Alfred Stieglitz, *Spiritual America – Songs of the Sky A*, 1923, gelatin silver print. The J. Paul Getty Museum, 93.XM.25.12. © J. Paul Getty Trust.

164 Alfred Stieglitz, *Songs of the Sky, A7, 1923*, 1923. Lee Gallery, Winchester, Massachusetts.

165 Alfred Stieglitz, *Equivalents*, 1923, gelatin silver print. The Museum of Modern Art, New York, Alfred Stieglitz Collection, Gift of Miss Georgia O'Keeffe (28.1950). © 2010 Georgia O'Keeffe Museum/Artists Rights Society (ARS), New York. Digital Image: © Museum of Modern Art/Licensed by SCALA/Art Resource, NY.

166 Alfred Stieglitz, *Equivalent*, 1924, gelatin silver print. The Metropolitan Museum of Art, New York, Alfred Stieglitz Collection, 1928 (28.128.5). Copy photograph © The Metropolitan Museum of Art.

167 Alfred Stieglitz, *Equivalent*, 1924, gelatin silver print. The Metropolitan Museum of Art, New York, Alfred Stieglitz Collection, 1928 (28.128.4). Copy photograph © The Metropolitan Museum of Art.

168 Alfred Stieglitz, *Equivalent*, 1925, gelatin silver print. The Metropolitan Museum of Art, New York, Alfred Stieglitz Collection, 1928 (28.128.7). Copy photograph © The Metropolitan Museum of Art.

169 Alfred Stieglitz *Equivalent*, 1927, gelatin silver print. The Metropolitan Museum of Art, New York, Alfred Stieglitz Collection, 1928 (28.128.11). Copy photograph © The Metropolitan Museum of Art.

170 Alfred Stieglitz, *Equivalent*, 1927, gelatin silver print. The Art Institute of Chicago, Alfred Stieglitz Collection, 1949.808. Photograph by Greg Harris. Reproduction: The Art Institute of Chicago.

171 Alfred Stieglitz, *Equivalent*, 1929, gelatin silver print. The Art Institute of Chicago, Alfred Stieglitz Collection, 1949.816. Photograph by Greg Harris. Reproduction: The Art Institute of Chicago.

172 Alfred Stieglitz, *From the Shelton Looking North*, 1927, gelatin silver print. The J. Paul Getty Museum, 93.XM.25.78. © 2010 Georgia O'Keeffe Museum/Artists Rights Society (ARS), New York.

173 Alfred Stieglitz, *From Room 3003, The Shelton, New York, Looking North-East*, 1927, gelatin silver print. The Art Institute of Chicago, Alfred Stieglitz Collection, 1949.708. Photograph by Greg Harris. Reproduction: The Art Institute of Chicago.

174 K. Hoffman, *The Shelton Hotel* (currently a Marriott Hotel), 2008.

175 K. Hoffman, *Looking South From Near the Shelton Hotel*, 2008.

176 K. Hoffman, *Looking East From Near the Shelton Hotel*, 2008.

177 Alfred Stieglitz, *Apple Blossoms*, 1922, gelatin silver print. The J. Paul Getty Museum, 93.XM.25.30. © J. Paul Getty Trust.

178 Alfred Stieglitz, letter to Ida O'Keeffe, 1925. Yale Collection of American Literature, Beinecke Rare Book and Manuscript Library, New Haven, Conn.

179 Georgia O'Keeffe, letter to Alfred Stieglitz, 28 March 1926, p. 1. Yale Collection of American Literature, Beinecke Rare Book and Manuscript Library, New Haven, Conn.

180 Alfred Stieglitz, letter to Georgia O'Keeffe, 15 April 1927. Yale Collection of American Literature, Beinecke Rare Book and Manuscript Library, New Haven, Conn.

181 Alfred Stieglitz, letter to Georgia O'Keeffe, 10 July 1929. Yale Collection of American Literature, Beinecke Rare Book and Manuscript Library, New Haven, Conn.

182 Alfred Stieglitz, *Georgia O'Keeffe*, 1930, gelatin silver print. The Metropolitan Museum of Art, New York. Gift of Georgia O'Keeffe through the generosity of The Georgia O'Keeffe Foundation and Jennifer and Joseph Duke, 1997 (1997.61.43). Copy Photography © The Metropolitan Museum of Art.

183 Charles Demuth, *. . . And the Home of the Brave*, 1931, oil and graphite on fiber board. The Art Institute of Chicago, Gift of Georgia O'Keeffe, 1948.650. Reproduction: The Art Institute of Chicago.

184 Georgia O'Keeffe, *Cow's Skull; Red, White and Blue*, 1931, oil on canvas. The Metropolitan Museum of Art, New York, Alfred Stieglitz Collection. © 2010 Georgia O'Keeffe Museum/Artists Rights Society (ARS), New York. Image copyright © The Metropolitan Museum of Art/Art Resource, NY.

185 Arthur Dove, *Swing Music*, 1938, oil and wax emulsion on canvas. The Art Institute of Chicago, Alfred Stieglitz Collection, 1949.540. Photograph by Robert Hashimoto. Reproduction: The Art Institute of Chicago.

186 Checklist for *127 Photographs (1892–1932) by Alfred Stieglitz*, New York, An American Place, 15 February–5 March 1932. New York. Yale Collection of American Literature, Beinecke Rare Book and Manuscript Library, New Haven, Conn.

187 Checklist for *127 Photographs (1892–1932) by Alfred Stieglitz*, New York, An American Place, 15 February–5 March 1932. New York. Yale Collection of American Literature, Beinecke Rare Book and Manuscript Library, New Haven, Conn.

188 Checklist for Ansel Adams, *Exhibition of Photographs*, New York, An American Place, 27 October–25 November 1936. From Andrea Gray, *Ansel Adams, An American Place, 1936*. Center for Creative Photography, University of Arizona, 1982, p. 38.

189 Ansel Adams, *Latch and Chain*, 1927, printed c.1936, gelatin silver print. The Metropolitan Museum of Art, New York, Alfred Stieglitz Collection 1949 (49.55.176). Image copyright © The Metropolitan Museum of Art/Art Resource, NY; additional copyright supplied by the Center for Creative Photography, University of Arizona.

190 Ansel Adams, *Winter, Yosemite Valley*, 1933–4, gelatin silver print. The Metropolitan Museum of Art, New York, Alfred Stieglitz Collection, 1949 (49.55.177). Image copyright © The Metropolitan Museum of Art/Art Resource, NY; additional copyright supplied by the Center for Creative Photography, University of Arizona.

191 Ansel Adams, *Americana*, 1933, gelatin silver print. The Metropolitan Museum of Art, New York, Alfred Stieglitz Collection, 1949 (49.55.178). Image copyright © The Metropolitan Museum of Art/Art Resource, NY; additional copyright supplied by the Center for Creative Photography, University of Arizona.

192 Alfred Stieglitz, *Eliot Porter*, n.d., New York. Yale Collection of American Literature, Beinecke Rare Book and Manuscript Library, New Haven, Conn.

193 Eliot Porter, *Sick Herring Gull*, 1937, gelatin silver print. The Metropolitan Museum of Art, New York, Alfred Stieglitz Collection, 1949 (49.55.288). © Amon Carter Museum. Image copyright © The Metropolitan Museum of Art/Art Resource, NY.

194 Eliot Porter, *Jonathan*, 1938, gelatin silver print. The Metropolitan Museum of Art, New York, Alfred Stieglitz Collection, 1949 (49.55.287). © Amon Carter Museum. Image copyright © The Metropolitan Museum of Art/Art Resource, NY.

195 Eliot Porter, *Song Sparrow's Nest in Blueberry Bush*, 1938, gelatin silver print. The Metropolitan Museum of Art, New York, Alfred Stieglitz Collection, 1949 (49.55.180). © Amon Carter Museum. Image copyright © The Metropolitan Museum of Art/Art Resource, NY.

196 Eliot Porter, *Penobscot Bay from Eagle Island*, Lee Gallery, Winchester, Massachusetts. © Amon Carter Museum.

197 Alfred Stieglitz, *From An American Place*, c.1932, gelatin silver print. The Metropolitan Museum of Art, New York, Alfred Stieglitz Collection, 1949 (49.55.46). Copy photograph © The Metropolitan Museum of Art.

198 Alfred Stieglitz, *From An American Place Looking North*, 1931. The Metropolitan Museum of Art, New

York, Alfred Stieglitz Collection, 1949 (49.55.47). Copy photograph © The Metropolitan Museum of Art.

199 Alfred Stieglitz, *Looking North From An American Place, New York*, 1930, gelatin silver print. Philadelphia Museum of Art. From the collection of Dorothy Norman, 1978-135-4. Photographed by Andrea Nuñez.

200 Alfred Stieglitz, *From An American Place*, 1931, gelatin silver print. The Metropolitan Museum of Art, New York, Alfred Stieglitz Collection (49.55.48). Copy photograph © The Metropolitan Museum of Art.

201 Alfred Stieglitz, *New York*, 1931, gelatin silver print. Philadelphia Museum of Art. From the collection of Dorothy Norman, 1997-146-19. Photographed by Andrea Nuñez.

202 Alfred Stieglitz, *From the Shelton Hotel*, 1931, gelatin silver print. The Metropolitan Museum of Art, New York, Alfred Stieglitz Collection, 1949 (49.55.45). Copy photograph © The Metropolitan Museum of Art.

203 Alfred Stieglitz, *New York from the Shelton*, 1934, gelatin silver print. The Art Institute of Chicago, Alfred Stieglitz Collection, 1944.786. Photograph by Greg Harris. Reproduction: The Art Institute of Chicago.

204 Alfred Stieglitz, *New York, Spring*, 1931–5. Philadelphia Museum of Art. From the collection of Dorothy Norman, 1997.

205 Alfred Stieglitz, *From the Shelton*, 1933–5, gelatin silver print. The J. Paul Getty Museum, 93.XM.25.67. © J. Paul Getty Trust.

206 Alfred Stieglitz, *From the Shelton West*, 1935, gelatin silver print. The Museum of Modern Art, New York, Alfred Stieglitz Collection, Gift of Miss Georgia O'Keeffe (56.1950). © 2010 Georgia O'Keeffe Museum/ Artist Rights (ARS), New York. Digital image: © The Museum of Modern Art/Licensed by SCALA/Art Resource, NY.

207 Alfred Stieglitz, *Window, An American Place*, 1930s. New York. Yale Collection of American Literature, Beinecke Rare Book and Manuscript Library, New Haven, Conn.

208 K. Hoffman, *New York from Rockefeller Center, Looking South*, 2008.

209 K. Hoffman, *From Near An American Place Location*, 2008.

210 Alfred Stieglitz, *New York from 405 E. 54th St*, 1936–7, gelatin silver print. National Gallery of Art, Washington, D C., Alfred Stieglitz Collection, 1949.3.1263. Image courtesy of the Board of Trustees, National Gallery of Art.

211 Alfred Stieglitz, *New York from 405 E. 54th St*, 1937, gelatin silver print. National Gallery of Art, Washington D.C., Alfred Stieglitz Collection, 1949.3.1266. Image courtesy of the Board of Trustees, National Gallery of Art.

212 Alfred Stieglitz, *Equivalent*, 1930. Philadelphia Museum of Art, from the collection of Dorothy Norman, 1967.

213 Alfred Stieglitz, *Equivalent*, c.1930, gelatin silver print. The Metropolitan Museum of Art, New York, Alfred Stieglitz Collection, 1949 (49.55.28). Copy Photograph © The Metropolitan Museum of Art.

214 Alfred Stieglitz, *Equivalent*, 1930, gelatin silver print. The Metropolitan Museum of Art, New York, Alfred Stieglitz Collection, 1949 (49.55.27). Copy photograph © The Metropolitan Museum of Art.

215 Alfred Stieglitz, *Equivalent*, c.1929/30. Lee Gallery, Winchester, Massachusetts.

216 Alfred Stieglitz, *Equivalent*, c.1930. Lee Gallery, Winchester, Massachusetts.

217 Alfred Stieglitz, *Georgia O'Keeffe*, 1932, gelatin silver print. The Metropolitan Museum of Art, New York. Gift of Georgia O'Keeffe, through the generosity of The Georgia O'Keeffe Foundation and Jennifer and Joseph Duke, 1997 (1997.61.69). Copy photograph © The Metropolitan Museum of Art.

218 Alfred Stieglitz, *Georgia O'Keeffe Leaning on a Car*, 1935. Yale Collection of American Literature, Beinecke Rare Book and Manuscript Library, New Haven, Conn.

219 *Alfred Stieglitz and Georgia O'Keeffe at Lake George*, c.1932. Photographer unknown. Yale Collection of American Literature, Beinecke Rare Book and Manuscript Library.

220 Alfred Stieglitz, *Georgia O'Keeffe*, 1931, gelatin silver print. The Metropolitan Museum of Art, New York. Gift of Georgia O'Keeffe through the generosity of the Georgia O'Keeffe Foundation and Jennifer and Joseph Duke, 1997 (1997.61.67). Copy Photography © The Metropolitan Museum of Art.

221 Alfred Stieglitz, *Georgia O'Keeffe – A Portrait*, 1931, gelatin silver print. The J. Paul Getty Museum, 93. XM.25.58. © J. Paul Getty Trust.

222 Alfred Stieglitz, *Georgia O'Keeffe*, 1932, gelatin silver print. The Metropolitan Museum of Art, New York. Gift of Georgia O'Keeffe through the generosity of The Georgia O'Keeffe Foundation and Jennifer and Joseph Duke, 1997 (1997.61.35). Copy photograph © The Metropolitan Museum of Art.

223 Alfred Stieglitz, *Georgia O'Keeffe*, 1933, gelatin silver print. The Metropolitan Museum of Art, New York. Gift of Georgia O'Keeffe through the generosity of The Georgia O'Keeffe Foundation and Jennifer and Joseph Duke 1997 (1997.61.39). Copy photograph © The Metropolitan Museum of Art.

224 Alfred Stieglitz, *Georgia O'Keeffe: A Portrait*, 1932, gelatin silver print. The J. Paul Getty Museum, 93. XM.25.50. © J. Paul Getty Trust.

225 Alfred Stieglitz, *Georgia O'Keeffe: A Portrait*, 1933, gelatin silver print. The J. Paul Getty Museum, 93. XM.25.65. © J. Paul Getty Trust.

226 Alfred Stieglitz, *Georgia O'Keeffe*, 1936/37, gelatin silver print. National Gallery of Art, Washington, D.C., Alfred Stieglitz Collection, 1980.70.329. Image courtesy of the Board of Trustees, National Gallery of Art.

227 Alfred Stieglitz, *Georgia O'Keeffe*, 1936, gelatin silver print. National Gallery of Art, Washington D.C., Alfred Stieglitz Collection, 1980.70.313. Image courtesy of the Board of Trustees, National Gallery of Art.

228 Alfred Stieglitz, *Georgia O'Keeffe*, 1936, gelatin silver print. National Gallery of Art, Washington D.C., Alfred Stieglitz Collection, 1980.70.325. Image courtesy of the Board of Trustees, National Gallery of Art.

229 Alfred Stieglitz, *Georgia O'Keeffe: A Portrait*, 1936, gelatin silver print. The J. Paul Getty Museum, 93. XM.25.75. © J. Paul Getty Trust.

230 Alfred Stieglitz, *Georgia O'Keeffe: A Portrait*, 1933, gelatin silver print. The J. Paul Getty Museum, 93. XM.25.24. © J. Paul Getty Trust.

231 Alfred Stieglitz, *Georgia O'Keeffe*, 1935, gelatin silver print. The Metropolitan Museum of Art, New York. Gift of Georgia O'Keeffe through the generosity of The Georgia O'Keeffe Foundation and Jennifer and Joseph Duke 1997 (1997.61.38). Copy photograph © The Metropolitan Museum of Art.

232 Alfred Stieglitz, *Georgia O'Keeffe*, 1932, gelatin silver print. The Metropolitan Museum of Art, New York. Gift of Georgia O'Keeffe through the generosity of The Georgia O'Keeffe Foundation and Jennifer and Joseph Duke, 1997 (1997.61.71). Copy photograph © The Metropolitan Museum of Art.

233 Alfred Stieglitz, *Dorothy Norman (Hands)*, 1930, gelatin silver print. Philadelphia Museum of Art, from the collection of Dorothy Norman, 1997-146-18. Photographed by Lynn Rosenthal.

234 Alfred Stieglitz, *Dorothy Norman XIV – Woods Hole*, 1931, gelatin silver print. Philadelphia Museum of Art. From the collection of Dorothy Norman, 1997-146-14. Photographed by Lynn Rosenthal.

235 Alfred Stieglitz, *Dorothy Norman XLII*, 1931, gelatin silver print. Philadelphia Museum of Art. From the collection of Dorothy Norman, 1997-146-16. Photographed by Lynn Rosenthal.

236 Alfred Stieglitz, *Dorothy Norman XXVII*, 1932, gelatin silver print. Philadelphia Museum of Art. From the collection of Dorothy Norman, 1967-285-2.

237 Alfred Stieglitz, *Dorothy Norman LXXIV*, 1936, gelatin silver print. Philadelphia Museum of Art. From the collection of Dorothy Norman, 1967-285-8.

238 Alfred Stieglitz, *Dorothy Norman LXXVII*, 1937, gelatin silver print. Philadelphia Museum of Art. From the collection of Dorothy Norman, 1967-285-13.

239 Alfred Stieglitz, *Dorothy Norman LXXXVII*, 1930–31, gelatin silver print. Philadelphia Museum of Art. From the collection of Dorothy Norman, 1997-146-165. Photographed by Lynn Rosenthal.

240 Alfred Stieglitz, *Dorothy Norman LXXXII*, 1931, gelatin silver print. Philadelphia Museum of Art. From the collection of Dorothy Norma, 1997-146-159. Photographed by Lynn Rosenthal.

241 Alfred Stieglitz, *Dorothy Norman with Telephone XXXVIII*, 1933, gelatin siler print. Philadelphia Museum of Art. From the collection of Dorothy Norman, 1986, 1967-164-2.

242 Alfred Stieglitz, *Dorothy Norman*, [key set – NGA title *Dualities – Dorothy Norman*] 1932. The Art Institute of Chicago, Alfred Stieglitz Collection, 1949.739. Photograph by Greg Harris. Reproduction: The Art Institute of Chicago.

243 Alfred Stieglitz, *Dorothy Norman XXIV – Hands with Camera*, 1932, gelatin silver print. Philadelphia Museum of Art. From the collection of Dorothy Norman, 1979-183-3.

244 Alfred Stieglitz, *Dorothy Norman with Camera*, 1932, gelatin silver print. Philadelphia Museum of Art. From the collection of Dorothy Norman, 1968-68-34. Photographed by Andrea Simon.

245 Dorothy Norman, *Alfred Stieglitz, New York*, 1930s [probably 1931]. Collection Center for Creative Photography, University of Arizona © 2000 The University of Arizona Foundation.

246 Dorothy Norman, *Alfred Stieglitz, New York*, 1932. Collection Center for Creative Photography, University of Arizona © 2000 The University of Arizona Foundation.

247 Dorothy Norman, *Portrait, Alfred Stieglitz*, 1935. Collection Center for Creative Photography, University of Arizona © 2000 The University of Arizona Foundation.

248 Dorothy Norman, *Alfred Stieglitz*, 1930s, gelatin silver print. The J. Paul Getty Museum, 84.XM.895.5. © 1988 Center for Creative Photography, The University of Arizona Foundation.

249 Dorothy Norman, *Alfred Stieglitz Spotting Portrait of Dorothy Norman (with Marin paintings and Stieglitz Photograph in Background) An American Place, New York*, 1930s, gelatin silver print. The J. Paul Getty Museum, Bequest of Dorothy S. Norman, 97.XM.78.21.

250 Dorothy Norman, *Telephone in Front of Stieglitz Equivalent*, 1940. Collection Center for Creative Photography, University of Arizona © 2000 The University of Arizona Foundation.

251 Dorothy Norman, *Stieglitz's Hat and Coat in Stieglitz Vault, An American Place*, 1940s. Collection Center for Creative Photography, University of Arizona © 2000 The University of Arizona Foundation.

252 Dorothy Norman, *Alfred Stieglitz XXII, New York*, 1944. Collection Center for Creative Photography, University of Arizona © 2000 The University of Arizona Foundation.

253 Dorothy Norman, *Stieglitz and Steichen, An American Place*, 1946, gelatin silver print. The J. Paul Getty Museum, Bequest of Dorothy S. Norman, 97.XM.78.20.

254 Alfred Stieglitz, *Margaret Prosser, Lake George*, c.1935, chloride print. Courtesy of the Adirondack Museum, Blue Mountain Lake, New York (P61427).

255 Alfred Stieglitz, *Margaret Prosser, Lake George*. Inscribed "For Margaret/1937" chloride print. Courtesy of the Adirondack Museum, Blue Mountain Lake, New York (P61422).

256 Alfred Stieglitz, *Margaret Prosser*, inscribed "For Margaret/1936". Courtesy of the Adirondack Museum, Blue Mountain Lake, New York (P61426).

257 Alfred Stieglitz, *Georgia O'Keeffe and Margaret Prosser at Lake George*, c.1936, chloride print. Courtesy of the Adirondack Museum, Blue Mountain Lake, New York (P61423).

258 Alfred Stieglitz, *Margaret Prosser's Clasped Hands in Lap*, 1933, gelatin silver print. The Metropolitan Museum of Art, New York. Gift of Georgia O'Keeffe through the generosity of The Georgia O'Keeffe Foundation and Jennifer and Joseph Duke, 1997 (1997.61.74). Copy photograph © The Metropolitan Museum of Art.

259 Alfred Stieglitz, *Margaret Prosser Sorting Blueberries, Lake George*, c.1936, gelatin silver print. The Metropolitan Museum of Art, New York, Warner Communications Inc. Purchase Fund, 1976 (1976.569). Copy photograph © The Metropolitan Museum of Art.

260 Alfred Stieglitz, *Margaret Prosser, Kitchen, Lake George*, c.1936, chloride print. Private collection.

261 Alfred Stieglitz, *Margaret Prosser Seated Outside, Sewing*, 1930s. Private collection.

262 Alfred Stieglitz, *Frank Prosser*, 1920s. Private collection.

263 Alfred Stieglitz, *Frank Prosser and Friends at Lake George* [Peggy Davidson, unknown boy, Frank Prosser, Sue Davidson], c.1930, chloride print, inscribed "For Margaret/1936." Courtesy of the Adirondack Museum, Blue Mountain Lake, New York (P61432).

264 Alfred Stieglitz, *Georgia O'Keeffe and Frank Prosser at Lake George*, c.1933. Courtesy of Adirondack Museum, Blue Mountain Lake, New York (P61450).

265 Alfred Stieglitz, *Frank Prosser, Lake George*, c.1935. Courtesy of the Adirondack Museum, Blue Mountain Lake, New York (P61451).

266 Alfred Stieglitz, *Frank Prosser and Emil Zoler, Lake George*. Inscribed "For Margaret/1936." Courtesy of the Adirondack Museum, Blue Mountain Lake, New York (P61431).

267 Alfred Stieglitz, *Swami Nikhilanada*, 1937, gelatin silver print. National Gallery of Art, Washington D.C., Alfred Stieglitz Collection, 1949.3.763. Image courtesy of the Board of Trustees, National Gallery of Art.

268 Alfred Stieglitz, *Swami Nikhilanada*, 1937, gelatin silver print. National Gallery of Art, Washington D.C., Alfred Stieglitz Collection, 1949.3.764. Image courtesy of the Board of Trustees, National Gallery of Art.

269 Alfred Stieglitz, *Swami Nikhilanada*, 1937, gelatin silver print. National Gallery of Art, Washington D.C., Alfred Stieglitz Collection, 1949.3.760. Image courtesy of the Board of Trustees, National Gallery of Art.

270 Alfred Stieglitz, *Poplars. Lake George*, 1935, gelatin silver print. The Art Institute of Chicago, Alfred Stieglitz Collection, 1949.729. Photograph by Greg Harris. Reproduction: The Art Institute of Chicago.

271 Alfred Stieglitz, *Poplars, Lake George*, 1936. Lee Gallery, Winchester, Massachusetts.

272 Alfred Stieglitz, *Chestnut Tree, Lake George*, 1932–4, gelatin silver print. The J. Paul Getty Museum, 84. XM.217.7. © 2010 Georgia O'Keeffe Museum/Artists Rights Society (ARS), New York.

273 Alfred Stieglitz, *Later Lake George*, 1933, gelatin silver print. The Art Institute of Chicago, Alfred Stieglitz Collection, 1949.777. Photograph by Greg Harris. Reproduction: The Art Institute of Chicago.

274 Alfred Stieglitz, *Tree Set 3*, 1930, gelatin silver print. The Art Institute of Chicago, Alfred Stieglitz Collection, 1949.731. Photograph by Greg Harris. Reproduction: The Art Institute of Chicago.

275 Alfred Stieglitz, *The Barn, Lake George*, 1936, gelatin silver print. The Art Institute of Chicago, Alfred Stieglitz Collection, 1949.738. Reproduction: The Art Institute of Chicago.

276 Alfred Stieglitz, *Lake George, House on the Hill*, c.1930, chloride print. Courtesy of the Adirondack Museum, Blue Mountain Lake, New York (P61435).

277 Alfred Stieglitz, *House and Poplars, Lake George*, 1932, chloride print. Courtesy of the Adirondack Museum, Blue Mountain Lake, New York (P61446).

278 Alfred Stieglitz, *First Snow and the Little House*, c.1930, chloride print. Courtesy of the Adirondack Museum, Blue Mountain Lake, New York (P61436).

279 Alfred Stieglitz, *Back of the Little House*, c.1930. Courtesy of the Adirondack Museum, Blue Mountain Lake, New York (P61453).

280 Alfred Stieglitz, *Later Lake George*, 1934, gelatin silver print. The Art Institute of Chicago, Alfred Stieglitz Collection, 1949.763. Reproduction: The Art Institute of Chicago.

281 Alfred Stieglitz, *Lake George Porch*, 1934, gelatin silver print. The Art Institute of Chicago, Alfred Stieglitz Collection, 1949.764. Photograph by Greg Harris. Reproduction: Art Institute of Chicago.

282 Alfred Stieglitz, *Lake George From the Hill*, c.1931, chloride print. Courtesy of the Adirondack Museum, Blue Mountain Lake, New York (P61447).

283 Alfred Stieglitz, *Study at Lake George*. c.1930. Lee Gallery, Winchester, Massachusetts (W2154).

284 Alfred Stieglitz, *Untitled – Grasses, Lake George*, 1933, gelatin silver print. The Art Institute of Chicago, Alfred Stieglitz Collection, 1949.768. Photograph by Greg Harris. Reproduction: The Art Institute of Chicago.

285 Alfred Stieglitz, *Later Lake George*, 1933, gelatin silver print. The Art Institute of Chicago, Alfred Stieglitz Collection, 1949.780. Photograph by Greg Harris. Reproduction: The Art Institute of Chicago.

286 Alfred Stieglitz, *Untitled*, (daughter of Rhoda Hoff de Terra and nurse, Lake George, New York), (?)1939 (dated by Harvard Art Museum), Harvard Art Museum, Fogg Art Museum, Purchased through the generosity of Melvin R. Seiden, P1982.187. Photo: Imaging Department © President and Fellows of Harvard College.

287 Alfred Stieglitz, *Untitled*, (daughter of Rhoda Hoff de Terra, Lake George, New York), (?)1939 (dated by Harvard Art Museum). Harvard Art Museum, Fogg Art Museum, Purchased through the generosity of Melvin R. Seiden, P1982.188. Photo: Imaging Department © President and Fellows of Harvard College.

288 K. Hoffman, *Leopold Stieglitz's House, Lake George*, 2008.

289 K. Hoffman, *Back of Leopold Stieglitz's House, Lake George*, 2008.

290 Georgia O'Keeffe, letter to Alfred Stieglitz, 16 June 1931, p. 1. Yale Collection of American Literature, Beinecke Rare Book and Manuscript Library, New Haven, Conn.

291 Georgia O'Keeffe, letter to Alfred Stieglitz, 18 October 1935, p. 2. Yale Collection of American Literature, Beinecke Rare Book and Manuscript Library, New Haven, Conn.

292 Alfred Stieglitz, letter to Georgia O'Keeffe, 20 July 1936. Yale Collection of American Literature, Beinecke Rare Book and Manuscript Library, New Haven, Conn.

293 Lotte Jacobi, *Alfred Stieglitz at An American Place*, 1935. Currier Museum of Art, Manchester, New Hampshire. Museum Purchase: The Henry Melville Fuller Acquisition Fund, 2004.38.

294 Article, illustrated by Stieglitz's *New York – Night* (1931), announcing the new Department of Photography at the Museum of Modern Art, from the *Bulletin of the Museum of Modern Art*, vol. VIII, December/January 1940/41. The Museum of Modern Art Archives, New York. Digital Image: © Museum of Modern Art/ Licensed by SCALA/Art Resource, NY.

295 John Marin, *Pertaining to New York – Circus and Pink Ladies*, An American Place Exhibition Announcement, 21 March–12 April 1942.

296 K. Hoffman, *Lake George* (the site where Stieglitz's ashes were supposedly scattered), 2008.

297 K. Hoffman, *Lake George* (taken from the site where Stieglitz's ashes were scattered), 2008.

298 Alfred Stieglitz, letter to Georgia O'Keeffe, 5 August 1940, p. 2. Yale Collection of American Literature, Beinecke Rare Book and Manuscript Library, New Haven, Conn.

299 Georgia O'Keeffe, letter to Alfred Stieglitz, 26 June 1941, p. 1. Yale Collection of American Literature, Beinecke Rare Book and Manuscript Library, New Haven, Conn.

300 Alfred Stieglitz, letter to Georgia O'Keeffe, 28 June 1946, p. 5. Yale Collection of American Literature, Beinecke Rare Book and Manuscript Library, New Haven, Conn.

APPENDIX

EXHIBITIONS IN STIEGLITZ'S GALLERIES, 1905–1946

Listings for the exhibitions at the Little Galleries of the Photo-Secession and 291 are from Larry Hugh Taylor, "Alfred Stieglitz and the Search for American Equivalents," Ph.D. diss., University of Illinois at Champaign-Urbana, 1973, pp. 221–4, and Dorothy Norman, Alfred Stieglitz: An American Seer, Millerton, N.Y.: Aperture, 1973, pp. 232–5. Listings for the Anderson Galleries, Intimate Gallery, and An American Place are from Sarah Greenough, ed., *Modern Art and America: Alfred Stieglitz and His New York Galleries*, Washington, D.C.: National Gallery of Art, and New York, Boston, and London: Bulfinch Press, Little, Brown, 2001, pp. 547–53.

THE LITTLE GALLERIES OF THE PHOTO-SECESSION (LATER CALLED 291)

	1905
24 November –4 January 1906	Exhibition of members' work.
	1906
10–24 January	Exhibition of French photographers: Robert Demachy, E. F. Puyo, Constant Le Bègue.
26 January–4 February	Herbert French, photographs.
5–19 February	Gertrude Käsebier and Clarence White, photographs.
21 February–7 March	British exhibition: J. Craig Annan, Frederick H. Evans, David Octavius Hill.
9–24 March	Edward Steichen, photograph.
7–28 April	German and Austrian photographers: Heinrich Kühn, Hugo Henneberg, Theodor and Oscar Hofmeister, Hans Watzek.
10 November–30 December	Exhibition of members' work.

1907

5–24 January	Drawings by Pamela Colman Smith.
25 January–12 February	Photographs by Adolph de Meyer and George Henry Seeley.
19 February–5 March	Photographs by Alice Boughton, William B. Dyer, C. Yarnall Abbot.
11 March–10 April	Photographs by Alvin Langdon Coburn.
18 November–30 December	Exhibition of members' work.

1908

2–21 January	Auguste Rodin, drawings.
7–25 February	George Henry Seeley, photographs.
26 February–11 March	Willi Geiger and Donald Shaw McLaughlan, etchings; Pamela Colman Smith, drawings.
12 March–25 April	Henri Matisse, drawings, lithographs, watercolors, and etchings.
8–30 December	Exhibition of members' work.

1909

4–16 January	Marius de Zayas, caricatures; J. Nilsen Laurvik, autochromes.
18 January–1 February	Alvin Langdon Coburn, photographs.
4–22 February	Baron Adolph de Meyer, photographs in color and monochrome.
26 February–15 March	Allen Lewis, etchings, drypoints, and bookplates.
17–27 March	Pamela Colman Smith, drawings.
30 March–17 April	Alfred Maurer, sketches in oil; John Marin, watercolors.
21 April–7 May	Edward Steichen, photographs of Auguste Rodin's Balzac.
18 May–2 June	Exhibition of Japanese prints from the F. W. Hunter Collection, New York.
24 November–17 December	Eugene Higgins, monotypes and drawings.
20 December–14 January 1910	Henri de Toulouse-Lautrec, lithographs.

1910

21 January–5 February	Edward Steichen, color photographs.
7–19 February	John Marin, watercolors, pastels, and etchings.
23 February–6 March	Henri Matisse, drawings and reproductions of paintings.
9–21 March	Younger American Painters: D. Putnam Brinley, Arthur Carles, Arthur Dove, Laurence Fellowes, Marsden Hartley, John Marin, Alfred Maurer, Edward Steichen, Max Weber.
21 March–18 April	Auguste Rodin, drawings and watercolors.
26 April–[n.d.] November	Marius de Zayas, caricatures.
18 November–8 December	Lithographs by Edward Manet, Paul Cézanne, Pierre August Renoir, and Henri de Toulouse-Lautrec; drawings by August Rodin; paintings and drawings by Henri Rousseau.

| 10 December–8 January 1911 | Gordon Craig, drawings and etchings. |

1911

11–31 January	Max Weber, drawings and paintings.
2 February–22 February	John Marin, watercolors.
1 March–25 March	Paul Cézanne, watercolors.
28 March–25 April	Pablo Picasso, exhibition "Complete Evolution Through Cubism": drawings and watercolors.
[n.d.] November–8 December	Gelett Burgess, watercolors.
18 December–15 January 1912	Baron Adolph de Meyer, photographs.

1912

18 January–3 February	Paintings by Arthur Carles.
7–26 February	Paintings and drawings by Marsden Hartley.
27 February–12 March	Pastels by Arthur Dove.
14 March–6 April	Sculpture and drawings by Henri Matisse.
11 April–10 May	First exhibition of children's work (watercolors and pastels by children aged two to eleven).
Exact dates unknown	Sculptures by Manuel Manolo.
20 November–12 December	Caricatures by Alfred J. Frueh.
15 December–14 January 1913	Drawings and paintings by Abraham Walkowitz.

1913

20 January–15 February	Watercolors by John Marin.
24 February–15 March	Photography by Alfred Stieglitz.
17 March–5 April	Exhibition of New York studies by Francis Picabia.
8 April–20 May	Exhibition by Marius de Zayas.
19 November–3 January 1914	Drawings, pastels, and watercolors by Abraham Walkowitz.

1914

12 January–14 February	Paintings by Marsden Hartley.
18 February–11 March	Second exhibition of children's work (drawings by boys aged eight to fourteen).
12 March–4 April	Sculpture by Constantine Brancusi.
6 April–6 May	Paintings and drawings by Frank Burty Haviland.
9 November–8 December	African sculpture.
9 December–11 January 1915	Drawings and paintings by Pablo Picasso and Georges Braque; archaic Mexican pottery and carvings; kalograms by Torres Palomar.

1915

| 12–26 January | Paintings by Francis Picabia. |
| 27 January–22 February | Paintings by Marion H. Beckett and Katharine Rhoades. |

23 February–26 March	Oils and watercolors by John Marin.
27 March–17 April	Third exhibition of children's work.
10 November–7 December	Drawings and paintings by Oscar Bluemner.
8 December–17 January 1916	Sculpture and drawings by Elie Nadelman.

1916

18 January–12 February	John Marin watercolors.
14 February–12 March	Drawings and watercolors by Abraham Walkowitz.
13 March–3 April	Photographs by Paul Strand.
4 April–22 May	Paintings by Marsden Hartley.
23 May–5 July	Drawings by Georgia O'Keeffe; watercolors by C. Duncan; oils by René Lafferty.
22 November–20 December	Watercolors and drawings by Georgia S. Engelhard, a ten-year-old child.
27 December–17 January 1917	Watercolors by Abraham Walkowitz.

1917

22 January–7 February	Recent work by Marsden Hartley.
14 February–3 March	Watercolors by John Marin.
6–17 March	Paintings, drawings, and pastels by Gino Severini.
20–31 March	Paintings and sculpture by Stanton Macdonald-Wright.
3 April–14 May	Watercolors, drawings, and oils by Georgia O'Keeffe.

ANdERSON GALLERiES

1921

7–(?) February	Photography by Alfred Stieglitz: 145 prints from 1886 to 1921.
10–17 May	Five Pictures by James Rosenberg and 117 Pictures by Marsden Hartley

1922

18–23 February	Works by Living American Artists of the Modern Schools: exhibition and auction of 177 paintings, drawings, and prints by more than 50 artists including Demuth, Dove, Hartley, Marin, O'Keeffe, and Sheeler.

1923

29 January–10 February	Alfred Stieglitz Presents One-Hundred Pictures, Oils, Water-colors, Pastels, Drawings by Georgia O'Keeffe, American (as of 3 February, 137 works were on the exhibition price list; two days later, 136 works were listed).
2–[?] April	The Second Exhibition of Photography by Alfred Stieglitz: 116 prints.

3–16 March	The Third Exhibition of Photography by Alfred Stieglitz: Songs of the Sky–Secrets of the Sky as revealed by My Camera and Other Prints.
3–16 March	Alfred Stieglitz Presents Fifty-One Recent Pictures, Oils, Water-colors, Pastels, Drawings by Georgia O'Keeffe, American.

1925

9–28 March	Alfred Stieglitz Presents Seven Americans: 159 Paintings, Photographs and Things, recent and never before publicly shown by Arthur G. Dove, Marsden Hartley, John Marin, Charles Demuth, Paul Strand, Georgia O'Keeffe, Alfred Stieglitz.

THE INTIMATE GALLERY

1925–1926

7 December 1925–11 January 1926	John Marin Exhibition: retrospective of watercolors by Marin, c.1912–24.
11 January–7 February	Arthur G. Dove, including paintings on glass and metal, and assemblages.
11 February–11 March (announcement, or 11 February–3 April (exhibition schedule)	Fifty Recent Paintings by Georgia O'Keeffe.
5 April–2 May	Charles Demuth: paintings, watercolors, and portrait posters.

1926–1927

9 November 1926–9 January 1927	John Marin.
11 January–27 February	Georgia O'Keeffe paintings, 1926: 47 oils. Oscar Bluemner wrote "A Painter's Comment" in the catalogue.
7 March–3 April (catalogue), or 9 March–14 April (exhibition schedule)	Gaston Lachaise sculptures: 20 works in alabaster, marble, bronze, and plaster, including a portrait of O'Keeffe.

1927–1928

9 November–11 December	John Marin: 40 new water-colors.
12 December 1927–11 January 1928 (catalogue), or 12 December 1927– 7 January 1928 (exhibition schedule)	Arthur G. Dove paintings, 1927: 19 paintings. Introductory statement by the artist
9 January–27 February	Georgia O'Keeffe exhibition. Lewis Mumford, "O'Keeffe and Matisse," reprinted from the New Republic in the catalogue.
28 February–27 March	Oscar Bluemner, new paintings: 22 watercolors and 6 oils.

| 27 March–17 April | Peggy Bacon exhibition: drawings and pastels. Catalogue foreword by Charles Demuth. |
| 19 April–11 May | Picabia exhibition: 11 paintings. Catalogue noted, "[t]his exhibition . . . takes place at the initiative of Marcel Duchamp." |

1928–1929

14 November–29 December 1928	John Marin exhibition: 47 watercolors from 3 series – Deer Isle, Maine (1927), and White Mountain Country (summer and fall 1927). Catalogue introduction by Marsden Hartley, biography by the artist, and essays by Julius Meier-Graefe, reprinted from Vanity Fair, November 1928), and Murdock Pemberton, reprinted from The New Yorker, 24 November 1928.
1–31 January 1929	Marsden Hartley exhibition: works are listed as "one hundred paintings in oil, watercolor, silver-point, and pencil: still-life, landscape–mountains–trees–etc. – by Marsden Hartley, painted in Paris and Aix-en-Provence – France – 1924–1927."
4 February–17 March	Georgia O'Keeffe, paintings, 1928: 35 paintings with a short introductory quotation from Demuth.
19 March–7 April	Paul Strand, new photographs: 32 photographs from 1925 to 1928. Catalogue introduction by Gaston Lachaise.
9–28 April	Arthur Dove exhibition: 23 paintings. Notes by the artist in the catalogue.
29 April–18 May	Charles Demuth: "Five Paintings" – watercolors and canvases, including "I Saw the Figure Five in Gold" (1927)

AN AMERICAN PLACE

1929–1930

15 December 1929–30 January 1930	John Marin: 50 new watercolors.
7 February–17 March	Georgia O'Keeffe: 27 new paintings.
22 March–22 April	Arthur G. Dove: 26 new paintings.

1930–1931

November	John Marin, recent watercolors, New Mexico and New York: 32 works.
15 December 1930–18 January 1931	Marsden Hartley, new paintings: landscapes – New Hampshire – still lifes – Paris and Aix-en-Provence.
18 January–27 February	Georgia O'Keeffe, recent paintings: 33 paintings, including the Jack-in-the-Pulpit series and the Ranchos Church, New Mexico, series.
9 March–4 April	Arthur G. Dove: 27 new paintings – Abstractions. Landscapes. Etc. – Etc. – Etc. Checklist noted 33 paintings and drawings.
14 April–11 May	Charles Demuth, only solo exhibition at An American Place.
May	Group exhibition of Dove, Demuth, Hartley, Marin, and O'Keeffe.

11 October–27 November	John Marin: 14 oil paintings – Maine: 30 water colors – New Mexico: 4 etchings – New York (all new).
27 December 1931–11 February 1932	Georgia O'Keeffe: 33 new paintings (New Mexico).
15 February–5 March	Alfred Stieglitz: 127 photographs (1892–1932). First showing of later New York subjects.
14 March–9 April	Arthur G. Dove exhibition, 1932: 19 paintings and 20 framed sketches.
10 April–May	Paul Strand: almost 100 photographs, including the 1929 driftwood series, New Mexican landscapes from 1930, and New Mexico and Colorado prints from 1931. Rebecca Salsbury Strand, paintings on glass.
16 May–14 June	Group exhibition of Dove, Marin, O'Keeffe, Demuth, and Hartley.

1932–1933

3–29 October 1932	Stanton Macdonald-Wright: 13 new paintings. Artist's statement on checklist.
7 November–17 December	John Marin: new oil paintings and watercolors and drawings.
7 January–22 February 1933 (extended until 15 March)	Georgia O'Keeffe, paintings–new and some old: 23 paintings from 1926 to 1932. Introductory catalogue paragraph, "A Woman in Flower," by Herbert J. Seligmann.
20 March–15 April	Arthur Dove and Helen Torr, paintings and watercolors.
May	Group exhibition of Dove, Marin, and O'Keeffe.

1933–1934

20 October–27 November (announcement)/ 9 November–10 December (announcement)/ 9 November–7 December (announcement)	*Twenty-Five Years of John Marin, 1908–1932*: 33 watercolors. Catalogue published a list of the most significant exhibitions at the gallery, noting that the Marin exhibition "occurs in the year of the twenty-ninth anniversary of the opening of '291' and as it constitutes a part of the Progression, we here list a number of the outstanding public demonstrations at that laboratory."
20 December 1932–1 February 1933	John Marin, new watercolors, new oils, new etchings: 15 watercolors and 12 oils.

29 January–17 March
(extended until 27 March [?]) Georgia O'Keeffe: 44 Selected Paintings (1915–27). (Reviews indicated that several paintings from 1931 were also shown.)

17 April–15 May (extended until 1 June [?]) Arthur G. Dove, new oils and watercolors, paintings from 1922 to 1926, and recent oils and watercolors.

1934–1935

3 November–1 December John Marin, new oil paintings and watercolors and drawings: 20 Maine watercolors from 1933, and 7 Maine and New York oils from 1934. Checklist included a quotation from Duncan Phillips.

11 December 1934–17 January 1935 Alfred Stieglitz, exhibition of photographs (1884–1934): 69 photographs of scenes from Europe made in the 1880s and 1890s, portraits of O'Keeffe and others, views of New York and Lake George, Equivalents, and Dead Tree series. Introductory catalogue statement by Stieglitz.

27 January–11 March
(extended until 27 March) Georgia O'Keeffe, exhibition of paintings (1919–34): 28 paintings, half of which were of New Mexico. Catalogue included quotes from Henry McBride, Ralph Flint, Thomas Craven, and Lewis Mumford, as well as a short "Painter's Comment" by Oscar Bluemner.

17 March–14 April George Grosz, exhibition: 38 watercolors from 1933 and 1934. Catalogue introduction by Marsden Hartley.

21 April–22 May Arthur G. Dove, exhibition of paintings (1934–5): 17 oils and 28 watercolors.

1935–1936

27 October–15 December 1935
(extended until 1 January 1936) John Marin, exhibition of watercolors, drawings, oils (1934–5): 12 watercolors (Maine series) and 6 oils. Catalogue included an "Extract from a Letter from Marin, Cape Split, Maine, August 18, 1935."

7 January–27 February Georgia O'Keeffe: Exhibition of Recent Paintings, 1935. Seventeen oils, including Sunflower, New Mexico I and II, and Ram's Head, White Hollyhock-Hills.

29 February–20 March Some Work by Robert C. Walker. Thirty-three works, including nineteen paintings, five wood prints, and nine drypoints.

22 March–14 April Marsden Hartley: First Exhibition in Four Years All Pictures Shown for the First Time Publicly. Thirty paintings, including six panels "intended for use as focus motives in a convalescent pavilion," "four modern ikons for a wooden sea-chapel in the bitter north," as well as seven paintings from the artist's New England series and seven Alpine vistas.

20 April–20 May	New Paintings by Arthur G. Dove. Nineteen oils and thirty-one watercolors.

1936–1937

27 October–25 November	Ansel Adams, exhibition of photographs: 45 photographs. William Einstein: paintings and drawings.
27 November–31 December	Charles Demuth, Arthur G. Dove, Marsden Hartley, John Marin, Georgia O'Keeffe, exhibition of paintings; and new paintings on glass by Rebecca S. Strand.
5 January–3 February	John Marin, new watercolors, oils, and drawings: 5 drawings, 16 watercolors (Marine series, 1935), and 7 oils.
5 February–17 March	Georgia O'Keeffe, new paintings: 21 paintings from 1934 to 1936. Annotated checklist indicates 7 other paintings.
23 March–16 April	Arthur G. Dove, new oils and watercolors: 32 watercolors and 20 oil-temperas. Catalogue introduction by William Einstein.
20 April–17 May	Marsden Hartley, exhibition of recent paintings, 1936: 21 works. Catalogue included a poem, "Signing family papers," by the artist, as well as an essay, "On the Subject of Nativeness – A Tribute to Maine."

1937–1938

27 October–27 December	*Beginnings and Landmarks: 291 – 1905–1917.*
27 December 1937–11 February 1938	Georgia O'Keeffe, 14th annual exhibition of paintings: 17 paintings and 2 pastels from Ghost Ranch, New Mexico, and 8 flower, shell, and rock paintings. Catalogue included letters by O'Keeffe to Stieglitz from Ghost Ranch, July–September 1937.
22 February–27 March	John Marin, recent paintings: watercolors and oils. Catalogue included a poem, "To my Paint Children," by the artist.
29 March–10 May	Arthur G. Dove, exhibition of recent paintings, 1938: 22 paintings and 16 watercolors. Catalogue essay by Duncan Phillips.

1938–1939

7 November–27 December	John Marin, exhibition of oils and watercolors. Catalogue essays by Duncan Phillips, Justice Benjamin Cardozo, Henry McBride, Forbes Watson, and Thomas Craven.
29 December 1938–18 January 1939	Eliot Porter, exhibition: 29 photographs of New England, Canada, and the Austrian Tyrol, dating from 1934 to 1938. (Porter's first show anywhere.)
29 December 1938–18 January 1939	Charles Demuth exhibition.
22 January–17 March	Georgia O'Keeffe, exhibition of oils and pastels: 22 paintings, all but one from 1938. Introductory essay by William Einstein and artist's statement "About Myself."

10 April–17 May	Arthur G. Dove, exhibition 21 oil and tempera paintings and nine watercolors, dating from 1924 to 1939.

1939–1940

15 October–21 November	Beyond all "Isms": 20 Selected Marins (1908–1938).
3 December 1939–17 January 1940	John Marin, new oils, new watercolors: 12 watercolors and 19 paintings.
1 February–17 March (announcement), or 3 February–17 March (catalogue)	Georgia O'Keeffe, exhibition of oils and pastels: 20 paintings from Hawaii and 1 from Long Island. Introductory catalogue statement by the artist.
30 March–14 May	Arthur G. Dove, exhibition of new oils and watercolors. 20 oils, 15 watercolors, and 1 composition on plaster. Short statement by the artist.

1940–1941

17 October–11 December	*Some Marins, Some O'Keeffes, Some Doves, "Some" Show*: 8 watercolors by Marin from 1922 to 1936; 9 paintings by O'Keeffe from 1927 to 1938, and 3 paintings by Dove from 1935 to 1940.
11 December 1939–21 January 1940	John Marin: 12 new watercolors – 1949: 9 new oils –1940: some new drawings – 1940.
27 January–11 March	Georgia O'Keeffe: 13 oil paintings from 1940, 1 pastel from 1941, and 2 oils from 1930 and 1937; most images from New Mexico.
27 March–17 May	Arthur G. Dove, new paintings: 16 oil paintings and 14 watercolors.

1941–1942

17 October–27 November	Arthur G. Dove: 3 oils from 1938 to 1941; John Marin: 4 watercolors and 1 oil, from 1926 to 1937; Georgia O'Keeffe: 5 oils, from 1927 to 1936; Pablo Picasso: 1 collage (1912–1913), 1 etching (1904), and 1 charcoal (1910); Stieglitz: 12 photographs, from 1894 to 1936.
9 December 1941–27 January 1942	John Marin, exhibition, vintage–1941: "Oils 1 to 9 inclusive, Water Colors 1 to 15 inclusive, done at Cape Split, Maine – with the exception of 3 oil figure pieces done at my home – Cliffside, New Jersey." Catalogue included a letter from Marin to Stieglitz of 10 August 1941, Addison, Maine.
2 February–17 March	*Georgia O'Keeffe: Recent Paintings from 1941* including 14 paintings from series "Near Abiquiu, New Mexico."
21 March–12 April	John Marin exhibition, *Pertaining to New York, Circus and Pink Ladies*: 37 works, including 7 paintings from the Nassau Street, N.Y., series (1936).
14 April–27 May	Arthur G. Dove: 20 recent paintings, from 1941 to 1942.

1942–1943

17 November 1942–11 January 1943	John Marin, oils and watercolors: 20 recent paintings, 1942.
11 February–17 March	Arthur G. Dove: 22 paintings, 1942–3.
27 March–22 May	Georgia O'Keeffe, paintings, 1942–3. (There are several checklists for this exhibition. Originally, 15 paintings were to be exhibited, but subsequent annotations indicate that 21 were shown.)

1943–1944

5 November–9 January	John Marin: paintings – 1943: 5 oils, 7 watercolors painted at Cape Split, Maine (1943), as well as 2 other paintings and 6 sea paintings. Catalogue included letter from Marin to Stieglitz, 29 September 1943, Cape Split, Maine.
11 January–11 March	Georgia O'Keeffe: 19 paintings – 1943. Artist's catalogue statement, "About Painting Desert Bones."
21 March–21 May	Arthur G. Dove: 20 recent paintings – 1944.

1944–1945

27 November 1944–10 January 1945	John Marin, paintings – 1944: 11 oils and 13 watercolors, primarily seascapes.
22 January–22 March	Georgia O'Keeffe: paintings – 1944. (Original checklist lists 13 paintings, including 4 from the pelvis series, but later annotations indicate that 16 were on view.)
3 May–15 June	Arthur G. Dove: 16 paintings – 1922–44.

1945–1946

30 November 1945–17 January 1946	John Marin: 9 oils and 21 watercolors from Maine, from 1945.
4 February–27 March	Georgia O'Keeffe: 10 oils from Abiquiu, New Mexico (1945), and 4 pastels from 1945. An annotated checklist indicates that 3 oils and 1 pastel were also exhibited.
April–May	John Marin: 160 drawings, primarily of New York subjects.
6 May–4 June	Arthur G. Dove: 11 paintings.

SELECTED BIBLIOGRAPHY

Archive Sources and Abbreviations

Ansel Adams Archive, Center for Creative Photography, University of Arizona, Tucson.

Archives of American Art, Smithsonian Institution, Washington, D.C.: AAA/SI

Century Collection, Manuscripts and Archives, New York Public Library: CC/NYPL.

J. Dudley Johnston Papers, Royal Photographic Society, Bath, England.

Mitchell Kennerley Papers, Manuscripts and Archives, New York Public Library.

Mabel Dodge Luhan Archive, Yale University Collection of American Literature, Beinecke Rare Book and
Manuscript Library, Yale University, New Haven, Connecticut.

Dorothy Norman Papers, Center for Creative Photography, University of Arizona, Tucson.

Philadelphia Museum and Library, Pennsylvania.

Royal Photographic Society Archives, Bath, England: RPSA

Alfred Stieglitz Archive, Yale University Collection of American Literature, Beinecke Rare Book and
Manuscript Library, Yale University, New Haven, Connecticut: ASA/YCAL

Edward Stieglitz Papers, Yale University Collection of American Literature, Beinecke Rare Book and
Manuscript Library, Yale University, New Haven, Connecticut: ESP/YCAL

Paul Strand Collection, Center for Creative Photography, University of Arizona, Tucson.

Historical Periodicals

291. Published by 291 gallery, 12 issues. March 1915–February 1916, ed. Marius de Zayas, Paul Haviland, and
Agnes Ernst Meyer.

391. 19 issues. January 1917–October 1924, ed. Francis Picabia.

The Blind Man. 2 issues. April–May 1917, ed. Marcel Duchamp.

Broom. 21 issues. November 1921–January 1924, ed. Harold Loeb and Alfred Kreymborg; subsequent editors
included Slater Brown, Malcolm Cowley, and Matthew Josephson.

Camera Notes. Published by The Camera Club of New York, 24 issues. 1897–1903, ed. Alfred Stieglitz (1897–
1902), Juan C. Abel (1903).

Camera Work. 50 issues and 2 supplements. January 1903–June 1917, ed. and published by Alfred Stieglitz.

The Dial. 86 vols. 1880–1929, ed. Scofield Thayer (1920–25).

The Little Review. 12 vols. March 1914–May 1929, ed. Margaret Anderson and Jane Heap.

MSS [Manuscripts]. 6 issues. February 1922–May 1923, ed. Paul Rosenfeld.

New York Dada. 1 issue. April 1921, ed. Marcel Duchamp.

The Seven Arts. 12 issues. November 1916–October 1917 (then merged with *The Dial*).

Twice A Year. 17 issues. 1938–48, ed. Dorothy Norman.

Abrahams, Edward. "Alfred Stieglitz and the Metropolitan Museum of Art." *Arts Magazine* 53 (June 1979), 86–8.

—. "Alfred Stieglitz and/or Thomas Hart Benton." *Arts Magazine* 55 (June 1981): 108–13.

—. *The Lyrical Left: Randolph Bourne, Alfred Stieglitz, and the Origins of Cultural Radicalism in America.* Charlottesville: University Press of Virginia, 1986.

"Alfred Stieglitz Prints." *Christian Science Monitor* (22 December 1934): 10.

"Alfred Stieglitz Dies Here at 82." *New York Times* (14 July 1946).

Alinder, Mary and Andrea Stillman, eds. *Ansel Adams: Letters and Images 1916–1984.* Boston, New York, and London: Little, Brown, 1988.

"An American Collection." *The Philadelphia Museum Bulletin* 40, 206 (May 1943).

Anderson, Sherwood. *Mid-American Chants.* New York: John Lane, 1918.

—. *Winesburg, Ohio.* New York: Huebsch, 1919.

—. "Alfred Stieglitz." *New Republic* (25 October 1922): 215.

—. *A Story Teller's Story.* Garden City, N.Y.: Garden City Publishing, 1924.

—. *The Letters of Sherwood Anderson*, ed. Howard Mumford Jones and Walter B. Rideout. Boston: Little, Brown, 1953.

Appel, Alfred, Jr. *Jazz Modernism.* New York: Alfred Knopf, 2002.

Arens, Egmont. "Alfred Stieglitz: His Cloud Pictures." *Playboy: A Portfolio of Arts and Satire* (July 1924): 15.

Arrowsmith, Alexandra and Thomas West, eds. *Two Lives, Georgia O'Keeffe and Alfred Stieglitz: A Conversation in Paintings and Photographs.* New York: Harper Collins, 1992.

Art in America 51, 1 (February 1963), special issue commemorating the 50th anniversary of the Armory Show.

Bachelard, Gaston. *The Poetics of Space.* Boston: Beacon Press, 1969.

Baigell, Matthew. *The American Scene: American Painting of the 1930's.* New York and Washington, D.C.: Praeger, 1974.

—. "American Landscape Painting and National Identity: The Stieglitz Circle and Emerson." *Art Criticism* 4, 1 (1987): 27–47.

Bailey, Craig R. "The Art of Marius de Zayas." *Arts Magazine* 53 (September 1978): 136–44.

Balken, Debra Bricker. "In Focus: Alfred Stieglitz." *Art Journal* (Summer 1996).

—. *Dove/O'Keeffe: Circles of Influence.* New Haven and London: Yale University Press with the Sterling and Francine Art Institute, 2009.

—. *Debating American Modernism: Stieglitz, Duchamp, and the New York Avant-Garde.* New York: American Federation of the Arts, 2003.

Barth, Miles, ed. *Intimate Visions: The Photographs of Dorothy Norman.* San Francisco: Chronicle Books, 1993.

Barthes, Roland. *Camera Lucida: Reflections on Photography*, trans. Richard Howard. New York: Hill and Wang, 1981.

Baur, John. *Revolution and Tradition in Modern American Art.* Cambridge, Mass.: Harvard University Press, 1951.

Beckers, Marion and Elisabeth Moortgat. *Lotte Jacobi.* Berlin: Das Verborgene Museum, 1998.

Benson, E. M. *John Marin: The Man and His Work.* Washington's American Federation of Arts, 1936.

—. "Alfred Stieglitz: The Man and the Book." *The American Magazine of Art* (January 1936): 36–42.

Benton, Thomas Hart. "America and/or Alfred Stieglitz." *Common Sense* 4 (January 1935): 22–4.

Bergson, Henri. "An Extract from Bergson." *Camera Work* 36 (October 1911): 20–21.

—. *Creative Evolution*, trans. Arthur Mitchell. New York: Modern Library, 1944.

Berman, Marshall. *All That is Solid Melts into Air: The Experience of Modernity.* New York: Penguin Books, 1982.

Beyond a Portrait: Photographs. Dorothy Norman, Alfred Stieglitz. Exh. cat. New York: Aperture, 1984.

Biderman, Martha. "Three Portrait Photographs of Dorothy Norman by Alfred Stieglitz." Typescript. Philadelphia Art Museum, 1960.

Blake, Rodney [Selma Stieglitz Schubert, pseudonym]. *Random Rhythms.* New York: Publishers Press, 1924.

Bloch, Suzanne. *Ernest Bloch, Creative Spirit.* New York: Jewish Music Council of the National Jewish Welfare Board, 1976.

Boas, George. *The Cult of Childhood.* Dallas, Tex.: Spring Publications, 1966.

Bochner, Jay. *An American Lens: Scenes from Alfred Stieglitz's New York Secession.* Cambridge, Mass. and London: MIT Press, 2005.

Bolloch, Joëlle. *The Hand,* Paris: Musée d'Orsay, 2007.

Bourne, Randolph. "The War and the Intellectuals." *The Seven Arts* 2 (June 1917): 133–46.

Bradbury, Ellen and Christopher Merrill, eds. *From the Faraway Nearby: Georgia O'Keeffe as Icon.* New York: Addison Wesley Publishers, 1992.

Bragdon, Claude. *Man the Square: A Higher Space Parable.* Rochester, N.Y., 1912.

Brandow, Todd and William Ewing, eds. *Edward Steichen.* Minneapolis Foundation for the Exhibition of Photography, 2007.

Brassaï. "A Letter from Alfred Stieglitz." *Camera* 48 (January 1969): 37.

Brennan, Marcia. "Alfred Stieglitz and New York Dada: Faith, Love, and the Broken Camera." *History of Photography* (Summer 1970): 156–61.

—. "Abstract Passion: Images of Embodiment and Abstraction in the Art and Criticism of the Alfred Stieglitz Circle." Ph.D. diss., Brown University, 1997.

—. "Alfred Stieglitz and Paul Rosenfeld: An Aesthetics of Intimacy." *History of Photography* 23, 2 (Spring 1999): 73–81.

—. *Painting Gender, Constructing Theory: The Alfred Stieglitz Circle and Formalist Aesthetics.* Cambridge, Mass. and London: MIT Press, 2001.

Brock, Charles. *Charles Sheeler: Across Media.* Washington, D.C. and Berkeley: National Gallery of Art in association with University of California Press, 2006.

Brooks, Van Wyck. *America's Coming-of-Age.* New York: B. W. Huebsch, 1915.

—. "Young America." *The Seven Arts* 1 (December 1916): 144–51.

—. *Fenollosa and His Circle.* New York: Dutton, 1962.

—. Alfred Kreymborg, Lewis Mumford, and Paul Rosenfeld, eds. *The American Caravan: A Yearbook of American Literature.* New York: Literary Guild of America, 1927.

Brown, Milton W. "Alfred Stieglitz: Artist and Influence." *Photo-Notes* (August–September 1947): 1 and 7–8.

—. *American Painting from the Armory Show to the Depression.* Princeton University Press, 1955.

Bruno, Guido. "The Passing of 291." *Pearson's Weekly* 13 (March 1918): 402–3.

Bry, Doris. "The Stieglitz Archive at Yale University." *Yale University Library Gazette* 25, 4 (April 1951): 233–6.

—. *An Exhibition of Photographs by Alfred Stieglitz.* Washington, D.C.: National Gallery of Art, 1958.

—. *Alfred Stieglitz: Photographer.* Boston: Museum of Fine Arts, 1965; reprint 1996.

—. *Alfred Stieglitz and An American Place, 1924–1946.* New York: Zabriskie Gallery, 1978.

Bunnell, Peter. "Alfred Stieglitz and Camera Work." *Camera* (December 1969): 8–27.

—. *Degrees of Guidance: Essays on Twentieth-Century and American Photography.* Cambridge University Press, 1993.

—, ed. *A Photographic Vision: Pictorial Photography, 1889–1923.* Salt Lake City: Peregrine Smith, 1980.

—. "Three by Stieglitz." *In Alfred Stieglitz: Photographs from the Collection of Georgia O'Keeffe.* New York: Pace Macgill Gallery; Santa Fe, N.M.: Gerald Peters Gallery, 1993.

Burgin, Victor, ed. *Thinking Photography.* London: Macmillan, 1982.

Caffin, Charles. "Forum Exhibition of Modern American Paintings." *New York American* (20 March 1916): 7.

—. [Review of Paul Strand exhibition at 291]. *Camera Work* 48 (October 1916): 57–8.

Camfield, William A. *Francis Picabia.* New York, 1970.

—. *Francis Picabia: His Art, Life, and Times.* Princeton University Press, 1979.

Campbell, Susan. *Women of the Stieglitz Circle.* Santa Fe, N.M.: Owings Gallery, 1998.

Carlson, Kathryn E. "The Photographer as Educator: A Study of the Work of Alfred Stieglitz and Jacob A. Riis." Ph.D. diss., University of Massachusetts, 1981.

Cheney, Sheldon. *A Primer of Modern Art.* New York: Liveright, 1924.

Clarke, Graham. "Alfred Stieglitz and Lake George: The American Place." *History of Photography* 15, 22 (1991): 78–83.

—. *Alfred Stieglitz.* New York and London: Phaidon Press, 2006.

Clifford, Henry and Carl Zigrosser. *History of an American: Alfred Stieglitz, "291," and After.* Philadelphia Museum of Art, 1944.

Coates, Robert M. "Alfred Stieglitz." *New Yorker* 23 (21 June 1947): 43–6.

Coke, Van Deren. "The Cubist Photography of Paul Strand and Morton Schamberg." In *One Hundred Years of Photographic History: Essays in Honor of Beaumont Newhall.* Albuquerque: University of New Mexico Press, 1975: 35–52.

Connor, Celeste. *Democratic Visions: Art and Theory of the Stieglitz Circle, 1924–1934.* Berkeley, Los Angeles, and London: University of California Press, 2001.

Coomaraswamy, Ananda. "A Gift from Mr. Alfred Stieglitz." *Museum of Fine Arts Bulletin* (Boston, April 1924).

Copeland, Roger and Marshall Cohen, eds. *What is Dance? Readings in Theory and Criticism.* New York: Oxford University Press, 1983.

Corn, Wanda M. *The Color of Mood: American Tonalism, 1880–1910.* San Francisco: M. H. De Young Memorial Museum, 1972.

—. "Apostles of the New American Art: Waldo Frank and Paul Rosenfeld." *Arts Magazine* 54–55 (February 1980): 159–63.

—. *In the American Grain: The Billboard Poetics of Charles Demuth.* Poughkeepsie: Vassar College, 1991.

—. *The Great American Thing: Modern Art and National Identity, 1915–1935.* Berkeley: University of California Press, 1999.

Cornell Daniell. *Alfred Stieglitz and the Equivalent: Reinventing the Nature of Photography.* New Haven: Yale University Art Gallery, 1999.

—. "Embodying Gender: Narrative and Spectacle in the Photography of Alfred Stieglitz, Imogen Cunningham, Minor White, and Robert Mapplethorpe." Ph.D. diss., City University of New York, 2002.

Cowart, Jack and Juan Hamilton with Sarah Greenough. *Georgia O'Keeffe: Art and Letters.* Washington, D.C.: National Gallery of Art, 1988.

Cramer, Konrad. "Stupendous Stieglitz." *Photographic Society of America Journal* (November 1947): [n.p.].

Crane, Hart. *The Bridge.* New York: Liveright, 1930.

—. *The Letters of Hart Crane, 1916–1932,* ed. Brom Weber. Berkeley and Los Angeles: University of California Press, 1965.

Craven, Thomas, "Art and the Camera." *The Nation* (16 April 1924): 456–7.

—. *Modern Art: The Men, the Movements, the Meaning.* New York: Simon and Schuster, 1935.

—. "Stieglitz, Old Master of the Camera." *Saturday Evening Post* 216 (8 January 1944).

Crawford, Nicole M. "A Journey From New York to New Mexico: The Impact of Alfred Stieglitz on the Development of American Modernism Through American Landscaping." M. A. thesis, University of Nebraska, 2005.

Cross, Jennifer, ed. *The Société Anonyme: Modernism for America*. New Haven and London: Yale University Press, 2006.

Crunden, Robert M. *Body and Soul: The Making of American Modernism*. New York: Basic Books, 2000.

Danly, Susan. "Miss O'Keeffe: Photography, and Fame." In *Georgia O'Keeffe and the Camera: The Art of Identity*. New Haven and London: Yale University Press and Portland Museum of Art, Maine, 2008.

Danzker, Jo-Anne B., Ulrich Pohlmann, and J. A. Eisenwerth. *Franz von Stuck und die Photographie*. New York and Munich: Prestel, 1996.

Davidson, Abraham A. *Early American Modernist Painting, 1910–1935*. New York: Harper & Row, 1981.

Davidson, M. "Beginning and Landmarks of a Pioneer Gallery: 291 and An American Place." *Art News* 36, 27 (1937): 13.

Demuth, Charles. "Confessions: Replies to a Questionnaire." *Little Review* 12 (May 1929): 30–31.

—. "Across a Greco is Written." *Creative Art* 5 (September 1929): 629–34.

Dijkstra, Bram. *The Hieroglyphics of a New Speech: Cubism, Stieglitz, and the Early Poetry of William Carlos Williams*. Princeton University Press, 1969.

—. *Georgia O'Keeffe and the Eros of Place*. Princeton University Press, 1998.

Dimock, George. *Priceless Children: American Photographs, 1890–1925*. Greensboro, N. C.: Weatherspoon Art Museum, 2001.

Dove, Arthur. "A Different One." *America and Alfred Stieglitz: A Collective Portrait*, ed. Waldo Frank et al. New York: Doubleday, Doran & Co., 1934.

Dow, Arthur Wesley. *Composition*. Boston: J. M. Bowles, 1899.

—. "Modernism in Art." *Magazine of Art* 8 (January 1917).

Dreier, Katherine S. *Western Art and the New Era: An Introduction to Modern Art*. New York: Brentano's, 1923.

Eisinger, Joel. *Trace and Transformation: American Criticism of Photography in the Modernist Era*. Albuquerque: University of New Mexico Press, 1995.

Eisler, Benita. *O'Keeffe and Stieglitz: An American Romance*. New York: Penguin, 1991.

Eldredge, Charles C. "The Arrival of European Modernism." *Art in America* 61 (July–August 1973): 35–41.

—. *Georgia O'Keeffe: American and Modern*. New Haven and London: Yale University Press, 1993.

Engelhard, Georgia. "Alfred Stieglitz: Master Photographer." *American Photography* 39 (April 1945): 8–12.

—. "The Face of Alfred Stieglitz." *Popular Photography* (19 September 1946): 52–5 and 120–26.

—. "Alfred Stieglitz: Father of Modern Photography." *The Camera* 69 (June 1947): 48–53 and 102–3.

—. "Grand Old Man." *American Photography* 44 (May 1950): 18–19.

Enyeart, James L. *Harmony of Reflected Light: The Photographs of Arthur Wesley Dow*. Santa Fe, N.M.: Museum of New Mexico Press, 2001.

Esterow, Milton. "Ansel Adams: The Last Interview." *Art News* (Summer 1984): 76–89.

Eversole, Ted. "Alfred Stieglitz's 'Camera Work' and the Early Cultivation of American Modernism." *Journal of American Studies of Turkey* 22 (2005): 5–18.

Fahlman, Betsy. "Arnold Ronnebeck and Alfred Stieglitz: Remembering the Hill." *History of Photography* 20, 4 (Winter 1996): 304–11.

Fairbrother, Trevor. *Ipswich Days: Arthur Wesley Dow and His Hometown*. New Haven and London: Yale University Press, 2007.

Family: Photography by Gertrude Käsebier. Winchester, Mass.: Lee Gallery, and San Francisco: Paul M. Hertzmann, 2007.

Fanning, Patricia J., ed. *New Perspectives on F. Holland Day*. North Easton and Norwood, Mass.: Massachusetts Foundation For Humanities, 1998.

Farnham, Emily. *Charles Demuth: Behind a Laughing Mask*. Norman: University of Oklahoma Press, 1989.

Field, Hamilton Easter. "At the Anderson Galleries." *Brooklyn Daily Eagle* (13 February 1921).

Fine, Ruth, Elizabeth Glassman, and Juan Hamilton. *The Book Room: Georgia O'Keeffe's Library in Abiquiu.* New York: Grolier Club, 1997.

Fisher, William Murrell. "Georgia O'Keeffe: Drawings and Paintings at 291." *Camera Work* 49–50 (June 1917): 5.

Flint, Ralph. "Alfred Stieglitz." *Art News* 30 (20 February 1932): 9.

—. "What is 291: Alfred Stieglitz and Modern Art in the United States." *Science Monitor Weekly Magazine* (17 November 1937).

—. "Prize Song." In *Stieglitz: A Memorial Portfolio, 1864–1946*, ed. Dorothy Norman. New York: Twice a Year Press, 1947.

The Forum Exhibition of Modern American Painters. New York: Anderson Galleries, 1916.

Frank, Waldo. "Vicarious Fiction." *The Seven Arts* 1 (January 1917): 294–303.

—. *Our America.* New York: Boni and Liveright, 1919.

—. "The Poetry of Hart Crane." *New Republic* 50 (16 March 1927): 116–17.

—. "Alfred Stieglitz: The World's Greatest Photographer." *McCall's Magazine* 54 (May 1927): 24 and 107–8.

—. *Memoirs of Waldo Frank*, ed. Alan Trachtenberg. Amherst: University of Massachusetts Press, 1973.

—, Lewis Mumford, Dorothy Norman, Paul Rosenfeld, and Harold Rugg, eds. *America and Alfred Stieglitz: A Collective Portrait.* New York: Doubleday, Doran & Co., 1934; reprint Aperture, 1979.

Franko, Mark. *Dancing Modernism/Performing Politics.* Bloomington and Indianapolis: Indiana University Press, 1995.

Fried, Michael. *Why Photography Matters as Art as Never Before.* New Haven and London: Yale University Press, 2008.

Fryd, Vivien Green. *Art and the Crisis of Marriage.* University of Chicago Press, 2003.

Fryer, Judith. "Women's Camera Work: Seven Propositions in Search of a Theory." *Prospects* 16 (1991): 57–117.

Fuller, John. "Seneca Stoddard and Alfred Stieglitz: The Lake George Connection." *History of Photography* 19, 2 (Summer 1995): 150–58.

Gates, William P. *Millionaires' Row on Lake George, NY.* New York: W. P. Publishing, 2008.

Gee, Helen. *Stieglitz and the Photo-Secession: Pictorialism to Modernism 1902–1917.* Trenton, N.J.: New Jersey State Museum, 1975.

Gerlernter, David. *1939: The Lost World of the Fair.* New York: Avon Books, 1995.

Giboire, Clive, ed. *Lovingly Georgia: The Complete Correspondence of Georgia O'Keeffe and Anita Pollitzer.* New York: Touchstone Books, 1990.

Glennon, Lorraine, ed. *Our Times.* Atlanta: Turner Publishing, 1995.

Goethe, Johann Wolfgang von. *Faust: Parts I and II.* Trans. George Madison Priest. New York: Alfred Knopf, 1969.

Grad, Bonnie L. "Georgia O'Keeffe's Lawrencean Vision." *Archives of American Art Journal* 38, 3–4 (1998): 2–19.

Gray, Andrea. *Ansel Adams: An American Place, 1936.* Tucson: Center for Creative Photography, University of Arizona, 1982.

Green, Jonathan, ed. *Camera Work: A Critical Anthology.* Millerton, N.Y.: Aperture, 1973.

Greenough, Sarah. "From the American Earth: Alfred Stieglitz's Photographs of Apples." *Art Journal* 41, 1 (Spring 1981): 46–54.

—. "Alfred Stieglitz's Photographs of Clouds." Ph.D. diss., University of New Mexico, 1984.

—. "How Stieglitz Came to Photograph Clouds." In *Perspectives on Photography: Essays in Honor of Beaumont Newhall*, ed. Peter Walch and Thomas Barrow: Albuquerque: University of New Mexico Press, 1986: 151–65.

—. *Paul Strand: An American Vision.* New York: Aperture Foundation, 1990.

—. *Alfred Stieglitz: The Key Set.* 2 vols. New York: Harry N. Abrams; Washington, D.C.: National Gallery of Art, 2002.

— and Juan Hamilton, eds. *Alfred Stieglitz: Photographs and Writings.* New York: Callaway; Washington, D.C.: National Gallery of Art, 1983.

—, et al., eds. *Modern Art and America: Alfred Stieglitz and His New York Galleries.* Washington, D.C.: National Gallery of Art; Boston, New York, and London: Bulfinch Press, Little, Brown, 2000.

Gregory, Horace, ed. *The Portable Sherwood Anderson.* New York: Viking, 1949.

Grundberg, Andy. "Stieglitz Felt the Pull of Two Cultures." *New York Times* (13 February 1983).

Guimond, James. *The Art of William Carlos Williams: A Discovery and Possession of America.* Urbana: University of Illinois Press, 1968.

—. *American Photography and the American Dream.* Chapel Hill and London: University of North Carolina Press, 1991.

Haas, Karen, and Rebecca Senf. *Ansel Adams.* Boston: Museum of Fine Arts Publications, 2005.

Hagen, Charles. "Dorothy Norman: On Her Own." *New York Times* (23 April 1993).

Haines, Robert E. "Image and Idea: The Literary Relationships of Alfred Stieglitz." Ph.D. diss., Stanford University, 1967.

—. "The Alfred Stieglitz Collection." *Metropolitan Museum Journal* 3 (1970): 371–92.

—. "Alfred Stieglitz and the New Order of Consciousness in American Literature." *Pacific Coast Philology* 6 (April 1971): 26–34.

—. *The Inner Eye of Alfred Stieglitz.* Washington, D.C.: University Press of America, 1982.

Hambourg, Maria M. *Paul Strand: Circa 1916.* New York: Metropolitan Museum of Art, 1998.

—, and Christopher Phillips, eds. *The New Vision: Photography Between the World Wars.* New York: Metropolitan Museum of Art and Harry N. Abrams, 1989.

Hammond, Anne. "Ansel Adams and Georgia O'Keeffe: On the Intangible in Art and Nature." *History of Photography* 32, 4 (Winter 2008): 301–13.

—, and Mike Weaver, eds. *History of Photography* 26, 4 (Winter 1996) issue dedicated to Stieglitz on 50th anniversary of his death.

Hapgood, Hutchins. *A Victorian in the Modern World.* New York: Harcourt Brace, 1939.

Harker, Margaret F. *The Linked Ring.* London: Heinemann, 1979.

Harris, Susan Baker. "Florine Stettheimer's Portrait of Alfred Stieglitz," M.A. thesis, Nashville, Tenn.: Vanderbilt University Press, 1995.

Hartley, Marsden. "Epitaph for Alfred Stieglitz." *Camera Work* 48 (October 1916): 70.

—. *Adventures in the Arts: Informal Chapters on Painters, Vaudeville, and Poets.* New York: Boni and Liveright, 1921.

—. "291 and the Brass Bowl." In *America and Alfred Stieglitz: A Collective Portrait,* ed. Waldo Frank et al. New York: Doubleday, Doran & Co., 1934.

Hatfield, Henry. *Goethe: A Critical Introduction.* New York: New Directions, 1963.

Haviland, Paul B. "Marius de Zayas: Material, Relative, and Absolute Caricatures." *Camera Work* 46 (April 1914): 33–4.

—. "Man, the Machine, and Their Product, the Photographic Print." *291,* 7–8 (September 1915): n.p.

Hayes, Jeffrey. "Oscar Bluemner's Late Landscapes: The Musical Color of Fateful Experience." *Art Journal* (Winter 1984): 352–60.

Haz, Nicholas. "Alfred Stieglitz, Photographer." *The American Annual of Photography* (1936): 7–17.

Heard, Gerald. *The Third Morality.* London and Toronto: Cassell & Co., 1937.

Heilbrun, Françoise. *Camera Work: Stieglitz, Steichen, and Their Contemporaries,* trans. Ruth Sharman. New York: Thames and Hudson, 1991.

—. *Alfred Stieglitz.* Paris, Musée d'Orsay, 2004.

Heller, Adele, and Lois Rudnick, eds. *1915, The Cultural Moment: The New Politics, the New Woman, the New Psychology, the New Art, and the New Theater in America.* New Brunswick, N.J.: Rutgers University Press, 1991.

Henderson, Linda Dalrymple. "Mabel Dodge, Gertrude Stein, and Max Weber: A Four-Dimensional Trio." *Arts Magazine* 57 (September 1982): 106–11.

—. *The Fourth Dimension and Non-Euclidean Geometry in Modern Art.* Princeton University Press, 1983.

Herbert, Robert L., ed. *The Société Anonyme and the Dreier Bequest at Yale University: A Catalogue Raisonné.* New Haven and London: Yale University Press, 1984.

Hirsch, Robert. *Seizing the Light: History of Photography.* Boston: McGraw Hill, 2000.

Hoffman, Katherine Ann. *An Enduring Spirit: The Art of Georgia O'Keeffe.* Metuchen, N.J. and London: Scarecrow Press, 1984.

—. "The Multicolored and Polyphonic Surf of Revolution." In *Mediterranean Perspectives: Philosophy, Literature, History and Art*, ed. James Caraway. New York: Dowling College Press, 1997: 183–93.

—. *Georgia O'Keeffe: A Celebration of Music and Dance.* New York: George Braziller, 1997.

—. *Stieglitz: A Beginning Light.* New Haven and London: Yale University Press, 2004.

Hoffman, Michael, ed. "Spirit of an American Place." *Bulletin of the Philadelphia Museum of Art 76* (Winter 1980): 331.

Holborn, Mark. *Beyond a Portrait: Dorothy Norman, Alfred Stieglitz.* New York: Aperture Books, 1984.

Homer, William Innes. "Stieglitz and 291." *Art in America* 61, 4 (July–August 1973): 50–57.

—. "Alfred Stieglitz and the American Aesthete." *Arts Magazine* 49 (September 1974): 25–8.

—. *Avant-Garde: Painting and Sculpture in America, 1910–25.* Wilmington: Delaware Art Museum, 1975.

—. "Stieglitz, 291, and Paul Strand's Early Photography." *Image* 19 (June 1976): 6–10.

—. *Alfred Stieglitz and the Photo-Secession.* Boston: New York Graphic Society, 1983.

Hopper, Inslee. "Vollard and Stieglitz." *The American Magazine of Art* (December 1933): 542–5.

Indyke, Dottie. "Women Artist Pioneers of New Mexico." *Collector's Guide to Santa Fe, Taos, and Albuquerque* 16 (2006): n.p.

Ivins, Jr., William. "Photographs by Alfred Stieglitz." *Metropolitan Museum of Art Bulletin* 24, 2 (February 1929): 44–5.

—. *Prints and Visual Communication.* New York: Da Capo Press, 1969.

Jackson, John B. *Discovering the Vernacular Landscape.* New Haven and London: Yale University Press, 1984.

Jewell, Edward Alden. "Stieglitz in Retrospect." *New York Times* (16 December 1934).

—. "Alfred Stieglitz." *New York Times* (14 July 1946).

—. "Exhibition Honors Alfred Stieglitz." *New York Times* (11 June 1947).

—. "Hail and Farewell." *New York Times* (15 June 1947).

Johnson, Eric. "Ernest Bloch, A Composer's Vision." *Camera* (February 1976): 6–37.

—. "Charles Sheeler, Romantic Pragmatist, at the National Gallery." *New York Times* (2 June 2006).

Jussim, Estelle. "Icons or Ideology: Stieglitz and Hine." In Jerome Liebling, ed., *Photography: Current Perspectives*. Rochester, N.Y.: Light Impressions, 1978: 52–64.

—. "Technology or Aesthetics: Alfred Stieglitz and Photogravure." *History of Photography* 3 (January 1979): 81–92.

—, and Elizabeth Lindquist-Cook. *Landscape as Photograph.* New Haven and London: Yale University Press, 1985.

Kalonyme, Louis. "Georgia O'Keeffe: A Woman in Painting." *Creative Art* 2 (January 1928): 35–6.

Kandinsky, Wassily. "Extracts from 'The Spiritual in Art.'" *Camera Work* 39 (July 1912): 34.

—. *Concerning the Spiritual in Art*, trans. M. T. H. Sadler. London: Constable & Co., 1914; reprint, New York: Dover Publications, 1977.

Kennedy, Randy. "A Big Sale Spurs Talk of a Photography Gold Rush." *New York Times* (17 February 2006).

Kent, Richard John. "Alfred Stieglitz and the Maturation of American Culture." Ph.D. diss., Johns Hopkins University, 1974.

Kettlewell, James. *Artists of Lake George, 1776–1976*. Glens Falls, N.Y.: Hyde Collection, 1976.

Kootz, Samuel. *Modern American Painters*. New York: Brewer and Warren, 1930.

Krauss, Rosalind. "Stieglitz/*Equivalents*." *October* 11 (Winter 1979): 129–40.

—. "Alfred Stieglitz's *Equivalents*." *Arts* 54 (February 1980): 134–7.

Larkin, Oliver W. "Alfred Stieglitz and '291.'" *Magazine of Art* 40, 5 (May 1947): 179–83.

Lawrence, D. H. *Studies in Classic American Literature*. New York: Doubleday and Co., [1923] 1953.

—. *Lady Chatterley's Lover*. New York: Bantam Books, 1968.

Lee, Rose. "Charting the Progress of Art in America." *New York Times* (20 April 1924).

Lemoine, Serge. *New York et l'art moderne: Alfred Stieglitz et son cercle, 1905–1930*. Paris: Editions de la Réunion des Musées Nationaux, 2004.

—, ed. *La Revue du Musée d'Orsay* 19 (Fall 2004), special issue on photography: Serge Lemoine, "Stieglitz: New York et l'art moderne"; idem, "Alfred Stieglitz et son cercle (1904–1930);" idem, "Autour du don de la Fondation O'Keeffe"; Joel Smith, "Stieglitz et New York"; Anne McCawley, "Alfred Stieglitz et le nu feminin" ;Peter Bunnell, "La Photographie pictorialiste."

Leonard, Neil. "Alfred Stieglitz and Realism," *The Art Quarterly* 29, 3–4 (1966): 277–86.

Levin, Gail. "Wassily Kandinsky and the American Avant-Garde, 1912–1950." Ph.D. diss., Rutgers University, 1976.

—. *Synchronism and American Color Abstraction: 1916–1925*. New York: George Braziller and Whitney Museum of American Art, 1978.

— and Marianne Lorenz. *Theme and Improvisation: Kandinsky and the American Avant-Garde, 1912–1950*. Boston: Bulfinch; Dayton Art Institute, 1992.

Levinson, Jerrold. *Music, Art, and Metaphysics: Essays in Philosophical Aesthetics*. Ithaca and London: Cornell University Press, 1990.

Lipsey, Roger. "Double Portrait: Alfred Stieglitz and Ananda Coomaraswamy." *Aperture* 16, 3 (1972): n.p.

Louchheim, Aline B. "An American Place to Close Its Doors." *New York Times* (26 November 1950).

Lowe, Sue Davidson. *Stieglitz: A Memoir/Biography*. New York: Farrar Straus and Giroux, 1983.

Lukach, Joan J. "Severini's 1917 Exhibition at Stieglitz's 291." *Burlington Magazine* 113 (April 1971): 196–209.

Lynes, Barbara Buhler. *O'Keeffe, Stieglitz, and the Critics, 1916–1929*. University of Chicago Press, 1989.

—. *Georgia O'Keeffe: Catalogue Raisonné*, 2 vols. New Haven and London: Yale University Press; Washington, D.C.: National Gallery of Art and Georgia O'Keeffe Foundation, 1999.

—, ed. "Visiting Georgia O'Keeffe." *American Art* 20, 3 (Fall 2006): 2–31.

—, Sandra Phillips, and Richard Woodward. *Georgia O'Keeffe and Ansel Adams: Natural Affinities*. Boston: Little Brown, 2008.

Lyons, Nathan, ed. *Photographers on Photography: A Critical Anthology*. Englewood Cliffs, N.J.: Prentice Hall, 1966.

McBride Henry. "Work by a Great Photographer." *The New York Herald* (13 February 1921).

—. "Modern Art." *The Dial* 70 (April 1921): 480–82.

—. "The Paul Strand Photographs." *The New York Sun* (23 March 1929).

McCausland, Elizabeth. "Georgia O'Keeffe in a Retrospective Exhibition." *Springfield Republic* (26 May 1946).

McNaught, William. "Interview with Dorothy Norman." *Smithsonian Archives of American Art* (1979): 1–42.

Maeterlinck, Maurice. "Maeterlinck on Photography." *Camera Work* 37 (January 1912): 41–2.

Manthorne, Katherine. "Experiencing Nature in Early Film: Dialogues With Church's Niagara and Homer's Seascapes." *Moving Pictures: American Art and Early Film, 1880–1910*. Manchester, Vt.: Hudson Hills Press and Williams College, 2005: 55–60.

Margolis, Marianne Fulton, ed. *Alfred Stieglitz – Camera Work: A Pictorial Guide*. New York: Dover, 1978.

Marin, John. "Foreword." *MSS* 2 (March 1922): 3–4.

—. "Notes." *MSS* 2 (March 1922): 5.

—. *Letters*, ed. Herbert Seligmann (1931). Westport, Conn.: Greenwood Press, 1970.

—. "The Man and the Place." In *America and Alfred Stieglitz: A Collective Portrait*, ed. Waldo Frank et al. New York: Doubleday, Doran & Co., 1934: 118–19.

—. *The Selected Writings of John Marin*, ed. Dorothy Norman. New York: Pellegrini and Cudahy, 1949.

Marks, Robert W. "Stieglitz: Patriarch of Photography." *Popular Photography* 6 (April 1940): 20–21, 76–9.

Martin, Marianne W. "Some American Contributions to Early Twentieth-Century Abstraction." *Arts Magazine* (June 1980): 158–65.

Marx, Leo. *The Machine in the Garden: Technology and the Pastoral Idea in America*. New York: Oxford University Press, 1964.

May, Henry F. *The End of American Innocence: A Study of the First Years of Our Own Time*. New York: Knopf, 1959.

Meinig, D. W., ed. *The Interpretation of Ordinary Landscapes: Geographical Essays*. New York and Oxford: Oxford University Press, 1979.

Meister, Sarah Hermanson, ed. *Life of the City: New York Photographs from the Museum of Modern Art*. New York: Museum of Modern Art, 2007.

Mellquist, Jerome. *The Emergence of an American Art*. New York: Scribner's, 1942.

—. "Eulogy to Paul Rosenfeld." *Twice a Year* 14–15 (Fall–Winter 1946–7): 206–7.

— and Lucie Wiese, eds. *Paul Rosenfeld: Voyager in the Arts*. New York: Creative Age Press, 1948.

Miller, Henry. "Stieglitz and John Marin." *Twice a Year* 8–9 (Spring–Summer, Fall–Winter 1942): 146–55.

Milliken, William. "Alfred Stieglitz, Photographer: An Appreciation." *Cleveland Museum of Art Bulletin* 3 (March 1935): 32–4.

Millstein, Barbara and Sarah M. Lowe. *Consuelo Kanaga, An American Photographer*. New York and Seattle: Brooklyn Museum in association with University of Washington Press, 1992.

Minuit, Peter [Paul Rosenfeld]. "291 Fifth Avenue." *The Seven Arts* 1 (November 1916): 61–5.

Mitchell, Stewart, "Stieglitz." *Adirondack Life* (September–October 2006): 67–73.

Moffat, Frederick C. *Arthur Wesley Dow*. Washington, D.C.: Smithsonian Institution Press, 1977.

Morgan, Ann Lee, ed. *Dear Stieglitz, Dear Dove*. Newark: University of Delaware Press, 1985.

Morris, Nelson. "Alfred Stieglitz: A Color Portrait and Notes on Photography's Grand Old Man." *Popular Photography* 14–15 (March 1944): 52–3.

Muir, Ward. "*Camera Work* and Its Creator." *The Amateur Photographer and Photography* 56 (28 November 1923): 465–6.

Mulligan, Therese, ed. *The Photography of Alfred Stieglitz: Georgia O'Keeffe's Enduring Legacy*. Rochester, N.Y.: George Eastman House, 2000.

Mullin, Glen. "Alfred Stieglitz Presents Seven Americans." *The Nation* 120 (20 May 1925): 577–8.

Mumford, Lewis. *Destinations: A Canvass of American Literature Since 1900*. New York: J. H. Sears & Co., 1928.

—. *The Brown Decades*. New York: Harcourt Brace, 1931.

—. "A Camera and Alfred Stieglitz." *The New Yorker* (22 December 1934).

458

Munson, Gorham. " '291': A Creative Source of the Twenties." *Forum* 3, 5 (Fall–Winter 1960): 4–9.

Naef, Weston J. *The Arts of Seeing: Photographs from the Alfred Stieglitz Collection*. New York: Metropolitan Museum of Art, 1978.

—. *The Collection of Alfred Stieglitz: Fifty Pioneers of Modern Photography*. New York: Viking, 1978.

—. *Alfred Stieglitz: Seen and Unseen*. Los Angeles: J. Paul Getty Museum, 1996.

—. *Photographers of Genius at the Getty*. Los Angeles: J. Paul Getty Museum, 2004.

—, ed. *Alfred Stieglitz*. In Focus series. Los Angeles: J. Paul Getty Museum (1995), 2002.

Naumann, Francis M. *New York Dada 1915–23*. New York: Harry N. Abrams, 1994.

Newhall, Beaumont, *Photography: A Short Critical History*. New York: Museum of Modern Art, 1938.

—. "Stieglitz and 291." *Art in America* 51 (February 1963): 49–51.

—, ed. *Photography: Essays and Images*. New York: Museum of Modern Art, 1980.

Newhall, Nancy. "What Is Pictorialism?" *Camera Craft* 48 (November 1941): 653–63.

—. *From Adams to Stieglitz: Pioneers of Modern Photography*. New York: Aperture, 1999.

Nietzsche, Friedrich Wilhelm. "To the Artist Who is Eager for Fame. His Work Finally Becomes But a Magnifying Glass Which He Offers to Everyone Who Happens to Look His Way." *Camera Work* 28 (October 1909): 39.

—. *The Birth of Tragedy and the Genealogy of Morals*, trans. Francis Golffing. New York: Doubleday, 1956.

—. *The Portable Nietzsche*, ed. and trans. Walter Kaufmann. New York: Viking Press, 1968.

Niven, Penelope. *Steichen: A Biography*. New York: Clarkson Potter, 1997.

Norman, Dorothy. *Dualities*. New York: An American Place, 1933.

—. "Marin Speaks, and Stieglitz," *The Magazine of Art* 30 (March 1937): 151.

—. "Alfred Stieglitz." *Twice a Year* 14–15 (Fall–Winter 1946–7): 188–202.

—. "Alfred Stieglitz on Photography." *The Magazine of Art* 43 (December 1950): 298–301.

—. "Alfred Stieglitz: Seer." *Aperture* 3, 4 (1955): 3–24.

—. "Alfred Stieglitz: Introduction to an American Seer." *Aperture* 8, 1 (1960).

—. "Stieglitz and Cartier-Bresson." *Saturday Review* (27 September 1962): 52–6.

—. "Stieglitz's Experiments in Life." *New York Times Magazine* (29 December 1963): 9.

—. Introduction. *291, Nos. 1–12: 1915–1916*. New York: Arno Press, 1972.

—. *Alfred Stieglitz: An American Seer*. Millerton, N.Y.: Aperture, 1973.

—. *Alfred Stieglitz: A Talk*. Tucson: University of Arizona Press, 1976.

—. *Encounters: A Memoir*. New York: Harcourt Brace Jovanovich, 1987.

—. *Alfred Stieglitz*. New York: Aperture, 1989.

—. *Alfred Stieglitz* (1976). Millerton, N.Y.: Aperture, 1989.

—, ed. *Stieglitz: A Memorial Portfolio, 1864–1946*. New York: Twice a Year Press, 1947.

—. *The Selected Writings of John Marin*. New York: Pellegrini and Cudahy, 1949.

—. *Selections from The Dorothy Norman Collection on Exhibition at the Philadelphia Museum of Art, May 24–September 1, 1968*. Philadelphia Museum of Art, 1968.

Northrop, F. S. C. *The Meeting of East and West: An Inquiry Concerning World Understanding*. New York: Macmillan, 1946.

Nye, David, and Thomas Johansen, eds. *The American Century*. Odense: University of Southern Denmark, 2007.

Oden, Lori. *Gertrude Käsebier (1852–1934): Dawning Individuality*. Oklahoma City: International Photography Hall of Fame and Museum, 2004.

O'Keeffe, Georgia. *Georgia O'Keeffe: A Portrait by Alfred Stieglitz*. New York: Metropolitan Museum of Art and Viking, 1978.

—. "Stieglitz: His Pictures Collected Him." *New York Times Magazine* (11 December 1949).

"Miss Georgia O'Keeffe Explains Subjective Aspects of Her Work." *The Sun* (5 December 1922).

Oring, Stuart A. "A Comparative Investigation of the Similarities and Differences in the Aesthetic Theories of Alfred Stieglitz, Edward Weston, Ansel Adams, and Minor White." M. A. thesis, American University, 1970.

Orvell, Miles. *The Real Thing: Imitation and Authenticity in American Culture, 1880–1940*. Chapel Hill and London: University of North Carolina Press, 1989.

Pearl, Sandy. *The Aura of Alfred Stieglitz*. New York: Bernard Goldberg Fine Arts, 2006.

Peeler, David P. "Alfred Stieglitz: From Nudes to Clouds." *History of Photography* 20, 4 (Winter 1996): 312–19.

—. *The Illuminating Mind in American Photography: Stieglitz, Strand, Weston, Adams*. Rochester, N.Y.: University of Rochester Press, 2001.

Perloff, Steven. *Camera Work: A Centennial Celebration*. Exh. cat. James A. Michener Art Museum, Doylestown, Penn., 2003.

Peters, Sarah Whitaker. *Becoming O'Keeffe*. New York: Abbeville, 2001, 2nd edn.

Peterson, Christian A. *Camera Work: Process and Image*. Minneapolis Institute of Art, 1985.

—. *Alfred Stieglitz's "Camera Notes."* New York: W. W. Norton; Minneapolis Institute of Art, 1993.

"Picabia, Art Rebel: Here to Teach New Movement." *New York Times* (16 February 1913).

Plagens, Peter. "The Critics: Hartmann, Huneker, De Casseres." *Art in America* 61, 4 (July–August 1973): 66–71.

Pollitzer, Anita. *A Woman on Paper: Georgia O'Keeffe*. New York: Simon and Schuster, 1988.

Pollock, Lindsay. *The Girl With the Gallery*. New York: Parsons Books, 2006.

Potter, Hugh M. *False Dawn: Paul Rosenfeld and Art in America, 1916–1946*. Ann Arbor, Mich.: UMI for University of New Hampshire, 1980.

Pultz, John, "Equivalence, Symbolism, and Minor White's Way into the Language of Photography." *Record of the Art Museum, Princeton University* 39 (1980): 28–39.

—, and Catherine B. Scallen. *Cubism and American Photography 1910–1930*. Williamstown, Mass.: Sterling and Francine Clark Art Institute, 1981.

Pyne, Kathleen. *Modernism and the Feminine Voice: O'Keeffe and the Women of the Stieglitz Circle*. Berkeley, Los Angeles, and London: University of California Press, 2000.

Ranck, Rosemary. "Acts of Love and Wonder." *In Short* (1993): 32.

Read, Helen Appleton. "Alfred Stieglitz Shows Recent Photographs." *The Brooklyn Daily Eagle* (8 April 1923).

Rhoades, Katherine. "I Walked into a Moment of Greatness." *291* 3 (May 1915): n.p.

Rice, Shelley. "New York: A Pictorial History." *Picture* 19 (1982): 4–13.

Rich, Daniel Catton. "The Stieglitz Collection." *Bulletin of the Art Institute of Chicago* 43 (15 November 1949): 64.

Richard, Paul. "Reaching for the Sky." *International Herald Tribune* (9–10 March 2002): 12.

Richter, Peter-Cornell. *Georgia O'Keeffe and Alfred Stieglitz*. New York, London, and Munich: Prestel, 2001.

Ringel, Fred J., ed. "Stieglitz: Done by Mirrors." *The New Republic* 81 (6 February 1935): 365–6.

Rodgers, Timothy Robert. "Alfred Stieglitz, Duncan Phillips and the '$6000 Marin.'" *Oxford Art Journal* 15, 1 (1992): 54–66.

Rolland, Romain. "America and the Arts." *The Seven Arts* 1 (November 1916): 52–6.

Rosenfeld, Paul. "The Novels of Waldo Frank." *The Dial* 70 (January 1921): 115–19.

—. "Stieglitz." *The Dial* 70 (April 1921): 397–409.

—. "American Painting." *The Dial* 71 (December 1921): 649–70.

—. "The Watercolors of John Marin." *Vanity Fair* 18 (April 1922): 48, 88, 92, 110.

—. "The Paintings of Marsden Hartley." *Vanity Fair* 18 (August 1922): 47, 84, 94, 96.

—. "The Paintings of Georgia O'Keeffe." *Vanity Fair* 19 (October 1922): 56, 112, 114.

—. *Port of New York: Essays on Fourteen American Moderns*. New York: Harcourt Brace, 1924.

—. *Musical Portrait*. New York: Harcourt Brace, 1925.

—. *By Way of Art*. New York: Coward-McCann, 1928; reprinted Freeport, N.Y.: Books for Libraries Press, 1967.

—. "Photography of Alfred Stieglitz." *The Nation* 134 (23 March 1932), 350–51.

—. "The Boy in the Dark Room." In *America and Alfred Stieglitz: A Collective Portrait*, ed. Waldo Frank et al. New York: Doubleday, Doran & Co., 1934.

—. "Alfred Stieglitz (1 January 1864–13 July 1946)." *Twice a Year* 14–15 (1946–7): 203–10 and 263–5.

Rugg, Harold. "The Artist and the Great Transition." In *America and Alfred Stieglitz: A Collective Portrait*, ed. Waldo Frank et al. New York: Doubleday, Doran & Co., 1934.

Sandler, Martin W. *Against the Odds: Women Pioneers in the First Hundred Years of Photography*. New York: Rizzoli, 2002.

Santayana, George. *The Sense of Beauty* (1896). New Brunswick, N.J., and London: Transaction, 2003.

Schenkenberg, Bonnie Ford. *Ernest Bloch: Photographer and Composer*. Tucson, Ariz.: Center for Creative Photography, University of Arizona, 1980.

Schiffmann, Joseph. "The Alienation of the Artist: Alfred Stieglitz." *American Quarterly* 3, 3 (Autumn 1951): 244–58.

Schjeldahl, Peter. "20th Century Strand." *Artnet Magazine* (2004).

Schleier, Merrill. *The Skyscraper in American Art, 1890–1931*. Ann Arbor, Mich.: UMI Research Press, 1986.

Schloss, Carol. *In Visible Light: Photography and the American Writer: 1840–1940*. New York and Oxford: Oxford University Press, 1987.

"Scissors Grinder." *Twice A Year* 10–11 (Spring–Summer 1943): 256–60.

Sekula, Allan. "On the Invention of Photographic Meaning." *Artforum* 13 (January 1975): 37–45.

Seligmann, Herbert J. "A Photographer Challenges." *The Nation* 112, 2902 (16 February 1921): 268.

—. "Why 'Modern' Art?" *Vogue* 62 (15 October 1923): 76–7, 110, 112.

—. "Music and Words." *The New York Tribune* (18 November 1923).

—. *D.H. Lawrence: An American Interpretation*. Freeport, N.Y.: Books for Libraries Press, 1924.

—. "Alfred Stieglitz and His Work at 291." *American Mercury* (May 1924): 83–4.

—. [Letter]. *New York Times* (28 February 1932).

—. *Alfred Stieglitz Talking: Notes on Some of His Conversations, 1925–1931*. New Haven: Yale University Library, 1966.

Shaw, George Bernard. *The Perfect Wagnerite* (1923). New York: Dover Publications, 1967.

Sheeler, Charles. "Recent Photographs by Alfred Stieglitz." *The Arts* 3, 5 (May 1923): 345.

Sinnott, Trip. *Tea Island: A Perfect Little Gem*. Clinton Corners, N.Y.: Attic Studio Press, 1993.

Smith, Joel. "How Stieglitz Came to Photograph Cityscapes." *History of Photography* 20, 4 (Winter 1996): 320–31.

Smith, Roberta. "A Sense of Touch, a Tenderness." *Art In Review* (1993): 1135.

—. "Dorothy Norman, 92, Writer Who Sought Social Change." *New York Times* (14 April 1997).

—. "Only Through a Lens Did a Master Emerge." *New York Times* (6 June 2003).

Soby, James Thrall. "Alfred Stieglitz," *Saturday Review* 29 (28 September 1946): 22–3.

"Speaking of Pictures." *Life* (5 April 1943): 6–7 and 9.

"Spirit of An American Place: An Exhibition of Photographs by Alfred Stieglitz." *Bulletin of the Philadelphia Museum of Art* 76, 331 (1981).

Stebbins, Theodore, Jr. and Norman Keyes, Jr. *Charles Sheeler: The Photographs*. Boston: Little Brown, 1988.

Steichen, Edward. "The Fighting Photo-Secession." *Vogue* (15 June 1914): 22–5.

—. "The Lusha Nelson Photography of Alfred Stieglitz." *U.S. Camera* 1 (February–March 1940): 16–19.

Stein, Gertrude. "Portrait of Mabel Dodge at the Villa Curonia." *Camera Work* special number (June 1913): 3–5.

Stieglitz, Alfred. "The Hand Camera: Its Present Importance." *American Annual of Photography and Photographic Times Almanac for 1897*. New York, 1897.

—. "Simplicity in Composition." In *The Modern Way of Picture Making*. Rochester, N.Y.: Eastman Kodak, 1905.

—. "What is 291?" *Camera Work* 47 (January 1915): 5.

—. "One Hour's Sleep – Three Dreams." *291* 1 (March 1915): n.p.

—. [Statement in Foreword]. In *The Forum Exhibition of Modern American Painters*. New York: Anderson Galleries, 1916: n.p.

—. "Photographs by Paul Strand." *Camera Work* 48 (October 1916): 11–12.

—. [Letter]. *Blind Man* 2 (1917): 15.

—. "Our Illustrations." *Camera Work* 49–50 (June 1917): 36.

—. "A Statement." *Exhibition of Photography by Alfred Stieglitz*. New York, 1921.

—. "Regarding the Modern French Masters Exhibition." *Brooklyn Museum Quarterly* 8 (July 1921): 105–13.

—. [Letter]. *The Arts* 2 (August–September 1921): 61.

—. "Portrait – 1918." *MSS* 2 (March 1922): 61.

—. "Is Photography a Failure?" *The New York Sun* (14 March 1922).

—. *Alfred Stieglitz Presents One Hundred Pictures, Oils, Water-Colors, Pastels, Drawings, by Georgia O'Keeffe, American*. New York: Anderson Galleries, 1923.

—. "Some of the Reasons." In *The Complete Photographer*, ed. R. Child Bayley. Rev. edn. New York: McClure Phillips, 1923.

—. "How I Came to Photograph Clouds." *Amateur Photographer and Photography* 56 (1923): 225.

—. "Chapter III." *Third Exhibition of Photography by Alfred Stieglitz*. New York: Anderson Galleries, 1924: n.p.

—. "Sky-Songs." *The Nation* 118 (1924): 561–2.

—. *Alfred Stieglitz Presents Seven Americans*. New York: Anderson Galleries, 1925.

—. [Statement]. *Marin Exhibition*. New York: Intimate Gallery, 1927: n.p.

—. "To the Art Editor." *Creative Art* 12 (February 1933): 152.

—. "Not a Dealer." *American Magazine of Art* 27 (1934): 4.

—. "From the Writings and Conversations of Alfred Stieglitz." *Twice a Year* 1 (Fall–Winter 1938): 77–100 and 175.

—. "The Boston Museum and the Metropolitan Museum." *Twice a Year* 5–6 (Fall–Winter 1940, Spring–Summer 1941).

—. "Ten Stories." *Twice a Year* 5–6 (Fall–Winter 1940, Spring–Summer 1941): 135–63.

—. "Four Happenings." *Twice a Year* 8–9 (Spring–Summer, Fall–Winter 1942): 105–36.

—. "Alfred Stieglitz Replies to 'Officialdom.' " *Twice a Year* 8–9 (Spring–Summer, Fall–Winter 1942): 172–5.

—. "How *The Steerage* Happened." *Twice a Year* 8–9 (Spring–Summer, Fall–Winter 1942): 175–8.

—. "Is It Wastefulness or Is It Destruction?" *Twice a Year* 10–11 (Spring–Summer, Fall–Winter 1943): 254–5.

—. "Random Thoughts – 1942." *Twice a Year* 10–11 (Spring–Summer, Fall–Winter 1943): 261–4.

—. "Stories." *Twice a Year* 10–11 (Spring–Summer, Fall–Winter 1943): 264.

—. "Thoroughly Unprepared." *Twice a Year* 10–11 (Spring–Summer, Fall–Winter 1943): 245–53.

—. "Six Happenings and a Conversation." *Twice a Year* 14–15 (Fall–Winter 1946–7): 188–202.

—. "Six Happenings: Photographing the Flat-Iron Building, 1902–3." *Twice a Year* 14–15 (Fall–Winter 1946–7): 188–90.

"Alfred Stieglitz and His Influence." *Christian Science Monitor* (21 February 1921): 12.

"Alfred Stieglitz of '291' Begins Again in Room 303." *The World* (20 December 1925).

"Stieglitz." *Art Design* 1 (March 1927): 20.

"Alfred Stieglitz at Seventy Recalls Birth of Modern Art." *The New York Herald Tribune* (1 January 1934): 17.

"Stieglitz Assails W.P.A. Art as 'Wall Smears.'" *The New York Herald Tribune* (3 December 1936): 9.

"Mr. Alfred." *Adirondack Life* (Winter 1976): 6–10.

Strand, Paul. "Stieglitz." *Conservator* 27 (December 1916): 137.

—. "Photography." *The Seven Arts* (August 1917): 524–6.

—. "Alfred Stieglitz and a Machine." New York: Privately Printed, 14 February 1921.

—. "Alfred Stieglitz and a Machine." *MSS* 2 (March 1922): 6 and 7.

—. "Photography and the New God." *Broom* 3 (November 1922): 252–8.

—. "Photographers Criticized." *The New York Sun* (27 June 1923).

—. "The Art Motive in Photography." *British Journal of Photography* 70 (5 October 1923): 612–15.

—. "Alfred Stieglitz 1864–1946." *New Masses* 60 (6 August 1946): 6–7.

—. "Stieglitz: An Appraisal." *Popular Photography* 21 (July 1947): 62, 88–98.

—, and Naomi Rosenblum. *The Stieglitz Years at 291 (1915–1917)*. New York: Zabriskie Gallery, 1983.

Sussman, Elisabeth with Barbara Bloemink. *Florine Stettheimer: Manhattan Fantastica*. New York: Whitney Museum of American Art, 1995.

Sweeney, James Johnson. "Rebel With a Camera." *New York Times Magazine* (8 June 1947): 21–2.

—. "Stieglitz." *Vogue* 109 (15 June 1947): 58–9, 93.

Szarkowski, John. *Alfred Stieglitz at Lake George*. New York: Museum of Modern Art, 1995.

Tarshis, Jerome. "Alfred Stieglitz, Editor." *Portfolio* (August–September 1979): 50–55.

Tashjian, Dickran. *William Carlos Williams and the American Scene, 1920–1940*. Berkeley, Los Angeles, and London: University of California Press with the Whitney Museum of American Art, 1978.

Taylor, Francis Henry. "America and Alfred Stieglitz." *The Atlantic Monthly* 155 (January 1935): 8 and 10.

Taylor, Larry Hugh. "Alfred Stieglitz and the Search for American Equivalents." Ph.D. diss., University of Illinois at Champaign-Urbana, 1973.

Terry, James. "The Problem of the Steerage." *History of Photography* (July–September 1982): 211–22.

Thomas, Richard F. *Literary Admirers of Alfred Stieglitz*. Carbondale and Edwardsville: Southern Illinois University Press, 1983.

Thompson, Jan. "Picabia and His Influence on American Art, 1913–17." *Art Journal* 43, 1 (Fall 1979): 14–21.

Thornton, Gene. *Masters of the Camera: Stieglitz, Steichen and Their Successors*. New York: Holt, Rinehart, and Winston, 1976.

Tillyard, E. M. "The Cosmic Dance." In *What Is Dance? Reading in Theory and Criticism*, ed. Roger Copeland and Marshall Cohen. New York: Oxford University Press, 1983.

Toomer, Jean. *Cane*. New York: Liveright, 1923.

Trachtenberg, Alan. "Camera Work/Social Work." In *Reading American Photographs: Images as History, Matthew Brady to Walker Evans*, ed. Alan Trachtenberg. New York: Hill and Wang, 1989: 164–230.

—, ed. *Classic Essays on Photography*. New Haven: Leete's Island Books, 1980.

Travis, David. *At the Edge of the Light*. Boston: David Godine, 2003.

—, and Anne Kennedy. *Photography Rediscovered: American Photographs, 1900–1930*. New York: Whitney Museum of American Art, 1979.

Tsujimoto, Karen. *America and Modern Photography*. Seattle and London: University of Washington Press, 1982.

Tuchman, Maurice, ed. *The Spiritual in Art: Abstract Painting 1890–1985*. New York and Los Angeles: Abbeville with Los Angeles County Museum of Art, 1986.

Tucker, Anne. *Target II: 5 American Photographers*. Houston: Museum of Fine Arts, 1981.

Tudor, Hart P. "The Analogy of Sound and Color." *Cambridge Magazine* (2 March 1918): 480–83.

Turner, Elizabeth Hutton. "I Can't Sing So I Paint." In *Two Lives, Georgia O'Keeffe and Alfred Stieglitz: A Conversation in Paintings and Photographs*, ed. Alexandra Arrowsmith and Thomas West. New York: Harper Collins, 1992: 79–89.

—. *In the American Grain: Arthur Dove, Marsden Hartley, John Marin, Georgia O'Keeffe, and Alfred Stieglitz*. Washington, D.C.: Phillips Collection, 1995.

"291." *The New Yorker* (18 April 1925): 9–10.

Tyrell, Henry. "What is Stieglitz?" *The World* (15 April 1923).

Udall, Sharyn. "Finding a Self in Nature: Georgia O'Keeffe and Nature." *El Palacio* 102, 1 (Summer/Fall 1997): 26–35.

Valéry, Paul. *Aesthetics*, trans. Ralph Manheim. New York: Pantheon, 1964.

Van Vechten, Carl. *The Alfred Stieglitz Collection*. Nashville, Tenn.: Fisk University Press, 1984.

Venn, Beth, and Adam Weinberg, eds. *Frames of Reference: Looking at American Art, 1900–1950*. New York: Whitney Museum of American Art; Berkeley and Los Angeles: University of California Press, 2002.

Voorhies, James Timothy, ed. *My Dear Stieglitz: Letters of Marsden Hartley and Alfred Stieglitz, 1912–1915*. Columbia: University of South Caroline Press, 2002.

Walch, Peter, and Thomas Barrow, eds. *Perspectives on Photography: Essays in Honor of Beaumont Newhall*, Albuquerque: University of New Mexico Press, 1986.

Ware, Katherine, and Peter Barberie. *Dreaming in Black and White: Photography at the Julien Levy Gallery*. New Haven and London: Yale University Press; Philadelphia Museum, 2006.

Wasserstrom, William, ed. *Civil Liberties and the Arts: Selections from Twice a Year 1938–1948*. Syracuse University Press, 1964.

Weaver, Mike. "Alfred Stieglitz and Ernest Bloch: Art and Hypnosis." *History of Photography* 20, 4 (Winter 1996): 293–303.

Webb, Todd. *Looking Back: Memoirs and Photographs*. Albuquerque: University of New Mexico Press, 1991.

Weber, Max. "The Fourth Dimension from a Plastic Point of View." *Camera Work* 31 (July 1910): 25.

—. *Essays on Art*. New York: Rudge, 1916.

Weichsel, John. *Commemorating the 50th Anniversary of "The Forum Exhibition of Modern American Painters."* New York: ACA Heritage Gallery, 1916, n.p.

Wertheim, Arthur F. *New York Little Renaissance: Iconoclasm, Modernism, and Nationalism in American Culture, 1908–1917*. New York University Press, 1976.

"What is 291? The Cosmos, Answers Alfred Stieglitz." *New York Evening Post* (14 April 1925).

Whelan, Richard. *Alfred Stieglitz: A Biography*. New York: Da Capo Press, 1997.

—, ed. *Stieglitz on Photography: His Selected Essays and Notes*. New York: Aperture, 2000.

Whitman, Walt. *The Illustrated Leaves of Grass*, ed. Howard Chapnick. New York: Madison Square Press, 1971.

Wickstrom, Richard. *"Camera Work": Transformations of Pictorial Photography*. Iowa City: University of Iowa Museum of Art, 1975.

Williams, Raymond. *The Politics of Modernism*. New York: Verso, 1989.

Williams, William Carlos. *The Great American Novel*. Paris, 1923.

—. *In the American Grain*. New York: Random House, 1925; reprint New York: New Directions, 1956.

—. *The Autobiography of William Carlos Williams*. New York, 1959.

Willis, Patricia C. *Petals on a Wet Black Bough: American Modernist Writers and the Orient*. New Haven: Beinecke Rare Book and Manuscript Library, Yale University, 1996.

Wilson, Edmund. "Greatest Triumphs: The Stieglitz Exhibition." *The New Republic* 42 (18 March 1925): 97–8.

Wilson, Kristina. "The Intimate Gallery and the Equivalents: Spirituality in the 1920s Work of Stieglitz." *Art Bulletin* (December 2003): 746–68.

Wilson, Richard G., Dianne H. Pilgrim, and Dickran Tashjian, *The Machine Age in America, 1918–1941*. New York: Harry N. Abrams, 1986.

Wright, Willard Huntington. *Modern Painting: Its Tendency and Meaning*. New York: John Lane, 1915.

—. *The Creative Will: Studies in the Philosophy and the Syntax of Aesthetics*. New York: John Lane, 1916.

—. "The Aesthetic Struggle in America." *Forum* 55 (February 1916): 201–20.

Zayas, Marius de [Untitled]. *291* 5–6 (July–August 1915): n.p.

—. "Comments on 'The Steerage.' " *291* 7–8 (September–October 1915): n.p.

—. *African Negro Art: Its Influence on Modern Art*. New York: Modern Gallery, 1916.

—. "Modern Art . . . Negro Art . . ." *291* 12 (February 1916): n.p.

—. "The Steerage." *American Photography* 10 (March 1916).

—. "Modern Art in Connection with Negro Art." *Camera Work* 48 (October 1916): 7–9.

—. "Clouds: Photographs by Stieglitz." *The World* (1 April 1923): 11.

—. *How, When, and Why Modern Art Came to New York*, ed. Francis M. Naumann. Cambridge, Mass. and London: MIT Press, 1996.

—, and Paul Haviland. *A Study of the Modern Evolution of Plastic Expression*. New York: 291, 1913.

Zigrosser, Carl. "Alfred Stieglitz." *New Democracy* 4 (April 1935): 65–7.

—. "Alfred Stieglitz." *Twice A Year* 8–9 (Spring–Summer, Fall–Winter 1942): 137–45.

Zilczer, Judith Katy. "The Aesthetic Struggle in America, 1913–1918: Abstract Art and Theory in the Stieglitz Circle." Ph.D. diss., University of Delaware, 1975.

—. "Synaesthesia and Popular Culture: Arthur Dove, George Gershwin, and the 'Rhapsody in Blue.' " *Art Journal* (Winter 1984): 361–6.

—. "Alfred Stieglitz and John Quinn: Allies in the American Avant-Garde." *American Art Journal* 17, 3 (Summer 1985): 18–33.

Zorn, Amy Mizrahi. *The Stieglitz Circle*, New York: Whitney Museum of American Art, 1992.

INDEX

A Nous La Liberté 267
Abbott, Berenice (Bernice) 39, 189, 275, 276, 279
 Changing New York 277–78
Abiquiu, New Mexico 145, 399, 405
abstract expressionism 265, 388, 411
abstract painting 265, 281
Adams, Ansel 294–99, 302, 380
 and AS 294–97
 correspondence with AS 262, 295, 296, 298, 389, 392
 and Mabel Dodge Luhan 271
 exhibition checklist *290*
 exhibitions 189, 278, 294, 297–99, 299, 384, 390, 392
 and f/64 group 275, 294
 and MoMA 384, 392, 398
 and music 295
 New York series 297
 and Georgia O'Keeffe 299, 374, 376
 and Photo League 278
 Americana 296
 Latch and Chain 296
 Picket Fence near Tomales, California 296
 Poplars 297
 Portfolio One 299
 Winter, Yosemite Valley 296
African art 69, 136, 238, 303
Agee, James 277
Albers, Josef 155, 265
Albright, Ivan 265
Alès 60
Alfred Stieglitz and Georgia O'Keeffe at Lake George 321
Alfred Stieglitz Photographing at 4 July 1915 Party 101
Allen, Frederick 137, 262
Alone 267
Amateur Photographer 25
Amateur Photographer and Photography 72–73
America and Alfred Stieglitz: A Collective Portrait (ed. Frank, Mumford et al.) 152, 272–73, 300, 390

American Abstract Artists Organization 265
American Amateur Photographer 27, 28
American Annual of Photography and Photographic Times Almanac for 1898 33
American Civil Liberties Union (A.C.L.U.) 177
American Express 127
American scene painting 264
Anderson, Maxwell, *Wintersee* 262
Anderson, Sherwood
 on Anderson Galleries exhibition 169
 AS's images of 149, 159, 214, 291
 correspondence with AS 196, 200, 223, 242–43, 399
 and *The Dial* 152–53
 Lewis Mumford on 167
 and nature as theme 264
 and Dorothy Norman 341
 and Paul Rosenfeld 142
 Paul Strand on 166
 A Story Teller's Story 149
 Tar: A Mid-West Childhood 149
Annan, J. Craig 272, 293, 301, 389
Aperture 393
Apollinaire, Guillaume
 Les Soirées de Paris 52
 Voyage 53–55
Archipenko, Alexander 46, 59, 155
Arensberg, Walter 78, 79, 80
Armory Show (1913) 45, 77, 81, 82, 86, 155, 156, 188, 281
Armstrong, Louis, and Hot Five Band 136
Army Air Force (U.S.) 386
Art Front 265
Art News 397
Art Students League 265
Artnews 187, 231
Arts and Crafts Movement 42
Arts et Métiers Graphiques 279
Ashcan School 264, 397
Atget, Eugene 189, 275, 278, 279, 393
Atlanta, Georgia 268
Austin, John 381

Austria 263, 377
 Tyrol 299
Avedon, Richard 278
Avery, Milton 265

Bach, Johann Sebastian 23, 165, 234, 255, 256, 258, 368
Bachelard, Gaston 240
 The Poetics of Space 220
Bacon, Peggy 175, 280
Bakst, Léon 113
Ball, Hugo 80
Ballets Russes 113
Balzac, Honoré de 190
Bambi 381
Barbizon School 26
Barlach, Ernst 152
Barnes, Djuna 50
Barnes Collection 177
Barr, Alfred Hamilton, Jr. 188, 278, 387
Barrymore, John 148
Basker, Jacqueline, "The Cloud as Symbol" 237–38
Bastien-Lepage, Jules 26
The Battleship Potemkin 136
Baudelaire, Charles 16, 150
Bauer, Rudolph 281
Bauhaus 155, 262
Bauschmied, Paula 26, 67
Bayard, Hippolyte 15
Bayley, R. Child 101
Beach, Frederick 27
Bearden, Romare 265
Beaton, Cecil 189, 275, 276
Beckett, Marion H. 96, 127
Beckett, Samuel, *Waiting for Godot* 59
Beckmann, Max 174
Beekman Hill Press 295
Beethoven, Ludwig van 24, 39, 88, 234, 255, 258, 368
Belgium 126
 German invasion 52
Bell, Clive, *Art* 411
Bellagio, Italy 25

Ben-Hur 240
Benoit, Pierre André 60
Benoit-Lévy, Jean 267
Benson, E. M. 273–74
Benton, Thomas Hart 13, 78, 264, 273
 "America and/or Alfred Stieglitz" 273, 300
Bergman, Ingrid 381
Bergner, Elisabeth 267
Bergson, Henri 146, 190, 292
 Creative Evolution 42, 83
 Laughter 83
Berlin 26, 153
 Atelier Jacobi 388
 Café Bauer 25
 Herbstsalon 148
 Polytechnic Institute 195
 Reichstag 262
 Royal Industrial Museum 145
 Technische Hochschule 22
 University 22
Berlin, Irving
 God Bless America 381
 This is the Army 381
Bermuda 287
The Bhagavad Gita (tr. Nikhilananda) 350
The Bible 287
Bierstadt, Albert 234–37
 Mt. Whitney 237
 Storm in the Rocky Mountains 237
Birth of a Nation 50
Bizet, Georges 23
 Carmen 17, 24
Black Mountain College 155
Black Renaissance 150
Blake, William 143, 245, 246, 363
 "To the Christians" 140
Blaue Reiter group 148
Blechen, Karl 234
Blériot, Louis 86
The Blind Man 80
Bliss, Lillie 188
Bloch, Ernest 142, 152–53, 223, 224–28
Bloch, Ivan, *Anthropological Studies in the Strange Sexual Practices of All Races...* 271
Blossfeldt, Karl 145, 176, 275
The Blue Light 262
Bluemner, Oscar 78, 86, 304, 390, 399
Blume, Peter 265
Bochner, Jay 53–55

Bogart, Humphrey 381
Bolotowsky, Ilya 265
Boni and Liveright 147
Bonney, Theresa 387
Boone, Daniel 138
Booth, John Wilkes 16
Boston 281–82, 341
 Camera Club 27
 Museum of Fine Arts 74, 160–65, 281–82
 Art School 73
 Symphony 93
Boston Museum of Fine Arts 398
Bouguereau, Adolphe-William 26
Bourke-White, Margaret 276, 390
 You Have Seen Their Faces (with Erskine Caldwell) 277
Bourne, Randolph 47, 60, 61, 72, 138, 142, 143, 152, 166
Boursault, George and Yvonne 95
Bowles, Paul 341
Brady, Mathew 16
Bragaglia, Anton Giulio 155
Bragdon, Claude 82, 237, 393
 Democracy 84
 Four-Dimensional Vistas and Architecture 84
 Frozen Fountain: Being Essays on Architecture and the Art of Design in Space 84
 More Lives than One 84
 New Image 368
 A Primer of Higher Space (The Fourth Dimension) 83–84, 84
 Projective Ornament 84
Brahms, Johannes 258, 368
Brancusi, Constantin 38, 59, 61, 155, 188, 272, 278, 301, 390
 Head of a Child 69
Brandeis, Georg, *Voltaire* 246
Braque, Georges 59, 61, 62, 77, 271, 278, 301, 388
Brazil 303
Brecht, Bertolt 341
Brennan, Marcia, *Painting Gender, Constructing Theory* 411
Brett, Dorothy 272, 303
Breuning, Margaret 170
Brigman, Anne 116, 175, 293
 Songs of a Pagan 403

Brill, A. A. 49, 88, 108, 145
Brinton, Christian 50, 78
Britain 381, 403
British Royal Photographic Society 412
Brooklyn Daily Eagle 275
Brooks, Van Wyck 61, 138, 142, 143, 152, 153
 The Ordeal of Mark Twain 144
Broom 153, 158
Brotherhood of the Linked Ring 28–29, 31
The Brothers Karamazov (film) 267
Brown, Milton W. 397–98
Bruehl, Anton 276
Brugière, Francis 50, 61
Bruno, Guido 12
Bry, Doris 25, 108, 392, 399
Budapest 125
Buddhism 150, 173
Buffalo, NY, Albright Knox Gallery 44, 276
Buffet, Gabrielle 60, 89
Bulletin of the Museum of Modern Art 385
Bunnell, Peter 314–15
Buñuel, Luis 136
Burchfield, Charles 264
Burke, Kenneth 153
Burnham, Daniel H., & Co. 39
Burr, Aaron 138

Caffin, Charles 51, 94
 Photography as a Fine Art 34
Cahill, Holger 266
Calder, Alexander 388
Calderón de la Barca, Pedro 23
Caldwell, Erskine 262, 277
Camera Club of New York 31, 38
Camera magazine 224
Camera Notes 31–32, 33, 390
Camera Work
 AS closes down 91
 AS considers reviving 154
 AS on 13, 89, 126
 AS's images in 29, 34, 55, 57, 304
 and Bergson 83
 and Anne Brigman 403
 closes down 61, 68, 72
 De Zayas number 126
 and Mabel Dodge 83
 foundation of 38, 42
 as *Gesamtkunstwerk* 24
 and Graflex camera 30
 and Hartley 125

issues exhibited 300, 396
and Kanaga 303
and Kandinsky 45, 237
and Kirnon 96–100
and Liebovitz 248
and MoMA exhibition 279
and Virginia Myers 116
and O'Keeffe 116
periods of history of 42–43
and Picabia 81, 82
and Picasso 278
proposed article by A. A. Brill 88
and Katherine Rhoades 96
and George Bernard Shaw 146
and Sheeler 68, 72
and Strand 62, 64, 86
and symbolism 228
table of contents 370
"291" issue 50–53, 126, 127
unsold and back issues 174, 176, 178, 180,
 248, 255
as vehicle for AS circle 73, 77
and Walkowitz 85–86
Cameron, Julia Margaret 26, 272, 301, 389
Campbell, Frank 393
Campendonk, Heinrich 155
Canada 299
Canyon, Texas 209
Cape Cod, Massachusetts 381
Capone, Al 137
Carles, Arthur B. 214
Carpenter, John Alden, *Skyscrapers* 305
Carroll, Howard 17
Cartier-Bresson, Henri 11, 275, 393
Carus, Carl Gustav, *Nine Letters on
 Landscape Painting* 234
Casablanca 381
Center Lovell, Maine 175
Century Magazine 39
Ceylon Armory 160
Cézanne, Paul 22, 38, 46, 77, 86, 101, 188,
 272, 278, 301, 389
Chabot, Maria 407
Chagall, Marc 152, 174, 281, 341
Chamberlain, Neville 263
Champs Elysées 267
Chaplin, Charlie 153, 174, 240, 267, 381
Charlesworth, Sarah 411
Chávez, Carlos 292
Cheney, Sheldon, *Primer of Modern Art* 83

Chicago
 Art Institute 87, 388, 398
 University 123
 World's Fair 73, 266
Un Chien Andalou 136
Chopin, Frédéric, *Funeral March* 24
Christensen, Nora 276
The Christian Science Monitor 231
Christianity 173
Chrysler, Walter 265
Church, Frederic 234–37
 Autumn View of Olana 237
 Twilight in the Wilderness 237
 Winter Landscape from Olana 237
Churchill, Winston 267
Citizen Kane 381
Clair, René 267
Clifford, Henry 389
Cliffside, New Jersey 167
Clurman, Harold 292, 341
Coburn, Alvin Langdon 39, 62, 63, 74, 272,
 293, 304, 389
Cohasset, Massachusetts 299
Coleman, A. D. "Return of the Suppressed:
 Pictorialism's Revenge" 411
Coleridge, Samuel Taylor 234
Colorado 292
Columbia Teachers College 272, 291
Columbia University, Teachers College 123
Columbus, Christopher 138, 139, 269
Common Sense 273
Condé Nast Publications 174, 412
Condor legion 262
Constable, John 234
Constructionism 155
Coolidge, Calvin 18, 137
Coomaraswamy, Ananda K. 160, 165, 176,
 182, 238, 281, 341
 The Dance of Shiva 182
Coomaraswamy, Mrs 281
Cooper, Gary 408
Cooper, James Fenimore 147
Copland, Aaron, *Appalachian Spring* 382
Cornell, Joseph 278, 388
 Medici Slot Machine 382
Corot, Camille 26
Cortissoz, Royal 45
Courbet, Gustave 26, 396
Covert, John 78
Cowley, Matthew 153

Cramer, Konrad 93–94
Crane, Hart 137, 138–41, 143, 152, 176,
 217–18, 223, 238, 399
 The Bridge 138–39, 140, 141, 269
 White Buildings: Poems by Hart Crane
 139
Craven, Thomas 51–52, 143, 165, 265
Crawford, Cheryl 292
Cropsey, Jasper 218
 Dawn at Morning, Lake George 18
 "Up Among the Clouds" 234
cubism 43, 50, 58, 76, 93, 176
Cummings, E. E. 152, 153
Cunningham, Imogen 275, 294
Curry, John Steuart 264
Curtiz, Michael 381
Czechoslovakia 263, 377

D-Day invasion 380
dadaism 52, 60, 80, 82, 136, 148, 155, 157
Daguerre, Louis 11, 15, 25
Dahl, Johan Christian 234
Dakota 372
Dalí, Salvador 136, 381, 388
Dana, William Henry 147
Daniel, Charles 50, 77, 125, 126, 127, 130, 187
Darmstadt, Germany 143
Darwin, Charles 172, 195, 240
Daudet, Alphonse
 Sappho 22
 Tartarin series 22
Davidson, Donald 111, 191, *191*
Davidson, Elizabeth Stieglitz (AS's niece)
 105, 130, 168, 350
Davidson, Peggy (AS's grandniece) 53, 349,
 353, 364
Davidson, Sue (AS's grandniece, later Lowe)
 53, 349, 353, 364
Davies, Arthur 46
Davies, Captain Thomas 218
Davis, Stuart 152, 187, 265
 American Painting 281
Davison, George 28
Day, F. Holland 36
de Kooning, Willem 265, 388
de Mille, Agnes 381
de Terra, Rhoda Hoff (AS's niece) 363
De Zayas, Marius
 on AS 60
 and AS's 70th birthday 272

and *Camera Work* 42, 57
Camera Work 44
first exhibition 293
and Hartley 127
and Modern Gallery (later De Zayas
 Gallery) 59, 69, 72, 77, 79
and Picabia 82, 89
portrait by AS 390
and Sheeler 72
and 291 gallery 5, 51, 61, 69
and *291* magazine 52, 55, 59, 60
*African Negro Art: Its Influence on
 Modern Art* 69
African Negro Wood Sculpture 69
Debussy, Claude 142
Degas, Edgar 26
"Degenerate Art" exhibition 263
Delaney, Beauford 382
Delano, Jack 277
Delaunay, Robert 88
Delaunay, Sonia 147
Dell, Floyd 47
Demachy, Robert 293, 301, 389
Demuth, Charles
 AS on 368, 372
 and AS's 70th birthday 272
 AS's images of 94, *97*, 214, 215
 correspondence with AS 215, 399
 and dada 80
 estate of 400
 exhibitions 77, 158, 159, 168, 188, 189,
 280, 283, 304, 390, 392, 396
 and Intimate Gallery 175
 and *MSS* 153
 and Dorothy Norman 341
 on Georgia O'Keeffe 410
 and Stettheimer sisters 182, 183
 and theme of nature 84
 ...And the Home of the Brave 284
 Buildings 280, 281
 I Saw the Figure 5 in Gold 138, 175, *175*,
 176, 187
 My Egypt 280
Denmark 372
Depression 238, 261–63, 265, 267, 268, 277,
 292, 377
Devens, Mary 39
Dewey, John 152
Diaghilev, Serge 113
The Dial 152–53, 156, 186

Dickinson, Emily 148, 269, 287
Dijkstra, Bram 195, 214
 The Hieroglyphics of a New Speech 138
Diller, Burgoyne 265
Disdéri, André Adolphe Eugène 16
Disney, Walt 136, 268, 381
Dixon, Maynard 271
Dodge (later Luhan), Mabel 42, 60, 82–83,
 145, 146, 147, 151, 188, 254, 256, 271, 303,
 372, 388
 "Speculations" 83
 Winter in Taos 271
Dole Pineapple Company 304, 377
Dos Passos, John 143, 262
 Manhattan Transfer 305
Dostoyevsky, Fyodor 153
Double Indemnity 381
Doughty, Thomas 218
Dove, Arthur
 and AS 182
 AS on 280, 380, 392, 406
 and AS's 70th birthday 272
 AS's images of *96*, 214
 and Oscar Bluemner 86
 correspondence with AS 212, 215, 399
 death 396
 estate of 400
 exhibitions 78, 155, 168, 172, 173, 187, 189,
 280, 283, 293, 390, 392, 396
 and Intimate Gallery 175–76, 187
 and *MSS* 153
 and Duncan Phillips 187
 poetry of 169
 Rosenfeld and 142, 145
 and theme of nature 84, 145
 Chinese Music 180
 Gear 214–15
 Gershwin 175–76
 Rhapsody in Blue, Parts I and II 175–76
 Silver Sun 181
 Swing Music 285
Dow, Arthur Wesley 73, 74–75
 Composition 74
Downes, Bruce 397
Doylestown, Bucks County, Pennsylvania
 69–70, 151, 303
Dreier, Katherine 84, 154–55
Dreiser, Theodore 341
Dresden painters 234
Duchamp, Marcel

on AS *53*
AS's images of *53*, 214
and *The Blind Man* 80
as emigré 80
exhibitions 159, 278, 301, 390
and Julien Levy 274
and *New York Dada* 148
and John Quinn 84
and Société Anonyme 154–55
and Society of Independent Artists 78
and Stettheimer sisters 182
Fountain 79–80, *79*
Dudley, Katherine 202, 291
Dumbo 381
Duncan, Charles 86, 88, 390
Duncan, Isadora 85, 113
Dunga 282
Durand, Asher 218
Duse, Eleonora 29

Earhart, Amelia 269
Eastman Kodak 56, 173, 300
Eastman, Max 47, 83
Echegaray, José 23
Eckstein, Gustav, *Noguchi* 271–72
Eder, Josef 26
Edison, Thomas 268–69
Egotist Press 146
Eilshemius, Louis 265, 390
Einstein, Alfred 49–50, 388
Einstein, William 189, 283, 301–2, 401
Eisenstein, Sergei 136
Elambert, Paulette 267
Eliot, T. S. 152, 153, 410
 Four Quartets 6, 410
Ellington, Duke, *Black, Brown and Beige*
 381
Ellis, Havelock 271
 The Dance of Life 145
 From Rousseau to Proust 383
Ellis Island 57
embodied formalism 411
Emerson, Peter Henry 25, 27
Emerson, Ralph Waldo 61, 152, 237
Empire State Corporation 305
Engelhard, George (AS's brother-in-law)
 167
Engelhard, Georgia (AS's niece) 86, 202,
 209, *210, 211, 212*
Ernst, Max 388

Ethical Culture School 62
Eugene, Frank 34, 39, 61, 62, 104, 293, 389
Evans, Fred H. 293
Evans, Walker 189, 269, 276, 276–77, 278, 279, 292
 Let Us Now Praise Famous Men (with James Agee) 277
Evergood, Philip 265
Expressionism 50

f/64 group 275, 294
Fantasia 381
Farm Security Administration (F.S.A.) 276, 277
Farman, Henri 86
Farrell, James 262
Faulkner, William 149
fauvism 43, 76
Federal Art Project 261, 264, 266, 277
Fenollosa, Ernest 73–74, 238
 Epochs of Chinese and Japanese Art 73
Field, Hamilton Easter 185
"Film and Foto" 276
Finland 267
First International Dada Fair 136
Fisher, William Murrell 90
Fisk University, Nashville, Tennessee 87
Fitzgerald, F. Scott 137
591 (magazine) 60
Fivoosiovitch, Gregor and Frances 183
Fivoosiovitch, Sonia 183
Flanner, Janet, *The Cubical City* 305
Flaubert, Gustave 290
Flexner, Abraham 263
Flint, Ralph 24, 231, 240, 280
Florence 146, 173
Florida 303
Flowers and Trees 268
Fontainebleau, France 150
Foord, John 17
Foord, Maggie 17
Force, Juliana 280
Ford Motor Company, River Rouge Plant 174
Foreign Correspondent 271
Forster, Thomas 234
Fort Peck dam, Montana 277
Fortune magazine 295, 382
The Forum Exhibition of Modern American Painters 77–78

Forum magazine 76
The Four Riders of the Apocalypse 240
491 (magazine) 60
Fox Talbot, William Henry 15–16, 26
France 269, 372, 380
 French Revolution 268
 German invasion 52
Franco, Francisco 262
Frank, Waldo
 and Bloch 224
 AS on 221
 and AS's 70th birthday 272
 AS's images of *58, 151*
 correspondence with AS 60, 261, 399
 and Hartley 147, 148
 and *MSS* 153
 and Dorothy Norman 341
 and *The Seven Arts* 60–61
 and Toomer 149
 and 291 gallery 61
 and William Carlos Williams 138
 The Jew in Our Day 383
 Our America 61, 144, 237
 see also America and Alfred Stieglitz: A Collective Portrait
Frankenthaler, Helen 411
Frankl, Paul 305
Franklin, Benjamin 18, 147
"French Modernists and Odilon Redon" (exhibition) 77
Freud, Sigmund 61, 88, 108, 145–46, 147, 158, 166, 167, 214, 411
 The Interpretation of Dreams 42, 49–50, 145
 Leonardo da Vinci: A Psychosexual Study of an Infantile Reminiscence 145
Fuller, Loïe 90
Fuller, Margaret 152
Futurism 43, 86

Gabo, Naum 155
Gandhi, Indira 341
Garbo, Greta 174, 267
Gardner, Alexander, *Photographic Sketchbook of the War* 16
Gauguin, Paul 74, 188
Genauer, Emily 397
Genthe, Arnold 116
Georgetown, Maine 175
Georgia O'Keeffe: A Portrait by Alfred

Stieglitz (exhibition) 105–6
Germany 26, 50, 52, 79, 91, 126, 136, 143, 173, 216, 403
 Nazi regime 262–64, 269, 370, 372, 387
 see also Stieglitz, Alfred, German roots and influences
Getty Museum, Los Angeles 90
Ghost Ranch, New Mexico 301, 399
Gibbs, Helen 50
Gibran, Kahlil 152
 The Prophet 84
Gifford, Samuel Robinson 218
Gilder, Richard 39
Gilpin, Laura 271
Glackens, William 280
Gleizes, Albert 80
Glens Falls, New York 363
Gluck, Christoph Willibald 24
Goerz lenses 30
Goethe, Johann Wolfgang von 20, 23, 234
 Faust 23, 89, 93, 128, 141, 166–67, 383
Goetz, Frederick 72, 154
Gogol, Nikolai 22
Golden Gate Bridge, San Francisco 266
Goldman, Emma 247
Goldsmith, Bee 186
Gone with the Wind 268
Goodrich, Lloyd 185
Goodyear, Anson Conger 188
Gorky, Arshile 265
Gorky, Maxim 383
Gowin, Emmet 58–59
Graeff, Werner, *Here Comes the New Photographer* 189
Graflex camera 30, 56, 231, 333, 364
Graham, Martha 50, 138
The Grapes of Wrath (film) 262
Great Britain 269
The Great Dictator 381
"Great German Art" exhibition 263
Green, Jonathan, *Camera Work: A Critical Anthology* 42–43
Greene, Balcombe 265
Greene, Belle 51
Griffith, D. W. 50
Gris, Juan 155
Grossberg, Paul 290
Grosz, George 174, 189, 283, 372
Group Theatre 292
Grundberg, Andy 233, 318

Guernica 262–63
Guggenheim, Peggy 388
Guggenheim, Solomon R. 281
Guggenheim Fellowships 382
Guislain, Jean-Marie 246
Guitry, Sacha 267
Gurdjieff, George 84, 150–51, 393
Guthrie, Woody
 Dust Bowl Ballads 381
 This Land is Your Land 381

Haldane, J. B. S., *Daedalus: or, Science and
 the Future* 246
Halpert, Edith Gregor 183–87, 400, 408
Halpert, Samuel 185, 186
Hamilton, Alexander 138
Hapgood, Hutchins 47, 50, 82, 83, 116
Harding, Warren 137
Harlem Renaissance 136
Harper's New Monthly Magazine 219–20
Harrison, William Preston 186
Hartford, Connecticut, Wadsworth
 Atheneum 276
Hartley, Marsden
 on AS 157
 AS on 368–69, 372, 389, 406
 and AS's 70th birthday 272
 AS's images of 95
 auction 143–44, 158
 correspondence with AS 125–28, 399
 death 389
 exhibitions 78, 79, 86, 88, 148, 168, 172,
 175, 182, 189, 280, 283, 293, 386, 390,
 392, 396
 Waldo Frank on 148
 and George Grosz 189
 and Samuel Halpert 187
 and David Liebovitz 245
 at Ogunquit 185
 and O'Keeffe 147–48, 173
 O'Keeffe on 130
 poetry of 149, 368–69
 and Rosenfeld 142
 and Société Anonyme 154
 and Stettheimer sisters 182
 and theme of nature 84, 115
 and theosophy 237
 and 291 gallery 50, 51
 Adventures in the Arts 147–48, 157, 173
 Last of New England – The Beginning of

New Mexico 94
Portrait of a German Officer 94
Twenty-Five Poems 149
The Warriors 79
Hartmann, Sadakichi 116
Harvard Society for Contemporary Art 189,
 276
Harvard University 168, 274, 300
 Fogg Museum 281
Hatfield, Henry 23
Havemeyer family 26
Haviland, George 89
Haviland, Paul Burty 44, 52, 55, 57, 82,
 88–89, 94
Hawaii 304, 377
Hawthorne, Nathaniel 147
Heade, Martin Johnson 218, 237
 Dark Hunters in the Marshes 237
 Lake George 237
 Lake George, New York 18
Heap, Jane 174
Hedgerow Theatre Group 406–7
Hegel, Friedrich 74, 240
Heliochrome Company 28, 33
Hemingway, Ernest 137, 143
 The Sun Also Rises 137
Henneberg, Hugo 61, 272
Henri, Robert 77
Hermann, Anna and Frank 202
Hermann, Eva *201*, 202, *203*, 283
Hess, Thomas 397
Hesse, Hermann 142, 152
Hill, David Octavius 101–4, 272, 279, 293,
 301, 389
Hindenberg (airship) 269
Hine, Lewis 36–37, 57, 62, 278, 305
 Men at Work 305
Hiroshima atomic bomb attack 381
Hirotaka 73
Hitchcock, Alfred 271, 381
Hitler, Adolf 262, 263, 289–90, 370, 380
Hoboken, New Jersey 15, 16
Hoeber, Arthur 86
Hoffman, K.
 *Back of Leopold Stieglitz's House, Lake
 George 367*
 *From Near An American Place Location
 315*
 Lake George 19, 394, 395
 Lake George – Location of House on "The

Hill" 222
Lake George House with Gable 159
*Leopold Stieglitz's House, Lake George
 367*
*Looking East From Near the Shelton
 Hotel 244*
*Looking South From Near the Shelton
 Hotel 243*
New York from Rockefeller Center 315
The Shelton Hotel 243
Hoffmann, Josef 43
Hofmann, Hans 265
Holland 372
Hollywood 381
Holmes, Oliver Wendell 11
Homer, *The Odyssey* 146
Homer, Winslow 148
 On the Road to Lake George 18
Hoover Dam 266
Hopper, Edward 188, 264
 Nighthawks 382
House Un-American Activities Committee
 289
Howard, Evelyn 285
Howard, Luke, "On the Modification of
 Clouds" 234
Hsieh Ho, Six Canons 407
Hudson River School 18, 218, 234–37
Hughes, Robert 13
Humphrey, Doris 50
Hunter, I. W. 51
Hurwitz, Leo 292
Huxley, T. H. 195

Ibsen, Henrik 23
impressionism 26, 76
Independent Woman 401
India 341, 346
India League of America 341
Ingres, Jean Auguste Dominique, *La Source*
 202
Institute for Harmonious Development,
 Fontainebleau, France 150
Iowa 374
Isaiah 272–73
Islam 173
Italy 26, 216
Ivins, William, Jr. 176

Jackson, William Henry 16

Jacobi, Lotte 387–88
 Abstractions 388
 Alfred Stieglitz at An American Place 378, 387–88
James, Henry 61, 148
James, William, *Character and Opinion in the United States* 145
Japan 73
The Jazz Singer 136, 176
Jefferson, Martha 18
Jefferson, Thomas 18
Jesus Christ 273
Jewell, Edward Alden 273, 316
John, gospel of 273
Johns Hopkins University 295
Johnson, Eric 224
Johnson, Philip 276, 278
Johnston, J. Dudley 412
Jolas, Eugene and Maria 271
Jolson, Al 136, 176
Josephson, Matthew 153
Joyce, James, *Ulysses* 146, 246
Judaism 383
Jung, Carl Gustav 108, 142, 271
 Psychological Types 238, 246
 Psychology of the Unconscious 145–46

Kafka, Franz 289
Kaiser Wilhelm II (liner) 55–56
Kalonyme, Louis 293
Kanaga, Consuelo 303
 "Negro Studies" 303
 She is a Tree of Life to Them 303
Kandinsky, Wassily 42, 45–46, 88, 93, 142, 155, 174, 281, 388, 390
 Concerning the Spiritual in Art 45, 237
 The Garden of Love (Improvisation Number 27) 45–46, *46*, 281
Kane, John 265
Kano Yeitoku 73
Karl August, Duke 20
Karlsruhe, Germany, Realgymnasium 22
Karlsruhe School (of painters) 26, 191
Käsebier, Gertrude 36, 39, 62, 272, 293, 390
Katwijk, Netherlands 202
Kazan, Elia 341
Keller, Helen 377
Kelley, Joseph 39, 57
Kennerley, Mitchell 156, 257
Kensett, John Frederick 237

Lake George 18
Keppler, Joseph 17
Kerfoot, J. B. 51
Keyserling, Hermann 142, 152
 Travel Diary of a Philosopher 143, 246
Kiesler, Frederick 388
King Kong 266
King, Martin Luther 12
Kirnon, Hodge 50, 96–97, *99*
Kirstein, Lincoln 189, 275, 276, 277
Klee, Paul 155, 174, 281
Klimt, Gustav 39
Kline, Frank 411
Kodak 29, 73
Koeniger, Ellen 104, *104*, 156
Koons, Jeff 411
Krauss, Rosalind 228
Kreisler, Fritz 255, 258
Kreymborg, Alfred 143, 153, 259
Ku Klux Klan 136, 137
Kuan-yin Pu-sa 282
Kühn, Heinrich 61, 272, 293, 390
Kuniyoshi, Yasuo 185

Lachaise, Gaston 152, 175, 180, 182, 183, 272, 304, 390
 portrait bust of Georgia O'Keeffe 175–76
Lafferty, René 86, 88
Lake George, New York 12, 13, 18–19, *19*, 24, 104, 106, 111, 128, 133, 135, 151–52, 159, *159*, 165, 188, 191, 200, 202, 206, 209, 212–13, 216, 218–20, *222*, 225, 233, 237, 268, *321*, 332, 333, 353–66, *367*, 380, *394*, *395*, 404, 411
 dying chestnut tree 123, *220*, 242–44, *243*, 291, 293, *355*, 363
 Fort William Henry Hotel 18
 The Hill 218, 243, 256, 259, 318, 350, 363
 Kanaga at 303
 Little House 348, 353, 374
 Oaklawn 19, 218, *394*
 Margaret Prosser and 346, 348, 353
 Swami Nikhilananda at 350–53
 see also O'Keeffe, Georgia, at Lake George; Stieglitz, Alfred, images of Lake George
Lamb, William 265
Lane, Fitzhugh 237
Lang, Fritz 136

Lange, Dorothea 277
 An American Exodus (with Paul Schuster Taylor) 277
 "Migrant Mother, Nipomo, California" 277
Lassaw, Ibram 265
Latimer, Marjorie 151
Laurencin, Marie 147
Laurent, Robert 185
Laurvik, J. N. 51
Lawrence, D. H. 83, 138, 146–47, 152, 251, 287, 370, 374, 389
 correspondence with AS 399
 death 261
 in Taos 271
 A Propos of Lady Chatterley's Lover 270–71
 Lady Chatterley's Lover 146–47
 Pansies: Poems 146
 Studies in Classic American Literature 147
 Sun 146
Lawrence, Frieda 83, 303, 399
Lawrence, Jacob 265
 Migration Series 382
Lawrence, Ruth 284
Lawrence, S. B. 93
Le Bègue, René 293
Le Witt, Sol 412
League of Nations 136
Leban, Harold 412
Lee, Russell 277
Léger, Fernand 155, 281, 388
Lenin, V. I. 172
Leonardo da Vinci 169
Lermontov, Mikhail Yuryevich, *A Hero in Our Times* 22
Lessing, Gotthold Ephraim 23
Levine, Jack 265
Levitt, Helen 278
Levy, Julien 274–75, 276, 278
Lewis, Arthur Allen 61
Lewis, Sinclair 264, 279
 Babbitt 137
 Main Street 137
Liebovitz, David 245–48
 John Hawthorn 245
 Youth Dares All 245
Life magazine 277, 391, 393
Lincoln, Abraham, Gettysburg Address 16

Lindbergh, Charles 262
Lipchitz, Jacques 389
Lippmann, Walter 153, 263
Liszt, Franz 23, 142, 259
Literary Guild 273
Little Galleries of the Photo-Secession *see* New York, 291 Gallery
The Little Review 146, 174
Loeb, Harold 153
Look magazine 277
Los Angeles
 County Museum 186–87
 Museum of History, Science and Art 186–87
The Lotus 74
Lowe, Sue Davidson *see* Davidson, Sue
Luce, Henry 277
Luhan, Tony 83, 254, 271
Luks, George 202
Luminist school 18, 218, 237
Lusitania, RMS 50
Lynes, George Platt 275
Lyrical Left 47

McAlpin, David Hunter 299, 384
 on AS 384–86
McBride, Henry 153, 156, 157, 169–70, 182, 183, 257, 265, 281
McCausland, Elizabeth 261, 277, 284, 306
McDonald, Dick and Mac 381
Macdonald-Wright, Stanton 76, 77, 78, 86, 88, 189, 272, 283, 390
"Machine Age Exposition" (1927) 174, 305
Mackintosh, Charles Rennie 43
MacLeish, Archibald
 Land of the Free 277
 Panic 262
Madison, James 18
Maeterlinck, Maurice 42
magic realism 265
Mahler, Gustav 142
Maine 126, 251
Malevich, Kasimir 155
Malinowski, Bronislaw, *The Sexual Life of Savages* 271
Malraux, André 289, 290
The Maltese Falcon 381
Man Ray 50, 77, 78, 80, 136, 148, 154, 155, 174, 189, 275, 276, 279, 372, 390
Manchester, New Jersey 213

Manet, Edouard 26, 396
Manhatta 72, 305
Mann, Thomas 152
 The Magic Mountain 270
 Past Master 270
Manolo, Manuel 46, 389
Manship, Paul, *Prometheus* 266
Margulies, Joseph 369
Marin, John
 "Artist in Exile" (exhibition) 284–85
 AS on 126, 175, 248, 363, 368, 369, 372, 377, 380, 406, 408
 and AS's 70th birthday 272
 at AS's wedding 167
 correspondence with AS 123, 129–30, 399
 Demuth and 176
 and Mabel Dodge Luhan 271
 estate of 400
 exhibitions 78, 86, 88, 158, 159, 168, 172, 174, 175, 177, 188, 189, 278, 283, 284–85, 293, 295, 301, 302, 386, 387, 389, 390, 391, 392, 396, 404
 as father 126
 images of New York 304, 388
 Liebovitz and 245
 at Meyer estate 89
 John Morris on 393
 Mumford and 272
 Dorothy Norman and 341
 Duncan Phillips and 187
 and Rosenfeld 142
 and Société Anonyme 155
 Strand on 166
 and theme of nature 84, 145
 Back of Bear Mountain 187
 Blue Sea 179
 Gray Sea 187
 Hudson River Near Blue Mountain 187
 Maine Island 187
 Near Great Barrington 187
 Pertaining to New York – Circus and Pink Ladies 391
 The Red Sun – Brooklyn Bridge 178
 Sunset Rockland County 187
 "To My Paint Children" 302–3
Marin, Marie 126
Martin, Paul 33
Marx, Karl 61
Mason, Alice 265

The Masses 172
La Maternelle 267
Matisse, Henri 38, 51, 76, 77, 126, 153, 188, 271, 272, 278, 293, 301, 389
 Ma Vie 190
Maurer, Alfred 78, 94–95, 269, 272, 386, 390
Medici, Piero de' 382
Medunetsky, Konstantin 155
Melville, Herman 147
 Moby-Dick 293–94
Mencken, H. L. 262
Mental Photographs album 19–22, *21*
Merriam, Eve 290
Metropolis 136
Mexican National Conservatory of Music 292
Mexican Symphony Orchestra 292
Meyer, Baron Adolf de 116, 182, 293
Meyer, Agnes Ernst 52, 55, 59, 72, 82, 89, 100, 127
Meyer, Eugene, Jr. 50, 51, 55, 127
Meyerovitz, Joel 412
Millay, Edna St. Vincent, *Conversation at Midnight* 262
Miller, Henry 289, 290
 The Amazing and Invariable Beauford Delaney 382
Miller, Kenneth Hayes 142, 280
Miller, Lee 275
Miró, Joan 155, 388
MMS 390
Model, Lisette 278
"Modern Photography at Home and Abroad" (exhibition) 276
Modern Times 267
The Modern Way of Picture Making 28
Modotti, Tina 189
Moholy-Nagy, László 189, 275, 276, 279, 281
Mondrian, Piet 155, 281
Montross, N. E. 50, 168
Moore, Marianne 152, 153
Morgan, J.P. 51
Morgan, J.P., and Company 63–64, *64*
Morgan, Willard 387
Morimura, Yasumara 411
Morocco 381
Morris, George L. K. 265
Morris, John 393
Morris, John T., Collection 69

Morris, Nelson 390–91
Morris, William 42
Morrison, Herbert 269
Motherwell, Robert 388
Mount Rushmore, South Dakota 266
Mozart, Wolfgang Amadeus 23
 The Magic Flute 17
MSS (*Manuscripts*) 153–54, 228, 251
Mt. Kisco, New York 89
Muir, Ward, "*Camera Work* and Its
 Creator" 72–73
Mumford, Lewis
 on AS 116, 272, 274, 283, 293–94
 AS on 258, 287, 372, 382
 and atomic bombs 383
 correspondence with AS 279, 399
 and Freudian interpretations 411
 Liebovitz and 245
 and Dorothy Norman 341
 on O'Keeffe 167, 287
 and Rosenfeld 143
 and skyscrapers 305
 *The Brown Decades: A Study in the Arts
 in America 1865–1895* 272
 City Development 274
 Faith for Living 382–83
 The Human Prospect 274
 Men Must Act 382
 "The Metropolitan Milieu" 274
 *see also America and Alfred Stieglitz: A
 Collective Portrait*
Munch, Edvard 152
Munich 148
Murren, Switzerland 221
Mussolini, Benito 262
Mutt, J. R., Ironworks 79
Mycerinus and His Queens 282
Myers, Virginia 113–16

Nadelman, Elie 61, 185
Naef, Weston 104, 108–11, 213
Nagasaki atomic bomb attack 381
Naill, Mahlon 406–7
Napierkowska, Stacia 81
Nashville, Tennessee, Fisk University 398
The Nation 97, 202, 251
National Art Week 401
National Birth Control League 49
Naumberg, Margaret 142
Nazi Party 262, 267

Nehru, Jawaharlal 341, 346
Nelson, W. H. de B. 77–78
Neumann, J. B. 174
Neutrality Act 269
New Deal 264, 266, 277
New England 138, 299
The New Masses 395
New Mexico 83, 135, 145, 146, 148, 151, 188,
 196, 248, 256, 271, 289, 292, 301, 304,
 348, 388, 399–400, 405
New Orleans 149
New Republic 167, 272, 382
New School for Social Research 155
New York 13, 16, 20, 23, 26–27, 36, 37, 52–53,
 57, 63, 153, 200, 277–78
 An American Place (gallery) 152, 268,
 279, 377, 389
 AS's images from 305, 306, *306, 308,
 309, 314,* 315, *315*
 "Beginnings and Landmarks, '291'
 (1905–1917)" 189, 300–301
 Chaplin at 240
 checklist for Ansel Adams exhibition
 290
 exhibitions 276, 278, 293–94, 299
 final exhibition and closing 391–93,
 410
 Fourteenth Annual Exhibition 301
 It Must Be Said 287
 Lotte Jacobi and 387
 E. A. Jewell on 273
 Henry Miller at 382
 Lewis Mumford on 283
 Beaumont Newhall and 386
 Victoria Ocampo on 273
 Georgia O'Keeffe and 400
 Paul Strand on 292
 Twice a Year (ed. Dorothy Norman)
 see Twice a Year
 Anderson Galleries 77–78, 123, 149, 156,
 158, 165, 168–70, 173, 187–88, 245, 246
 "Alfred Stieglitz Presents Seven
 Americans" 168–70, *169*
 Art of this Century Gallery 388
 Belmaison Gallery 154
 Beverly Hotel 245
 Bloomingdales 183
 Bourgeois Gallery 154
 Brooklyn Bridge 138, 269, 277, 388
 Brooklyn Museum 154

"42nd Annual Exhibit of Pictorial
 Photography" 275
International Exhibit of Modern Art
 (1926) 155
"International Photographers" 276
"Primitive Negro" art exhibition 136
Carnegie Hall 83, 381
Carroll Galleries 77
Charlier Institute 18, *18*
Chrysler Building 265, 306
Clarence H. White School of Photogra-
 phy 76
Cornell Center 306
Daniel Gallery 77, 127, 154, 187
De Zayas Gallery 72, 77
Delphic Studios 275
Downtown Gallery (Our Gallery)
 186–87
East 54th Street 305, 306, 332, 384
East River 306
Ehrich Gallery 63
Empire State Building 265–66, 305, 306
Federal Hall 63
Fifth Avenue 29, 37
Flatiron building 304
foundation 138, 189–90, 259
George Washington Bridge 266
Grand Army Plaza 33
Grand Central Palace 79
Greenwich Village 172, 186
Haas Gallery 76
Harlem 136
Hindu Center 350
Hotel and Industrial Mart 306
Hotel Pierre 305
Intimate Gallery 155, 167, 168, 172–75,
 177–78, 180–82, 187, 196, 243, 245,
 291, 389, 390
 AS closes down 187–88
 "Paul Strand: New Photographs"
 174–75
Julien Levy gallery 274, 275, 278
Lincoln Warehouse 187
Little Review Gallery 174
Macy's 183
Madison Square Garden 26
Manhattan Life Insurance Building 26
Marquis Apartment/Hotel 101
Metropolitan Museum of Art 26, 87, 89,
 154, 165, 176, 183, 263, 280, 398, 403

Metropolitan Opera House 381–82
Modern Gallery (later De Zayas Gallery) 59, 61, 69, 70, 72, 77, 79
Montross Gallery 77, 154, 168, 185, 188
Museum of Modern Art 87, 136, 183, 187, 188, 266, 276, 278–79, 296, 389, 403
 American Photographs (monograph) 277
 and Stieglitz collection 398
 Department of Photography 295, 299, 384, *385*
 "Abstraction in Photography" 388
 "Alfred Stieglitz: His Photography and Collection" 396–98
 "Art in Progress: Fiftieth Anniversary Exhibition" 387
 "Britain at War" 387
 "Cubism and Abstract Art" 278
 "Family of Man" 346, 387
 "Fantastic Art, Dada, and Surrealism" 278
 "Machine Art" 278
 "Mass Media" 387
 "Murals by American Painters and Photographers" 276
 "New Acquisitions: Photographs by Alfred Stieglitz" 386–87
 "Paintings by Nineteen Living Americans" 188, 274
 "Photographs of Nineteenth Century American Houses by Walker Evans" 276
 "Photography 1839–1937" 278–79
 "Power in the Pacific" 387
 "Road to Victory" 387
 "Romantic Painting in America" 387
 "Sixty Photographs: A Survey of Camera Aesthetics" 384
 "Twentieth Century Portraits" 386–87
 "War Comes to the People, a Story Written with the Lens" 387
National Academy of Design 183
National Arts Club 39
New Art Circle 174
New York Trust Company 305
 Dorothy Norman and 180, 282, 285, 288, 333, 340
Penguin Gallery 79
People's Art Guild 185

Post Office 30
Pratt Institute 76
Radio City Music Hall 266, 287
R.C.A. building 266
RCA Victor Building (later GE Building) 305
Rockefeller Center 172, 266, 306, 314
Rockefeller Institute 272
St Patrick's Cathedral 314
Savoy Hotel 33
Shelton Hotel *10*, 83, 176, *242*, *243*, *244–45*, *244*, 305, *311*, *312*, *313*
Singer Building 43, 304
Sixty-Ninth Regiment Armory 45
Société Anonyme 84, 154–55
Solomon R. Guggenheim Museum (earlier Museum of Non-Objective Painting) 280, 281
Squibb Company 305
Steinway Hall 174
Sterns Brothers 183
Theater Guild 245
Triboro Bridge 266
291 Gallery (earlier Little Galleries of the Photo-Secession)
 and *291* magazine 52–53
 African art exhibition (1914) 136
 and An American Place 300–301, 410
 AS on 89, 91
 AS's catalogue of past exhibitions 293
 and *Camera Work* 42–43, 50, 53, 96–97
 closes down 91–92
 commemorative exhibitions 300–301, 389–90
 debates at 145
 exhibitions 61–2, 84–8, 89=90 94, 158, 278
 founded 38
 Edith Gregor Halpert and 185
 as inspiration for other galleries 77
 and MoMA 188
 Mumford on 283
 opening 43–44, 293
 responses to 51–52
 Rosenfeld and 143
 Strand and 64–66
Waldorf Astoria Hotel 305
Welfare Island (later Roosevelt Island) 306

Weyhe Gallery, "Photographs of Art Forms in Nature" (Blossfeldt) 275
Whitney Museum of American Art 183, 185, 274, 280–81
 "First Biennial Exhibition of Contemporary Paintings" 280–81
Whitney Studio Club 185
Woolworth Building 304, 305
World's Fair 266–67
World's Fair Tomorrow Committee 377
Zabriskie Gallery 392
see also Armory Show; Stieglitz, Alfred, images of New York
New York Camera Club 31, 38, 63
New York Dada 148, 390
New York Evening Express 16
New York Evening Post 170
New York Globe 86
New York Herald Tribune 272, 396–97
New York Morning Sun 52
New York Post 346
New York Times 17, 273, 394–95, 398
New York Tribune 263, 381
New York World Telegram 394
New Yorker 272, 283, 287
Newhall, Beaumont 279, 295, 299, 384, 386, 387, 398, 401
Newhall, Nancy 380, 386, 398, 412
Nicholson, Irving 290
Nietzsche, Friedrich 42, 61, 231
Nijinsky, Vaslav 113
Nikhilananda, Swami 304, 350–53, *352*, 364, 365, 374
 Hinduism, Its Meaning for the Liberation of the Spirit 350
 Man in Search of Immortality 350
Noguchi, Hideyo 271–72
Norman, Dorothy 332–46
 and *An American Place* 287, 333, 340
 and Coomaraswamy 341
 and Paul Strand 340
 AS on 408
 and AS's epitaph 394
 at AS's funeral 393–94
 correspondence with AS 180, 286
 exhibited 384
 founds Alfred Stieglitz Center 398
 on AS 273, 288, 300–301
 portraits of AS 333–40, 340, *344–46*, 390

Alfred Stieglitz 344
Alfred Stieglitz, New York 344
Alfred Stieglitz Spotting Photograph of Dorothy Norman (with Marin paintings and Stieglitz Photograph in Background) An American Place, New York 345
Alfred Stieglitz XXII 345
Dualities 285–86, 294
"The Purity of Alfred Stieglitz – White Disc Against Any Color" 286
Stieglitz and Steichen, An American Place 346
Stieglitz's Hat and Coat in Stieglitz Vault, An American Place 345
Telephone in Front of Stieglitz Equivalent 345
(ed.) *Twice a Year* see *Twice a Year*
"A World to Live in" 346
see also Stieglitz, Alfred, images of Dorothy Norman; Stieglitz, Alfred, relationship with Dorothy Norman
Norman, Edward A. 177, 180, 181
Norman, Nancy 178
Northrop, F. S. C., *The Meeting of East and West: An Inquiry Concerning World Understanding* 75
Norton, Charles Eliot 73
Nuremberg rally 262

Oakland, California 275
Obama, Barack 12
Obermeyer, Mrs 33
O'Brien, Frances 202, *202–6, 204, 205*
Ocampo, Victoria 273
Occultism 150
Odessa, Russia 183
Office of War Information (O.W.I.) 381
Ogunquit, Maine 185–86
O'Keeffe, Alexius 151
O'Keeffe, Claudia 131, 133, 202, 209–12, *209*
O'Keeffe, Georgia
 and Adams 299
 and Sherwood Anderson 149
 on AS 398
 and AS memorial exhibition 396
 and AS's cloud images 221, 223
 at AS's funeral 393–94
 AS's images of 37, 48, *48*, 96, 104, 105, *105–23, 106–13, 115, 117–22,* 156,

190–202, *191–98,* 196, *212–13,* 229, 232, 240, *260,* 291, 293, 304, 320–33, *320, 321, 321–22, 324–32,* 332, *347, 349, 351, 390*
 and Bragdon 83
 and *Camera Work* 61, 68
 crisis over Radio City Music Hall mural 349–50
 and Beauford Delaney 382
 and Demuth 176
 distribution of Stieglitz collection 398–99
 and Mabel Dodge Luhan 42, 83, 188, 271, 303, 388
 and Dove 176
 and Arthur Wesley Dow 74–75
 and Katherine Dreier 155
 as driver 196–200
 erotic connotations found in work of 89, 166–67
 exhibitions 79, 86, 89–90, 158, 165–67, 168, 172, 173, 175, 188, 189–90, 280–81, 283–84, 287, 301, 387, 388, 390, 391–92, 396, 400, 408
 Ralph Flint on 280–81
 and Edith Gregor Halpert 187
 and Hartley 147–48
 images of hands 13, 72, *109, 192*
 influences 83–84, 145
 and Kirstein 189
 at Lake George 60, 95, 218, 231, 245, 247–48, 287, 304, 318, 350
 and D. H. Lawrence 146–47, 261, 287
 letter to AS *253*
 library of 145
 and Liebovitz 246, 247
 and *MSS* 153
 and Mumford 272, 287
 in New Mexico 83, 188, 196, 271, 289, 321, 348
 Frances O'Brien on 202–6
 one-person show at 291 88, 112–13, 158
 and Margaret Prosser 349–50
 Frank Prosser on 348
 and Rodakiewicz 268
 and Rosenfeld 142, 259
 on Steichen 403
 and Florine Stettheimer 182–83
 Strand on 166
 and Toomer 151–52

travels 135, 287, 304
 Edmund Wilson on 170
 and world of nature 84, 145
 and World's Fair Commission 267
 and W.P.A. projects 265
 Abstraction 111–12
 Birch and Pine Tree, No. 1 186
 Black Cross, New Mexico 188, 388
 Black Iris 184, 283
 Black Lines 75
 Blue and Green Music 90, 186
 Blue I 111
 Blue Lines 75, 376
 Blue Nos. 1–4 113
 Cow's Skull; Red, White and Blue 284
 Farm House Window and Door 280–81
 First Drawing of Blue Lines 75
 Jack in the Pulpit series 75
 Lake George with Crows 149, 214
 Music Pink and Blue I 112, 156
 Music Pink and Blue, No. 2 214
 My Shanty 190
 No. 9 Special 90, 113
 No. 12 Special 111
 No. 15 Special 111
 No. 17 Special 111
 Pelvis with Shadows and the Moon 406
 Radiator Building 188
 Ranchos Church 368, 369, 374
 Specials series 23
 Summer Days 283
 Untitled 149, 214
 The Wave 214
 White Birch 190
 The White Wave 149, 214
 Yellow Hickory Leaves with Daisy 185
 see also Stieglitz, Alfred, correspondence with Georgia O'Keeffe; relationship with Georgia O'Keeffe
O'Keeffe, Ida 202, 212–13, *212, 213,* 370, 386
Oklahoma 381
Olana, Hudson, N.Y. 237
O'Neill, Eugene 143, 176
Oppenheim, James 60, 61
Orage, Alfred Richard 84, 150
Ornstein, Leo 142, 153
Ouspensky, P. D., *Tertium Organum: The Third Canon of Thought, a Key to the Enigmas of the World* 84, 237
Outcast series 382

Palmer raids 136, 137
Paris 38, 76, 85, 96, 148, 271, 274, 390, 396
 fall of 267
 Galérie Surréaliste 136
 International Art and Industry (Art
 Deco) exhibition (1925) 136, 186
 Salon 16
Paterson, New Jersey 138
Pearl Harbor 269, 380
Peignot, Charles 279
Pennsylvania
 Museum *see* Philadelphia Museum of Art
 University 177
Peschel, Oskar 195
Peterson, Christian 31–32
Petrouchka 113
Phidias 169
Philadelphia Museum of Art (earlier
 Pennsylvania Museum) 67, 398
 Alfred Stieglitz Center 398
 "History of an American: Alfred
 Stieglitz, '291' and After" 389–90
Phillips, Duncan 187, 188, 406
Phillips, Mrs 187, 406
Phillips Exeter Academy 168
Photo League 278, 303, 397
Photo-Notes 397
Photo-Secession 39, 62, 292, 390, 411
Photochrome company 28
Photographic Mosaics 28
Photographic Society of Great Britain 28
Photographic Society of London 16
Photographic Society of Philadelphia 27
Die Photographische Rundschau 26
Photography 101
Photography, A Short Critical History
 (exhibition catalogue) 279
Picabia, Francis 51, 52, 55, 59, 60, 77, 80,
 81–82, 83, 89, 90, 126, 155, 175, 278, 301,
 389, 390
 *Chanson Negre I and II (Negro Song I
 and II)* 81
 *Danseuse étoile et son école de danse (Star
 Dancer with her Dance School)* 81, *81*
 *Danseuse étoile sur un translantique (Star
 Dancer on a Transatlantic Liner)* 81
 La Musique est comme la peinture 82
 Portrait of Alfred Stieglitz 52, 55
Picasso, Pablo 11, 38, 46, 59, 61, 62, 77, 126,
 141, 152, 153, 188, 212, 272, 278, 293, 301,

388, 389, 392
 Les Demoiselles d'Avignon 58
 Guernica 262–63
 Head of a Woman 94
 Standing Nude 278
 Still Life 62, 94–95
pictorialism 28, 32, 36, 411
Pierie, Captain William 218
Plato
 Phaedo 354
 Philebus 278
 Timaeus 75
Playboy: A Portfolio of Art and Satire 166
The Plow that Broke the Plains 292
Pocahontas 139
Poe, Edgar Allan 138, 147
Poland, invasion of 267
Pollitzer, Anita 88, 408
Pollock, Jackson 388
Pont-Aven 74
Popular Photography 390–91, 397
Porter, Eliot 189, 275, *298*, 299–300, 384,
 390, 392, 411
 Jonathan 299
 Penobscot Bay from Eagle Island 300
 Sick Herring Gull 298
 *Song Sparrow's Nest in Blueberry Bush
 299*
Porter, Fairfield 299, 300
*Portrait of a Young Man in Three Move-
 ments* 268
Post, William B. 29
Pound, Ezra 74, 152, 153
Pozner, Vladimir 290
Precisionists 68, 138, 176
Progressive Party 49
Prohibition 267
Prosser, Frank 348–49, *350, 351,* 364, 367,
 376
Prosser, Margaret 304, 346–50, *347, 348,
 349,* 353, 363, 367, 368, 369, 374
 on AS and O'Keeffe 349
Proust, Marcel 152
Provincetown Players 50
psychoanalysis 42
Puck magazine 17
Pushkin, Alexander Sergeyevich 22
Putnam, H. Phelps 370
Putnam, Wallace Bradstreet 303
Puyo, C. 293

Quakers 151
Quinn, John 78–79, 84

Rand School for Social Science 155
Rapp, Marie (later Boursault) 50–51, 89, 95,
 96, 97, 127
Rasay, Charles 50
Read, Helen Appleton 165–66, 170, 275
Rebay, Baroness Hilla 281
Reed, Alma 275
Reed, John 47, 83, 172
Rembrandt van Rijn 56
Renoir, Pierre-Auguste 389
Rettig, Julie 20
Reyher, Ferdinand 393
Rhoades, Katharine Nash 95, 96, 100,
 231–32
Rich, Daniel Catton 75–76, 388
Richardson, Henry 272
Richter, Hans 341
Riefenstahl, Leni 262
Riis, Jacob 36
Rilke, Rainer Maria 152, 220, 289, 290
 Letters to a Young Poet 287–88
 Moving Forward 242, 410
 Notebooks of Malte Laurids Brigge 228
 On Music 240–42
Rimsky-Korsakoff, Nikolai 142
Rivera, Diego 77, 172, 390
Robinson, Henry Peach 28
Rockefeller, Abby Aldrich 187, 188, 280
Rockefeller, Nelson 276
Rockwell, Norman 380
Rodakiewicz, Henwar 268, 384, 400–401
Rodgers, Richard, and Hammerstein, Oscar
 381
Rodin, Auguste 38, 85, 88, 90, 126, 132, 190,
 272, 293, 389
Roebling, John A. 269
Roh, Franz, *Foto-Eye* 189
Romanticism 141, 234, 357
Rome 153
Rönnebeck, Arnold 169, *170*
Roosevelt, Eleanor 377
Roosevelt, Franklin D. 264, 266, 276–77,
 380
 "Four Freedoms Speech" 379
Roosevelt, Theodore 18, 49, 93
Root, John 272
Rosenfeld, Paul

on AS 22, 111, 149, 157, 396
and AS 262, 264, 272
AS on 252, 368, 369
and AS's 70th birthday 272
AS's portraits of *59*, 144–45, *144*, 214, 291
and Bloch 224, 228
correspondence with AS 142, 143, 175, 248, 258–59, 370, 372, 399
death 396
as editor of anthologies 143
and Freudian interpretations 411
at Lake George 60
and *MSS* 153
and music 60, 191–92, 224, 228
and *The Seven Arts* 60–61, 138
soirées 90
in Stettheimer portrait of AS 182
works 142
(ed.) *The American Caravan* (with Lewis Mumford and Alfred Kreymborg) 143, 259, 372
An Hour with American Music 258–59
Musical Portraits 144
Port of New York 142–43, 153, 215
Ross, Cary 287, 293, 370
Rosskam, Edwin 277
Rothko, Mark 388, 411
Rothstein, Arthur 277
Rouault, Georges 174
Rousseau, Henri 148
Royal Photographic Society 168
Rugg, Harold 272
Ruskin, John, *Modern Painters* 234
Russell, Bertrand 251
Icarus: or the Future of Science 246
Russell, Morgan 77, 88, 390
Russell Company 33
Russia 267, 381, 403
Revolution 136, 172
Ryder, Albert Pinkham 132, 142
Rye, New York 113

Sacco and Vanzetti case 137, 265
St. Denis, Ruth 50
Salmon, André 271
San Francisco 297
DeYoung Museum 297
Laurel Hill cemetery 298
Museum of Modern Art 398

Sand, George 290
Sandburg, Carl 142, 152, 153
Mary Lincoln 372
Smoke and Steel 144
Sanger, Margaret 49
Santa Fe, New Mexico 399
Santayana, George 152
"Little Essay" 145
Realms of Being 270
Realms of Truth 270
The Sense of Beauty 145
Saroyan, William 382
Saturday Evening Post 380
Saturday Review 396
Schadow, Johann 20
Schamberg, Morton 69, 72, 80, 155
Schauffler, Bennet and Marnie 186
Schiller, Friedrich 23
Schinkel, Karl Friedrich 20
Schliemann, Heinrich 20
Schnelle, Werner 412
Schoenberg, Arnold 142, 153
School of Wisdom 143
Schubart, Dorothy 123
Schubart, William (AS's nephew) 123
Schumann, Robert 23, 24
Schwitters, Kurt, *Merz* collages 155
Scopes Trial 137, 172, 240
Scriabin, Alexander, *Prometheus: The Poem of Fire* 83
Sears Roebuck 177
Secessionists 214
Secretariat of Education 292
Seeley, George 116, 293
Sekula, Allan 57
Seligmann, Herbert 143, 153, 157, 172–73, 232, 243, 245, 251, 289, 291, 357, 369, 398, 399
Alfred Stieglitz Talking 173
"Observations on Barbarism and its Alternatives" 290
Sessions, Roger 142
Seurat, Georges 188
The Seven Arts 60–61, 67, 138
791 (magazine) 60
Severini, Gino 78, 86–87, 90, 278, 293, 301, 390
Danseuse = Hélice = Mer (*Dancer = Helix = Sea*) 86, 87
Femme et enfant (*Woman and Child*) 86, 87

Nature morte (expansion centrifuge de couleurs) 87
Shahn, Ben 265, 277
Shakespeare, William 23
King Lear 383
Othello 383
Shaw, George Bernard
Nine Answers 146
St Joan 265
Shawn, Ted 50
Sheehan, Vincent 271
Sheeler, Charles 68–72, 78, 80, 138, 160, 174, 187, 189, 275, 279, 305, 390, 411
Doylestown House – The Stove 69–70, *70*
Open Door with Desk Mirror 69–70
River Rouge series 276
The Sheik 136
Shelley, Percy Bysshe 234
Sherman, Cindy 411
Sherwood, Robert, *The Petrified Forest* 262
Shirer, William 381
Shostakovich, Dmitri 267
Shreve, Lamb and Harmon 265
Sierra Nevada 298
significant form 411
Simmons, Laurie 411
Simonson, Lee 125
Sinclair, Upton, *The Goose Step* 137
Sipprell, Clara 275
691 (magazine) 60
Sloan, John 188
Smith College, Northampton 34, 168, 177
Smith, Pamela Colman 44, 74
Smith, W. Eugene 397
Snow White and the Seven Dwarfs 268
Soby, James Thrall 379, 384, 396
social realism 264, 292
Société Française de Photographie 16
Society of Amateur Photographers 27–28, 29, 30, 31
Society of Independent Artists 79, 82
Sommer, Frederick 303
South Carolina 112
Spanish Civil War 262–63, 271
Sparta, Georgia 150
Le Spectre de la rose 113
Speicher, Eugene 280
Spellbound 381
Spencer, Niles 280
Spewack, Samuel, *The Skyscraper Murder* 305

Springfield Union and Republican 284
Squibb Institute for Medical Research, New Brunswick 263
Stagecoach 240
Stalin, Josef 262
Steamboat Willie 136
Stearns, Milton (AS's grandson) 167–68, 282, 380
Stearns, Milton Sprague (AS's son-in-law) 34, 168, 380
Steffens, Lincoln 83
Steichen, Edward *346*
 on AS 390
 and AS's 70th birthday 272
 at AS's funeral 393–94
 belief in arts 467
 and Bergson 42
 and *Camera Work* 43, 61
 collaboration with AS 34, 38
 commercial work 174, 387
 and Condé Nast 174, 411–12
 correspondence with AS 46–47, 399
 and dance imagery 116
 exhibitions 276, 279, 293, 389–90
 "Family of Man" (exhibition) 303, 346, 387
 images of children 36
 images of New York 39, 304
 "In and Out of Focus" (exhibition) 388
 and Intimate Gallery 182
 as leading photographer 276
 and MoMA 387, 398
 O'Keeffe on 403
 and Alma Reed 275–76
 relationship with AS 37–38
 rift with AS 13, 265, 387, 390, 411
 and 291 gallery 43, 44, 52, 61–62
 visit to AS 408
 and *Vogue* 403
 "The Fighting Photo-Secession" 390
 The Pond Moonlight 11
Stein, Gertrude 42, 143, 149, 152, 153, 176, 183, 271, 272, 399
 The Autobiography of Alice B. Toklas 271
Stein, Leo 96, *97*, 153
Steinbeck, *The Grapes of Wrath* 262
Steiner, Ralph 174, 189, 275, 279, 292
Steinheil company 26
Stella, Joseph 154, 155, 269, 280
Stendhal, *The Red and the Black* 270, 363

Stettheimer, Carrie 182, 183
Stettheimer, Ettie
 Crystal Flowers 182–83
 Love Days 182
Stettheimer, Florine 182–83, 390
 Cathedrals of Art 183
 Cathedrals of Fifth Avenue 280–81
 "cathedrals" series of paintings 183
 Portrait of Alfred Stieglitz 182
Stevens, Wallace 137, 152
Stieglitz, Agnes (AS's sister) 17, 374
Stieglitz, Alfred *52, 101, 344–46, 378*
 autograph album 19–20
 Bloch on 228
 character and personality 19, 24, 25
 cloud images 220–42, 251, 316–20
 correspondence with Georgia O'Keeffe 12–13, 70–72, 91, 93, 127–28, 130–33, 139, 146, 217, 248–58, *253*, 268, 270, 280–82, 301–2, 346, 350–53, 363, 364–65, 366–77, *371, 373, 375*, 383, 399, 400–410, *402, 405, 409*
 correspondence and papers at Beinecke Library 399
 distribution of collection after death 398–99
 German roots and influences 16–17, 22, 61, 88, 93, 108, 141, 145, 173, 174, 195, 246, 354
 Andy Grundberg on 318
 ill-health 168, 304, 377, 384
 images of Lake George 123, *161*, 212–13, *215–16*, 217–18, 219, *219–21*, 225–27, 231, 279, 297, *321, 347–51*, 354, *354–56, 358, 360–62, 364–66*
 images of New York 31, 33, 37, 39, 43, 244–45, 246, 278, 290–91, 293, 297, 304–16, 318
 images of Dorothy Norman 294, 304, 332–33, *334–43*, 386
 images of trees 101, 117, 123, 217, 243–44, 268, 291, 354, 357, 363, 397
 interest in cinema 136, 240, 267–68, 382
 interest in music 23–24, 28, 159, 220–28, 234, 255–56, 258, 270, 291, 295–96, 354, 382
 Julien Levy on 275
 literary and cultural influences 22–24, 138–54, 270–74
 Nelson Morris on 390–91

 Mumford on 274, 279, 293–94
 as non–driver 196–200
 Dorothy Norman on 273, 288, 300–301
 relationship with Dorothy Norman 177–82, 188, 285–87, 332–41
 relationship with Georgia O'Keeffe 83, 117–22, 133, 135, 146, 151–52, 188, 190, 196, 200–202, 231, 244, 259, 349, 399–400, 410
 on religion 173
 replies to questionnaire 20–22
 scrapbooks 23
 sexuality and love of women 213–14, 270–71
 Steichen on 390
 on Paul Strand 64–67
 Zigrosser on 389
 see also O'Keeffe, Georgia, AS's images of
 LIFE
 birth 15
 childhood 16–22
 education 18, 22
 in Berlin 22–26
 decides on career as photographer 25–26
 in Vienna 25, 26
 returns to New York 26–27
 becomes editor of *American Amateur Photographer* 28
 becomes editor of *Camera Notes* 31
 marries Emmeline Obermeyer 33
 birth of daughter Kitty 33
 founds Photo-Secession 39
 founds *Camera Work* 42
 opening of 291 gallery 43–44
 first one-man exhibition 45
 marriage to Emmy fails 92
 moves into 291 building 92–93
 lives with O'Keeffe at East 59th and East 65th Streets 135
 second exhibition 159–65
 third exhibition 165
 opens Intimate Gallery 167, 168
 divorced from Emmy and marries Georgia O'Keeffe 167–68, 213
 awarded Progress Medal of RPS 168
 moves into Shelton Hotel with O'Keeffe 83, 244, 305
 opens An American Place 189–90, 259

celebration volume for 70th birthday 272–74

retrospectives 276, 290–92, 293–94

suffers heart attack 304

moves to East 54th Street with O'Keeffe 305, 332, 384

80th birthday 390–91

death and funeral 189, 391, 393–94

obituaries and posthumous tributes 394–400

WORKS

Abendstimmung (Amerika) 26

The Aeroplane 43, 86, *87*

After the Rain 217

After a Walk Back of Mabel's 320

Alfred Maurer 95

Apple Blossoms 217, 249

Apples and Gable of the Farm, in Rain 386

Apples and Gable, Lake George 217–18, *219*

The Approaching Storm 26

Arnold Rönnebeck 170

Arthur Dove 96

Back of the Little House 359

The Barn, Lake George 357

Barns, Lake George 217, 297

Birds, Apples and Gable, Death (series) 218

The Black Barn and White Snow 207, 217

The Blizzard, New York 31

Charles Demuth 97, 175

Chestnut Tree, Lake George 355

Chicken House – Lake George 216

Chicken House, Window with Snow, Lake George 216

The City of Ambition 43, 45, 72, 156

Claudia O'Keeffe 209

Clouds – Music No. 6 162

Clouds – Music No. 7 163

Clouds – Music No. 8 164

Dancing Trees 221

A Dirigible 43, 86

Dorothy Norman 341

Dorothy Norman with Camera 343

Dorothy Norman (Hands) 334

Dorothy Norman LXXIV 338

Dorothy Norman LXXVII 339

Dorothy Norman LXXXII 340

Dorothy Norman LXXXVII 340

Dorothy Norman with Telephone XXXVIII 341

Dorothy Norman XIV – Woods Hole 335

Dorothy Norman XLII 336

Dorothy Norman XXIV – Hands with Camera 342

Dorothy Norman XXVII 337

Dorothy True 123, *124*

Dualities 294

Duchamp's *Fountain* 79

The Dying Chestnut at Lake George 123

The Dying Chestnut Tree – My Teacher 220, 243, 291

East River from the 38th Story of the Shelton Hotel 244

Eliot Porter 298

Ellen Koeniger 104, *104*, 156

Emil Zoler 98

Equivalent 235, 236, 238, 239, 317, 318, 319

Equivalent 27A, 27B, 27C 316

Equivalent, A3 230

Equivalents 236

Equivalents (series) 19, 24, 43, 157, 160, 179, 196, 220, 228, 233–34, 237–42, 259, 268, 290, 291, 293, 296, 297, 304, 315, 316–20, 357, 388, 392, 412

Eva Hermann 201, 203

The Ferry Boat 43, 72

First Snow and the Little House 359

The Flatiron 39, 40, 41, 291

Frances O'Brien 204, 205

Frank Prosser 350

Frank Prosser and Emil Zoler, Lake George 351

Frank Prosser and Friends at Lake George 350

Frank Prosser, Lake George 351

From An American Place 305, 306, 309

From An American Place Looking North 307

From the Back Window of 291, Snow–Covered Tree, Back Yard 100, *103*

From My Window at the Shelton North 10

From Room 3003, The Shelton, New York, Looking North-East 242

From the Shelton 313

From the Shelton Hotel 311

From the Shelton Looking North 241

From the Shelton, New York, Looking East 244

From the Shelton West 313

From the Window of 291 102

Georgia and Ida O'Keeffe, Lake George 212, 213

Georgia O'Keeffe 48, 106, 107, 108, 110, 113, 115, 119, 122, 193, 194, 195, 196, 197, 260, 320, 322, 324, 325, 328, 329, 330, 332

Georgia O'Keeffe: A Portrait 112, 118, 120, 121, 195, 196, 198, 326, 327, 331, 332

Georgia O'Keeffe – A Portrait 323

Georgia O'Keeffe – A Portrait – Hands 109

Georgia O'Keeffe – After Return from New Mexico, Equivalent O 196

Georgia O'Keeffe – [Feet] 108

Georgia O'Keeffe – Hands 192

Georgia O'Keeffe – a Portrait 114

Georgia O'Keeffe and Donald Davidson Pruning Trees 191

Georgia O'Keeffe and Frank Prosser at Lake George 351

Georgia O'Keeffe Leaning on a Car 321, *321*, 332

Georgia O'Keeffe and Margaret Prosser at Lake George 347

Georgia O'Keeffe Sitting on the Lawn at Oaklawn 105

Granddaughter of Marie Rapp with a Farmer Shucking Corn 215

The Hand of Man 39, 43, 72, 156, 291

Hedwig Stieglitz 199

Hodge Kirnon 99

House and Grape Leaves, Lake George, New York 279, 354

House and Poplars, Lake George 358

Icy Night 291

In the New York Central Stockyards 39, 72

Installation view of the Kühn, Henneberg, Watzek exhibition 62

Interpretation 112, 117

Jean Toomer *151*
John Marin *177*
Katharine Rhoades in a Hammock *100*
Katherine Dudley *200*
Kitty in Profile *36*
Konrad Cramer *96*
Lake George *227*, *231*
Lake George – the Barn with Tree *215*, *297*
Lake George – Music No. 2 *161*
Lake George From the Hill *362*
Lake George, House on the Hill *358*
Lake George Porch *361*
The Last Days of *291* *91–92*, *92*
"The Last Joke, Bellagio" or "A Good Joke" *25*, *156*
The Last Load *216*
Later Lake George *220*, *356*, *360*, *365*
Leo Stein *97*
letter to Ida O'Keeffe *250*
letters to Georgia O'Keeffe *133*, *254*, *257*
Life and Death *243*
Life and Death – Hands and Skull *321*
The Little House – Front View *223*
Looking North From An American Place, New York *308*
Marcel Duchamp *53*
Margaret Prosser *347*
Margaret Prosser, Kitchen, Lake George *349*
Margaret Prosser, Lake George *347*
Margaret Prosser Seated Outside, Sewing *349*
Margaret Prosser Sorting Blueberries, Lake George *348*
Margaret Prosser's Clasped Hands in Lap *348*
Marsden Hartley *95*
Mittenwald *216*
Music: A Sequence of Ten Cloud Photographs (Clouds in Ten Movements) *159*, *159*, *160*, *220–31*
My Room at 14 East Sixtieth Street *17*
New York *310*
New York – Night *384*, *385*
New York from 405 R. 54th St. *316*
New York from An American Place *306*

New York from the Shelton *312*
New York, Spring *312*
Night – Fifth Avenue *291*
Night – The Savoy *291*
Nudes in Lake *291*
The Old Maple, Lake George *221*
Old and New New York *43*, *71*, *72*, *101*, *304*
Paul Rosenfeld *144*
Paul Rosenfeld with Books *59*
"Photographic Journal of a Baby" *34–36*, *35*
Picasso/Braque exhibition *63*
Picturesque Bits of New York and Other Stories *33*
Poplars *297*
Poplars, Lake George *354*
Portrait – K. N. R., No. 1 – Songs of the Sky C *232*
Portrait – K. N. R., No. 4 – Songs of the Sky C4 *232*
Portrait – K. N. R., No. 6 – Songs of the Sky *231*
Portrait of Georgia, No. 2 – Songs of the Sky *232*
Portrait of Georgia, No. 3 – Songs of the Sky *229*, *232*
Primitive Negro Sculpture exhibition *62*
Rain Drops *224*
Rainbow, Lake George *226*
Rebecca Salsbury Strand *207*, *208*
Rebecca Strand *206*
River, New York *244*
Savoy Hotel, New York *33*
Shadows on the Lake *85*, *85*
Sherwood Anderson *150*
Songs of the Sky, A7 *233*
Songs of the Sky (series) *19*, *24*, *43*, *160*, *231–33*, *240*, *357*
Spiritual America – Songs of the Sky A *232*, *233*
The Steerage *54*, *55–59*, *91*, *156*, *177*, *291*, *315*, *407*
The Street – Design for a Poster *37*, *38*
Study at Lake George *362*
Sun Rays, Paula (Sunlight and Shadow) *24*, *26*, *27*, *67*
Swami Nikhilananda *352*
The Terminal *29*, *32*, *43*, *156*, *291*

Torsos *291*
Tree Set 3 *357*
Tristan Motif *291*
291 – Georgia O'Keeffe Exhibition *117*
Untitled – Grasses, Lake George *364*
Untitled – Lake George *225*
Untitled (daughter of Rhoda Hoff de Terra and nurse, Lake George) *366*
Untitled (Rebecca Strand) *208*, *209*
Waldo Frank *57*, *151*
Weary *26*, *191*
The White Tombstone *298*
Window, An American Place *314*
Winter, Fifth Avenue *14*, *29*, *31*, *156*, *291*
Winter, New York *31*
PUBLICATIONS
"How I Came to Photograph Clouds" *220–23*
How the Steerage Happened *269*
The Intimate Gallery Exhibition Announcement *171*
One Hour's Sleep – Three Dreams *53*
127 Photographs (1892–1932) *288*, *289*
"A Plea for Art Photography in America" *28*
"Portrait – 1918" *153–54*
"Simplicity in Composition" *28*
"Stories, Parables and Correspondence" *290*

Stieglitz, Amanda (AS's sister-in-law) *363*
Stieglitz, Edward (AS's father) *15*, *16*, *22*, *25*
Stieglitz, Elizabeth Stieffel (AS's sister-in-law) *123*
Stieglitz, Emmeline (Emmy, née Obermeyer, AS's first wife) *33–36*, *38*, *55*, *58*, *130*, *135*, *146*, *167*, *213–14*
Stieglitz, Flora (AS's sister) *17*, *26*, *191*, *218*
Stieglitz, Hedwig (née Werner, AS's mother) *15*, *16*, *22*, *123*, *202*, *218*, *221*, *231*, *386*
Stieglitz, Julius (AS's brother) *17*, *123*, *304*, *364*
Stieglitz, Kitty (Katherine, later Stearns, AS's daughter) *33–37*, *94*, *95*, *105*, *167–68*
Stieglitz, Leopold (AS's brother) *17*, *123*, *135*, *304*
Stieglitz, Mary (née Reising, AS's sister-in-law) *364*
Stieglitz, Selma (AS's sister) *17*

Still, Clyfford 388
Stokowski, Leopold 255
Strand, Paul 62–68, 182
 and Albright Gallery 276
 and An American Place 189
 on AS 67, 157–58, 395, 397
 AS on 64–67, 132, 401
 and AS's 70th birthday 272
 at AS's funeral 393
 AS's influence on 411
 AS's portraits of 67
 AS's rift with 13, 261, 292, 293
 and Bloch 228
 Margaret Breuning on 170
 and *Camera Work* 43, 61, 62, 64, 86, 91
 correspondence with AS 72, 96, 216
 exhibitions 62, 63, 69, 86, 168, 174–75,
 189, 275, 276, 279, 292, 293, 300, 387,
 389, 392
 as film-maker 292–93, 305
 and Intimate Gallery 172, 174–75
 joint exhibition with Rebecca Strand
 292
 marriage and divorce 208, 292
 military service 72
 and *MSS* 153
 and New York Camera Club 63
 and Dorothy Norman 178, 340
 and Georgia O'Keeffe 106
 O'Keeffe on 106
 on O'Keeffe's work 166
 and Photo League 278
 "Photography" 64
 "Photography and the New God" 158
 and Charles Sheeler 72
 and 291 Gallery 64–66
 Abstraction 300
 Alfred Stieglitz 134
 Alfred Stieglitz and a Machine 157
 The East Siders 300
 Leaves 170
 New York 65, 66, 68
 New York – Wall Street 63, 64, 72
 New York (Blind Woman) 68
 Photograph (Abstraction, Bowls) 67, 69
 Photograph (Abstraction, Porch Shadows)
 67, 69
Strand, Rebecca 178, 188, 189, 202, 206–9,
 206, 207, 208, 209, 212, 271, 283
 joint exhibition with Paul Strand 292

Strasberg, Lee 292
Strauss, Flora Stieglitz (AS's niece) 123, 135
Strauss, Richard 142
Stravinsky, Igor 369
Strindberg, August 265
structural abstraction 265
Struss, Karl 63
Stryker, Roy 276–77
Stuck, Franz von
 Sin (Sensuality) 214
 The Sphinx's Kiss 214
Stuttgart, Germany, "Film and Photo"
 exhibition 189
Sullivan, Louis 272
Sullivan, Mary 188
The Sun 394
surrealism 50, 136, 265, 303
Swanson, Gloria 174
Sweeney, James Johnson 276, 387, 396
Swinburne, Algernon Charles 270
Switzerland 26
symbolism 90, 159, 228, 292
synchronist painting 77
Synthesists 74
Szarkowski, John 59

Taos, New Mexico 188, 248, 256, 271, 388
 Ranchos Church 188
Tapié, Michel 60
Taylor, Paul Schuster 277
Tchelitchew, Pavel 183
Tea Island, NY 19
Teapot Dome scandal 137
The Ten Commandments 240
Tennant, John 157
Tennessee 303
Texas 105, 108, 112
Thayer, Scofield 152, 153
Theosophy 150, 237
Thompson, Dorothy 263–64
Thompson, Virgil, *Four Saints in Three Acts*
 183
Thoreau, Henry David 61, 237
 Walden 411
391 (magazine) 60, 82, 300, 390
Time magazine 295
Tintoretto, Jacopo, *Alessandro Farnese* 282
Tokyo, University of 73
Tolstoy, Leo 22, 383
 What is Art? 383

Toomer, Jean 149–52, *151,* 153, 166, 214, 271,
 272, 303
 Cane 149–50
Torr, Helen 189, 283
Toulouse-Lautrec, Henri de 272, 293, 389
Transcendentalists 237
Transition, "Testimony against Gertrude
 Stein" 271
Triumph of the Will 262
True, Dorothy 123, *124*
Truman, Harry S. 380
Turgenev, Ivan 22
Turner, J. M. W. 234
Tutankhamun, tomb of 136
Twice a Year 29, 55, 285, 288–90, 390, 396
 "Observations on Barbarism and its
 Alternatives" (Seligmann) 290
 "Stories of War – of Tyranny – of
 Unemployment" 290
Twin Lakes, Connecticut 67
291 (magazine) 52–55, 61, 80, 88, 300, 390
 291 Throws back its Forelock 55
 closes down 91
 see also New York, 291 Gallery
Tzara, Tristan 271

Ulmann, Doris 189, 275
Union for Democratic Action 341
Union Tobacco Company 31
United Nations 38
United States Information Agency 387
The Upanishads (tr. Nikhilananda) 350
*Urformen der Kunsts Photographische
 Pflanzenbilder* 145
U.S. Resettlement Administration 292
Utamaro, Kitagawa 390

Vachon, John 277
Valentino, Rudolph 136
Valéry, Paul 152
 L'âme et la danse 90
Van Alen, William 265
Van Doren, Carl 273
Van Dyke, Willard 275, 294
Van Gogh, Vincent 77, 152, 155, 188
Van Vechten, Carl 83, 271
Vanity Fair 113, 174, 412
Varèse, Edgard 153, 341
Varnum, Fred 217
VE II Day 380

Verdi, Giuseppe 23
Vermont 303
Vienna 25, 125
 Graphische Lehr- und Versuchsanstalt
 26
 Secession 39, 43
 Wiener Club der Amateur Photogra-
 phen 26
Virginia 138
Vogel, Hermann 25
Vogt, Karl, *Lectures on Man* 195
Vogue 174, 403, 412
"Voice of America" 381
Voltaire 142, 143
 Candide 143
vorticists 79

Wagner, Richard 23–24, 91, 108, 142, 169,
 234, 259, 291, 396
 Götterdämmerung 23
 Die Meistersinger 23, 24
 Parsifal 258
 Das Rheingold 23
 Tannhäuser 23, 270
 Tristan and Isolde 17, 23
Walden Pond, Massachusetts 411
Walker, John 189, 276
Walker, Robert 283
Walkowitz, Abraham 77, 78, 84–86, 86, 88,
 89, 154, 280, 390
 From My Window 281
Wallis, Reese 271
Warburg, Edward 189, 276
Ward, Jacob Caleb 218
Warner Brothers 136
Warren, Robert Penn 143
Washburn, George 276
Washington, George 29
Washington, D. C.
 Library of Congress 398
 Lincoln Memorial 266
 National Gallery of Art 25, 46, 91, 151,
 398
 Phillips Memorial Gallery 187, 389

Watson-Schütze, Eva 39
Watzek, Hans 61, 272, 293
The Wave 292
Webb, Todd 393
Weber, Max 44, 57, 74, 76, 82, 83, 84, 101,
 185, 187, 188, 372, 406
 Essays on Art 76
 Still Life 281
Weegee (Arthur Fellig), *Naked City* 392
Weichsel, John 51, 78
Weidman, Charles 50
Welles, Orson 381
Wellesley College, Massachusetts 188
Werner, Adolph 17
Wertheim, Alma 291
Weston, Brett 412
Weston, Charis Wilson Weston 382
Weston, Edward 158, 189, 271, 275–76, 278,
 279, 294, 399
 California and the West (with Charis
 Wilson Weston) 382
Weyhe, Erhard 176
Whelan, Richard 17, 19
Whistler, James McNeill, *At the Piano* 28
White, Clarence 36, 38, 39, 44, 62, 63, 116,
 272, 293, 389, 406, 411
White, Minor 392–93
Whitman, Walt 61, 72, 138, 147, 148, 269,
 285
Whitney, Gertrude Vanderbilt 280
Whittridge, Thomas Worthington 218
Wilder, Billy 381
Wilder, Thornton, *Our Town* 262
Wilkie, Wendell 379
Williams, William Carlos 42, 137, 138, 142,
 143, 152, 153, 272, 292
 "The Great Figure" 138, 176
 In the American Grain 138
 Paterson 138
Williamsburg, Virginia, College of William
 and Mary 377
Wilson, Edmund 170
Wilson, Woodrow 49, 93, 136
Wisconsin 108, 158

The Wizard of Oz 268
Wojtowicz, Robert 272
Wolcott, Marion Post 277
Wolff, Adolf 51
Women's Auxiliary Army Corps 381
Wood, Grant, *Daughters of the Revolution*
 281
Woodbury, Walter 33
Woods Hole, Massachusetts 282, 340, 393
Works Progress Administration (W.P.A.)
 264, 265, 266, 295, 303
World War I 47, 68, 76, 79, 88, 93, 135, 174,
 382
World War II 174, 267, 269, 295, 377, 381,
 411
Wright, Frank Lloyd 369
Wright, Orville and Wilbur 43, 86
Wright, Richard 341
 12 Million Black Voices 277
Wright, Willard Huntington 76–77, 77
 The Creative Will 76
 *Modern Painting: Its Tendency and
 Meaning* 76–77
Wyoming 372

Yale University 60, 75
 Beinecke Library 23, 399
Yeats, W. B. 152
York Beach, Maine 135, 185–86
Yosemite Valley *296*, 297–98, 376
Young, Anita 287

Zen Buddhism 393
Zigrosser, Carl 176–77, 246, 290, 389
Zola, Emile, *L'Oeuvre* 22–23
Zoler, Emil 51, 91, 96, 97, *98*, 370, 401, 408
Zorach, Marguerite 78, 183, 185, 187
Zorach, William 51, 78, 369
Zurich, Cabaret Voltaire 80